FROM THE CLASSICISTS
TO THE IMPRESSIONISTS

From the

CLASSICISTS

to the

IMPRESSIONISTS

Art and Architecture
in the 19th Century

Volume III of *A Documentary History of Art*

SELECTED AND EDITED BY

Elizabeth Gilmore Holt

Yale University Press
New Haven and London

First published in paperback in 1966 by Anchor Books
(Doubleday & Co., Inc.). First published in hardcover in
1966 by New York University Press.

Printed in the United States of America.

Library of Congress catalog card number: 85–51918
International standard book numbers: 0–300–03358–3
0–300–03692–2(pbk.)

*The paper in this book meets the guidelines for per-
manence and durability of the Committee on Produc-
tion Guidelines for Book Longevity of the Council on
Library Resources.*

10 9 8 7 6 5 4 3 2

To the memory of Katherine Gilbert
philosopher, teacher, and friend

PREFACE TO THE YALE EDITION

Society's relation to every form of art has been intensified during the twenty years since this selection of documents first appeared. Urban planning and renewal, construction of civic buildings, cultural community centers, museums, and libraries erected throughout the world have directed people's attention to contemporary architectural forms. In these twenty years the artist in the western world has become the interpreter of the social concerns of his community, and of contemporary culture itself. At the same time, art historians have reexamined and interpreted the concepts of "Classicism," "Romanticism," "Realism," and "Impressionism." Publications about these movements abound, and exhibitions are viewed by thousands of visitors.

As time carries us further away from the art and architecture of the nineteenth century and as our views of this period change, the contemporary documents retain their freshness and authenticity. They are indeed essential for interpretation and understanding. Thus the original collection of sources and the suggested readings at the end of each section have not been changed since the first edition of this book was published in 1966. For a full bibliography that reflects the recent developments in nineteenth-century art research, see Robert Rosenblum and H. W. Janson, *Nineteenth Century Art* (New York, 1984).

ELIZABETH GILMORE HOLT *Georgetown, Maine, 1985*

PREFACE

During the nineteenth century institutions and attitudes gave way to new forms and relationships. Traditions in governmental and social institutions, traditions in social behavior and processes of production, traditions in methods and materials of construction in architecture and in modes of representation in the visual arts were discarded.

The nineteenth-century artists were therefore called upon to devise forms that would be expressive of European life, which was transforming itself into the industrial and technological age of the twentieth century. Throughout the century new expressions were sought for cultural concepts, the products of a freedom unfettered by conventional conformity. Architecture acquired new social functions in the changed society, and the architect was called to meet the requirements of various groups of citizens. Painters and sculptors reached behind the screen of traditional art to bring forward new symbols and emblems to satisfy their own "inner necessity" and that of their culture.

This search, carried on throughout the century, produced a constant tension between the academic, official, and conventional members of society and society's creative artists, who were compelled by their genius to be thus engaged. The first group was determined to maintain a *status quo*. The second was bound to discover means and methods to represent the concepts that were emerging from the cultural heritage. These periods of transformation called for the critic both to defend the accepted and the known and to explain the new gestation to eyes fixed on traditional images. The patron, to whom both parties addressed their case with the aid of the critic, was now the public, rather than the connoisseur.

Romanticism dominated the entire century. Styles of the past were used for their sentimental association rather than for aesthetic qualities, and in architecture, archaeological exactitude and historical re-constitution became the disciplining factor rather than taste.

It was the century of historicism. History was seen as the key to the problems of "the brave new world." A sense of history impregnated all visions and concepts. The nineteenth-century historian and artist shared the same aim, to present the unsystematic diversity of peoples, cultures, customs, and myths in a process of evolutionary transformation, that was to be comprehended by feeling. The artist must bring back to life the spirit of the past "to show only what really happened," as Leopold von Ranke, the great nineteenth-century German historian, expressed it. The present, the "becoming," was likewise portrayed through the prism of temperament.

In view of the quantity of material for the nineteenth century, its documentation within the limits of a single volume could not be as comprehensive as it could be for previous centuries. The documents have been chosen to show features that are most characteristic of the century. Because the changes in society were so extensive and so diversified, the choice had to be one limited to those which seem to be the most particular to the epoch.

As the growth of Western European culture is the fruit of the various national components, documents have been selected to illustrate some of the contributions of English, German, French, and American artists and writers during the nineteenth century to the evolution of Western European art.

The nineteenth century is not an exception in being dominated by a few great creative geniuses, and the documents pertaining to them are predominant in such a collection. To these have been added documents less known but no less important for a comprehension of the century and significant for the formulation of the art of the century.

The editor does not presume to be an authority on the many divergent trends and subjects in the various fields of art or on the lives of the artists of the nineteenth century. Collections such as this can only be made with the constant consultation of the authoritative studies of the period, such as H. R. Hitchcock, *Architecture: Nineteenth Century;* F. Novotony, *The Painting and Sculpture of the 19th Century;* John Rewald, *History of Impressionism and Post-Impressionism;* A. Whittick, *Symbols, Signs and Their Meaning;* A. M. Whitehead, *Symbolism, Its Meaning and Effect;* The Arts Council of Great Britain, *The Romantic Movement; Les Sources du XX siècle, les arts en Europe de 1884 à 1914;* the numerous

monographs on the individual artists (listed at the end of the biographical sketches in this text); and the stimulation to be received from Werner Hofmann, *The Earthly Paradise, Art in the Nineteenth Century*. The editor is glad to express again her obligation to Dr. Katherine Gilbert and *The History of Aesthetics*. As the field of knowledge is ever widening, every scholar is obliged to learn the lesson of humility in his dependence on the knowledge of his colleagues.

The biographical sketches attempt to bring together from the writings of the specialists information necessary for greater comprehension of the documents. To these authorities, the editor, as any student, is glad to acknowledge their contribution to the head-notes and biographical sketches.

Translating the writings of the nineteenth-century artists presents particular difficulties. These artists attempted to express wholly new concepts, to approach their subject matter in a different manner. As conventional expression or words often did not satisfy them, what they wrote was clear at times only to themselves. Some of the works in this volume—comparable in their complexity to fifteenth-century Italian texts—have never before been translated into English. In the translations which appear here, obscure passages have not been subjectively interpreted for clarity in the translation. The readability that could be achieved through paraphrase has been sacrificed so that the groping for expression of the artist may be apparent. Reference to the original texts should be made by those who wish to make their own interpretation. The translations here are offered with that sense of inadequacy that every translator experiences, and with the hope that other translations may be the positive consequence of any dissatisfaction with these.

For translations from the French, the editor thanks Mr. William Homer, Princeton, for his translation of George Seurat's letter; Celina Jenkins for her assistance with those of Ledoux, Boullée, and Durand; and Elizabeth Holt Muench for all others. Dr. Gertrude Harms Halloway and Gerhard Froehlich collaborated in those from German.

All footnotes are from the original texts, except those in brackets, which are by the editor.

It is a pleasant task to recall and express my gratitude for the kindly, patient counselling I have received from many scholars, curators, librarians, and friends. Among these I mention especially Professor E. Gombrich, Dr. N. Pevsner, Dr.

L. D. Ettlinger, M. Jean Adhemar, M. Philippe Aries, Profes-
sor Howard Mumford Jones, Professor W. Sypher, Professor
H. W. Janson, Miss Agnes Mongan, Professor J. Coolidge,
Dr. U. Middeldorf, Professor R. Alexander, Professor F. Dek-
natel, Professor S. Slive, Professor M. Barash, Miss Dorothy C.
Miller, Mme I. Giron, Miss E. Louise Lucas, Miss Caroline
Shillabar, Mr. Bernard Karpel.

I am most grateful to Mr. Pyke Johnson, Jr., the editor, for
his wisdom, discerning judgment, and unfailing understanding,
and to Mrs. Diane Appelbaum and Mrs. Angelica Rudenstine
for their assistance.

The selection of the illustrations has been made with the
present-day limitations of the technical processes in mind.
Miss Agnes Mongan and Miss Elizabeth Mongan gave wel-
come counsel in their selection. The handsome Flaxman draw-
ing is reproduced with the kind permission of Miss Agnes
Mongan. The kindness of the Director of the Rodin Museum,
Mme Goldscheider, made possible the inclusion of the unique
photograph of "St. John the Baptist" in that Museum. Per-
mission to reproduce pictures and photographs is gratefully
acknowledged here and in the captions for the illustrations.

As I am an itinerant scholar, I have deeply appreciated the
courtesy shown me and the privileges extended to me in the
use of the library facilities and the book collections at the fol-
lowing institutions: The Eidgenoessiche Technische Hoch-
schule, the Zentrale Bibliothek, Zürich, Salles des Estampes,
Bibliothèque Nationale, Courtald Institute of Art, and War-
burg Institute, University of Washington, State University of
Iowa, American University, Bowdoin College, The Library
of Congress, the Museum of Modern Art, the Fogg Art Mu-
seum Library, and Widener Library, Harvard University, and
the Lalit Kala Akademi, New Delhi.

The encouragement and assistance I received from the
Trustees of the Chapelbrook Foundation contributed in large
measure to the completion of this volume.

ELIZABETH GILMORE HOLT *Georgetown, Maine, 1965*

CONTENTS

I. Classicism

II. Romanticism

III. On the Architecture of the Nineteenth Century and Some Architectural Forms Characteristic of the Century

V. Artist and Society

VI. Search for Form and Symbols

LIST OF ILLUSTRATIONS

PLATES

Following page 92

LINE DRAWINGS

BIBLIOGRAPHICAL ABBREVIATIONS

The editor's two other volumes in this series have been cited throughout in abbreviated form. These are:

Holt, Vol. I	E. G. Holt, *A Documentary History of Art,* Volume I: The Middle Ages and the Renaissance. New York: Doubleday, Anchor Books, 1957; Princeton: Princeton University Press, 1981.
Holt, Vol. II	E. G. Holt, *A Documentary History of Art,* Volume II: Michelangelo and the Mannerists: The Baroque and the Eighteenth Century, New York: Doubleday, Anchor Books, 1958; Princeton: Princeton University Press, 1982.

Great spirits now on earth are sojourning,
He of the cloud, the cataract, the lake,
Who on Helvellyn's summit, wide awake,
Catches his freshness from Archangel's wing:
He of the rose, the violet, the spring,
The social smile, the chain for freedom's sake:
And lo! whose steadfastness would never take
A meaner sound than Raffaele's whispering.
And other spirits there are standing apart,
Upon the forehead of the age to come;
These, these will give the world another heart,
And other pulses. Hear ye not the hum
Of mighty workings?—
Listen awhile, ye nations, and be dumb.[1]

[1] B. R. Haydon received from John Keats this sonnet, November 19, 1816, the day following Haydon's dinner at which Wordsworth, Keats, and Shelley were guests. *The Autobiography and Memoirs of Benjamin Robert Haydon,* ed. by Tom Taylor, London, 1926, p. 252.

I. CLASSICISM

[JACQUES-LOUIS DAVID (1748–1825) had his first art lessons with François Boucher, the popular court painter of sophisticated prettiness, who advised him to enter Vien's atelier. When Vien, the leader of the new "sublime" style, was named director of the French Academy in Rome, David, winner of the Prix de Rome (1774), accompanied him. During the years there, 1775–80, David laid the foundation for his style of painting. It was shaped by the principles of art then being developed in Rome as a result of the discovery of Herculaneum and the excavations at Pompeii.

Winckelmann, Lessing, Caylus, and the influential painter and teacher Anton Raphael Mengs, held that the highest beauty was Greek art as expressed in the human figure. The beauty resulted from the tranquil effect of the figure's various parts and was achieved by means of a functional elliptical line that gave a harmonious design to their relationship. Winckelmann asserted, " 'Tis not in the power of Algebra to determine which line, more or less elliptic, forms the divers parts of the system into beauty—but the ancients knew it; I attest their works, from the gods down to their vases." These scholars looked to a return to the aesthetic standards of Greek art as the means for reforming the art of their time burdened by excessive expressions of emotion and delicate sophistication. The art they envisioned, they believed, would likewise serve to restore the moral fiber of their culture; the result desired from the art of the past was a return to virtue comparable to that sought from nature by Rousseau.

With Quatremère de Quincy and another young sculptor, David went to Pompeii and Herculaneum where he was vividly impressed with the life and art of the classical past. He determined to express in his own art that reality of nature which he saw in classical art.

David's first picture, "Belisarius Asking Alms," depicting

the victim of an emperor's ingratitude, was painted on his return to Paris (1781) and characterized his severe neo-classic style in which nature is expressed by the functional contour line of the antique art. This scored him success in the 1781 Salon, and he was admitted as an *agréé* or officer to the Academy. Great acclaim was given to the "Grief of Andromache" (1783), the "Oath of the Horatii" (1785) painted after a short trip to Rome, the "Death of Socrates" (1787), "Paris and Helen" (1788), and "Brutus" (1789). These vast canvases—executed in a restrained cool manner, the forms given by elliptical lines and arranged to achieve an effect of dignity and severity—became political manifestations because visually and in subject matter they corresponded to the current interest in the civic virtues of republican Rome and to the constant French predilection for moralizing and rationality. This style of neo-classicism became identified with the revolutionary movement in France and answered an ethical demand. Although his paintings were viewed as salutary for the national morality, the entrenched Academicians attempted to exclude them from the Salons. David thus became the acknowledged leader of a new school of painting, a recognized opponent of the ancient Academy, and the most famous painter of France.

David participated actively in the political events that led to the overthrow of the monarchy and, as a Jacobin, was known as the "Robespierre of the brush." He sought the reform of the Royal Academy of Painting and Sculpture and, unable to achieve that, set out to destroy the monopolistic, despotic, and aristocratic institution and its school with a rotating faculty. David favored the studio method that had been practiced prior to the seventeenth century and admitted students to his own studio for instruction. In this he was opposed by Quatremère de Quincy, who favored the establishment of an Ecole des Beaux Arts for academic instruction and would provide state control of all education. In September 1790, David was able to form the Commune of the Arts and to open the Salon (1791) to all artists, academicians, and non-academicians. At the same time, the society formed from the third estate to celebrate the anniversary of the "Oath of the Tennis Court" commissioned David to execute a large painting to commemorate the event. Although the painting was never completed, a finished drawing was exhibited and engraved.

David was elected to the National Convention in Septem-

ber 1792. He served with his close friend, Robespierre, on the Committee of General Security, voted for the death of Louis XVI, was the dominant member of the Committee of Public Instruction, and was elected in June 1793, President of the Convention. David secured a Commission of Arts to replace the Academy, and suppressed the Commune des Arts which had become dictatorial, creating in its place a Jury of Arts, to which he named the fifty members. This gave way in October 1795, to the Institut de France formed from members of the Commune des Arts and surviving members of the Academie Royale. It received the social functions of the Academy and the instruction was assigned to the Ecole des Beaux Arts. David also envisioned a complete reconstruction of Paris. Many features of his "Plan des Artistes" were carried out by Napoleon I and later by Baron Haussmann under Napoleon III.

During this period of intense political activity, as the "pageant master of the Republic," David arranged and staged the national fetes, religious festivals, and the state funerals for Marat and two preceding Jacobin martyrs. His painting "Marat Murdered" is masterly in its composition and simplicity. At this time, 1793, David was in full control of all that pertained to art and artistic monuments in France.

Imprisoned after the fall of Robespierre, David renounced all political activity on being released by the Directory. He established a studio to which young painters came from all Europe that in a way took the place of the Academy. In it life drawing, formerly only an addition to craftsmanship training, now replaced such training as the principal activity. The "Rape of the Sabines" (1799) marked the culmination of his fame and the realization of the principles of ideal beauty found in the Greek style.

Responsive as he was to heroic, patriotic, and naturalistic qualities, David early attached himself to Bonaparte. His admiration began with his first idealized portrait, "Napoleon at St. Bernard" (1800). Napoleon, recognizing David's value to himself, named him *premier peintre* in 1804 and a Knight of the Legion of Honor, and commissioned four great canvases for Versailles, of which only the "Sacre" (1808; also known as "Napoleon Crowning Josephine") and the "Distribution of the Eagles" (1810) were completed.

The painting of David's final period is "Leonidas at Thermopylae" (1814).

For half a century David's style dominated the art of Europe, with only Spain and England excepted. As an acute observer with skill in recording the reality that he saw, his portraits such as "Mme Récamier" (1800) and "Pope Pius VII" (1805) are among the greatest of the century. He was a marvelous draftsman, a master of linear decoration and possessed a sureness in arrangement that achieved for his work an effect of restrained vigor and dignity.

After the Hundred Days, David fled to Brussels. He opened a studio and lived there in exile as an active influence in European art until his death in 1825.

SEE: W. Friedlaender, *David to Delacroix*, Cambridge, Mass., 1963.

D. L. Dowd, *Pageant Master of the Republic, J. L. David and the French Revolution*, Lincoln, Neb., 1948.]

THE PAINTING OF THE SABINES[1]

Foreword

Antiquity has not ceased to be the great school of modern painters, the source from which they draw the beauties of their art. We seek to imitate the ancient artists, in the genius of their conceptions, the purity of their design, the expressiveness of their features, and the grace of their forms. Could we not take a step further and imitate them also in the customs and institutions established by them to bring their arts to perfection?

For a painter the custom of exhibiting his works before the eyes of his fellow citizens, in return for which they make individual payment, is not new. The wise Abbé Barthélemy, in his *Journey of the Young Anacharsis*, speaking of the famous Zeuxis, did not lose the opportunity of observing that the painter acquired, from the showing of his paintings, rewards

[1] The Picture of the Sabines, exhibited to the public at the National Palace of the Sciences and the Arts, Hall of the Former Academy of Art by The Citizen DAVID, member of the National Institute, Paris, Year VIII. Translated from the texts found in *Recueille* by P. J. Mariette, C. N. Cochin, and M. Deloynes. *Catalogue de la Collection de Pièces sur les Beaux Arts*, George Duplessis, Paris, 1881, Tome XXI.

that so enriched him that he himself was often able to make gifts of his masterpieces to the nation, saying that he knew no private individual capable of paying for them. On this subject he cited also as witnesses Elien and Pausanias to prove that the habit of public exhibition of paintings was permitted by the Greeks, and that certainly, when we have to do with the arts, we should not fear to err ourselves if we followed in their footsteps.

In our own time this custom of showing the arts to the public is practised in England and is called *Exhibition*. The pictures of the death of General Wolf and of Lord Chatham, painted by our contemporary, West,[2] and shown by him, won him immense sums. The custom of exhibition existed long before this, and was introduced in the last century by Van Dyck: the public came in crowds to admire his work: he gained by this means a considerable fortune.

Is this not an idea as just as it is wise, which brings to art the means of existing for itself, of supporting itself by its own resources, thus to enjoy the noble independence suited to genius, without which the fire that inspires it is soon extinguished? On the other hand, could there be a more dignified and honourable means of gaining a share of the fruit of his labours than for an artist to submit his works to the judgment of the public and to await the recompense that they will wish to make him. If his work is mediocre, public opinion will soon mete out justice to it. The author, acquiring neither glory nor material reward, would learn by hard experience ways of mending his faults and of capturing the attention of the spectators by more happy conceptions.

Of all the arts which genius practises it is painting that incontestably demands the most sacrifices. It is not unusual to have spent two or three years on the completion of an historical painting. I will not enter here into any detail as to the expenses which the painter must consider before undertaking the work. The cost of costumes and models alone is considerable. These difficulties, one cannot doubt, have discouraged many artists and we have perhaps lost many masterpieces which the genius of not a few among them had conceived, which poverty alone had prevented them from carrying out. I will go further: how many honest and virtuous painters, who would never have lent their brushes except to noble and

[2] [American Benjamin West (1738–1820), President of the Royal Academy from 1792–1805.]

moral subjects, have made them serve degraded and unworthy ends because of their need? They have prostituted themselves for the money of the Phrynes and the Laïses:[3] it is their poverty alone which has made them guilty, and their talent, born to strengthen the respect for good conduct, has helped to corrupt it. How sweet would it be to me, how happy I should consider myself, if by giving the example of public exhibition I could favour such a custom. If the habit of exhibition could offer to the gifted a means of release from poverty, and if, as a result of this first opportunity, I might help to bring the arts nearer to their true destination which is to serve morality and to elevate the soul, thus extend to the hearts of the spectators those generous sentiments called into being by the productions of the artists! It is a great secret to touch the human heart, and by this means a great impulse might be given to the public energy and to the national character. Who can deny that until now the French people have been strangers to the arts, and that they have lived among them without participating in them? Painting or sculpture offer rare gifts; they become the conquest of a rich man who may have purchased them at a low price. Jealous of his exclusive possession, he admits only a few friends to share a sight forbidden to the rest of society. Now, at least, by favouring the custom of public exhibition, the public, for a modest payment, shares a portion of the riches of genius; they may likewise come to know the arts, to which they are not as indifferent as they affect to believe; their understanding will increase, their taste be formed. Although not experienced enough to pronounce upon the fine points or the difficulties of art, their judgment, constantly inspired by nature and always born of emotion, might often flatter and even enlighten an artist whom they have learned to appreciate.

Moreover, with what regret and grief have men, sincerely devoted to the arts and their country, seen masterpieces of great price pass to foreign nations while their own country, where they were produced, scarcely took notice. Public exhibition would tend to keep such masterpieces in the happy country where they were born; by such means we might hope to see the great days of Greece live again—a land where the artist, satisfied with the sums awarded to him by his fellow citizens, will be happy to make a gift to his countrymen of the masterpieces which they have admired. Having been hon-

[3] [Two famous Greek courtesans.]

oured for his talents, he will end by deserving well of his fellow citizens for his generosity.

I shall doubtless be told that every people has its customs; and that the public exhibition of the arts has never been introduced into France. I answer, in the first place, that I do not undertake to give an explanation of the contradictions of human nature: but I do ask whether it is not true that a dramatic artist gives the greatest possible publicity to his work and receives a portion of the money of the spectators in exchange for the emotions and the varying pleasure he has given them by displaying their passions or their absurdities? I ask if a composer of music, who has given soul and life to a lyric poem, blushes when he shares with the author of the words of the poem, the profits of his creation? Shall what is honourable in one art be humiliating in another? And if the different arts themselves are all members of one family, may not all artists feel themselves as brothers and follow the same laws by which they may arrive at gain and fortune?

I answer again that we must make speed to do what has not yet been done if we wish to do good. What holds us back, then, from introducing into the French Republic a custom which the Greeks and the modern nations have given us? Our old prejudices no longer oppose us in the exercise of public liberty. The nature and the development of our ideas have changed since the Revolution, and we shall not return, I hope, to the false delicacy which had for so long constrained genius. As for myself, I recognize no honour higher than that of having the public as judge. I fear from it neither passion nor partiality: the rewards it bestows are voluntary gifts, witnesses to its taste for the arts: its praise is the free expression of the enjoyment it experiences; such recompense is, without doubt, equal to that of academic times.

The considerations I have proposed as to the custom of public exhibition, of which I shall have been the first to give an example, was especially suggested to me by the wish to obtain for the artists, dedicated to painting, a means by which they might be repaid for the sacrifice of their time and money, and to insure to them a resource against poverty—not seldom their unhappy lot. I have been encouraged and helped in these ideas by the government which, on this occasion, has given me a proof of the remarkable protection it accords to the arts, in furnishing me a place for my exhibition, together with other considerable requirements. I shall have received a most

flattering reward if, by the public having come to enjoy my picture, I may have been able to point a useful road to the artist, and, by giving him encouragement, contribute to the advancement of art and to the perfecting of a righteous spirit which we should, without doubt, have for our aim.

After having here set forth my sincere intentions, it remains for me only to give to the public an explanation of the subject which I put before their eyes.

Explanation of the Exhibition

The origin of the Roman Empire is wrapped in obscurity. The fact on which historians differ least is that after the fall of Troy, some Trojans took to their ships and, having been tossed by the winds on the coast of Tuscany, landed near the river Tiber and established themselves at the foot of the Palatine Hill.

It is outside my subject to enter into the details of the happenings that preceded the existence of Romulus. I shall attempt only to make known the sense of grandeur and the traditions of divine descent which the Roman people were pleased to attribute to their founder.

What is only fiction for the historian is an incontestable fact to the painter or the poet. In their eyes Romulus and Remus, his brother, are the twin sons of Mars and Rhea, a priestess consecrated to the cult of Vesta.

Amulius, king of Albe, father of Rhea, viewing the pregnancy of his daughter with opprobrium, resolved to have the children perish by exposing them, both in the same cradle, on the waters of the Tiber. These children of a god were saved by a double miracle. They were thrown on the bank of the river, where a she-wolf, shedding for them her natural ferocity, took care to suckle them. The shepherd, Faustulus, witnessing this wonder, was struck with astonishment; and, touched by the charm of these infants, took them to his home and reared them as though they had been his own sons.

From earliest infancy, an air of nobility and grandeur, together with an extraordinary stature, enhanced the appearance and seemed to predict a high destiny for the twins. Romulus, however, invariably outshone his brother, as much by force of character as by boldness of ideas. The children of the neighbouring shepherds, his companions, were not slow to

recognize his superiority; they named him their chief, and they placed him at their head in all their enterprises.

Romulus loved war. His natural ambition was strengthened by predictions made to him by certain oracles, foretelling that he should one day found a city which should rise to the heights of splendour and glory. When he laid down the foundations of Rome, he forgot nothing that would attract the shepherds of the neighbouring countries, the fugitive slaves, and all strangers suited for great enterprises. Such were the humble beginnings of an empire which, in the future, should subjugate the world. *Genus unde latinum.*[4]

In this state of a new-born people, there were few women among the Romans. The daughters of the Sabines, a tribe living at a distance of about five leagues, in the neighbourhood of Rome, attracted their attention. These women were celebrated for their beauty and modesty. In order to secure them, Romulus used a means familiar to warrior peoples—violence.

He let it first be known that he had found, buried in the ground, the altar of a god called *Consus,* a divinity held in veneration by his neighbours, believed to be *Equestrian Neptune.* When this rumor had been accepted as true, he announced to all that upon a day he named he would make a solemn sacrifice. This would be followed by a festival and games, to which he invited all strangers, and in particular, the Sabines, whose women he coveted. Strangers flocked to the spectacle from all sides. Romulus, dressed in purple and accompanied by the leaders of the Romans, was seated on the highest place. He had agreed upon a signal when, after standing, he should fold a part of his robe and then unfold it; his soldiers should then rush to the daughters of the Sabines, seize them, and carry them off, while allowing the Sabine men to flee without pursuit.

This daring plan was carried out, and the young Sabine women, despite their prayers, their despair, and their cries, were carried off to Rome, where the Romans married them, treating them afterwards with every token of esteem.[5]

Sooner or later punishment comes. The Sabines, keenly alive

4 ["From whence the Latin race."]
5 We here note in passing that the event of this rape has been portrayed by the severe and moving brush of Poussin, to whom the modern Romans have given the name of *divine.* I have dared to treat a later episode at the moment when the armies of the Sabines and the Romans are separated by the Sabine women.

to the outrage done to their daughters, tried on many oc-
casions to wreak revenge upon the Romans. At the end of
three years, and after the Sabine women had become mothers,
Tatius, their king, still burning with anger at so infamous a
kidnapping, called together his most courageous warriors and
swooped down with them upon Rome, in order to destroy the
ravishers. Rome was taken by surprise. The Sabines already
held the ramparts of the Capitol, which they had secured
through the treason of Tarpeia. Hearing this news, the Romans
armed themselves in haste, set out and marched upon the
enemy. Battle was joined; both sides attacked. The two chiefs,
animated by equal fury, met in the centre of the melee and
made ready for the single combat according to the custom of
these heroic days.

But what may not conjugal and maternal love together ac-
complish? The Sabine women, who had been kidnapped by
the Romans, suddenly rushed upon the scene of battle; their
hair streaming in the wind, carrying their naked children at
their breasts, they passed the piles of dead and the horses
frenzied with the combat. They called loudly to their fathers,
their brothers, their husbands, addressing themselves now to
the Romans, now to the Sabines, calling them by the sweetest
names known to men. The combatants, softened by pity, gave
place to them. One of them, Ersilia, wife to Romulus, to whom
she had borne two children, came forward between the two
chiefs. "Sabines, what are you doing below the walls of Rome?"
she cried. "These are no longer daughters whom you would
restore to their parents, nor ravishers whom you would punish.
We should have been dragged from their arms while we were
still strangers. But now we are bound to them by the most
sacred ties; you would tear wives from their husbands, mothers
from their children. The succour which you wish to give us
now is a thousand times more heart rending than the abandon-
ment you left us to suffer when we were carried away. If you
make war for a cause that is not ours, we still have the right
to call upon your pity, since it is by us that you have been
made grandfathers, fathers-in-law, brothers-in-law, and allies
to those whom you fight. If this war has been undertaken only
for us, we beg you to give back to us our fathers and our
brothers from among you, without taking from us those of the
Romans who are our husbands as well as our little children."
These words of Ersilia, accompanied by her tears, echoed in
every heart. Some of the women who accompanied her laid

their children at the feet of the soldiers, who let their bloody swords fall from their hands. Others lifted up their nurslings in their arms and held them like shields against the forest of lances, which dropped when confronted by them. Romulus laid down the javelin that he held ready to hurl at Tatius. The general of the cavalry thrust his sword into its sheath. The soldiers took off their helmets as a token of peace. The feelings of conjugal, paternal, and fraternal love spread from rank to rank in both armies. Soon the Romans and the Sabines embraced and then became one people.

Note: On the Nudity of My Heroes

One criticism which has been made to me, and will without doubt be repeated, deals with the nudity of my heroes. The examples to be noted in my favour are so numerous in what remains to us of ancient art, that the only difficulty I find is to make a choice. This is what I would answer: It was a recognized custom among the painters, sculptors, and poets of antiquity to portray gods, heroes, and in general the men whom they wished to represent, in the nude. Were they painting a philosopher? He was nude, with a mantle on his shoulders and the emblems of his character. Were they painting a warrior? He was nude, a helmet on his head, his sword hanging from its band, a shield on his arm, and his buskins on his feet. Sometimes a drapery was added, if they judged that it would add to the grace of the figure, as may be seen in my painting of Tatius; or still better as one may observe displayed at the Central Museum of the Arts, the figure of Phocion, newly come from Rome. Are not the sons of Jupiter, Castor and Pollux, the works of Pheidias and Praxiteles at Monte Cavallo, nude? The Achilles of Villa Borghese is likewise nude. At Versailles, on the so-called Medici vase, a bas-relief may be seen representing the sacrifice of Iphigenia: Achilles is here again nude, as is the majority of the other warriors around the vase. In the museum of the sculptor Giraud[6] in the Place Vendôme, a bas-relief of Perseus and Andromeda is shown. The hero there is nude, although he has just ended his battle with a monster who spits forth poison. In the national library,

6 [Pierre François Giraud (1783–1836) possessed an academic style that gave ingratiating charm to his statues.]

in the book of prints of Herculaneum,[7] is depicted the departure of Ippolitus for the hunt, in the presence of Phedre; he is nude. How many other authorities could I mention? Those that I have just spoken of will without doubt be enough, so that the public will not be surprised that I should have tried to imitate the great models in my Romulus, who is himself the son of a god. Here is one example that I have kept for the last, since it is the sum of all the others: it is Romulus himself, represented nude on a medal, at the moment when, after having killed Acron, king of the Cenineens, he brings on his shoulders a trophy made of the royal arms, which he afterwards places in the Temple of Jupiter Feretrien; these were the first arms seized from the enemy's general. I believe now that I have satisfactorily answered the criticism which has been made to me—or may be made—on the nudity of my heroes: such an answer permits me to appeal to the artists. They know better than any one else how much easier it would have been for me to paint my figures clothed; let them say how much draperies would have helped me to find easier ways to make my figures stand out on my canvas. I think, on the contrary, that they will be satisfied with the difficult task I imposed on myself, convinced of the truth that he who may accomplish the most could have done the least. In a word, in painting the picture my desire was to represent the customs of antiquity with such an exactitude that the Greeks and the Romans, had they seen my work, would not have found me a stranger to their customs.

Observations on the Painting

JOURNAL DE PARIS[8]

The ruling custom of the arts has changed, or, rather, there is no longer any system for the arts. Brought back once more to their true goal by the imitation of nature, supported by the study of antique models, they turn once more to moral and political preoccupations. In perpetuating the traits of heroism and virtue, even during the storms of the Revolution, they

7 [Herculaneum was a Roman city at the foot of Mt. Vesuvius. It and Pompeii were destroyed by the same volcanic eruption in A.D. 79. It was excavated in 1736, and Pompeii in 1748. Both cities were visited by David.]

8 [*Journal de Paris* published the views of the government.]

have ventured on a new flight, and all proclaim that this movement toward a state of greatness should gain in strength and that they should receive from the new order of things a real and permanent lustre.

The artists themselves have begun this valuable work of regeneration: it is for the government to carry it on. It should be convinced that these arts, so useless in the eyes of cold and superficial politicians, will have a powerful influence on every branch of industry and consequently upon the national glory and prosperity. What can the lovers of fine arts not look for from an honourable peace, the outcome of which cannot be doubted?

We have said that the artists have united all their efforts for the regeneration of the arts. One of these artists, long distinguished in the most flattering manner by the public, has once more renewed a custom which in the happy days of Greece assured to painters and sculptors a fortune worthy of their talents—a noble independence, lasting celebrity, and above all, the means of offering as gifts to their country the masterpieces which made them famous.

It was to the public exhibition of their works that the men of the ancient world owed their most brilliant success. One among the moderns who emulates them, the author of the painting of the Sabines, has cause to boast. He has imitated them in this praiseworthy custom. The lovers of art go in crowds to admire his work, and the material gain which he will acquire by this exhibition will be the least of his rewards. The appreciation of the public is a more worthy object of his ambition.

We invite our readers, who are perhaps expecting from us a description of the painting of the Sabines, to go to see the work itself in the *atelier* of the artist. We should be loth to weaken the effect by analyzing the composition. The subject is well known. The Romans kidnapped the daughters of the Sabines. Three years later, to revenge the outrage done them, the Sabines surprised the ravishers and fought them under their own walls. But the Sabine women, who had tasted the joys of Hymen, precipitated themselves, with their little children, into the melee of the two armies. By their tears and their prayers they prevailed upon the two chiefs to renounce the single combat for which they were arming, to reconcile their fathers with their husbands, and at last to unite the two people by bonds of blood and of friendship.

14

CLASSICISM

It is this sublime and touching scene which Citizen David has treated with a success worthy of his reputation. Beauty of style, noble characterization, truth of expression, tense and correct draughtsmanship, large, simple and natural effect, true colour, profound erudition in the portrayal of countenances and costumes, sure and deeply-felt execution: these are the principal qualities which strike one in this beautiful work. Could the meticulous eye of cold criticism discover the slight flaws from which the most celebrated masterpieces are not exempt, even before the pictures of Raphael and of Rubens, those two lights of art, it is easy to be convinced that the same work may combine the most obvious faults with the most sublime beauty.

[ANTOINE C. QUATREMÈRE DE QUINCY (1755–1849), influential scholar and permanent secretary of the Institut des Beaux Arts, began his career as a sculptor. His study tour in Rome coincided with that of David's. Quatremère also imbibed the doctrine of Winckelmann in Rome and turned from sculpture to archaeology.

On his return to Paris, Quatremère secured by a prize-winning essay the editorship of the *Dictionnaire d'architecture,* a work of contemporary importance that appeared between 1795–1825. With this work, Quatremère began his career as an essayist and well-known writer.

Active as a moderate in the revolutionary movement, Quatremère was elected by the "communes" of Paris to the Legislative Assembly in 1791. A defender of Lafayette and a spokesman for a constitutional monarchy, Quatremère was imprisoned but was acquitted from a death sentence. With the changing political events, he became a deputy in the newly established parliamentary system under the Directory, the Council of Five Hundred. Throughout the Revolution, he was allied with David but opposed David's extreme measures with more moderate ones. His *Considérations sur les Arts du Dessin* (1791) attacked the Academicians.

Quatremère courageously published a protest, *Lettres sur le préjudice qui occasionne orient aux arts,* over the removal of art works from Italy to Paris for the Museum of Napoleon. Some of the *Lettres* were included in a later publication, *Lettres sur l'élevement des ouvrages de l'art antique à Athenes et*

à Rome (1836). This had wide circulation in Europe and was helpful in securing the restitution of the Italian art works after the defeat of Napoleon. Quatremère contended that Italy, and especially Rome, was a type of museum to which students must go in order to complete their studies.

With the restoration of the Bourbons and Louis XVIII, Quatremère was made (1816) permanent secretary of the section of fine arts that was responsible for the social functions in the Institut des Beaux Arts, an establishment comparable to the former Royal Academy, and served for twenty-three years. In this position he opposed the nascent romanticism and confirmed the principles of Winckelmann in France.

Quatremère left numerous treatises on archaeology and the fine arts. *The Destination of Works of Art and the Use to Which They Are Applied* and *An Essay on the Nature, the End and the Means of Imitation in the Fine Arts* (1823) were widely read and translated into English. Quatremère traveled to London to view the Elgin Marbles and his essay letters on them to the Italian sculptor, Canova, were published and also translated into English. In a lecture on the Venus de Milo, Quatremère, as in all his writings, identifies the ideal value of art with classical art. It and the Elgin Marbles, two original masterpieces of Greek art, did as much to change the existing conception of classical art as they did to free art from the concept of a single ideal type and thereby stimulated naturalism in the representation of the nude in the first half of the nineteenth century.

SEE: R. Schneider, *Quatremère et son intervention dans les arts, 1788–1830,* Paris, 1910.

A. Rodin, *Venus, to the Venus of Melos,* translated by D. Dudley, New York, 1912.]

A COMMENTARY ON AN ANTIQUE STATUE OF VENUS FOUND ON THE ISLAND OF MILOS

Discovered on the island of Milos in 1820; transported to Paris by Marquis de Rivière, French Ambassador to the Ottoman Court.[1]

[1] Translated from *Notice sur la statue antique de Venus, découverte dans l'île de Milo en 1820,* Paris, 1821.
Notice read at the Royal Academy of the Beaux-Arts, April 21, 1821, by A. C. Quatremère-de-Quincy, Paris, 1821.

The appearance of a new work of Greek genius is always an event in the empire of the arts, above all when unimpeachable testimonies of the authenticity or the presumable originality of this work add the weight of their authority to the judgement of taste. It was in this manner that the happy expatriation of the fragments of the statues which had remained on the frontons of the Parthenon at Athens produced ancient witnesses for the history of art in Greece, and they have already destroyed more than one theory and ruined more than one modern system. This was accomplished through the sole merit of those precious fragments. It cannot be doubted that the certitude of the place in which they were found, of the epoch in which they were made, has given on the one hand a firm base to the scholar, and on the other a reason for confidence to the public, which most of these antique remnants, that come down to us without a title, without a date, without the name of an author or a country, without any certificate as to their origin, cannot furnish.

Greece was certainly, it may be said, the home of all the works of art that the ruins of Rome and of other ancient cities have given us. But how great the differences and how many degrees of quality within these monuments, whose generations, if it may be put that way, have succeeded each other over a period of ten centuries! Above all, because the luxury of statuary having become a necessity in all parts of the Roman Empire, it happens, as one can well believe, that many are either mediocre works or repeated copies of other copies, become a thousand times more common than the great models or the originals. These latter were those whose preservation Time begrudged us the most. Of course, those among the originals fashioned of precious materials (and these were the majority) were most apt to feel the effects of barbarism. Concerning works in marble, almost the only ones that the genie of Destruction have allowed to survive to our day, it is well enough known that they were manufactured in large numbers in Greece for Rome, and by Greeks in Rome, and this at a time long after the golden age of the art.

If it is to this class that the ever growing number of statues, continually excavated in Rome, belong, then the immense majority -of these works are probably degenerate productions, copies or copies of copies, whose influence, interest, and utility in many ways we are still far from presuming to contest.

The multiplicity of the antique products has propagated the

taste for them throughout all the countries, and this taste has also contributed to making the discoveries more and more numerous in Italy. But this has also caused a novel effect on opinion and criticism. They have become stricter in their judgements. In the beginning, each work brought to light was called an original, and each was reputed to be the masterpiece of a famous Greek sculptor. But, the more similar works that accumulated in Rome following new excavations, the more problematical opinions on the originality of the better and more beautiful works have become. The very soil of Rome, far from giving a guarantee of the question of quality, has seemed to raise an obstruction to this quality, or at least an unfavorable presumption. In some peoples' minds, Italy seems to be no more than a sort of secondary market for Greek works. It was decided to find the means to obtain some at first hand, if we may use the term, by going to the actual sources of the art.

Very soon, in effect, the passion for discovery extended the circle of research. For some years now, companies have been formed, voyages have been undertaken, to excavate in Greece and on its islands, on the coasts of Asia Minor, and on the banks of the Nile. Already abundant harvests have reimbursed the expenditures and the zeal of the searchers. We have seen them, come from the different countries of Europe, quarrelling over the soil of Egypt, and the privilege of stirring up its debris, as in other times, when other conquerors quarrelled over land in the New World. Let us hope that the spirit of conquest never produces more serious contentions.

In any case it would have been preferable had these disputes taken place on Greek soil. Egypt, in matters of art, was and always will be sterile. A greater number of monuments will never add anything to what a smaller number can teach us in matters of invention and imitation of nature. In actual fact (understood in the moral sense) there is and there has been but a single figure, a single head, a single edifice, a single bas-relief, a single painting in Egypt. All Egypt was condemned to uniformity; and the only differences that a skillful eye can perceive in its works reduce themselves to a lesser or greater finish in the mechanical processes.

In Greek works of art it was quite different. Even if we had a hundred thousand statues, a hundred thousand pieces, come directly or indirectly from their schools, one could be discovered tomorrow which would reveal to us, in one way or

another, a way of seeing or imitating nature, different from that known before, and superior in its way to the works already possessed. This is without counting that novelty in the composition of subjects which the innumerable variations of genius can always offer, the development of actions, and the expression of passion or feelings through the movement of the body and the face.

This is because in Greece the artist had all the freedom necessary to depict his own thoughts, and to imprint his way of seeing nature on his work. Finally, in Greece works of art were reflections of nature, while in Egypt they were only the ordained signs of a sacred writing which is unreadable today.

This feeling of the Greeks on the subject of art has just been, I feel, confirmed by the discovery, on the island of Melos in 1820, of a statue of Venus, purchased on the spot through the care of the French ambassador to the Sublime Porte, the Marquis de Rivière; he had it transported to Paris, where it arrived about the middle of February 1821, and presented it to the king on the first of March.[2] I feel that this statue can give us an idea of the art of the Greeks perhaps superior to that which previous statues of this nature have given us with respect to the type of ideal beauty belonging to the imitation of feminine nature. I feel that it shows us a style, a character, and a way of proceeding, which must have been that of one of the most famous masters of Greece or of his school. I believe, further, that certain parallels and analogies can allow us to designate, with the highest degree of probability, both the master and the school.

First, a few words must be said about the place in which this statue was found. Then its former entirety must be re-

[2] Grateful tribute must also be paid to Mr. de Marcellus, son of the Honorable Deputy of that name, and secretary to the ambassador for the zeal, skill, and activity which he displayed in accomplishing this purchase and his cleverness in surmounting the guileful and selfish politics with which the people of the country opposed the statue's departure. The Greeks are today very much aware of the value of these objects, and they have learned that this "stone business," as it is called at Constantinople, is often very profitable. They would have experienced its profitability again, if Mr. de Marcellus had not been able to anticipate the representatives of other nations, who arrived too late.

stored through incontestable proofs and authorities, that is to say, that we must show what it was like originally. When I speak of making it whole again, I wish to do so verbally; for I believe that not only should it be left in the mutilated state in which it was found, but also that it would be impossible to restore it. I hope that you will agree with me when this paper has been read.

Baron Haller discovered in 1814, on the island of Melos, in the middle of an area strewn with ruins, the remains of a theatre, which taken together with the large amount of debris and some traces of ramparts, were sufficient to determine the position of the ancient city of Melos; it is on a hill overlooking the entrance to the harbor, to the south of Castro, the modern village, built on top of the peak which dominates the island. Toward the end of the month of February 1820, a Greek peasant, digging in a garden which contains this enclosure of ruins, discovered a sort of subterranean cavity, whose construction was buried six to eight feet below the present ground level. He excavated this ruin and found, knocked off their pedestals and scattered in confusion, three small Hermes, about three feet tall; a statue of Venus, half draped and separated into two blocks; a marble fragment, which cannot in any way have belonged originally to either the Venus or its pedestal, and which carries a somewhat altered inscription, in addition to some other insignificant debris. . . .

The question of originality (taking the word in an absolute sense) will probably long and perhaps forever remain unsolved with regard to the most beautiful art antiques.[3] This is not to be wondered at, since the same question is also a problem with a certain number of modern works, or paintings, whose fame has led them to be copied by their authors, by the latter's pupils, or by skillful contemporary copyists. Many antique fragments were reputed to be originals before a more enlightened criticism and the discovery of the same figure executed by a more skillful chisel showed them to be copies. For these reasons we are not able to pronounce the word "original" in an absolute sense at the sight of even the most beautiful works.

If, on the other hand, one wishes to use this word in a sense

[3] [The presentation of the statue's condition and attribution is omitted. Contemporary scholarship considers it to be one of the finest examples of Hellenistic sculpture (323–146 B.C.). See F. Tarbell, *A History of Greek Art,* New York, 1927, p. 249.]

relative to the superiority of different examples of the same
work, there cannot be, I feel, any reason to doubt that the
Venus de Milo, in the group of which it originally was a part,
was the original of those we have named. The distance which
separates them is immeasurable.

This would be the time to extend the parallel and to include
all the antique Venuses which have come down to us, if such
a course did not lead us too far astray. Also, how could we
establish, by simple speech, a comparison of the beauty of
objects whose nature it is to be appreciated through the eyes,
and which should, to do it properly, be stood next to each
other? . . .

Regarding the impression that the view of that work pro-
duced upon me, I must admit that it was similar to that made
by every fragment of superior style within a given type. To
develop the reasons for this impression would be to try to
analyze the causes of the effect of beauty in general. This
would not be appropriate here. There is, I am aware, another
way of communicating to readers, if not the image, at least a
vague idea of the impression made by beauty. An intense or
profound feeling can inspire the writer to compose those bril-
liant descriptions which seize the imagination. In every case,
though, I have noticed that the most beautiful phrases, in
such matters, are never more than useless approximations of
the sensation one wishes to depict; and I admit that those pre-
tended transpositions from one type of imitation into an-
other, seem to me to be only mistaken ideas on the true re-
lationship of the different arts, and their respective limits.

Nor will I expose myself to the hazards of a verdict which
pretends to establish an absolute, definitive ranking of all the
antique statues of Venus, which the variety of their attitudes,
compositions, the intention of their sculptors, etc., would make
more or less disputable. I will limit myself to saying that when
we consider the Venus de Milo in relation to the qualities
which artists usually define by the words GRANDEUR OF STYLE,
AMPLITUDE OF FORM, IDEAL CHARACTERISTICS, PURITY OF DE-
SIGN, ACCURACY, LIFE AND MOVEMENT, and also in respect to
HANDSOME EXECUTION, I will not hesitate to give it the first
place among all those which I have seen. I have realized with
pleasure that the impression I have so imperfectly described
has been felt by all the connoisseurs, and all the artists whose
opinions I have had occasion to obtain. . . .

[JOHN FLAXMAN (1755–1826) was the son of a successful London merchant of the plaster models and casts required by fashion for neo-classical decoration and furnishings. At fifteen he secured admission to the Royal Academy and soon received various medals and awards. Flaxman's friendship with the artist George Romney (1734–1802), recently returned from Rome, intensified his study of classical sculpture and gems and led him into circles where there was a strong interest in the rediscovery of the Greco-Roman world.

The famous firm of potters, Wedgwood and Bentley, employed Flaxman (1775–84) as a modeler of their classical and domestic friezes, plaques, and ornamental vases. Such tasks were congenial to Flaxman's talent, which lay in the tender and sentimental rather than in the dramatic, and expressed itself in decorative contour lines. Flaxman's relief executed for Wedgwood, "The Dancing Hours," illustrates his skill in delicate modeling, his sensitivity for a balanced rhythmic design which animates the decorative pattern of the drapery. His style was the result not only of classical art but of an early enthusiasm for English gothic sculpture which was fed by his close friend, William Blake. They were congenial in their mutual inclination to a pietist mysticism and their affiliation with Swedenborgianism.

By 1780 Flaxman was well enough known to secure commissions himself for reliefs and sepulchral monuments, his principal sculptural activity.

From 1787 to 1794 Flaxman resided in Rome, assured of some income as supervisor of Wedgwood modelers located there. He supplemented his income, as did other artists, by executing commissions for the tourists.

On his return to England in 1794, Flaxman resumed his activity as a popular sculptor of sepulchral and memorial monuments. These were grandiose tributes to departed glory, completely insulated from their architectural setting. His public monuments—such as those to Sir Joshua Reynolds (1807) and Lord Nelson (1808) in St. Paul's—suffer from compositional discrepancies that result from their enlargement from small scale designs.

Flaxman considered one of his important works the commission from the silversmiths, Rundell and Bridge, in 1818, for the design of an Achilles' shield, nine feet in circumference.

Alexander Pope's popular translation of the *Iliad* and his essay on the shield had aroused interest in it.

A chair of sculpture was created for Flaxman at the Royal Academy in 1810. His lectures given there reveal the ideals of his neo-classical style with its reliance on sentiment and grace rather than on form and action. His renown and his influence on European art were due more to his illustrations of Homer, Aeschylus, Hesiod, and Dante, commissioned by individuals, than to his sculpture or lectures. Flaxman chose episodes with a moral and depicted them in line drawings possessing a sentimental refinement and a decorative abstract quality that had great appeal. The *Iliad*, the *Odyssey*, and *Aeschylus*, published in Rome in 1793 and in London in 1795, had German editions in 1802 and 1804 and were widely circulated in Europe, as were the Dante illustrations published in Rome in 1802 and in London in 1807. His drawings for Hesiod's *Theogony*, were published in 1816–17, and were engraved by William Blake, who had re-engraved some of the *Iliad* drawings in 1795.

The elegance and delicacy of Flaxman's drawings made them especially congenial to the German romantic artists. Because of his fusion of classic themes with a Christian pathos, the Nazarenes (a communal society dedicated to renewing the religious basis of German art) took Flaxman's illustrations as models for their style. They were equally valued in France, appreciated by David, and formed part of the study material of young artists, especially "Les Primitifs" or the "Barbus," who were dissatisfied with the austere classicism of David. Flaxman's contour line utilized in a stylized design is a characteristic of the neo-classical style.

SEE: W. G. Constable, *John Flaxman, 1755–1826*, London, 1927.]

LECTURES ON SCULPTURE[1]

Lecture VI. Composition. . . . For the sake of clearness, the rules of composition shall be given under distinct heads:

First, a poet speaks by words.

[1] John Flaxman, *Lectures on Sculpture* (London: George Bell & Sons, 1892) pp. 150–58; 160–62; 163–65; 168–71; 188–92; 204–6; 247–49; 282–84; 292–93.

The painter and sculptor by action.

Action singly, or in series—the subject of composition being comprised in the arts of design; thus the story of Laocoön[2] is told by the agony of the father and sons, inextricably wound about in the folds of serpents.

The anger of Achilles is shewn by drawing his sword on Agamemnon in the council of the kings. And every action is more perfect as it comprehends an indication of the past, with a certainty of the end, in the moment chosen.

Ananias, falling in the contractions of death at the feet of St. Peter, proves a divine authority in the apostle's rebuke, whilst Sapphira, counting the silver, leads to the nature of his offence. See Raffaelle's Cartoon.

In the group of Haemon and Antigone, he supports the expiring woman, whilst he kills himself with the same sword which slew her, shewing his death to be a consequence of hers.

Expression distinguishes the species of action in the whole and in all the parts—in the faces, figures, limbs, and extremities. Whether the story be heroic, grave, or tender, it is the very soul of composition—it animates its characters and gradations, as the human soul doth the body and limbs—it engages the attention, and excites an interest which compensates for a multitude of defects—whilst the most admirable execution, without a just and lively expression, will be disregarded as laborious inanity, or contemned as an illusory endeavour to impose on the feelings and the understanding.

The general forms of masses in composition have been enumerated and ably described by the professor of painting; but as these particularly concern the sculptor, whose whole study is form, a repetition will not be useless.

The forms are the pyramid—erect, inverted, or lateral, the circle, and the oval; they may be radiated, and the whole will have a flame-like undulation in effect, from the ever-varying succession of curves in the outline and action of the human figure.

The parts will be more simple and rectilinear in repose, more angular in violent action,[3] and partaking of gentle curves when the subject is tender, and the person elegant: when the

[2] [See Holt, Vol. II, Lessing, *Laocoön*, pp. 351–59.]
[3] Athenian and Amazon.

limbs are entwined as struggling, or in any sympathetic act
either of force or tenderness, the joints, the general curves
and views of the limbs should never be exactly and mechani-
cally the same, but partake of the wonderful variety of nature,
in which all faces, all bodies, and all efforts are different. This
gives life and motion.

What has been said above is equally applicable to the
group or basso-relievo, but the application must be accommo-
dated to the subject. . . .

The ancients, who considered simplicity as a characteristic
of perfection, represented stories by a single row of figures in
the bas-relief, by which the whole outline of the figure or
group, the energy of action, the concatenation of limbs, the
flight or flow of drapery were seen with little interruption;
but there are instances of the best in low relievo, where many
horsemen are advancing before each other, the nearer horse
hiding the hinder parts of the preceding, and sometimes part
of the rider, without causing the least confusion of effect, as in
the frieze from the Temple of Minerva in Lord Elgin's col-
lection. . . .

The story may require that the upper part of one figure
should be principal, whilst, perhaps, the lower parts are con-
cealed by an intervening object; some figures may be running
in different directions, more crowded, or separate. To regulate
these spaces and quantities harmoniously, concerns the sculp-
tor in his composition, equally with the poet or musician in
theirs. This is to be done by the same means, according to
different modes of manifestation; and the 3rds, 5ths, and 8ths,
with their subdivisions, taken by gross calculation in the arts
of design, not exact measurement, will produce the same
agreeable effect in lines, light and shadow, space and the ar-
rangements of colours, as is produced by similar quantities
in music.

One simple instance only shall be given of opposition, and
another of harmony, in lines and quantities:[4] two equal curves,
set with either their convex or concave faces to each other,
produce opposition; but unite two curves of different size and

[4] Opposition and harmony of lines:
 Opposition) (()
 Harmony .½.
[See Holt, Vol. II, Winckelmann, pp. 335–51.]

segment, and they will produce that harmonious line, termed graceful, in the human figure.

Concerning the quantity of light and shadow in a group, if the light be one-third, and shadow two-thirds, the effect will be bold. If the light be one part, and the shade four, it will be still bolder, and accord with a tragic or terrific action; but the more general effect of sculpture is two-thirds of light on the middle of the group, with a small proportion of very dark shadow in the deeper hollows. . . .

The lines of Grecian composition enchant the beholder by their harmony and perfection; and this portion of study seems to have been highly improved by Pamphilus, the learned Macedonian painter, who denied that any one could succeed in the study of painting without arithmetic and geometry. The application of these two sciences is very evident in the arts of design: by arithmetic, the proportions of the human figure and other animals are reckoned, and the quantities of bodies, superficies, or light and shade ascertained; geometry gives lines and diagrams for the motion, outline, and drapery of the figure, regulated by the harmony of agreeable proportions, or the opposition of contrast. The effect is evident in the groups of Laocoön and the Boxers, the bas-relief of the Niobe family, and that of the rape of Proserpine; but this magic bond of arrangement was utterly lost when the other perfections of Grecian genius were overwhelmed in barbarism, and were in no degree recovered until late in the resurrection of the arts, when they were reproduced by the same means which had discovered them.

The study of geometry became more general, and had been applied with more success to the improvement of science and art, after the learned Greeks, who fled from Constantinople, settled in Italy.

Leonardo da Vinci and Michael Angelo were greedy partakers in this abundant harvest of knowledge. Michael Angelo shewed his sensibility to the play of lines in his picture of the Holy Family, in which the Virgin, sitting on the ground, receives the infant Jesus, whom Joseph, stooping behind, presents over her right shoulder.

Leonardo da Vinci, who had devoted much time to mechanical and geometrical studies, composed the Contest for the Standard, intended to be painted in the great hall of the old palace of Florence. This was indeed a prodigy in modern

advancement, and the first great example of complicated grouping since the arts flourished in ancient Greece. . . .

Lecture VII. Style. The introduction to a theory, whether of science or art, practical or abstracted, should contain such a compendious view of the subject as will connect all the branches or members with the principle on which they depend for their essential quality and peculiar characteristic distinction; so that our view of the whole should comprehend the parts of which it is composed, and our inquiries concerning the parts should be guided and regulated by that common principle in which they are all united.

This universal and indispensable maxim, applied to a course of lectures on sculpture, will naturally lead us to some well-known quality which originates in the birth of the art itself; increases in its growth; strengthens in its vigour; attains the full measure of beauty in the perfection of its parent cause; and, in its decay, withers and expires. Such a quality will define the stages of its progress, and will mark the degrees of its debasement; it will point out how, and when, proportions were obtained by measure and calculation; when geometrical figures, more simple or complicated, decided form; how the harmony of lines in composition produce energy by contrast, and sympathy by assimilation. Such a quality immediately determines to our eyes and understanding the barbarous attempt of the ignorant savage, the humble labour of the mere workman, the highest examples of art conducted by science, ennobled by philosophy, and perfected by the zealous and extensive study of nature.

This distinguishing quality is understood by the term style, in the arts of design. This term, at first, was applied to poetry, and the style of Homer and Pindar must have been familiar long before Phidias or Zeuxis were known; but, in process of time, as the poet wrote with his style or pen, and the designer sketched with his style or pencil, the name of the instrument was familiarly used to express the genius and productions of the writer and the artist; and this symbolical mode of speaking has continued from the earliest times through the classical ages, the revival of arts and letters, down to the present moment, equally intelligible, and is now strengthened by the uninterrupted use and authority of the ancients and the moderns.

And here we may remark, that as by the term style we designate the several stages of progression, improvement, or

decline of the art, so by the same term, and at the same time, we more indirectly refer to the progress of the human mind, and states of society; for such as the habits of the mind are, such will be the works, and such objects as the understanding and the affections dwell most upon, will be most readily executed by the hands. Thus the savage depends on clubs, spears, and axes for safety and defence against his enemies, and on his oars or paddles for the guidance of his canoe through the waters: these, therefore, engage a suitable portion of his attention, and, with incredible labour, he makes them the most convenient possible for his purpose; and, as a certain consequence, because usefulness is a property of beauty, he frequently produces such an elegance of form as to astonish the more civilized and cultivated of his species.[5] He will even superadd to the elegance of form an additional decoration in relief on the surface of the instrument, a wave-line, a zig-zag, or the tie of a band, imitating such simple objects as his wants and occupations render familiar to his observation—such as the first twilight of science in his mind enables him to comprehend. Thus far his endeavours are crowned with a certain portion of success; but if he extend his attempts to the human form, or the attributes of divinity, his rude conceptions and untaught mind produce only images of lifeless deformity, or of horror and disgust. . . .

The characters of style may be properly arranged under two heads—the natural and the ideal.

The natural style may be defined thus: a representation of the human form, according to the distinctions of sex and age, in action or repose, expressing the affections of the soul.

The same words may be used to define the ideal style, but they must be followed by this addition—"selected from such perfect examples as may excite in our minds a conception of the supernatural."

Lecture VIII. Drapery. . . . We will next consider the effect of motion upon drapery: such motion is here intended as the garment partakes of, or is propelled from, the wearer's movement only.

As soon as a limb is moved from a perpendicular towards a horizontal direction, the drapery hanging on it changes the forms of its folds. The perpendicular folds bend by their

[5] New Zealand canoe.

weight into a curve, from the impulse of motion, or change from perpendicular to the inverted arch, the strongest portion of the fold depending from the stronger of the two supporters, whether it be that part of the person which is in rest, or that part in motion. This is more particularly seen in the cloak or loose outer garment, but the principle is evident in all drapery worn by the human figure: as, for example, the lower portion of a tunic falls in perpendicular folds over the legs in a state of rest, but the instant one leg is advanced beyond the other in walking, the perpendicular folds, falling from the greatest projection in front of the figure, become curved, clinging in the lower extremities to the unmoved leg, until that limb is set forward, when the same change is produced on the other side: and this effect is still more evident in running violently, when the curved folds at last become horizontal, at right angles with the limbs.[6]

Motion of the figure affects the whole mass of drapery about the body; the folds are most interrupted and broken on the side moved in shortest space, as the curves are most lengthened on the side moved in a greater extent, and they are twisted most diagonally where there is the greatest power of motion.

Upon the legs, the folds change from downright to long curves, in walking or running, alternately as one leg or the other is set forward. The greater quantity of folds naturally falls in the hollow spaces; and in quick motion, the heavier portion of folds are left behind the figure by their own weight, in a diagonal curve, from the point on which they are supported. . . .

Lecture X. Modern Sculpture. . . . The Cathedral of Pisa, built by Buschetto, an architect from Dulichium, was the second sacred edifice (St. Mark's in Venice being the first) raised after the destruction of the Roman power in Italy. It has received the honour of being allowed by posterity to have taken the lead in restoring art: and indeed, the traveller, on entering the city gates, is astonished by a scene of architectural magnificence and singularity not to be equalled in the world. Four stupendous structures of fine marble in one group—the solemn cathedral, in the general parallelogram of its form

[6] [This description suggests the use of lines to express motion employed by Marcel Duchamp (1887–19–) in his painting "Nude Descending a Staircase" (1912).]

resembling an ancient temple,[7] which unites and simplifies the arched divisions of its exterior; the Baptistery, a circular building, surrounded with arches and columns, crowned with niches, statues and pinnacles, rising to an apex in the centre, terminated by a statue of the Baptist; the Falling Tower (which is thirteen feet out of the perpendicular), a most elegant cylinder, raised by eight rows of columns surmounting each other, and surrounding a staircase; the Cemetery, a long square corridor of elegant pointed architecture, 400 by 200 feet, containing the ingenious works of the improvers of painting, down to the sixteenth century. This extraordinary scene in the evening of a summer's day, with a splendid red sun setting in the dark-blue sky, the full moon rising on the opposite side over a city nearly deserted, affects the beholder's mind with such a sensation of magnificence, solitude, and wonder, that he scarcely knows whether he is any longer an inhabitant of this world or not.

To describe the numerous works of painting and sculpture with which the restorers of art laboured to adorn these magnificent edifices during 500 years would require time equal to that allowed for the Lectures on Sculpture during one season. Fortunately for the student, fine prints from the paintings in the Campo Santo,[8] with outlines of the sarcophagi in the same corridor, may be seen in the library of the Royal Academy.

The general effect of this group of buildings deserves to be dwelt on, for these two reasons in particular—first, because noble ideas, finely executed, cannot fail to produce an irresistible effect on the mind; and, secondly, this assemblage of buildings contains a more regular series of those labours by which the restoration of art was effected than is to be found within the same compass in any other place.

[7] A Latin cross.
[8] [Campo Santo was founded in 1278 and decorated with frescoes by leading Italian painters beginning with Ugolino da Siena and continuing to Benozzo Gozzoli.]

AN ADDRESS ON THE DEATH OF THOMAS BANKS[9]

. . . In Rome (the centre from which the arts have ema-
nated for centuries past), about 150 years since, the taste of
Bernini, the Neapolitan sculptor, infected and prevailed over
the Florentine and Roman schools. He had studied painting,
and seems to have been enamoured with the works of Cor-
reggio, who, to avoid the dryness of his master, Andrea
Mantegna, gave prodigious flow to the lines of his figures, and
redundance to his draperies; of which Bernini's statues are
only caricatures, totally devoid of the painter's ecstatic grace
and sentiment. Before he was twenty years old, he not only
composed but completed a marble group, the size of nature,
of Apollo and Daphne, at the moment the nymph is changing
into a laurel-tree; the delicate characters of the figures, the
sprightly expression, the smooth finish of the material and the
light execution of the foliage, so captivated the public taste
that M. Angelo was forgotten, the antique statues disregarded,
and nothing looked on with delight that was not produced
by the new favourite. It is true, Bernini showed respectable
talents in the group above mentioned, and had he continued
to select and study nature with diligence, he might have been
a most valuable artist; but sudden success prevented him, and
he never improved; the immense works crowded on him
made him spurn all example, and consider only how he might
send out his models and designs most speedily. The attitudes
of his figures are much twisted, the heads turned with a
meretricious grace, the countenances simper affectedly, or are
deformed by low passions; the poor and vulgar limbs and
bodies are loaded with draperies of such protruding or flying
folds, as equally expose the unskilfulness of the artist and the
solidity of the material on which he worked; his groups have
an unmeaning connection, and his basso-relievos are filled up

[9] An address delivered at The Royal Academy on the Death of
Thomas Banks, R.A., 1805. Quoted from John Flaxman *Lectures
on Sculpture* (London: George Bell & Sons, 1892) pp. 282–84,
292–93.

[Thomas Banks (1735–1805), sculptor, studied in Rome and
worked in St. Petersburg in the employ of Catherine the Great.
On his return to England, he was given recognition and commis-
sions. His best-known monuments are in St. Paul's and in Stratford-
on-Avon ("Shakespeare Attended by Painting and Poetry").]

with buildings in perspective, clouds, water, diminished figures, and attempts to represent such aerial effects as break down the boundaries of painting and sculpture, and confound the two arts. Pope Urban VIII was patron of this artist, and so passionately did he admire and promote his works, that, not contented with spending immense sums upon them, he took the ancient bronze ornaments from the roof in the portico of the Pantheon, to the amount of 186,000 pounds, for Bernini to cast his bizarre and childish baldachin[10] for St. Peter's, and then published their mutual shame in a boasting Latin inscription, affixed to the building he had robbed so shamefully. Thus the pope and the sculptor carried all before them in their time, and sent out a baneful influence, which corrupted public taste for upwards of one hundred years afterwards.

. . . Before the time of Bernini, two kinds of sepulchral monuments prevailed, one from the highest antiquity, which was a sarcophagus, either plain or covered with basso-relievos, with or without the statue of the deceased on its top. The other kind was introduced by Michael Angelo, in the Mausoleum of Julius the Second, and those of the Medici family, in the Chapel of St. Lorenzo at Florence. In these, the sarcophagus, as in the former kind, was suited to the niche or architecture against which it was placed, and surmounted or surrounded by statues of the deceased and his moral attributes.

Both these practices were rational and proper, the one for plainer, the other for more magnificent tombs. This branch of sculpture was of too much importance to be neglected by Bernini; he stripped it of its ancient simple grandeur, leaving it neither group, statue, basso-relievo, sarcophagus, or trophy, but an absurd mixture of all, placed against a dark marble pyramid, and thus sacrificing all that is valuable in sculpture to what he conceived a picturesque effect.

The pyramid is—from its immense size, solid base, diminishing upwards—a building intended to last thousands of years. How ridiculous, then, to raise a little pyramid of slab marble, an inch thick, on a neat pedestal, to be the background of sculpture belonging to none of the ancient classes, foisted into architecture, with which it has neither connection nor harmony, and in which it appears equally disgusting and deformed! The first monuments he raised of this kind, were two in the Chigi Chapel, in the Church of Santa Maria del Popolo, in Rome. This novelty soon found its way into every country

10 [See Holt, Vol. II, "F. Baldinucci," p. 114.]

in Europe; our Westminster Abbey is an unfortunate instance of its prevalence.

[JEAN AUGUSTE DOMINIQUE INGRES (1780–1867), the son of a sculptor, grew up in southwestern France. He began his art studies at the Academy of Toulouse where Raphael's art became and remained his ideal. Continuing his training in Paris, Ingres was admitted to David's studio, a school whose dogma of "ideal beauty" was congenial to his natural inclination. Ingres was early attracted to Flaxman's stylized line illustrations of Homer. Delayed by political events from receiving the stipend of the Prix de Rome that he won in 1802 for the painting, "Achilles Receives the Ambassadors of Agamemnon," which Flaxman had praised as the finest picture in Paris, Ingres established a studio with the young Italian sculptor, later the famous, Lorenzo Bartolini. During the next four years Ingres painted some of his finest portraits, characterized by elegance, sensuous refinement, and an abstract quality of line. Free as they are from chiaroscuro and only tinted with flat planes of color, the resulting decorative effect brought the portraits, such as "Mme Rivière" and the "Belle Zelie," criticism as "Gothic" by adherents of David's school.

When Ingres received his stipend in 1806, he went to Rome and remained for eighteen years. After the first three years, he supported himself principally by executing superb portraits of tourists. The majority of these were line drawings done in a few hours. His large historical group compositions of this period are "Jupiter and Thetis" and "Oedipus and the Sphinx" (1808).

In the representation of the female nude, a recurrent motif in Ingres' work, are the qualities that form the core of his artistic expression. "La Baigneuse" (1808) was followed by the "Odalisque Pourtales" (1814), the "Odalisque with the Slave" (1839), "Birth of Venus" (1848), "The Source" (1856), and the "Turkish Bath" (1862). Each is an image of pure art, achieved at the price of anatomical accuracy if necessary, lovely in color, superb in the composition of the contour line that defines the volumes of the form.

Raphael's paintings provided elements for Ingres' large canvases, such as "The Oath of Louis XIII" (1824), commissioned by his native town of Montauban. This picture was so

well received in the Salon of 1824 that Ingres could return to Paris the acknowledged leader of the classical linear style of painting. It was hung in the same room with "The Massacre of Scio" by Delacroix, the exponent of the colorists. Thus were the basic differences in their method of expressing form and their conception of it publicly established, and it was then that the rivalry between the two artists and their followers began. In the Salon of 1827, Ingres' "Apotheosis of Homer," commissioned to decorate a ceiling in the Louvre, received all the official praise and confronted Delacroix' "Death of Sardanapalus." In the 1834 Salon, Ingres' unimaginative treatment of the "Martyrdom of Saint Symphorien" received such adverse criticism that he resolved never to exhibit in the Salon again.

Determined to leave Paris and yet retain the authority to defend the principles of his art, Ingres asked for and obtained the directorship of the French Academy in Rome (1834–40). "Stratonice" (1840) was so acclaimed in Paris that Ingres, feeling himself and his doctrine vindicated, returned. Two of his best-known pictures are of this last period, "The Source," begun in Florence in 1824 and finished in 1856, and the "Turkish Women" (1859). Both illustrate his doctrine of the beautiful—an entwining of contour lines into a decorative design, illuminated by tints of color that emphasize the single plane. They are related in style to the Italian "primitive" painters and led his contemporaries to compare his work to Chinese or "Etruscan" painting. His single-minded investigation of form and his disregard for any social or literary content are qualities that explain his influence on the succeeding generation of artists, such as the Nabis, searching for an affirmation of form and an abstract linearism.

Ingres did not write down his doctrine. His sayings were collected and published by various pupils, admiring disciples of his school of art.

SEE: W. Friedlaender, *David to Delacroix*, Cambridge, Mass., 1963.
W. Pach, *Ingres*, New York, 1939.]

THE DOCTRINE OF INGRES[1]

Here are, in systematic order, some aphorisms taken from Ingres' own writings or from the memories of his students, upon which one should reflect in order to understand the doctrine of Ingris.[2]

First of all, on the necessity of a doctrine: "Poussin would never have been as great if he had not had a doctrine."

On works of art: "If I had a son, I would wish him to learn to paint only by making paintings."

On nature and beauty: "Superior nature is the mistress; she grants everything to those who ask her boldly and is stingy only with those who are embarrassed."
"Copy, copy simply, whole-heartedly, abjectly that which you have before your eyes; art is never so perfect as when it resembles nature so closely that it might be mistaken for nature herself."
"Always keep that happy naïveté, that charming ignorance."
"Love truth because it is also beauty."
"The name of ideal beauty, so ill-received in our time, designates only visible beauty, nature's beauty."

But on the other hand: "Art should only depict beauty."
"If you wish to see that leg as ugly, I am sure you will find reasons. But I say to you: borrow my eyes and you will see it as beautiful."
"If I could make musicians out of all of you, you would benefit as painters. Everything is harmonious in nature. . . .

[1] Translated from M. Denis, *Théories* (1890–1910) "La Doctrine d'Ingres," Paris, 1912, pp. 95–101.
[2] [Maurice Denis, one of the founders of the "Nabi," made the selection of Ingres' sayings given here. Of his selection, Denis says:] The major part of the citations from Ingres, those whose sources I do not indicate, are taken from the Montauban notebooks, from which Mr. Lapauze has published analytical résumés and judiciously chosen extracts in his important work, the *Dessins d'Ingres*. I have also consulted *Ingres* by Delaborde, *l'Atelier d'Ingres* by Amaury-Duval, *Enseignement du dessin,* by R. Balze, etc.

Today many artists cry out against compositions, no longer wishing a picture to be arranged. . . . Accidental nature with nothing added, and on it, colours daubed in lumps, those are their principles."

"Do you believe that I send you to the Louvre to find ideal beauty, something different from that which is nature? Similar idiocies in ill-fated epochs brought about the decadence of art. I send you there because you will learn from the ancients to see nature because they are themselves nature; one must be nourished by them . . ."

"Let legs be like columns . . ."

"Paint without any model. You must completely realize that your model is never the thing you wish to paint, neither in character of drawing nor in colouring; but at the same time, it is absolutely necessary to do nothing without the model . . ."

"And no matter what your genius, if you paint to the last stroke not according to nature, but your model, you will always be its slave; your manner of painting will smack of servitude. The proof of the contrary is seen in Raphael. He tamed the model to such a point and possessed it so thoroughly in his memory, that instead of the model giving him orders, one would say that the model obeyed him . . ."

"Poussin often said that it is in observing objects that a painter becomes skillful, rather than in tiring himself by copying; true, but the painter must use his eyes."

Amaury-Duval reports that Ingres did not wish the word *chic* pronounced in the studio. He also recounts Ingres' horror of anatomy and that business of the skeleton. "Anatomy, that dreadful science! If I had had to learn anatomy, I would never have made myself a painter!"

He said to Monsieur Degas: "Draw lines, many lines, from memory or from nature; it is by this that you will become a good artist."

This bit copied by him from the Montauban notebooks which may be considered a fitting formula of his thought is given in an article by Delécluze: ". . . He never ceased to make noble efforts to conserve intact the nature and the dignity of the art that he practises. . . . Even in portraits, this need to concentrate his thought to make forms homogeneous, this instinct that leads him to return to the unity possessed by the

principal traits of a face, the details which tend to separate
themselves . . . is very striking."

Or again this emphatic advice: "To form yourself in beauty,
see only the sublime; walk with your head raised to the sky
instead of keeping it toward the earth like pigs searching in
the mud."

On the ancients: "The masterpieces of antiquity were made
with models like those we have at the moment before our
eyes in Paris. . . . The secret of beauty must be found in
Truth."
 "The ancients have seen all, understood all, felt all, de-
picted all."
 "The figures of antiquity are only beautiful because they
resemble the beauty of nature. . . . And nature will always
be beautiful when it resembles the beauties of antiquity."
 "Greek art proves its superiority by the masterfulness of
even the simple artisans, the potters for example. Just the
composition of a handsome vase would make a modern
painter illustrious."
 "I, I am a Greek."
 "Study vases, it was with them that I began to understand
the Greeks."
 His ideal, wrote Janmot, was to re-create antiquity by the
study of nature; also, of his passionate, dominating teaching,
only realism remains.

In speaking of the "primitives" of Pisa, 1806:[3] "Those men
should be copied on one's knees!"
 "I know very well that that one (a giottesque figure) has
too pointed a nose and eyes like a fish; but Raphael himself
never attained a similar expression."

Well before the Romantic epoch, Amaury-Duval remarks that
Ingres depicted medieval subjects, "Let us paint French pic-
tures!" and that he even borrowed from the art of that epoch
a certain naïve stiffness (*Charles VII, Francesca, Angelique*).
Let us add that Ingres was one of the first to introduce into
historical scenes a concern for local colour and archaeology;
his notebooks are full of sketches of costumes lovingly drawn
from engravings or pictures of the Primitives.
 Of Raphael he preferred the "Disputa" and, above all, the

3 [See above Flaxman, p. 21.]

"Mass of Bolsena." "Raphael [is] a god, an inimitable being, absolute, incorruptible, and Poussin the most perfect of men."

"Be nourished by them, gentlemen; take all that you can from them; it is manna fallen from heaven, which will nourish you, fortify you."

On drawing: "I will write on the door of my studio: School of drawing, and I will make painters."

"Drawing is the probity of art."

"Drawing includes everything except colour. It is the expression, the interior form, the plan, the modelling."

"The line is drawing, that is all."

"Smoke itself should be expressed by a line."

"Drawing is everything; it is all of art. The material processes of painting are very easy and may be learned in eight days; through the study of drawing with lines, one learns proportion, character, knowledge of all human natures of all ages, their types, their forms, and the modelling which completes the beauty of the work."

"Expression is the essential part of art and is intimately linked to form."

"There is neither correct nor incorrect drawing; there is only beautiful or ugly drawing. That is all!"

"To arrive at the form of Beauty (la belle forme), one must model in the round and without interior details."

"Beautiful forms are straight planes rounded."

"Why is great character not seen in painting? Because, instead of one great form, three small ones are made."

"Have, in its entirety, in your soul, and in your eyes, the figure that you wish to represent, and let the execution be only the realization of this possessed and preconceived image."

What he taught beginners, according to Amaury-Duval, was the line and the masses, that is to say, the movement that he himself seized so quickly, and the silhouette of the mass of shadows seen through squinting eyes.

"Health must be given to the shape."

On painting: "A thing well-drawn is always adequately painted."

"There is no example of a great draughtsman not having found the colour suitable to the character of his drawing."

"The essential qualities of colour are more in the ensemble of the masses or the deepest tones of the painting."

"Colour, the animating part . . ."

"Colour [is] one of the ornaments of painting, the lady with her sister's finery, because it is colouring which brings the amateurs and the admirers to the more important perfections of art."[4]

"In front of Rubens, put on blinders like those a horse wears."

"Gentlemen, put white in shadows."

"In a contour shadow, the colour must not be placed beside the line; it must be placed on the line."

"Narrow reflections in the shadows, reflections following the length of the contours, are not fit for the majesty of historical painting."

"The quality of making objects stand out in painting, which many regard as the most important thing in a picture, was not one of the aspects upon which Titian, the greatest colourist of all, concentrated his attention."

"Painters of inferior ability have made the principal quality of a painting consist [of detaching objects]; this attitude is still held by the swarm of amateurs who experience the greatest satisfaction when they see a [painted] figure around which it seems, so they say, they may walk."

"Now they want paintings one could walk around in; I do not give a fig for that!"

"One only finishes the finished work."

"Don't waste your time in copying. Make simple sketches from the masters."

"One must use facility while disdaining it, but in spite of this, when you have a hundred thousand francs worth of facility, you must still give yourself another two sous worth."

[Maurice Denis commented:]

To summarize, Ingres taught nature and its translation through drawing. But drawing is not a copy of the model. Beauty must be sought first. And what is beauty? It is what one discerns by frequenting the Greeks and Raphael . . .

4 [The French text of this often cited sentence is: "Le coloris un des ornaments de la peinture, la dame d'autours de sa soeur, à cause que c'est le coloris qui procure des amateurs et des admirateurs aux plus importantes perfections de l'art."]

[MARIE HENRI BEYLE (1783–1842), famous as a writer and critic under his *nom de plume* "Stendhal," was born in Grenoble and educated in Paris. In 1799 during the Directory, Beyle secured a position in the Ministry of War which led to his following Napoleon to Italy and his employment in Paris from 1806 to 1814. After Napoleon's defeat, Stendhal retired to Milan to enjoy the literary circle, frequented also by Byron, grouped around the writer and patriot, Alessandro Manzoni (1785–1873), and began his literary career. The *Historie de la Peinture en Italie* appeared in 1817 in which Stendhal questioned whether beauty expressed in the antique mode was compatible with the current times and Winckelmann's tenet that all art, including contemporary art, was to be judged by the standards of Greek art.

Exiled by the Austrians from Milan in 1821, Stendhal returned to Paris to support himself as a novelist and art critic of the Salons. His novels, *Le Rouge et le Noire* (1830) and the best known, *La Chartreuse de Parme* (1839)—both published after Stendhal's departure from Paris in 1830 to serve as Consul at Civita Vecchia—were acclaimed by Balzac and Zola shortly before Stendhal's death in 1842.

For his criticism of the Salons, Stendhal ranks as one of the first of the outstanding French art critics of the nineteenth century. His criticism was published both in England and in Germany. The Salon, established in 1746, was an annual or biannual exhibition of painting, sculpture, and architectural designs held in Paris to which artists of any nationality could submit entries with the French. From the Salon's inception, it became customary for well-known writers—Diderot being the most distinguished in the eighteenth century—to give literary accounts of the art exhibited that generalized on art, explained it, and thereby promoted it. Because the critic was obliged to apply his aesthetic theories to actual art works, his writing was kept in the field of criticism, and aesthetic abstractions were prevented, even though the critic might be allied in theory to either the traditionalist or the avant-gardist. Thus the Salon offered an opportunity unique in Europe for the development of criticism. The French artists, during and after the Revolution, also participated, both by their paintings and by writings in the ardent social and political debates of France. Thus a

close relationship was established in France between the social
life and the arts that was also fostered by the critics.

SEE: L. Venturi, *History of Art Criticism*, Dutton, New
 York, 1964.
 J. E. Sloane, *French Painting between Past and Present*,
 1848–70; Princeton, 1951.
 Mary Pittaluga, *La Critica dei Salons*, Florence, 1948.]

SALON OF 1824[1]

ARTICLE 1, AUGUST 31, 1824, *Journal de Paris*

We are at the dawn of a revolution in the Fine Arts. The
huge pictures composed of thirty nude figures inspired by
antique statues and the heavy tragedies in verse in five acts
are, without a doubt, very respectable works; but in spite of
all that may be said in their favor, they have begun to be a
little boring. If the painting of the "Sabines" were to appear
today, we would find that its figures were without passion and
that in any country it is absurd to march off to battle with no
clothes on. "But that is the way it is done in antique bas-
relief!" cry out the classicist painters, those men who swear
by David and who cannot say three words without speaking
of *style*. And what do I care about antique bas-relief! Let us
try to do good modern painting. The Greeks liked the nude;
we, we never see it, and I will go further and say that it dis-
gusts us.

Without heeding the clamours of the opposite party, I am
going to tell the public frankly and simply what I feel about
each of the pictures it will honor with its attention. I will give
the reasons for my particular point of view. My aim is to make
each spectator search his soul, analyze his personal manner
of feeling, and come in this manner to form his own opinion,
to a way of seeing based on his individual character, his taste,
his dominating passions, provided that he has passions, for
unfortunately they are necessary in the judgement of art. To
disabuse[2] equally the youthful painters of the school of David

[1] Translated from Stendhal, *Mélanges d'Art*, le Divan, Paris, 1932.
[2] [The *Mélanges d'Art et literature*, 1867, printed "détourner" as
"discourage."]

and of the imitation of Horace Vernet,[3] that is my second
aim; my love of art inspires me. . . .

ARTICLE 4, SEPTEMBER 12

Throw the most ordinary man into prison, one the least
familiar with every idea of art and literature, in a word, one
of those ignorant lazybones who are encountered in such
large numbers in a vast capital, and as soon as he has recov-
ered from his initial fright, tell him that he will be set free if
he is capable of showing at the Salon a nude figure perfectly
drawn according to the system of David. You would be as-
tonished to see the prisoner in the experiment re-appear in
the outside world at the end of two or three years. Correct,
scholarly drawing imitated from antiquity as the school of
David comprehends it is an exact science like arithmetic,
geometry, trigonometry, etc. That is to say, with infinite pa-
tience and with the brilliant genius of Barême,[4] one can ar-
rive in two or three years at a knowledge of the conformation
and the exact position of the hundred muscles which cover
the human body and be able to reproduce them with a brush.
During the thirty years that David's tyrannical government
has lasted, the public has been obliged to believe, under pen-
alty of being charged with bad taste, that to have had the
patience necessary to acquire the *exact science* of drawing
was to be a genius. Do you still remember the handsome
pictures of nude figures of Madame —? The last excess of this
system was the "Scene of the Deluge" by Girodet,[5] which
may be seen at the Luxembourg.

But I return to the prisoner we have thrown into a tower of
Mont San Michel. Tell him: "You will be free when you are
capable of depicting in a manner recognizable by the public,
the despair of a lover who has just lost his sweetheart, or the
joy of a father who sees the son appear whom he believed to

3 [Horace Vernet (1789–1863), the third well-known painter of
this family, he likewise painted military scenes with a patriotic
appeal. Ingres succeeded him as director of the French School in
Rome.]
4 [Barême: an eighteenth-century mathematician, whose name be-
came proverbial; "to count as Barême," meaning the idea of an
infallible science in practical arithmetic.]
5 [A. L. Girodet-Trioson (1767–1824), poet, essayist, and painter
of romantic pictures.]

be dead"; and the unfortunate will find himself condemned by this to perpetual imprisonment. This is because, unfortunately for many artists, the passions are not an *exact science* that the ignorant may master. To be able to paint the passions, they must have been seen, their devouring flames must have been felt. Note well that I do not say that all passionate people are good painters; I say that all great artists have been passionate men. This is equally true in all the arts, from Giorgione dying of love at thirty-three because Morto de Feltre, his student, had stolen his mistress, to Mozart, who died because he imagined that an angel disguised as a venerable old man called him to heaven.

The school of David *can only paint bodies; it is decidedly inept at painting souls.*

ARTICLE 7, OCTOBER 9

. . . With the best will in the world, I cannot admire Delacroix and his *Massacre of Scio*. This work always appears to me to be a picture that was originally intended to depict a plague, and whose author, after having read the newspapers, turned it into a *Massacre of Scio*. I can only see in the large animated corpse which occupies the middle of the composition an unfortunate victim of the plague who has attempted to lance his own boils. This is what the blood appearing on the left side of this figure indicates. Another fragment that no young painters ever omit from their pictures of the plague is an infant who tries to suckle at the breast of his already dead mother; this can be found in the right-hand corner of Mr. Delacroix' painting. A "Massacre" demands that there be an executioner and a victim. There should have been a fanatical Turk, as handsome as Girodet's Turk, slaughtering Greek women of angelic beauty and menacing an old man, their father, who will in turn succumb to his blows.

Delacroix, like Schnetz, has a feeling for color; this is important in this century of *draughtsmen*. I seem to see in him a student of Tintoretto; his figures have movement. The *Journal des Débats*[6] of day before yesterday says that the "Massacre of Scio" is like *Shakespearian* poetry. It seems to me

[6] [Eugene Delécluze, friend of Ingres, uncle of Viollet-le-Duc (see Section III on Architecture) wrote art criticism for the *Journal des Débats*.]

that this painting is mediocre through insignificance, as are so many classical pictures which I could name, and which I will carefully not attribute to the School of Homer, whose spirit must be turning in his grave at what is being said and done in his name. Delacroix has, in any case, that immense superiority over all the painters of the large pictures which paper the great salons, that at least the public has greatly concerned itself with his work. This is better than being praised in three or four newspapers that hold on to old ideas and disguise new ones because they cannot disprove them. . . .

ARTICLE 8, OCTOBER 16

. . . However bad the portrait of Monsieur Richelieu by Sir Thomas Lawrence[7] may be, it has a little more character than that by Mr. Hersent. Mr. Lawrence's manner is the result of the neglect of genius. I admit I do not understand the reputation of this painter. He is good for us in that he seeks to depict the appearance of nature by means that are absolutely opposed to those of French painters. His figures do not have a *wooden appearance* (if I may be excused that studio term); but truthfully, they possess very little merit. The mouth of his portrait of a woman looks like a small piece of red ribbon glued to the canvas. And it is with a talent of this strength that one places oneself at the head of the arts in England! Mr. Lawrence must be very clever, or else our neighbors in London must be very poor connoisseurs. Certainly, Monsieur Horace Vernet does not excel in his feminine portraits; he does not know how to give the shading of the complexion; he paints women with the same *brush stroke* he uses for men; and yet his portrait of a woman with her head in the shadow, placed beside that of Mr. Lawrence, to the left of the door of the grand gallery, is a hundred times superior to the work of the English painter.

If the foremost portraitist of London is quite mediocre and completely in the type of Carl Vanloo, in contrast the English have sent us magnificent landscapes this year, those of Mr.

[7] [Sir Thomas Lawrence (1769–1830), a brilliant portraitist commissioned by the Congress of Allied Nations, Napoleon's conquerors, to paint the kings of Europe, was esteemed in all Europe. He was made President of the Royal Academy in 1820.]

Constable.[8] I do not think we have anything to equal them. The truthfulness catches the eye and draws one to these charming works. The casualness of Mr. Constable's brush is extreme and the composition of his pictures is not thought through, also he has no ideal; but his delightful landscape with a dog at the left is the mirror of nature and it completely eclipses a large landscape by Mr. Watelet placed near it in the grand Salon. . . .

ARTICLE 13, NOVEMBER 23

. . . I do not think very much of water-colour, it is a poor genre; but the fable, too, is a small thing compared to an epic poem, and LaFontaine is as immortal as Homer. In the fine arts, where mediocrity is nothingness, one must excel no matter by what means. I do not claim that the water-colour of Fielding showing "Macbeth and Banquo stopped on the heath by the three witches,"[9] is a small work as perfect as a fable by LaFontaine; but I have decided to speak of it, because, since I discovered this picture two weeks ago at the end of the halls of industry, near the Prussian candelabra, I have never been able to leave the exposition without going to see it again.

This little work of no consequence perfectly depicts that scene with the witches with which the protectors of superannuated ideas so frequently reproach Shakespeare. I see in this water-colour a telling lesson in poetry; this is how supernatural things must be presented to the imagination. During the tempest, the witches are seen in a black cloud distinctly enough to say that they exist, but not enough for the eye to distinguish the members of those bodies formed from the air, into which they will dissolve themselves as soon as Macbeth's restless ambition presses them with questions. A year from now, I will still remember this poor little water-colour of two square feet, and I will have forgotten, as will the public, those immense oil paintings which paper the grand Salon. In

[8] [Constable's painting "The Hay Wain." See Fig. 14. Constable wrote Dr. Fisher, Jan. 22, 1825, "I had this morning a letter from Paris informing me that on the king's visit to the Louvre he was pleased to award me a gold medal for the merit of my landscapes. At the same time he made Sir Thomas Lawrence a Knight of the Legion of Honour." (From C. R. Leslie, *Memoirs of the Life of John Constable,* London, 1951, p. 137.)]
[9] [Anthony Fielding (1787–1855), an outstanding water-colourist.]

a similar way, a little fable by LaFontaine wins out over a tragedy by LaHarp. In the arts, one must touch deeply, and leave a memory; it is not the time, it is the *manner* that has nothing to do with the business.

I went to the Louvre to ascertain the impression Saturday's visitors received from the paintings; I also wished to see a new work that is well spoken of: the picture by Ingres which has just been hung in the grand Salon.[10] It shows "Louis XIII putting France under the protection of the Virgin."[11] It is, in my opinion at least, a very dry work, and what is more, a patchwork of borrowing from the Italian masters. The Madonna is doubtlessly beautiful, but it is with a sort of *material beauty,* which excludes the impression of divinity. This fault, which is one of feeling *and not of science,* shows even more in the figure of the Infant Jesus. This Infant, which is, by the way, very well drawn, is anything but divine! The celestial physiognomy, the *unction* that is indispensable to such a subject, are entirely missing from the figures of this painting.

The catalogue says that Ingres lives in Florence. In studying the old masters, how has Ingres not seen the painting of Fra Bartolomeo, he who taught Raphael chiaroscuro? The works of this monk, which are common in Florence, are models of unction. Do you wish to know why? Fra Bartolomeo, touched by the preaching of Savonarola, stopped painting, in fear for his soul. Since he was one of the foremost painters of his century—and of all centuries, I feel—when four years had passed, the superior of his convent ordered him to resume painting; and Fra Bartolomeo, in the *spirit of obedience,* returned to painting masterpieces. This appears to me to be the whole secret of the superiority of the fifteenth century over ours. Two months ago, a steam cannon was invented which will fire twenty shells a minute the distance of a league. We triumph in the mechanical arts, in lithograph, in the Diorama;[12]

10 [Delacroix's "Massacre of Scio" was also hung in the grand Salon.]

11 ["Louis XIII's Vow" commemorates the King's gratitude for intercession obtained when the French forces forced passage through la Brunette, a pass into Italy, and defeated the Duke of Savoy, March 1629.]

12 [Diorama: a group of pictures 22m. long and 14m. high, painted on thin cloth and placed around a room as in a theatre. Illuminated from the back, and with sound effects accompanying the lighting, a spectacle was offered, full of surprises. Daguerre installed the first one in Paris in 1822.]

but our hearts are cold, all forms of passion are missing, and particularly so in painting. No painting in the exposition has as much spirit as is found in an opera by Rossini.

I hasten to drop this digression which will have scandalized scholarly painters, in order to return to Ingres, who is himself one of the great draughtsmen of our school. How Ingres, a perceptive man, could not see that the less touching the action in a religious picture, the more necessary *unction* is for the painter to put us under the spell? The angels holding back the drapery on either side of Ingres' painting are painted in a very dry manner, as are their draperies; the little cloud on which the Virgin stands is like marble; there is a general crudity in the colors.

Louis XIII's movement is very animated; but nothing shows us the head of a great empire imploring the divine blessing for his innumerable subjects. The little Spanish moustache of the principal figure, which is almost all one sees of the face, produces a rather meager effect. Here is an accumulation of criticism of Ingres' work, and yet I consider the "Vow of Louis XIII" one of the better religious paintings in the exposition. It benefits from being seen again; it would benefit still more from being placed in a church where one was forced to look at it for an entire hour. I find in this work a depth of learning and concentration that proves that Ingres is devoted to painting and exercises his art conscientiously.

This painting is valuable above all at this time when so many young painters seem to work only to give subjects to the lithographers. If the painter had been endowed with the necessary celestial fire to put a little soul and expression into the Madonna, he could easily have attracted the public's attention. As soon as we begin to meditate upon the works of the painters who shone twenty years ago, we always come to that disagreeable truth which I do not enjoy repeating; David's school, while very skillful in depicting the muscles that cover the human body, is not capable of doing faces that express accurately a given emotion.

Let us urge Ingres and his contemporary painters to treat historical subjects which do not demand a great depth of expression. Without departing from the story of Louis XIII, Ingres could have shown that brave king at the attack of *la Brunette,* at the moment when Bassompierre said: "Sire, the violins are ready; when your Majesty wishes, the ball will begin!" . . .

ARTICLE 15, DECEMBER 11

At this time, as my duty calls me to give an account of the impressions received by the public from the statues admitted this year to the exposition, . . . I think it useful to glance rapidly at the state of sculpture in Europe. Rome has just lost Canova,[13] who invented a new type of *ideal beauty,* closer to our taste than that of the Greeks. The Greeks esteemed *physical strength* most highly, while we esteem spirit and feeling. The ferocious Hellenes forced themselves over a long period of time into the regions in which their descendants are found today; it seems to me that *physical strength* was more necessary to Ulysses or to the brave captain Canaris than the wit of Voltaire.

Whether this theory is valid or not, Canova began with exact imitation of nature as is proved by the group of "Icarus and Dedalus." This great man is perhaps most badly spoken of in Rome. Need I add that this illustrious man is detested by the French school; his works are *expressive* as the "Madeleine Sommariva" proves, and he has *grace,* for the "Hebe" exhibited four years ago is still remembered. All this is somewhat lacking in the school of David. That illustrious painter, the most skillful of the eighteenth century, has had perhaps more influence on sculpture than on painting. We have seen, when discussing the pictures, that a new school has arisen this year to the great dissatisfaction of the pupils of David. Schnetz, Delacroix, Scheffer, Delaroche, Sigalon[14] have had the insolence to make themselves admired. According to me at least, two or three of Schnetz's pictures will still be admired a hundred years from now. No similar movement can be noticed in sculpture. "So much the better!" cries the school of David. "So much the worse!" says the amateur who leaves the hall of sculpture with no deeply felt emotion.

In Rome, a German school of painting exists which is not without merit. Cornelius, Weiss, Begas,[15] imitate Ghirlandajo,

[13] [A. Canova (1757–1821), the leading exponent of neo-classical art in sculpture and the most renowned sculptor of his era.]

[14] [These artists are characterized as Romanticists.]

[15] [The Lukasbund came to be known as the Nazarenes. Friedrich Overbeck (1789–1869) and Peter Cornelius (1788–1867) were its leaders in an attempt to revive German art through religious conviction, choosing German and Italian "primitives" for its prototypes.]

Perugino, and other painters preceding Raphael; they claim
that this great man spoiled painting. But what good is it to
stop with an artist's theories? Schiller when he wrote *William
Tell* and *Don Carlos* was irrational on the subject of the *sub-
lime*. The works of the German school in Rome are very
remarkable; these young artists give a very clear image of
what they undertake to show the spectator. An idea of good
style may be gained from the engravings exhibited at the
Salon in the halls of industry.

The young German artists speak even more badly of
Canova than do the French. But at least they can justify their
hard words with the works of two sculptors famous through-
out Europe: Thorwaldsen,[16] a Dane who lives in Rome, and
Dannecker[17] of Munich. Some people do not think that
Thorwaldsen's statues rise above a very scholarly mediocrity,
but his bas-reliefs are excellent. "The Entry of Alexander
into Babylon"—a bas-relief of great finish, the figures of which
are about two feet high—it is a magnificent work if the figure
of Alexander, whose pose is theatrical, is excepted. Nothing
shows up in a more ridiculous light the type of exaggeration
necessary to the theatre than the *eternal immobility* of sculp-
ture.

Several of Thorwaldsen's busts are excellent, and that which
proves that this artist is of the first rank, is that the merit of
these busts is entirely *different* from that of Canova's busts.
You will find too much idealized grace in the bust of the
painter Bossi at Milan, one of Canova's masterpieces, and his
own bust—both of colossal size. This grace is very ill-conceived
in the bust of Pope Pius VII, which served as an ornament
in the magnificent hall of the Museum Pio-Clementino, built
by that pontiff, a patron of the arts. There is a famous bas-
relief by Thorwaldsen depicting "Sleep" of which copies or
casts are found in all the northern cities. This charming work

[16] [B. Thorwaldsen (1779–1844), after being well trained in the
antique and the contour drawing of John Flaxman at the Copen-
hagen Academy by the painters Abilgaard and Jacob Carstens,
went to Rome, 1798. He soon became famous for his neo-classical
sculpture that gave an impression of a detached grace and flow-
ing motion not present in Canova's work. Patronized by popes and
kings, his fame equalled Canova's. These statues for the Frauen-
kirche were executed in the 1830s.]
[17] [J. H. von Dannecker (1758–1841), a German neo-classical
sculptor who reflects Winckelmann's theories.]

has not been able to enter France, for we feel that honour requires us to reject all foreign products. This is perhaps very well for cotton, broadcloth, or nankins; but if I had the honour to be a French artist, far from seeking to encourage this habit where the arts are concerned, nothing would seem more humiliating to me.

In Thorwaldsen's studio in Rome, I have seen thirteen colossal statues representing "Jesus and His Apostles." These statues are to be placed in the open air, to ornament the façade of a church in Copenhagen. I fear that there is *heaviness* in these large figures and that that fault particular to German sculpture, *rounded forms,* is noticeable in them. The statue of Christ is very handsome; it has no longer the fearsome expression that Michelangelo would have given the Redeemer. Our ideas have changed since the year 1510. Openness and goodness dominate in the type of ideal beauty adopted by the Danish sculptor.

I have heard Canova exalt the merit of Dannecker of Munich, but I have only been able to see one statue by this artist whom all Germany proclaims, with a certain affectation, to be the foremost sculptor of the century. I think that I perceived in this statue several aspects of ideal beauty, but also a bit of German heaviness, above all in the articulations. . . .

Many statues are made in England. Fortunately for the fine arts, aristocratic vanity holds to the custom of constructing marble tombs for illustrious men in the churches. If the Dean and the Chapter of Westminster had not refused the author of *Don Juan* and of *Cain* entry into their cathedral, English sculptors would have had a handsome sculptural subject, a young poet with a charming face, agitated by the most somber passions, whose genius was to paint the transports of a soul torn by the conflict of pride with the tender passions.

I would try in vain to describe the ridiculousness of most of the English statues decorating the tombs in Westminster and St. Paul. The English sculptor, far from neglecting detail like Sir Thomas Lawrence, undertakes to depict with a hopeless exactitude buckles, shoes, stockings, pants, even the perruque of the noble lord he is depicting on his tomb. His way of translating into stone the great blue sash of the country is side-splittingly funny. Recently, that sort of hypocrisy applied to everyday action, called *cant* in England, relaxing somewhat from the severity established by the Puritans, has permitted the placing of naked angels on the tombs of great men. The

tomb of the two naval captains killed before Copenhagen, placed near the north portal of St. Paul's Cathedral, has an angel whose profile is worthy of the century of Canova. General Moore's tomb, placed across from it, is really not bad.

But Chantrey's[18] busts are very good. This artist was herding cattle a few years ago. He went from there to being a sculptor, and I am sure he is earning as many millions as Sir Walter Scott. Like that genius, Chantrey has all the skill, all the cleverness, all the flexibility necessary to be a success in London, and never to shock the fashionable *cant*. It would be difficult to express the pleasure that the bust of Walter Scott gave me. I would like a cast of this bust in the Louvre next to the bust of Lord Byron by Flatters. The bust of Lord Byron by Thorwaldsen looks like a schoolboy's attempt compared to the work of Chantrey. . . .

ARTICLE 16, DECEMBER 22

. . . Mr. H. Vernet has *bravura* in his genius. In this timid and mincing century he dares and he dares happily; he paints well, he paints quickly, but he paints appropriately. The great fault of the French School of Painting is the total lack of chiaroscuro that also ranges among mediocre works and is in this large portrait so impatiently awaited. In representing the sacred person of the King[19] and that Prince who merely appeared in Spain yet who managed to acquire so much fame there, you will never guess where Vernet has placed the principal light of his picture, and thus fixed the attention and the first glance of the spectator. This principal light is thrown on the ground of the Champ-de-Mars where the scene takes place. From this light so strangely placed, the spectator's eye rises to the lower part of the figure's boots. It is only by a *mental effort* and against the natural inclination of his eye, which should above all be satisfied in painting, that the spectator, remembering that he has come to the Louvre to see the King, is able at last to make out the head of the principal figure. . . .

18 [Sir Francis Chantrey (1781–1841), who, exhibited first in 1803 and soon had success, was the last exponent of the eighteenth-century tradition of neo-classicism established by Flaxman and Thomas Banks.]
19 [The Portrait of Charles X, in Versailles.]

A critic, a great enemy of Romanticism, has applied the strange epithet of *Shakespearean* to Vernet's painting, while calling the pictures of Raphael and David, *Homeric*. It would be simpler to say; *I will call romantic everything that is not excellent*. Through this simple trick, bit by bit the word "romantic" would become a synonym of *bad* to the public. That which is *romantic* in painting is the "Battle of Montmirail," that masterwork by Vernet, in which everything can be found, even *chiaroscuro*. That which is *classic* is a battle by Salvator Rosa, of about the same size, and which can be seen at the end of the great gallery on the side towards the Seine. The *romantic* in all arts is that which shows the men of today and not those who probably never existed in those heroic times so distant from us. If you will take the trouble to compare the two battles that I have mentioned, and above all the *amount of pleasure* they give to the spectator, you can form a clear idea of what romanticism is in painting. The classic is, on the contrary, those entirely naked men that fill up the picture, the *Sabines*. With equal talent, Vernet's battle would be better than David's battle. What sympathy can a Frenchman feel, who has given some saber cuts in his life, with those men who fight *naked*? The simplest good sense says that the legs of such soldiers would soon be flowing with blood, and in every age it has been absurd to go into battle naked. That which may console *Romanticism* for the attacks of the *Journal des Débats* is that good sense applied to the arts has made immense progress in the last four years and particularly among the leaders of society. . . .

II. ROMANTICISM

[FRANCISCO GOYA (1746–1828) was born near Saragossa, Spain. His first lessons were given him by a Neapolitan trained artist, José Lazan. Having little chance to receive a government stipend to study in Rome, for he was a known adventurer, libertine, and sceptic, Goya joined a group of bullfighters and financed his own trip in 1770–71. By 1775, Goya had returned to Madrid and was married to the daughter of Bayeu, painter to the King.

Among Goya's first commissions on his return were thirty paintings for use at the royal tapestry factory and a series of frescoes for the church of San Antonio de la Florida on the outskirts of Madrid. Anton Raphael Mengs, the German painter, director of the Vatican school of painting (1754) and famous exponent of eclecticism, twice in Madrid to execute commissions for Charles III, had noted Goya's originality and brought him to the attention of the court.

Goya employed his great talent as a realist in portraiture, and the portraits of the Spanish royal family, the nobility, and famous visitors to the court were unequalled in the course of the nineteenth century for their psychological penetration and superb technique. In all his work Goya discarded both conventional subject matter and the academic method of painting and depicted genre scenes employing fragmentized color and deft light brush strokes. The figures in his compositions arranged in flat untraditional patterns were the precursors of those of the later French realists and explain Goya's influence on that school.

Goya executed four dramatic series of etchings, employing the new technique of aquatint. The first series, "Los Caprichos," was published in 1799 and mercilessly satirized the institutions, society, and customs of Madrid. As it met with no success, Charles IV accepted the plates and unsold sets in exchange for a pension for Goya's son. "Los Disastres de la

Guerra" (1810–14) depicted incidents from the Peninsula War (1804–14) and the Madrid Famine (1811–12). In "Los Proverbios" (1816–24), Goya blended figures and forms with grotesque fantasies drawn from his imagination to portray the stupidity, avariciousness, and cruelty of contemporary life. There was no edition of the last two series in Goya's lifetime. When they were published in 1863–64, they had a tremendous influence, for the subject matter in them that was endowed by fantasy acquired symbolic meaning which corresponded to the attempts artists were then making to attain a symbolic art.

Free of any political allegiance, Goya painted for both the conquering Bonapartes and the restored Bourbons. Totally deaf from the age of fifty, he lived outside Madrid in his house, "La Quinta del Sorda," whose dining room he decorated with monumental frescoes of fantastic figures painted in black and brown. At the end of his life, Goya executed thirty-three plates depicting the bullfight which represent the consummation of his artistic skill in their composition, technique, and terse realism.

In 1824, at the age of seventy-eight, Goya obtained permission to visit Paris where he was seen by Gericault and Delacroix as he made the rounds of the ateliers. He stopped briefly in Bordeaux on his return where he died in 1828. His art links the art of the two centuries in which he lived.

SEE: F. D. Klingender, *Goya in the Democratic Tradition,* London, 1948.]

THE CAPRICHOS[1]

Dream[2]

"The artist dreaming. His only purpose is to banish harmful, vulgar beliefs, and to perpetuate in this work of caprices the solid testimony of truth."

"Imagination, deserted by reason, begets impossible monsters. United with reason, she is the mother of all arts, and the source of their wonders." [See Plate 7.]

"As soon as day breaks, they fly each one his own way, the

[1] Quoted from José Lopez-Rey, *Goya's Caprichos, Beauty, Reason and Caricature,* Vol. I, Princeton University Press, 1953, p. 79.
[2] [Goya explained the meaning of his etchings with these captions.]

witches, the hobgoblins, the visions, and the phantoms. It is a good thing that these people show themselves only by night and in the dark. No one has ever been able to find out where they hide and lock themselves up during daytime. He who would catch a group of goblins in their den, and show them in a cage at ten o'clock in the morning on the Puerta del Sol, would not need any rights of primogeniture to an entailed estate."

[WILHELM H. WACKENRODER (1773–98) lived in Berlin except for short intervals of study at different universities and a brief trip which affected his life and writings, to Paris, passing through Nürnberg, Bamberg, and Ansbach on his way. Wackenroder's short book *Effusions from the Heart of an Art-Loving Monk* (1797), arranged and published by his intimate friend, Ludwig Tieck, had great influence on his contemporaries and marked the point of departure of a new concept of the artist and art, a concept that dominated romanticism and has prevailed ever since. In his book, Wackenroder sensed that the creation of art is a miracle accessible only to feeling and unattainable by reason. It is a religious service of a sacramental nature in which the artist is priest, and by and through his work, he communes with God. By surrendering his mind to God the artist is enabled then to receive the mystic stream of the universe. The artist's secret of creation is artistic intuition that permits him the execution of an art work which comes into being involuntarily. Because artistic activity and the enjoyment of art have a sacramental character, any approach to art must be devout, and Wackenroder wrote his book as though he were a monk.

His conception of art led to a new appraisal of the nature of the artist. The divine inspiration, identified with the spontaneity of the artist's creation, is unconcerned with the method or manner of representation in his work, and as criticism can only be given of the external, the method of representation, the artist's creation is freed from any criticism. The inspired artist is only concerned with his subject, with his way of feeling, which in turn determine his method of representation and his style. Beauty is the transfiguration and spiritualization of appearance for the romantic painter, sculptor, or poet, for

whom the distinction and balance between his senses or feelings and his intellect has disappeared.

Wackenroder's conception brought him intuitively a recognition of the universality of art and in particular of the beauty of northern medieval art and the genius of Albrecht Dürer.

Wackenroder's influence was great. He belonged chronologically and spiritually to the first group of German romanticists and strongly influenced it. This was a circle in Jena formed by the two Schlegel brothers, Friedrich, the classicist, and August, Mme Staël's literary adviser, Friedrich Schelling, the poet "Novalis" (Friedrich Hardenberg) and Ludwig Tieck. Tieck published *Fantasies Concerned with Art for Friends of Art* (1799), (*Phantasien ueber die Kunst fuer Freunde der Kunst*), half of which was Wackenroder's original discussion on the nature of the art of sound, from which Tieck expanded his own theory of poetry as verbal music. From Jena and later from Dresden, with and without the specific religious character, it infected all European thought on artistic creation.

Direct results of Wackenroder's influence were the founding of the Order of St. Luke ["Hl. Lukasbund"] (1809), or "Nazarenes," by Friedrich Overbeck (1789–1869) of artists dedicated to realizing Wackenroder's precepts as a means of renewing German art. It also led to a new appreciation of German, Flemish, and Dutch medieval and Renaissance art and their conservation and preservation. Wackenroder and German Romanticism unwittingly provided the material and expression for the nationalistic aspirations that were stirring at that time in Germany.

SEE: H. Beenken, *Das 19 Jahrhundert in der deutschen Kunst,* Munich, 1944.]

EFFUSIONS FROM THE HEART
OF AN ART-LOVING MONK[1]

To the Reader of These Pages

In the loneliness of cloistered life in which I sometimes look back gloomily on the distant world, the following essays, one by one, were written. In my youth I loved art intensely, and this love has accompanied me like a true friend to my present age. Without noticing it I wrote down from an inner impulse my memories which you, beloved reader, must peruse with an indulgent eye. They are not written in the style of the present day because that style is not in my power and because, if I may speak quite frankly, I do not like it.

In my youth I was entangled in the world and in many worldly affairs. My greatest pleasure was art, and I wished to dedicate my life and my few talents to it. I was not entirely unskilled in drawing, in the judgement of some friends, and my copies as well as my own inventions were not wholly displeasing. I always thought with a grave, sacred awe of the great blessed saints of art. When the name of Raphael or Michelangelo came into my thoughts, I found it strange, yes, even silly, that I handled charcoal or held a brush in my hand. I may indeed confess that sometimes in an indescribably sad ardour I was obliged to weep when I clearly imagined their works and their lives. I could never bring myself to that—yes, a thought like that would have seemed to me impious—to separate from my selected favorites the good from the bad, and finally put them in one row to observe them with a cold critical gaze as young artists and so-called friends of art nowadays are accustomed to do. Thus, to admit it freely, I have read the writings of H. von Ramdohr[2] with very little pleasure; and he who likes those should lay aside at once what I have written, because he will not like it.

[1] These excerpts are translated from W. H. Wackenroder und L. Tieck: *Herzenergiessungen e eines kunstliebenden Klosterbruders, Kunstanschauung der Fruehromanik,* Leipzig, 1931, Vol. 3, pp. 15–20; 46–60.
[2] [An art scholar and critic living in Dresden. He wrote a critical essay of Friedrich's paintings.]

These pages, which in the beginning I did not intend to
publish, I dedicate only to young beginning artists or youths
who are thinking of devoting themselves to the arts and still
possess a sacred reverence for former times in hearts not yet
become arrogant. Perhaps they will be touched even more by
my words, otherwise unimportant, and be moved to an even
deeper awe, for they will read with the same love with which
I have written.

Heaven decreed that I fulfill my life in a cloister. These at-
tempts are, therefore, the only thing that I now may do for
the arts. If they do not entirely displease, perhaps a second
part may follow in which I would like to set down my criticism
of certain works of art and to arrange the thoughts I have
written down and bring them into a clear form, if heaven
grants me health and leisure.

The Vision of Raphael

The inspiration of poets and artists has ever been for the
world an offense and a subject of strife. Ordinary people can-
not understand what its conditions are and certainly form very
false and absurd ideas about it. Therefore, there is as much
useless chatter and treatment of the inner revelation of the
genius of art within and without systems, methodically and
unmethodically, as on the mysteries of our sacred religion.
The so-called theorists and systematicians explain to us the
inspiration of the artist by hearsay, and are perfectly content
with themselves, when in their vain and profane sophistry
they have used words for something the spirit of which cannot
be expressed in words, nor can the meaning be known. They
speak of artists' inspiration as of a thing that they might have
before their eyes; they explain it and speak much about it;
and truly they should blush to utter the holy word, for they do
not know of what they speak.

With how many unnecessary words have over-clever writers
of modern times sinned in the cause of the ideals in plastic
arts. They agree that the painter and the sculptor reach their
ideals by a more extraordinary way than the way common
nature and experience must go. They admit that this occurs
in a mysterious manner: and yet they imagine that they them-
selves and their pupils may know the How, because, it seems,
they would be ashamed if there were something hidden and

secret in the soul of man, of which they could not give information to inquisitive young people.

Others in fact are even sceptical and deluded scoffers who, with diabolical laughter, entirely deny the divinity of art "enthusiasm," and will accept no special distinction or dedication of certain rare sublime spirits because they feel themselves too remote from them. Such are entirely aside from my path and I do not speak with them.

But the sophists I mentioned, I wish to instruct. They damage the young souls of their pupils when they teach them such rash and thoughtlessly arrived at opinions of sacred things, as if these things were human, and in the way they plant in their pupils the mad illusion that it would be within their power to comprehend confidently what the greatest masters of art—I may say it freely—could only attain through divine inspiration.

So many anecdotes have been told over and over again, so many meaningful pronouncements of artists have been set down and repeated; it seems impossible that people have listened only with superficial wonderment, and that it has occurred to nobody to suspect from all these clear indications that the holiest men of art were pointing to what they reveal, or to recognize the trace of God's finger.

I, for my part, have always cherished this belief; but now my tentative thoughts have grown into a bright conviction. Happy am I whom Heaven has destined to spread its renown through a revealing proof of its unknown wonders; it is given to me to build a new altar to the honour of God.

Raphael, the bright sun among all painters, has left us, in a letter to Count Castiglione, the following words that are worth more than gold, and which I never could read without a mystical, obscure sense of awe and adoration: "As one sees so few beautiful feminine figures, I hold myself to a certain picture in my thoughts that comes into my soul."[3]

With these meaningful words, totally unexpected, a bright light rouses me to inner joy.

I searched through the treasure of old manuscripts in our cloister and found, among some worthless dusty parchments,

[3] ["Essendo carestia die belle donne, io mi servo di certa idea che viene al mente." The English translation is "I use a certain idea that comes to mind."]

several pages from the hand of Bramante.[4] I cannot imagine
how they came to this place. On one of the leaves the follow-
ing was written which, without further digression, I will trans-
late into my own language:

"For my own pleasure and to preserve it exactly for myself,
I will note here an amazing event which the faithful Raphael,
my friend, confided to me under an oath of secrecy. Some-
time ago, from a full heart, I expressed my admiration for his
Madonnas and the Holy Family, beautiful above everything,
and urged him repeatedly to tell me from where in this world
he had borrowed the incomparable beauty, the moving features
and unrivalled expressions for his pictures of the Holy Virgin.
After he had delayed for some time with his singular, youthful
modesty and silence, at last with emotion and tears, he em-
braced me and revealed his secret. He told me that from his
earliest childhood he had always had a special inner reverence
for the Mother of God, so that at times only to speak aloud
her name moved him to melancholy. Later when he took an
interest in painting, it always had been his deepest desire to
paint the Virgin Mary in her true heavenly perfection; but
this he had never trusted himself to do. In his mind, day and
night he constantly worked on her picture; but he could never
complete it to his satisfaction; he always felt as if his fantasy
worked in obscurity. And at times it was as if a beam of
heavenly light had fallen on his soul so that he could see the
bright features as he wanted to paint them, and yet he was
able to hold them for a moment only, and could never fix
them in his mind. Thus was his soul in constant unrest. He had
always seen the features only in movement, and his obscure
image had never been able to resolve into a clear picture.
Finally, unable to restrain himself any longer, and with trem-
bling hands, he began a picture of the Holy Virgin. During the
work his inward self became more and more aglow. Once in
the night while he, as it so often happened, prayed to the
Virgin in a dream, he was violently affected and suddenly
started up from sleep. In the gloomy night his eye was drawn
by a bright light to the wall opposite his bed, and when he
looked carefully, he realized that his picture of the Madonna,
which hung still unfinished on the wall, had become in the
gentle light beam a complete, perfect and truly vivid picture.

[4] [Bramante (1444–1514) preceded Michelangelo as architect of
St. Peter's. See Holt, Vol. II, pp. 18–19.]

The godly divinity in this picture so overwhelmed him that he burst into tears. The eyes had gazed at him in an indescribably touching way, seeming about to move at any moment, and indeed it had seemed to him as if they had actually moved. What was most wonderful was that it seemed to him as if this picture was just that for which he had always searched, even if he always had only a dark and bewildered awareness. How he had fallen asleep again he could not with certainty remember. In the morning he rose like one newborn; the vision remained firmly impressed in his mind and in his senses. It was now possible for him always to paint the Mother of God as she had floated before his soul, and he himself always experienced a certain awe before his pictures. This, my friend, my faithful Raphael, told me, and this miracle has always been so important and extraordinary to me that I have written it down for my pleasure."

Such is the content of the priceless pages that fell into my hands. Will people now see clearly before their eyes what the Divine Raphael means by the remarkable words when he says: "I hold myself to a certain picture in spirit which comes into my soul"?

Will people understand, taught by this obvious miracle of heavenly power, that his innocent soul expresses in these simple words a very deep and great meaning? Will people comprehend that all the profane gossiping about the inspiration of the artist may be a real sin, and be convinced that it depends on nothing less than direct divine assistance?

But I add nothing else in order to leave each to his own meditations on the important subject of this great observation.

Some Words on Universality, Tolerance and Humanity in the Arts

The Creator, who made our earth and everything that is on it, has spanned the whole globe with His gaze, and has poured the stream of His blessing over the entire circle of the earth. But from His mysterious workshop He has strewn over our sphere thousands of endlessly varied seeds which bear endlessly varied fruits, and to His honour bloom as the largest, most colourful garden. In a miraculous way He leads His sun in measured circles around the globe, so the beams come to the earth in a thousand directions and extract and force from

the earth's core a variety of creations, at each latitude. . . .
Man also in a thousand shapes has come forth from His crea-
tive hand. The brothers of *one* house do not know each other
nor understand each other; they talk different languages and
are surprised by each other: but He knows them all and re-
joices in them all; with the same glance He rests on His hands'
work, and receives the sacrifices of all nature. . . .

Thus He hears the inner feelings of men in different zones
and in different epochs speaking in different languages, and
hears how they fight with each other and do not understand
each other. But in the eternal spirit everything dissolves in
harmony; He knows that everybody speaks the language which
He has created for him, that everybody should express his
inner life as he can and shall; if men in their blindness fight
with each other, He knows and recognises that each one in
himself is right; He looks with pleasure on each one and on
all, and enjoys the motley mixture.

Art should be named the flower of human feeling. In eter-
nal, changing form she rises from earth's varied zones to
heaven; and for the universal Father, who holds in His hand
the globe with everything that is on it, there is only one com-
bined fragrance from this seed.

He sees in every work of art, in all zones of the earth, the
trace of the heavenly spark, which, coming from Him, passed
through the breast of men into their little creations, from
which the spark gleams towards the great Creator. To Him
the gothic temple is as pleasant as the temple of the Greeks;
and the rough battle music of the savages is to Him the same
lovely sound as artistic choirs and church chants. . . .

For stupid people it is incomprehensible that on our globe
there are antipodes, and that they themselves are antipodes.
They always think of the place where they stand as the centre
of the whole, and their spirit lacks the wings to fly around the
earth and to embrace with one glance the self-contained en-
tireness. . . .

The multiplication-table of the common sense follows in all
nations of the world the same laws, only that here it is applied
to a larger infinite—there, to a very much smaller field of ob-
jects. In a similar way the feeling of art is only one and the
same divine light-beam, but through the varied cut glass of the
senses the light breaks into thousands of different colours in
different zones.

Beauty: a miraculously strange word! Just invent new words

for every single art feeling, for every single work of art! In one plays another colour, and for every one other nerves are created in the buildings of Man.

But you are spinning out of this word, with the skill of your intelligence, a rigid system, and you want to force all men to feel according to your instructions and rules—and you do not feel yourselves.

Who believes in a system has pushed common love out of his heart! More bearable is the intolerance of feeling than the intolerance of the intellect; superstition better than belief in a system.

Can you force the melancholy to enjoy comic songs and gay dance? Or the sanguine to offer his heart with joy to the tragic horrors?

O let us leave every mortal being and every race under the sun in his belief and his happiness! and rejoice when others rejoice, even if you do not understand how to rejoice with them in that which for them is the dearest and worthiest.

We, sons of this century, have the advantage that we stand on top of a high mountain, and that many countries and epochs are open to our eyes, and lie around us and spread out at our feet. So let us use this good luck, let our eyes wander freely over all eras and peoples, and let us strive always to find in all their varied feelings and the products of this feeling the human spirit.

Every being strives for the most beautiful; but he can not free himself, and sees the beauty only in himself. Every mortal eye receives another picture of the rainbow, and thus to everyone is reflected another image from the surrounding world. But the universal, original beauty, which we can name only in moments of blessed contemplation and not resolve into words, shows itself in Him, who made the rainbow and the eye—the eye that sees it.

I began my speech with Him, and I return again to Him: as does the spirit of art—as all spirits go out from Him, and through the atmosphere of the earth again force their way back to Him as sacrifice.

Memorial to Our Worthy Ancestor Albrecht Dürer

Nürnberg! you once world-famous town! How I liked to wander through your crooked streets; with what childlike love I looked at your ancestral houses and churches which bear

the firm trace of our old, paternal art! How deeply I love the forms of those times, that speak such a rough, strong, and true language! How they draw me back to that grey century, when you, Nürnberg, were the lively, swarming school of national art and a truly fruitful, exuberant spirit of art dwelt and stirred in your walls:

When the Master Hans Sachs and Adam Kraft, the sculptor, and above all Albrecht Dürer with his friend Wilibaldus Pirkheimer, and so many other highly praised and honoured men were still alive! How often have I wished myself back into that time! How often, born in my thoughts, did it again pass before me, Nürnberg, as I sat in a narrow corner, in the twilight from the small round windows, in your venerable library-halls, and brooded over the volumes of the gallant Hans Sachs, or over other old, yellow, worm-eaten papers; or when I wandered under the bold vaults of your dark churches, where through the colourful, painted windows all the sculpture and paintings of the olden times were wonderfully lighted by the day.

You are surprised again, and look at me, you narrow-minded and fainthearted people! Oh, indeed I know the myrtle forests of Italy; indeed I know the heavenly ardour of those enthusiastic men of the blessed South. Why am I called where the thoughts of my soul always dwell, where is the homeland of the most beautiful hours in my life! You, who see frontiers everywhere, where there are none; are Rome and Germany not on one earth? Has not the Heavenly Father laid roads from North to South, as well as from West to East over the globe? Is one human life too short? Are the Alps insurmountable? And surely more than one love must live in the breast of men.

But now my mournful spirit walks over the consecrated place before your walls, Nürnberg; over the graveyard, where rest the remains of Albrecht Dürer, once the pride of Germany—yes, of Europe. Visited by few, they rest beneath numberless gravestones, each marked with a bronze sculpture, the mark of the old art, and between them grow in profusion high sunflowers, which make the graveyard into a lovely garden. Thus rest the forgotten bones of Dürer, because of whom I am glad that I am a German.

Few, it must be allowed, are able to understand the spirit of your pictures, and enjoy, with such fervour, the singular and the special within them as it seems to be given me by Heaven more than to many others; because I look around,

and I find few who stop before you with such ardent love, such admiration, as I have.

Is it not as if the figures in your pictures were real men, who talk together? Each is so characteristically marked that one would recognise him in a large crowd; each one is taken so from the midst of nature that he entirely fulfills his purpose. None, with half his soul is there, as one would often say of the very delicate pictures of modern artists; everyone is conceived in full life, and like that placed in the picture. He, who is to mourn, mourns; he, who has to be angry, is angry; and he who has to pray, prays. All the figures speak, and speak loudly and distinctly. No arm moves uselessly, or just for the play of the eyes, or for filling the space; all limbs, everything speaks to us with force, so that we grasp the idea and the spirit of the whole firmly. We believe everything that the artful man shows us; and it is never erased from our memory.

How does it happen that today's artists in our country seem to me so different from those praiseworthy men of the old times, and especially you, my beloved Dürer? How is it that it seems to me as if you have handled the art of painting much more seriously, more earnestly, and more worthily than all the delicate artists of our days? It seems to me that I see you as you stand thoughtfully before the picture you have begun; how the conception that you want to make visible, entirely complete, floats before your soul; how you thoughtfully ponder what features and which positions would arrest the observer most strongly and surely, and as he viewed them would most powerfully affect his soul; and how you then, with deep interest and friendly earnestness truly and slowly draw on the panel the beings befriended by your vivid imagination. But, the modern artists do not seem to wish that we should seriously take part in what they present to us; they work for noble gentlemen, who wish neither to be moved nor ennobled by the art, but wish only to be hoodwinked and tickled; they strive to make their painting into a sample of many lovely and deceiving colours; they try their cleverness in the scattering of lights and shadows; but the human figures often appear only to stand in the picture because of the colour and of the light—really, I would like to say—as a necessary evil.

I must cry "woe" over our times in that we practice art only as a light-minded plaything of the senses, when it really is something very serious and noble. Do people no longer respect mankind, that they neglect them in art and find pretty

colours and all kinds of artificiality with light more worthy of their observation? . . .

If now art (I mean its main and most essential part) is really of such importance, then it is very unworthy and light-minded to turn away from the expressive and instructive human figures of our old Albrecht Dürer, because they are not furnished with the deceitful outward beauty that today's world holds as highest in art. It does not show an entirely healthy and pure soul, if somebody before a spiritual observation, which in itself is weighty and impressive, stops his ears because the speaker does not arrange his words in delicate order, or because he has a bad, strange pronunciation, or awkward gesturing with his hands. But would such thoughts hinder me from esteeming and admiring, according to merit, this external and, so to speak, corporeal beauty of art, where I find it?

You are also charged, my dear Albrecht Dürer, with the grave offense of placing your human figures, without entangling them artificially, comfortably beside each other, so that they form a homogeneous group. I love you for your ingenious simplicity, and fix my gaze involuntarily, first on the soul and the profound meaning of your beings without any censorious spirit ever coming into my mind. Many persons seem to be plagued by this, as an evil tormenting spirit, so much so that they are induced to despise and ridicule before they can observe quietly, and least of all, become able to go beyond the limits of the present and transfer themselves to former times. I will gladly admit, you eager newcomers, that a young student of today may speak more cleverly and learnedly about colours, light, and the arrangement of figures than would the venerable Dürer; but is it his own intelligence that speaks out of the youth, or is it not much more the knowledge and experience of art from former times? The true inner soul of art is only grasped, as a whole, by single chosen spirits, even if the handling of the brush is still very faulty; but all the aspects of art are brought, one after the other, to perfection, through invention, practice, and meditation. But it is a base and deplorable vanity, which sets the achievement of their times as crowns on their own weak heads, and hides their nothingness under borrowed splendour.

And also for that reason, today's teachers do not want to name Dürer, as well as many other good painters of his century, beautiful and noble, because they clothe the history

of all nations, and even the sacred history of our religion, in the costume of their time. Here, I think that every artist who lets the spirit of former centuries pass through his heart has to give it life from the spirit and breath of his age; and it is fair and natural, that from love the creative power men have brings near to them all strange and distant things, as well as the heavenly beings, and envelopes them in the familiar and beloved forms of their world and their horizon.

At the time Albrecht Dürer was holding his brush, a German had still a special and excellent character of stability in the arena of nations in our part of the world; and his pictures bear truly and clearly, not only in their features and in the entire external appearance but also in their inner spirit, this serious, straight, and strong nature of the German character. In our times, this German character as well as German art has been lost. The young German learns the languages of all European nations, and by examining and judging, is supposed to draw nourishment from the spirits of all nations; and the student of art is taught how he is supposed to copy the expressions of Raphael, the colours of the Venetian school, the truth of the Netherlands, the magical light of Correggio, all at the same time, and in this way should obtain an unsurpassable perfection.

O sad sophistry! O blind belief of the time, that you can combine all kinds of beauty and every excellence of all the world's great artists and by observation of everything and by the begging of their manifold and great gifts, unite within yourselves all their spirits and conquer them all! The period of one's own power is gone; with poor imitation and clever arrangement they will try to force a missing talent, and cold, slick, characterless works are the fruit. German art was a pious youth reared among kinsmen, within the walls of a small town; now that he is older, he has become an ordinary man of the world, who has wiped from his soul, together with the provincial customs, his feeling and his special character.

I would not wish that the enchanting Correggio or the brilliant Paolo Veronese, or even the mighty Buonarotti had painted as Raphael. And I also do not join in the empty phrases of those who say: "If Albrecht Dürer had only lived for a while in Rome, and had learned the true Beauty and the Ideal from Raphael, then he would have become a great painter; one must feel sorry for him, and only wonder how in his place he

still could have come so far." I find nothing to feel sorry for here; on the contrary, I am glad that with this man fate has bestowed to German soil a truly national painter. He would not have remained himself; his blood was not Italian blood. He was not born for the Ideal and the exalted majesty of a Raphael; he had his pleasure in showing us how the people around him really were, and in this he succeeded excellently.

But in spite of this, it occurred to me, when, in my younger years, I saw in a magnificent gallery the first pictures of Raphael as well as of you, my beloved Dürer, how of all the painters I know, these two had a very special, close kinship to my heart. In both, what pleased me so much was that they placed, so clearly and distinctly, mankind full of spirit before our eyes, simple and straightforward, without the ornamental digressions of other painters. At that time I did not dare to disclose my opinion to anybody, because I believed that everybody would laugh at me, and I knew quite well that most people saw in the old German painter something stiff and dry.[5] Comparison is a dangerous enemy of enjoyment; even the purest beauty in art only impresses us as it should with its full power, when our eye does not at the same time glance sidewards to other beauty. Heaven has so distributed her gifts among the great artists of the world that we need to stand still in front of each one and offer to each his share of our admiration.

Not only under the Italian sky, under majestic domes and Corinthian columns, but also under pointed arches, intricately decorated buildings, and gothic towers true art grows.

Peace be with your remains, my Albrecht Dürer! and may you know how I love you, and hear how I am the herald of your name in this, to you, modern, strange world! Blessed be your golden time for me, Nürnberg! the only time that Germany could boast of a true national art. But the beautiful times pass away over the world and disappear, as splendid clouds move over the arch of the sky. They are gone and not thought of any more; only a few from an intimate love in their soul summon them back out of dusty books and remaining works of art.

[5] [An account of a dream, in which he enters the old gallery of the castle and sees the ancient painters standing next to their pictures, with Raphael and Dürer standing hand in hand, is omitted.]

Of Two Marvelous Languages and Their Mysterious Power

The language of words is a great gift of heaven, and it was an eternal favour of the Creator that He loosened the tongue of the first man, so that he could name all things that the All-Mighty had set around him in the world, all spiritual images that He had placed in his soul, and with this richness of names could exercise his mind in various games. With words we rule the whole earth; with words, with little effort we bargain for all treasures of the world. Only the invisible, hovering above us, words cannot draw down into our being.

Earthly things we have in our grasp, when we speak their names; but when we hear named the All-Bountiful God or the virtue of the Saints, which are indeed objects that should affect our whole existence, our ear is filled with only empty sounds, nor is our spirit exalted as it should be.

But I know two miraculous languages by means of which the Creator has allowed men to grasp and behold heavenly things in all their power, that is, (not to speak audaciously) as far as this is possible for human beings. They come to our inner being by quite different means than words. All at once in a wonderful way they move our whole existence and force themselves into every nerve and drop of blood we own. One of these wonderful languages only God speaks; the other is spoken by only the few chosen from mankind whom He has anointed as His beloved ones. I mean: Nature and Art.

From my earliest youth, when I first learned to know the God of mankind from the ancient holy books of our religion, nature was always for me the fundamental and clearest explanation of His being and His qualities. The rustling at the top of the forest, the rumbling of thunder, told me mysterious things about Him that I cannot put into words. A beautiful valley enclosed by fantastic rock forms, a smooth river reflecting the inclining trees, or a gay green meadow brightened by the blue sky—ah, these things brought to pass more wonderful emotions in my inward being, have filled my spirit deeper with God's omnipotence and bounty, and have cleansed and exalted my soul far more than the language of words could ever do. Language, it seems to me, is much too earthly and clumsy a tool with which to handle the immaterial as one handles the material. . . .

Art is a speech of quite a different kind from nature; but

she also has, by similar dark and secret ways, a wonderful power over the hearts of men. She speaks with pictures of men and makes use of a hieroglyphic writing, whose signs we know and understand by their outward appearance. But Art fuses the spiritual and sensuous in such an affecting and wonderful way into visible forms that once more our whole being and everything within us is stirred and shaken to the depths. Some paintings of Christ's Passion, of our Holy Virgin, or of the history of the Saints, have, I must say, cleansed my heart more, and infused my inner mind with more virtuous thoughts, than systems of moral and spiritual observations. Among others I still think with fervour of a magnificently painted picture of our Holy Sebastian; as he stands naked bound to a tree, an angel draws the arrows from his breast, while another brings a wreath of flowers for his head. I owe to this picture very deep and lasting Christian convictions, and I can scarcely recall it without tears coming into my eyes.

The teachings of the wise only stir our brain, only one-half of our self; but the two wonderful languages whose power I announce, move our senses as well as our spirit; or rather seem (as I cannot express it otherwise), to fuse all parts of our (for us incomprehensible) being into one single, new organ, which now in this twofold way grasps and understands the heavenly miracles.

One of the languages that the All-Highest Himself speaks from eternity to eternity, the eternal, living, infinite nature, draws us up through the wide spaces of air directly to God. But art, with ingeniously mixed coloured earth and a little liquid, copies the human form in a narrow, limited space, striving for an inner perfection (a kind of creation granted to mortal beings to produce); art opens to us the treasures within the human heart, directs our glance inwardly and shows us the spiritual, I mean, everything that is noble, great, and divine in the human form.

When, after having viewed Christ on the cross, I step out into the open, from our cloister's temple dedicated to God, and the sunshine of the blue heavens embraces me warmly and vitally, and the beautiful landscape with mountains, waters, and trees strikes my eye; then I see a special world of God rise before me, and feel in a singular way great things rise in my heart. When again I return from the open into the temple and contemplate sincerely and fervently the picture of Christ on the cross, then again I see quite another special

world of God rise before myself, and feel in another particular way great things rising in my heart.

Art depicts for us the highest human perfection. Nature, as much of it as a mortal eye can see, resembles broken oracular utterances from God's mouth. But if it is allowed to speak of such things, then we perhaps could say that God may see all nature or the whole world in a way similar to the way we see a work of art.

[PHILIP OTTO RUNGE (1777–1810) was born in Wolgast, a small Baltic coast town near Hamburg. His family, devout Lutherans, were shippers and shipbuilders. Runge's first teacher was the poet, Reverend Kosegarten, a follower of the seventeenth-century mystic, Jacob Boehm. Runge began his art studies in Hamburg and continued (1799–1801) at the Copenhagen Academy, which was directed by the painters, N. A. Abilgaard, a classicist, and J. Juel, a student of color and light. Runge was a pupil of the latter until his studies were interrupted by events of the Napoleonic Wars. Continuing his study in Dresden, Runge came in contact with Ludwig Tieck and the romanticists, congenial to him for his natural inclination was toward a mystic pietism.

From Dresden, Runge submitted an entry to the Weimarer Kunstfreunde, an annual art competition with a given subject sponsored by Goethe. The competition did much to stimulate discussions among the artists on the nature of art and the qualities required of the artist. One result was Runge's letter to his brother Daniel.

When many of the German romanticists realized that inner subjective experience could not renew art, if art were separated from symbols possessing traditional meaning, and entered the Roman Catholic Church, Runge, influenced by Wackenroder and stimulated by Tieck, determined to create a new art of landscape painting that would be Christian in symbol and allegory. He turned to color, and with Jacob Boehm as his source, he evolved a meaningful color symbolism for such allegorical and symbolic paintings as "Lehrestunde der Nachtigall," (1802). On his return to Hamburg in 1804, he began the famous series "The Four Times of Day" (Viertageszeiten) in which the choice of color, the composition and design were to create an image of the growth and decay in

nature so identical to the idea of Christian redemption that its meaning would be clear to all. In the painting "Rest on the Flight into Egypt" (1805–6), by the selection of the proportions of the composition, by the choice of foliage, by the symbolic color and the introduction of allegorical figures, Runge achieved a religious picture.

Runge's attempt to find color satisfactory to his purpose led him to study it and its relation to mathematics and music. He developed a color sphere from a system of color co-ordinates which, shortly after Runge's death, Goethe published at the end of his own exposition of the "ethico-aesthetic values of color" and the influence of color radiation on the mind and spirit, *Die Farbenlehre* (1810).

Runge's art in its anti-classicism and abstract linearism was contemporary in style with that of "Les Primitifs" or "Barbus" in France.

SEE: G. Berefelt, *Ph. O. Runge, Zwischen Aufbruch und Opposition, 1777–1802*, Stockholm, 1961.]

LETTERS[1]

To Daniel Runge[2] Dresden, March 9, 1802

It has always rather embarrassed me, when Hartmann or somebody else presumed to believe—or at least said about others: "He and he actually do not quite know what art is." Because I have to confess that I also could not say what it is. That weighed terribly on my mind and annoyed me. Then I tried to find light in such general sentences, as for example: "A work of art is eternal," or: "One should see his life as a work of art," and other such statements, all of which seemed to me to signify one point, which however still has had to be explored before I would be able to understand completely these phrases heard batted about. Now, for some time it has become clear to me as a light in my soul, and I shall see if I can briefly and clearly explain my long-winded ideas to you.

Once upon a time I thought about a war that could change the whole world, or how such a war might occur; but today throughout the world, since war has become a science, and

[1] Translated from *Briefe von Ph. O. Runge,* Ausgewahlt von E. Hanke, bei Bruno Cassirer, Berlin, 1913.
[2] [Older brother of the artist.]

therefore real war no longer exists; since there is no longer a nation that could massacre all Europe and the whole civilized world, as the Germans once did with the Romans when all spirit had left that race—I saw, I say, no other means except the Last Judgement Day, when the earth would open and swallow us all, the entire human race, so that no trace of splendour would remain today.

These thoughts which also tend toward the Judgement Day, arose from some gloomy remarks on the spread of culture, by Tieck, when he was recently ill, and I asked myself what actually is the state of this advanced culture, where we have no means, other than such a harsh one, of bringing her to consciousness; what relationship, as far as our traditions go, does this culture have to the nature of mankind in former times. I also wondered how the earth once looked, and how little by little the raw masses of granite and water, opposed to each other, had more and more united. I found both these transformations everywhere—in men, in our life, in nature, and in every period of art; I thought about the different religions, how they originated and vanished; and again, a remark of Tieck occurred to me, that just when a period is declining, masterworks of art will always be created—for example, Homer, Sophocles, Dante, great Greek works of art and the newer Roman ones, likewise in architecture—and that each time, these works of art bear within themselves the highest spirit of the vanished religion. From what had been, it became obvious to me that after the climax of every period of art (for example after the creation of the Olympian Jupiter and after the creation of the *Last Judgement*), each time art declined, dissolved, and then gained a quite different height, an almost more beautiful point was again reached; I asked myself: Are we now once more to carry an epoch to the grave?

. . . I lost myself in wonderment; I could not think any farther; I sat in front of my picture,[3] and all that I had thought of at first—how it came to me, the feelings that are aroused in me each time by the moon, or by the sunset, the awareness of the ghosts, of the destruction of the world, the clear consciousness of all that I had ever felt about this—passed through my soul; and the consciousness of this would be with me to eternity. You can only be aware of the presence of God behind these

[3] ["The Triumph of Love."]

golden mountains; but you are sure of yourself, and what you feel in your eternal soul, that is also eternal—what you created from it, that is immortal; art must arise from this if it will be eternal.[4] What then happened to me, how I worked myself out of this confused feeling, how I tried to order it, you will now hear; what then happened, and whatever needs explanation, more of that later on.

When above me the sky swarms with countless stars, the wind blusters through the wide space, the wave breaks roaring in the wide night, over the forest the atmosphere reddens, and the sun lights up the world; the valley steams, and I throw myself on the grass sparkling with dewdrops. Every leaf and every blade of grass swarms with life, the earth is alive and stirs beneath me, everything rings in one chord, then the soul rejoices and flies in the immeasurable space around me. There is no up and down any more, no time, no beginning and no end, I hear and feel the living breath of God, who holds and carries the world, in whom everything lives and works: here is the highest, that we feel—God.

This deepest awareness of our soul—that God is above us, that we see how everything was created, was, and faded; how everything is created, is, and fades around us; and how everything will be created, will be, and will fade again; how there is no peace and no rest in us; this vital soul in us, that comes from Him and returns to Him, will exist when earth and heaven vanish—this is the most certain, the clearest consciousness of ourselves and our own eternity.

We feel that a pitiless severity, a terrifying eternity, and an eternal, sweet, boundless love stand opposing each other in a harsh and violent struggle, like "hard" and "smooth," or rock and water. We see those two everywhere, in the smallest and in the largest, in the whole as in the part: these two are the basic beings of the world and are based in the world, and they come from God and above them is only God. . . . When our feelings dash us along, so that all our senses shiver at their very core, then we search for the firm, important outward signs found by others, and unite them with our feeling; in the most wonderful moment, we can then communicate it to others; but if we want to extend this moment longer, an over-tension occurs, that is, the spirit flees from the signs that we

[4] These ideas are comparable to those expressed in Tieck's *Phantasien über die Kunst* No. X: "Die Ewigkeit der Kunst." [See Wackenroder headnote.]

found and we cannot again regain the association in us, until we return to the first intimacy of the feeling, or until we again become a child. Everyone experiences this circle where one will always die once, and the oftener one experiences it, the deeper and more intimate the feeling certainly becomes. And so art develops and declines, and there is nothing left but lifeless signs, when the spirit has returned to God.

This perception of the relationship of the whole universe to us; this joyful delight of the most intimate, vivid spirit in our soul; this unifying harmony, which in its buoyance touches every string in our heart; the love that holds us and carries us through life, this sweet being next to us, that lives in us and in whose love our soul glows; it is this in our heart that drives us and urges us to communicate; we hold fast to the consummation of these feelings and in this way certain thoughts arise in us.

We express these thoughts in words, tones, or pictures, and thus inspire the same feeling in the hearts of men near us. Truth of feeling affects everybody, all feel themselves together in this relationship, all who feel Him praise the single God; and thus originates *religion*. We place these words, tones, or pictures in an association with our most intimate feeling, with our awareness of God, and with the certainty of our own eternity through a feeling of the relationship of the whole, that is: we line up these feelings with the most meaningful and vivid beings around us, and, holding fast to the most characteristic features—to those features that correspond to the feelings—we represent the symbols of our thoughts of great forces in the world: these are the pictures of God or of the Gods. The more men keep themselves and their feelings pure and exalted, the more certain these symbols of God's power become, and the more intensely the great almighty power is felt. The symbols crowd together into one being all the infinite varied forces of nature; they try to concentrate simultaneously everything in a picture and thus to present a representation of infinity. (When the human spirit has attained the greatest apprehension, then an overtension occurs and the signs collapse of themselves; then as soon as the spirit has fled, man must begin again with the first child-like feeling.)

We use these symbols when we try to explain clearly to others great events, beautiful thoughts about nature, delightful or terrifying feelings of our soul, thoughts of events, or the

inner association of our feelings. We seek an event that corresponds in character to the feeling we want to express, and when we have found it, we have chosen the subject of the art.

When we link this subject to our feeling, when we confront every symbol of natural forces, or the feeling in us, so that they seem congenial in *themselves,* in the *subject,* and in our *feeling:* that is the *composition.* (Here, as in representing the unique exalted symbol of God, man again seeks to express a picture of God by means of the most exalted symbolic composition; he unites his loftiest feeling with the greatest event of the world, lets all the symbols of feelings and nature affect it, until he has expressed his thought on the deepest feelings of his soul, of the almightiness of God in the greatest and ultimate event of the world. In this manner the spirit is again spent; the lifeless elements sink of themselves, and there is the frontier of historic composition.)

In this way, as we feel more clearly and more coherently the forms of the beings from whom we take our symbols, we also derive a more distinctive outline and representation from their basic existence, from our feeling, and from the consistency of the natural subject. We observe this in all positions, directions, and expressions; arrange every object of the whole [picture] exactly after nature and in agreement with the composition, the effect, the single action as such, and the arrangement of the whole work, letting them be small or large according to the perspective, observing all details and those things which pertain to the basic idea, in which everything is effective, just as it is in nature and in the object; and that is the *design.*

As we observe the colours of the sky and the earth, the change in the colours of people caused by emotions and feelings, in the effects of colours as they occur in grand natural phenomena, and in the harmony, even in so far as certain colours have become symbolic. So we give to each object in the composition its colour that is in harmony with the first intense feeling and likewise to each symbol and object separately; and that is the *colour-scheme.*

These colours we unite or raise to their purity depending on whether each object should appear to be near or far, or if the space between the object and the eye is large or small: that is the *harmony,* or *balance.*

We observe the consistency of each object in its inner colour as well as the effect of bright or weak light on it, or shadow,

and the effect of illuminated objects nearby on it: that is the *colour-scale*.

We try to find nuances through the reflections and the effects of one object and its colours on another; we observe all colours simultaneously with the effect of the air and the given time of the day, try to observe thoroughly this tone, the last chord of our feelings; and that is the *tone*—and the end.

Thus art is the most beautiful endeavour, if it begins with that which belongs to all and is in unison with it. Therefore I will once again mention here how the requirements for a work of art follow each other, not only with regard to essential importance, but also with regard to the way in which they should be formed:

1. Our awareness of God,
2. The perception of ourselves in relationship with the whole, and out of these two;
3. Religion and Art; that is, to express our highest feelings in words, tones, or pictures; and there the plastic art looks first for:
4. the object; then
5. the composition,
6. the design,
7. the colour-scheme,
8. balance,
9. the colour-scale,
10. the tone.

In my opinion no work of art can be formed by any means, if the artist does not start from the first motives. Also, in no other way is a work of art eternal: for the eternity of a work of art certainly is only in its relationship to the soul of the artist, and by this, it is a picture of the eternal origin of his soul. A work of art, springing from these first impulses—and even if in its completion, it only attains the composition—has more worth than any artificiality, which came only from the composition without the preceding impulses and even if it is completely executed, to [the stage of] the tone, and it is obvious, that without these first [stages], the parts up to the tone can certainly not be brought into relationship and purity. Thus, only in this progression can art be renewed; here, out of the inner core of man, it must arise, otherwise it remains mere play; from this originated the art of Raphael, Michelangelo Buonarroti, Guido,[5] and others. Afterwards, it is said, art has

5 [Guido Reni (1575–1642).]

declined; what does that mean but that the spirit has escaped? Annibale Carracci[6] and others only began with the composition, Mengs with the design; our noisy people nowadays begin only with the tone.

If I look at such a progression and apply it to life, and see a dressy gentleman who can do nothing more than show off his French, yet still knows how to keep himself in vogue, unconsciously it occurs to me: *he is at tone*. The entire progression is the same in human life, and "blessed are they who are pure in heart, for they shall see God."[7]

And of what use will be all the chit-chat in Weimar,[8] where in their stupidity they want to recall something that has been before with mere signs? Has anything ever been renewed? I hardly believe that such beauty as occurred at the climax of historical art will again arise until all the corrupting newer works of art have been destroyed once and for all; then it would have to occur in an absolutely new way. This way is already fairly clearly indicated, and perhaps a time may come soon when a truly beautiful art can again arise, and that art would be landscape painting. Indeed we could say that actually there have not been fine artists in this field, only one now and again, and especially in recent times some who have also been aware of the spirit of art in this field.

As there is no work of art that has not been founded in our own eternal existence, certainly it is the same with that person who is not aware of God. The blossoms we raise from the consciousness of our origin, which draw the sap from this stem of the world, those blossoms ripen to fruit. Every man is a branch of this great tree, and only through the stem can we obtain the sap for this eternal, immortal fruit. He who no longer feels related to the stem is already withered.

To Ludwig Tieck Dresden, December 1, 1802

—Dear T., it really seems to me that soon I will be able to see how I could become quite a decent human being. Ev-

[6] [Annibale Carracci (1560–1609), the famous Bolognese painter and founder of the *Accademia degli Incamminati*. See Holt, Vol. II, pp. 70–73.]

[7] [Matt. 5:8.]

[8] [The reference is to the annual Weimarer Kunstfreunde exhibitions inaugurated by Goethe to stimulate a renaissance in the visual arts in Germany.]

erything works toward the end that I find something solid in me to which I can cling.

Various thoughts have occurred to me which seem to have such a foundation that I cannot get them to totter. I almost think they stand firmly. I believe I now understand a little of what you actually mean by "landscape." In all ancient history —as it appears to me—artists have always striven to see and express in man the stirring and moving of elements and natural powers. In Homer and in actual history, people are never taken individually, but in such a manner as the mighty times have stirred within them; also in Shakespeare and above all in the ancient pictures; this according to my thoughts would probably be the distinguishing mark and the determining difference between historical art [historical composition] and "landscape"; in that manner nothing greater would have been possible after the *Last Judgement* by Michelangelo.

"Landscape" would naturally consist of the reverse premise, that people would see themselves and their properties and passions in all flowers and plants and in all natural phenomena. Especially with regard to all flowers and trees it becomes clearer to me and always more certain, how in each is contained a certain human spirit, concept, or feeling, and it is very clear to me that it must have originated in Paradise. It is the purest thing there is in this world, in which we can recognize God or his image—namely, that which God called man at the time when he created man.

It is very clear to me, that flowers—at least for me—are very understandable creatures; I should imagine that I could bring, through my life, matters to the point where flowers would be very well understood, if one would only attempt it in an intelligent manner. I want to tell you how I intend to assign to myself and the worthy public—if they care about it— a theme, which I could repeat again and again and carry out completely.

You know of my idea for "The Water-Spring." I have often talked with you about it, and therefore all these thoughts have come to me. I wanted to paint in this picture all the well-known flowers which I know and which have meaning: all flowers have if we only observe them for that purpose. I would try to express by means of the composition of the flowers the whole idea, beginning with the first formation, so that the lily stands in the highest light where the red, yellow, and blue flowers are clustered and where the oak tree, like a hero,

spreads his branches over them.[9] The flowers shall receive
their true significance through the gay sounds of the spring,
which vanish among the flowers. In them there must be the
same composition so that it represents a transition. As the
spirit is in the flowers, so it is also in the trees. Of course it is
necessary that one finds the right spot for the Figure in the
flower; however, I think this will be found. Everything depends
on courage and practice. After all, a butcher can chop between
his toes with a meat cleaver without hurting himself! Now I
think that if in such a manner the corresponding human feel-
ing were always painted in all flower compositions, people
would have to become accustomed gradually to the idea of
thinking about them on every occasion. This, of course, could
not be accomplished quickly, but for that reason I intend
never to make a flower composition without figures during my
lifetime.

I cannot say—and much less write—the real things as I mean
them.[10] I had intended to depict in paintings how I came to
these concepts of flowers and nature. I did not want to show
only what I think, what I have to feel, and what true and con-
necting ideas can be seen in it, but also how I arrived at this
and how I still see, think, and feel this, as well as the way that
I have gone.[11] It would be curious, indeed, if other people
would not comprehend this at all. Only, what I wanted at first
is much more difficult, and one has to be able to control[12]
oneself enormously, but any other approach cannot help me
very much. On most days, to be sure, it is not possible to show
oneself like this without going mad; however, these days do
not exist for that purpose, and everything will turn out all
right through habit. The matter would almost lead more to-
ward arabesques and hieroglyphics. However, from these,
"landscapes" ought to emerge, as historic composition also
has emerged from them. In no other way is it possible for this
art to be understood except by means of the deepest mysticism
of religion. For art must derive from that, and that must be
the firm foundation of it, otherwise it will collapse like a house

[9] [See O. von Simson, *P. O. Runge and the Mythology of Land-
scape, Art Bulletin,* Dec. 1942, p. 336, for the influence of J. Mac-
Pherson's "Ossian" poems on Runge.]
[10] [See O. von Simson, *op. cit.,* pp. 335 ff.]
[11] In the *Tageszeiten,* Runge strove to make the idea and the image
so identical that anyone could grasp the one by means of the other.
[12] [The text is "attrapieren," also means "to deceive," "to trick."]

built on sand. I also am almost sure that it would ruin everything to speak with someone who cannot understand or comprehend it; it would be worse to do this publicly. That cannot lead to anything. Everyone who does not comprehend and cannot understand it—even if one says it a thousand times—must be brought to do so in a practical way which will be put before their eyes. It certainly is better that way.

To Goethe Wolgast, July 3, 1806
After a brief wandering tour, which I made through our charming island Rügen, where the quiet gravity of the ocean is broken in many ways by friendly peninsulas and valleys, hills and rocks, I found, together with the friendly welcome of my family, your esteemed letter. It is a great relief to my mind that my sincere wish is fulfilled, that my work really does appeal in some way. I appreciate very much that you esteem a study that lies outside the direction which you wish for art; it would be just as foolish to tell you my reason for working this way, as for me to persuade you that my way was the right one.

If the technique of painting is connected with such great difficulties for everyone, so it is to the highest degree for a person in our epoch who, at an age when the intellect already has attained superiority, only begins to practice in the elementary fields. Therefore it is impossible for him, without going to pieces, to transfer himself out of his own individuality into a common effort. That person who loses himself in the limitless abundance of life which is spread out around him, and will therefore be irresistibly drawn to imitation, feels himself also powerfully seized by the total effect. He will certainly likewise, as he considers the characteristics of the detail, investigate the relationship of nature and the force of the large masses. Who, with constant feeling, observes the great masses of everything alive down to the smallest detail and is reciprocally affected, that person cannot imagine this without a special connection or relationship, much less represent it, without engaging in the basic motives. If he does that he cannot win the first freedom before he has to some extent worked down to the sound foundation.

To make my meaning clearer: I believe, that the old German artists, if they had known something of form, would have lost the directness and the naturalness of the expression in their figures, until they had attained a certain level of this

technical knowledge. There have been many people who with a free hand have built bridges, suspension work and truly artistic things. It may take a long time, but if the artist comes to a certain level, and by himself hits upon mathematical conclusions, then his whole talent is lost, unless he himself works through that science and comes again into freedom. For this reason it was impossible for me to relax after I was first astonished by the special phenomena in mixing of the three colours, until I had obtained a certain picture of the entire world of colours, that would be large enough to include all changes and phenomena.

On seeing a beautiful landscape, on being touched in some way by an effect in nature, it is very natural for a painter to desire to know with what mixture of substances this effect should be reproduced. This urged me to study the peculiarities of the colours and if it were possible to penetrate so deeply in their qualities that it would be clear to me what they accomplish or what is affected by them, or what affects them.

I hope that you peruse with lenient forbearance this essay that I have written only in order to make clear to you my opinion, which, I believe, to be useful, must be expressed in its entirety. However, I do not think that looking at the colours in this way is useless for painting and that painting can be done without it. This opinion will also neither contradict nor render unnecessary the optical experiments undertaken to learn something definite of the colours. As I cannot give you incontestable proof that is based on complete experience, I also beg that you rely on your own feeling to understand the way I meant that a painter need not be concerned with any other elements than those which you find listed here.[13]

The firm belief in a certain spiritual union existent in the elements can at the last give comfort and cheer to the painter which he can obtain in no other way. As his own life becomes so lost in his work and cause, means, and aim, all in one, at last produce in him perfection, a perfection which certainly must be produced through a constant, diligent, and faithful effort, so that it cannot remain without a beneficent effect on others.

If I observe the materials with which I work, and maintain

[13] This list, the part on the theory of colours as well as the essay on the colour sphere, is omitted. A letter, in which Runge explains the results of his occupation with the science of colours, is reprinted in Goethe's "Zur Farbenlehre."

the standard of these qualities, I certainly know where and how I can employ them, as no material that we work with is all clean. I cannot enlarge here on technique because, firstly, it would be too lengthy, and also I had only the intention of showing you the point of view from which I observe the colours. I also will readily admit that there is still a lot of error in it. You will at least recognize my effort, and that I will not be deterred by anyone from the method which, in my opinion, has to be taken to resist from within the stupidity which exists in the technical aspects of painting today. Also, I do not believe that I have followed this path until now without benefit to others. But I lack the necessary chemical and mathematical knowledge to do something more basic. I wish with all my heart to have the opportunity to obtain this knowledge.

If by means of this exposition certain things in the "Four Times of Day" become clearer to you, I hope to clarify them even more, when one day I send you a sketch in oil colours.

[CASPAR DAVID FRIEDRICH (1774–1840) was born at Greifswald on the Baltic Sea. After thorough classical training (1794–98) in painting from N. A. Abilgaard at the Copenhagen Academy, Friedrich went to Dresden. There he may have earned a living drawing panoramic "prospects," the antecedent of the picture postal card of famous and frequented places.

Through Runge's introduction to Ludwig Tieck, Friedrich entered the circle of German romantic writers in Dresden, the Schlegel brothers, the poet "Novalis," Jean Paul Richter, and Schelling, their philosophical spokesman. Schelling's concept of art as a totality of creative impulse that blends Nature and the spirit became the basis of Friedrich's art.

Friedrich enjoyed his first success in 1805 when two of his drawings shared in an award at the Weimarer Kunstfreunde exhibition and Goethe called attention to his talent. In 1807, Friedrich began to paint with oils, working without previous drawings of color sketches directly on the canvas lest his fantasy grow cold. The image "alive" in his soul should not be devised, it could only be felt. Friedrich placed his subject matter in the half-light of dawn or twilight with a localized intense concentration of light. Within the enclosed space he thus created, Friedrich fixed a view of nature, invested it

with a spiritual quality to achieve a religious landscape. The character of the landscape and meaning of the Christian elements Friedrich introduced in his painting stood in a close relationship and made his paintings the expression of an individual religious feeling of the world. The appearance of nature which he strove to represent was the reflection of the being he sought in his inner self, the "I" that contains the key to the world. He portrayed the time and seasons of nature, choosing that which enabled him to depict a moment of transition in nature. The French painter David d'Angers characterized Friedrich's art with the exclamation, "There is a man who has discovered the tragedy of Landscape!"

Friedrich, always esteemed by his contemporaries, a member of the Dresden Academy, and named the Professor of Painting in 1824, lived in a circle of artists, writers, and scholars, among whom was von Kleist, the philosopher, and the physician-artist, Carus, whose *Neun Briefe über Landschafts-malerei (Nine Letters on Landscape Painting)* owe much to Friedrich's thought. After Friedrich's death, Carus selected certain of the artist's aphorisms on art and published them in Friedrich's memory.

SEE: H. von Einen, *Caspar David Friedrich,* Berlin, 1938.]

THOUGHTS ON ART[1]

The painter should not just paint what he sees before him, but also what he sees inside himself. However, if he does not see anything inside himself, he should abstain from painting, otherwise his pictures will be similar to Spanish folding screens, behind which one expects only to find sick or even dead people. Thus Mr. N.N.[2] did not see anything that everybody else who is not blind does not also see, and of the artist you certainly expect that he should see more.

This painter knows what he does, and that one feels what he does; if you only could make one out of the two!

[1] These excerpts are translated from Carl G. Carus, *Friedrich der Landschaftermaler, Zu Gedaechtnis Besten Fragmenten aus seinem Faksimile,* Dresden, 1841.
[2] Identity unknown.

What is regarded as virtuous for the qualified is very often a vice for the unqualified.

You should keep sacred every pure impulse of your mind; you should keep sacred every pious presentiment; because that is art in us! In an inspired hour she will appear in a clear form, and this form will be your picture!

The picture is big but greatness is missing.

This painter X is also one of the many at this time whose studies, drawn or painted from nature, are excellent; but when these studies are used for pictures and the originals are removed so the painter is dependent on his spiritual eye, then no one recognises any of his former studies. Other painters, instead, often draw painstakingly and awkwardly from nature, but when it comes to using the sketch for a painting, then everything gains life and soul.

The good God certainly lets his sun shine on just and unjust and stretches his arch of grace over the entire earth; but if the painter wants to represent a rainbow and tries this with the imperfection of the means that are at his disposal, then he also must draw this heavenly apparition over a landscape worthy of the sublime object, and not, as N.N. here, who lets it shine over a pair of well-known beer-halls. With this it should not be said, that it absolutely has to be quite a special part of the country, for example the grand part, like Switzerland, or the boundless ocean. A simple cornfield would be sufficient, or an otherwise plain but worthy landscape.

The painters practise inventing, composing, whatever they call it; does that perhaps not mean, in other words, that they practise patching and mending? A picture must not be devised but perceived.

Shut your corporeal eye, so that you see first your picture with your spiritual eye. Then bring to light that which you saw in darkness, that it may reflect on others from the outside to the inside.

The artist's feeling is his law. Pure perception never can be against nature but can only be natural. But never should the feeling of another be imposed on us as law. Spiritual relationship creates similar works, but this relationship is far removed from mere aping. Whatever one may say of N.N.'s pictures, and however they may be like N.N.'s pictures, these pictures nevertheless came forth from him and are his property.

It is said of this painter, he would be master of his brush.

Would it probably not be more accurate to say that he is dominated by the power of his brush? Only through his vanity, to show off in painting the skill of his brush, he sacrificed the greater qualities of nature and truth, and so attained the miserable fame of showing off as a practical painter.

Two halves make a whole, but he who is half a musician and half a painter is always only a whole half. Thus there may also be whole quarters, and our schools seem to make even smaller fractions their aim.

One sees in this great picture of moonlight by the justly famous finger-artist N.N. more than one wishes to see, and truthfully more than can be seen in moonlight. But what the perceptive sensitive soul rightly demands to find in every picture is seen here as little as in all N.N.'s pictures. If it were in his power to paint a few deeply felt pictures instead of so many devised pictures, his contemporaries and posterity would be more grateful.

Unessentials here and unessentials there! Nothing is unessential in a picture; everything absolutely belongs to the whole, therefore nothing may be neglected. He who only knows how to give value to the main part of his picture so that he neglects secondary parts is working badly. Everything has to be and can be done with care, without any part being too prominent. True subordination does not lie in the neglect of the unessential for the essential; but on the contrary, in the arrangement of things, and in the distribution of shadow and light.

One word gives the other and also one picture the other. Now I work again on a big picture, the biggest I have ever done. *3 Ellen, 12 Toll high and 2 Ellen, 12 Toll wide.* Like the picture mentioned in my last letter, it represents again the interior of a church in ruins. And actually I did take as a base the beautiful still-standing and well-preserved Cathedral of Meissen. Out of the high rubble, which fills the inner space, soar powerful piers with slender, delicate columns, still supporting a part of the high arched vault. The time of the temple's glory and its servants are gone, and from the ruined whole emerges another time and another demand for clarity and truth. High, slender, evergreen spruces grow from the ruins. On decayed pictures of saints, destroyed altars, and broken holy water basins, an evangelical priest stands with the Bible in his left hand, his right on his heart, and leans against the remains of a bishop's monument. His eyes are raised to a blue heaven, and pensively he watches the bright light clouds.

N.N. is known for his tendency to paint gloomy subjects, yet in his company one would not miss cheerfulness of heart. Therefore his friends try hard to divert him from this tendency and commission him to paint cheerful subjects. Because of his nature, he can probably never execute those commissions with satisfaction and pleasure, while, with a cheerful spirit, he could represent sombre air and grave, gloomy landscapes. O, you good-natured people, who do not recognize the inner drive and tension of the soul, and want Man not as the loving God has created, coined, and stamped him, but as time and fashion will have him. Our time laments the loss of character, and yet, if character is found to some marked extent, we try to crush it. O God, forgive these men for they do not know what they do; they also cause the opposite of what they intend.

If only N.N. would remain in the narrow circle assigned to him by nature, where he has already produced some beautiful things. For example, what does a cross mean suddenly [placed] here? In this instance, would not a cud-chewing ox have suited much better? Don't always ape everything, if you don't feel yourselves called on to do it!

[CARL CARUS (1789–1869), a naturalist and doctor, studied painting and drawing to acquire the skill required for his botanical studies. With such interests Goethe's influence is to be found in all aspects of Carus' work. He dedicated his *Nine Letters on Landscape Painting* (1831) (*Neun Briefe über Landschaftsmalerei*), written between the age of twenty-five and thirty-six years, to Goethe, whose *Faust* had aroused men to an awareness of the cosmic dimension of nature. At the same time, a relationship was also discovered between the forms of nature and those of art; for example, the Gothic cathedral and a pine forest.

In the letters, which he signed as Albertus, to signify a spiritual relationship with Albrecht Dürer, Carus posed the question: "What is the meaning of landscape painting and what is its worth?" He reversed the attitude of the classicists and saw landscape as the essential part of art. A landscape painting is an "earth-life-picture" whose effect is to produce the same spiritual well-being that is experienced in nature. It is the product of the painter's physical and spiritual communion with nature, his identification with nature as Schelling in his con-

ception of the "soul of the world" "Weltseele" expressed it. The human figure is present in landscape only to heighten the effect of nature and to provide the spectator with a point of self-identification as the figures do in the pictures of Friedrich or later of Camille Corot.

However, a mystical feeling of the universality of nature is insufficient. Nature is not a hieroglyph behind which lies a secret. Nature itself is the secret. Therefore, the landscape painter is required to possess, as the scientist, a knowledge of the inner structure of rocks and mountains, the growth of plants, and atmospheric phenomena. This postulate contributed to the development of the objective reality of the Austrian Biedermeier school of painting represented by Ferdinand Waldmuller's (1793–1865) and Karl Blechen's (1798–1840) work, and explains the appeal German painting held for the realist, Courbet.

Carus was able by his original approach to landscape to recognize the worth of the seventeenth-century landscapists, Rysdael (1600–70) and Hobbema (1638–1709), and to equate their work with the classical landscapist, Claude Lorrain (1600–82), in the same way that Wackenroder had done for the art of Dürer and the art of the Northern Renaissance.]

NINE LETTERS ON LANDSCAPE PAINTING[1]

Letter II

Let us now, dear friend! go to a closer discussion of the purpose and the meaning of landscape painting: an art which belongs to the recent times and which in general is much less enclosed in itself, and perhaps still looking forward to its Golden Age, than the other arts, most of which resemble the head of Janus, looking backward, or even stand as memorials to better days on the graves of the past. Any imitative art has necessarily a twofold effect on us: once through the nature of the copied object, whose particular property affects us in a picture in a way similar to nature itself; and next as a work of

[1] Translated from Carl G. Carus, *Neun Briefe über Landschaftsmalerei, geschrieben in den Jahren 1815 bis 1824,* Ed., K. Gerstenberg, Dresden, W. Jess, 1955, pp. 25–29; 47–49; 98–100.

art which is a creation of man's intellect, and through a true experience lifts the kindred intellect above the commonplace (in the same way that the world in the highest sense may be called an appearance of divine thought).

Let us now consider separately these two effects of landscape art, in order to prepare a final result that is general and useful. "What then is really the effect of landscape objects in free nature?" Let us ask first, and then we will be able later to estimate their effect in the picture—firm ground, with all its varied forms, like cliffs, mountain, valley, and plain, quiet or moving water, air and clouds with their diversified appearance, these are in general the pattern through which the life of the earth manifests itself; a life, however, of such immensity compared with our smallness, that men scarcely are able to recognize or appraise it as life. In contrast, the life of plants is higher and closer to us, and these, in connection with the first mentioned phenomena, constitute the proper objects of landscape art. All these phenomena in nature certainly do not impress us in a passionate, violent way; for this they are too removed from us, if we were to speak of their esthetic effect at all; for it is self-evident that the shipwrecked are not interested in the beauty of the surf, nor the man ruined by fire in the beauty of the illumination. What touches us closely and is tightly bound to us can only by means of its transformations also stimulate us most intensely, fill us with desire or with hate; but in the free, and to us quite objective appearing nature, we notice much more a quiet, withdrawn, uniform, ordered life: the changes of time, of day, and year, the passage of the clouds and all the colour-splendour of the sky, the ebb and flow of the sea, the slow but inevitably advancing change of the earth's surface, the weathering of naked cliffs, whose crags, soon washed down, produce fertile soil, the welling up of the springs, whose waters follow the direction of the mountain-chains, are gathered into creeks and finally into streams: everything obeys quiet and eternal laws, by whose power we ourselves of course are also controlled. In spite of all resistance we are dragged along with them in that they force us with secret power to glance at the great, yes, enormous circle of natural phenomena; they divert us from ourselves and let us realise our pettiness and weakness; the observation of them, however, will at the same time soothe our inner tension and in every way have a quieting effect. Go up to the top of the mountains, look over the long range

of hills, observe the flow of the rivers and all the splendour that opens before your eyes, and what feeling touches you? It is one of quiet devotion within you; you lose yourself in boundless space; your whole being undergoes a quiet refining and cleansing; your ego vanishes; you are nothing; God is all.

Not only powerful immensity, as it appears in the life of a planet, but an intense penetrating glance at the quiet, serene life of the plant world has the same effect. Look how the plant slowly but vigorously raises itself from the ground; how stage by stage the leaves unfold, in quiet evolving advancing transformation into bud and blossom; and at last the circle closes in the seed, while simultaneously causing the opening of a new one. If we now find ourselves surrounded by a self-contained luxuriant plant world, with a glance we survey the varied life cycle of so many plants, encountering some venerable trees, whose endurance spans centuries to remind us that the life of the earth is counted in millennia as well as in days, then we experience the same effect as induced by the above mentioned conditions; a quiet thought takes possession of us; we feel restless endeavour and strife restrained, we enter into the sphere of nature and rise above ourselves. Yes, it is indeed strange that the world of plants exercises a similar effect physically on our body, like the exhalation from blossoms —the highest developed plants—which usually has something narcotic that causes sleep and physical rest, as so many juices produced close to the blossom often exercise these effects in an even higher degree—yes, even induce an absolute dissolution of ordinary nature leading to death. Therefore the ancients hung the cave of the god of dreams with various herbs and sleep-inducing poppies. Yes, even animals and men at last become mild and calm with a continuing vegetarian diet, while eating meat seems to favour violent desires and motion. Certainly, these observations throw some light on the effect of landscape objects in the picture, they will clarify the reason for that sense of well-being, of an inner peace and clarity experienced before genuine works of landscape painting, and will be able to give us many directions in the further course of these elucidations. But enough for now! I await your friendly answer.

Your ALBERTUS.[2]

2 [This signing of "Albertus" to establish an association with Albrecht Dürer is an example of a form of hero-worship characteristic of the Romanticists.]

Letter III

ON THE REPRESENTATION OF THE IDEA OF BEAUTY IN "LAND-
SCAPE"-NATURE[3]

Before we venture to make a closer investigation of the
manner in which the idea of beauty, expressive of the inner
life in the life of nature, should be represented, it is necessary
to consider briefly a question, the solution of which, even
though many maintain it is impossible, may in the end be
closer to solution than some other things, namely: what is
beauty? But if first of all we consider why the many attempts
to answer this question only open the way to almost as many
errors, then the reason seems very simply to lie in this, that
people have never tried to comprehend the idea of beauty,
which is unlimited in its essence, but have always piled up
limitations and desired to exile the spirit into an empty sound-
ing word without being able to raise their vision to the eternal
and the divine. It was much the same with the definition of
the concept of life, where the attempt was to represent life
only as real, as single, existent by itself, different from the
other essences of nature, not suspecting that life had to be
comprehended as the primary source of all natural phenom-
ena, so that instead of Juno, the cloud should be embraced.

My answer to that question is thus: that beauty may not
be anything but that by which the perception of the Divine
Being in nature—that is, the world of sensual appearance—
would be inspired; and in a like manner, as truth is to be
called the recognition of Divine Being and virtue the life of
the Divine Being in nature, proceeding from that direct de-
votion of nature to the absolutely supreme, which is her pri-
mary source, is called religion (brotherhood, unification).
Therefore Beauty can be nothing else but the uniform pene-
tration of reason and nature, since the Supreme and the One
only reveal themselves in the forms of nature and reason.
Therefore, as soon as nature appears to be penetrated and
formed by reason, the idea of divine being will also appear
to us. The ego will enter into contact with the revealing in-
finity, and the perception, the feeling (just caused by the di-
rection toward the infinity, as above) appears defined as the

[3] [*Von Darstellung der Idee der Schoenheit in Landschaftlicher
Natur.*]

feeling for beauty, in which then this whole aspect of men attains its focus and its goal (esthetic satisfaction). Beauty is consequently the threefold sound of God, Nature, and Man, and the sight of its essence only emerges out of the firm, sincere conviction (which underlies all knowledge and perception of an absolute supremacy). Therefore, it can be asserted that, without a vital relationship of men to God, there can be as little feeling for beauty as feeling for truth and right; and for that very reason then, because this relationship can never really be lacking, this holy triad lives also in every man's heart, though sometimes more, sometimes less veiled, yes, clouded. . . .

Letter VII

. . . Now that I have laid before you these examples, either I have deluded myself or I have made myself clear about that which floats before me as the Ideal of the new landscape painting, but I still must add something to the name of this art. Actually seen from this standpoint, the trite name of "landscape" is no longer sufficient for us, for it has a connotation of something of the handicrafts, to which my whole being is strongly opposed. Another word should be searched for and found, and I propose herewith: the art of the earth-life-picture. At least in this word there certainly lies more of the ideas that I wanted to present here, than in the word "landscape."

But when I re-read what I have written, it occurs to me that, out of all the above, a misunderstanding of another kind still could arise, which I must forestall immediately. It could be concluded from what has been said, also from what was intimated, of such earth-life-pictures, that only the most gigantic scenes in the largest formats should be depicted, that only representations of the world of the Alps, storms at sea, immense mountain forests, volcanoes, and waterfalls should be the models for such earth-life-pictures. But that is not in the least my opinion, and I also would not hesitate to declare that those scenes, really well conceived, would depict the sublimest of the earth-life-picture-art; however, actually every aspect, even the quietest and simplest side of life on earth, is a noble and beautiful object of the art, if only its own particular meaning, the hidden and divine idea in it, is truly comprehended. What Goethe says about the life of men, we could say about

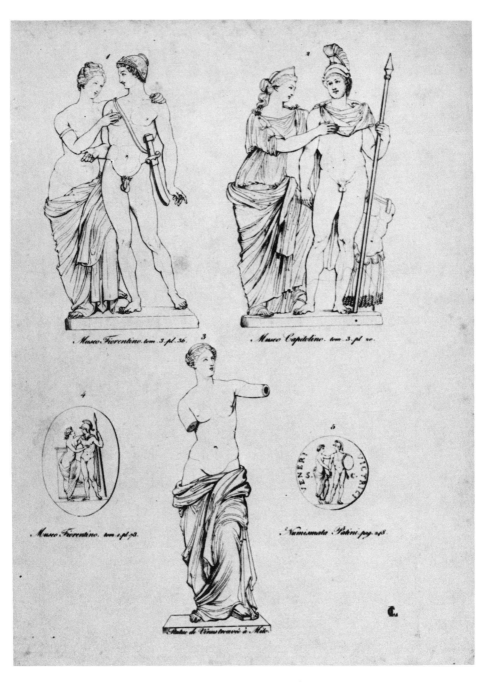

1. Venus de Milo. Photo from Quatremère de Quincy.
Notice sur la statue antique de Venus, Paris, 1821

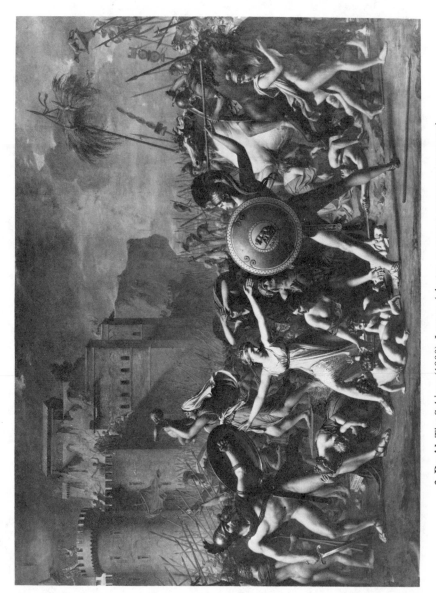

2. **David,** The Sabines (1800). Louvre (photo: ARCHIVES PHOTOGRAPHIQUES)

3. **Flaxman,** Venus (1817). Fogg Art Museum, Cambridge, Mass.
Agnes Mongan Collection

4. **Ingres,** The Oath of Louis XIII (1824). Cathedral, Montauban
(photo: ARCHIVES PHOTOGRAPHIQUES)

5. **Ingres,** The Bather,
called "La Baigneuse Valpençon" (1808). Louvre
(photo: ARCHIVES PHOTOGRAPHIQUES)

6. **Ingres,** Portrait of E. J. Delécluse.
Courtesy of Fogg Art Museum, Cambridge, Mass.
Grenville L. Winthrop Collection

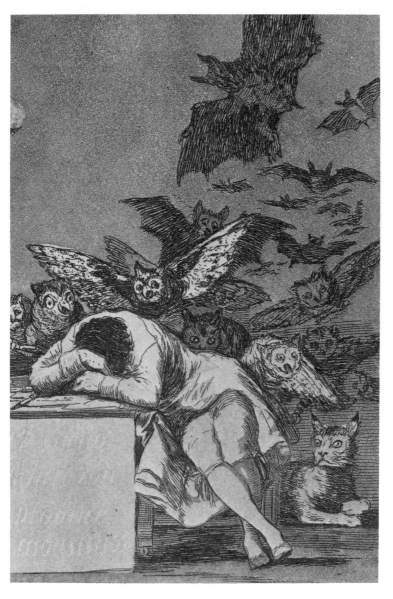

7. **Goya,** When Reason Sleeps, Monsters Are Born,
Caprichos No. 43 (1799).
Courtesy of the Museum of Fine Arts, Boston, Mass.

8. **Runge,** Rest on the Flight into Egypt (1805-6). Kunsthalle, Hamburg, Germany

9. **Runge,** Night. Viertages Zeiten.
Kunsthalle, Hamburg, Germany

10. **Friedrich**, Abbey in Oak Wood (1809). Verwaltung der Schlosser und Garten, Berlin

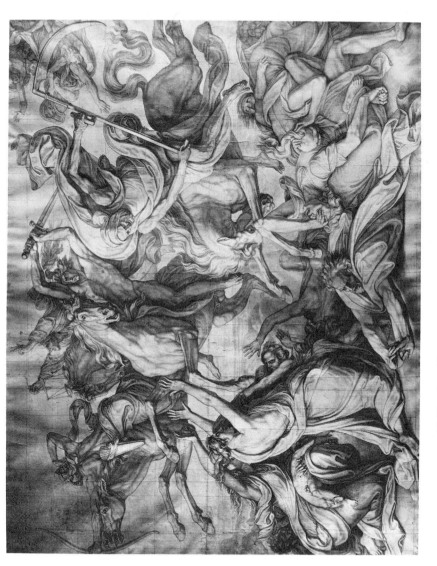

11. **Von Cornelius,** The Four Riders of the Apocalypse (1842).
National Galerie, East Berlin

Can any understand the spreadings of the Clouds
the noise of his Tabernacle

15

Also by watering he wearieth the thick cloud by his counsels
He scattereth the bright cloud also it is turned about

Of Behemoth he saith, He is the chief of the ways of God
Of Leviathan he saith, He is King over all the Children of Pride

Behold now Behemoth which I made with thee

WBlake invenit & sculpt

London, Published as the Act directs March 8: 1825 by Will Blake N3 Fountain Court Strand

Proof

12. **Blake,** Behemoth and the Leviathan.
Book of Job, Vol. II, Pl. 15 (1824).
Courtesy of the Museum of Fine Arts, Boston, Mass.

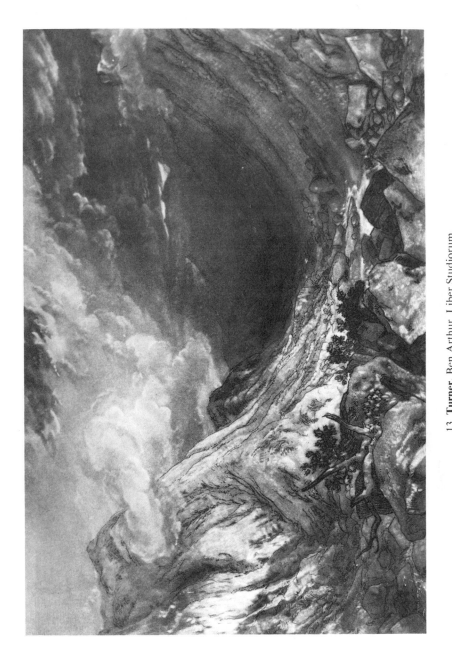

13. **Turner,** Ben Arthur, Liber Studiorum.
Courtesy of the Fogg Art Museum, Cambridge, Mass.

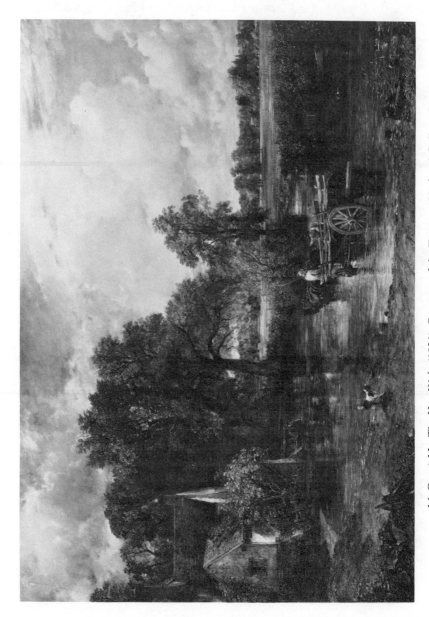

14. **Constable**, The Hay Wain (1821). Courtesy of the Trustees, National Gallery, London

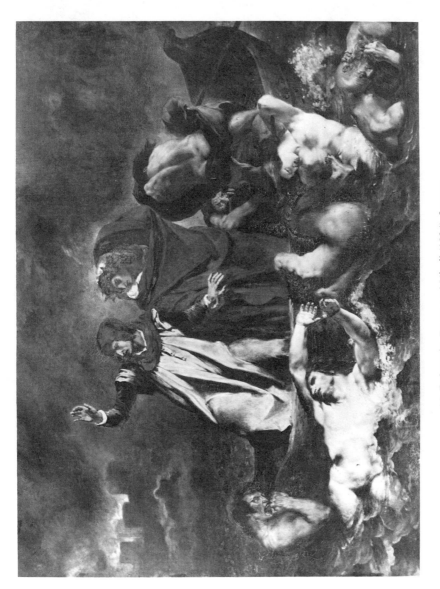

15. **Delacroix,** Dante and Virgil (1824). Louvre
(photo: ARCHIVES PHOTOGRAPHIQUES)

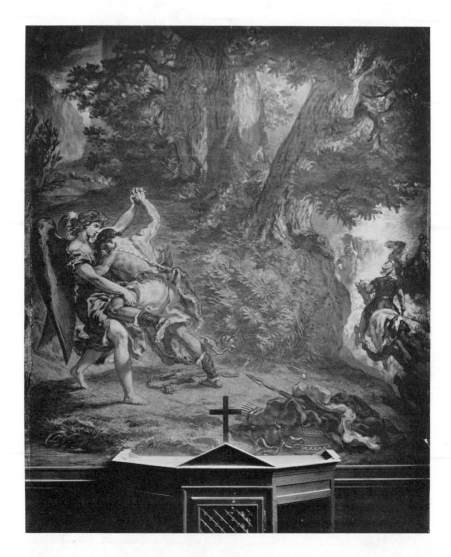

16. **Delacroix,** Jacob Wrestling with the Angel (1861).
Ste. Sulpice, Paris (photo: GIRAUDON)

the life on earth: "Plunge into the fullness of human life, each lives it, but few know it; and wherever it is seized, there it is interesting."[4]

The smallest corner of the forest with its manifold stirring vegetation, the simplest grassy hill with its delicate plants, before the bluish distance arched by a misty blue sky, will offer the most beautiful earth-life-picture, which, done in a small or large space, will leave nothing to be wished for, if only it is grasped by the soul. But furthermore, it also should not be said that an earth-life-picture should contain only objects of the clean, free nature, without a trace of mankind; man is indeed the most beautiful product of the earth, and the earth without man is as imperfect as man can be thought perfect without the earth. Therefore, evidence of the life of mankind only completes the earth-life and its artistic representation and consequently, men and the work of men can appear well in a true picture of earth-life, provided the description of the earth-life dominates. The unity of a work of art demands that, and it cannot be achieved otherwise. Indeed, for this last reason, in the earth-life-picture, men and the work of men should seem to be determined by the nature of the earth; and it has already been acknowledged empirically that, for example, because of this inner contradiction, a recently finished, sharp-edged, and freshly-painted building does not fit in landscape painting; that human figures, who characterize life in nature (as hunters or shepherds) belong more to it that Homeric heroes, etc.—all of which is understandable if the above premises are correctly comprehended. And so I would wish, that it might be expressed clearly, what ideal of future landscape or earth-life painting really was in my mind; but what furthermore could actually be gathered for the study of art has to be reserved for a future letter.

Your ALBERTUS

[PETER VON CORNELIUS (1783–1867) was born in Düsseldorf, but grew up in Dresden where his father was the curator of the Museum. He returned to study at the Düsseldorf Academy. An early enthusiasm and interest for the northern painting of the Renaissance was encouraged by his friendship with the

4 Goethe, *Faust,* Prologue, Comedian; 2nd Speech.

Boisserée brothers, who were among the first to rescue and collect the then neglected art works of that period. They were also active in the movement to revive German art, a movement which led to the completion of the Cologne Cathedral as a museum and a monument after the discovery of the original plans in 1814.

Cornelius was stimulated on seeing the Emperor Maximilian's *Book of Hours* (1515–18), illustrated by marginal drawings of Dürer and others, to illustrate German epics in graphic art. He began (1809–11) with pen drawings of Goethe's *Faust,* which were engraved and published in 1816. Cornelius went for the customary study-trip to Rome (1811). There he continued his series with the "Nibelungenlied," relying on Raphael and Dürer as models for his severe linear style. This work awakened in him an interest in the fresco cycles of religious legends executed in the fourteenth and fifteenth centuries. In Rome, Cornelius was received into the Order of St. Luke, the "Lukasbund" or "Nazarenes" as they came to be called. The group was founded (1809) in Vienna by a Luebecker, Friedrich Overbeck (1789–1869) and Franz Pforr (1788–1812), who were dissatisfied with the instruction at the Vienna Academy. Inspired by Wackenroder's writings and early German paintings, they resolved to paint in that manner and thus to renew the religious basis of German art. Overbeck had gone to Rome in 1810, and had adapted the Convent of S. Isidorio for the brotherhood. They proposed to achieve their aim by employing the German technique of painting and by observing "the way of phantasy" as represented by Michelangelo, "the way of beauty" as represented by Raphael, and "the way of nature" as represented by Dürer.

When the Nazarenes received from the Prussian consul Bartholdy a commission (1815) for a fresco cycle of the story of Joseph and his brethren, Cornelius was assigned two scenes.

The acclaim the frescoes received was significant, for Cornelius was called to Munich (1819) by Ludwig I. There, Cornelius had the opportunity he had sought to renew the arts by re-instituting the practice of fresco painting which would re-establish the personal relationship of the great master teaching his pupils as they assisted him. In this way, Cornelius decorated (1820–30) the new Glyptothek with frescoes of the myths of the Greek Gods and Heroes, the Alte Pinakothek stairways with scenes from the history of Italian and German art, and simultaneously with them, he executed an enormous

fresco of the "Last Judgment" (1826–40) in the Lud-wigskirche. Until 1824 Cornelius taught at the Düsseldorf Academy during the winters and proposed a reform for its teaching program with the important innovation of the "Mei-ster Klassen," the master-class. In 1824, Cornelius was named director of the Munich Academy. Cornelius was called to Ber-lin (1841) to fresco the "Campo Santo" of a projected Gothic cathedral for which Schinkel had made the designs, a building that was never constructed. The expressionistic quality of Cor-nelius' line, such as he achieved in the cartoon for one of the murals for its Campo Santo, "The Four Riders of the Apoca-lypse," brought succeeding generations of expressionists to a study of his drawings and graphic work. Cornelius' hope for a revival of fresco painting found no response in his epoch, but the urge to create monumental symbolic murals mani-fested itself again at the end of the century in the work of the "Nabis," Munch and Hodler.

SEE: Keith Andrews, *The Nazarenes, a Brotherhood of Ger-man Painters*, Oxford, 1964.]

LETTERS[1]

To Carl Mossler[2] Rome, March 1812
 . . . What you told me about the painting in the cathedral was a real comfort to me. Here, apart from the brothers of the cloister, one hears German art spoken of only with a cer-tain politeness, which is especially distressing to me, since only here in Italy its nature in its true glory first appeared to me and becomes ever dearer to me. I tell you, Mossler, and I really believe it, a German painter should not go away from his fatherland. I have taken this step against time, and in this way it is good, but I do not want to live long under this warm sky, where hearts are so cold. With pain and joy I feel that I am a German to the core. However, one cannot deny that there is much art material to be obtained here, although also much is seductive, and indeed the most refined is in Raphael himself. In his art, more than I ever thought possible, lies the greatest poison and the true spirit of rebellion and protestant-

1 Translated from *Künstlerbriefe über Kunst*, ed. H. Uhde-Bernarys, Dresden, Jess Verlag, 1926, pp. 377–83.
2 [Carl Mossler was a critic and a painter.]

ism. One would like to weep tears of blood when one sees that a spirit, who saw the Almighty even as that mighty angel at the throne of God, that such a spirit could become faithless. More on this point another time; now a word about the brothers of the cloister. They are a company of very excellent people who, for art and everything good, have united and who love one another and are attached to one another. There are six of them, five here and one in Vienna. Overbeck from Lübeck is the one who, by his gentleness of soul and the power of his noble spirit, has gathered all the others around him and has inspired them to everything magnificent. He may be the greatest artist now living, and you would be astounded if you saw his work. Besides this, he is true humility and modesty personified. Pforr you know already through his works; he possesses the noblest and most faithful heart in the world, an imperturbable solidity in things that he considers genuine, but also a severity, which often becomes harsh and is very detrimental to him. A chest illness, which has confined him to his bed for the whole time that I have been here, makes him milder and kinder, but may God shorten his time of trial and give him the happiness and confidence which his noble heart so much deserves. Vogel from Zürich is a man vigorously and richly endowed by nature. With open heart and spirit he seizes upon everything beautiful, good, and kind that nature has sown in the souls of men in order to unite them. He feels all relations between hearts as pure and humanly beautiful as I have ever seen. In addition, he possesses an astonishing artistic talent. He paints most gloriously episodes from Swiss history. Wintergerst from Swabia possesses, in addition to an open mind for everything good and beautiful, all those virtues which are not well regarded now and are therefore named the lesser ones, but which will be inscribed large in heaven: humility, fidelity, thankfulness, helpfulness to the point of submission, attachment, and love. He works in the style of Michelangelo and is extremely active and busy.

. . . On our way here we found a man in Lodi, called Hollinger, who also belonged to them, but who had changed for the worse and had left. They regretted this loss of a soul, as one justly should, because it is the greatest loss. I have been accepted in his place; their joy in this is so great and unfeigned that I count it among the happiest events of my life; thus the distance from the fatherland becomes more endur-

able. You too, my dear Mossler, will envy me, but I hope you, too, will some day belong to us; you already do in your opinions, your endeavors, and your unity with me. However, since our company is republican in nature, everyone must and shall win the heart of everyone else, since love is the bond. No one can recommend anyone else; each must do it in his own way; then, however, he belongs for life and death.

At the moment I am doing drawings for the song of the Nibelungs. Today I received the news that Remmer in Berlin wants to publish them under the very favorable conditions which I suggested to him. Thus my stay in Italy is assured in a very pleasant manner. I am selling to him each plate, three by four, each page for 12 *Carolin*. This is adequate, isn't it? But for myself I am, of course, making things hard as you can believe. This way it will not fail in its purpose to sow a little seed for the best of our nation.

Farewell dear, best friend. Eternally yours,

CORNELIUS

To Josef Goerres[3] Rome, November 3, 1814

My friends from Frankfurt notified me that you had been kind enough to try to secure a pension for me at the Prussian court. Please accept my most sincere gratitude not only for the benefits which the success of your kind attempt would have for the practise of my art, but also for the good faith and trust which you have in my minor talents and their application. Therefore, please accept my apologies, if I open my heart to you—stimulated by the same faith—to say a few words to you about a topic which fills it completely; I mean Art, that is the art of our fatherland. Unfortunately one must say that at the present time it has been surpassed by the Italians in true culture, as well as in spirit and life. The least of their heroes who voluntarily joined that veritable crusade carried in his breast a higher poetry—if I may call it that—than the foremost professors of any very wise academy, befogged by the gloom of their negative *eclectic storeroom of antiquated ideas about art*. This, however, seems to me to be the harshest word of judgment on any spiritual endeavor in the world and above all in art, for it should be a part of the salt of the earth. If such salt, however, has become tasteless, it is good for nothing, except to be thrown into the alleys and

[3] [A well-known Catholic publicist.]

tread on by the people. You will undoubtedly consider it to be a most desirable, excellent thing, if art in our fatherland would awaken to its old power, beauty, and simplicity, and would keep in step with the reborn spirit of the nation; if it would follow quietly, clearly, and lovingly its powerful but mysterious longing for higher realms, not breaking any power, but putting it in order, directing it to the highest Being, as is the task of all true education, as true art has done at all times and among all noble ancestors. Our fatherland has reached a point where it should not lack such art; it could be a mighty tool for many excellent things! I do not doubt in the least that such an art can rise again like the Phoenix from its ashes; the seed lies embedded deeply in the German mother earth, and spring is near—this thought first and above everything else! Secondly, I believe that God wants to make use of all the splendid seeds that lie within the German nation, in order to propagate a new life, a new kingdom of his power and glory on the earth. Thirdly, I believe that the nation is free, free by its own power and virtue and through God, who has endowed it with this freedom; the nation knows this power and longs for its original source in everything positive; it does not want to lose this precious, unique possession, and it has a genuine joy in every fruit that comes forth from its womb. Fourthly, a small number of German artists—permeated as if by divine revelation by the true nobility and godliness of their art—have begun to clean the grown-over path to their holy temple, in order to prepare it for him who shall come, in order to rid its interiors of buyers and sellers. This small group waits for a worthy opportunity and burns with the desire to show to the world that art can now enter gloriously into life, as it did before, if it will only stop being a venal servant of presumptuous masters, a shopkeeper and a miserable maid-servant of fashion; if overpowered by a mighty love, it will go about in a vassal's garb, with no other adornment than love, purity, and the power of faith as the true patent of its divine origin.

The factors which terribly hinder the free development of such an art are, in my opinion: first, the total lack of sensibilities of a higher nature among our princes and noblemen. They are truly the camel that is to go through the eye of a needle; their hearts are not where the hearts of the people are; they have drunk too deeply from the cup of the great whore! Secondly, there is the lying spirit of modern art in general, which, with its negative eclecticism, agrees perfectly with the vanity

and weakness of our nobles. Especially the deadly art acade-
mies and, in our country, their stiff directors, who have as goal
only themselves, their machine-like correctness, and nothing
else, and know how to direct into their channels everything
important that the state wants to do for art, where it just dis-
solves in foam and smoke. For as long as academies have
existed, nothing great has been created, and those things that
were created are good only when they distance themselves
from their spirit and powerless existence. Yet with all this
inner nothingness, this lank academic Philistine armed with
all the worthiness of bourgeois life, entrenched behind a thou-
sand bulwarks and breastplates of hundred-year-old author-
ity, seems invincible; he even quotes nature, Raphael, and the
ancients continuously and calls to them, as the Pharisees did
to Moses and the prophets. However, I am of the firm con-
viction that sooner or later a small rock will be slung at his
forehead.

Finally, I will speak of what according to my innermost
conviction is the most powerful—I would like to say—the in-
fallible remedy to give German art the basis for its direction
to a new great age, worthy of the spirit of the nation. This is
nothing but the reintroduction of fresco painting as it was in
Italy during the time of the great Giotto up to the time of the
divine Raphael. Since I have seen works of this epoch, have
familiarized myself with them, and have compared them with
those of our ancestors, I must indeed confess that the latter
art has an intention just as high, pure, and true, perhaps even
deeper and most certainly more unique. However, with refer-
ence to the former, I must agree with those who are of the
opinion that it has developed more freely, more perfectly and
greater in its nature. Next to the extraordinary and true en-
couragement, which art received through the lively participa-
tion of the whole nation, and next to other external causes, I
consider the practice of fresco painting as the foremost that
caused this. Of course, I presuppose inner causes; because if
the spirit of God is not with art, all other means do not help
at all, and the greatest efforts and encouragement are nothing
but trifles. Presupposing this spirit, fresco painting is well
suited to adopt all the elements of art in the freest and great-
est manner. Instead of merely wanting to unite incompatible
external properties in the manner of empty eclecticism, it cen-
ters as in a focal point all the life rays radiating from God in
a blazing fire that benevolently lights and warms the world.

From a spiritual and a physical viewpoint, these works belong actually to that spot on the earth where they were created; they are in most beautiful unison with God, nature, time, and surrounding life; no educated barbarian will carry them away; they are like a noble, excellent man, whose power and high value of humanity is in general a blessing, a joy. Yet the most beautiful, the most effective part, the most tender relations of his life belong to a small, close circle of selected hearts, who actually possess him. For the furtherance of a good beginning in this matter nothing would be more desirable and more effective than to have well-deserved confidence in someone who has seized the truth in art with a brave heart and has increased and formed its power in the struggle. Thus united powers should be used—according to their unanimous wish—for a great, dignified, extensive work in a public building in any German city. Public life is poor indeed in all noble ornamentation, and much talent and power is consumed in unsatisfied longing for activity and employment. Of what use is a light burning under a bushel when it should shine before the world? There is, after all, enough darkness in the world. If my suggestion were realized, I believe I could predict that this would give the signal from the mountain tops to a new noble upsurge in art. In a short time, powers would show themselves of which no one had believed our modest people were capable of in this art. Schools would be founded in the old spirit which would pour their truly exalted art with effective power into the heart of the nation, into the full life of man, and would adorn it so that from the walls of high cathedrals, of quiet chapels, and lonely monasteries, of city halls, stores, and halls, old, patriotic, well-known figures in renewed, fresh abundance of life would tell the new generations in sweet color language of that old love, old faith, and in the new generations the old strength of our forefathers would be reborn, and therefore the Lord God would be again reconciled with his people. These, my most worthy man, are the words that shout from a full German heart to you across the Alps into the fatherland. Would to God that the arrow of their truth might pierce your heart in spite of the feeble talent of the speaker, and that you would be the man who could find between us and our people the tie of unity that is lacking in order to apply and further develop, for God's honor and that of our nation, the powers which He and nature have given us!

Finally, I do not beg your forgiveness for my frankness,

so you may not believe that I have spoken for myself and for my advantage; rather, I put my hand on my heart, unstained by that fault, with the assurance that I have spoken with the purest, most ardent love (a measure of which you can find only in your own heart) and in the name of many richly talented, noble, and proven people, not in my own; and to you as one of the noblest members of our people. Please accept this as a token of our gratitude, our veneration, and our love. I commend myself especially to your further good will and remembrance.

<div align="right">

P. CORNELIUS,
German painter, at the Café Greco.

</div>

[WILLIAM BLAKE (1757–1827), an early advocate of prophetic vision and romanticism, was born in London. He began at the age of ten to draw from casts of antique sculpture and later was apprenticed to the engraving firm of James Basire, where an order had been received to provide the illustrations for Gough's *Sepulchral Monuments of Great Britain*. Blake's first task was to make copy drawings of those monuments that were in Westminster Abbey. When his own style developed, based as it was on line, it retained a decorative linear quality related to English Gothic art. Blake studied prints of Michelangelo's work and derived from them an inspiration which remained throughout his life.

After a brief and unrewarding period of study at the Royal Academy, Blake set himself up first with a partner and then alone as a designer and engraver for book illustrations. His friend, John Flaxman, commissioned him to re-engrave (1795) some of the *Iliad* illustrations for the English edition, and engrave (1816) those for the *Hesiod Theogony*.

Blake, the visionary who spoke familiarly with God in the fashion of Swedenborg, who lived to "see visions, dream dreams, prophesy and speak parables," endeavored to support himself as a poet-artist and offered to the public his exquisite *Songs of Innocence* (1789) and the various books of prophecy. The subject matter for the last was the result of Blake's having been infected with a thought that appeared in the seventeenth century, namely, that the Hebrew prophets, whose utterances followed immediately God's creation of the world, were the antecedents of all prophecies, irrespective of

epoch or culture. In the illustrating figures, Blake combined abstract elements with the classicists' linear mode and Henry Fuseli's elongated limbs and exaggerated muscles. In spite of their small size, the pictures possess an atmosphere of awe and sublimity.

Blake held that after a vision is seen, the forms to express it must be found in nature. The representation of it must be in line because there is neither line nor outline in nature. Therefore to study nature in order to imitate it is a waste of time, for painting, like poetry, is unrelated to the real world. Nature's forms are mere symbols, understandable only by means of the insight that imagination, whose source is divine inspiration, supplies.

To illustrate his poems, Blake devised a complicated technique, a type of relief etching with the color laid on the plate and fused with the line in the printing. By this method, he succeeded in approximating the effect of a medieval illuminated manuscript and achieved a like correspondence between the meaning of the text, the images, and the ornamental motifs. He found art forms congenial for his adaptation in the similarly inspired art of the middle ages and the Orient.

Blake used his poems and the accompanying illustrations to give expression to his liberal social ideas. His vision of energy as the means of severing the bonds of convention and false morality was given in "Marriage of Heaven and Hell," his protest against marriage conventions in "Visions of the Daughters of Albion," and his belief that the only source of happiness lies in a mutual forgiveness of sins in "The Gates of Paradise."

Except for three years (1800–3) in Sussex, Blake lived in straitened circumstances in London. Experiencing acute financial need in 1806, Blake held a sale of his pictures executed in a variant of the tempera medium which he termed "fresco." The "Descriptive Catalogue" for the sale was a profession of faith in his own art.

Blake published (1821) *The Pastorals of Virgil*, illustrated with wood-cuts. His last three years were spent on his great work *The Book of Job*, which he dedicated to Edmund Burke, who influenced him in the selection of the verses to illustrate. This Blake finished before his death, but left unfinished the illustrations to Dante's "Divina Comedia."

Blake was an early champion of the primacy of poetic genius. His art style was charged with a quality of magical

intensity and his art forms drawn from his subconscious world of imagery relate his art to the surrealist movement of the twentieth century.

SEE: A. Blunt, *The Art of William Blake*, New York, 1959.
M. Schorer, *William Blake, the Politics of Visions*, New York, 1959.]

A DESCRIPTIVE CATALOGUE OF PICTURES[1] (*1806*)

Poetical and Historical Inventions,
Painted by William Blake in Water Colors,
being the Ancient Method of Fresco Painting Restored:
and Drawings, for Public Inspection,
and for Sale by Private Contract

Number V. The Ancient Britons

In the last Battle of King Arthur, only Three Britons escaped; these were the Strongest Man, the Beautifullest Man, and the Ugliest Man; these three marched through the field unsubdued, as Gods, and the Sun of Britain set, but shall arise again with tenfold splendor when Arthur shall awake from sleep, and resume his dominion over earth and ocean.

The three general classes of men who are represented by the most Beautiful, the most Strong, and the most Ugly, could not be represented by any historical facts but those of our own country, the Ancient Britons, without violating costume. The Britons (say historians) were naked civilized men, learned, studious, abstruse in thought and contemplation; naked, simple, plain in their acts and manners; wiser than after-ages. They were overwhelmed by brutal arms, all but a small remnant; Strength, Beauty, and Ugliness escaped the wreck, and remain for ever unsubdued, age after age.

The British Antiquities are now in the Artist's hands; all his visionary contemplations, relating to his own country and its ancient glory, when it was, as it again shall be, the source of learning and inspiration. Arthur was a name for the constellation Arcturus, or Boötes, the keeper of the North Pole. And

[1] Quoted from *The Complete Writings of William Blake* with all the variant readings, ed., Geoffrey Keynes, London, 1957, pp. 577–83; 791–95, 814–16.

all the fables of Arthur and his Round Table; of the warlike
naked Britons; of Merlin; of Arthur's conquest of the whole
world; of his death, or sleep, and promise to return again; of
the Druid monuments or temples; of the pavement of Watling-
street; of London stone; of the caverns in Cornwall, Wales,
Derbyshire, and Scotland; of the Giants of Ireland and Brit-
ain; of the elemental beings called by us by the general name
of fairies; and of these three who escaped, namely Beauty,
Strength, and Ugliness. Mr. B. has in his hands poems of the
highest antiquity. Adam was a Druid, and Noah; also Abra-
ham was called to succeed the Druidical age, which began to
turn allegoric and mental signification into corporeal com-
mand, whereby human sacrifice would have depopulated the
earth. All these things are written in Eden. The artist is an in-
habitant of that happy country; and if every thing goes on as
it has begun, the world of vegetation and generation may
expect to be opened again to Heaven, through Eden, as it was
in the beginning.

The Strong Man represents the human sublime. The Beau-
tiful Man represents the human pathetic, which was in the
wars of Eden divided into male and female. The Ugly Man
represents the human reason. They were originally one man,
who was fourfold; he was self-divided, and his real humanity
slain on the stems of generation, and the form of the fourth
was like the Son of God. How he became divided is a subject
of great sublimity and pathos. The Artist has written it under
inspiration, and will, if God please, publish it; it is voluminous,
and contains the ancient history of Britain, and the world of
Satan and of Adam.

In the meantime he has painted this picture, which supposes
that in the reign of that British Prince, who lived in the fifth
century, there were remains of those naked Heroes in the
Welsh Mountains; they are there now, Gray saw them in the
person of his bard on Snowdon; there they dwell in naked
simplicity; happy is he who can see and converse with them
above the shadows of generation and death. The giant Albion
was Patriarch of the Atlantic; he is the Atlas of the Greeks,
one of those the Greeks called Titans. The stories of Arthur
are the acts of Albion, applied to a Prince of the fifth century,
who conquered Europe, and held the Empire of the world in
the dark age, which the Romans never again recovered. In
this picture, believing with Milton the ancient British history,
Mr. B. has done as all the ancients did and, as all the moderns

who are worthy of fame, given the historical fact in its poetical vigour as it always happens, and not in that dull way that some historians pretend, who, being weakly organized themselves, cannot see either miracle or prodigy; all is to them a dull round of probabilities and possibilities; but the history of all times and places is nothing else but improbabilities and impossibilities; what we should say was impossible if we did not see it always before our eyes.

The antiquities of every Nation under Heaven is no less sacred than that of the Jews. They are the same thing, as Jacob Bryand and all antiquaries have proved. How other antiquities came to be neglected and disbelieved, while those of the Jews are collected and arranged, is an enquiry worthy both of the Antiquarian and the Divine. All had originally one language, and one religion: this was the religion of Jesus, the everlasting Gospel. Antiquity preaches the Gospel of Jesus. The reasoning historian, turner and twister of causes and consequences, such as Hume, Gibbon, and Voltaire, cannot with all their artifice turn or twist one fact or disarrange self-evident action and reality. Reasons and opinions concerning acts are not history. Acts themselves alone are history, and these are neither the exclusive property of Hume, Gibbon, and Voltaire, Echard, Rapin, Plutarch, nor Herodotus. Tell me the Acts, O historian, and leave me to reason upon them as I please; away with your reasoning and your rubbish! All that is not action is not worth reading. Tell me the What; I do not want you to tell me the Why, and the How; I can find that out myself, as well as you can, and I will not be fooled by you into opinions that you please to impose, to disbelieve what you think improbable or impossible. His opinions, who does not see spiritual agency, is not worth any man's reading; he who rejects a fact because it is improbable must reject all history and retain doubts only.

It has been said to the artist, "Take the Apollo for the model of your beautiful Man, and the Hercules for your strong Man, and the Dancing Fawn for your ugly Man." Now he comes to his trial. He knows that what he does is not inferior to the grandest Antiques. Superior they cannot be, for human power cannot go beyond either what he does, or what they have done; it is the gift of God, it is inspiration and vision. He had resolved to emulate those precious remains of antiquity; he has done so and the result you behold; his ideas of strength and beauty have not been greatly different. Poetry

as it exists now on earth in the various remains of ancient authors, Music as it exists in old tunes or melodies, Painting and Sculpture as it exists in the remains of Antiquity and in the works of more modern genius, is Inspiration and cannot be surpassed; it is perfect and eternal. Milton, Shakespeare, Michael Angelo, Rafael, the finest specimens of Ancient Sculpture and Painting and Architecture, Gothic, Grecian, Hindoo and Egyptian, are the extent of the human mind. The human mind cannot go beyond the gift of God, the Holy Ghost. To suppose that Art can go beyond the finest specimens of Art that are now in the world, is not knowing what Art is; it is being blind to the gifts of the spirit.

LETTERS

To Dr. Trusler,[2] Lambeth, August 16, 1799

Revd Sir,

I find more & more that my Style of Designing is a Species by itself, & in this which I send you have been compell'd by my Genius or Angel to follow where he led; if I were to act otherwise it would not fulfill the purpose for which alone I live, which is, in conjunction with such men as my friend Cumberland, to renew the lost Art of the Greeks.

I attempted every morning for a fortnight together to follow your Dictate, but when I found my attempts were in vain, resolv'd to shew an independence which I know will please an Author better than slavishly following the track of another, however admirable that track may be. At any rate, my Excuse must be: I could not do otherwise, it was out of my power!

I know I begged of you to give me your Ideas, & promised to build on them; here I counted without my host. I now find my mistake.

The Design I have Sent Is:

A Father, taking leave of his Wife & Child, Is watch'd by Two Fiends incarnate, with intention that when his back is turned they will murder the mother & her infant. If this is not Malevolence with a vengeance, I have never seen it on Earth; & if you approve of this, I have no doubt of giving

2 John Trusler (1735–1820), author of *Hogarth Moralized*.

you Benevolence with Equal Vigor, as also Pride & Humility, but cannot previously describe in words what I mean to Design, for fear I should Evaporate the Spirit of my Invention. But I hope that none of my Designs will be destitute of Infinite Particulars which will present themselves to the Contemplator. And tho' I call them Mine, I know that they are not Mine, being of the same opinion with Milton when he says[3] That the Muse visits his Slumbers & awakes & governs his Song when Morn purples the East, & being also in the predicament of that prophet who says: I cannot go beyond the command of the Lord, to speak good or bad.[4]

If you approve of my Manner, & it is agreeable to you, I would rather Paint Pictures in oil of the same dimensions than make Drawings, & on the same terms; by this means you will have a number of Cabinet pictures, which I flatter myself will not be unworthy of a Scholar of Rembrandt & Teniers, whom I have Studied no less than Rafael & Michael Angelo. Please to send me your orders respecting this, & In my next Effort I promise more Expedition.

<div style="text-align:center">I am, Rev^d Sir,
Your very humble serv^t</div>

<div style="text-align:right">Will^m Blake</div>

To Dr. Trusler, Lambeth, August 23, 1799

Rev^d Sir,

I really am sorry that you are fall'n out with the Spiritual World, Especially if I should have to answer for it. I feel very sorry that your Ideas & Mine on Moral Painting differ so much as to have made you angry with my method of Study. If I am wrong, I am wrong in good company. I had hoped your plan comprehended All Species of this Art, & Especially that you would not regret that Species which gives Existence to Every other, namely, Visions of Eternity. You say that I want somebody to Elucidate my Ideas. But you ought to know that What is Grand is necessarily obscure to Weak men. That which can be made Explicit to the Idiot is not worth my care. The wisest of the Ancients consider'd what is not too Explicit as the fittest for Instruction, because it rouzes the faculties to act. I name Moses, Solomon, Esop, Homer, Plato.

[3] *Paradise Lost*, book vii, ll. 29, 30.
[4] Numbers, xxiv:13.

But as you have favor'd me with your remarks on my De-
sign, permit me in return to defend it against a mistaken one,
which is, That I have supposed Malevolence without a Cause.
Is not Merit in one a Cause of Envy in another, & Serenity &
Happiness & Beauty a Cause of Malevolence? But Want of
Money & the Distress of A Thief can never be alledged as the
Cause of his Thieving, for many honest people endure greater
hardships with Fortitude. We must therefore seek the Cause
elsewhere than in want of Money, for that is the Miser's pas-
sion, not the Thief's.

I have therefore proved your Reasonings Ill proportion'd,
which you can never prove my figures to be; they are those
of Michael Angelo, Rafael & the Antique, & of the best living
Models. I percieve that your Eye is perverted by Caricature
Prints, which ought not to abound so much as they do.
Fun I love, but too much Fun is of all things the most loath-
som. Mirth is better than Fun, & Happiness is better than
Mirth. I feel that a Man may be happy in This World. And I
know that This World Is a World of imagination & Vision.
I see Every thing I paint In This World, but Every body does
not see alike. To the Eyes of a Miser a Guinea is more beauti-
ful than the Sun, & a bag worn with the use of Money has
more beautiful proportions than a Vine filled with Grapes. The
tree which moves some to tears of joy is in the Eyes of others
only a Green thing that stands in the way. Some See Nature
all Ridicule & Deformity, & by these I shall not regulate my
proportions; & Some Scarce see Nature at all. But to the Eyes
of the Man of Imagination, Nature is Imagination itself. As a
man is, So he Sees. As the Eye is formed, such are its Pow-
ers. You certainly Mistake, when you say that the Visions of
Fancy are not to be found in This World. To Me This World
is all One continued Vision of Fancy or Imagination, & I feel
Flatter'd when I am told so. What is it sets Homer, Virgil &
Milton in so high a rank of Art? Why is the Bible more En-
tertaining & Instructive than any other book? Is it not because
they are addressed to the Imagination, which is Spiritual Sen-
sation, & but mediately to the Understanding or Reason? Such
is True Painting, and such was alone valued by the Greeks &
the best modern Artists. Consider what Lord Bacon says:
"Sense sends over to Imagination before Reason have judged,
& Reason sends over to Imagination before the Decree can be
acted." See Advancemt of Learning, Part 2, P. 47 of first Edi-
tion.

But I am happy to find a Great Majority of Fellow Mortals who can Elucidate My Visions, & Particularly they have been Elucidated by Children, who have taken a greater delight in contemplating my Pictures than I even hoped. Neither Youth nor Childhood is Folly or Incapacity. Some Children are Fools & so are some Old Men. But There is a vast Majority on the side of Imagination or Spiritual Sensation.

To Engrave after another Painter is infinitely more laborious than to Engrave one's own Inventions. And of the size you require my price has been Thirty Guineas, & I cannot afford to do it for less. I had Twelve for the Head I sent you as a Specimen; but after my own designs I could do at least Six times the quantity of labour in the same time, which will account for the difference of price as also that Chalk Engraving is at least six times as laborious as Aqua tinta. I have no objection to Engraving after another Artist. Engraving is the profession I was apprenticed to, & should never have attempted to live by any thing else. If orders had not come in for my Designs & Paintings, which I have the pleasure to tell you are Increasing Every Day. Thus If I am a Painter it is not to be attributed to Seeking after. But I am contented whether I live by Painting or Engraving.

I am, Rev^d Sir, your very obedient servant,

WILLIAM BLAKE

To George Cumberland, Lambeth, August 26, 1799

Dear Cumberland,

I ought long ago to have written to you to thank you for your kind recommendation to D^r Trusler, which, tho' it has fail'd of success, is not the less to be remember'd by me with Gratitude.

I have made him a Drawing in my best manner; he had sent it back with a Letter full of Criticisms, in which he says It accords not with his Intentions, which are to Reject all Fancy from his Work. How far he expects to please, I cannot tell. But as I cannot paint Dirty rags & old shoes where I ought to place Naked Beauty or simple ornament, I despair of Ever pleasing one Class of Men. Unfortunately our authors of books are among this Class; how soon we Shall have a change for the better I cannot Prophecy. D^r Trusler says: *"Your Fancy,* from what I have seen of it, & I have seen variety at

Mr Cumberland's, seems to be in the other world, or the World of Spirits, which accords not with my Intentions, which, whilst living in This World, Wish to follow *the Nature of it*." I could not help Smiling at the difference between the doctrines of Dr Trusler & those of Christ. But, however, for his own sake I am sorry that a Man should be so enamour'd of Rowlandson's caricatures as to call them copies from life & manners, or fit Things for a Clergyman to write upon. . . .

To Thomas Butts; Felpham, Novr 22, 1802

Dear Sir,

My Brother[5] tells me that he fears you are offended with me. I fear so too, because there appears some reason why you might be so. But when you have heard me out, you will not be so.

I have now given two years to the intense study of those parts of the art which relate to light & shade & colour, & am Convinc'd that either my understanding is incapable of comprehending the beauties of Colouring, or the Pictures which I painted for you Are Equal in Every part of the Art, & superior in One, to any thing that has been done since the age of Rafael.—All Sr J. Reynolds's discourses to the Royal Academy will shew that the Venetian finesse in Art can never be united with the Majesty of Colouring necessary to Historical beauty; & in a letter to the Revd Mr Gilpin, author of a work on Picturesque Scenery, he says Thus:[6] "It may be worth" "consideration whether the epithet Picturesque is not ap-" "plicable to the excellencies of the inferior Schools rather" "than to the higher. The works of Michael Angelo, Rafael, &c," "appear to me to have nothing of it: whereas Rubens & the" "Venetian Painters may almost be said to have Nothing Else." "—Perhaps Picturesque is somewhat synonymous to the word" "Taste, which we should think improperly applied to Homer" "or Milton, but very well to Prior or Pope. I suspect that the" "application of these words are to Excellencies of an inferior" "order, & which are incompatible with the Grand Style. You" "are certainly right in saying that variety of Tints & Forms" "is Picturesque; but it must be remember'd, on the other"

[5] James Blake.
[6] *Three Essays on Picturesque Beauty*, by William Gilpin, 1792, p. 35.

"hand, that the reverse of this (*uniformity of Colour* & a"
"*long continuation of lines*) produces Grandeur."—So Says Sir
Joshua, and So say I; for I have now proved that the parts of
the art which I neglected to display in those little pictures &
drawings which I had the pleasure & profit to do for you, are
incompatible with the designs.—There is nothing in the Art
which our Painters do that I can confess myself ignorant of.
I also Know & Understand & can assuredly affirm, that the
works I have done for You are Equal to Carrache or Rafael
(and I am now Seven years older than Rafael was when he
died), I say they are Equal to Carrache or Rafael, or Else I
am Blind, Stupid, Ignorant and Incapable in two years' Study
to understand those things which a Boarding School Miss can
comprehend in a fortnight. Be assured, My dear Friend, that
there is not one touch in those Drawings & Pictures but what
came from my Head & my Heart in Unison; That I am Proud
of being their Author and Grateful to you my Employer; &
that I look upon you as the Chief of my Friends, whom I
would endeavour to please, because you, among all men, have
enabled me to produce these things. I would not send you a
Drawing or a Picture till I had again reconsider'd my notions
of Art, & had put myself back as if I was a learner. I have
proved that I am Right, & shall now Go on with the Vigour I
was in my Childhood famous for.

But I do not pretend to be Perfect: but, if my Works have
faults, Carrache, Corregio, & Rafael's have faults also; let me
observe that the yellow leather flesh of old men, the ill drawn &
ugly young women, &, above all, the dawbed black & yellow
shadows that are found in most fine, ay, & the finest pictures,
I altogether reject as ruinous to Effect, tho' Connoisseurs may
think otherwise.

Let me also notice that Carrache's Pictures are not like Cor-
reggio's, nor Correggio's like Rafael's; &, if neither of them
was to be encouraged till he did like any of the others, he
must die without Encouragement. My Pictures are unlike any
of these Painters, & I would have them to be so. I think the
manner I adopt More Perfect than any other; no doubt They
thought the same of theirs.

You will be tempted to think that, as I improve, The Pic-
tures, &c, that I did for you are not what I would now wish
them to be. On this I beg to say That they are what I intended
them, & that I know I never shall do better; for, if I were to

do them over again, they would lose as much as they gain'd, because they were done in the heat of My Spirits.

But You will justly enquire why I have not written all this time to you? I answer I have been very Unhappy, & could not think of troubling you about it, or any of my real Friends. (I have written many letters to you which I burn'd & did not send) & why I have not before now finish'd the Miniature I promiss'd to M^rs Butts? I answer I have not, till now, in any degree pleased myself, & now I must intreat you to Excuse faults, for Portrait Painting is the direct contrary to Designing & Historical Painting in every respect. If you have not Nature before you for Every Touch, you cannot Paint Portrait; & if you have Nature before you at all, you cannot Paint History; it was Michael Angelo's opinion & is Mine. Pray Give My Wife's love with mine to M^rs Butts; assure her that it cannot be long before I have the pleasure of Painting from you in Person, & then that She may Expect a likeness, but now I have done All I could, & know she will forgive any failure in consideration of the Endeavour.

And now let me finish with assuring you that, Tho' I have been very unhappy, I am so no longer. I am again Emerged into the light of day; I still & shall to Eternity Embrace Christianity and Adore him who is the Express image of God; but I have travel'd thro' Perils & Darkness not unlike a Champion. I have Conquer'd, and shall still Go on Conquering. Nothing can withstand the fury of my Course among the Stars of God & in the Abysses of the Accuser. My Enthusiasm is still what it was, only Enlarged and confirm'd.

I now Send Two Pictures & hope you will approve of them. I have inclosed the Account of Money reciev'd & Work done, which I ought long ago to have sent you; pray forgive Errors in omissions of this kind. I am incapable of many attentions which it is my Duty to observe towards you, thro' multitude of employment & thro' hope of soon seeing you again. I often omit to Enquire of you. But pray let me now hear how you do & of the welfare of your family.

Accept my Sincere love & respect.

I remain Yours Sincerely,

Will^m Blake

A Piece of Sea Weed serves for a Barometer; as [it] gets wet & dry as the weather gets so.

[JOHN CONSTABLE (1776–1837), the son of a well-to-do farmer and miller, was born in a Sussex village overlooking the river Stour which, as a result of his concentration on a few scenes, remained a lifetime subject for his painting. During a visit to Sir George Beaumont, a famous art patron, connoisseur and amateur landscape painter, young Constable first saw a landscape painting by Claude Lorrain, and was encouraged by Sir George to be a painter. He was largely self-taught until he was admitted to study at the Royal Academy in 1799. Neither portraits nor historical subjects appealed to his creative urge. His sole interest was the representation of the essence of landscape and the beauty of nature visible to "an humble mind." For this he evolved a personal technique of painting, employing a palette knife as well as brushes to attain the effect of vividness he sought. He discarded the traditional color scheme of tonal gradations and divided a color into its components in order to intensify it. By careful observation of a specific moment in the day and the season, Constable learned to give the effective tone of light to his work. He chose to forget that he had ever seen a picture. To conform to the taste of the day, Constable produced two types of paintings: one in his own technique which gave them the freshness of a sketch, and the other "finished" by smoothing the broad brush work and unmixed color. His pictures, free from sentiment or literary content and from the traditional rendition of nature, roused the attention of young artists and the censure of the critics.

Constable's first official recognition was the award of a gold medal at the Salon of 1824 for the "Hay Wain," which also attests to the accurate sensitivity of the French critics to a new development in popular taste. In England he was not made an Associate or an Academician until he was fifty-three, in 1829.

Constable's theoretical view of landscape painting may be studied in a preface he wrote in 1830 for the portfolio of engravings "English Landscape" and in his Lectures on Landscape Painting delivered to the Literary and Scientific Society of Hampstead, at the Royal Institution founded for the promotion of science in 1833.

Constable is one of the creators of landscape painting in the style of the nineteenth century, where atmospheric condi-

tions serve as the subject matter of the painting in a setting which is familiar and congenial to the artist.

SEE: R. B. Beckett, *John Constable and the Fishers,* 1952.
E. Gombrich, *Art and Illusion,* London, 1960.]

LETTERS TO REV. FISHER[1]

Hampstead, October 23rd, 1821

My dear Fisher, . . . I am most anxious to get into my London painting-room, for I do not consider myself at work unless I am before a six-foot canvas. I have done a good deal of skying, for I am determined to conquer all difficulties, and that among the rest. And now talking of skies, it is amusing to us to see how admirably you fight my battles; you certainly take the best possible ground for getting your friend out of a scrape (the example of the old masters). That landscape painter who does not make his skies a very material part of his composition, neglects to avail himself of one of his greatest aids. Sir Joshua Reynolds, speaking of the landscapes of Titian, of Salvator, and of Claude, says: "Even their *skies* seem to sympathise with their subjects." I have often been advised to consider my sky as *"a white sheet thrown behind the objects."* Certainly, if the sky is obtrusive, as mine are, it is bad; but if it is evaded, as mine are not, it is worse; it must and always shall with me make an effectual part of the composition. It will be difficult to name a class of landscape in which the sky is not the key note, the standard of scale, and the chief organ of sentiment. You may conceive, then, what a "white sheet" would do for me, impressed as I am with those notions, and they cannot be erroneous. The sky is the source of light in nature, and governs everything; even our common observations on the weather of every day are altogether suggested by it. The difficulty of skies in painting is very great, both as to composition and execution; because, with all their brilliancy, they ought not to come forward, or, indeed, be hardly thought of any more than extreme distances are; but

[1] Quoted from C. R. Leslie: *Memoirs of the Life of John Constable,* ed., J. Mayne, Phaidon Press, London, 1951, pp. 84–86, 133–34; 290–300, 314–18. Archdeacon John Fisher of Salisbury, a lifelong friend.

this does not apply to phenomena or accidental effects of sky, because they always attract particularly. I may say all this to you, though *you* do not want to be told that I know very well what I am about, and that my skies have not been neglected, though they have often failed in execution, no doubt, from an over-anxiety about them, which will alone destroy that easy appearance which nature always has in all her movements.

How much I wish I had been with you on your fishing excursion in the New Forest! What river can it be? But the sound of water escaping from mill-dams, etc., willows, old rotten planks, slimy posts, and brickwork, I love such things. Shakespeare could make everything poetical; he tells us of poor Tom's haunts among "sheep cotes and mills." As long as I do paint, I shall never cease to paint such places.[2] They have always been my delight, and I should indeed have been delighted in seeing what you describe, and in your company, "in the company of a man to whom nature does not spread her volume in vain." Still I should paint my own places best; painting is with me but another word for feeling, and I associate "my careless boyhood" with all that lies on the banks of the Stour; those scenes made me a painter, and I am grateful; that is, I had often thought of pictures of them before I ever touched a pencil, and your picture is the strongest instances of it I can recollect; but I will say no more, for I am a great egotist in whatever relates to painting. Does not the Cathedral look beautiful among the golden foliage? Its solitary grey must sparkle in it.

Charlotte Street, December 17th, [1825]

My dear Fisher, . . . How much I should like to pass a day or two with you at Bath; but after such an interrupted summer, and so much indisposition in the autumn, I find it quite impossible to leave London, my work is so much behind-hand. We hear of sad illnesses all round us, caused, no doubt, by the excessive wet. I have just received a letter from Sir George Beaumont; he has been seriously ill, and quite unable until lately to touch a pencil. Everything which belongs to me

[2] The last picture he painted, and on which he was engaged on the last day of his life, was a mill, with such accompaniments as are described in this letter. This was the "Arundel Mill and Castle," exhibited at the Royal Academy, 1837 [and is now in the Toledo Museum of Art].

belongs to you, and I should not have hesitated a moment about sending you the Brighton sketch-book, but when you wrote, my Frenchman was in London, we were settling about work, and he has engaged me to make twelve drawings, to be engraved here, and published in Paris,[3] all from this book. I work at these in the evening. This book is larger than my others, and does not contain odds and ends, but all regular compositions of boats or beach scenes; there may be about thirty of them. If you wish to see them for a few days, tell me how I am to send them to you. My Paris affairs go on very well. Though the director, the Count Forbin, gave my pictures very respectable situations in the Louvre in the first instance, yet on being exhibited a few weeks, they advanced in reputation, and were removed from their original situations to a post of honour, two prime places in the principal room. I am much indebted to the artists for their alarum in my favour; but I must do justice to the count, who is no artist I believe, and thought that as the colours are rough, they should be seen at a distance. They found the mistake, and now acknowledge the richness of texture, and attention to the surface of things. They are struck with their vivacity and freshness, things unknown to their own pictures. The truth is, they study (and they are very laborious students) pictures only; and as Northcote says, "They know as little of nature as a hackney-coach horse does of a pasture." In fact, it is worse, they make painful studies of individual articles, leaves, rocks, stones, etc., singly; so that they look cut out, without belonging to the whole, and they neglect the look of nature altogether, under its various changes. I learnt yesterday that the proprietor asks twelve thousand francs for them. They would have bought one, "The Waggon,"[4] for the nation, but he would not part them. He tells me the artists much desire to purchase and deposit them in a place where they can have access to them. Reynolds is going over in June to engrave them, and has sent two assistants to Paris to prepare the plates. He is now about

[3] There is no record that these engravings were published. The reference is to "The Hay Wain" and "The Bridge" and seven small paintings Constable sold in 1824.
[4] [Stendhal in Article 10, October 27, 1824, *Journal de Paris* wrote: "In the paintings of the old school, the trees have *style;* they are elegant, but they lack accuracy. Constable, on the contrary, is truthful as a mirror; but I wish that the mirror were not placed vis-à-vis a hay wain fording a canal of still water . . ."]

"The Lock," and he is to engrave the twelve drawings. In all this I am at no expense, and it cannot fail to advance my reputation. My wife is translating for me some of the criticisms. They are amusing and acute, but shallow. After saying, "It is but justice to admire the truth, the colour, and the general vivacity and richness of surface, yet they are like preludes in music, and the full harmonious warblings of the Æolian lyre, which *mean nothing";* and they call them "orations and harangues, and high flowery conversations affecting a careless ease," etc. However, it is certain they have made a stir, and set the students in landscape to thinking. Now you must believe me, there is no other person living but yourself to whom I could write in this manner, and all about myself; but take away a painter's vanity, and he will never touch a pencil again.

[JOHN RUSKIN (1819–1900), the art critic and social reformer, was the only son of a successful sherry merchant. He was trained from infancy in music and drawing and learned early to note his observations as he accompanied his parents on their systematic search for the beautiful and unique in art and scenery in England and on the Continent. His earliest writing was influenced by German fairy tales that were made familiar to the English of his generation by the German governesses much employed in the nineteenth century. His mastery of English prose contributed to the general acceptance of his ideas. When he entered Christ College, Oxford, Ruskin had already published essays on natural science, art, and a defense of the painter J. M. William Turner (1775–1851). Immediately after receiving his degree, Ruskin began his study of Turner, published as Volume I of *Modern Painters* in 1843, which was followed by other volumes in 1846, 1856, and 1860. Turner, a rebel against the "rules" of drawing, for which he substituted "the principle of love" and the primacy of vision, was therefore Ruskin's ideal painter. For Ruskin the artist's whole function was to be a seeing, feeling creature, "an instrument of such tenderness and sensitiveness that nothing shall be left unrecorded." Turner made no selection in the elements of nature, only in the mode of representation, choosing either line or color, form or chiaroscuro. After making this subjective choice, the artist transfers nature by the

process he has chosen into art. Ruskin recognized that Turner's light and shade were related to an abstract conception of reality and his color to the spontaneity and freedom of artistic imagination.

Ruskin thus freed taste from the notion that one mode of representation is superior to another, color to line or vice versa, and freed from criticism that which the artist creates from his artistic imagination. Ruskin also made a correct aesthetic evaluation that an arrangement of lines and colors free of any representation is art comparable to the art of music. However, when it came to judging an individual artist, Ruskin could not divorce the man from his art; to him Whistler's art was inferior because Whistler dressed as a dandy and appeared superficial and insincere. The Pre-Raphaelists received his endorsement for they were earnest men.

Between the second and third volumes of *Modern Painters,* Ruskin published his influential *Elements of Drawing* (1857) and the *Elements of Perspective* (1859). The advanced color theory of the former advocating a stippling technique of pure color over a white ground influenced the Neo-Impressionists through the sections of it that Ogden Rood included in his *Modern Chromatics* (1879), published in a French translation *Théorie scientifique des coleurs* (1881).

The *Seven Lamps of Architecture* (1849) and the *Stones of Venice* (1851–53) reflect a tendency in then current historicism to look to the past for a solution of the social evils of the day. Sir Walter Scott's novels and Thomas Carlyle's *Past and Present* offered examples from medieval and modern England when Ruskin wished to contrast the periods. But above all, A. W. Pugin's small book *Contrasts: or, a Parallel between the Noble Edifices of the Middle Ages and the Corresponding Buildings of the Present Day; Showing the Present Decay of Taste, by A. Welby Pugin, Architect, (1836)* contained the germs of the thought developed in Ruskin's two books, that a work of art is essentially connected with the state of society and the middle ages presents the model for the reform of contemporary society.

In the *Stones of Venice* that city's architecture is used by Ruskin as a lesson in social morality, an indictment of mass production, the by-product of industrialization, and a program for the future. The first half of the chapter on "Nature of Gothic," reprinted separately and sold for 6d. to workers, had

great influence. A precise description of the features of Gothic Architecture followed.

Although Ruskin was elected to the Slade Professorship of Fine Arts at Oxford (1869) and continued throughout his life his theoretical and aesthetical interest in art—in the later years, to Pre-Renaissance Italian art—his major concern was to find solutions for social problems by means of the arts. To this end he founded a school of drawing, stimulated the establishment of the Victoria and Albert Museum and the Guild of St. George as a model for industrial training. His lectures and essays published as *Sesame and Lilies* (1864–68), *The Crown of Wild Olive* (1866) and *Munera Pulveris* (1872), giving his views on a great variety of subjects, were widely read and had great influence in England, America, and on the Continent. His artistic doctrines spread by his followers, notably William Morris, continue their influence into the present day.

SEE: John Ruskin, *Lamp of Beauty,* ed. Joan Evans, New York Graphic, 1959. Joan Evans, *John Ruskin,* Oxford, 1954. Harold Bloom, *The Literary Criticism of John Ruskin,* Doubleday Anchor, 1965. Robert Herbert, *The Art Criticism of John Ruskin,* Doubleday Anchor, 1964.]

MODERN PAINTERS[1]

Preface to the Third Edition

The work now laid before the public originated in indignation at the shallow and false criticism of the periodicals of the day on the works of the great living artist to whom it principally refers [J. M. W. Turner]. . . .

The reputation of the great artist to whose works I have chiefly referred, is established on too legitimate grounds among all whose admiration is honorable, to be in any way affected by the ignorant sarcasms of pretension and affectation. But when *public* taste seems plunging deeper and deeper into degradation day by day, and when the press universally exerts such power as it possesses to direct the feeling of the nation more completely to all that is theatrical, affected, and

[1] *Modern Painters,* Volume I—*Of General Principles and of Truth,* by John Ruskin, M.A., Boston, Dana Estes & Company, 1873.

false in art; while it vents its ribald buffooneries on the most exalted truth, and the highest ideal of landscape that this or any other age has ever witnessed, it becomes the imperative duty of all who have any perception or knowledge of what is really great in art, and any desire for its advancement in England, to come fearlessly forward, regardless of such individual interests as are likely to be injured by the knowledge of what is good and right, to declare and demonstrate, wherever they exist, the essence and the authority of the Beautiful and the True.

Part I. Of General Principles

. . . The name I have last to mention is that of J. M. W. Turner. I do not intend to speak of this artist at present in general terms, because my constant practice throughout this work is to say, when I speak of an artist at all, the very truth of what I believe and feel respecting him; and the truth of what I believe and feel respecting Turner would appear in this place, unsupported by any proof, mere rhapsody. I shall therefore here confine myself to a rapid glance at the relations of his past and present works, and to some notice of what he has failed of accomplishing: the greater part of the subsequent chapters will be exclusively devoted to the examination of the new fields over which he has extended the range of landscape art.

It is a fact more universally acknowledged than enforced or acted upon, that all great painters, of whatever school, have been great only in their rendering of what they had seen and felt from early childhood; and that the greatest among them have been the most frank in acknowledging this their inability to treat anything successfully but that with which they had been familiar. . . .

English artists are usually entirely ruined by residence in Italy, but for this there are collateral causes which it is not here the place to examine. Be this as it may, and whatever success may be attained in pictures of slight and unpretending aim, of genre, as they are called, in the rendering of foreign character, of this I am certain, that whatever is to be truly great and affecting must have on it the strong stamp of the native land; not a law this, but a necessity, from the intense hold on their country of the affections of all truly great men; all classicality, all middle-age patent reviving, is utterly vain

and absurd; if we are now to do anything great, good, awful, religious, it must be got out of our own little island, and out of this year 1846, railroads and all: if a British painter, I say this in earnest seriousness, cannot make historical characters out of the British House of Peers, he cannot paint history; and if he cannot make a Madonna of a British girl of the nineteenth century, he cannot paint one at all.

The rule, of course, holds in landscape; yet so far less authoritatively, that the material nature of all countries and times is in many points actually, and in all, in principle, the same; so that feelings educated in Cumberland, may find their food in Switzerland, and impressions first received among the rocks of Cornwall, be recalled upon the precipices of Genoa. . . .

I do not know in what district of England Turner first or longest studied, but the scenery whose influence I can trace most definitely throughout his works, varied as they are, is that of Yorkshire. Of all his drawings, I think, those of the Yorkshire series have the most heart in them, the most affectionate, simple, unwearied, serious finishing of truth. There is in them little seeking after effect, but a strong love of place, little exhibition of the artist's own powers or peculiarities, but intense appreciation of the smallest local minutiæ. . . .

It is, I believe, to those broad wooded steeps and swells of the Yorkshire downs that we in part owe the singular massiveness that prevails in Turner's mountain drawing, and gives it one of its chief elements of grandeur. Let the reader open the Liber Studiorum,[2] and compare the painter's enjoyment of the lines in the Ben Arthur with his comparative uncomfortableness among those of the aiguilles about the Mer de Glace. Great as he is, those peaks would have been touched very differently by a Savoyard as great as he.

I am in the habit of looking to the Yorkshire drawings as indicating one of the culminating points in Turner's career. In

[2] [The "Liber Studiorum" is a series of etchings executed by Turner to exhibit his art and to make money. It is divided into parts of five plates each with five landscape subjects—that were made from Turner's drawings, and reproduced in aquatint. Turner etched some of the plates himself. Subscriptions were sold for one hundred plates, but only seventy-one were published. The idea was taken from Claude Lorrain's "Libro d'Invenzioni," a series of drawings of his compositions that was engraved later as "Liber veritatis." The "Ben Arthur" is the last of the great etchings in the "Liber Studiorum."]

these he attained the highest degree of what he had up to that time attempted, namely, finish and quantity of form united with expression of atmosphere, and light without color. . . .

The painter evidently felt that he had farther powers, and pressed forward into the field where alone they could be brought into play. It was impossible for him, with all his keen and long-disciplined perceptions, not to feel that the real color of nature had never been attempted by any school; and that though conventional representations had been given by the Venetians of sunlight and twilight, by invariably rendering the whites golden, and the blues green, yet of the actual, joyous, pure, roseate hues of the external world no record had even been given. He saw also that the finish and specific grandeur of nature had been given, but her fulness, space, and mystery never; and he saw that the great landscape painters had always sunk the lower middle tints of nature in extreme shade, bringing the entire melody of color as many degrees down as their possible light was inferior to nature's; and that in so doing a gloomy principle had influenced them even in their choice of subject.

For the conventional color he substituted a pure straightforward rendering of fact, as far as was in his power; and that not of such fact as had been before even suggested, but of all that is *most* brilliant, beautiful, and inimitable; he went to the cataract for its iris, to the conflagration for its flames, asked of the sea its intensest azure, of the sky its clearest gold. For the limited space and defined forms of elder landscape, he substituted the quantity and the mystery of the vastest scenes of earth; and for the subdued chiaroscuro, he substituted first a balanced diminution of oppositions throughout the scale, and afterward, in one or two instances, attempted the reverse of the old principle, taking the lowest portion of the scale truly, and merging the upper part in high light.

Innovations so daring and so various could not be introduced without corresponding peril; the difficulties that lay in his way were more than any human intellect could altogether surmount. In his time there has been no one system of color generally approved; every artist has his own method and his own vehicle; how to do what Gainsborough did, we know not; much less what Titian; to invent a new system of color can hardly be expected of those who cannot recover the old. To obtain perfectly satisfactory results in color under the new conditions introduced by Turner, would at least have required

the exertion of all his energies in that sole direction. But color has always been only his second object. The effects of space and form, in which he delights, often require the employment of means and method totally at variance with those necessary for the obtaining of pure color. It is physically impossible, for instance, rightly to draw certain forms of the upper clouds with the brush; nothing will do it but the pallet-knife with loaded white after the blue ground is prepared. Now it is impossible that a cloud so drawn, however glazed afterward, should have the virtue of a thin warm tint of Titian's, showing the canvas throughout. So it happens continually. Add to these difficulties, those of the peculiar subjects attempted, and to these again, all that belong to the altered system of chiaroscuro, and it is evident that we must not be surprised at finding many deficiencies or faults in such works, especially in the earlier of them, nor even ourselves to be withdrawn by the pursuit of what seems censurable from our devotion to what is mighty.

Notwithstanding, in some chosen examples of pictures of this kind, I will name three: Juliet and her Nurse; the old Téméraire;[3] and the Slave Ship: I do not admit that there are at the time of their first appearing on the walls of the Royal

[3] [The following comment is from W. M. Thackeray, "A Second Lecture on the Fine Arts," by Michael Angelo Titmarsh, Esq. (Fraser's Magazine, June 1838). *Thackeray's Works,* Riverside Press, Boston, 1889, Vol. XXII, pp. 125–26.]

THE EXHIBITIONS

"If you are particularly anxious to know what is the best picture in the room, not the biggest (Sir David Wilkie's is the biggest, and exactly contrary to the best), I must request you to turn your attention to a noble river-piece by J. W. M. Turner, Esquire, R.A., 'The Fighting *Téméraire*'—as grand a painting as ever figured on the walls of any Academy, or came from the easel of any painter. The old *Téméraire* is dragged to her last home by a little, spiteful, diabolical steamer. A mighty red sun, amidst a host of flaring clouds, sinks to rest on one side of the picture, and illumines a river that seems interminable, and a countless navy that fades away into such a wonderful distance as never was painted before. The little demon of a steamer is belching out a volume (why do I say a volume? not a hundred volumes could express it) of foul, lurid, red-hot, malignant smoke, paddling furiously, and lashing up the water round about it; while behind it (a cold gray moon looking down on it), slow, sad, and majestic, follows the brave old ship, with death, as it were, written on her. . . ."

Academy, any demonstrably avoidable faults. I do not deny
that there may be, nay, that it is likely there are; but there is
no living artist in Europe whose judgment might safely be
taken on the subject, or who could without arrogance affirm
of any part of such a picture that it was *wrong;* I am perfectly
willing to allow that the lemon yellow is not properly repre-
sentative of the yellow of the sky, that the loading of the
color is in many places disagreeable, that many of the details
are drawn with a kind of imperfection different from what
they would have in nature, and that many of the parts fail of
imitation, especially to an uneducated eye. But no living au-
thority is of weight enough to prove that the virtues of the
picture could have been obtained at a less sacrifice, or that
they are not worth the sacrifice; and though it is perfectly
possible that such may be the case, and that what Turner has
done may hereafter in some respects be done better, I believe
myself that these works are at the time of their first appearing
as perfect as those of Phidias or Leonardo; that is to say, in-
capable, in their way, of any improvement conceivable by
human mind. . . .

In the conclusion of our present sketch of the course of
landscape art, it may be generally stated that Turner is the
only painter, so far as I know, who has ever drawn the sky
(not the clear sky, which we before saw belonged exclusively
to the religious schools, but the various forms and phenomena
of the cloudy heavens), all previous artists having only repre-
sented it typically or partially; but he, absolutely and univer-
sally: he is the only painter who has ever drawn a mountain,
or a stone; no other man ever having learned their or-
ganization, or possessed himself of their spirit, except in part
and obscurely (the one or two stones noted of Tintoret's,
Vol. II., Part iii., Ch. 3, are perhaps hardly enough on which
to found an exception in his favor). He is the only painter
who ever drew the stem of a tree, Titian having come the
nearest before him, and excelling him in the muscular devel-
opment of the larger trunks (though sometimes losing the
woody strength in a serpent like flaccidity), but missing the
grace and character of the ramifications. He is the only
painter who has ever represented the surface of calm, or the
force of agitated water; who has represented the effects of
space on distant objects, or who has rendered the abstract
beauty of natural color. These assertions I make deliberately,
after careful weighing and consideration, in no spirit of dis-

pute, or momentary zeal; but from strong and convinced feel-
ing, and with the consciousness of being able to prove them.

Section II. Of General Truths

OF TRUTH OF COLOR.

It is true that there are, here and there, in the Academy
pictures, passages in which Turner has translated the unat-
tainable intensity of one tone of color, into the attainable
pitch of a higher one: the golden green, for instance, of in-
tense sunshine on verdure, into pure yellow, because he knows
it to be impossible, with any mixture of blue whatsoever, to
give faithfully its relative intensity of light, and Turner always
will have his light and shade right, whatever it costs him in
color. But he does this in rare cases, and even then over very
small spaces; and I should be obliged to his critics if they
would go out to some warm, mossy green bank in full sum-
mer sunshine, and try to reach its tone; and when they find,
as find they will, Indian yellow and chrome look dark beside
it, let them tell me candidly which is nearest truth, the gold of
Turner, or the mourning and murky olive browns and verdi-
gris greens in which Claude, with the industry and intelligence
of a Sèvres china painter, drags the laborious bramble leaves
over his childish foreground.

But it is singular enough that the chief attacks on Turner
for overcharged brilliancy are made, not when there could
by any possibility be any chance of his outstepping nature,
but when he has taken subjects which no colors of earth
could ever vie with or reach, such, for instance, as his sunsets
among the high clouds. . . .

Suppose, where the "Napoleon" hung in the Academy last
year, there could have been left, instead, an opening in the
wall, and through that opening, in the midst of the obscurity
of the dim room and the smokeladen atmosphere, there could
suddenly have been poured the full glory of a tropical sunset,
reverberated from the sea: How would you have shrunk,
blinded, from its scarlet and intolerable lightnings! What pic-
ture in the room would not have been blackness after it? And
why then do you blame Turner because he dazzles you? Does
not the falsehood rest with those who do *not?* There was not
one hue in this whole picture which was not far below what
nature would have used in the same circumstances, nor was
there one inharmonious or at variance with the rest—the

stormy blood-red of the horizon, the scarlet of the breaking sunlight, the rich crimson browns of the wet and illumined sea-weed; the pure gold and purple of the upper sky, and, shed through it all, the deep passage of solemn blue, where the cold moonlight fell on one pensive spot of the limitless shore—all were given with harmony as perfect as their color was intense; and if, instead of passing, as I doubt not you did, in the hurry of your unreflecting prejudice, you had paused but so much as one quarter of an hour before the picture, you would have found the sense of air and space blended with every line, and breathing in every cloud, and every color distinct and radiant with visible, glowing, absorbing light.

It is to be observed, however, in general, that wherever in brilliant effects of this kind, we approach to anything like a true statement of nature's color, there must yet be a distinct difference in the impression we convey, because we cannot approach her *light*. . . . But the painter who really loves nature will not, on this account, give you a faded and feeble image, which indeed may appear to you to be right, because your feelings can detect no discrepancy in its parts, but which he knows to derive its apparent truth from a systematized falsehood. No; he will make you understand and feel that art *cannot* imitate nature—that where it appears to do so, it must malign her, and mock her. He will give you, or state to you, such truths as are in his power, completely and perfectly; and those which he cannot give, he will leave to your imagination. If you are acquainted with nature, seek elsewhere for whatever may happen to satisfy your feelings: but do not ask for the truth which you would not acknowledge and could not enjoy.

Nevertheless the aim and struggle of the artist must always be to do away with this discrepancy as far as the powers of art admit, not by lowering his color, but by increasing his light. And it is indeed by this that the works of Turner are peculiarly distinguished from those of all other colorists, by the dazzling intensity, namely, of the light which he sheds through every hue, and which, far more than their brilliant color, is the real source of their overpowering effect upon the eye, an effect so *reasonably* made the subject of perpetual animadversion, as if the sun which they represent were quite a quiet, and subdued, and gentle, and manageable luminary, and never dazzled anybody, under any circumstances whatsoever. . . .

OF TRUTH OF CHIAROSCURO

. . . Now if there be one principle, or secret more than another, on which Turner depends for attaining brilliancy of light, it is his clear and exquisite drawing of the *shadows*. Whatever is obscure, misty, or undefined in his objects or his atmosphere, he takes care that the shadows be sharp and clear—and then he knows that the light will take care of itself, and he makes them clear, not by blackness, but by excessive evenness, unity, and sharpness of edge. He will keep them clear and distinct, and make them felt as shadows, though they are so faint, that, but for their decisive forms, we should not have observed them for darkness at all. He will throw them one after another like transparent veils, along the earth and upon the air, til the whole picture palpitates with them, and yet the darkest of them will be a faint gray, imbued and penetrated with light. The pavement on the left of the Hero and Leander is about the most thorough piece of this kind of sorcery that I remember in art; but of the general principle, not one of his works is without constant evidence. . . .

Part II. Of Water, as Painted by Turner

. . . More determined efforts have at all periods been made in sea-painting than in torrent-painting, yet less successful. As above stated, it is easy to obtain a resemblance of broken running water by tricks and dexterities, but the sea *must* be legitimately drawn; it cannot be given as utterly disorganized and confused, its weight and mass must be expressed, and the efforts at expression of it end in failure with all but the most powerful men; even with these few a partial success must be considered worthy of the highest praise.

. . . But, I think, the noblest sea that Turner has ever painted, and, if so, the noblest certainly ever painted by man, is that of the Slave Ship, the chief Academy picture of the exhibition of 1840. It is a sunset on the Atlantic after prolonged storm; but the storm is partially lulled, and the torn and streaming rain-clouds are moving in scarlet lines to lose themselves in the hollow of the night. The whole surface of sea included in the picture is divided into two ridges of enormous swell, not high, nor local, but a low, broad heaving of the whole ocean, like the lifting of its bosom by deep-drawn breath after the torture of the storm. Between these two ridges,

the fire of the sunset falls along the trough of the sea, dyeing it with an awful but glorious light, the intense and lurid splendor which burns like gold and bathes like blood. Along this fiery path and valley, the tossing waves by which the swell of the sea is restlessly divided, lift themselves in dark, indefinite, fantastic forms, each casting a faint and ghastly shadow behind it along the illumined foam. They do not rise everywhere, but three or four together in wild groups, fitfully and furiously, as the under strength of the swell compels or permits them; leaving between them treacherous spaces of level and whirling water, now lighted with green and lamp-like fire, now flashing back the gold of the declining sun, now fearfully dyed from above with the indistinguishable images of the burning clouds, which fall upon them in flakes of crimson and scarlet, and give to the reckless waves the added motion of their own fiery flying. Purple and blue, the lurid shadows of the hollow breakers are cast upon the mist of the night, which gathers cold and low, advancing like the shadow of death upon the guilty[4] ship as it labors amidst the lightning of the sea, its thin

[4] She is a slaver, throwing her slaves overboard. The near sea is encumbered with corpses.
[The following is from W. M. Thackeray, "A Pictorial Rhapsody" by Michael Angelo Titmarsh, with an Introductory Letter to Mr. Yorke, *Thackeray's Works,* Riverside Press, 1889, Vol. XXII, pp. 158–59:
We have said how Mr. Turner's pictures blaze about the rooms; it is not a little curious to hear how artists and the public differ in their judgment concerning them; the enthusiastic wonder of the first-named, the blank surprise and incredulity of the latter. . . .
230. "Slavers throwing overboard the Dead and Dying: Typhoon coming on." J. M. W. Turner, R.A.

"Aloft all hands, strike the topmasts and belay!
Yon angry setting sun and fierce-edged clouds
Declare the Typhoon's coming.
Before it sweeps your decks, throw overboard
The dead and dying—ne'er heed their chains.
Hope, Hope, fallacious Hope!
Where is thy market now?"
 M.S. FALLACIES OF HOPE

Fallacies of Hope, indeed: to a pretty mart has she brought her pigs! How should Hope be hooked on to the slaver? By the anchor, to be sure, which accounts for it. As for the picture, the R.A.'s rays are indeed terrific; and the slaver throwing its cargo overboard

masts written upon the sky in lines of blood, girded with condemnation in that fearful hue which signs the sky with horror, and mixes its flaming flood with the sunlight—and cast far along the desolate heave of the sepulchral waves, incarnadines the multitudinous sea.

I believe, if I were reduced to rest Turner's immortality upon any single work, I should choose this. Its daring conception—ideal in the highest sense of the word—is based on the purest truth, and wrought out with the concentrated knowledge of a life; its color is absolutely perfect, not one false or morbid hue in any part or line, and so modulated that every square inch of canvas is a perfect composition; its drawing as accurate as fearless; the ship buoyant, bending, and full of motion; its tones as true as they are wonderful; and the whole picture dedicated to the most sublime of subjects and impressions—completing thus the perfect system of all truth, which we have shown to be formed by Turner's works—the power, majesty, and deathfulness of the open, deep, illimitable Sea.

[WILLIAM HOLMAN HUNT (1827–1910) was born in London, and entered the Royal Academy of Painting in 1845. There he met a fellow pupil, John Millais (1829–96), who shared his disapproval of the teaching methods at the Academy. Joined by the poet Dante G. Rossetti and four others, they formed a society whose object was to establish in England a school of painting based on sound technique, a study of nature, accuracy in the depiction of historical scenes, and a selection of meaningful subject matter. They chose the name Pre-Raphaelite to designate their work as pre-Academy, rather

is the most tremendous piece of color that ever was seen; it sets the corner of the room in which it hangs into a flame. Is the picture sublime or ridiculous? Indeed I don't know which. Rocks of gamboge are marked down upon the canvas; flakes of white laid on with a trowel; bladders of vermilion madly spirted here and there. Yonder is the slaver rocking in the midst of a flashing foam of white lead. The sun glares down upon a horrible sea of emerald and purple, into which chocolate-colored slaves are plunged, and chains that will not sink; and round these are floundering such a race of fishes as never was seen since the *saeculum Pyrrhae;* gasping dolphins, redder than the reddest herrings; horrid spreading polypi, like huge, slimy, poached eggs, in which hapless niggers plunge and disappear. Ye gods, what a "middle passage"! . . .]

than an emulation of a specific period as did the German "Nazarenes." The Pre-Raphaelites were, in the words of Rossetti, a *camaraderie* of young artists and writers who shared a common dissatisfaction with the accepted art forms. Hunt's early painting, "The Flight of Madeline and Porphyro" (1849) with its subject taken from a poem of the then little known Keats, was a first essay in their program. "The Hireling Shepherd" (1852) and, the most revealing example of Hunt's aim, "The Light of the World" (1852–54), possessed the moral implications that satisfied Ruskin's dictum that "what is good is beautiful." Hunt's intense concern with the realistic representation of an object was combined with the symbolic meaning he assigned each object, realism being the means used to provoke an interest in the symbolic meaning. "The Light of the World" became one of the most popular religious pictures of the century and the image of the Christ presented in it a widely accepted one.

The correctness of the depiction of the real objects became synonymous with the sincerity of Hunt's intention and a guarantee of the moral integrity of his paintings. Hunt traveled to Palestine in order to paint "The Scapegoat" (1856), a symbol of "the church on earth, subject to all the hatred of the unconverted world," "The Finding of Christ in the Temple" (1860), and "The Shadow of Death" (1874).

Hunt's autobiographical papers published as *Pre-Raphaelitism and the Pre-Raphaelite Brotherhood* provide valuable documentation for the artists and art of England during the second half of the century.

SEE: R. Ironside and J. Gere, *Pre-Raphaelite Painters,* 1948.
J. Ruskin, letter to the *Times,* May 25, 1854. (Hunt, *Pre-Raphaelitism,* 2nd ed., 1914, II, p. 300.)]

PRE-RAPHAELITISM AND THE
PRE-RAPHAELITE BROTHERHOOD[1]

Volume I

CHAPTER V: 1847

When all the inmates of the house were sleeping we [John Millais] were still steadily working. Occasionally we refreshed ourselves with a little coffee; it was this, perhaps, which gave us extra energy for talk about the new views we had ventured to form of the art which in other circles was esteemed as above judgment, and of the ideals we were raising up for ourselves. There was perhaps much boyish bumptiousness in our verdicts upon the old art, and in our aspirations for the new, but we wrought out the reason of each question, intending that it should be tried in the fire. . . .

Often when standing before them we had talked over Raphael's cartoons; now we again reviewed our judgment of these noble designs. We did so fearlessly, but even when most daring we never forgot their claim to be honoured; we did not bow to the chorus of the blind, for when we advanced to our judgment on "The Transfiguration" we condemned it for its grandiose disregard of the simplicity of truth, the pompous posturing of the Apostles, and the unspiritual attitudinising of the Saviour. Treating of the strained and meaningless action of the epileptic, I quoted the arguments of Sir Charles Bell, saying, "You must read them for yourself."[2] In our final esti-

[1] The text is from: W. Holman Hunt, *Pre-Raphaelitism and the Pre-Raphaelite Brotherhood,* The Macmillan Company, London, New York, 1905, pp. 99–101, 112, 115–16, 121–22, 125–26, 128–34, 135–38, 140–42, 150, 151–152.

[2] . . . "In the same painter's great picture of 'The Transfiguration' in the Vatican there is a lad possessed, and in convulsions. I hope I am not insensible to the beauties of that picture, nor presumptuous in saying that the figure is not natural. A physician would conclude that this youth was feigning. He is, I presume, convulsed; he is stiffened with contractions and his eyes are turned in their sockets. But no child was ever so affected. In real convulsions the extensor muscles yield to the more powerful contractions of the flexor muscles; whereas, in the picture, the lad extends his arms, and the fingers of the left hand are stretched unnaturally backwards. Nor do the lower extremities correspond with truth." —Bell's *Anatomy of Expression.*

mation this picture was a signal step in the decadence of Italian art. When we had advanced this opinion to other students, they as a *reductio ad absurdum* had said, "Then you are Pre-Raphaelite." Referring to this as we worked side by side, Millais and I laughingly agreed that the designation must be accepted. . . .[3]

I had now determined to quit my father's house, so as to be more free for my work. Immediately Rossetti[4] heard of my resolution he again broached the project of working under me for my hourly superintendence and instruction in painting. He had, so far, made no way in the new plan of work. . . .

Before Rossetti had well got to work in my studio [August 1848], and while the autumn still left light for the evening meal, I once returned from the Academy class at dusk and found Gabriel—for this was his name when his brother[5] was also of the circle—and Thomas Woolner[6] [a sculptor] in possession. When I entered, the latter was finishing the survey of my abandoned picture of "Christ and the Two Maries," which Gabriel, without my having authorised him to do, had turned round for inspection. I felt so much irritation at this unforeseen consequence of having a pupil as a fellow-tenant, that I would scarcely trust myself to notice this breach of etiquette; I turned the canvas again to the wall, and talked on other topics. . . .

In the British Institution, where I also exhibited, I next saw Brown's[7] picture of "Parisina." It had been painted, as was

[3] [Of the Pre-Raphaelites, P. G. Hamerton said, "The marks of the sect were intellectual and emotional intensity, marvellous power of analysis, sensitiveness to strong colours, insensitiveness to faint modulations of sober tint, curious enjoyment of quaintness and rigidity in arrangement, absolute indifference of grace, and size, and majesty." "Reactions from Pre-Raphaelitism," *Thoughts about Art,* Boston, 1882, p. 185.]

[4] [Dante Gabriel Rossetti (1828–82), poet and painter, who studied first with F. Madox Brown, then with Hunt, was active as a painter 1849–60, but became increasingly more active as a poet.]

[5] [Wm. Rossetti (1829–1919), the editor of *The Germ,* the Pre-Raphaelite Brotherhood magazine.]

[6] [Thomas Woolner (1825–92) unsuccessful as a sculptor, migrated to Australia 1852; on his return in 1857, he enjoyed success with portrait busts and statues.]

[7] [Ford Madox Brown (1821–93) trained first at Academy in Antwerp. Came to England, had little success with religious or histori-

then usual on the Continent, for lamplight effects, with the subject lit up in an inner chamber, the canvas being outside in daylight, a condition which forced the artist to give a hot glare on the group much in excess of that observable when estimating the tone in the lamplight itself. The painting throughout was accomplished and facile; the drawing defied criticism as to correctness, but not as to grace and beauty. The surface was less unctuous in its sheen than was the earlier picture, but the gloom was without mystery or transparency; the style was a combination of that of Rembrandt and Rubens as interpreted by the then leaders of the Belgian School. The subject, objectionable even in verse, was incalculably more so when realised on canvas. From his Flemish manner he turned to that then flourishing in Munich, and, lastly, faced about to the opposite of his Antwerpian mode, to the new school under Overbeck and others, who set themselves to imitate all the child-like immaturities and limitations of the German and Italian quattrocentists. Brown, however, added quaintnesses which marked his strong vitality, but often did so without calm judgment, which left many of his true appreciators to wonder if he was not mocking them. There were in Brown two incongruous spirits, one, desire for combination with a power in favour with the world, the other in open defiance of sedate taste; with all his variableness it was certainly not then notable that he had become a seeker after new truths. It must be remembered that the originator of a new character of work does not attain to the perfection of his idea in a sudden revulsion from a previous practice, but, following a new conviction, he must test his way, advancing only by gradual steps until he reaches the new standard of excellence he has in mind. *The early Christian style*—the term used by himself—was first shown by him in two of his compositions, one an elaborate drawing some three feet in height and two in breadth, now entitled "Our Lady of Good Children," then known paradoxically as "Our Lady of Saturday Night," and a painting here reproduced from Rossetti's copy, "Cherub Angels watching the Crown of Thorns." . . .

It may appear presumptuous that I systematically examined the pretensions of my elders. That I should dare at first intro-

cal subjects. Painted himself and wife in "Last of England." "Work" includes portraits of Ruskin and Morris—ladened with moral symbolism.]

duction to sit in judgment on an artist who had made such
profitable use of his advantages may indeed savour of irrev-
erence. I am obliged, therefore, to repeat that the first principle
of Pre-Raphaelitism was to eschew all that was conventional
in contemporary art, and that this compelled me to scrutinise
every artist's productions critically. Impressed as I felt by his
work as the product of individual genius, I found nothing in-
dicative of a child-like reversion from existing schools to Na-
ture herself.

The striking characteristic of Madox Brown's design in his
large painting is, to use his own word, its architectonic con-
struction. Had the composition [Chaucer reading his poems at
the court of Edward III] he was then employed upon been
for a wall divided into a triptych with spandrils on the side
panels, the device for filling the spaces might have been ap-
proved, and would have defended him from the charge of
artificiality of treatment; and the resemblance in the central
design to a builder's elevation would not have seemed so un-
called for. In Germany, subject painters had conceived a pas-
sion, encouraged by mural practice, for groups built one upon
the other and contoured against the background, as if cut out
of cardboard. In the composition before us, with figures in
the wings, attired conventionally, each part was so studiously
balanced by an opposite quantity that the method of construc-
tion forced itself laboriously upon attention, and thus op-
pressed the mind by the means employed to gain the effect,
not at all recognising that only the veiling of the means to
this end liberated the spectator's soul for the enjoyment of the
idea treated. . . .

The conference was ended by Millais proposing to ask them
[Rossetti, Woolner, etc.] all to his studio one evening that he
might see how things looked, for he, no more than I, foresaw
evil in the plan proposed.

The meeting at Millais' was soon held. We had much to
entertain us. Firstly, there was a set of outlines of Führich[8]
in the Retzsch[9] manner, but of much larger style. The mis-

[8] [Joseph Führich (1800–76), leader of second generation of Naz-
arenes and of Austrian art in nineteenth century. After studying
with Overbeck in Rome, returned to Vienna. Executed frescoes
(1844–48) for the Neu Johannis Kirche in style of Nazarenes.]
[9] [Frederich Retzsch (1779–1850), a professor at Dresden Acad-
emy who became well-known through his illustrations for Shake-
speare and the German poets.]

fortune of Germans as artists had been that, from the days of Winckelmann, writers had theorised and made systems, as orders, to be carried out by future practitioners in ambitious painting. The result was an art sublimely intellectual in intention, but devoid of personal instinct and often bloodless and dead; but many book illustrators had in varying degrees dared to follow their own fancies, and had escaped the crippling yoke. The illustrations by Führich, we found, had quite remarkable merits. In addition to these modern designs, Millais had a book of engravings of the frescoes in the Campo Santo at Pisa[10] which had by mere chance been lent to him. Few of us had before seen the complete set of these famous compositions.

The innocent spirit which had directed the invention of the painter was traced point after point with emulation by each of us who were the workers, with the determination that a kindred simplicity would regulate our own ambition, and we insisted that the naïve traits of frank expression and unaffected grace were what had made Italian art so essentially vigorous and progressive, until the showy followers of Michael Angelo had grafted their Dead Sea fruit on to the vital tree just when it was bearing its choicest autumnal ripeness for the reawakened world. . . .

Millais would not ratify the initial acceptance of the four candidates [Woolner, Collinson, Stephens, W. Rossetti] without check on their understanding of our purpose, for he feared the distortion of our original doctrine of childlike submission to Nature. The danger at the time arose from the vigour of the rising taste for Gothic art rather than from the classical form of design, whose power was fast waning, having few men of force to support it. For the last thirty or forty years architecture had become mainly mediæval in character, and the fashion for feudal forms had grown altogether slavish. At the introduction of the Renaissance in Italy new life and growth had been imparted to the Greek types chosen; our manner of adopting Gothic examples had not been so wise. To follow ancient precedent line for line had become a religion. The imitative Gothic which was in fashion demanded that art used in its embellishments should be in accordance with it. To reproduce the English round and pointed styles

10 [The visual effect of the complex buildings at Pisa was a powerful stimulant in arousing interest in the Italian primitives. See above p. 28, Flaxman, "Modern Sculpture."]

with the barbarous embellishments wherewith the rudest of ancient masons had often satisfied their patrons, was the limit of modern ambition. The Palace of Westminster was then being fitted up externally with coarse images undeserving the name of statues; faults of proportion and clumsiness of shape were even a merit in the eyes of the revivalists, and artists with a strong strain of quattrocento antiquarianism were thus preferred for the interior work; the fashion for this resuscitation had originated in Germany, while the current was so strong here that all over the country clergymen and gentlemen with public funds in their hands were nursing it, and were busy in putting up in churches stained-glass windows and decorations by painters whose school seemed to have been that of heraldic design interpreted in garish colours. Had all the artists so employed been mere resurrectionists they could have misled only the whimsical, but in fact some of the masters employed at St. Stephen's were men of such elevated capacity that they gave more than a passing charm to their imitations, by unwonted brilliancy of effect and by touches of individual genius, and this made their example a greater snare to the young and timid, who always need the support of precedent.

Millais felt that Collinson's discipleship to Wilkie had ignored the grace which had elevated that master's work; he wanted more proof of original design in Woolner, and was further avowedly dubious of the other two.

We had recognised as we turned from one print to another that the Campo Santo designs were remarkable for incident derived from attentive observation of inexhaustible Nature, and dwelt on all their quaint charms of invention. We appraised as Chaucerian the sweet humour of Benozzo Gozzoli, which appeared wherever the pathos of the story could by such aid be made to claim greater sympathy, and this English spirit we acclaimed as the standard under which we were to make our advance. Yet we did not curb our amusement at the immature perspective, the undeveloped power of drawing, the feebleness of light and shade, the ignorance of any but mere black and white differences of racial types of men, the stinted varieties of flora, and their geometrical forms in the landscape; these simplicities, already out of date in the painter's day, we noted as belonging altogether to the past and to the dead revivalists, with whom we had determined to have neither part nor lot. That Millais was in accord with this conviction was

clear from his latest designs and from every utterance that came from him with unmistakable heartiness as to his future purpose, and may be understood now from all his after-work. Rossetti's sentiment of these days is witnessed to, not from his painting in hand (which was from a design made earlier, when he was professedly under the fascination of the Early Christian dogma), but by his daily words put into permanent form in the short prospectus for *The Germ* (2nd series), issued a year or so later, in which Nature was insisted upon as the one element wanting in contemporary art. The work which was already done, including all the landscape on my "Rienzi" picture, and my past steps leading to the new course pursued, spoke for me, and thus was justified the assumption that all our circle knew that deeper devotion to Nature's teaching was the real point at which we were aiming. It will be seen that the learned commentators have ever since declared that our real ambition was to be revivalists and not adventurers into new regions. Why and how this misunderstanding arose it devolves on me henceforth to trace out.

CHAPTER VI: 1848

Not alone was the work that we were bent on producing to be more persistently derived from Nature than any having a dramatic significance yet done in the world; not simply were our productions to establish a more frank study of creation as their initial intention, but the name adopted by us negatived the suspicion of any servile antiquarianism. Pre-Raphaelitism is not Pre-Raphaelism. Raphael in his prime was an artist of the most independent and daring course as to conventions. He had adopted his principle, it is true, from the store of wisdom gained by long years of toil, experiment, renunciation of used-up thought, and repeated efforts of artists, his immediate predecessors and contemporaries. What had cost Perugino, Fra Bartolomeo, Leonardo da Vinci, and Michael Angelo more years to develop than Raphael lived, he seized in a day —nay, in one single inspection of his precursors' achievements. His rapacity was atoned for by his never-stinted acknowledgments of his indebtedness, and by the reverent and philosophical use in his work of the conquests he had made. He inherited the booty like a prince, and like Prince Hal, he retained his prize against all disputants; his plagiarism was the wielding of power in order to be royally free. . . . There is no need

here to trace any failure in Raphael's career; but the prodigality of his productiveness, and his training of many assistants, compelled him to lay down rules and manners of work; and his followers, even before they were left alone, accentuated his poses into postures. They caricatured the turns of his heads and the lines of his limbs, so that figures were drawn in patterns; they twisted companies of men into pyramids, and placed them like pieces on the chessboard of the foreground. The master himself, at the last, was not exempt from furnishing examples of such conventionalities. Whoever were the transgressors, the artists who thus servilely travestied this prince of painters at his prime were Raphaelites. And although certain rare geniuses since then have dared to burst the fetters forged in Raphael's decline, I here venture to repeat what we said in the days of our youth, that the traditions that went on through the Bolognese Academy, which were introduced at the foundation of all later schools and enforced by Le Brun, Du Fresnoy, Raphael Mengs, and Sir Joshua Reynolds, to our own time were lethal in their influence, tending to stifle the breath of design. The name Pre-Raphaelite excludes the influence of such corrupters of perfection, even though Raphael, by reason of some of his works, be in the list, while it accepts that of his more sincere forerunners.

It is needless to trace the fall which followed pride in other schools; the Roman case is the typical one. At the present day it is sometimes remarked that with such simple aims we ought to have used no other designation than that of art naturalists. I see no reason, however, to regret our choice of a name. Every art adventurer, however immature he may be in art lore, or whatever his tortuousness of theory, declares that Nature is the inspirer of his principles. All who call themselves *self-taught* are either barbarians, or else are ignoring indirect teaching. Life is not long enough in art for any one who starts from the beginning, to arrive beyond the wide outposts. Wise students accept the mastership of the great of earlier ages. True judgment directed us to choose an educational outflow from a channel where the stream had no trace of the pollution of egoism, and was innocent of pandering to corrupt thoughts and passions. We drew from this fountain source, and strove to add strength to its further meanderings by the inflow of new streams from nature and scientific knowledge. Our work was condemned by established artists

for its daring innovation. Now unobservant critics, seeing that certain afterworks of our elders possess the characteristics which these elders, amongst others, originally cavilled at, call them our teachers. At the time of our boyish combination we had no thought that such pretensions could ever be made; we were too strongly engrossed with the desire to supply a defect in modern training to think of personal penalties. . . .

In my own studio soon after the initiation of the Brotherhood, when I was talking with Rossetti about our ideal intention, I noticed that he still retained the habit he had contracted with Ford Madox Brown of speaking of the new principles of art as "Early Christian." I objected to the term as attached to a school as far from vitality as was modern classicalism, and I insisted upon the designation "Pre-Raphaelite" as more radically exact, and as expressing what we had already agreed should be our principle. The second question, what our corporation itself should be called, was raised by the increase of our company. Gabriel improved upon previous suggestion with the word Brotherhood, overruling the objection that it savoured of clericalism. When we agreed to use the letters P.R.B. as our insignia, we made each member solemnly promise to keep its meaning strictly secret, foreseeing the danger of offending the reigning powers of the time. It is strange that with this precaution against dangers from outside our Body, we took such small care to guard ourselves against those that might assail us from within. The name of our Body was meant to keep in our minds our determination ever to do battle against the frivolous art of the day, which had for its ambition "Monkeyana" ideas, "Books of Beauty," Chorister Boys, whose forms were those of melted wax with drapery of no tangible texture. The illustrations to Holy Writ were feeble enough to incline a sensible public to revulsion of sentiment. Equally shallow were the approved imitations of the Greeks, and paintings that would ape Michael Angelo and Titian, with, as the latest innovation, through the Germans, designs that affected without sincerity the naïveté of Perugino and the early Flemings. . . .

It is now high time to correct one important misapprehension. In agreeing to use the utmost elaboration in painting our first pictures, we never meant more than to insist that the practice was essential for training the eye and hand of the young artist; we should not have admitted that the relinquishment of this habit of work by a matured painter would make

him less a Pre-Raphaelite. I can say this the better because I have retained later than either of my companions did, the restrained handling of an experimentalist. . . .

My past experience in pattern designing, and my criticisms upon the base and vulgar forms and incoherent curves in contemporary furniture, to which I drew Rossetti's attention on his first visit to me, encouraged visions of reform in these particulars, and we speculated on improvement in all household objects, furniture, fabrics, and other interior decorations. Nor did we pause till Rossetti enlarged upon the devising of ladies' dresses and the improvement of man's costume, determining to follow the example of early artists not in one branch of taste only, but in all.

For sculpture Gabriel expressed little passion; he professed admiration of many men engaged in plastic work, but he could not understand their devotion to what in those days never rose to the height of human interest; the fact was, the reason of this baldness lay in neglect of drawing and painting by exercise in which the great sculptors of old made themselves subtle designers and masters of form, light, shade, and colour. We agreed that architecture also came within the proper work of a painter, who, learning the principles of construction from Nature herself, could apply them by shaping and decorating the material he had to deal with. Music Rossetti regarded as positively offensive; for him it was nothing but a noisy nuisance. It may be that this opinion was not permanent.

In our scheme, when we obtained recognition, each of us was to have a set of studios attached to his house, some for working in ourselves in diverse branches of art, some for showing our productions to admirers, who would be attended to by our pupils when we were too busy to be disturbed. We were also by such means to introduce worthy students, and to make art take its due place in life.

[MRS. ANNA JAMESON (1794–1860), an Irish writer, began her literary career and interest in art as a result of accompanying a pupil to Italy, the account of which she published as the *Diary of an Ennuyée* (1826). A subsequent trip to Germany in 1833 roused in her a serious interest in art that led her to prepare for travelers to Germany *A Companion to Private Galleries* and a *Handbook to the Public Galleries*. These mir-

ror the art taste of the time and particularly show Mrs. Jameson's enthusiasm for Cornelius' frescoes in Munich.

Quite different are her series, *The Poetry of Sacred and Legendary Art* (1848), *Legends of the Monastic Orders* (1850), *Legends of the Madonna* (1852). In this work she was among the first to point out the connection between the pre-Renaissance art and the Acta Sanctorum and the Book of the Golden Legend (Legenda Aurea), which was a collection of many centuries of Christian legend. The last, assembled in 1275, helped to develop a scheme of emblems by which each saint could be recognized and his story read. This branch of knowledge, iconography, deals with the use of visual symbols. All representational art is governed by conventions in the choice of subject matter and in the symbols chosen to convey it. It has been stated that society is held together by the acceptance of and the reverence for its symbols. As a consequence of the Reformation, the Protestant church disallowed sacred subjects in the visual arts, and the meaning of the symbols was lost. Mrs. Jameson's rediscovery of the symbolic meaning of objects in painting and sculpture of a religious nature followed that of a German, F. E. Husenbeth, *Emblems of Saints* (third edition, 1822), and paralleled that of the French scholar A. H. Didron, *Iconographie Chrétienne, Histoire de Dieu* (Paris, 1843; English translation, 1849). Mrs. Jameson's and Didron's books precede by a few years the time when painters and poets, turning away from an objective scientific realism, attempted to formulate a new symbolic language.

Mrs. Jameson's last book *The History of Our Lord* was completed after her death by Lady Eastlake, the wife of the distinguished medieval scholar, Sir Charles Eastlake.

SEE: A. Whittick, *Symbols, Signs and Their Meaning,* London, 1960.
A. N. Whitehead, *Symbolism: Its Meaning and Effect,* Cambridge, 1928.]

SACRED AND LEGENDARY ART[1]

Introduction

I. OF THE ORIGIN AND GENERAL SIGNIFICANCE OF THE LEGENDS
REPRESENTED IN ART

We cannot look round a picture gallery, we cannot turn
over a portfolio of prints after the old masters, nor even the
modern engravings which pour upon us daily, from Paris,
Munich, or Berlin, without perceiving how many of the most
celebrated productions of Art, more particularly those which
have descended to us from the early Italian and German
schools, represent incidents and characters taken from the
once popular legends of the Catholic Church. This form of
"Hero-Worship" has become, since the Reformation, strange
to us—as far removed from our sympathies and associations
as if it were antecedent to the fall of Babylon and related to
the religion of Zoroaster, instead of being left but two or three
centuries behind us and closely connected with the faith of
our forefathers and the history of civilization and Christianity.
Of late years, with a growing passion for the works of Art of
the Middle Ages, there has arisen among us a desire to com-
prehend the state of feeling which produced them, and the
legends and traditions on which they are founded—a desire
to understand, and to bring to some surer critical test, repre-
sentations which have become familiar without being intelligi-
ble. To enable us to do this, we must pause for a moment at
the outset; and, before we plunge into the midst of things,
ascend to higher ground and command a far wider range of
illustration than has yet been attempted, in order to take cog-
nizance of principles and results which, if not new, must be
contemplated in a new relation to each other.

The Legendary Art of the Middle Ages sprang out of the
legendary literature of the preceding ages. For three centuries
at least this literature, the only literature which existed at the
time, formed the sole mental and moral nourishment of the
people of Europe. The romances of Chivalry, which long

[1] Quoted from Anna Jameson, Sacred and Legendary Art, River-
side Press, Cambridge, 1890, Vol. I., pp. 1–6, 8–10, 11–14, 16–18,
26–28, 30–35.

afterwards succeeded, were confined to particular classes, and left no impress on Art, beyond the miniature illuminations of a few manuscripts. This legendary literature, on the contrary, which had worked itself into the life of the people, became, like the antique mythology, as a living soul diffused through the loveliest forms of Art, still vivid and vivifying, even when the old faith in its mystical significance was lost or forgotten. And it is a mistake to suppose that these legends had their sole origin in the brains of dreaming monks. The wildest of them had some basis of truth to rest on, and the forms which they gradually assumed were but the necessary result of the age which produced them. . . .

Now, if we go back to the *authentic* histories of the sufferings and heroism of the early martyrs, we shall find enough there, both of the wonderful and the affecting, to justify the credulity and enthusiasm of the unlettered people, who saw no reason why they should not believe in one miracle as well as in another. In these universally diffused legends, we may recognize the means, at least one of the means, by which a merciful Providence, working through its own immutable laws, had provided against the utter depravation, almost extinction, of society. . . .

Now the Legendary Art of the three centuries which comprise the revival of learning was, as I have said, the reflection of this literature, of this teaching. Considered in this point of view, can we easily overrate its interest and importance? . . .

It is curious, this general ignorance with regard to the subjects of Mediaeval Art, more particularly now that it has become a reigning fashion among us. We find no such ignorance with regard to the subjects of Classical Art, because the associations connected with them form a part of every liberal education. Do we hear any one say, in looking at Annibale Caracci's picture in the National Gallery, "Which is Silenus, and which is Apollo?" In every sacred edifice, and in every public or private collection enriched from the plunder of sacred edifices, we look for the usual proportion of melancholy martyrdoms and fictitious miracles—for the predominance of Madonnas and Magdalenes, St. Catherines and St. Jeromes: but why these should predominate, why certain events and characters from the Old and the New Testament should be continually repeated, and others comparatively neglected; whence the predilection for certain legendary person-

ages, who seemed to be multiplied to infinity, and the rarity of others—of this we know nothing.

In the old times the painters of these legendary scenes and subjects could always reckon securely on certain associations and certain sympathies in the minds of the spectators. We have outgrown these associations, we repudiate these sympathies. We have taken these works from their consecrated localities, in which they once held each their dedicated place, and we have hung them in our drawing-rooms and our dressing-rooms, over our pianos and our side-boards—and now what do they say to us? That Magdalene, weeping amid her hair, who once spoke comfort to the soul of the fallen sinner —that Sebastian, arrow-pierced, whose upward ardent glance spoke of courage and hope to the tyrant-ridden serf—that poor tortured slave, to whose aid St. Mark comes sweeping down from above—can they speak to *us* of nothing save flowing lines and correct drawing and gorgeous color? Must we be told that one is a Titian, the other a Guido, the third a Tintoret, before we dare to melt in compassion or admiration? Or the moment we refer to their ancient religious signification and influence, must it be with disdain or with pity? This, as it appears to me, is to take not a rational, but rather a most irrational, as well as a most irreverent, view of the question; it is to confine the pleasure and improvement to be derived from works of Art within very narrow bounds; it is to seal up a fountain of the richest poetry, and to shut out a thousand ennobling and inspiring thoughts. Happily there is a growing appreciation of these larger principles of criticism as applied to the study of Art. People look at the pictures which hang round their walls, and have an awakening suspicion that there is more in them than meets the eye—more than mere connoisseurship can interpret; and that they have another, a deeper, significance than has been dreamed of by picture dealers and picture collectors, or even picture critics.

II. OF THE DISTINCTION TO BE DRAWN BETWEEN THE DEVO-
 TIONAL AND THE HISTORICAL SUBJECTS

At first, when entering on a subject so boundless and so diversified, we are at a loss for some leading classification which shall be distinct and intelligible, without being mechanical. It appears to me, that all sacred representations, in as far as they appeal to sentiment and imagination, resolve them-

selves into two great classes, which I shall call the DEVO-TIONAL and the HISTORICAL.

Devotional pictures are those which portray the objects of our veneration with reference only to their sacred character, whether standing singly or in company with others. They place before us no action or event, real or supposed. They are neither portrait nor history. A group of sacred personages, where no action is represented, is called in Italian a *"sacra conversazione":* the word *conversazione,* which signifies a society in which there is communion, being here, as it appears to me, used with peculiar propriety. All subjects, then, which exhibit to us sacred personages, alone or in groups, simply in the character of superior beings, must be considered as *devotionally* treated.

But a sacred subject, without losing wholly its religious import, becomes historical the moment it represents any story, incident, or action, real or imagined. All pictures which exhibit the events of Scripture story, all those which express the actions, miracles, and martyrdoms of saints, come under this class; and to this distinction I must call the attention of the reader, requesting that it may be borne in mind throughout this work.

We must also recollect that a story, action, or fact may be so represented as to become a symbol expressive of an abstract idea: and some Scriptural and some legendary subjects may be devotional or historical, according to the sentiment conveyed; for example, the Crucifixion and the Last Supper may be so represented as either to exhibit an event or to express a symbol of our Redemption. The raising of Lazarus exhibits, in the catacombs, a mystical emblem of the general resurrection; in the grand picture by Sebastian del Piombo, in our National Gallery, it is a scene from the life of our Savior. Among the legendary subjects, the penance of the Magdalene, and St. Martin dividing his cloak, may be merely incidents, or they may be symbolical, the first of penitence, the latter of charity, in the general sense. And again, there are some subjects which, though expressing a scene or an action, are *wholly* mystical and devotional in their import; as the vision of St. Augustine and the marriage of St. Catherine. . . .

In the sacred subjects, properly called HISTORICAL, we must be careful to distinguish between those which are *Scriptural,* representing scenes from the Old or New Testament, and those which are *Legendary.*

Of the first, for the present, I do not speak, as they will be fully treated hereafter.

The historical subjects from the lives of the saints consist principally of *Miracles* and *Martyrdoms.*

In the first, it is worth remarking that we have no pictured miracle which is not imitated from the Old or the New Testament (unless it be an obvious emblem, as where the saint carries his own head). There is no act of supernatural power related of any saint which is not recorded of some great Scriptural personage. The object was to represent the favorite patron as a copy of the great universal type of beneficence, CHRIST OUR REDEEMER. And they were not satisfied that the resemblance should lie in character only; but should emulate the power of Christ in his visible actions. We must remember that the common people of the middle ages did not, and could not, distinguish between miracles accredited by the testimony of Scripture, and those which were fabrications, or at least exaggerations. All miracles related as divine interpositions were to them equally possible, equally credible. If a more extended knowledge of the natural laws renders us in these days less credulous, it also shows us that many things were possible, under particular conditions, which were long deemed supernatural.

IV. OF CERTAIN EMBLEMS AND ATTRIBUTES

To know something of the attributes and emblems of general application, as well as those proper to each saint, is absolutely necessary; but it will also greatly assist the fancy and the memory to *understand* their origin and significance. For this reason I will add a few words of explanation.

The GLORY, NIMBUS, or AUREOLE—the Christian attribute of sanctity, and used generally to distinguish all holy personages —is of pagan origin. It expressed the luminous nebula (Homer, *Iliad* xxiii, 205) supposed to emanate from, and surround, the Divine Essence, which stood "a shade in midst of its own brightness." Images of the gods were decorated with a crown of rays, or with stars; and when the Roman emperors assumed the honors due to divinity, they appeared in public crowned with golden radii. . . . Considered in the East as *the attribute of power only,* whether good or evil, we find, wherever early Art has been developed under Byzantine in-

fluences, the nimbus thus applied. Satan, in many Greek, Saxon, and French miniatures, from the ninth to the thirteenth century, wears a glory. In a psalter of the twelfth century, the Beast of the Apocalypse with seven heads has six heads surrounded by the nimbus; the seventh, wounded and drooping, is without the sign of power.

But in Western Art the associations with this attribute were not merely those of dignity, but of something divine and consecrated. It was for a long time avoided in the Christian representations as being appropriated by false gods or heathen pride; and when first adopted does not seem clear.

The glory round the head is properly the nimbus or aureole. The oblong glory surrounding the whole person, called in Latin the *vesica piscis,* and in Italian the *mandorla* (almond), from its form, is confined to figures of Christ and the Virgin, or saints who are in the act of ascending into heaven. When used to distinguish one of the three divine persons of the Trinity the glory is often cruciform or triangular. The square nimbus designates a person living at the time the work was executed. In the frescos of Giotto at Assisi the allegorical personages are in some instances distinguished by the hexagonal nimbus. In other instances it is circular. From the fifth to the twelfth century the nimbus had the form of a disc or plate over the head. From the twelfth to the fifteenth century, it was a broad golden band round, or rather behind, the head, composed of circle within circle, often adorned with precious stones, and sometimes having the name of the saint inscribed within it. From the fifteenth century it was a bright fillet over the head, and in the seventeenth century it disappeared altogether. In pictures the glory is always golden, the color of light; in miniatures and stained glass I have seen glories of various colors, red, blue, or green.

The FISH was the earliest, the most universal, of the Christian emblems, partly as the symbol of water and the rite of baptism, and also because the seven Greek letters which express the word Fish form the anagram of the name of Jesus Christ. In this sense we find the fish as a general symbol of the Christian faith upon the sarcophagi of the early Christians; on the tombs of the martyrs in the catacombs; on rings, coins, lamps, and other utensils; and as an ornament in early Christian architecture. It is usually a dolphin, which among the Pagans had also a sacred significance. . . .

The CROSS [see Figure 1]. About the tenth century the Fish disappeared, and the Cross—symbol of our redemption, from the apostolic times—became the sole and universal emblem of the Christian faith. The cross placed in the hand of a saint is usually the Latin cross, the form ascribed to the cross on which our Savior suffered. Other crosses are used as emblems or ornaments, but still having the same signification.

At first the cross was a sign only. When formed of gold or silver, the five wounds of Christ were signified by a ruby or carbuncle at each extremity, and one in the centre. It was not till the sixth century that the cross became a CRUCIFIX, no longer an emblem, but an *image*.

FIG. 1. Jameson, "Crosses," redrawn from *Sacred and Legendary Art,* Cambridge, Mass., 1890

The LAMB, in Christian Art, is the peculiar symbol of the Redeemer as the sacrifice without blemish: in this sense it is given as an attribute to John the Baptist. The lamb is also the general emblem of innocence, meekness, modesty; in this sense it is given to St. Agnes, of whom Massillon said so beautifully, "Peu de pudeur, où il n'y a pas de religion; peu de religion, où il n'y a pas de pudeur."

The PELICAN, tearing open her breast to feed her young with her own blood, was an early symbol of our redemption through Christ.

One or both of these emblems are frequently found in ancient crosses and crucifixes; the lamb at the foot, the pelican at the top, of the cross. . . .

The LION, as an ancient Christian symbol, is of frequent recurrence, more particularly in architectural decoration. Antiquaries are not agreed as to the exact meaning attached to the mystical lions placed in the porches of so many old Lombard churches; sometimes with an animal, sometimes with a man, in their paws. But we find that the lion was an ancient symbol of the Redeemer, "the Lion of the tribe of Judah";

also of the resurrection of the Redeemer; because, according to an Oriental fable, the lion's cub was born dead, and in three days its sire licked it into life. In this sense it occurs in the windows of the cathedral at Bourges. In either sense it may probably have been adopted as a frequent ornament in the church utensils, and in ecclesiastical decoration, supporting the pillars in front, or the carved thrones, &c.

The lion also typifies solitude—the wilderness; and, in this sense, is placed near St. Jerome and other saints who did penance, or lived as hermits in the desert; as in the legends of St. Paul the hermit, St. Mary of Egypt, St. Onofrio. Further, the lion as an attribute denoted death in the amphitheatre, and with this signification is placed near certain martyrs, as St. Ignatius and St. Euphemia. The lion, as the type of fortitude and resolution, was placed at the feet of those martyrs who had suffered with singular courage, as St. Adrian and St. Natalia.

When other wild beasts, as wolves and bears, are placed at the feet of a saint attired as abbot or bishop, it signifies that he cleared waste land, cut down forests, and substituted Christian culture and civilization for paganism and the lawless hunter's life: such is the significance in pictures of St. Magnus, St. Florentius, and St. Germain of Auxerre. . . .

The CROWN [see Figure 2], as introduced in Christian Art, is either an emblem or an attribute. It has been the emblem from all antiquity of victory, and of recompense due to superior power or virtue. In this sense the word and the image are used in Scripture in many passages: for example, "Henceforth there is laid up for me a crown of glory." And in this sense, as the recompense of those who had fought the good fight to the end, and conquered, the crown became the especial symbol of the glory of martyrdom. In very ancient pictures, a hand is seen coming out of heaven holding a wreath or circlet; afterwards it is an angel who descends with the crown, which is sometimes a coronet of gold and jewels, sometimes a wreath of palm or myrtle. . . .

But it is necessary also to distinguish between the *symbol* and the *attribute:* thus, where St. Cecilia and St. Barbara wear the crown, it is the symbol of their glorious martyrdom; when St. Catherine and St. Ursula wear the crown, it is at once as the symbol of martyrdom and the attribute of their royal rank as princesses.

The crown is also the symbol of sovereignty. When it is

placed on the head of the Virgin, it is as Queen of Heaven, and also as the "Spouse" of Scripture allegory.

But the crown is also an attribute, and frequently, when worn by a saint or placed at his feet, signifies that he was royal or of princely birth: as in the pictures of Louis of France, St. William, St. Elizabeth, St. Helena, and many others.

The crowns in the Italian pictures are generally a wreath, or a simple circle of gold and jewels, or a coronet radiated with a few points. But in the old German pictures the crown is often of most magnificent workmanship, blazing with jewels.

I have seen a real silver crown placed on the figures of certain popular saints, but as a votive tribute, not an emblem.

FIG. 2. Jameson, "Crowns," redrawn from *Sacred and Legendary Art,* Cambridge, Mass., 1890

[EUGÈNE DELACROIX (1798–1863) was born in Charenton, near Paris. With the Revolution his father was elected to the Convention, became the administrator of the Marine Department, Minister of Foreign Affairs, Ambassador to the Netherlands, and Prefect at Marseilles and Bordeaux. Delacroix inherited a recognized position and matured in a circle of culture.

Delacroix entered the studio of Guerin (1774–1833) in 1815, a painter who had "listened at the door of David's studio" and had softened and mannered the vigor and severity of that artist. Delacroix found little to nourish his innovating spirit in such an academic tradition. He educated himself by studying Michelangelo's drawing, copying Rubens' paintings, and associating with Gericault (1791–1824), a former pupil of Guerin's.

The elements that mark Delacroix's style, an intensely poetic interpretation of the subject matter and color selected to heighten the interpretation, are present in his first painting "Dante and Virgil," exhibited in the 1824 Salon. In the same Salon, John Constable's "Hay Wain," by its luminous color and unconventional painting technique, stimulated Delacroix to go to England. He stayed there with Richard Bonington (1801–28), the brilliant painter and watercolorist, and studied Constable's and Turner's painting. From Eugene Chevreul, then director of the dye laboratories at the Gobelin Tapestry Factory, Delacroix learned to intensify color by dividing it into its components.

Three great paintings, "Massacre of Chios" (1824), "Sardanaplus" (1827), and "Liberty Leading the People to the Barricades, the 28th of July" (1831) established Delacroix as the leader of the romantic school. The school took imagination as the point of departure for artistic creation, and color as the medium of expression.

Delacroix was freed further from the color conventions of Europe and introduced to the color harmonies of Islamic culture by a journey to Morocco in 1832. In the bright light there, the laws of complementary color could be observed and studied. Delacroix combined and modified his observations with lessons in color composition learned from copying the Venetians and from a study trip to the Lowlands. He never went to Italy. Rubens' "Elevation of the Cross" remained a constant source of artistic inspiration. Delacroix's work that followed the African trip, the "Jewish Wedding in Morocco" (1839), "Buffons Arabs" (1848), the various "Tiger" paintings, and the different variations of the shipwreck theme show his lightened palette.

The arresting effect of Delacroix's paintings is achieved by their composition, based on classical and traditional principles, and strengthened by the direction of his brush strokes. The verisimilitude of his color is convincing, and he used it as the painters of the seventeenth century did to intensify the subject matter of the picture. By his method, Delacroix created a pictorial unity that lent reality to his imaginative interpretation of each subject. Unfortunately, the color he used was of poor quality and his method of mixing has resulted in the color darkening in his paintings.

Delacroix's mural decoration in the Palais Bourbon (Chambre des Députés), the Palais du Luxembourg library, the

ceiling of the Galerie d'Apollon in the Louvre, and the two murals in the Chapelle des Anges, St. Sulpice, show him to be the last great frescoist respecting the architectural setting and employing large brush strokes to break the colors that are then blended by the distance from which they are seen. "Jacob Wrestling with the Angel" at St. Sulpice, designed between 1853–57 and completed in 1861, is the culmination of his superb technique and artistic genius.

Delacroix's production of over 1,000 paintings was prodigious, his water colors and pastels number over 2,000, the lithographs illustrating Goethe's *Faust, Gotz von Berlichingen* and Shakespeare's *Hamlet* are numerous, and 9,000 drawings are known. His subject matter had an equal magnitude: battles, portraits, literary interiors, landscapes, seascapes, animals, all epochs of history, literary and religious subjects were encompassed by his artistic imagination. The numerous drawings for each painting attest to his painstaking search for a convincing "Classical" composition.

In spite of his reputed aloofness, Delacroix gave much time to serving on Salon juries. He early formed a habit of writing, keeping in his journal a running account of his life from 1822, with a brief break in 1846, until his death. He also found, satisfaction in expressing his aesthetic thought and replying to critics in essays that were published in different reviews. In style, however, they do not equal that of the journal.

Delacroix was a great artist in the traditional use of the word with its implication of universality. His definition of the task of the artist has remained in force: "to draw from his imagination the means of rendering nature and its effect, and to render them according to his own temperament." His literary remains and his painting make him one of the principal contributors to the creative vitality of the nineteenth and twentieth centuries.

SEE: E. Delacroix, *Oeuvres littéraires,* Paris, G. Cres, 1923, 2 vols.]

JOURNAL[1]

1822. October 6. It must not be thought that just because I rejected a thing once, I must ignore it when it shows itself

[1] The excerpts are from *The Journal of Eugène Delacroix* and translated by W. Pach, Crown, New York, 1948.

today. A book in which I had never found anything worth-while may have a moral, read with the eyes of a more mature experience.

I am borne, or, rather, my energy is borne, in another direction. I will be the trumpeter of those who do great things.

There is in me something that is often stronger than my body, which is often enlivened by it. In some people the inner spark scarcely exists. I find it dominant in me. Without it, I should die, but it will consume me (doubtless I speak of imagination, which masters and leads me).

When you have found a weakness in yourself, instead of dissembling it, cut short your acting and idle circumlocutions—correct yourself. If the spirit had merely to fight the body! But it also has malign penchants, and a portion of it—the most subtle, most divine—should battle the other unceasingly. The body's passions are all loathsome. Those of the soul which are vile are the true cancers: envy, etc. Cowardice is so loathsome it must needs be the child of body and soul together.

When I have painted a fine picture, I haven't expressed a thought. Or so they say. What fools people are! They deprive painting of all its advantages. The writer says nearly everything to be understood. In painting a mysterious bond is established between the souls of the sitters and those of the spectator. He sees the faces, external nature; but he thinks inwardly the true thought that is common to all people, to which some give body in writing, yet altering its fragile essence. Thus grosser spirits are more moved by writers than by musicians and painters. The painter's art is all the more intimate to the heart of man because it seems more material; for in it, as in external nature, justice is done frankly to that which is finite and to that which is infinite—that is, to whatever the soul finds to move it inwardly in the objects which affect the senses alone.

1824. May 14. Intense sadness and despondency all evening.

This morning, reading the review of Lord Byron at the beginning of the volume, I felt again awakening in me that insatiable desire to create. Can I tell whether that would be happiness for me? At least, it seems so. Happy poet and happier still in having a tongue that submits to his imaginings! Yet, French is sublime. But I should have to give battle many times to this rebellious Proteus before subduing him.

What torments my soul is its loneliness. The more it expands among friends and the daily habits or pleasures, the more, it seems to me, it flees me and retires into its fortress. The poet who lives in solitude, but who produces much, is the one who enjoys those treasures we bear in our bosom, but which forsake us when we give ourselves to others. When one yields oneself completely to one's soul, it opens itself completely to one, and then it is that the capricious thing allows one the greatest of good fortunes, that of which the account of Lord Byron speaks, that of sympathizing with others, of studying itself, of painting itself constantly in its works, something that Byron and Rousseau have perhaps not noticed. I am not talking about mediocre people: for what is this rage, not only to write, but to be published? Outside of the happiness of being praised, there is that of addressing all souls that can understand yours, and so it comes to pass that all souls meet in your painting. What good is the approbation of friends? It is quite natural that they should understand you; so what importance is there in that? What is intoxicating is to live in the mind of others. What is so devastating! I ask myself. You can add one soul more to the number of those who have seen nature in a way that is their own. What all these souls have painted is new for them, and you will paint them new again! They have painted their soul, in painting things, and your soul asks its turn, also. And why should you resist when it does so? Is its request more absurd than the need for repose that your limbs ask, when they and all your physical being are fatigued? If they have not done enough for you, neither have they done enough for others. Those very ones who believe that everything has been said and done, will greet you as new and yet will close the door behind you. And then they will say again that everything has been said and done. Just as man, in the feebleness of age, believes that nature is degenerating, so men with commonplace minds and who have nothing to say about what has already been said, think that nature has allowed certain ones, and those only in the beginning of time, to say new and striking things. What there was to say in the times of those immortal spirits, attracted the notice of all their contemporaries, just as in our time, but for all that not many tried to seize the new thing, to enter their name hastily, in order to steal for themselves the harvest that posterity was to reap. Novelty is in the mind that creates, and not in nature, the thing painted. The modesty of him who writes always

keeps him from including himself among the great minds of which he speaks. He always speaks, we agree, to one of those luminaries, if there are any, whom nature . . .

. . . Thou who knowest there is always something new, show it to them in that which they have disregarded. Make them believe that they have never heard of the nightingale or the vast ocean, and everything that their gross senses try to feel only when others have first taken the trouble of feeling it all for them. Don't let words embarrass you. If you nourish your soul, they will find an occasion to come forth. They will unite in language which will be well worth the hemistiches of this man or the prose of that one. Look—you are original, you say, and yet your verse takes fire only at reading Byron or Dante, etc.! That fever, you take it for the power to create, but it is, rather, a mere need to imitate. . . . Ah, no. The fact is that they have not said the hundredth part of what there is to say; the fact is that with a single one of the things that they skim over, there is more material for original geniuses than there is . . . and that nature has put in safe keeping in the great imaginations to come more new things to say about her creations than she has created things.

What shall I do? I am not allowed to do a tragedy: the law of the unities is against that. A poem, etc.

1832. Tangier, February 21. The Jewish wedding.[2] The Moors and the Jews at the entrance. The two musicians. The violinist, his thumb in the air, the under side of the other hand very much in the shadow, light behind, the haik on his head transparent in places; white sleeves, shadowy background. The violinist; seated on his heels and on his gelabia. Blackness between the two musicians below. The body of the guitar on the knee of the player; very dark toward the belt, red vest, brown ornaments, blue behind his neck. Shadow from his left arm (which is directly in front of one) cast on the haik over his knee. Shirtsleeves rolled up showing his arms up to the biceps; green woodwork at his side; a wart on his neck, short nose.

At the side of the violinist, pretty Jewish woman; vest, sleeves, gold and amaranth. She is silhouetted halfway against the door, halfway against the wall; nearer the foreground, an

[2] This scene inspired the famous *Jewish Wedding* of the Salon of 1841 (Catalogue Robaut, 867), now in the Louvre.

older woman with a great deal of white, which conceals her almost entirely. The shadows full of reflections; white in the shadows.

A pillar cutting out, dark in the foreground. The women to the left in lines one above the other like flower pots. White and gold dominate, their handkerchiefs are yellow. Children on the ground in front.

At the side of the guitarist, the Jew who plays the tambourine. His face is a dark silhouette, concealing part of the hand of the guitarist. The lower part of his head cuts out against the wall. The tip of a gelabia under the guitarist. In front of him, with legs crossed, the young Jew who holds the plate. Gray garment. Leaning against his shoulder, a young Jewish child about ten years old.

Against the door of the stairway, Prisciada; purplish handkerchief on her head and under her throat. Jews seated on the steps; half seen against the door, strong light on their noses, one of them standing straight up on the staircase; a cast shadow with reflections clearly marked on the wall, the reflection a light yellow.

Above, Jewesses leaning over the balcony rail. One at the left, bareheaded, very dark, clear-cut against the wall, lit by the sun. In the corner, the old Moor with his beard on one side; shaggy haik, his turban placed low on the forehead, gray beard against the white haik. The other Moor, with a shorter nose, very masculine, turban sticking out. One foot out of the slipper, sailor's vest and sleeves the same.

On the ground, in the foreground, the old Jew playing the tambourine; an old handkerchief on his head, his black skullcap visible. Torn gelabia; his black coat visible near the neck.

The women in the shadow near the door, with many reflections on them.

1847. January 19. Went at half past ten to see Gisors[3] about the project for the stairway in the Luxembourg. Then to the gallery of the Luxembourg to meet M. Masson; he gives up the idea of engraving the picture himself. Went to the Pantheon. Saw the cupola with the decorations by Gros; alas what thinness and uselessness. The pendentives by Gerard

[3] Alphonse-Henry de Gisors (1796–1866), architect. There had been a question of having Delacroix decorate the walls of the great staircase, to the left of the court of the Luxembourg palace. The project was not carried out.

which I did not know. The whole thing frightful in color. Slaty skies, tones that stab one another, on all sides; the shiny surface of the painting gives one the final shock and makes the whole thing unbearably thin. A gilt frame badly suited in its character to that of the monument, taking up too much room as compared with the painting. *Prometheus on the Rock,* with nymphs who are consoling him. It is lacking in the sense of the ideal.

From Vimount's studio on the Jardin des Plantes. The natural history collection open to the public on Tuesdays and Fridays. Elephants, rhinoceros, hippopotamus, strange animals! The way Rubens has rendered this is marvelous. On entering this collection I had a feeling of happiness. The further I went along, the more this feeling increased: it seemed to me that my being was rising above the commonplaces, the small ideas, the small anxieties of the moment. What a prodigious variety of animals, and what a variety of species, of forms, and of destinations! At every moment, what seems to us deformity side by side with what seems to us grace. Here are the herds of Neptune, the seals, the walruses, the whales, the immensity of the fishes with their insensitive eyes, and their mouths stupidly open; the crustaceans, the crabs, the turtles; then the hideous family of the serpents. The enormous body of the boa, with his small head. The elegance of its coils wound around a tree; the hideous dragon, the lizards, the crocodiles, the alligators, the monstrous gavials with their jaws tapering suddenly and ending at the nose with a curious protuberance. Then the animals which are nearer in their nature to our own: the innumerable deer, gazelles, elks, bucks, goats, sheep, with forked feet, horned heads, the horns being straight, twisted or in curls; the bovine race, with the wild ox and the bison; the dromedaries and the camels, the llamas, the vicunas, which are related to them; finally the giraffe, the ones from Levaillant, sewn together and patched up; but also the one of 1827 which, after having been the delight of all idlers and having shone with incomparable splendor, had to pay mortal tribute in his turn, dying in obscurity as complete as his entry into the world had been brilliant. Here he is, all stiff and clumsy as nature made him. The ones that preceded him in the catacombs had doubtless been stuffed by men who had not seen the appearance of the animal during its lifetime: they had made it rear its neck proudly, not being

able to imagine the bizarre turn of that head pushing forward, the characteristic movement of a living creature.

The tigers, the panthers, the jaguars, the lions, etc.

Whence comes the impression which the sight of all that produced on me? From the fact that I got out of my everyday ideas which are my whole world, that I got out of my street which is my universe. How necessary it is to give oneself a shaking up, to get one's head out, to try to read in the book of creation, which has nothing in common with our cities and with the works of men! Certainly, seeing such things renders one better and calmer. When I came out of the museum, the trees got their share of admiration, and they had their share in the feeling of pleasure that this day has given me. I returned by way of the far end of the garden on the quay. On foot a part of the way and the rest in the omnibuses. . . .

1847. March 2.

. . . Feeling badly, I tried, very late, to work on the background of the Christ /au Tombeau/. Re-worked the mountains.

One of the great advantages of the lay-in by tone and effect without bothering about the details, is that one is compelled to put in only those which are absolutely necessary. Beginning here by finishing the backgrounds, I have made them as simple as possible, so as not to appear overloaded, alongside the simple masses which the figures still are. When I finish the figures, the simplicity of the backgrounds will, by the same token, permit me or even force me to put in only what is absolutely needed. The real thing would be, once the lay-in is established, to push each section as far as possible, yet not allow the picture as a whole to advance: this of course presupposes that the effect and the tone of all parts have been determined. What I am saying is that the figure one would prefer to finish, as compared with the others—which are merely massed in—would necessarily preserve simplicity in the details, and so would not be too much out of keeping with its neighbors, even though they are still in the state of a sketch. Once the picture has, through a lay-in, reached a condition where it is satisfying to the mind as a matter of lines, color and effect, it is evident that if one continues to the end to work in the same manner, that is to say, to proceed with sketchy painting, one loses a large part of the profit of that great sim-

plicity of impression which one attained in the beginning. The eye accustoms itself to the details which have gradually been introduced into each of the figures, and into all at the same time; the picture never seems finished. First defect of the method: the details stifle the masses; second defect: the work takes much longer to do.

1849. July 15.

I write Peisse[4] with reference to his article of the 8th:

"I do not venture to say that everything you write there is exactly right, because I am reaping the benefit of it; what you say about color and the art of color has never been said very strongly. Criticism is like many other things, it drags along after what has already been said and does not get out of its rut. That famous element, the beautiful, which some see in the serpentine line, others see in the straight line, but they are all resolved that it is to be seen only in line. I am at my window, and I see the most beautiful landscape: the idea of a line does not come to my mind. The lark sings, the river sparkles with a thousand diamonds, the foliage murmurs; where are any lines to produce these charming sensations? Those people refuse to see proportion and harmony unless they are between lines: the rest is chaos for them, and the compass alone is the judge. Pardon me my vigor as a critic in speaking against my critics. Note that I very humbly take shelter under the great names which you cite, even while I recognize in those masters qualities even finer than those usually attributed to them. Yes, Rubens draws, yes, Correggio draws. Not one of these men has broken with the ideal. Without the ideal, there is neither drawing, nor painting, nor color; and what is worse than lacking it, is to have that borrowed ideal which those people go to school to learn, and which is enough to cause hatred of the models. As several volumes might be written on the subject, I stop at this point, so as to speak once more of the pleasure that you have given me, etc."

1850. Antwerp, August 10. Went to the Museum. Made a sketch after Cranach. Admired the *Souls in Purgatory*, it is in the finest manner of Rubens. I could not tear myself away

[4] Jean-Louis Peisse (1803–88), doctor, writer, curator of the collections of the Ecole des Beaux Arts. Delacroix writes to thank him for an article of praise on his pictures at the Salon.

from the picture of the *Trinity,* from the *Saint Francis,* from the *Holy Family,* etc. The young man who is copying the large *Christ on the Cross* lent me his step-ladder, and I saw the picture in a different light. It is of the finest period; the halftone gives a frankly round modeling as a preparation, and then bold touches of light and dark are laid on with very thick impasto, especially in the light. How is it that I never noticed before now to what extent Rubens proceeds by means of the halftone, especially in his very fine works? His sketches ought to have put me on the track. The reverse of what we are told about Titian, he sketches in the tone of the figures which seem dark against the light tone. That also explains how it is that when he then does the background, having an extreme need to produce effect, he sets himself to render the flesh tones excessively brilliant by darkening the background. The head of the Christ, that of the soldier descending the ladder, the legs of the Christ and those of the other crucified man strongly colored in the preparatory work, with the lights laid on in small areas only. The Magdalen is remarkable for the following quality, that one sees clearly how the eyes, the lashes, the eyebrows, and the corners of the mouth are laid on over the underpainting, while it was still wet I think, contrary to the practice of Paul Veronese.

Le Coup de Lance. The soldier who is piercing the flank, darker in tonality than the thief who is behind him, by which means the figure is perfectly detached. The thief, of a golden tone, and his drapery of the same value, mingling it with the sky, which is of a warm gray. The neck of the horse is of a lighter color; there is a very vivid shine on the armor of the soldier with the lance under his arm; the sky is very blue under the arm of the other man.

On the legs of the Christ there is a gradation of the light from the knees onward. The head, the arm, and the other hand of the Magdalen, very vivid. The feet of the Christ mostly rendered with halftones, but of an admirable likeness. The knee detaches marvelously against the arm and the hand of the Magdalen. . . .

Finally, saw the famous *Raising of the Cross:*[5] extreme emotion! A great deal of relationship with the *Medusa.*[6] He

[5] At the cathedral. The picture dates from 1610, soon after Rubens' return from Italy.
[6] The *Raft of the Medusa,* by Géricault.

is young yet and is thinking of satisfying the pedants. Full of
Michelangelo. Extraordinary loading on of the paint. Dryness
that approaches that of Mauzaisse,[7] in certain parts, and yet
it is not disturbing. Hair very dryly treated in the curly heads,
in the old man with the red head and white hair who, below
and to the right, is lifting up the cross, also in the dog, etc. Is
this not prepared by the halftone? In the panel to the right,
one sees heavily loaded preparations such as I often use, and
a glaze on top of them, notably in the arm of the Roman who
holds the staff, and in the criminals who are being crucified.
Still more probable, although concealed by the finish, in the
left-hand panel. The coloration has disappeared in the flesh,
the light passages there being yellow and the shadows black.
The folds are studied for stylistic purposes, the arrangement
of the hair on the heads of the figures has been carefully con-
sidered. There is more freedom, though the brush is still that
of a student, in the central picture; but he is completely free
and returns to his own temperament in the panel containing
the horse, which goes beyond everything. When I see this
art, Géricault grows greater in my eyes: he divined this force
and his work is in no respect inferior to what is here. Al-
though Rubens has not yet reached the height of his knowl-
edge of painting in the *Raising of the Cross,* it must be ad-
mitted that the impression is perhaps more gigantic and more
elevated than in his masterpieces. He was steeped in sublime
works, and one cannot say that he imitated. He had that char-
acteristic, he and the other masters he bore in him. What a
difference from the Carracci! When one thinks of them, one
sees clearly that he did not imitate; he is always Rubens.

This will be useful to me for my ceiling.[8] I had that feeling
when I began. Did I perhaps also owe it to others? The study
of Michelangelo has exalted one generation of painters after
another and lifted them all up above themselves.

The grand style cannot dispense with drawings established
in advance. When you proceed by halftones, the contour is
added at the end: that gives more of reality, but also a softer
quality and perhaps less of character.

[7] J. B. Mauzaisse (1783–1844), an academic painter who manu-
factured battle pictures for Versailles.
[8] The ceiling of the Galerie d'Apollon in the Louvre, for which
Delacroix had received the commission that same year.

1852. February 23. Painters who are not colorists produce illumination and not painting. All painting worthy of the name, unless one is talking about a black-and-white, must include the idea of color as one of its necessary supports, in the same way that it includes chiaroscuro and proportion and perspective. Proportion applies to sculpture as to painting; perspective determines the contour; chiaroscuro gives relief through the disposition of lights and shadows in their relationship with the background; color gives the appearance of life, etc.

The sculptor does not begin his work with a contour; with his material, he builds up an appearance of the object which, rough at first, immediately presents the chief characteristic of sculpture—actual relief and solidity. The colorists, the men who unite all the phases of painting, have to establish, at once and from the beginning, everything that is proper and essential to their art. They have to mass things in with color, even as the sculptor does with clay, marble or stone; their sketch, like that of the sculptor, must also render proportion, perspective, effect and color.

The contour is as much a thing of idea and convention in painting as it is in sculpture; it should result naturally from the right placing of the essential parts. The combined preparation of the effect (including perspective) and of color will approach more or less closely to its definitive appearance, according to the ability of the artist; but in this point of departure, there will be an unmistakable beginning of what is to come later on.

1853. Champrosy. May 9. A delightful morning. Reached the oak of Antin, which I did not recognize—it seemed so small to me; jotted down some new observations, similar to those which I have noted here, on the effect produced by unfinished things: sketches, lay-ins, etc.

I get the same impression from disproportion. Perfect artists do not astonish us so much through their perfection itself; what we feel, with them, is that there is no incongruity in their work, to reveal how perfect and well-proportioned a whole they have produced. When on the contrary, I approach this magnificent tree and stand beneath its immense branches, perceiving parts only in their relation with the ensemble, I am struck by its grandeur. And so I am led to infer that some of the effect produced by the statues of Michelangelo is due to

certain disproportionate or unfinished parts which augment the importance of the parts which are complete. If one can judge of his paintings through engravings, it seems to me that they do not present this defect to the same degree. I have often told myself that, whatever he himself thought, he was more of a painter than a sculptor. In his sculpture, he does not proceed as did the ancients, which is to say by the masses; it always seems as if he had drawn an outline in his mind and then set himself to fill it in, as a painter does. One would say that his figure or his group presents itself to him from one angle alone; that is the painter. Hence, when one must change one's position as sculpture demands, there are twisted limbs and planes that lack exactitude, in a word everything that one does not see in the antique.

/Second entry/[9] I am at Champrosy since Saturday. I take a solitary walk in the forest while waiting for my room to be arranged so that I can get back to the famous Poussin. Noticing the Antin oak from a distance, I did not recognize it at first, finding it so ordinary, and my mind went back to an observation I had set down in my notebook about two weeks ago, as to the effect of the sketch in its relation to the finished work. I said that the sketch of a picture or a monument—and the same is true of a ruin or, in a word any work of the imagination in which parts are lacking—ought to react on the soul in just the proportion that we have to add to the work, while it is producing its impression on us. I add that perfect works, like those of a Racine or of a Mozart, do not, at the first moment, produce as much effect as those of less correct or even careless geniuses, who give you salient parts standing out in all the stronger relief because others, beside them, are vague or completely bad.

Standing before this fine tree (the Antin oak) which is so well proportioned, I find a new confirmation of these ideas. At the distance necessary for the eye to seize it as a whole, it seems to be of ordinary size; if I place myself under its branches the impression changes completely: perceiving only the trunk which I almost touch and the springing-point of the thick branches which spread out over my head like the im-

[9] This passage comes from a notebook of 1857 in which Delacroix —re-reading what he had written four years previously—amplifies his ideas, which are here given as a sequel to the original note.

mense arms of the giant of the forest, I am astonished at the grandeur of its details; in a word I see it as big, and even terrifying in its bigness.

Can it be that disproportion is one of the conditions which compel admiration? If, on one side, Mozart, Cimarosa, and Racine cause less of astonishment by reason of the admirable proportion in their works, do not Shakespeare, Michelangelo and Beethoven owe a part of their effect to an opposite course? In my own opinion, that is the fact.

The antique never surprises, never gives that gigantic and exaggerated effect. One finds oneself at ease with those admirable creations; reflection alone makes them seem big and places them on their incomparable height. Michelangelo astonishes, and brings into the soul a troubled sentiment which amounts to admiration, but one is not long in perceiving shocking incongruities which are, in his art, the consequence of too hasty work, caused either by the fire with which the artist engaged upon it or else by the fatigue which probably seized him at the end of a labor impossible of completion.

That last cause is evident in his statues, as we should know even had his historians not taken care to inform us that he was almost always seized with disgust when finishing, because of the impossibility, as they say, of rendering his sublime ideas. One sees clearly, from the parts left in a sketchy condition, from feet not yet cut from the block, and others where the material was lacking, that the vice of the work comes rather from the manner of conceiving and executing than from the extraordinary demands of a genius made for higher attainments and arrested before he could content himself. It is more probable that his conception was vague, and that he counted too much on the inspiration of the moment for the development of his thought; if he often stopped in his discouragement, the reason is that he could really do no more.

1853. Champrosy. October 20. What an adoration I have for painting! The mere memory of certain pictures, even when I don't see them, goes through me with a feeling which stirs my whole being like all those rare and interesting memories that one finds at long intervals in one's life, and especially in the very early years of it. . . .

. . . Glory to that Homer of painting /Rubens/ to that father of warmth and of enthusiasm in the art where he blots out everything—not, if you like, through the perfection which

he has brought to one part or another, but through that secret force and that life of the soul which he has attained everywhere. How strange! the picture which perhaps gave me the strongest sensation, the *Raising of the Cross,* is not the one most brilliant through the qualities peculiar to him and in which he is incomparable. It is neither through color nor through the delicacy nor the frankness of the execution that this picture triumphs over the others but, curiously enough, through Italian qualities which, in the work of the Italians, do not delight me to the same degree; I think it is appropriate for me to take note here of the quite analogous way I have felt before Gros' battle pictures, and before the *Medusa,* especially when I saw it half finished. The essential thing about these works is their reaching of the sublime, which comes in part from the size of the figures. The same pictures in small dimension would, I am sure, produce quite a different effect on me. In the effect of Rubens and in that of Géricault there is also an indefinable something of the style of Michelangelo, which adds again to the effect produced by the dimension of the figures and which gives them something terrifying. Proportion counts for very much in the greater or lesser power of a picture. Not only, as I was saying, would these pictures, executed in small size, be ordinary work for the master, but, were they merely life-size, they would not attain the effect of the sublime. The proof is that the engraving after the picture by Rubens does not at all produce that effect on me.

I ought to say that the matter of dimensions is not everything, for several of his pictures in which the figures are very large do not give me that type of emotion which, for me, is the most elevated one; neither can I say that it is something exclusively Italian in style, for Gros' pictures, which do not present a trace of it and which are completely his own, transport me to the same degree into that state of the soul which I regard as the most powerful that painting can inspire. The impressions produced by the arts on sensitive organisms are a curious mystery: confused impressions, if one tries to describe them, clear-cut and full of strength if one feels them again, and if only through memory! I strongly believe that we always mix in something of ourselves with feelings which seem to come from the objects that strike us. It is probable that the only reason why these works please me so much is that they respond to feelings which are my own; and since they give me the same degree of pleasure, different as they are, it must be

that I find in myself the source of the effect which they pro-
duce.

The type of emotion peculiar to painting is, so to speak,
tangible; poetry and music cannot give it. You enjoy the actual
representation of objects as if you really saw them, and at
the same time the meaning which the images have for the
mind warms you and transports you. These figures, these
objects, which seem the thing itself to a certain part of your
intelligent being are like a solid bridge on which imagination
supports itself to penetrate to the mysterious and profound
sensation for which the forms are, so to speak, the hieroglyph,
but a hieroglyph far more eloquent than a cold representation,
a thing equivalent to no more than a character in the printer's
font of type: it is in this sense that the art is sublime, if we
compare it to one wherein thought reaches the mind only with
the help of letters arranged in an order that has been agreed
upon; it is a far more complicated art, if you will (since the
font of type is nothing and thought seems to be everything),
but a hundred times more expressive if one consider that,
independently of the idea, the visible sign, the speaking hiero-
glyph, a sign without value for the mind in the work of the
writer becomes a source of the liveliest enjoyment in the work
of the painter. And so, looking upon the spectacle of cre-
ated things, we have here the satisfaction given by beauty,
proportion, contrast, harmony of color, and everything that
the eye looks upon with so much pleasure in the outer world—
one of the great needs of our nature.

Many people will consider that it is precisely in this simpli-
fication of the means of expression that the superiority of
literature resides. Such people have never considered with
pleasure an arm, a hand, a torso from the antique or from
Puget; they care for sculpture even less than painting, and
they are strangely deceived if they think that when they have
written: *a foot or a hand,* they have given to my mind the
same emotion as the one I experience when I see a beautiful
foot or a beautiful hand. The arts are not algebra, in which
the abbreviation of the figures contributes to the success of
the problem; success in the arts is by no means a matter of
abridging, but of amplifying, if possible, and prolonging the
sensation by all possible means. What is the theater? One of
the most certain witnesses to man's need for experiencing the
largest possible number of emotions at one time. It gathers

together all the arts so that each may make us feel their combined effect more strongly; pantomime, costume, and the beauty of the performer double the effect of the word that is spoken or sung. The representation of the place in which the action occurs adds still further to all these types of impression.

It will now be clearer why I have spoken as I have about the *power of painting*. If it possesses but a single moment, it concentrates the *effect* of that moment; the painter is far more the master of that which he wants to express than is the poet or the musician, who is in the hands of interpreters; in a word, if his memory is directed toward fewer aspects of things, he produces an effect which is absolutely one and which can satisfy completely; in addition, the work of the painter is not subject to the same variations, as regards the manner in which it may be understood at different periods. Changing fashion and the prejudices of the moment may cause its value to be looked upon in different ways; but in the end it is always the same, it remains as the artist wanted it to be, whereas the same is not true of things that must pass through the hands of interpreters, as must the works of the theater. Since the feeling of the artist is no longer there to guide the actors or the singers, the execution can no longer respond to the original intention of the work; the accent disappears, and with it the most delicate part of the impression. Indeed, it is a happy author whose work is not mutilated, an affront to which he is exposed even during his lifetime! The mere change of an actor changes the whole physiognomy of a piece.

1854. Dieppe. September 2. Scientists do no more, after all, than find in nature what is there. The personality of the scientist is absent from his work; it is quite a different matter with the artist. The seal that he imprints on his production is what makes it the work of an artist, which is to say of an inventor. The scientist discovers the elements of things, if you like, and the artist, with elements having no value in the place they chance to be, composes, invents a unity, in one word, creates; he strikes the imagination of men by the spectacle of his creations, and in a particular manner. He summarizes, he renders clear the sensations that things arouse within us, and which the great run of men, in the presence of nature, only vaguely see and feel.

1855. August 3. I went to the Exposition;[10] I noticed that fountain which spouts gigantic artificial flowers.

The sight of all those machines makes me feel very bad. I don't like that stuff which, all alone and left to itself, seems to be producing things worthy of admiration.

After leaving, I went to see Courbet's exhibition;[11] he has reduced the admission to ten cents. I stay there alone for nearly an hour and discover that the picture of his which they refused is a masterpiece;[12] I simply could not tear myself away from the sight of it. He has made enormous progress, and yet that made me admire his *Burial.* In the latter work the figures are one on top of the other, the composition is not well understood. But there are superb details: the priests, the choir boys, the vase of holy water, the weeping women, etc. In the later work (*The Atelier*) the planes are well understood; there is atmosphere and there are some parts that are important in their execution: the haunches, and the thigh of the nude model and her bosom; the woman in the front plane, with a shawl. The only fault is that the picture he is painting offers an ambiguity: it looks as if it had a *real sky* in the midst of the picture. They have refused one of the most singular works of this period; but a strapping lad like Courbet is not going to be discouraged for so small a thing as that.

I dined at the Exposition, sitting between Mercey and Mérimée; the former thinks as I do about Courbet; the latter does not like Michelangelo!

Detestable modern music by those singing choirs which are in fashion.

1856. May 30. . . . On coming home, I continued my reading of Edgar Poe. His book awakes in me anew that sense of the mysterious which used, in former times, to be a greater preoccupation for me in my painting; it fell away, I believe, because of my work from nature, with allegorical subjects, etc. Baudelaire, in his preface, says that I bring back to painting the feeling for that so singular ideal which delights in the terrible. He is right: but the disjointed and incomprehensible

[10] The Universal Exposition of 1855.
[11] Courbet, whose *Burial at Ornans* and *The Atelier* had been refused by the jury, organized a special exhibition of his works at No. 7 avenue Montaigne, near the Exposition. (See p. 348.)
[12] The picture referred to is *The Atelier,* which had been refused with the *Burial at Ornans.*

qualities which mingle with his[13] conceptions do not suit my mind. His metaphysics and his researches into the soul and the future life are most singular, and give one a lot to think about. His Van Kirck, talking about the soul during a hypnotic sleep, is a bizarre and profound piece of writing which throws you into a state of contemplation. There is the same monotony in the fables as in all his stories; to tell the truth, it is only the phantom gleam with which he illumines those confused but terrifying figures that makes up the charm of this singular and very original poet and philosopher.

1857. March 5. Today, while I was at lunch, two pictures attributed to Géricault were brought to me for my opinion. The small one is a very mediocre copy: costume of Roman beggars. The other, a No. 12 canvas, approximately (a study for an amphitheatre picture: arms, feet, etc., with cadavers), has a strength, a rendering of relief, that is admirable, with negligences which belong to the author's style, and add even more to its value.

Placed next to the portrait by David,[14] this painting takes on an even greater accent. Through it one sees everything that David always lacked, that power of the picturesque, that vigor, that daring which is to painting what the *vis comica* is to the art of the theater. Everything is even; there is no more interest in the head than in the draperies or the chair.

His complete enslavement to that which the model offered to his eyes is one of the causes of this coldness: but it is more exact to think that this coldness was in himself: it was impossible for him to find anything outside the limit offered him by the imperfect means of the little piece of nature which he had under his eyes, and it seems as though he was satisfied when he had imitated it well: his whole audacity consisted in placing side by side fragments modeled on the Antique, such as a foot and an arm, and in bringing his living model as much as possible to that type of the beautiful, ready to hand, which the plaster cast offered him.

This fragment from Géricault is truly sublime: it proves more than ever that *there is no serpent nor odious monster*, etc. It is the best argument in favor of the Beautiful, as it

[13] I.e., Poe's.
[14] The portrait of his sister, Henriette de Verninac, by David, which Delacroix owned at the time.

should be understood. The lapses from correctness do not in the least take away from the beauty of this piece of painting: alongside the foot, which is very precise and has more resemblance to nature (save that it is influenced by the personal ideal of the painter), there is a hand in which the planes are soft and as if done without consulting the model, as was the case, indeed, with figures that he used to do in the studio; and that hand does not take away from the beauty of the rest: it is raised by the power of style to the level of the other parts. This type of merit has the greatest relationship with that of Michelangelo, with whom incorrectitudes do no harm whatsoever.

1859. Strasbourg. September 1. The most obstinate realist[15] is still compelled, in his rendering of nature, to make use of certain conventions of compositions or of execution. If the question is one of composition, he cannot take an isolated piece of painting or even a collection of them and make a picture from them. He must certainly circumscribe the idea in order that the mind of the spectator shall not float about in an ensemble that has, perforce, been cut to bits; otherwise art would not exist. When a photographer takes a view, all you ever see is a part cut off from a whole: the edge of the picture is as interesting as the center; all you can do is to suppose an ensemble, of which you see only a portion, apparently chosen by chance. The accessory is capital, as much as the principal; most often, it presents itself first and offends the sight. One must make more concessions to the infirmity of the reproduction in a photographic work than in a work of the imagination. The photographs which strike you most are those in which the very imperfection of the process as a matter of absolute rendering leaves certain gaps, a certain repose for the eye which permits it to concentrate on only a small number of objects. If the eye had the perfection of a magnifying glass, photography would be unbearable: one would see every leaf on a tree, every tile on a roof, and on these tiles, mosses, insects, etc. And what shall we say of those disturbing pictures produced by actual perspective, defects less disturbing perhaps in a landscape, where parts in the foreground may be magni-

[15] This passage is certainly a reply to the critics of the Salon of 1859, and to opinion that was hostile to Romanticism and favorable to the Realism that was triumphing with Courbet.

fied in even an exaggerated way without the spectator's being offended, save when human figures come into question? The obstinate realist will therefore, in his picture, correct that inflexible perspective which falsifies our seeing of objects by reason of its very correctness.

In the presence of nature herself, it is our imagination that makes the picture: we see neither the blades of grass in a landscape nor the accidents of the skin in a pretty face. Our eye, in its fortunate inability to perceive these infinitesimal details, reports to our mind only the things which it ought to perceive; the latter, again, unknown to ourselves, performs a special task; it does not take into account all that the eye presents to it; it connects the impressions it experiences with others which it received earlier, and its enjoyment is dependent on its disposition at the time. That is so true that the same view does not produce the same effect when taken in two different aspects.

[CHARLES BAUDELAIRE (1821–67), the brilliant essayist, poet, and critic, was educated at Lyons and Paris, where his family was well connected. On receiving an ample inheritance, he led a dissolute life, then journeyed to India to escape the ennui of his dissipation, a trip that left him with a nostalgia for the bizarre and the strange. With his property placed in a trust by his family, allowing him only a minimal allowance, he determined on a literary career. His first essays were on the Salons of 1845 and 1846 and attracted attention because of the originality of the position from which he made his judgment. He did not proceed from an aesthetic theory, or from literary content, but from his intuitive experience and his sensitivity as he responded to the artistic and spiritual qualities present in an art work. His judgment was based only on his emotional reaction or the feeling that was called forth by the nature of the art work that the artist had felt and expressed when he created it. With this standard, which has become the accepted one for criticism, Baudelaire considered the art in the Salons and evaluated the art of Ingres and Delacroix. He recognized the qualities that form the "strange charm" of Ingres and those that produce the passionate, and at the same time melancholy, poetic appeal of Delacroix. Being himself a gifted imaginative poet, he intuitively depreciated the imita-

tors of nature, though he was sensitive to Courbet's vitality, and appreciated religious painting except where it was stultified by didacticism. He responded to the synthesis of essentials in the art of caricature that he admired as "sureness" in Daumier's work, for he sought the great and the epic as well as the beauty within the environment of Paris to which he felt the people were blind. Later in 1863, however, when Baudelaire devised the aesthetic requirements for an artist and applied them, he went against the judgment of later critics in thinking Constantin Guys a great painter, and he was blinded to the limitations of Guys, who was at best a facile draftsman and watercolorist and a clever improvisator, because Guys combined contemporaneity with grace and charm. Nor was Baudelaire able to comprehend the art of his friend Edouard Manet.

Baudelaire published his first poems in 1857 under the title *Fleurs du Mal*. The public was offended by the morbidness of the subjects, his consummate art was ignored, and he and his publishers were successfully prosecuted and fined for an offense against public morals. His second volume, *Les Paradis artificiels,* appeared in 1860. Variations on human suffering were the theme of his *Petits Poèmes en prose*. His major literary effort was his masterly translation of the writings of Edgar Allan Poe, whom he "discovered" in 1846, and the analysis of Poe's art that was based on a search for "the novelty of beauty."

Richard Wagner's attempt to weld music, drama, and poetry into a single artistic creation interested Baudelaire, who also believed that all the arts were one. His own idea that perfume, color, and sound correspond is expressed in the famous sonnet "Correspondences." As he thought in a spiritual mode, he sought the spiritual meaning in all objects.

Baudelaire experienced ever increasing financial difficulties and went to Belgium to earn more by lecturing, but his health broke down under the strain and his excesses, and he was returned to Paris where he died.

Baudelaire, aware of the danger of "realism," allied himself with the "art for art's sake" movement, which was a continuation of German romanticism and Poe's thought. The group formed of the writers, Gustave Flaubert, Théophile Gautier, the de Goncourt brothers, Walter Pater, Oscar Wilde, and the painter, James McNeill Whistler, rejected the industrial world and sought Beauty as an absolute value in an

aesthetic life of sensations. For them the only artist is he who pursues beauty as his single goal, seeking the intrinsic value of the object, unrelated to himself, and, utterly detached, recording an objective image. Baudelaire's quest was for beauty in the ugliness of life in the mid-nineteenth century, and this he found in his "other life."]

THE SALON OF 1846[1]

I

WHAT IS THE GOOD OF CRITICISM?

What is the good?—A vast and terrible question-mark which seizes the critic by the throat from his very first step in the first chapter that he sits down to write.

At once the artist reproaches the critic with being unable to teach anything to the bourgeois, who wants neither to paint nor to write verses—nor even to art itself, since it is from the womb of art that criticism was born.

And yet how many artists today owe to the critics alone their sad little fame! It is there perhaps that the real reproach lies. . . .

I sincerely believe that the best criticism is that which is both amusing and poetic: not a cold, mathematical criticism which, on the pretext of explaining everything, has neither love nor hate, and voluntarily strips itself of every shred of temperament. But, seeing that a fine picture is nature reflected by an artist, the criticism which I approve will be that picture reflected by an intelligent and sensitive mind. Thus the best account of a picture may well be a sonnet or an elegy.

But this kind of criticism is destined for anthologies and readers of poetry. As for criticism properly so-called, I hope that the philosophers will understand what I am going to say. To be just, that is to say, to justify its existence, criticism

[1] Quoted from Charles Baudelaire, *The Mirror of Art,* translated by Jonathan Mayne, Anchor Books, Doubleday & Co., Inc., New York, 1956. Footnotes are by the translator except those identified by (C.B.), which are from the original text, and those in brackets, which are by the editor. The exhibition opened on March 16 at the Musée Royal. Baudelaire's review appeared as a booklet on May 13.

should be partial, passionate, and political, that is to say, written from an exclusive point of view, but a point of view that opens up the widest horizons.

To extol line to the detriment of colour, or colour at the expense of line, is doubtless a point of view, but it is neither very broad nor very just, and it indicts its holder of a great ignorance of individual destinies.

You cannot know in what measure Nature has mingled the taste for line and the taste for colour in each mind, nor by what mysterious processes she manipulates that fusion whose result is a picture.

Thus a broader point of view will be an orderly individualism—that is, to require of the artist the quality of *naïveté* and the sincere expression of his temperament, aided by every means which his technique provides. An artist without temperament is not worthy of painting pictures, and—as we are wearied of imitators and, above all, of eclectics—he would do better to enter the service of a painter of temperament, as a humble workman. I shall demonstrate this in one of my later chapters.

The critic should arm himself from the start with a sure criterion, a criterion drawn from nature, and should then carry out his duty with passion; for a critic does not cease to be a man, and passion draws similar temperaments together and exalts the reason to fresh heights.

Stendhal has said somewhere, "Painting is nothing but a construction in ethics."[2] If you will understand the word "ethics" in a more or less liberal sense, you can say as much of all the arts. And as the essence of the arts is always the expression of the beautiful through the feeling, the passion, and the dreams of each man—that is to say, a variety within a unity, or the various aspects of the absolute—so there is never a moment when criticism is not in contact with metaphysics.

As every age and every people has enjoyed the expression of its own beauty and ethos—and if, by *romanticism,* you are prepared to understand the most recent, the most modern expression of beauty—then, for the reasonable and passionate critic, the great artist will be he who will combine with the

[2] *Histoire de la Peinture en Italie,* Chapter 156 (edition of 1859, p. 338, n. 2). Stendhal's phrase is "de la morale construite," and he explains that he is using the past participle in the geometric sense.

condition required above—that is, the quality of *naïveté*—the greatest possible amount of romanticism.

II.

WHAT IS ROMANTICISM?

Few people today will want to give a real and positive meaning to this word; and yet will they dare assert that a whole generation would agree to join a battle lasting several years for the sake of a flag which was not also a symbol?

. . . Romanticism is precisely situated neither in choice of subjects nor in exact truth, but in a mode of feeling.

They looked for it outside themselves, but it was only to be found within.

For me, Romanticism is the most recent, the latest expression of the beautiful.

There are as many kinds of beauty as there are habitual ways of seeking happiness.[3]

This is clearly explained by the philosophy of progress; thus, as there have been as many ideals as there have been ways in which the peoples of the earth have understood ethics, love, religion, etc., so romanticism will not consist in a perfect execution, but in a conception analogous to the ethical disposition of the age.

It is because some have located it in a perfection of technique that we have had the *rococo* of romanticism, without question the most intolerable of all forms.

Thus it is necessary, first and foremost, to get to know those aspects of nature and those human situations which the artists of the past have disdained or have not known.

To say the word Romanticism is to say modern art—that is, intimacy, spirituality, colour, aspiration towards the infinite, expressed by every means available to the arts.

Thence it follows that there is an obvious contradiction between romanticism and the works of its principal adherents.

Does it surprise you that colour should play such a very important part in modern art? Romanticism is a child of the North, and the North is all for colour; dreams and fairy tales

[3] Stendhal. (C.B.) Baudelaire seems to have in mind a footnote in Chapter 110 of the *Histoire de la Peinture en Italie,* where Stendhal wrote, "La beauté est l'expression d'une certaine manière habituelle de chercher le bonheur . . ."

are born of the mist. England—that home of fanatical colour-
ists—Flanders and half of France are all plunged in fog;
Venice herself lies steeped in her lagoons. As for the painters
of Spain, they are painters of contrast rather than colourists.

The South, in return, is all for nature; for there nature is so
beautiful and bright that nothing is left for man to desire, and
he can find nothing more beautiful to invent than what he
sees. There art belongs to the open air; but several hundred
leagues to the north you will find the deep dreams of the
studio and the gaze of the fancy lost in horizons of grey.

The South is as brutal and positive as a sculptor even in his
most delicate compositions; the North, suffering and restless,
seeks comfort with the imagination, and if it turns to sculpture,
it will more often be picturesque than classical.

Raphael, for all his purity, is but an earthly spirit cease-
lessly investigating the solid; but that scoundrel Rembrandt is a
sturdy idealist who makes us dream and guess at what lies
beyond. The first composes creatures in a pristine and vir-
ginal state—Adam and Eve; but the second shakes his rags
before our eyes and tells us of human sufferings.

And yet Rembrandt is not a pure colourist, but a harmonizer.
How novel then would be the effect, and how matchless his
romanticism, if a powerful colourist could realize our dearest
dreams and feelings for us in a colour appropriate to their
subjects!

But before passing on to an examination of the man who
up to the present is the most worthy representative of roman-
ticism, I should like to give you a series of reflections on
colour, which will not be without use for the complete under-
standing of this little book.

III.

ON COLOUR

Let us suppose a beautiful expanse of nature, where there
is full licence for everything to be as green, red, dusty, or
iridescent as it wishes; where all things, variously coloured in
accordance with their molecular structure, suffer continual
alteration through the transposition of shadow and light; where
the workings of latent heat allow no rest, but everything is
in a state of perpetual vibration which causes lines to tremble
and fulfils the law of eternal and universal movement. An

immensity which is sometimes blue, and often green, extends
to the confines of the sky; it is the sea. The trees are green,
the grass and the moss are green; the tree-trunks are snaked
with green, and the unripe stalks are green; green is nature's
ground-bass, because green marries easily with all the other
colours.[4] What strikes me first of all is that everywhere—
whether it be poppies in the grass, pimpernels, parrots, etc.—
red sings the glory of green; black (where it exists—a solitary
and insignificant cipher) intercedes on behalf of blue or red.
The blue—that is, the sky—is cut across with airy flecks of
white or with grey masses, which pleasantly temper its bleak
crudeness; and as the vaporous atmosphere of the season—
winter or summer—bathes, softens, or engulfs the contours,
nature seems like a spinning-top which revolves so rapidly
that it appears grey, although it embraces within itself the
whole gamut of colours.

The sap rises, and as the principles mix, there is a flowering
of *mixed tones;* trees, rocks, and granite boulders gaze at
themselves in the water and cast their *reflections* upon them;
each transparent object picks up light and colour as it passes
from nearby or afar. According as the daystar alters its posi-
tion, tones change their values, but, always respecting their
natural sympathies and antipathies, they continue to live in
harmony by making reciprocal concessions. Shadows slowly
shift, and colours are put to flight before them, or extinguished
altogether, according as the light, itself shifting, may wish to
bring fresh ones to life. Some colours cast back their reflec-
tions upon one another, and by modifying their own quali-
ties with a *glaze* of transparent, borrowed qualities, they
combine and recombine in an infinite series of melodious mar-
riages which are thus made more easy for them. When the
great brazier of the sun dips beneath the waters, fanfares of
red surge forth on all sides; a harmony of blood flares up at
the horizon, and green turns richly crimson. Soon vast blue
shadows are rhythmically sweeping before them the host of
orange and rose-pink tones which are like a faint and distant
echo of the light. This great symphony of today, which is an
eternal variation of the symphony of yesterday, this succes-

[4] Except for yellow and blue, its progenitors: but I am only speak-
ing here of pure colours. For this rule cannot be applied to tran-
scendent colourists who are thoroughly acquainted with the science
of counterpoint. (C.B.)

sion of melodies whose variety ever issues from the infinite, this complex hymn is called *colour*.

In colour are to be found harmony, melody, and counterpoint.

It is often asked if the same man can be at once a great colourist and a great draughtsman.

Yes and no; for there are different kinds of drawing.

The quality of pure draughtsmanship consists above all in precision, and this precision excludes *touch;* but there are such things as happy touches, and the colourist who undertakes to express nature through colour would often lose more by suppressing his happy touches than by studying a greater austerity of drawing.

Certainly colour does not exclude great draughtsmanship —that of Veronese, for example, which proceeds above all by ensemble and by mass; but it does exclude the meticulous drawing of detail, the contour of the tiny fragment, where touch will always eat away line.

The love of air and the choice of subjects in movement call for the employment of flowing and fused lines.

Exclusive draughtsmen act in accordance with an inverse procedure which is yet analogous. With their eyes fixed upon tracking and surprising their line in its most secret convolutions, they have no time to see air and light—that is to say, the effects of these things—and they even compel themselves *not* to see them, in order to avoid offending the dogma of their school.

It is thus possible to be at once a colourist and a draughtsman, but only in a certain sense. Just as a draughtsman can be a colourist in his broad masses, so a colourist can be a draughtsman by means of a total logic in his linear ensemble; but one of these qualities always engulfs the detail of the other.

The draughtsmanship of colourists is like that of nature; their figures are naturally bounded by a harmonious collision of coloured masses.

Pure draughtsmen are philosophers and dialecticians.

Colourists are epic poets.

IV.

EUGÈNE DELACROIX

Romanticism and colour lead me straight to Eugène Delacroix. I do not know if he is proud of his title of "romantic," but his place is here, because a long time ago—from his very first work, in fact—the majority of the public placed him at the head of the *modern* school. . . .

Up to the present, Eugène Delacroix has met with injustice. Criticism, for him, has been bitter and ignorant; with one or two noble exceptions, even the praises of his admirers must often have seemed offensive to him. Generally speaking, and for most people, to mention Eugène Delacroix is to throw into their minds goodness knows what vague ideas of ill-directed fire, of turbulence, of hazardous inspiration, of confusion, even; and for those gentlemen who form the majority of the public, pure chance, that loyal and obliging servant of genius, plays an important part in his happiest compositions. In that unhappy period of revolution of which I was speaking a moment ago and whose numerous errors I have recorded, people used often to compare Eugène Delacroix to Victor Hugo. They had their romantic poet; they needed their painter. . . .

For Delacroix justice is more sluggish. His works, on the contrary, are poems—and great poems, *naïvely*[5] conceived and executed with the usual insolence of genius. In the works of the former, there is nothing left to guess at, for he takes so much pleasure in exhibiting his skill that he omits not one blade of grass nor even the reflection of a street lamp. The latter in his works throws open immense vistas to the most adventurous imaginations. The first enjoys a certain calmness, let us rather say a certain detached egoism, which causes an unusual coldness and moderation to hover above his poetry —qualities which the dogged and melancholy passion of the second, at grips with the obstinacies of his craft, does not always permit him to retain. One starts with detail, the other

[5] By the *naïveté* of the genius you must understand a complete knowledge of technique combined with the γνῶθι σεαυτόν [know thyself] of the Greeks, but with knowledge modestly surrendering the leading role to temperament. (C.B.) The word *naïveté,* used in this special sense, is one of the keywords of this *Salon.*

with an intimate understanding of his subject; from which it follows that one only captures the skin, while the other tears out the entrails. Too earth-bound, too attentive to the superficies of nature, M. Victor Hugo has become a painter in poetry; Delacroix, always respectful of his ideal, is often, without knowing it, a poet in painting.

As for the second preconception, the preconception of pure chance, it has no more substance than the first. Nothing is sillier or more impertinent than to talk to a great artist, and one as learned and as thoughtful as Delacroix, about the obligations which he may owe to the god of chance. It quite simply makes one shrug one's shoulders in pity. There is no pure chance in art, any more than in mechanics. A happy invention is the simple consequence of a sound train of reasoning whose intermediate deductions one may perhaps have skipped, just as a fault is the consequence of a faulty principle. A picture is a machine, all of whose systems of construction are intelligible to the practised eye; in which everything justifies its existence, if the picture is a good one; where one tone is always planned to make the most of another; and where an occasional fault in drawing is sometimes necessary, so as to avoid sacrificing something more important.

This intervention of chance in the business of Delacroix's painting is all the more improbable since he is one of those rare beings who remain original after having drunk deep of all the true wells, and whose indomitable individuality has borne and shaken off the yokes of all the great masters in turn. Not a few of you would be quite astonished to see one of his studies after Raphael—patient and laborious masterpieces of imitation; and few people today remember his lithographs after medals and engraved gems.[6]

Here are a few lines from Heinrich Heine which explain Delacroix's method rather well—a method which, like that of all robustly-framed beings, is the result of his temperament:

"In artistic matters, I am a supernaturalist. I believe that the artist cannot find all his forms in nature, but that the most remarkable are revealed to him in his soul, like the innate symbology of innate ideas, and at the same instant. A modern professor of aesthetics, the author of *Recherches sur l'Italie*,[7]

[6] Delacroix made six such lithographs in 1825.
[7] The reference is to Carl Friedrich von Rumohr (1785–1843); his book, *Italienische Forschungen,* was published in three volumes between 1827 and 1831.

has tried to restore to honour the old principle of the *imitation of nature,* and to maintain that the plastic artist should find all his forms in nature. The professor, in thus setting forth his ultimate principle of the plastic arts, had only forgotten one of those arts, but one of the most fundamental—I mean architecture. A belated attempt has now been made to trace back the forms of architecture to the leafy branches of the forest and the rocks of the grotto; and yet these forms were nowhere to be found in external nature, but rather in the soul of man."[8]

Now this is the principle from which Delacroix sets out—that a picture should first and foremost reproduce the intimate thought of the artist, who dominates the model as the creator dominates his creation; and from this principle there emerges a second which seems at first sight to contradict it—namely, that the artist must be meticulously careful concerning his material means of execution. He professes a fanatical regard for the cleanliness of his tools and the preparation of the elements of his work. In fact, since painting is an art of deep ratiocination, and one that demands an immediate contention between a host of different qualities, it is important that the hand should encounter the least possible number of obstacles when it gets down to business, and that it should accomplish the divine orders of the brain with a slavish alacrity; otherwise the ideal will escape.

Eugène Delacroix is universal. He has painted genre-pictures full of intimacy, and historical pictures full of grandeur. He alone, perhaps, in our unbelieving age has conceived religious paintings which were neither empty and cold, like competition works; nor pedantic, mystical or neo-Christian, like the works of all those philosophers of art who make religion into an archaistic science, and who believe that not until they have made themselves masters of the traditions and symbology of the early church, can they strike and sound the chords of religion.

This is easy to understand if you are prepared to consider that Delacroix, like all the great masters, is an admirable mixture of science—that is to say, a complete man. . . .

But to explain what I declared a moment ago—that only Delacroix knows how to paint religious subjects—I would have the spectator note that if his most interesting pictures

[8] From Heine's *Salon of 1831,* which was published in a French translation in his *De la France,* 1833.

are nearly always those whose subjects he chooses himself—
namely, subjects of fantasy—nevertheless the grave sadness of
his talent is perfectly suited to our religion, which is itself
profoundly sad—a religion of universal anguish, and one
which, because of its very catholicity, grants full liberty to
the individual and asks no better than to be celebrated in
each man's own language—so long as he knows anguish and
is a painter. . . .

To complete this analysis, it only remains for me to note
one last quality in Delacroix—but the most remarkable quality
of all, and that which makes him the true painter of the nine-
teenth century; it is the unique and persistent melancholy with
which all his works are imbued, and which is revealed in his
choice of subject, in the expression of his faces, in gesture, and
in style of colour. . . .

Each one of the old masters has his kingdom, his preroga-
tive, which he is often constrained to share with illustrious
rivals. Thus Raphael has form, Rubens and Vernonese colour,
Rubens and Michelangelo the "graphic imagination." There
remained one province of the empire in which Rembrandt
alone had carried out a few raids; I mean drama, natural and
living drama, the drama of terror and melancholy, expressed
often through colour, but always through gesture.

In the matter of sublime gestures, Delacroix's only rivals
are outside his art. I know of scarcely any others but Frédér-
ick Lemaître[9] and Macready.[10]

It is because of this entirely modern and novel quality that
Delacroix is the latest expression of progress in art. . . .

In an article which must seem more like a prophecy than a
critique, what is the object of isolating faults of detail and
microscopic blemishes? The whole is so fine that I have not
the heart. Besides, it is such an easy thing to do, and so many
others have done it! Is it not a pleasant change to view people
from their good side? M. Delacroix's defects are at times so
obvious that they strike the least trained eye. You have only
to open at random the first paper that comes your way, and
you will find that they have long followed the opposite method
from mine, in persistently not seeing the glorious qualities
which constitute his originality. Need I remind you that great

[9] Frédérick Lemaître (1800–76) was one of the great French actors
of the Romantic generation.
[10] William Charles Macready (1793–1873), the notable English
tragedian.

geniuses never make mistakes by halves, and that they have the privilege of enormity in every direction?

VI.

ON SOME COLOURISTS

There are two curiosities of a certain importance at the Salon. These are the portraits of *Petit Loup* and of *Graisse du dos de buffle,* by M. Catlin,[11] the impresario of the redskins. When M. Catlin came to Paris, with his Museum and his Ioways, the word went round that he was a good fellow who could neither paint nor draw, and that if he had produced some tolerable studies, it was thanks only to his courage and his patience. Was this an innocent trick of M. Catlin's, or a blunder on the part of the journalists? For today it is established that M. Catlin can paint and draw very well indeed. These two portraits would be enough to prove it to me, if I could not call to mind many other specimens equally fine. I had been particularly struck by the transparency and lightness of his skies.

M. Catlin has captured the proud, free character and the noble expression of these splendid fellows in a masterly way; the structure of their heads is wonderfully well understood. With their fine attitudes and their ease of movement, these savages make antique sculpture comprehensible. Turning to his colour, I find in it an element of mystery which delights me more than I can say. Red, the colour of blood, the colour of life, flowed so abundantly in his gloomy Museum that it was like an intoxication; and the landscapes—wooded mountains, vast savannahs, deserted rivers—were monotonously, eternally green. Once again I find Red (so inscrutable and dense a colour, and harder to penetrate than a serpent's eye)—and Green (the colour of Nature, calm, gay, and smiling)—singing their melodic antiphon in the very faces of these two heroes. There is no doubt that all their tattooings and pigmentations had been done in accordance with the harmonious modes of nature.

I believe that what has led the public and the journalists into error with regard to M. Catlin is the fact that his painting

11 [George Catlin (1795–1872), the American artist.]

has nothing to do with that *brash* style, to which all our young men have so accustomed us that it has become the *classic* style of our time. . . .

SOME FRENCH CARICATURISTS

. . . But now I want to speak about one of the most important men, I will say not only in caricature, but in the whole of modern art. I want to speak about a man who each morning keeps the population of our city amused, a man who supplies the daily needs of public gaiety and provides its sustenance. The bourgeois, the businessman, the urchin and the housewife all laugh and pass on their way, as often as not—what base ingratitude!—without even glancing at his name. Until now his fellow artists have been alone in understanding all the serious qualities in his work, and in recognizing that it is really the proper subject for a study. You will have guessed that I am referring to Daumier.

There was nothing very spectacular about Honoré Daumier's beginnings. He drew because he had to—it was his ineluctable vocation. First of all, he placed a few sketches with a little paper edited by William Duckett;[12] then Achille Ricourt, who was a print-dealer at that time, bought some more from him.[13] The revolution of 1830, like all revolutions, occasioned a positive fever of caricature. For caricaturists, those were truly halcyon days. In that ruthless war against the government, and particularly against the king, men were all passion, all fire. It is a real curiosity today to look through that vast gallery of historical clowning which went by the name of *La Caricature*[14]—that great series of comic archives to which every artist of any consequence brought his quota. It is a hurly-burly, a farrago, a prodigious satanic comedy, now farcical, now gory, through whose pages all the political elite march past, rigged out in motley and grotesque costumes.

[12] Presumably *La Silhouette* (1829–31), the first journal of its kind to be published in Paris. In spite of his name, William Duckett was a Frenchman.

[13] Ricourt's shop was near the Louvre, in the rue du Coq. In 1832 he founded *L'Artiste,* to which Baudelaire contributed.

[14] Founded by Charles Philipon (1800–62) in 1830, it lasted until 1835. Daumier contributed to it a great deal, sometimes under the pseudonym Rogelin.

Among all those great men of the dawning monarchy, how many are there not whose names are already forgotten!

A moment ago, I think, I used the words "a gory farce"; and indeed these drawings are often full of blood and passion. Massacres, imprisonments, arrests, trials, searches, and beatings-up by the police—all those episodes of the first years of the government of 1830 keep on recurring. Just judge for yourselves—

Liberty, a young and beautiful girl, with her Phrygian cap upon her head, is sunk in a perilous sleep. She has hardly a thought for the danger which is threatening her. A *Man* is stealthily advancing upon her, with an evil purpose in his heart. He has the burly shoulders of a market-porter or a bloated landlord. His pear-shaped head is surmounted by a prominent tuft of hair and flanked with extensive side-whiskers. The monster is seen from behind, and the fun of guessing his name must have added no little value to the print. He advances upon the young person, making ready to outrage her.

"Have you pray'd to-night, Madam?"—It is Othello-Philippe about to stifle innocent Liberty, for all her cries and resistance! . . .

It was with just such a fury that *La Caricature* waged war on the government. And Daumier played an important role in that chronic skirmish. A means had been invented to provide money for the fines which overwhelmed the *Charivari;* this was to publish supplementary drawings, the money from whose sale was appropriated to that purpose.[15] Over the deplorable massacres in the rue Transnonain, Daumier showed his true greatness; his print has become rather rare, for it was confiscated and destroyed.[16] It is not precisely caricature—it is history, reality, both trivial and terrible.

It was about the same time that Daumier undertook a satirical portrait gallery of political notabilities. There were two series—one of full-length, the other of bust-portraits: the latter series came later, I think, and only contained members

[15] This was the *Association Mensuelle Lithographique,* which was started in August 1832. On the whole subject, see *Freedom of the Press and L'Association Mensuelle: Philipon versus Louis-Philippe,* by E. de T. Bechtel (New York, Grolier Club, 1952).

[16] Published in July 1834 by the *Association Mensuelle* (Delteil 135), it is now one of Daumier's best-known lithographs.

of the upper house.[17] In these works the artist displayed a wonderful understanding of portraiture; whilst exaggerating and burlesquing the original features, he remained so soundly rooted in nature that these specimens might serve as models for all portraitists. Every little meanness of spirit, every absurdity, every quirk of intellect, every vice of the heart can be clearly seen and read in these animalized faces; and at the same time everything is broadly and emphatically drawn. Daumier combined the freedom of an artist with the accuracy of a Lavater. And yet such of his works as date back to that period are very different from what he is doing today. They lack the facility of improvisation, the looseness and lightness of pencil which he acquired later. Sometimes—though rarely —he was a little heavy, but always very finished, conscientious, and strict. . . .

To make a complete analysis of Daumier's *oeuvre* would be an impossibility; instead, I am going to give the titles of his principal series of prints, without too much in the way of appreciation and commentary. Every one of them contains marvellous fragments.

Robert Macaire, Moeurs conjugales, Types parisiens, Profils et silhouettes, les Baigneurs, les Baigneuses, les Canotiers parisiens, les Bas-bleus, Pastorales, Histoire ancienne, les Bons Bourgeois, les Gens de Justice, la Journée de M. Coquelet, les Philanthropes du jour, Actualités, Tout ce qu'on voudra, les Représentants representés. Add the two sets of portraits of which I have already spoken.[18]

I have two important observations to make about two of these series—*Robert Macaire* and the *Histoire ancienne. Robert Macaire*[19] was the decisive starting-point of the carica-

[17] In fact the two series were approximately contemporary with one another; the full-length portraits were published in *La Caricature* in 1833–34, and the majority of the bust-portraits in *Le Charivari* in 1833.

[18] A ceaseless and regular production has rendered this list more than incomplete. Once, with Daumier himself, I tried to make a complete catalogue of his works, but even together we could not manage to do it. (C.B.) The catalogue by Delteil, to which reference has been made in notes above, contains almost 4000 lithographic items.

[19] A hundred plates of this series appeared in *Le Charivari* between August 1836 and November 1838; and a further twenty between October 1840 and September 1842. Daumier developed Robert Macaire into a classic symbol of the rascally impostor.

ture of manners. The great political war had died down a little. The stubborn aggressiveness of the law, the attitude of the government which had established its power, and a certain weariness natural to the human spirit had damped its fires a great deal. Something new had to be found. The pamphlet gave way to the comedy. The *Satire Ménippée*[20] surrendered the field to Molière, and the great epic-cycle of Robert Macaire, told in Daumier's dazzling version, succeeded to the rages of revolution and the drawings of allusion. Thenceforth caricature changed its step; it was no longer especially political. It had become the general satire of the people. It entered the realm of the novel.

The *Histoire ancienne*[21] seems to me to be important because it is, so to say, the best paraphrase of the famous line "Qui nous délivrera des Grecs et des Romains?"[22] Daumier came down brutally on antiquity—on false antiquity, that is, for no one has a better feeling than he for the grandeurs of antiquity. He snapped his fingers at it. The hotheaded Achilles, the cunning Ulysses, the wise Penelope, Telemachus, that great booby, and the fair Helen, who ruined Troy—they all of them, in fact, appear before our eyes in a farcical ugliness which is reminiscent of those decrepit old tragic actors whom one sometimes sees taking a pinch of snuff in the wings. It was a very amusing bit of blasphemy, and one which had its usefulness. I remember a lyric poet of my acquaintance[23]— one of the "pagan school"—being deeply indignant at it. He called it sacrilege, and spoke of the fair Helen as others speak of the Blessed Virgin. But those who have no great respect for Olympus, or for tragedy, were naturally beside themselves with delight.

To conclude, Daumier has pushed his art very far; he has made a serious art of it; he is a *great* caricaturist. To appraise him worthily, it is necessary to analyse him both from the artistic and from the moral point of view. As an artist, what distinguishes Daumier is his sureness of touch. He draws as the great masters draw. His drawing is abundant and easy—it

[20] A political pamphlet written in the form of a dramatic farce in one act, with prologue and epilogue. It was directed against the *Ligue,* and published in 1594.

[21] A series of 50 plates which appeared in *Le Charivari* between December 1841 and January 1843 (Delteil 925–74).

[22] The first line of a satire by Joseph Berchoux.

[23] Probably Théodore de Banville.

is a sustained improvisation; and yet it never descends to the "chic." He has a wonderful, an almost divine memory, which for him takes the place of the model. All his figures stand firm on their feet, and their movement is always true. His gift for observation is so sure that you will not find a single one of his heads which jars with its supporting body. The right nose, the right brow, the right eye, the right foot, the right hand. Here we have the logic of the *savant* transported into a light and fugitive art, which is pitted against the very mobility of life.

As a moralist, Daumier has several affinities with Molière. Like him, he goes straight to the point. The central idea immediately leaps out at you. You have only to look to have understood. The legends which are written at the foot of his drawings have no great value, and could generally be dispensed with.[24] His humour is, so to speak, involuntary. This artist does not search for an idea; it would be truer to say that he just lets it slip out. His caricature has a formidable breadth, but it is quite without bile or rancour. In all his work there is a foundation of decency and simplicity. Often he has gone so far as to refuse to handle certain very fine and violent satirical themes, because, he said, they passed the limits of the comic, and could wound the inner feelings of his fellow-men. And so, whenever he is harrowing or terrible, it is almost without having wished to be so. He has just depicted what he has seen, and this is the result. As he has a very passionate and a very natural love for nature, he would find difficulty in rising to the absolute comic. He even goes out of his way to avoid anything which a French public might not find an object of clear and immediate perception.

A word more. What completes Daumier's remarkable quality and renders him an exceptional artist who belongs to the illustrious family of the masters, is that his drawing is naturally coloured. His lithographs and his wood-engravings awake ideas of colour. His pencil contains more than just a black trace suitable for delineating contours. He evokes colour, as he does thought—and that is the sign of a higher art—a sign which all intelligent artists have clearly discerned in his works. . . .

[24] They were mostly invented by Philipon.

III. ON THE ARCHITECTURE OF THE NINETEENTH CENTURY AND SOME ARCHITECTURAL FORMS CHARACTERISTIC OF THE CENTURY

NINETEENTH-CENTURY ARCHITECTURE

[The results of the discovery of an efficient use of steam power in 1769, the consequences of the acceptance of John Locke and Rousseau's doctrines of man's inalienable rights and the possibility of his improvement combined to change Western Europe's political and economic structure and social habits. The changes soon called for provisions to accommodate the re-groupings of people and the different needs of the individual. The state required new types of edifices. The monument, cemetery, public museum, public library, railroad station, commercial building, detached house, the city plan and civic buildings, were some of the many tasks that the altering society assigned to architects for re-interpretation and new designs. Technical inventions provided new materials and methods for their designs.

Architectural projections for the world that was to come were drawn as soon as the political and philosophical principles that would shape the world were spoken and written down.

Ledoux's "Ideal City," of which he built a segment and completed on paper, contained in a prophetic manner many of the new structures that the economic, political, and cultural changes would demand.

Old architectural styles, and borrowings from them, encased the buildings of the new types until their functional structure broke through to create a new style of architecture that recalled the "fantasies" drawn at the beginning of the century by the visionary architects.]

[ETIENNE LOUIS BOULLÉE (1728–99) spent his life in his native city, Paris, except for a probable trip to Rome. Boullée first studied painting, and never lost a desire to be a painter. To comply with his father's wish, he became an architect, studying with J. F. Blondel, a teacher who would have an appreciation for the originality of his pupil.

Of the little Boullée built, all that outside Paris has been destroyed. Within Paris, only in the Chapel of the Calvary of the church of St. Roch are features of his monumental style to be discovered in spite of the alterations, and in the Hotel Neuville, rue de la Ville l'Evèque, built in 1770. His other executed buildings must be studied from engravings.

Boullée's importance is due to his teaching, to his visionary projects of buildings, and to an *Essai* for a book on architecture. Neither the projects nor the text were published, but they were available as study materials to his pupils.

He first taught at the Ecole des Ponts et Chaussées, later became a professor at the Ecoles Centrales, and was active as a member of the Académie d'Architecture.

Boullée's *Essai* may be best described as a teacher's notebook whose entries, set down without order as explanations to the drawings, were written at different times and tend to be repetitive. To this notebook Boullée added an introductory essay to explain his philosophy, a résumé, and notes to conclude it. His philosophy reflects that of the writers Diderot and J. J. Rousseau. He was more a reformer than a revolutionary, and in his art more of a classical revivalist than Ledoux.

Boullée's manner of rendering his drawings that he had learned as a painter contributed to their appeal. In them an arresting use of light and shadow endowed the designs with a monumental, poetic, almost surrealistic character. In comparison with the dramatic drawings, any real building would be drab.

The sources for his imaginative projects were apparently

in the Chinese-English Garden and in Roman art as seen through Piranesi's engravings. Boullée had a predilection for Egyptian forms, especially the pyramid, and shared Piranesi's ideas for subterranean architecture.

Boullée's plans were made known by their inclusion in the widely circulated architectural textbook of J. N. Durand, Boullée's pupil.

SEE: E. Kaufmann, *Three Revolutionary Architects, Boullée, Ledoux and Lequeu*, Philadelphia, 1952.
E. Kaufmann, *Von Ledoux bis Le Corbusier*, Vienna, 1933.]

ARCHITECTURE, AN ESSAY ON ART (1770–84)[1]

To Men Who Cultivate the Arts

What is architecture? Shall I define it, with Vitruvius, as the art of building? No, this definition contains a vulgar error, Vitruvius mistakes effect for cause.

Your concept must be plain to you for you to be able to carry it out. Our forefathers did not build their huts before they had conceived a mental picture of them. Architecture is this process of the mind, this act of creation, and as a consequence we can define it as the art of producing and of bringing to the point of perfection every kind of building. The art of building is only a subsidiary art, and it would seem appropriate to call this the technical part of architecture.

The art itself and the technique of that art: we must distinguish between these two things in architecture.

The majority of authors who have treated of this subject have been more concerned with the technical aspect. An instant's thought shows this to be quite natural. It was necessary to make a building sound before making it pleasing to the eye. The technical aspect being of prime importance, and consequently the most essential, men naturally devoted themselves to it first of all in a special way.

Furthermore, all will agree that beauty in art is not subject to proof as is a mathematical truth: and although this beauty stems from nature, in order to feel it, to make it concrete,

[1] From *Boullée's Treatise on Architecture*, ed., H. Rosenau, London, 1954, pp. 27–28, 33–36, 43–45, 49–50, 51–52.

qualities are necessary of a kind which nature does not freely bestow.

What do you find in all books on Architecture? Ruins of ancient temples which our scholars have excavated in Greece. However perfect these examples may be, their scope is not wide enough for them to stand in lieu of a complete treatise on the art.

Vitruvius, in his Treatise, tells us everything that an architect should know; this, according to him, means universal knowledge.

Then in François Blondel's[2] pompous preface there is a description of the excellencies of architecture. This author relates how God, to punish his people, threatened to take away their architects. I have heard wits comment on this that you must consider yourself amongst the predestined to dare to take up the profession!

Reader! I shall astonish you when I state that in this pompous preface, as in Vitruvius' Treatise, I can extract no inkling of what is meant by architecture. I venture to add that neither of these authors has the faintest idea of the basic principles of the art they profess. At first sight my opinion could seem outrageous, but I can easily justify it. What I have alleged above is to be found in one of the two authors that I have just cited.

You will be acquainted with the famous controversy between Perrault,[3] the designer of the Louvre Peristyle, and François Blondel,[4] designer of the Gate of St. Denis. The former denied that architecture derived from nature. He described it as an art having its origins in fantasy and pure invention. In trying to refute Perrault's opinions, François Blondel made use of such feeble arguments that the problem remained unsolved. When I, in turn, reopened the discussion, I could find no one who would produce a satisfactory answer. On the contrary, I could sense that educated persons were of Perrault's opinion.

And now, Reader, I ask you, am I not to some extent right

[2] Jacques François Blondel (1705–74) was an architect, teacher, and prolific writer. See Holt, Vol. II, p. 328.

[3] Claude Perrault (1613–88) succeeded Bernini as architect for the east façade of the Louvre. See Holt, Vol. II, pp. 134–36.

[4] Francois Blondel (1617–86) built this gate as a triumph arch to celebrate Louis XIV's victories in Holland in 1673.

in submitting that architecture is still in its infancy, since there are no agreed ideas about the principles of this art?

I acknowledge, in common with all educated persons, that by combining discrimination with sensibility, excellent works can be produced; that artists who have a natural gift for choosing rightly, even though they have not acquired the knowledge necessary for researching into the basic principles of their art, will always be able people.

But it is not the less true that there are few authors who have treated architecture from the point of view of its being an art; I mean that few authors have troubled to examine thoroughly that part of architecture that I have called art, pure and simple. If some precepts have been deduced from sound examples, these are few in number.

Study of the controversy between Perrault, designer of the Peristyle of the Louvre, and François Blondel, designer of the Gate of St. Denis monument.

STATEMENT OF THE PROBLEM

Does architecture have its origins in fantasy and pure invention, or are the basic principles of this art to be found in Nature?

In the first place allow me to question whether there exists a single art stemming from invention alone.

If man, through the powers of his mind and by means of an art originating in that mind, were able to excite in us the sensations we experience on seeing natural objects, such an art would be far superior to any of those we practise, since the latter are restricted to an imitation more or less imperfect. But this art, with which we should be self-sufficing, does not exist, and its existence would betoken that the Divinity which created nature had endowed us with an attribute which was of its own essence.

Whatever then did Perrault mean by an art of pure invention? Are not all our ideas inspired by nature, and does not genius consist of the manner and vigour of expression whereby our senses are reminded of this.

I cannot visualise any products of an art based on fantasy, other than ideas thrown out at haphazard, incoherent, disconnected and pointless, in short just dreams. Piranesi, architect and engraver, has turned out a few such extravaganzas.

Italian painters have produced caricatures. The famous engraver Callot[5] was the creator of many grotesques. To the ancients we owe chimaeras, etc.

All these flights of imagination show the error into which you can stray. What do you find in this sort of work? Natural objects, exaggerated or distorted, but still natural objects. Can this be an authoritative hypothesis on which to base the possibility of an art of pure invention? In order to advance such a fictitious possibility you would have to prove that men can conceive visual images having no connection with any object in nature. It is out of the question that any idea should not emanate from nature.

Let us consult a modern philosopher: "All our ideas, everything we perceive, comes to us through the medium of external objects. External objects make different impressions on us according to how closely or otherwise they are analogous to our own organism." Let me add that we regard as beautiful those objects most closely related to the human organism, and reject those which, unrelated, are not fitted to our ways of behaving. . . .

Concerning the essential elements of bodies.

Concerning their properties, their analogy with the human organism.

In my inquiry into the essential elements of bodies, when trying to discover their properties and their analogy with the human organism, I began my research by considering dark bodies.

These I saw as masses with surfaces [les faces] which were convex, concave, angular, planimetrical, etc. Next I realised that the different contours resulting from the surfaces of these bodies, determined their appearance and emphasised their shapes. I noticed further that the number and complication of the irregular appearances of the surfaces, resulted in (I must not call it "variety") confusion.

Tired of the picture of muteness and sterility presented by irregular bodies, I went on to examine regular bodies. The first things I noticed were regularity, symmetry and variety,

[5] Jacques Callot (1592–1635), some of his best-known plates were the *Miseries of War,* (Balli di Sfessania). He published a *Treatise on the Art of Engraving* (1654).

and concluded that these determined their appearance and shape. I also realised that it was the regularity alone that had given men a clear idea of the appearance of bodies, and enabled their denomination to be determined, which, as you see, was the result not only of regularity and symmetry, but also of variety.

Made up of a multitude of surfaces, all different, the appearances of irregular bodies, as I have said above, are beyond what we can retain. Because they are so many and so complicated these surfaces depict nothing clearly; their picture is that of confusion only.

Why is it that the appearance of regular bodies can be grasped straight away? It is because their shapes are simple, their surfaces regular, and that they are always reduplicated. Now, as the impression an object makes on us is in direct relation to how conspicuous it is, we notice regular bodies the more particularly because their regularity and symmetry is a representation of order, and it is this representation that is so conspicuous.

From these observations it is clear that man could have no exact idea of the appearance of bodies, until he had one of regularity.

After having noticed that regularity, symmetry and variety were the components of regular bodies, I understood that proportion lay in a combination of these properties.

By the proportion of a body, I mean an effect born of regularity, symmetry and variety; regularity is the source of beauty of shape in objects, symmetry that of order and the overall beauty; variety produces the surfaces which account for their differences. Therefore it is from all of these properties, the way they are assembled and reconciled, that the harmony of bodies is born.

For example, the sphere can be considered as a combination of all the different properties of bodies. Each point on its surface is equidistant from its centre. The unique possessor of this advantage, from whichever side you look at it, no optical effect can ever mar the magnificent beauty of its shape as, ever perfect, it meets the eye.

The sphere is the solution of a problem which could be considered a paradox, were it not demonstrable by geometry that the sphere is an infinite polyhedron. Thus the most infinite degree of variety derives from the most perfect symmetry.

For if we suppose the surface of the globe to be divided into points, only one of these points meets the eye perpendicularly, and all the others will appear at an immense number of different angles.

The other advantages of the sphere are that it enables the eye to embrace the largest possible surface, thus producing an appearance of majesty; that it has the simplest possible shape and a beauty deriving from a surface quite devoid of interruption; that to all these qualities it unites the one of grace, for the contour of this body is as gentle and as fluid as a contour can be.

From the sum of these observations we must conclude that the sphere is, from every point of view, the image of perfection. It combines exact symmetry, the most perfect regularity, the greatest variety. It lays the greatest area before us, has the simplest shape, the pleasantest contour; finally, this body so enhances the effects of light, that it is not possible to find elsewhere more gradual, pleasing and varied shadings-off of colour. These are unique advantages which derive from nature and have unlimited power over our senses.

I have therefore proved that proportion and harmony in bodies are laid down in nature, and that properties deriving from the essential elements of bodies, through their analogy with the human organism, exercise power over our senses.

"Symmetry pleases," says the great Montesquieu, "because it is easily comprehended, and because the spirit, ceaselessly striving to conceive, encompasses and grasps without effort the general effect of symmetrical objects." In addition, I say that it pleases because it is the image of order and perfection.

Variety pleases because it satisfies a need of the spirit which, by its very nature, seeks to reach out to and encompass new objects. Now, as variety presents objects in a fresh guise, it follows that this is a means of quickening the spirit through the offer of fresh delights. If variety pleases through the appearance of bodies, it does so also through effects of light.

A representation of greatness pleases from all points of view, because the spirit, eager to drink from new sources, would like to embrace the universe.

Finally, the image of Grace is the one, above all, nearest to our hearts. . . .

Basilicas

The ancient temples were, properly speaking, nothing but
sanctuaries, where priests carried out their duties without hold-
ing any communication with the people. This did not require
much space nor consequently any complicated artistic scheme.
But our modern basilicas are intended for the use of both
people and priests; the most elaborate ceremonies, attended
by the largest audiences, take place there, so these basilicas
have needed to be of a considerable size and their proportions
suited to the number of participants. Our architects have had
to overcome a thousand difficulties. They have had to find a
method of supporting the immense roof spans of the main
naves, aisles and chapels; this is doubtless the reason why they
did not dare to decorate their churches with colonnades, these
base supports not being strong enough to bear the enormous
weight of the roofs. Means had to be found of endowing an
airy, elegant decoration with the necessary strength. Time and
study solve all problems. . . .

It is light which produces effects. According as to whether
these be bright or dark they produce in us corresponding sen-
sations. Could I but manage to flood my church with magnifi-
cent light, the spectator's soul would be filled with joy. Con-
trarily, dark effects must result in sadness. Then if I could
hinder the light from entering directly, let it be present without
the spectator realising from whence it came, the mysterious
effects of this dim, veiled light would be inconceivable in their
magic, a real enchantment. Able to distribute light as I chose,
by dimming it I would be able to inspire feelings conducive
to meditation or compunction, even ones of religious awe,
particularly if at times when gloomy ceremonies, tending to
excite such feelings, were held, I were careful to decorate the
building in a manner suited to the occasion. On the occasion
of joyful ceremonies, the effects of light must be brilliant and
the building strewn with flowers, always amongst the most
lovely of natural objects. So majestical and moving a scene
would transport the soul with delight.

These reflections inspired me with fresh courage. I could
think of nothing except how to bring into play all the devices
offered by nature. I said to myself at the time, and now confess
it with a certain amount of pride: through your art you will
master this medium: you also will have occasion to say, *fiat*

lux: at your pleasure the church will be brilliant with light or nothing but an abode of darkness. Soon my sole occupation was that of architecture.

I believed that the only way of giving a place of worship an impressive appearance was through a great and lofty arrangement of the architecture. I did all I could to make this apparent through my exterior decoration. Having learnt through my own experience that man's appraisal of himself is related to the space surrounding him, and wishing, moreover, that a very imposing entrance should proclaim the greatness and glory of the place, I decided I could not do better than devise an entrance to the church that would be overwhelming in its effect. This is the reason why I have not hesitated to carry the entrance to the height of the tops of the domes and to give it the same width as the main nave.

For a long time I have dwelt on the plan of joining to the beauties of Greek architecture, I will not call them the beauties of Gothic architecture, but methods of art which the Goths alone understood and practised. These, . . . had the art of concealing with delicate workmanship, the weight-bearing elements in their churches, so that it seemed only a miracle could possibly support them. I tried to arrange the interior of my church with these ideas in mind. After having thought out how I should place my weight-bearing elements, and having made them secure with the foundation walls necessary to carry the dome, the roof spans of the main nave, of the aisles and chapels, I surrounded these massive bodies by colonnades in all directions; thus, by using one of the happiest of architectural features, I managed to mask these same bodies from the spectator's gaze.

Through this arrangement, in the manner of the Goths, the weight-bearing elements of my church are concealed, and it will also seem to be supported by a miracle; again, in imitation of the Greeks, its decoration will be of the most sumptuous. Methods of indirect lighting are facilitated by the columns being in the foreground, as their projection will prevent anyone seeing exactly how the light comes in. This last arrangement possesses many advantages. Firstly, windows can be multiplied to any extent, and, as they are invisible, their shape is immaterial.

[J. N. Durand (1760–1834) had studied architecture with Boullée before he served as an engineer in Napoleon's army. On the establishment of the Ecole Polytechnique by Napoleon in 1795, Durand was named a professor of architecture and in this capacity exercised great influence in the formulation of the romantic classical style. His ideas of structional rationalism and his concern for construction, materials, and methods were combined with a synthesis of the trends in theory and practice then present in France. These ideas were put forth in his course of lectures. The *Précis des leçons d'architecture données à l'Ecole Polytechnique* published in two volumes 1802–5, and frequently republished until 1840, gave the content of the French architectural education. The *Précis* served as the basic text for the architects of the first half of the nineteenth century who had charge of the building programs in the states that arose after the collapse of Napoleon's Empire.

Durand's eclecticism permitted the inclusion in his course of a variety of styles from medieval modes and Renaissance elements to classical revival forms. But as his basic tenet was "True beauty is born in pleasing disposition," he used the diverse elements in a functional, often revolutionary manner, quite differently from the Ecole des Beaux Arts where the doctrine of the antique triumphed. The striking plates that accompanied the text illustrate his ingenious manner of combining architectural elements in structural modular systems from colonnades to arches. The combinations classified "vertical" or "horizontal" become arrestingly impressive because of their repetition. All the various structures required by the nineteenth-century city are presented classified, as Cuvier had done for the field of zoology, according to their function: palaces, treasures, temples, law courts, town halls, colleges, libraries, museums, observatories, lighthouses, markets, exhibition halls, theaters, hospitals, baths, prisons, barracks, and houses. Durand's sense of economy and utility led him to replace, in the non-representational, service type building, the colonnade and dome with plain walls and simple arch openings.

The *Précis* had been preceded by the equally influential *Recueil et parallèle des édifices en tout genre, anciens et modernes* (1801). The *Recueil*, or "Le Grand Durand," was a product of the current interest in the philosophy of history and

the lessons learned from the archaeological discoveries of the middle of the eighteenth century. The inclusion of well-known architectural examples from different cultures—Chinese, Indian, Egyptian, Assyrian—on the frontispiece was a striking example of the recognition of the universality of beauty that made all styles acceptable. With a confidence characteristic of the nineteenth century, Durand altered the proportions to conform to his own individual modular theory of proportions.

Durand's influence was marked on the great German architects of the Romantic Classical style. Durand's insistence on a utilitarian, functional, and logical architecture contributed, through the American students in Paris, to the functional structures of the Chicago school.]

A COLLECTION AND PARALLELS OF EVERY BUILDING TYPE[1]

Foreword

It is very important for architects, engineers, both civil and military, painters of both historical and landscape scenes, sculptors, draftsmen, theatrical decorators, in a word, for all those who build or depict buildings and monuments, to study and know all the most interesting things that have been done in architecture in every country throughout the ages.

But those buildings that deserve to be studied are mixed in with a flock of others that are not in the least remarkable; in addition they are scattered through nearly 300 volumes, for the most part in folios, whose purchase would mount up to an enormous sum; and it is impossible for an artist to come to know them well except through the services of a library.

Even this demands a great deal of time and is not practical except for artists living in large cities. In addition, even if they were all able to use this method, it is possible that the advantages it would give them would hardly repay their labors. Here is the reason: Often a volume is composed only of buildings of different types while those which are of the same type are scattered through a great number of volumes. You can see, this being the case, how long, difficult, imperfect and unfruitful

[1] Translated from J. N. Durand, *Recueil et parallèle des édifices en tout genre, anciens et modernes,* Paris, 1801.

the comparisons would be which are alone capable of forming judgment and reason. The difference of scale adds still more to this inconvenience. In this state of things, I felt that if the only objects that it is essential to be familiar with were culled from the 300 volumes I have just spoken of and if I reassembled them in just one volume whose price would not be higher than that of an ordinary work on architecture; this would offer artists a general and inexpensive panorama of architecture, a tableau that they could go through in a short time, examine without difficulty, study with fruitfulness; and above all, if I classified the edifices and monuments according to their kinds; if I arranged them in order of their degree of likeness; if in addition I drew them to the same scale: This is what I have attempted to do. To arrive at my goal more certainly, I have excluded from this collection not only all objects that offered no interest of themselves but also those that resembled more or less closely other pieces of major interest, that would have only swelled the volume without increasing the sum of ideas. Perhaps some buildings will be found in this collection that will seem to be of little interest; but because they are almost the only ones of their kind in existence, I have thought it necessary to include them in order to draw attention to this type of architecture.

Restorations whose authenticity is doubtful will also be found here, such as those of the *thermae* by Palladio and several buildings of ancient Rome by Piranesi, Pirro Ligorio, and others, but I did not wish to deny architects the handsome effect that these restorations give, and which they might frequently and happily apply.

I have even permitted myself, not only to simplify them, but also to add some which are almost entirely of my invention; I hope that I may be pardoned for having dared to put myself beside these great masters; if only you will notice that far from having wished to correct them I have tried to show in a clearer way, the spirit which reigns in their magnificent productions.

SUMMARY OF THE LECTURES ON ARCHITECTURE:

Introduction[2]

Importance of Architecture; goal of this art; means which it must naturally use to attain it; general principles; advantages which the human species and society will reap from their application; deleterious effects which will result from ignorance or non-observance of these principles; necessity for the study of Architecture.

Architecture is the art of creating and erecting all buildings, both public and private.

Of all the arts, Architecture is the one whose works are the most expensive; it costs a great deal to erect the least spacious of private buildings; the cost of raising public buildings is enormous; even when those in both categories have been conceived with the greatest wisdom; and if in their creation the sole guides have been prejudice, caprice or routine, the expense which they entail is incalculable.

A striking example of this truth is the château of Versailles, a building where you can find innumerable rooms but not one entrance; thousands of columns and not a single colonnade; a vast expanse without grandeur; extreme lavishness without magnificence. . . .

Since Architecture is of such great and universal importance, it follows that this art should be more generally understood; but since this is not the case, at least those who must exercise it should have a perfect understanding of it. . . .

In order to obtain both quick and certain results in the study of any art it is indispensable to understand first the nature of the art; to know why it is pursued and how in general it should be pursued; in other words, to ascertain the goal it sets itself, also the means which it must employ to attain it. . . .

To discover the goal of architecture will not be difficult. From what we have seen above it is demonstrably none other than public and private usefulness, the preservation and the happiness of individuals, of families and of society.

[2] Translated from J. N. Durand, *Summary of the Lectures on Architecture given at L'Ecole Polytechnique,* Paris, 1809, Vol. I, pp. 1–25.

The means to be employed to attain so interesting and so noble a goal will not be any harder to recognize; architecture being created for man and by man, these means can only be discovered by studying the way in which these are carried out: some very simple observations are sufficient to make these known.

If we observe the progress and development of intelligence and feeling, we shall find that in all periods and in all places, all the thoughts and actions of man have originated in two principles: love of comfort and dislike of any kind of pain. That is why men, whether when being alone they built themselves private dwellings, or being grouped in societies they erected public buildings, had to try firstly to extract the maximum advantages from the buildings they were putting up and therefore to create them in the manner most suited to their purpose, and secondly to build them in the least arduous and also in the least costly manner when money became the reward of work.

Thus, appropriateness and economy are the means which architecture must naturally employ, and these are the sources from which it must draw its principles, the only ones which can be a guide in the study and exercise of this art.

. . . For a building to be suitable, it must be sound, healthy, and convenient.

. . . These are the general principles which have guided reasonable men everywhere and in all ages when erecting buildings, and these are in fact the principles followed by the creators of those classical buildings most generally and rightly admired. The following is the proof of this:

These principles are demonstrably as simple as nature; you will see shortly that they are not less fertile.

Nonetheless, architecture is not generally thought of in this way, and the ideas we are putting forward are anything but those commonly accepted.

According to most architects, architecture is less the art of erecting useful buildings, than that of decorating them. Its chief purpose is to please the eye and thereby to excite pleasant sensations: which, as in the other arts, can only be induced by means of imitation. The model must be the shape of the first huts put up by men, and the proportions those of the human body. Now, as, according to some authors, the architectural orders invented by the Greeks, imitated by the Romans, and adopted by most European nations, are an imitation of

the human body and of the hut, it must result that these are the essential elements of architecture. From this it follows that the beauty of the decorations of the orders is such that no expense necessitated by these decorations should be questioned.

But as decorations are expensive, and the greater the amount of decoration the greater the expense entailed, it is only natural to determine whether it is true that architectural decoration, in the way that architects conceive it, does in fact produce the anticipated pleasure, or at any rate if this pleasure is worth the unavoidable outlay.

For architecture to please by means of imitation, it should imitate nature, as do the other arts. We will examine whether the first hut made by man was a natural object, whether the human body can serve as a model for the orders, and finally whether the orders are an imitation both of the hut and of the human body.

Let us take first one idea about this hut and the orders. This is what Laugier[3] has to say about the hut: "Consider man in the primitive state, with nothing to help or guide him but a natural instinct of what are his needs. He wants a place where he can rest. By the edge of a quiet stream he notices a stretch of grass; the fresh greenness is a delight, the downy texture inviting; he draws near; then, stretched languidly out on the enamelled carpet, he thinks of nothing but how peacefully he can enjoy the gifts of nature; lacking nothing, he desires nothing; but soon, forced by the scorching rays of the sun, he seeks some shelter; he notices a forest which offers him the coolness of its shade, he runs and hides in its depths, and lo, he is content. Meanwhile, a thousand vapours, rising by chance, collect and gather, then dense clouds fill the skies, torrential rains deluge this delightful forest. The man, sparsely clothed and sheltering beneath the foliage, looks in vain for protection against the ubiquitous, penetrating damp. There is a cave nearby, into which he steps, and finding himself in the dry, congratulates himself on his discovery: then fresh discomforts turn him against this abode. He realizes the place is dark, the air unhealthy. He leaves, determined to counteract Nature's careless negligence by using his own wits. He wants

[3] Abbé Laugier's (1713–69) *Essai sur l'architecture* was widely read and provoked considerable comment. Goethe wrote between 1770–73, *Of German Architecture* in answer to it. [See Holt, Vol. II, pp. 360–69.]

a dwelling that will cover but not bury him. Some branches fallen in the forest seem to be material suitable for his scheme. Choosing four of the strongest, he sets them up perpendicularly and in a square. On the top of these he lays across four others, and on these he sets up some more at an incline so that they meet at a point from both sides. This kind of roof he covers with leaves set closely together so that neither sun nor rain can penetrate; he is housed. It is true that cold and heat will make him aware of the inconveniences of a house open on all sides, but then he will fill in the spaces between the uprights and thus find protection."

"The little hut which I have just described," Laugier goes on to say, "is the model on which have been superimposed all architectural elaborations; the closer you keep, when putting up a building, to the simplicity of this first model, the more will you avoid elementary mistakes, embody true perfection. The pieces of wood set up perpendicularly produced the idea of columns; the surmounting horizontal pieces that of the entablature. Finally, the inclined pieces forming the roof produced the pediment. All masters of the art are agreed on this."

The combination of column, entablature and pediment into an architectural order, is the essential element of the art, its fundamental beauty; circumstances will dictate the addition of walls, doors, windows, arches, arcades and other parts, but these are only liberties taken and to be tolerated as such; this is the curious conclusion reached by the author whom we have just quoted.

We shall now pass from a study of the hut to that of the orders, and read what Vitruvius[4] has to say about this:

"Dorus, King of the Peloponnese, having built a temple to Juno at Argos, it chanced to be in the style we call 'Doric'; next, others were made in the same order, in several other towns, without there being yet any established rule as to architectural proportions. At that time the Athenians sent several colonies to Asia Minor under the leadership of Ion; the country where he settled was named Ionia. There they began by building Doric temples, principally one to Apollo. But, ignorant of the proportions of the columns, they looked for a method of making them sufficiently strong to support the superstructure, and at the same time pleasant to look upon. In order to

[4] [Vitruvius, see Holt, Vol. I, Alberte, pp. 203–43.]

do this they measured a man's foot, which is one-sixth of his height, and built their columns according to these measurements, so that they were [of the height] of six diameters. Thus, by means of the Doric column, the strength, the proportions and the beauty of a man's body, was put into buildings.

"Some time later, when building a temple to Diana, they looked for some new style which would be beautiful, and used the same method. This time they imitated the delicate body of a woman, . . . the flutings representing the folds of the dress; to this order, invented by the Ionians, was given the name of Ionian order.

"The Corinthian is made in the likeness of a young girl, at which age the slenderness of the figure invites a greater number of ornaments to set off its natural beauties. . . .

"Several Greek colonies having brought into Etruria, now known as Tuscany, an acquaintance with the only order which was still used in Greece, namely the Doric order, this was, for a long time, put into effect in the same way as in its country of origin: but in the end, several changes were made; the column was lengthened, it was given a base, the capital was changed, the entablature was simplified, and this order, incorporating these changes, was adopted by the Romans and given the name of the Tuscan order.

"At a much later date, the Romans, who had adopted the three Greek orders, thought of putting Ionian scrolls on the Corinthian capital: *Composite* was the designation for columns with this combination of styles."

Such are the five orders which are considered to be the essential elements of architecture, the fount of all the beauty afforded by decoration; because, so it is maintained, they are an imitation of the shape of the hut and of the proportions of the human body. Let us determine whether they are, in point of fact, such an imitation.

We will begin with the Doric order, which the Greeks fixed at a height of six diameters, because the length of a man's foot is one-sixth of his height. In the first place, the length of a man's foot is not one-sixth but one-eighth of his height. Then, in all Greek buildings the proportions of the Doric columns have an infinite number of variations, and among these variations the exact proportion of 6:1 is not found at all. If some Greek architect thought it right to assign these proportions to the Doric order, it would seem that the Greeks

ignored the fact, otherwise you would find them, if not in all of their buildings, at least in those that they built in the time of Pericles, buildings which are rated, and rightly so, as master-pieces.

The same variety can be found in the proportions of the other orders, those supposedly in imitation of the bodies of a woman and of a young girl. It is therefore untrue that the human body has served as a model for the orders.

But admitting that in the same cases, the same order always keeps the same proportions, that the Greeks did constantly follow the system attributed to them, and that the length of the foot is one-sixth of a man's height, does it then follow that the proportions of the orders are those of the human body? What comparison is valid between a man's body, of which the width varies depending on the particular height at which you measure it, and a kind of cylinder of which the diameter has the same overall measurement? What resemblance can there be between these two objects, even supposing that their bases and heights are the same? It is therefore clear that the pro-portions of the human body neither did, nor were able to, serve as a model for the orders.

If it is impossible that the proportions of the orders were those of the human body, the system of these orders has like-wise no connection with the shape of the hut. The columns have either bases with capitals or at any rate capitals; for a column to be a plain cylinder would be inadmissible. Now, there is nothing of this sort to be found either in the trunks of trees or in the posts supporting the hut. . . .

It is therefore obvious that the Greek orders were not imi-tations of the hut, and that had they been so they would have been the most imperfect of imitations, and consequently in-capable of producing the desired effect.

But is not this very model even more imperfect than its copy? Of what use is a hut, open on all sides to the wind, which man builds laboriously to protect himself, and which does not in fact protect him against anything? Can this hut be considered a natural object? Is it not obviously the crude product of a first attempt at building? Could it not be consid-ered a natural object only because, in this attempt, the instinct guiding man was so coarse that it could not be dignified by the name of art?

Now, if the cabin is not a natural object, if the human body was not used as an architectural model, if, to take the quite

contrary supposition, the orders are neither in imitation of the one nor of the other, then the conclusion must be that the orders are not the essential element of architecture; that the pleasure to be expected from their use and the decorative effect of that use, is nil; that this decorative effect is illusory and the incumbent expense pure folly.

From this it follows that if the principal goal of architecture was to give pleasure, it should either have been a better imitation, have found different models, or have used a method other than that of imitation.

But can it really be true that the principal goal of architecture was to give pleasure, and that decoration was its primary objective? In the passage just quoted, from Laugier, you see that the author, despite his strange bias, could not avoid recognizing that this art originated in necessity alone and had no other goal than public and private utility. . . .

Whether you appeal to reason, or examine the actual monuments, it is obvious that to please was never the goal of architecture, nor architectural decoration its object. Public and private utility, the happiness and preservation of the individual and of society, this, as we saw in the first place, is the goal of architecture.

But, someone will add, since some buildings are rightly admired or despised, then architecture must have certain beauties and defects: it must strive for the one and avoid the other, and it can therefore please; and if not to make this its principal goal, let it at least try to combine what is pleasing with what is useful.

Far from thinking that architecture cannot give pleasure, we assert the contrary, that it is impossible it should not do so when it is practised according to its real principles. . . .

Doubtless the grandeur, magnificence, variety, impressiveness and individual character that you find in buildings, are so many beauties, so many grounds for the pleasure that their appearance affords. But where is the need to run after all that? If you lay out a building in such a way that it is suited to its function, surely it will differ appreciably from one with another function? Will it not naturally have character, and what is more, a character of its own? If the various parts of the building, which have a different purpose, are arranged, each as they should be, then will not these parts necessarily differ from each other, and the building will have variety? Also, since the eye will be able to take in the maximum num-

ber of parts at once, the building, if laid out in the most economical, that is to say the simplest, fashion, will seem as large and as magnificent as possible, where is the necessity of running after all these parts of beauty?

Furthermore, such a thing far from being essential, is harmful to the decoration itself: if, as a matter of fact, because you have been struck by certain beauties in a building, you want to transpose them to another building which does not demand them, or, if in the building where these beauties belong naturally you insist on elaborating them to an unsuitable degree, then is it not evident the building will have an aspect, a physiognomy appearance different from what it ought to have, it will no longer have its individual character, its natural beauties will diminish to vanishing point, perhaps even be changed into the most distasteful blemishes? . . .

From the above we deduce that, in architecture, it is not necessary to aim at giving pleasure, since if it confines itself to its real goal it is impossible that it should not please, whilst by seeking only to please it may make itself ridiculous; neither should there be emphasis on variety, effect, or character in buildings, since it is impossible that they should not have these qualities in the highest degree if the architect, applying only the true principles of his art, confines himself to what is necessary, arranged as simply as possible.

The architect therefore must concern himself with arrangement alone; even the one who values architectural decoration will give real pleasure only to the extent that it has been produced by the most sensible and economical arrangement, since decoration in itself cannot be considered beautiful.

The exercise of architectural talent, should therefore be confined to the solution of two problems: in a private building to produce the most suitable one possible with the money specified; in a public building, its purpose being stated, to produce the least expensive one.

The preceding arguments show that far from being an obstacle to beauty, as is commonly believed, economy is, on the contrary, its most fertile source of inspiration.

Let us take an example that will make these ideas as plain as possible, and will give the maximum degree of certainty to those principles.

The building known as the French Pantheon was originally intended to be a place of worship: the usual goal in this kind of building, whatever the religion practised there, is not only

to assemble a multitude of people, but also to move their imaginations through their senses. Now, since a display of grandeur and magnificence is the means most suitable to this end, it would seem that decoration should be, if not the sole objective, at least a principal one when such buildings are in question, and that the incumbent expense should be discounted. Nevertheless, we shall see that if this particular building had been laid out in the most suitable and economical way, and all ideas of decoration put aside, the desired effect could have been produced by quite other methods. The Pantheon is 100 meters in length and 80 in width; it has an entrance and four naves, meeting under a dome, the whole making a Greek cross. The walls are 612 meters in extent. In all there are 206 columns, of which twenty-two have been allocated to the entrance, 136 to the naves, forty-eight to the dome, which has thirty-two on its outer face and sixteen on its inner one.

Who would question the magnificence and grandeur of a building of such considerable dimensions and with such a prodigious number of columns? Yet it has neither. Inside, the building has a surface area of only 3672 meters, which looks even less because the shape chosen by the architect, that of the Greek cross, prevents you from seeing more than half of the building when you first go in.

The number of columns gives no impression of magnificence, the dimensions none of grandeur. Of the twenty-two in the entrance you only see six or eight clearly: those in the dome are three-quarters hidden by the entrance. And when one has entered? Only sixteen can be seen distinctly and these completely screen the others. The columns on the inside of the dome are only partly to be seen and even that requires a great effort. Yet this building, so little imposing or magnificent, cost nearly eighteen millions.

If the architect, instead of running round looking for the design most likely to make an impression and a stir, had allowed natural ideas of economy to suggest the laying-out of the building in one piece, that is to say in a circle, if he had made the columns concentric with this circle so as to diminish the interior span of the dome and create a vast exterior portico, able to accommodate the huge crowds coming from everywhere, what grandeur, what magnificence such a building would have displayed! Every smallest part of a surface area of 4292 meters could have been seen at the same time, outside there would always have been thirty-two columns in full view

and a multitude of them inside. Here are two very different buildings. Wherein lies such a great difference? In the fact that in the first one the desire was to make something fine-looking, and it was believed that the only means to achieve this would be enormous outlays of money; whilst in the second building, the only consideration was to discover the most economical and appropriate design. As it happens, the latter, though far grander and more magnificent than the former, has only one hundred twelve columns, with walls a bare 248 meters in extent, so that the cost being only half that of the present building, with the same sum of money two buildings could have been put up, not indeed like the present one, but like the suggested one, or even one single building twice as big as the one outlined.

This example, admittedly by its nature very unfavourable to the system we are criticising, is sufficient proof of the soundness of our principles; on the one hand, it shows clearly what little help so-called decoration is in producing the impressive results expected of it, and on the other hand, how much an architecture, based solely on reason and the use of things as they are meant to be, is able in every way to increase and extend our enjoyment.

There is another example of the disastrous depths into which you can plunge by ignoring and disregarding the true principles of architecture.

Everyone is acquainted with the but too famous church of St. Peter's in Rome, a building which is an accumulation of all the poverty-stricken concepts of decoration, commonly called the splendours of architecture; a building, over a long period of time, used as a model for all that is worst in building; a building that many people still do not dare to criticise too openly, but which at least no architect would now consider worthy of imitation. We are also familiar with the old basilica built by Constantine, one laid out in the simplest and most appropriate manner with, as the direct result, an effect of the greatest magnificence. This building having fallen into ruin, it would have been natural to rebuild it according to the old plan: such a reconstruction would not have been burdensome even if, in order to produce a more stately effect, the dimensions had been so increased that the building became equal in size to the present one. But false ideas about architecture prevalent at the time would not allow of anything so sensible. People were convinced that arrangement in architecture was

of no account; that decoration was all important, elaboration of shape and proportion everything. As there could be no other source of architectural beauty, the most unsuitable, over-elaborate and bizarre plans were put forward. Everyone was aware of the enormous expense entailed, but influenced by the idea that nothing beautiful could be accomplished except at enormous expense, and wishing to build a place of worship outshining in beauty the most magnificent ones then in existence, an extravagance without limits was deemed indispensable. It is enough to take one brief glance at the illustration to discover whether the means used had the result that was intended.

Subsequent history having made us but too familiar with the dire consequences of applying the principles used in this building, we shall refrain from further terrifying detail; moreover we have said enough to make clear the importance of architecture, the truth of its principles, the influence it has on the fate of individuals and of society, and thus make all people who are obliged to erect buildings realise how necessary, indeed indispensable, it is that they should study closely an art whereby they become trustees of part of the wealth of both private individuals and of whole nations.

[EUGÈNE E. VIOLLET-LE-DUC (1814–79), a great architectural theorist, was also an archaeologist, writer, and teacher. From his teacher, A. F. R. Leclerc (1785–1853), who was a student of Durand, le Duc learned the rational functionalism of Durand. By his association with Henri Labrouste (1801–75), the brilliant architectural innovator, le Duc was encouraged to be imaginative in the use of his knowledge.

In spite of his study of Greek and Roman architecture in Italy and Sicily, le Duc's lifelong interest was Gothic architecture. He was attracted by its functional aspects, for he was one of a group who sought to develop, from the structural logic present in forms of the past, a new architecture.

Viollet-le-Duc acquired his profound knowledge of every aspect of medieval life and architecture from serving first as an assistant, and then as successor, to the celebrated writer Prosper Mérimée who was appointed Inspector General of the National Monuments and Historical Antiquities in 1834. In this capacity, le Duc assisted with the restoration of Carcas-

17. **Hunt,** Light of the World (1852-54). Courtesy of Keble College, Oxford

18. **Daumier,** The Baptism of Achilles.
From *Histoires Anciennes*
Courtesy of the Museum of Fine Arts, Boston, Mass.

19. **Durand,** Exemple des Avantages que Procurent à la Société.
From *Précis des leçons d'architecture données à l'Ecole Polytechnique,*
Plate I (1809). (photo: BIBLIOTHEQUE NATIONALE, PARIS)

20. **Durand**, Frontispiece, *Recueil et Parallèle des Edifices en tout genre* (1801)
(photo: FOGG ART MUSEUM, CAMBRIDGE, MASS.)

21. **Viollet-le-Duc,** Details de la Sculpture des Sacristies.
(photo: FOGG ART MUSEUM, CAMBRIDGE, MASS.)

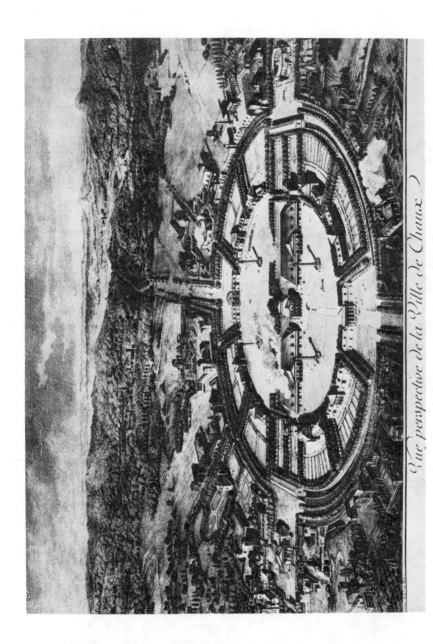

22. **Ledoux,** Vue Perspective de la Ville de Chaux.
From *Architecture Considered in Relation to Art, Mores, and Legislation,*
Paris, 1804

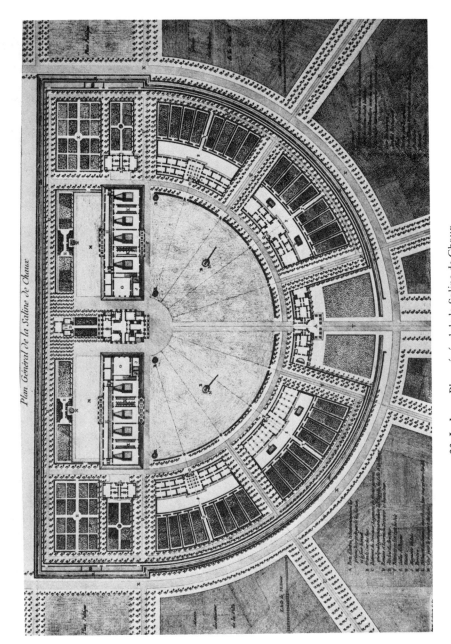

Plan Général de la Saline de Chaux

23. **Ledoux**, Plan général de la Saline de Chaux.

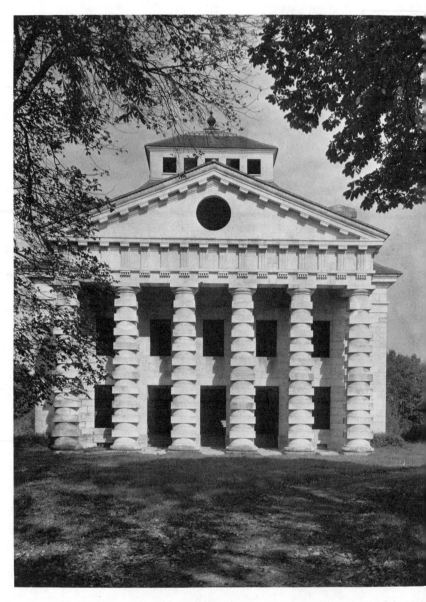

24. **Ledoux,** Central Pavilion, House of the Director, façade
facing the hemicycle, Saline de Chaux.
(photo: ARCHIVES PHOTOGRAPHIQUES)

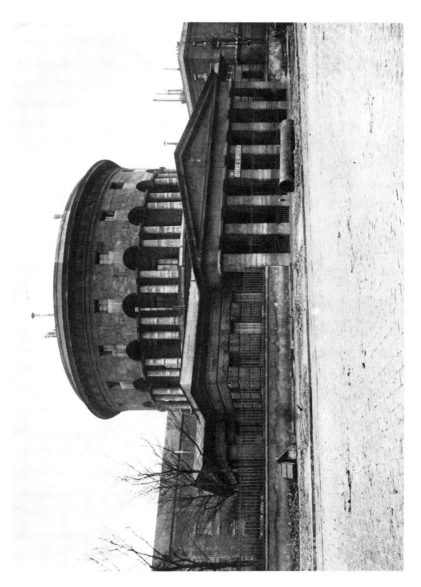

25. **Ledoux,** Barrière de la Villette. Paris (photo: ARCHIVES PHOTOGRAPHIQUES)

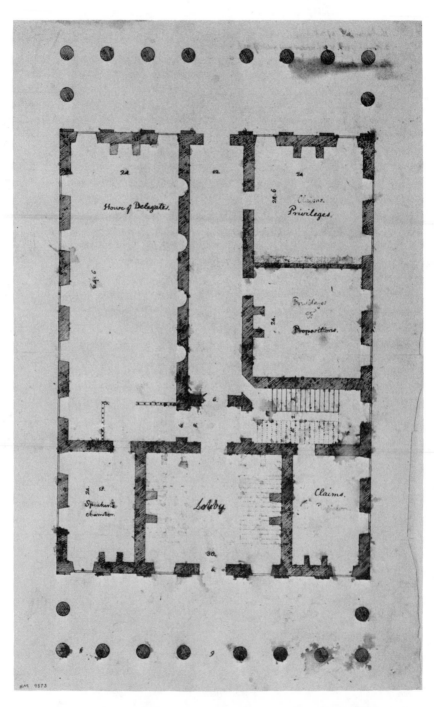

26. **Jefferson,** Ground Plan of the First Floor, Virginia State Capitol, Richmond.
By permission of the Huntington Library, San Marino, California

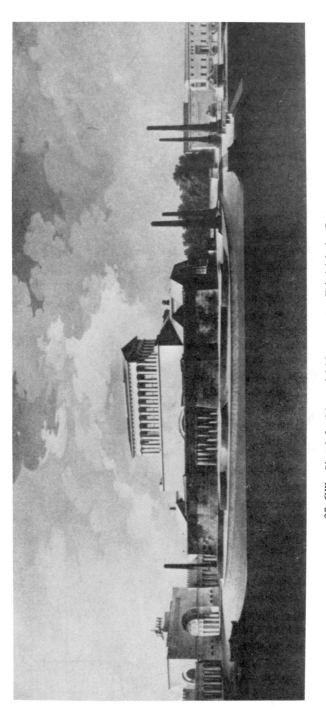

27. **Gilly**, Sketch for Memorial Monument to Friedrich the Great.

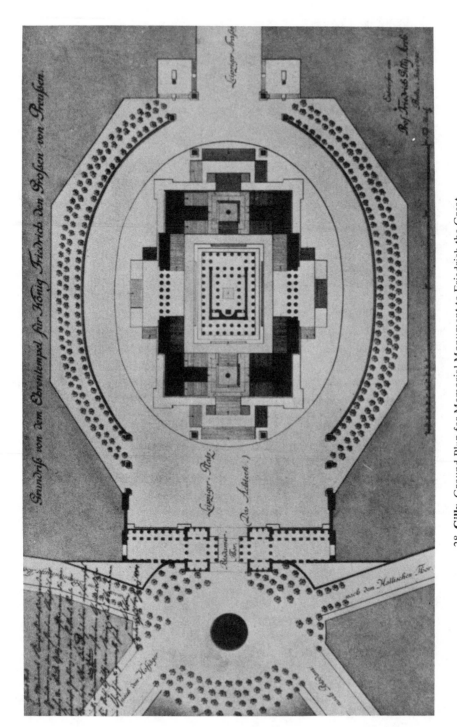

28. **Gilly**, Ground Plan for Memorial Monument to Friedrich the Great. From *Gilly, Wiedergeburt der Architectur*, Berlin (1940) (PHOTO: A. REITDORF)

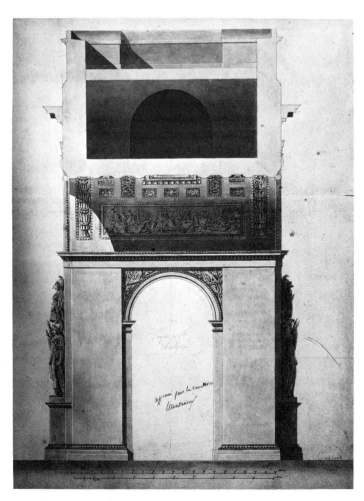

29. **Chalgrin,** Arc of Triumph, Cross Section.
(photo: ARCHIVES PHOTOGRAPHIQUES)

30. **Boullée**, A View of Newton Cenotaph by Night. (photo: BIBLIOTHEQUE NATIONALE, PARIS)

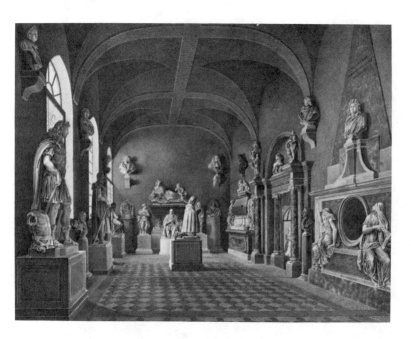

31. **Lenoir,** Première Vue de la Salle de 17me Siècle,
Musée des Monuments Français.
(photo: BIBLIOTHEQUE NATIONALE, PARIS)

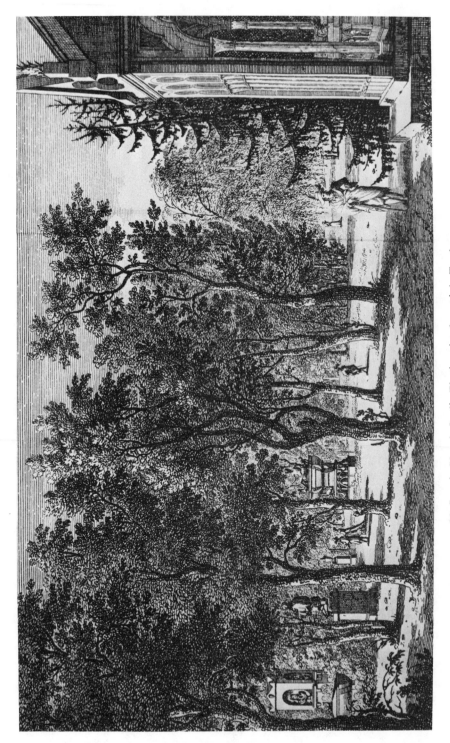

32. **Lenoir,** Vue de Jardin Elysée prise du coté du Tombeau
d'Heloyse, Musée des Monuments Français.
(photo: FOGG ART MUSEUM, CAMBRIDGE, MASS.)

sonne, the cathedrals of Laon, Vezelay, and Saint Savin. He directed the restoration of Sainte Chapelle (1840) and that of Notre Dame in Paris (1845–56) and restored the Château of Pierrefonds for Napoleon III (1859–70).

Restoration soon became replacement and reconstruction. The manner in which the reconstruction was executed was determined by a theoretic knowledge derived from careful study of extant monuments. Damaged portions were replaced by a contemporary copy and missing parts were reconstructed according to theory. The addition of the new elements often resulted in the creation of an entirely new form, a nineteenth-century interpretation of what the medieval form might have been.

Through this activity Viollet-le-Duc acquired an extraordinary knowledge and insight into the construction practices and building principles in use during the Middle Ages, and incorporated it in his writings. He suggested that these principles be applied in the utilization of the modern materials: iron, glass, and glazed brick. Viollet-le-Duc wrote numerous books and essays. The most important are his two famous dictionaries, illustrated with his drawings, with which he set a new standard in speculative archaeology: *Dictionnaire raisonné de l'architecture Française du XI^me au XVI^me siècle* (1854–68) and *Dictionnaire raisonné du Mobilier Française de l'époque carlovingienne à la Renaissance* (1858–75). As he was a master of the French language, individual articles from the *Dictionary of Rational Architecture* such as "Architecture" and "The Cathedral" have worth for their literary style. This added to the appeal of his ideas. Some of the articles were published separately in translation, such as "Restoration," and the notable "Construction." In his illustrations, Viollet-le-Duc charmingly improvised Gothic linear ornamental elements between the construction elements to anticipate and influence the creators of "l'art nouveau" or "Jugendstil" style.

Le Duc's *Entretiens sur l'architecture* (1863–72), models of the French method of deduction, summarize his theory of rational architecture, deduced from Gothic architecture, that construction itself is the basis of design. The *Entretiens* were written at the time of his appointment (1863) as Professor of Art and Aesthetics at the Ecole des Beaux Arts. He delivered six of the lectures, but vehement reaction against them led him to resign. Le Duc published the lectures in 1863 and in the accompanying volume of plates published in 1871, he

called attention by the examples he included to current innovations in construction methods, and thus they gained wide knowledge. The two volumes, text and plates, with their many editions and translations, were of great significance for all subsequent Western European architecture, and especially for the stimulation American architects derived from them.

Viollet-le-Duc built few new churches. The best of these is St. Denys de l'Estrée in the suburb of St. Denis. He was more audacious in his excellently written lectures and his daring, ingenious designs than when he was building, for, as he stated, he was then too burdened by a knowledge of the past.

His last work was a general scheme for the Paris Exhibition buildings of 1878.

Le Duc conceived "of an architecture that proceeds from the known terms of a problem to the unknown but discoverable solution," and thus laid the basis for a theory of modern architecture and had great influence on architects who sought construction methods and a functional style to meet the demand for ever wider and higher areas of enclosed space.

SEE: Viollet-le-Duc, *Rational Building,* being a translation of the article "Construction" in the *Dictionnaire raisonné de l'architecture française,* by George M. Huss, New York, 1895.

J. Summerson, *Heavenly Mansions,* London, 1949.]

TENTH DISCOURSE[1]

On the Architecture of the Nineteenth Century

ON METHOD

It must needs be confessed that modern architects, surrounded as they are by prejudices and traditions, and embarrassed by an habitual confusion in respect to their art, are neither inspired by original ideas nor guided by definite and well-understood principles; a fact the more plainly betrayed the more elaborate and complex are the monuments they are called upon to design and execute.

The libraries of our architects are full of works on the

[1] Quoted from Viollet-le-Duc, Eugène Emmanuel, *Discourses on Architecture,* translated by Van Brunt, Henry, Boston, 1875.

history and practice of art, and abound with drawings and engravings; yet if, in the midst of this affluence of the material elements of design, the artist is required to erect the most modest structure, his mind is at once closed to the reception and expression of new ideas for the sake of being correct in respect to his imitation of old ones, and refuses to draw any true inspiration from these accumulated but disordered resources. Evidences of nice appreciation and careful study, delicate and elegant execution, abound on all sides; but indications of really new ideas are rare indeed, and still more rare the rational observation of a principle. Our monuments seem to be bodies without souls, the fragments of some departed civilization, a language incomprehensible even to those who employ it. . . . Is it surprising that the public remains cold and indifferent in the presence of works thus void of ideas, and too often of reason, and that its appreciation is limited to considerations of cost? "This is very expensive, and so it must be beautiful."

Must this nineteenth century, then, come to a close without ever possessing an architecture of its own? Is this epoch, so fertile in discoveries, so abounding in vital force, to transmit to posterity nothing better in art than imitations, hybrid works without character and impossible to classify? This sterility can hardly be one of the consequences of our social state, nor can it be satisfactorily accounted for by any bias of education, for no school of art could be powerful enough to bring about such a result in the midst of the intellectual activity and enterprise of the time. Why, then, have we not an architecture of the nineteenth century? We are building everywhere and a great deal; we are lavish of our millions; and yet, among all the innumerable structures raised on every side, it is very difficult to point out any distinguished for a true and really artistic application of the boundless resources at our disposal.

Since the French Revolution Europe has been in a state of active transition; it has been ceaseless in investigating nature and history, and has accumulated immense resources of material. Yet architects have been unable to give body and original expression to these varied elements, simply because they have wanted method. In the arts, as in the sciences, without method, our investigations, our discoveries and acquisitions, are in vain; with the increase of our material and intellectual wealth, we gain practically only embarrassment and confusion; our very abundance is a stumbling-block. The more knowledge we

acquire, the greater the strength and accuracy of judgment needed to render this knowledge practically available and useful, and the more necessary it is to discriminate and classify according to severe principles.

But this state of transition in regard to art must, in the nature of things, be temporary; it must tend towards some definite result which can only be reached when, wearied with our profitless and unsystematic gropings among a chaos of ideas and materials, we at length seek to deduce from the chaotic mass certain principles of order and to develop and apply them by the aid of sure and intelligent method. This is the task before us, this the labor to which we must devote our energies with fixed determination, struggling against those deleterious elements of indecision and caprice which, like the miasmas which arise from all matter in fermentation, are the natural results of a state of transition.

The arts are sick; notwithstanding the energy of our vital principles, architecture seems to be dying in the very bosom of prosperity, dying of excess and the results of the debilitating régime under which its growth has so long been stunted. . . . Notwithstanding the efforts lately made to associate so many varieties of style, and to bring together so many conflicting influences, notwithstanding the capricious eclecticism with which the fancies of the moment are satisfied, the characteristic which strikes us most in modern monuments is monotony.

There are two ways of expressing truth in architecture: it must be true according to the programme of requirements, and true according to the methods and means of construction. To be true according to the programme, is to fulfil with scrupulous exactness all the conditions imposed by necessity; to be true according to the methods and means of construction, is to employ materials with a due regard for their qualities and capacities. That which is generally regarded as a matter of pure art, namely, symmetry, the apparent form, this is quite a secondary consideration. . . .

. . . But in the twelfth century there was introduced at Paris, the centre of European civilization at that time, a modern element out of the degenerate traditions of the empire. It concerned itself with mechanical forces, and employed materials solely in view of their natural adaptabilities; it investigated the laws of equilibrium to replace the laws of inert stability, which alone were known to the Greeks and Romans; it sought to economize material and human effort; into the

midst of unity of masses and orders it admitted variety of detail, that is to say, individuality within the limits of style, as also it admitted perfect liberty of means within the limits of unity of conception. . . .

. . . Roger Bacon [in 1267] put into words the principles of the lay school of architecture, which was founded upon the last traditions of Roman art. Method, examination, experience; the entire system is comprised in these three words. . . .

To restrict architectural education to a knowledge of a few fragmentary monuments of antiquity, or to imitate these monuments with more or less success, is certainly not the way to arrive at an architecture of the nineteenth century. It is far better to embrace in our studies that long historical series of efforts which developed in succession new principles, new methods, and new means, and to consider this series as a chain of human progress, all of whose links are riveted according to a logical order. . . .

. . . But where are we to seek for models, or, at least, for precedents of a style thus suited to all our modern exigencies? We shall perhaps be more apt to find it in Roman than in Greek antiquity; but if the question is concerning the use of iron, for instance, we shall find our motives, not among Roman precedents, but rather in the lay architecture of the Middle Ages, which seems almost to have anticipated the enlarged resources furnished by the industry, the mechanical ingenuity, and the immense facility of transportation of the present day. Are there not, for instance, very intimate relations between the great room of the palace at Paris, which was burned at the beginning of the seventeenth century, and the Library of Sainte-Geneviève, which was built a few years ago? And do not the classic appointments of this modern room, instead of adding to its merit, rather tend to disturb its unity by a mixture of foreign elements, a contrast of forms derived from two conflicting principles?

Now, assuming that we have ascertained how best to satisfy the practical requirements of our programme, and what our method of construction is determined on, how are we to proceed from the simple to the complex in composition . . . ? First, by knowing the nature of the materials we are to employ; second, by using these materials with a strict regard for their nature, attributes, and capacities, so that the form which they are made to assume shall exactly express these attributes and capacities; third, by admitting into this expression a prin-

ciple of unity and harmony, that is to say, a scale, a system or proportion, a method of decoration, appropriate and significant as regards the destination of the edifice, without disregarding that variety which may be suggested by the different character of the requirements we are endeavoring to satisfy.

To know the nature of the materials we are to employ is not only to know the strength and texture of stone, the pliability and toughness of forged iron, the rigidity and brittleness of cast iron, etc., but it is to be able to anticipate the effects these materials are capable of producing under certain conditions; it is to comprehend thoroughly, for example, the essential difference of expression between a monostyle set up on end and a pier built up of courses of masonry; . . .

To admit a principle of unity and harmony into the expression of the various requirements indicated by a programme, that is to say, a scale, a system of proportions, a method of decoration, which shall be appropriate and significant as regards the destination of an edifice, and at the same time not to disregard the variety suggested by the different nature of the requirements to be satisfied—this is another important point in architectural composition, one calling for the best intelligence of the artist. When the conditions of the programme have been satisfied, when the system of construction has been determined on, when in our design we have reasoned out such a form or style for each of its parts as shall best express its function and the materials of which it is made, there remains to bring the whole into harmony by the application of those principles of unity which must control every work of art. This is the rock upon which nearly all architects have split since the sixteenth century; they have either unreasonably sacrificed convenience and disregarded the most judicious use of material for the sake of an harmonious form, or satisfying all the conditions of their work, and employing their material most judiciously, they have been unable to harmonize the whole so as to produce a unity of expression. But the former error is that into which modern architects have been most apt to fall. The immeasurably vaunted architecture of the close of the seventeenth century in France, that which still remains the mistress of design, presents us with the most exaggerated examples of this deplorable system. . . .

"This principle of unity and harmony in the expression of the various requirements indicated by a programme" is, therefore, neither symmetry nor uniformity, still less an undigested

mixture of various styles and forms which is unintelligible and unsatisfactory, however skilfully made; but it is, in the first place, a strict regard for *scale,* that is, the proper relation of the various parts of a whole to a unit of admeasurement. The scale adopted by the Greeks in their temples was not an absolute but a relative unit, known as the *module,* although, in their dwelling-houses, it is certain that they used the absolute unit, which is the size of a man. . . .

With the Byzantine architects the column became the absolute scale, whatever might be the size of their buildings in other respects; although differing slightly in actual dimensions, it practically served as a standard of comparison to the eye. But among the mediaeval architects the only scale admitted was man, every part of their structures being composed with reference to the height of the human figure, and hence, necessarily, the unity of the whole. With a point of comparison so familiar, the real dimensions of their edifices became particularly appreciable.

If we should adopt in our architecture this principle of the human standard of admeasurement, together with such a system of geometrical proportions as was evidently used by the architects of antiquity and of the Middle Ages, we should unite two elements of composition which would compel us to remain true as regards the expression of dimensions and to establish harmonious relations between all the parts. The mediaeval architects, therefore, were in advance of the Greeks, in that the latter admitted only the *module* and not the invariable scale. Why should we, in continuing to use the *module,* voluntarily abandon the larger system invented by the artists of the Middle Ages? . . .

. . . The designer has by no means completed his work when he has arranged his plan in the most convenient and satisfactory manner and expressed its characteristics in his elevations; all the parts must be harmonized and bound together by a prevailing idea; all the materials he uses must be used judiciously and with a careful regard for their respective attributes; they must have neither too much strength nor too much lightness; they must indicate their function by their form; stone must appear plainly to be stone; iron must seem to be iron, and wood, wood; and at the same time all these materials must be treated so as to combine without offending the principles of unity. This was an easy task to the Romans, when they used only a concrete construction with clay, bricks, or

rubble, and a revetement of marble; but it is far otherwise with us, who have to employ materials of various or even conflicting properties, and to give to each of them the form which most naturally expresses these properties. Now, inasmuch as the builders of the Middle Ages seem, as I have already said, by the comprehensive and pliable character of their works, almost to have had a prescience of the larger resources of our own time, a thorough review, not only of all architectural precedents, but of those especially which were furnished by these active and intelligent artists, is quite indispensable, if we would make a true progress and not fall behind our predecessors. The works of the mediaeval school, at the moment of its first development, present a cohesion so complete, a mutual relation so intimate between the requirements, the means, and the form or style, they supply us with so many resources ready-made by which the peculiar difficulties inherent in modern programmes may be resolved, that we can nowhere else find precedents better fitted to facilitate the task before us. But to try to obtain from the good architecture of Greek or even of Roman antiquity anything more than a few very simple principles applied with an inflexible logic, to undertake to copy, imitate, or even to be inspired by the actual forms which were developed from these principles, is voluntarily to expose ourselves in our works to contradictions so much the more offensive as our requirements become more complicated and our resources more extended. During the seventeenth century there was a prevailing mania for Roman architecture, and every one was willing to suffer all imaginable inconveniences for the sake of being Roman. Not to incommode Roman art or to interfere with its development, every one was ready to incommode himself, with the best faith in the world. However unreasonable this passion, and however bad its results may have been in the architecture of that period, it was nevertheless a faith, and as such deserves respect. But it must be confessed that we are much more sceptical as regards art than people were in the reign of Louis XIV, and there is no one in modern times so infatuated with Greek or Roman art as to be willing to sacrifice for its sake the least of his daily comforts or to submit to the slightest inconvenience in the cause of classicalism. Why, then, this constant and bad copying of antique forms? What have we to do with them? . . . Are we compelled to this course by respect for art? If so, for what art? For a false and denaturalized one, reduced to the condi-

tion of a language which no one understands, and deprived
even of the benefit of the very rules out of which the prece-
dents which we worship were first developed. When an exact
and faithful imitation of the Parthenon was erected at Mont-
martre, near Paris, it was erected, I admit out of respect for
art, to preserve to the world a type of eternal beauty, the
original of which had been mutilated and destroyed; it was
then a question of a museum, of a perpetuated text. But when
Greek Doric columns are engaged between the arches of a
Roman arcade in the second story of a railway terminus, cov-
ered with mortar or plaster and smoothed down, with lintels
of jointed masonry, there is certainly neither reason, utility,
common sense, nor object in such an inconsistency. Instead
of being a mark of respect for art, is it not rather an indication
of disrespect or contempt? Who would engrave a verse of
Homer upon the walls of a warehouse? . . .

If we would really have an architecture of the nineteenth
century, we must, as a primary consideration, have a care that
it is indeed our own, taking its form and characteristics, not
from precedent, but from ourselves. We should get a thorough
knowledge of the formation of anterior styles, but this knowl-
edge should be accompanied by a spirit of intelligent discrimi-
nation and criticism. We should not use our knowledge like
pedants, but like persons who, having ideas of their own, are
choice in the language with which they would express them.
We should above all endeavor to forget those conventionalities
and commonplaces, which, with a persistency worthy of a
more noble object, have been reiterated for the last two hun-
dred years as if they were the only utterance of architecture.

The art we seek should be under the control of an harmonic
system, a pervading spirit of unity, but sufficiently elastic to be
a faithful monumental record of the modifications and results
of progress as they take their places in history; it should be
untrammelled by such purely conventional formulas as are
applied to the orders, for example, or as are derived from
what are called the laws of symmetry.

Symmetry is no more a general law of architecture than
equality is a law of society.

Municipal regulations, forbidding the erection of buildings
above a certain height or fixing the amount of projection al-
lowed beyond the street line, are reasonable and proper; but if
these regulations should require twenty different architects to
adopt in twenty different buildings the same cornice-profile,

the same style of window, or the same heights of string-courses, under pretence of symmetry, when the interior of each of these houses has its own individual characteristics in its arrangement of rooms, they certainly would not be justifiable. But if municipal authority should ever be stretched to such a deplorable point as this, the architects would have nobody to blame for it but themselves, in having set the example by practising under doctrines which recognize such absurdities, and by reducing architecture to the condition of a vulgar formula which any one can employ mechanically and without effort of reason.

Although, however, we cannot find in symmetry the qualities which constitute a law, there are certain cases in which it is satisfactory, and this is the most that can be said about it; but, on the other hand, harmony and balance of parts or ponderation are laws which should be understood and applied in architecture. . . .

In fact, balance may be defined as the art of giving an effect of completeness without the aid of symmetry; but when the architect's resources are such as to afford him no other means of obtaining this effect but symmetry, his art becomes like one of those trades whose perfection consists in marvellous exactness of repetition. If, therefore, the laws of symmetry, being mechanical, are not properly speaking, applicable to the art of architecture, we have seen, on the other hand, that the best architects of antiquity and of the Middle Ages respected and obeyed the laws of balance. These laws of balance, like those of proportion, are nothing more than the apparent expression of the laws of statics.

Geometry and calculation, then, are the fundamental bases of the art; by building upon such bases, we can escape the pitiable vulgarity of mere classicism, and, indeed, if our civil engineers, who are accustomed to nice calculations and who are excellent geometers, concerned themselves less with unreasonably reproducing in their works classic forms, and contented themselves with the simplest, most economical, and most unaffected manifestation of their construction, there is no doubt that they would produce some remarkable results, as seen from a purely artistic point of view; for a faithful observance of the laws of statics, developed by calculation and geometry, must lead to sincerity and truth of expression, and whenever these qualities control a work of art, it instinctively charms both the cultivated and the uncultivated mind. Al-

though the public taste has been led astray by the universal habit of insincerity or falsehood in architectural works, it is nevertheless invariably attracted by a true work, which appears what it really is. Everything which explains itself must have such qualities of fitness as to recommend it to the approbation of the beholder. By using such forms as shall most naturally and inartificially express the qualities and capacities of the materials we employ, by using cast-iron forms for cast-iron and wrought-iron forms for wrought-iron, by having appropriate distinctions of treatment for a form of granite, of sandstone, of marble, of brick, and of wood, we shall not only open a vast and inexhaustible field for variety and novelty of design, but must at last succeed in attracting the sympathy and appreciation of the public for an art which, by its false and arbitrary standards of criticism, has so long been alienated from them. If the people have been misled in matters of taste, is it not plainly the privilege and duty of the artist to enlighten them, and is it not the extreme of stupid folly to go on multiplying known and acknowledged errors? . . .

. . . Having at our disposal new materials, machinery until now unknown, enlarged resources, requirements much more complicated than those with which the ancients had to deal in their architecture, having an extensive knowledge of precedent in its development under various civilizations—if to all this we should add sincerity, in fulfilling to the letter the requirements we are to satisfy, and in using our materials honestly and wisely; if we should avail ourselves also of the discoveries of science and pay especial heed to the suggestions of common sense, trying above all to forget false doctrines and to lay aside all prejudice and caprice—we might then hope at least to lay the foundations of a true architecture of the nineteenth century, although perhaps we must leave to our successors the task of developing it to completion.

But in addition to the laws already indicated as applicable to architectural composition, there is yet another no less important, which in modern practice is almost entirely neglected; it touches pure art, and may be distinguished as the law of congruity. Thus, to give to a dwelling raised upon shop-fronts, which entirely destroy the effect of a basement, the façade of a palace; to decorate it with Corinthian pilasters which have no better resting-place than glass sashes, behind which are displayed dry-goods or hats and caps, is an evident offence against this law. To build in the same city and at the same moment a

church in the Gothic manner, a second after the Renaissance, a third in a pseudo-Byzantine style, is also, as far as art is concerned, an indication of a general disregard for congruity, or fitness; for, apart from considerations of the difference between religious sects and forms of worship, it would be difficult to explain how, in a healthy state of architectural art, the same sect can be accommodated equally well in churches entirely dissimilar in motive, style, and treatment. The question then is, which is the more Catholic or which the more Protestant, a Byzantine church, a Renaissance church, or a neo-Gothic church, and why should one be more Catholic or Protestant than the others? To make the classic façade of a municipal office simulate that of an ancient Gothic church built en pendant; to make a little theatre, next a great parish church, appear like a detached fragment of the church; to crown a courthouse with a cupola like that of a mosque—all these things, which have lately been done in the capital of France, indicate a prevailing disregard, or, at least, an ignorance of that law of congruity which must be strictly observed wherever there is true art. . . .

. . . It is only lines combined with skill and feeling, only forms easy to understand, only broad and massive treatment, which can produce a profound impression and elevate an idea to the dignity of a work of art. In this respect the ancients are our masters. So long as we disregard these principles, we have no right to boast of being their pupils; and so long as we continue to borrow from the age of Louis XIV some of its tinsel, without reproducing that feeling for form of which some traces still lingered even in that era, we have no right to cover up our shortcomings under the cloak of what we call respectable traditions; the public, weary of the gilded rags which cover such wretched bodies, weary of an art which has neither distinction nor choice, will soon demand a return even to those pale cold copies of antiquity so much in vogue at the beginning of the century, but which at least had the courage to expose their own nakedness and sterility, and did not conceal their emptiness of conception under a fictitious splendor stolen from a few old houses of the faubourg St. Germain.

This Discourse, then, is intended to embrace the conditions under which the true architect is developed; these conditions include, as we have seen, method in the study of architectural precedents, and the submission of the results of this study to the chastisement of reason; they include certain laws for the

government of the architect in design—laws which are either purely mathematical or purely aesthetical. . . .

It would be folly to undertake to oppose archaeological studies, for they are probably destined to serve as the solid basis of modern art; yet, inasmuch as archaeology seems lately to have influenced the material rather than the intellectual side of art, we should take care that they are not so misdirected as to become dangerous. If we would obtain substantial profit from the study of the past, we should not occupy ourselves with such trivial questions as whether the metopes of a certain temple were colored blue or red, whether the grilles of bronze were engraved with silver, whether the eyes of such a statue were incrusted with enamel or with precious stones; we should rather study to comprehend the reasons why such a method of decoration was adopted, and to obtain a broad and clear idea of those civilizations which manifest themselves to us in the few expressions of art which we are seeking to decipher. . . .

But the great question of this nineteenth century, that which daily assumes increased importance and must in the end predominate over all others, is the matter of expense, the financial question. The more prosperous society becomes and the more abundant the wealth of nations, the stronger is the tendency of mankind to employ their resources judiciously; useless expenses offend the public sentiment. . . . The forms of architecture [at the end of the thirteenth century] were the product and visible manifestation of the necessities of the time. In a word, the art was flexible to all the practical and aesthetical uses of building, was comprehended by all, and not a mere conventional formula, with which the public could have no sympathy and in which the available resources of the time found no natural expression. It accommodated itself readily to the prevailing customs, and, free in all its developments, had not yet learned to confine itself in a strait-jacket of unreasonable and inexplicable conventionalities.

CITY PLANNING

[The immediate antecedent of the nineteenth-century city plan was found in the seventeenth century. The concentration of power in the monarchial state, combined with the growth of

capital and population, forced the creation of the city with sufficient space to accommodate the increasing functions, wealth, and numbers.

Eighteenth-century England added the residential square and crescent to the city as an answer to the philosophers' and political revolutionaries' demand for an environment that would permit the development and improvement of the individual. The increase of population and the increase of mechanization of transportation necessitated a corresponding increase in space for movement and communication.

The science of city planning was developed to provide rational solutions for the necessities of a progressively more industrialized and mechanized society. It led to the conception that the city as a whole is "architecture." Its spatial relationships, its organization, its forms and levels of activity require a city to be "built."

The visionary architect Ledoux drew a first plan for a "built" city in which economic and social factors determined its organization. Throughout the century various and numerous plans were contrived to meet the urgent need for a new city-form. They culminated in two basically different solutions to the problem of urbanization, offered by Frank Lloyd Wright (1869–1959) and Le Corbusier (1888–1965).

Broadacre City of Frank Lloyd Wright, and the conceptional core for everything that he designed, was an ideal, living city with "No life imprisoned on shelves of vertical streets, above crowds on gridirons down below." It was horizontally planned with homes in garden plots around a few tall apartment buildings. It paralleled Ledoux's fantasy by offering a setting and buildings for the realization of an "ideal" society. In such a city that looked and functioned like a natural organism, the individual could live with joy.

The "Ville Contemporaine" evolved by Le Corbusier in 1922 provided for a functional relationship within the city that allowed space for transportation and recreation. Between the many vertical multiple-living buildings were units of varied size for the individual dwellings. The "Ville Contemporaine" proposed a plan to prevent the need for "Suburbia" and commuting, and it was designed to forestall the blight of the city's center.]

[CLAUDE NICOLAS LEDOUX (1736–1806) was born in the Department of the Marne. After attending school at Beauvais, he studied (1760) with J. F. Blondel, the famous teacher and author of the practical *Cours d'Architecture.*

Six years later Ledoux built the Hotel d'Hallwyl, the first of a number of houses in Paris. The continuous patronage of Madame du Barry—her commission for a "sanctuaire de la volupté" at Louveciennes in the environs of Paris (1771), stables, and a new residence in Paris—brought Ledoux early to the attention of the court. It was Madame du Barry's sensitivity to artistic genius and her loyal support that secured the construction of Ledoux's imaginative plans. He was elected to the Académie Royale and named *architect du roi* in 1773. His early buildings in the style of Louis XVI separate themselves from others' work in the independent use of ornament. The Château Bénouville (1777) near Caen illustrates the reiterative accent he gave to ornament as a contrast to the plain walls. A later residence, the Hotel de Thelusson (1781), no longer extant, became the curiosity of Paris because of its arbitrary combination of forms.

Ledoux's work in France was interrupted briefly by a call from the Grand Duke of Hesse-Cassel to Cassel, where the great park was being laid out that would be transformed into the fantastic Wilhelmshoehe in 1787–94.

Ledoux received the commission in 1775 for a Governor's Palace, a *palais du justice,* and a prison at Aix-en-Provence, but the construction on the first was not begun until 1786 nor were the other buildings finished. His designs (1785) for the Hotel de Ville, Neufchâtel, and a theater at Marseilles were refused by the timid municipalities.

A commission to which he devoted much time and study and which was marked by his imaginative originality and his social views was that for the Theater of Besançon (1778–84) (the interior was burnt out in 1958). The severe geometric form of the exterior with its steep plain roof is unrelieved by decoration. (Its imposing unpedimented portico was used by the French architect, M. Godefroy, for the City Hall in Richmond, Virginia.) The interior was designed for its acoustics. Except for a Doric colonnade at the rear, it was free from decoration and separate loges so that nothing might distract attention from the stage, anticipating Richard Wagner's the-

ater design. The seats arranged in rising banks offered an equal view to all spectators.

In 1786 the King's council approved Ledoux's plan for sixty toll-houses, *barrières* of Paris. Of these *Propylées,* only four remain to demonstrate Ledoux's unconventional creativeness in combining the form of the cube and cylinder and ornamentation to accent their geometric quality. Although Ledoux had envisaged each as contributing to the well-being of the employees they housed and their use as recreational halls, *"guinguettes,"* for the people, their unfamiliar massive form set in the ancient walls roused the hostility of the people —"Ce mur murant Paris rend Paris murmurant." In 1789 the *émutiers* sacked them and Ledoux was removed as the architect.

A Dominican sugar planter commissioned Ledoux to construct the Hosten Estates along the rue St. Georges in 1792. His design with the groupings of units and arcades became the prototype of the modern *cités jardins.* The estates were razed in the nineteenth century, but had their influence on John Nash's Regent Park and in the development that led to the Boulevards of Baron Haussmann.

A project whose conception was begun early and continued throughout his life was related to Ledoux being named, through Madame du Barry's influence, inspector of the *Salines du Roy,* the royal salt manufacturing plants, in 1771. In 1773 he was ordered to make alterations at the outmoded Salines d'Arc et Senans, in the southeast department of Franche-Comte, and submit plans for the Salines de Chaux nearby. Ledoux's plans were approved due to Madame du Barry's insistence in spite of the disapproval of the King's counselors, and work was begun in 1775 on one of the most extraordinary projects of the period. Ledoux, filled with the current enthusiasm for J. J. Rousseau's *Emile* and a dream of an improved social order, envisioned the site of the salt processing plant as an ideal city and drew his plan for it. The entrance, a temple portal ornamented with congealed salt drops as the decorative motif, the director's house, flanked by the processing plants, and enclosed by a semicircle of administration buildings, was erected before construction was stopped in 1779. Ledoux did not cease to amplify the plan of the "Ville Idéale de Chaux." When he was released in 1795 after two years of imprisonment by the Revolutionary government, he prepared the plan

and the designs of buildings which had been constructed for *L'architecture considérée sous le rapport de l'art, des moeurs, et de la législation,* which he published in 1804. He planned five volumes but completed only one before his death in 1806, abandoned except for his able pupil Vignon, the architect of the Madeleine.

The form of Ledoux's ideal town was a semicircle with the factory at its center and the important buildings on the rings, anticipating Ebenezer Howard's "Garden City" and Le Corbusier's *cité radieuse.* For the professional personnel he designed single houses, the exterior and the interior of which correspond to and serve the function of the inhabitant. In all the individual buildings, Ledoux's originality and poetic expression are apparent, the masses are simple geometric forms, the flat walls have few openings, and the roofs are planes. His designs are full of a personal symbolism to be read in the actual form of the building. In the accompanying text are passages of exalted metaphysics, punctuated with the reforming expressions of his age, often difficult to understand.

Ledoux's book continues to be influential because he boldly combined traditional elements with unexpected forms, utilizing the geometric forms of the cone, the cube, the sphere, and the cylinder in a unique manner, and choosing elements from Vitruvius, Palladio, and Piranesi to create dramatic buildings that possess qualities Edmund Burke defined as "sublime." In the uniqueness of his genius, Ledoux anticipated the styles of Romantic Classicism and, now that modern construction materials and method would permit the construction of such buildings as he designed, he may be seen as a precursor of the twentieth-century revolutionary architects. SEE: E. Kaufmann, *Architecture in the Age of Reason,* New York, 1955.]

ARCHITECTURE CONSIDERED IN RELATION TO ART, MORES, AND LEGISLATION[1]

The Ideal City of Chaux

INTRODUCTION:

In the midst of occupations that can be imagined from the immensity of the work, I place before the eyes of Nations; in the midst of agitations that have worn my constancy, in the center of persecutions inseparable from the publicity of grand conceptions, and of passions which have worn themselves against my energy; almost invariably tyrannised by shrunken estimates and insecure fortunes and changing desires that dampen the sparks of genius, I am not laying before my readers those projects that lose themselves in a cloud of speculation or whose terrifying possibilities forbid execution in advance.[2]

I am confident that through a perusal of history and the bringing together of the various principles and examples of architecture found there, I can extend the field of this art and stimulate the birth of masterpieces. I am, therefore, presenting in the form of a few days reading matter, all that I have gathered relating to those treasures of bygone centuries.

Before this vast undertaking, comprising all the various buildings essential in a community, lies under the dark veil of night, you will see large factories, the offspring and parent of industry, giving rise to huge gatherings of people; for these a town must be built which will be both a shelter and a crowning achievement. There luxury, friend and nourisher of the arts, can place on show everything wealth has brought to flower.

The surrounding countryside will be embellished with buildings dedicated to leisure and pleasures, and planted with gardens that rival those of legendary Eden.

[1] Translated from C. N. Ledoux, *L'architecture considérée sous le rapport de l'art, des moeurs, et de la législation*, Paris, 1804 (ed. 1962).

[The translation presents special difficulty, for as Landon, a contemporary of Ledoux, stated, "le style en est diffus et ampoûle."]

[2] *Omnia vincit amor:* This is the feeling which has inspired and sustained me throughout this long work.

The villages and the towns sheltering the hard-working artisans will add to the beauty of the view by their contrasting simplicity. The modest appearance of the poor man's cottage will heighten the splendor of the rich man's mansion, be a further embellishment to those palaces where, beneath their roofs of gold, the great seem the rivals in the glory of the morning star. . . .

Examples teach the most powerful lessons. A stately building is dedicated to the pursuit of wisdom, its many encircling porticos serving as a shelter for children at play, a place where the young can stroll and old persons meditate. A school is opened there, where man is taught his duties before being instructed in his rights. There he can be made to understand the inter-dependence of all the virtues, that the Platos, Socrates, St. Augustines worked to erect the same edifice and advanced toward the same goal. The Tables of Solon and of Niger, the Capitularies of Charlemagne will be placed there before the eye as a calendar for the upright man.

That Beauty which lies only in proportions has a power over humans which they can not resist, so statues harmonious in design adorn the enclosing walls. Their beauty will help to quicken into life the principles they personify. Do but consider for a moment the masterpieces that the Goths would have handed on to posterity, had but a Phidias of their time purified their style! . . .

One becomes virtuous or vicious as the pebble is rough or polished by the friction of our surroundings. Since health and happiness are to be found in pleasures enjoyed in common, communities will be built in the shade of quiet woods where philosophers, living together in accordance with the simple laws of nature, will try to re-create the desirable felicity of the fabled Golden Age. It follows that there will be buildings housing several families.

All is inspired by harmony. . . . If Society is based on mutual needs, which in turn generates reciprocity of affection, why not bring together under a common roof those tastes and feelings that honor man? Let my city, therefore, have houses for Brotherhoods. The character of edifices, like their nature, serves to propagate and purify moral customs, so in one place I have put theatres where man is made aware of his common humanity, at another triumphal arches which deify humanity, and further on cemeteries where humanity will be engulfed.

The Law sustains the morals. The lighted temple of justice

stands in salutary contrast to the sombre places in which crime is housed but which should never harbor the innocent.

The Tribunal will be the ever fertile and charitable source of public security, and in the Hall of Peace differing members of the same family can be reconciled, their quarrels prevented or settled. There also immorality can be bridled and the perversions found in cities held in check.

There will be dwellings appropriate to every art and rank of society, amongst them the workshop by whose help the mechanic, less strong but more skilled than Atlas, can like him hold up the world.

From the heart of immense forests will arise the sacred roof of their warden, who, like some new Sylvan, guards and watches over them; there also will be the pyramidal retreat of the wood-cutter who, at his master's order, strikes one of the forest giants and, inserting his wedge, proceeds to fell to the ground those of earth's children whose stature most befits them to lead our fleets on to prosperity and victory, also those whose limbs will maintain the hearths of chilly mortals, and their trunks the factory's hungry furnaces. The chemist's stove will be fed from the domed hut of the charcoal burner, whilst the precautions so necessary to his task can serve as a lesson on the dangers of asphyxiation. Lastly, in galleries divided into their several compartments and close to his own dwelling, the carpenter prepares, shapes and planes his wood, working so skilfully and wisely that he coaxes the busy, timely wind into blowing twice its strength through the long building[3] for condensation.

The countryside is set with temples dedicated to agriculture and numerous rustic gods, whose names, graven on altars, will remind us of their claim to our devotion. Parks, though proud of their proximity to castles, will take their natural place in this scene; barns, prosperous farms, overflowing sheep-folds, buildings so essential in a rural economy but too often despised, are found on all sides. . . .

Commerce, yet another precious source of abundance, must be promoted, with public markets to house every variety of produce. Hundreds of vaults will protect the fruits of the ever fertile soil and of the country's industrial genius from the

[3] [A building related to the manufacture of salt, through which pipes ran at various levels enabling the salt to condense.]

rigours of the climate. The courses of rivers will be changed in order to facilitate a richer exchange of goods.

Treasures from the far corners of the earth will be found in huge stores with wide arcades, treasures that an able merchant has carefully selected for distribution amongst the hardworking people.

A simple, dignified style will characterise the banks which, rejoicing in the public confidence, will find their own source of wealth in the riches they redistribute to all sections of the community.

Every man consults his own likes and dislikes; he alone is happy who can keep his passions at rest in a discordant world. . . . If art can offer only a humble dwelling to some, it will ensure it through the use of hardened clay against the incendiary caprice of lightning which consumes the neighboring thatch. It will distinguish it through that taste which is pleasing even in cities, when it makes the purity of line rule the simplest constructions.

But art will create for others mighty châteaux, numerous dependencies, stables that are show places, and other useful conceits; as if at the touch of a magic wand, the earth will bring forth country houses, residences for those delighting in games, places where the Graces, maybe the Muses, can mingle. The park entrances will recall the wonders of chivalry in the days of old; returns from the hunt of the potentates of the earth, their fame bruited abroad by a thousand tongues, will attract to us those nations most interested in our arts. Hotels will enable them to enjoy our hospitality at their leisure. The hospice, always open to the traveller, will, by its useful selectivity, permit the penetration of our frontiers only by men worthy to do so. Cities will provide baths to strengthen the body, also places to house the cherished provokers of those burning desires that exhaust the body. There will be libraries to feed the mind; tax-offices to wither it; a house of study from which light will flow, a gaming house where lights will be extinguished. Governors will inhabit huge, luxurious abodes as empty of contentment as they are full of bitterness. The workers will live in mean ones limited to the essentials; the walls of the financier will carry the spoils of a hundred families.

And you, the people, each one of you such an important part of the whole, you will not be forgotten in the architect's design. For you, buildings vying with the palaces of the great,

will rise at a proper distance from the city, halls where you can gather to enjoy your own pleasures. Special games will restore your energies, feasts will dispel your weariness; rested and refreshed, you will summon up the fresh strength and courage so necessary to your work.

It is through the illustrations of these varied and numerous buildings, each marked with its distinguishing character and which in its execution offers the analysis of all the principles, that I will instruct, stimulate and restrain the student embarking on an architectural career. . . .

Architecture may be likened to those heavenly bodies which light the world; like them it has its periods of waxing and waning; it experiences the same disrupting shocks; its light becomes obscured by dark clouds, only to shine forth the more brilliantly once the shadows are dissipated; shining satellites surround it, mirror its splendor; together they are poised in fearful equilibrium at the heart of the universe.

In order to expound in its entirety an art demanding universal knowledge, and on which every social factor exerts an influence, I have brought together diverse opinions concerning its origins, progress, variations and deviations. The volume of antiquity is in my hands, and in the meditations which those times evoke, I see gathering and taking shape before my astonished eyes those shadowy forces of inspiration.

See on the globe those additional spots set in the midst of deserts, which frighten the mind with terror and remind man that he is naught; those tombs where pride sleeps; those showy storehouses for man's paltry remains. . . .

What mortal in the face of such immensity, is not aware of his own littleness and does not prostrate himself before the Architect, rival of the Creator. . . .

The driving force which impels men to act should incline them to contribute to the happiness of society.

Acting purposefully in this way they cannot fail to dissipate the surrounding shadows, as lamps do when they are so placed that the light shed by each one cannot fail to bridge the darkness between itself and the next.

Let nations sound their trumpets, proclaim their need for all such help! The architect will be prompt to answer the call, and society will receive from his busy and generous hand a rain of treasures poured forth for which he will not require any recompense except to his ashes. Immortality must be his payment, remembered only as is the dew, that brilliant nurse

of our fields, honored when it is no more and when the fruits it has engendered have been harvested.

Posterity will conserve, will pay homage to his memory. In his works, propagators of art, posterity will admire the basic principles. All false amalgam, unique fruit of circumstance, will disappear.

There, as in some primer, these principles will develop with their different results all confirmed by experience. There will be rediscovered the series of simple but positive ideas that served as signposts for geniuses which so strongly fortify the judgment of the men who were destined to follow its path; in the choice of means which will so powerfully support the judgment in the choice of methods and the reasonings, and to the use that may be made of them.

The salubrity of the wind, the most auspicious site on the property, should always precede and determine the disposition and the manner of construction; one should build according to the temperature.

The out-buildings which usually have only perpetuated the faults of conception shall be counted as nothing and the advantages of position should not be subordinated to a use that is considered dangerous.

You must see that ideas relating to the different shapes of building, to their suitability, propriety, and economy make a coherent whole. Unity, always a pattern for beauty, *omnis porro pulchritudinis unitas est,* depends on the harmonious relationship between the main body of the building and its detail and ornament, on the eye being able to appreciate a continuity of line without the distraction of futile accessories.

Variety will give each building its proper physiognomy. Variety multiplies and changes this physiognomy according to the adjacent sites and the prospects opening out to the horizon; from one desire that is satisfied a thousand others are made to bloom.

The suitability which sets off riches and disguises misfortune, will subordinate the concepts to the locality and will meet the different needs through appearances that are both fitting and inexpensive.

Appropriateness will offer us the analogy of proportions and ornaments; it will show at first glance the reason for the constructions and for what they are destined.

Economy of materials will seem more imposing than the

actual expense, thanks to the magic prestige exercises that fools the eye through the arts' wise combinations.

Symmetry must not be forgotten; drawn from nature it can contribute towards solidity and establish parallel relationships that do not exclude the picturesque; I say even more, the bizarre that ought to be banished.

Who would neglect to consider good taste? To it we owe so many pleasures, the means by which ideas take definite shape.

The first reveals the good or bad manner of those who employ it; truly good taste implies the absence of mannerisms; it is not attached as is often believed, to the fleeting wings of caprice nor founded on some fantastic conventions; it is the product of an exquisite discernment which nature has placed in the brain she favors. The second presents infinite exceptions. It teaches us to link the simplest things with those that are composed; it gives us the means to extract the resulting conclusions. . . .

The man of the world indicates his needs; often he indicates them badly. The Architect rectifies them. The former separates general inconveniences from their relative advantages, believing that he has done everything by dictating the necessary; he seeks to legitimize children disbarred by the scruple of art: that is his error.

Nonetheless, the creative power of arrangement or distribution has bases which extend and define the will of man, limiting its errors, and even though they belong to all types of edifices, even though its researches can be individually applied, its modifications are infinite.

Progress has been delayed because only certain aspects of the question of distribution have been considered. Several nations have disregarded the question completely; others have abused the liberty it granted. In Italy where divisions are large, emphasis is on display; in France they are multiplied, fatigued, so constrained in abbreviated levels that one compromises health, convenience, perverts our senses and destroys the benefit of art.

In presenting variety in all the aspects it can take, I am far from believing that it should rest on the changing basis of caprice. Always subject to the refinement of taste, to the severity of lines, to the principle marked out by imperious need which commands all nature, distribution orders all these types of services to gather around it; whether in town or in the

country, it orders the economy of time and the assurance against fantasies which waste it. . . . I will attack, yes, I will attack the abuses due to the servitude to habits that delay the science of distribution; I will tear off the blindfold that for centuries has covered up the restraining practice. A consciousness of what is best will improve conditions more than laying down invariable rules.

Decoration is the expressive character, more or less simple, more or less complex, which is given to each edifice; it distinguishes the altars that dispute eternity with the Supreme Being from the fragile palace sustained by temporary power. It brings surfaces to life, immortalizes them, stamps them with all feeling and all passions. It modifies the irregularities of fate, humbling the ostentatious and uplifting the diffident; it stigmatises ignorance and elevates knowledge, and justly apportioned, it gives to nations the luster which makes them shine, and plunges into savagery those peoples ungrateful or heedless to people who neglect its favors. Sustained by the gentle arts of civilization this finished coquette plays any role. She is by turn strict or easy-going, sad or gay, calm or impassioned, in manner either imposing or seductive; jealous of everything, she is quick to take offense at her surroundings and will not endure any belittling comparison. A center of desires attracted within her orbit, she isolates herself from the outside world,[4] yet in her systematic retreat knows how to maintain the rhythm of her movements.

If science is a step towards perfection, if it lifts man on to a higher plane, this chameleon-like temptress with the transforming powers of the chameleon can transmute ordinary life by presenting the useful in the guise of the pleasant, and by associating with it those attractions and constraints which can turn it to best account.

If architecture will not tolerate directives from groups outside itself, if it finds in its isolation the independence that suits it, then it cannot give any guarantee of a working relationship among its own members.

Beauty can be increased or diminished through juxtapositions; it is fragile, delicate or robust. The pride of correct proportions lies in purity of contours and effective comparisons. Then the eye, wander where it may, will find rest and satisfaction at every turn but be drawn back by the bewitching

[4] Well thought-out decorations must be isolated and not dominated by any body which can destroy their effect or restrain them.

union of art and nature. It is no longer the creation of the architect, whose own magic has made him invisible and caused him to be forgotten; it is the oracle of good taste that proclaims beauty's sovereignty.

If ideas on decorations favor those architectural orders used by all nations; if homage is paid to those species of elongated tapers that bad taste delights in; if, I repeat, the incense of this homage blackens the idol it presumes to honor, yet there remains general agreement as to the beauty of the Greek orders. All the same it would be wrong to maintain that the rules governing them are equally applicable in all places, in all lands. Their diameter and spacing[5] must depend on the distance from which they are viewed. By closing their ranks those powerful columns can increase their impression of strength: nothing impairs the virility of their bearing; seen from close at hand their proportions are majestical, from a distance they are less powerful but become more elegant.

The more delicate orders are privileged beings; they, like sheltered places, are suited to delicate temperaments. The wind and the rain, the frosts of the North and the heats of the South, all crumble that curved acanthus adorning their heads, while Aquarius in his blustering rage blurs the fillets between the flutes.

What days those were when the walls of our rooms were graced by the paintings of the masters, when the cabinet-maker forswearing the tortured line, the partition, the moulding, turned back to styles approved by wisdom. In those days the gods, on guard above our heads, defended our ceilings against depraved fantasies. Our bronzes, our carpets were masterpieces, our silken stuffs from Lyons, companions to the sensuality of courts and the dalliance of kings, carried the beauties of the Vatican into the palaces of northern emperors. But those days are gone; wallpapers, economical to the point of extravagance that a breath can wilt, a sunbeam fade or a puff of wind tear away, sully our salons and our boudoirs with colors blackened under the lavas of Herculaneum. The dignity of our theatres suffers; everywhere the absence of taste is deplored.

I shall vary decoration so as to emphasise its contrasting effects. Quickened by art, stone will waken to fresh feelings,

[5] These orders seem more suited to northern lands. I have often used them successfully by placing them at a distance.

develop its own abilities. For the most part, I shall offer an arrangement that is free and untrammelled, one above all pleasing through its beautiful masses and which owes its pomp to underlying economy, to properly understood contrasts, to a skilful selection of detail which reveals knowledge. I shall avoid delicate ornamentations, those reliefs so vulnerable to wind and rain.

I should like to prove that such treatment is perhaps the only one suited to individual buildings set in great open spaces or exposed to the inclemency of the elements. Indeed, it is perhaps the only one that has the strength to resist destruction. . . .

Architecture is to masonry what poetry is to *belle-lettres;* they are the dramatic expression of the trade; if you speak of it at all, it must be in impassioned terms. If purpose determines form, it is from the latter that emanates the charm of any construction. Since no two men think alike, there can be no uniformity of expression.

Every individual has his own way of feeling, of expressing himself. Sometimes it is like a torrent pouring down from the mountain tops, carrying the rocks in its wake; sometimes like the calm of a beautiful day, the trees serenely mirrored in the silvery face of the moving waters. Man, uplifted, does not wait upon the moment but gives immediate expression to his feelings; the artist must write in the same way as he creates; under his hand offices are transformed into magnificent Propylaea, the house of a dancer into a temple to Terpsichore; the merchant's warehouse blossoms among the gardens of Zephyr and Flora, barren fields bring forth factories, or towns where columns grow alongside nettles.

You ask why I insist on using a decorated style? There must be a feeling of rest, areas of empty space in order to focus attention and bring out objects worthy of being admired. . . . When the architect describes the already abased habits of the country side, he must elevate his reader's soul; if he is not always obliged to give spirit to animals, he is always obliged to animate, I will say more, to breathe life into his walls.

Is he building places of worship or palaces? Often he does not fully accept their challenge. Art that lacks eloquence is like love without virility. The architect must be prepared to dress up his teaching in the trappings of art so that no hint of dry didacticism remains. The least of his schemes must be as rich in possibilities as the greatest, so that if he builds a

small town, from it people will be able to deduce a larger one. With this in mind let him remember that all things, whether pertaining to politics, morals, law, religion or government, lie within his province. . . . But if expression is the image of sentiment, what does he risk in elevating it? We are already too much inclined to debase this sublime art. Furthermore, like a sovereign, has he not the right to create princes, to choose among the humblest of his subjects?

I shall now take advantage of this same sovereign power to touch on a number of subjects which seem at first sight to have no connection with architecture; but allow me to correct myself, can there be any subject upon which architecture has no bearing? Surely the universal knowledge required by this art must include an acquaintance with general administration, court politics, public and private morality, science, literature, rural economy, and commerce. . . .

I shall only have achieved half of my task if the architect who commands all the arts does not command all the virtues. This is a grandiose conception without doubt; but what man wishes in this connection the gods wish also.

After having turned for you the many pages concerned with civic buildings, I shall now show you the Propylaea of Paris, as they were before they were so mutilated, evoking as they do a picture of some of our most interesting sites whose effects seem to belong to the magic world of our theatre.

My intention is to rusticate a small tribe of some eight hundred thousand people so as to ensure it that independence that an isolated position should confer on a town. I will place victory trophies at the exits which mutilate the lines of perspective. I shall transplant mountains, drain swamps and level precipices, so that their vapors, sucked up by the sun can no longer form into swirling clouds only to disgorge themselves on the heads beneath; gentle slopes will be accentuated so as to stimulate the flow of sluggish streams. I shall present roads intended to draw off the traffic from the town center, thus preserving those magnificent avenues, unparalleled in extent, now blocked by excessive loads which destroy the road surface and harass the timid or preoccupied citizen.

I shall show you buildings in such variety that even those thirsting for nothing but diversity will confess themselves satisfied. The outside virtues will be brought to hand so that all

can benefit and additional buildings constructed that adapt older styles to present day needs.

I will replace the splintering pine that the stubborn drops of the equinoctial rains penetrate by solid peristyles that will shelter the tax-payer.

For the first time the roadside tavern and the palace will vie with each other in point of magnificence; moral equality will not suffer, I will say further, will not even be annoyed; indeed those with superior minds and skills will find it a source of pride. Everything will be open to public inspection; building and demolition expenses, the cost of materials even where a loss has been incurred, ministerial conflicts, abuses of authority, the fears of vulgar minds, the consequences of employing people chosen solely to be instruments in hatching plots and carrying out plans of revenge.

All these details are connected to the great event which raise or destroy empires and must be pondered over by those shy, innocent artists who, while exercising their talents, will have to protect themselves against the assaults of mediocrity and the passions that accompany it. These artists will learn that genius creates, that talent undertakes, that aesthetic feeling places. They will also learn that political upheavals put back the clock for centuries, and that by indulging in acts of destruction you only beggar the profession and impoverish art.

ELEVATION OF THE DIRECTOR'S HOUSE

When an idea is relevant both to a particular site and purpose, we always experience astonishment, whether the outlay involved be great or small. It narrows or broadens our outlook, impresses us and wins our respect. It both surprises and moves us so that we are alive to the sensitive, appreciative feeling that inspired it. If it is neither suitable nor based on a properly thought-out point of view, then it will lead us astray.

The building before you dominates less important ones by reason of its height and simple design. By using such a building to crown a mass beneath, you can produce the effect of a pyramid. This I consider to be necessary when dealing with a large area, superfluous when there is a small one. In this case the stage is immense. There are no points of contrast to vary the background, and the vale softened by nature is not terminated by any of those gigantic formations fairly common

in the Franche Comté. Power that does not wear a crown makes but a slight impression. What is a body without its head?

The building should be viewed from 60 lengths away: we know that as you recede from them all objects seem to diminish and to taper off, their proportions are lost. Even by making use of the sturdiest orders you cannot avoid this distortion, while the most elegant ones are quite swallowed up. Colossal dimensions should not be used in private houses because of the multiplicity of storeys and windows. Still less can they be placed in the secondary parts of a plan, when they have already been used in the primary part. This would be a contradiction of effects. Where then is the solution? You must come to terms with the site, allowing it to suggest methods of relating the building both to its function and to its position in the plan. Any shape that can be drawn by a single compass stroke is recognized by good taste. The circle and the square are the letters of the alphabet with which the author will spell out his best work. With these, epic poems and elegies, hymns to the gods and simple airs for shepherds, are composed; temples can be raised up to Valour, Strength, and Voluptuousness; houses are built as well as the humblest places used by the community. When a factory is in question, the use of both round and square pillars, or columns which combine both, would seem more appropriate than just the usual orders. The projecting sections will throw interesting shadows, thereby giving an impression of strength and dispelling the air of slightness which distance produces.

I say further, proud architecture would have disdained the site, elegant architecture would have been still less suitable. Such is the power of forms that dominate distances. Imagination must draw on its own resources if practical considerations have not proved a sufficient guarantee against being led astray by abstract ideas . . .

[EBENEZER HOWARD (1850–1928) was born in London. After an extended trip to the United States he became interested in a method to counteract the industrial congestions of cities in England. He evolved the concept of the "garden city." A few English and American industrialists had preceded in part his notion by moving their factories into the country and estab-

lishing around them industrial villages. Howard's thought was a self-contained town of a predetermined size and plan with the control and limitation of the height of buildings on land that would eventually be owned by the citizens. Any increase in size would be met by the creation of satellites, with none nearer than four miles. The circular plan of Howard resembles that of Ledoux's "Ville Idéale de Chaux" with buildings, factories, stores, and houses placed on belts of open land to combine town and country advantages. In 1901 Howard's conception was realized at Letchwood, England.

Howard published his proposal in his book, *Tomorrow, a Peaceful Path to Reform* (1892). It was republished in 1902 as *Garden Cities of Tomorrow*. A Town and Country Association was formed in 1899 to promote the garden city. Howard served as its president as well as that of the international federation that was founded. By his travels and lectures, Howard contributed to a general-interest in other countries. By focusing attention upon the primary requirements of convenient healthy living and translating them into a specific solution, town planning came to be recognized as a necessary function of government.

SEE: W. Morris, *News from Nowhere,* London, 1890.
L. Mumford, *Culture of Cities,* New York, 1938.
F. R. Hiorns, *Town Building in History,* London, 1956.
C. Tunnard, *The City of Man,* New York, 1953.]

TOMORROW A PEACEFUL PATH TO REAL REFORM[1]

The Town-Country Magnet

The reader is asked to imagine an estate embracing an area of 6000 acres, which is at present purely agricultural, and has been obtained by purchase in the open market. . . .

The objects of this land purchase may be stated in various ways, but it is sufficient here to say that some of the chief objects are these: To find for our industrial population work at wages of *higher purchasing power,* and to secure healthier surroundings and more regular employment. To enterprising manufacturers, co-operative societies, architects, engineers,

[1] Quoted from E. Howard, *Garden Cities of Tomorrow,* Faber & Faber, London, 1902, pp. 53–57.

builders, and mechanicians of all kinds, as well as to many engaged in various professions, it is intended to offer a means of securing new and better employment for their capital and talents, while to the agriculturists at present on the estate as well as to those who may migrate thither, it is designed to open a new market for their produce close to their doors. Its object is, in short, to raise the standard of health and comfort of all true workers of whatever grade—the means by which these objects are to be achieved being a healthy, natural, and economic combination of town and country life, and this on land owned by the municipality.

Garden City, which is to be built near the centre of the 6000 acres, covers an area of 1000 acres, or a sixth part of the 6000 acres, and might be of circular form, 1240 yards (or nearly three-quarters of a mile) from centre to circumference. (Figure 3 is a ground plan of the whole municipal area, showing the town in the centre; and Figure 4, which represents

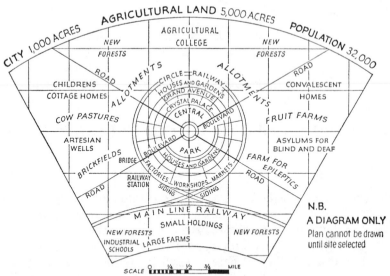

FIG. 3. Howard, Garden City and Rural Belt, redrawn from *Garden Cities of Tomorrow,* London, 1902

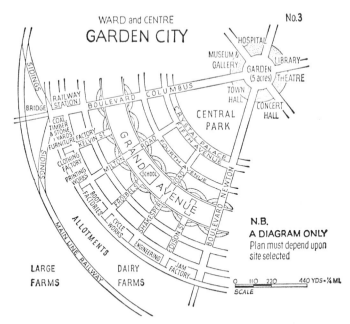

FIG. 4. Howard, Ward and Centre of Garden City, redrawn from *Garden Cities of Tomorrow,* London, 1902

one section or ward of the town, will be useful in following the description of the town itself—*a description which is, however, merely suggestive, and will probably be much departed from.*)

Six magnificent boulevards—each 120 feet wide—traverse the city from centre to circumference, dividing it into six equal parts or wards. In the centre is a circular space containing about five and a half acres, laid out as a beautiful and well-watered garden; and, surrounding this garden, each standing in its own ample grounds, are the larger public buildings—town hall, principal concert and lecture hall, theatre, library, museum, picture-gallery, and hospital.

The rest of the large space encircled by the 'Crystal Palace' is a public park, containing 145 acres, which includes ample recreation grounds within very easy access of all the people.

Running all round the Central Park (except where it is intersected by the boulevards) is a wide glass arcade called the 'Crystal Palace', opening on to the park. This building is in wet weather one of the favourite resorts of the people, whilst the knowledge that its bright shelter is ever close at hand

tempts people into Central Park, even in the most doubtful of weathers. Here manufactured goods are exposed for sale, and here most of that class of shopping which requires the joy of deliberation and selection is done. The space enclosed by the Crystal Palace is, however, a good deal larger than is required for these purposes, and a considerable part of it is used as a Winter Garden—the whole forming a permanent exhibition of a most attractive character, whilst its circular form brings it near to every dweller in the town—the furthest removed inhabitant being within 600 yards.

Passing out of the Crystal Palace on our way to the outer ring of the town, we cross Fifth Avenue—lined, as are all the roads of the town, with trees—fronting which, and looking on to the Crystal Palace, we find a ring of very excellently built houses, each standing in its own ample grounds; and, as we continue our walk, we observe that the houses are for the most part built either in concentric rings, facing the various avenues (as the circular roads are termed), or fronting the boulevards and roads which all converge to the centre of the town. Asking the friend who accompanies us on our journey what the population of this little city may be, we are told about 30,000 in the city itself, and about 2000 in the agricultural estate, and that there are in the town 5500 building lots of an *average* size of 20 feet × 130 feet—the minimum space allotted for the purpose being 20 × 100. Noticing the very varied architecture and design which the houses and groups of houses display—some having common gardens and co-operative kitchens—we learn that general observance of street line or harmonious departure from it are the chief points as to house building, over which the municipal authorities exercise control, for, though proper sanitary arrangements are strictly enforced, the fullest measure of individual taste and preference is encouraged.

Walking still toward the outskirts of the town, we come upon 'Grand Avenue'. This avenue is fully entitled to the name it bears, for it is 420 feet wide, and, forming a belt of green upwards of three miles long, divides that part of the town which lies outside Central Park into two belts. It really constitutes an additional park of 115 acres—a park which is within 240 yards of the furthest removed inhabitant. In this splendid avenue six sites, each of four acres, are occupied by public schools and their surrounding playgrounds and gardens, while other sites are reserved for churches, of such denominations

as the religious beliefs of the people may determine, to be erected and maintained out of the funds of the worshippers and their friends. We observe that the houses fronting on Grand Avenue have departed (at least in one of the wards—that of which Figure 4 is a representation)—from the general plan of concentric rings, and, in order to ensure a longer line of frontage on Grand Avenue, are arranged in crescents—thus also to the eye yet further enlarging the already splendid width of Grand Avenue.

On the outer ring of the town are factories, warehouses, dairies, markets, coal yards, timber yards, etc., all fronting on the circle railway, which encompasses the whole town, and which has sidings connecting it with a main line of railway which passes through the estate. This arrangement enables goods to be loaded direct into trucks from the warehouses and workshops, and so sent by railway to distant markets, or to be taken direct from the trucks into the warehouses or factories; thus not only effecting a very great saving in regard to packing and cartage, and reducing to a minimum loss from breakage, but also, by reducing the traffic on the roads of the town, lessening to a very marked extent the cost of their maintenance. The smoke fiend is kept well within bounds in Garden City; for all machinery is driven by electric energy, with the result that the cost of electricity for lighting and other purposes is greatly reduced.

The refuse of the town is utilized on the agricultural portions of the estate, which are held by various individuals in large farms, small holdings, allotments, cow pastures, etc.; the natural competition of these various methods of agriculture, tested by the willingness of occupiers to offer the highest rent to the municipality, tending to bring about the best system of husbandry, or, what is more probable, the best *systems* adapted for various purposes. Thus it is easily conceivable that it may prove advantageous to grow wheat in very large fields, involving united action under a capitalist farmer, or by a body of co-operators; while the cultivation of vegetables, fruits, and flowers, which requires closer and more personal care, and more of the artistic and inventive faculty, may possibly be best dealt with by individuals, or by small groups of individuals having a common belief in the efficacy and value of certain dressings, methods of culture, or artificial and natural surroundings.

This plan, or, if the reader be pleased to so term it, this

absence of plan, avoids the dangers of stagnation or dead level, and, though encouraging individual initiative, permits of the fullest co-operation, while the increased rents which follow from this form of competition are common or municipal property, and by far the larger part of them are expended in permanent improvements.

While the town proper, with its population engaged in various trades, callings, and professions, and with a store or depot in each ward, offers the most natural market to the people engaged on the agricultural estate, inasmuch as to the extent to which the townspeople demand their produce they escape altogether any railway rates and charges; yet the farmers and others are not by any means limited to the town as their only market, but have the fullest right to dispose of their produce to whomsoever they please. Here, as in every feature of the experiment, it will be seen that it is not the area of rights which is contracted, but the area of choice which is enlarged.

This principle of freedom holds good with regard to manufacturers and others who have established themselves in the town. These manage their affairs in their own way, subject, of course, to the general law of the land, and subject to the provision of sufficient space for workmen and reasonable sanitary conditions. . . .

Dotted about the estate are seen various charitable and philanthropic institutions. These are not under the control of the municipality, but are supported and managed by various public-spirited people who have been invited by the municipality to establish these institutions in an open healthy district, and on land let to them at a pepper-corn rent, it occurring to the authorities that they can the better afford to be thus generous, as the spending power of these institutions greatly benefits the whole community. Besides, as those persons who migrate to the town are among its most energetic and resourceful members, it is but just and right that their more helpless brethren should be able to enjoy the benefits of an experiment which is designed for humanity at large.

CIVIC BUILDINGS

[During the nineteenth century there was a transformation in the nature of government. The separation of the American

colonies from England and the establishment of a new state required the construction of buildings to house the government of the people. The style of the exterior should be appropriate to the idea of the building and a new disposition of the interior space was required to accommodate the different functions of the government.

Throughout the nineteenth century any radical change in the exterior design of the government building was inhibited by taste. Taste required a form that appeared to fulfill the purpose of the building. As the Roman Republic supplied the model for the form of government, and the virtues for the citizens, classical architecture was considered suitable to house the government of a republic.

The Capitol of the State of Virginia (1785–96) was the first major public building of the new republic. The new Federal Capitol (1792–1827) was designed as a building representative of a democratic form of government.

The French Revolution caused new dispositions of space to be made within existing buildings. Few new buildings were erected in France for the new form of government. The legislative chamber of the "Salle des Cinq Cents" of the First Republic was built (1795–97) as a hemicycle by J. P. Gisors (1755–1825) within the old Palais Bourbon. It became the model for the legislative chambers of many states.

A classical international style was used for government buildings of the national states that emerged during the nineteenth century. With the principle of the self-determination of the people in the twentieth century, indigenous forms have gradually come to be regarded as appropriate to symbolize the sovereignty of a people.]

[THOMAS JEFFERSON (1743–1826), the third president (1801–9) of the United States, was educated at William and Mary College, in the provincial capital of the Dominion of Virginia. The designs for its buildings and those of the college may have been provided by the English architect, Sir Christopher Wren, and were the most sophisticated and refined public buildings in the colonies.

When Jefferson went to Paris (1784–89) first as an assistant to Benjamin Franklin, the United States Minister, and then as the Minister, he had the opportunity to observe architec-

ture which he had studied as a young man, and the benefit of discussions with the architect and scholar, Charles L. Clerisseau (1722–1820). Clerisseau was a collaborator of Robert Adam, the English architect largely responsible for arousing enthusiasm for the style of classicism in England.

On learning that construction had been begun on the state capitol building at Richmond, Virginia, Jefferson wrote urging the acceptance of the Maison Carrée, a Roman temple, at Nîmes, France, as the model for the capitol. Its simplicity, beauty of proportion and unobtrusive detail gave it an appearance that the edifice of a capitol should symbolize. This building was familiar to him through Clerisseau's publication, *Les Antiquités de la France, Monuments de Nîmes,* of 1778. Jefferson utilized its classical style for an exterior and compressed within it the offices required for the state's government. The actual sight of the temple in 1797 confirmed Jefferson in the wisdom of his choice.

The Virginia state capitol was completed under Jefferson's supervision with the assistance of Benjamin H. Latrobe (1764–1820), an English architect trained in Germany and England. Latrobe assumed charge of the construction of the Federal Capitol in Washington in 1803. The classical forms that have been faithfully observed in the exterior of the Virginia Capitol were modified to gain a more austere and block-like form for the Federal Capitol.

After his retirement from the Presidency (1809), Jefferson provided the plans for the buildings of the University of Virginia as well as its curriculum. The University is a remarkable architectural entity with two rows of pavilions facing each other that contain the professors' houses and classrooms. The pavilions are linked by porticoed galleries, and two rows are closed at one end by the library. The Greek temple form of the pavilions established a temple-house type that was popular in the western territories up to 1850.

For his own house, Monticello (1808), Jefferson kept the classical style despite its site, modern plan, and ingenious detail; and thus he demonstrated his originality as an architect.

SEE: F. Kimball, *Thomas Jefferson, Architect,* Boston, 1916.]

LETTERS

To James Madison[1]

Paris, September 20, 1785.

Dear Sir,

By Mr. Fitzhugh, you will receive my letter of the first instant. . . .

I received this summer a letter from Messrs. Buchanan and Hay, as Directors of the public buildings, desiring I would have drawn for them, plans of sundry buildings, and, in the first place, of a capitol. They fixed, for their receiving this plan, a day which was within about six weeks of that on which their letter came to my hand. I engaged an architect of capital abilities in this business. Much time was requisite, after the external form was agreed on, to make the internal distribution convenient for the three branches of government. This time was much lengthened by my avocations to other objects, which I had no right to neglect. The plan, however, was settled. The gentlemen had sent me one which they had thought of. The one agreed on here, is more convenient, more beautiful, gives more room, and will not cost more than two-thirds of what that would. We took for our model what is called the *Maison Quarrée* of Nismes, one of the most beautiful, if not the most beautiful and precious morsel of architecture left us by antiquity. It was built by Caius and Lucius Caesar, and repaired by Louis XIV, and has the suffrage of all the judges of architecture who have seen it, as yielding to no one of the beautiful monuments of Greece, Rome, Palmyra, and Balbec, which late travellers have communicated to us. It is very simple, but it is noble beyond expression, and would have done honor to our country, as presenting to travellers a specimen of taste in our infancy, promising much for our maturer age. I have been much mortified with information, which I received two days ago from Virginia, that the first brick of the capitol would by laid within a few days. But surely, the

[1] A. E. Bergh, A. A. Lipscomb, *The Writings of Thomas Jefferson*, Washington, T. Jefferson Memorial Assoc., 1903, Vol. 5, pp. 134–37. [James Madison (1751–1836), fourth President of the U.S.]

delay of this piece of summer would have been repaired by the savings in the plan preparing here, were we to value its other superiorities as nothing. But how is a taste in this beautiful art to be formed in our countrymen unless we avail ourselves of every occasion when public buildings are to be erected, of presenting to them models for their study and imitation? Pray try if you can effect the stopping of this work. I have written also to E.R. [Edmund Randolph] on the subject. The loss will be only of the laying the bricks already laid, or a part of them. The bricks themselves will do again for the interior walls, and one side wall and one wall may remain, as they will answer equally well for our plan. This loss is not to be weighed against the saving money which will arise, against the comfort of laying out the public money for something honorable, the satisfaction of seeing an object and proof of national good taste, and the regret and mortification of erecting a monument of our barbarism, which will be loaded with execrations as long as it shall endure. The plans are in good forwardness, and I hope will be ready within three or four weeks. They could not be stopped now, but on paying their whole price, which will be considerable. If the undertakers are afraid to undo what they have done, encourage them to it by a recommendation from the Assembly. You see I am an enthusiast on the subject of the arts. But it is an enthusiasm of which I am not ashamed, as its object is to improve the taste of my countrymen, to increase their reputation, to reconcile to them the respect of the world, and procure them its praise.

I shall send off your books, in two trunks, to Havre, within two or three days, to the care of Mr. Limozin, American agent there. I will advise you, as soon as I know by what vessel he forwards them. Adieu.

Yours affectionately

To the Directors[2]

Paris, Jan. 26 — 1786

Gentlemen,

I had the honour of writing to you on the receipt of your orders to procure draughts for the public buildings, and again on the 13th of August. In the execution of those orders two methods of proceeding presented themselves to my mind. The one was to leave to some architect to draw an external according to his fancy, in which way experience shows that about once in a thousand times a pleasing form is hit upon; the other was to take some model already devised and approved by the general suffrage of the world. I had no hesitation in deciding that the latter was best, nor after the decision was there any doubt what model to take. There is at Nismes in the South of France a building, called the *Maison Quarrée,* erected in the time of the Caesars, and which is allowed without contradiction to be the most perfect and precious remain of antiquity in existence. Its superiority over anything at Rome, in Greece, at Balbec or Palmyra is allowed on all hands; and this single object has placed Nismes in the general tour of travellers. Having not yet had leisure to visit it, I could only judge of it from drawings, and from the relation of numbers who had been to see it. I determined therefore to adopt this model, & to have all its proportions justly drewed. As it was impossible for a foreign artist to know what number & sizes of apartments could suit the different corps of our government, nor how they should be connected with one another, I undertook to form that arrangement, & this being done, I committed them to an Architect (Monsieur Clerisseau) who has studied this art 20 years in Rome, who had particularly studied and measured the *Maison Quarrée* of Nismes, and had published a book containing 4 most excellent plans, descriptions, & observations on it. He was too well acquainted with the merit of that building to find himself restrained by my injunctions not to depart from his model. In one instance only he persuaded me to admit of this. That was to make the Portico two columns deep only, instead of three as the original is.

2 Quoted from Kimball, Fiske, "Thomas Jefferson and the First Monument of the Classical Revival in America," reprinted from the *Journal of the American Institute of Architects,* Vol. 3, September 1915.

His reason was that this latter depth would too much darken the apartments. Economy might be added as a second reason. I consented to it to satisfy him, and the plans are so drawn. I knew that it would still be easy to execute the building with a depth of three columns, and it is what I would certainly recommend. We know that the *Maison Quarrée* has pleased universally for near 2000 years. By leaving out a column, the proportions will be changed and perhaps the effect may be injured more than is expected. What is good is often spoiled by trying to make it better.

The present is the first opportunity which has occurred of sending the plans. You will accordingly receive herewith the ground plan, the elevation of the front, and the elevation of the side. The architect having been much busied, and knowing that this was all which would be necessary in the beginning, has not yet finished the Sections of the building. They must go by some future occasion as well as the models of the front and side which are making in plaister of Paris. These were absolutely necessary for the guide of workmen not very expert in their art. It will add considerably to the expence, and I would not have incurred it but that I was sensible of its necessity. The price of the model will be 15 guineas. I shall know in a few days the cost of the drawings which probably will be the triple of the model: however this is but my conjecture. I will make it as small as possible, pay it, and render you an account in my next letter. You will find on examination that the body of this building covers an area but two-fifths of that which is proposed and begun; of course it will take but about one half the bricks; and of course this circumstance will enlist all the workmen, and people of the art against the plan. Again the building begun is to have 4 porticos; this but one. It is true that this will be deeper than those were probably proposed, but even if it be made three columns deep, it will not take half the number of columns. The beauty of this is ensured by experience and by the suffrage of the whole world; the beauty of that is problematical, as is every drawing, however well it looks on paper, till it be actually executed: and tho I suppose there is more room in the plan begun, than in that now sent, yet there is enough in this for all the three branches of government and more than enough is not wanted. This contains 16. rooms. to wit 4. on the first floor; for the General court, Delegates, Lobby, & Conference. eight on the 2d floor for the Executive, the Senate, & 6 rooms for com-

mittees and juries: and over 4. of these smaller rooms of the 2d floor are 4. Mezzaninos or Entresoles, serving as offices for the clerks of the Executive, the Senate, the Delegates & the Court in actual session. It will be an objection that the work is begun on the other plan. But the whole of this need not be taken to pieces, and of what shall be taken to pieces the bricks will do for inner work, mortar never becomes so hard & adhesive to the bricks in a few months but that it may easily be chipped off, and upon the whole the plan now sent will save a great proportion of the expence. In my letter of Aug. 13, I mentioned that I could send workmen from hence as I am in hopes of receiving your orders precisely in answer to that letter I shall defer actually engaging any till I receive them. In like manner I shall defer having plans drawn for a Governor's house until further orders, only assuring you that the receiving and executing these orders will always give me a very great pleasure, and the more should I find that what I have done meets your approbation. I have the honour to be, etc.etc.

<div align="right">TH: JEFFERSON</div>

THE MONUMENT

[Symptomatic of a cultural change that occurred in Europe at the end of the eighteenth century and continued in the nineteenth century was the appearance of the monument. The nineteenth-century monuments are differentiated from those of the periods following the Middle Ages by their gigantic size and their association with the glorification and commemoration of a collective national sacrifice or the personification of the nation as symbolized by a father-leader.

The monuments were of two types, the column and the temple-shrine-mausoleum, with the notable exception of the Arc de Triomphe in Paris. The prototype for shrines to nationality such as von Klenze's Walhalla (1831–42), National Monument to Bavaria (Ruhmeshalle) (1843–53), and the monument to Victor Emmanuel II (1885–1911) in Rome was Friedrich Gilly's drawing (1799) for the temple-mausoleum to honor the head of the Prussian state.

In the spring of 1801, the Deputies of the First Republic of France issued a decree that answered the hope "for some

monument that would attest to the ages what this nation was"
and stipulated that "a colossal triumphant memorial column
will arise and perpetuate our glory as well as the memory of
the heroes to whose blood we owe our repose . . ." A wooden
model was constructed in the Place de la Concorde with an
alternative site on the hill of L'Etoile proposed. In 1806, fol-
lowing a decree of Napoleon that authorized a monument
to glorify and commemorate the sacrifice of the armies for
the nation, the colossal Arc de Triomphe was built (1809–37)
on the hill of L'Etoile.

A permanent column, the Colonne de la Grande Armée,
was finally erected (1810) with the Napoleon's statue crowning
it, in the Place Vendôme.]

TREATISE ON ARCHITECTURE[1]

Notes

In architecture, the true significance of the word "colossal"
is often confused with the word "gigantic" and that which the
artist uses, "great" [grand]. They are very different things.

A colossal monument should excite our admiration. To be
convinced of this truth, it is sufficient to say that it is an ex-
traordinary monument. Its proportions should dwarf every-
thing around it. The idea prompting it should be a great one;
in a word it must, in its own way, be unique.[2]

The Trajan Column in Rome is the best example of this
that I can offer. This monument excites our admiration. Its
proportions are extraordinary, the idea of it astounding; the
architecture, the sculpture of the bas-reliefs, the choice in
ornamentation, all of these are admirable. Proportions which
are gigantic, far from enhancing a general effect, lessen it. St.
Peter's in Rome is the obvious proof of this theory. This
Basilica is well known to be the biggest in Europe, but in this
church one experiences no sensation relevant to its size. This

[1] Translated from Boullée's *Treatise on Architecture*, ed., H. Rose-
nau, London, 1954, p. 98. [For headnote on Boullée see page 190.]
[2] [But W. Kandinsky noted: "Das Kolossale ist nicht das Monu-
mentale" in *Uber das Geistige in der Kunst,* Munich, 1912. I am
grateful to C. Giedion Welcker for this note.]

cannot be said of what one feels on entering the Rotunda. The astonished spectator leaves it with admiration.

The art of producing something great in architecture springs from an ingenious combining of the parts and the whole. This idea I have developed in my article *Metropole,* where I have tried to put forward all the ways and means in architecture that can be used when building a place of worship.

The Egyptians had very great ideas: we rightly admire their Pyramids. The arrangement of architecture prevailing in their temples is the very image of greatness. In their representations of their gods, the colossal is carried to the greatest degree possible.

[FRIEDRICH GILLY (1772–1800), son of the architect David Gilly (1733–1808), was called upon by Friedrich II to embellish Berlin, along with the architects, F. von Erdmannsdorff and K. G. Langhans, and the sculptor Gottfried Schadow. The first monument, and one that would be characteristic of Romantic Classicism everywhere was Langhans' Propylaeum to the city's center, the Brandenburg Gate (1789–93), topped with a classic *quadriga* designed by Schadow. The gate, original in composition, was executed in a modified Greek Doric style and also reflected Winckelmann's requirement of archaeological accuracy.

Friedrich Gilly, carefully trained from childhood to be an architect, was twenty-four when he executed his influential and original design for the Temple of Honor for Friedrich II (Ehrentempel für Koenig Friedrich den Grossen von Preussen). He audaciously placed a Doric temple on a massive masonry substructure pierced by vaults and arches in an open, but defined space and gave architectonic form to the classical elements he utilized. Such a temple to honor the king who inaugurated a new era for the Prussian state required extraordinary proportions so that it might tower above the ordinary. Gilly's conception, a by-product of an incipient romanticism and the individual's identification with his native land, separates this monument from the mausolea of the past and establishes a new form that is a tribute to nationality.

Similar originality is found in Gilly's plan for the National Theatre in which he breaks away from the amphitheater of antiquity and employs ascending steps of loges. In his de-

signs for town and country houses, the classical rigidity of the individual elements is loosened to benefit the effect of the whole.

After a study trip to France and England in 1797–98, Gilly returned to Berlin and was named a professor at the newly founded Bauakademie. He died the following year.

Most of Gilly's work is to be found in sketches and drawings. This was due not only to his sudden death and the external political situation, but also to the difficulty of securing a patron willing to translate into reality designs that reflected the artist's heroic and exalted conception of life. In this respect, Gilly shared the fate of other revolutionary artists of his time, and likewise left a rich bequest of designs to be exploited by succeeding generations.]

NOTES ON A SKETCH FOR A MEMORIAL MONUMENT TO FRIEDRICH THE GREAT[1]

One must consider this object less from external power than from inner values. The degree of dignity in the statue is worth more and makes it more characteristic than the features of the king would do, and I would like to say that one should pay more attention to that than to the truthfulness. Any lavish adornment of the external enclosing form is superfluous; it becomes a matter of indifference when not an annoying disturbance to the observer. Not Corinthian, not rich pomp. The dignity of the object leaves everything behind and below. Let the only splendor be simple—*the most simple*—beauty! Reverential size which removes all exuberant voluptuousness, which guides the sight with dignity to the great object and which does not represent more than an enclosure in proportion to the statue. Let this external enclosure show, even in its simple form as well as in its fixed and indestructible scale, that it is supposed to contain a single, unforgettable object for posterity; and thus it will appear as a unique, honourable monument for mankind.

A covered and closed room must be very large in order to seem large. Using glass for covering is improper. I know

[1] Translated from the text as given in A. Rietdorf, *Gilly, Wiedergeburt der Architektur,* Hans Hugo Verlag, Berlin, 1940, pp. 52, 57–61. [These are fragmentary notes written on a sheet of sketches for the Memorial Monument.]

of no more beautiful effect than to be enclosed on all sides—cut off from the bustle of the world, so to say—and to see above the open sky. In the evening . . .

Also large in scale. Easily the largest in the whole city. Jupiter's temple at Agrigentum. The *ancient people* have obeyed as a whole this role. In the detail, however, one often finds disproportions because of the architects whose monuments we still see today. There are too many and from various times. Athens is an example. Acropolis, Rome, however, not. Here a scale is assumed inasmuch as a scale is given to the antique statue. It is not yet colossal. In this respect architecture is the only art form, the works of which can become colossal without detriment. Only reduction in size makes them in their total effect a plaything. (The proportions, however, would remain beautiful and exquisite even in the model.) May there be found on all sides the strength and the means to raise such a monument to a noble size.

A SHORT EXPLANATION OF THE DESIGN FOR A MEMORIAL TO FRIEDRICH THE GREAT

Primary attention for the realization of the idea of a memorial to Friedrich—a temple with the statue of the late king —was first directed to a place suitable for the complete execution of the work. One believed that a better place was not to be found within the walls of the city than the octagon at the Potsdam Gate, where one of the longest and most beautiful streets of the city ends. This place offers the most imposing and advantageous impression of the beauty of the capital to a stranger entering through the main gate from one of the most frequented and conveniently designed military highways connecting the two [royal] residencies. In addition this square has all the other advantages which such a place must necessarily have and which another would hardly be able to offer:

It is not remote and is frequented by the inhabitants and travellers.

It belongs to the most beautiful part of the city, that is, to that part which owes its present beauty to the late king.

It is of a size that offers sufficient room for the projected work.

In the event of the completion of the work, the square, with suitable embellishment of the surrounding houses and

with the planting of trees that would be conducive to pleasant walks, would attract even more people; but also because of its close connection with the Tiergarten, would provide an even more pleasant and agreeable walk.

Although the square is frequented and would gain in popularity by the above mentioned embellishments, it is nevertheless removed from the bustle of business establishments. In their vicinity one could not avoid that at times the atmosphere of such a sanctuary might be desecrated through profane and scandalous scenes.

On the square the monument would appear best in all of its size, because no other building surrounding the square through unusual size or height could weaken the intended extraordinary effect of the monument. This, however, would easily be the case in all other squares of the city, much to the disadvantage of the work.

Since this square is in close proximity to the gate and road leading directly to Potsdam, the visitor to the monument can in no way escape the thought of Potsdam as the second residence of the late king, from where such blessings were poured out on the Prussian state through Friedrich's hand.

To be sure, one could make the objection that, if such a large building in a colossal style were shown to the stranger immediately upon entering the city, he would fix in his imagination a scale too large for the evaluation of the other buildings. These, in turn, would be bound to produce a poor impression, if these buildings did not correspond to the large scale.

However, if these other buildings are constructed according to a scale corresponding to their purpose, the last mentioned apprehension will hardly apply to a stranger with taste and good judgment; rather, the impression first gained through the monument will be even more lasting. The location of the monument in the center of the city, where it is surrounded by many other buildings, would make this impression more fleeting and weaker. Even those buildings next to the monument or in its vicinity will in turn lose their otherwise peculiar effect.

The monument itself stands in the center of the octagonal, oblong square. The temple rises from a rectangular base of dark color, in which the ascents to the temple are located. Vaulted arcades open a view through the base from the gate to the end of the street. Inside the base there is a broad vault,

which could perhaps be used for the display of a sarcophagus. That way the monument would receive an even higher value. Above the sarcophagus, which cannot be touched directly because of its manner of display [position], can be seen the wreath of stars in the eye of the vault. Covered with a bronze roof, the temple is of a lighter material in order to make striking the noble effect of its gleam against the sky. It is rectangular in the Doric order, after the manner of the ancient Greek temples, without any playful ornaments. A few parts on the columns at the entablature and [other] architectural decorations are in gilded bronze.

In the tympana of the temple are two bas-reliefs in ungilded bronze:

a) From a chariot drawn by winged horses, Friedrich, armed with lightning bolts, strikes his enemies to the ground: the eagle with the wreath of victory hovers above him.

b) Before the assembled people Friedrich appears on his throne with the palm of peace: the eagle, holding the bolts of lightning, rests beside him.

The open rows of columns in the halls lead to the interior of the temple, where the statue is placed on a large base in a niche opposite the entrance. Light enters the temple from above. This is the most beautiful kind of illumination, especially for a statue, which is never well illuminated in the open or in a sidelight, especially by several openings or even windows. Coming out of the temple one has from the top steps a view over a large part of the royal city, Friedrich's creation. A unique panorama of its kind!

Around the monument in the square there runs a street for carriages and riders. Somewhat elevated and next to the houses there is a tree-lined path or rather a promenade for pedestrians. The entrance to the square from Leipzig Street is decorated by four obelisks, two on each side of the gate. At the corners of the street are two resting lions of bronze intended for fountains.

The gate with the adjacent parts of the city wall and all surrounding buildings must appear to be built in a style which fits homogeneously into the effect of the whole. The gate has such a large arch that two carriages side by side can pass through it. Along the sides between the columns is a path for pedestrians. Under the covered gate carriages and people entering or departing are checked by guards and officials. Both openings to the sides between the colonnades are suffi-

ciently large to offer a convenient place for the guards' weapons and for their exit and on the other side a place for the business of the officials.

On top of the gate a quadriga stands without the statue of a victor or a nike, only with a victory standard to which the reins are tied after the example of antiquity; the horses are in the moment of taking a last step. The part of the fields lying outside the city wall and adjacent to the gate and the highway has to be laid out in such a way that the entrance into the gate and into the square of the monument is not disturbed by any disgusting and unpleasant impressions, but rather through some suitable landscaping is made pleasanter.

This could perhaps be best accomplished by the right planting of the area with trees, through the drainage of the frequently accumulating swamp water into a large basin, as in a reservoir—and by the removal of some small, shabby houses along the highway, and with some boulevards. This new, beautified park could be connected to the near-by Tiergarten.

AN HISTORICAL NOTE ON CHALGRIN[1]

The Arc de Triomphe

. . . It was as a guarantee of a peace even more deceptive than all the others that the colossal arch of the Etoile was begun, in 1809, whose completion Providence seems to have delayed on purpose to an era that has seen the closing of the sources of all discords, and for a reign which alone would have the right to raise the monument of universal peace.

[1] Translated from *Recueil de Notices Historique lué dans les séances publiques de l'Académie Royale des Beaux Arts,* Paris, 1834. An historical note on Chalgrin, Architect, Member of the Ancient Class of the Beaux Arts of the Institute, read [by Quatremère de Quincy] at the Public Meeting, October 5, 1816. [J. F. Chalgrin (1739–1811), a pupil of Servandoni (1695–1766), winner of the Grand Prix in Architecture, who, after his return from Rome, built much in Paris. Among his buildings best known are the Hotel Talleyrand, the church St. Philippe du Roule (1764–84), the north tower of St. Sulpice. The Arc de Triomphe (160 feet high, 150 feet wide, 72 feet deep) was completed, after Chalgrin's designs, in 1837.]

It would be impossible to relate by what strange quirk two architects (Raymond and Chalgrin) were at the beginning jointly charged with a work as simple and as unified as the arch of which we are speaking. . . . In the end Raymond obtained permission to leave the project; and Chalgrin, to have constructed in scaffolding and painted canvas, the model of his plan on the site. . . . You will remember, gentlemen, the majestic effect of this gigantic mass which dominated all Paris and promised one of those works capable of defying all those of ancient Rome and of ancient Egypt.

It was on this model that proceeded, first under the direction of Chalgrin, and after him under that of Goust his pupil, the execution of a monument in which the nobility of the mass and of the details, the hardness of the stone, the beauty of the decoration, and the solidity of the construction, make a new consecration strongly desired which will assure France of the completion of the greatest work of architecture that ever existed in this type.

Let us not be afraid to repeat that physical grandeur is one of the principal causes of the value and the effect of architecture. The reason is that the greatest part of the impressions produced by this art belong to the sense of admiration. Man's instinct is always to admire grandeur, which is always joined in his mind with ideas of strength and power. Enjoying this sensation, seeking it out in nature whose immensity humbles and humiliates him, reproaching him with his own smallness; how much more he enjoys himself in the presence of the grandeurs of architecture, in a relationship which flatters his pride; for at that moment he believes himself to be as great as he feels small. This is because he is proud to find himself small beside the work of his hands.

Chalgrin, who knew all the secrets of his art, realized that the tribute of admiration is only paid to monuments in which the feeling or the idea of greatness dominates. He also knew that, in addition to this grandeur which the architect cannot always achieve, there is another which he should always be able to make apparent, no matter what the dimension of the edifice, that is that which is the result of solidity, not only real, but apparent, in the construction; because sufficient solidity is not enough, there must be an over sufficiency so that people will feel that there is really enough. This over sufficiency is for them the guarantee of the durability of buildings, and without that guarantee there can be no feeling of grandeur. . . .

THE CEMETERY

[The congestion of the cities and the growth of population at the end of the eighteenth century placed a heavy strain on the Christian practice of burying the dead within the church or the churchyard. Unsanitary conditions were caused by a lack of space available in both places. A general secularization of society that had already begun was accelerated by the French Revolution to effect basic changes in the burial customs of northern Europe. During the Revolution the nation provided for the funerals of its martyrs. The church was no longer the sole custodian of the dead. The charnel house, the deposit of bones in the church's vaults and yard to await there the day of resurrection, gave way to a popular urge to possess a plot of ground in which to rest when one was dead.

To correct the unsanitary conditions and to answer the demand of individuals for a burial place of their own, the French government made provision in 1804 for the establishment of secular cemeteries outside Paris. On Mount Louis, the Prefect of the Seine bought for the *Cimetière de l'Est* 200 acres. They included the site of the *maison de plaisir* and garden of Louis XIV's confessor, Père La Chaise, and his name became the familiar one for the cemetery.

The task of designing the first secular cemetery was given to the architect A. Théodore Brongniart (1739–1813), a pupil of Boullée. He devised a type of *jardin Anglais,* a plan that recalled the tomb-lined winding paths of Lenoir's "Jardin Elysée." Brongniart joined the picturesque park to an avenue that, by an earlier plan, had been laid straight from the gate to a central chapel.

The first dead were interred in the new cemetery in 1804 and were marked with simple monuments. In 1806, with the order by a rich merchant for an elaborate tomb to be built on the burial plot he had bought, a new trend set in that called for monuments of art to glorify the dead. In 1813, a public procession brought the remains of the popular teacher and mediocre poet, Delille to the cemetery, and a monument to him was erected by public subscription. With the dissolution of the Musée des Monuments Français and the Jardin Elysée, certain sepulchral monuments were transferred to "Père La Chaise," among them the tomb of Abélard and Héloïse.

By the presence of these monuments, the cemetery was transformed into a shrine where art was used to glorify and recall to memory the spirit of the illustrious dead, now resting in native soil. It became a Jardin Elysée, a type of an "Apotheosis" of the gifted, the famous, and the wealthy, an assembly that brought the aura of the glory of the departed to the site. Planting of willows and cypress trees around the architectural monuments and sculptured memorials suggested an atmosphere of melancholy and repose and summoned up recollections of things past.

The Cimetière de l'Est, called "Père La Chaise" became the prototype for the garden cemeteries of northern Europe and America that attracted the tourists and were a favorite place for Sunday promenades during the nineteenth century.]

Funeral Monuments or Cenotaphs[1]

O Temple of death! the heart must freeze at your very sight! O artist! shun the light of Heaven! Descend deep into the Tomb, let the Sepulchral Lamps, with their wan, expiring gleams, light your way!

It is obvious, when building this kind of monument, that your intention is to immortalise the memory of those to whom it is consecrated. They must therefore be so constructed as to withstand the ravages of time.

The Egyptians have left us some celebrated examples of this. Their Pyramids are genuinely characteristic; their arid, unchanging piles are the very picture of desolation.

This kind of building, more than any other, cries out for the poetic in architecture. It is this especially affecting poetry that I have tried to emphasise in this work. Having formed the plan of making the entrance to a cemetery characteristic of the abode of death, I had a new and daring idea, that of chthonic architecture.

I propose to allow the reader to follow the sequence of my ideas, so that a rehearsal of the pitfalls may enable those embarking after me on a career in the arts, to avoid some of them.

In considering all the methods I might use in representing this subject, I had the feeling that I should only use propor-

[1] *Boullée's Treatise on Architecture,* ed., H. Rosenau, London, 1954, pp. 80–85, 94. For headnote on Boullée, see p. 190.

tions that were low or sunken (if I may so express myself). After having said to myself that an absolutely bare, denuded wall could be considered as the skeleton of architecture, then in order to present it as chthonic, I had to create something which, though satisfactory in its general effect, yet made the spectator feel that the earth had in some way hidden part of it from his sight.

It was after these general ideas had come to me, ideas quite in keeping with their subject, that I took up my pencil. But how great the distance between the conception of a plan and its execution! Making one's meaning clear is certainly the most difficult part of art.

If the Reader will but consider how difficult it is to produce a general effect which satisfies by the part above ground, without there being recourse to the parts beneath; if he will further consider that in this work I have limited myself to presenting only bare, denuded walls, and that finally there is no previous example of a like work, he will realise straight away that, however happy the idea seemed to the creator, only the first step has in fact been made towards its execution, which cannot be carried through in a moment. I must confess to having spent some little time on my drawings before I felt at all satisfied.

There may be people, little versed in the arts, who are surprised that a work which seems simple to them, should have caused so much trouble to its creator. Shall I tell them the reason? It is precisely because the work is a simple one.

The general effect of the Cenotaphs I am describing, is that of a precinct in the middle of which the principal monument rises up. The enclosing wall is formed of charnel houses, amongst which are to be found chapels for burial services. So as to keep the symmetry perfect, also so that the style of the general effect and of the individual buildings should be in keeping, I have made the charnel houses the equal in mass of the entrance. Nevertheless, the decoration of the chapels has no resemblance to that of the entrance, though the decoration of each is in keeping with its function.

As the Cenotaph is the principal monument, it is situated at the centre of the precinct; in the manner of the ancients, it is isolated on all sides.

I have supposed the one whose pyramid is bounded by a quadrilateral to be a monument erected in honour of a hero who, having saved his country by winning a considerable bat-

tle, had yet met his death on that field. The glorious death of Marshal Turenne[2] was the origin of this idea. Thinking that in this work I ought to find some means of uniting the laurel and the cypress, I have used a funerary triumphal arch to mark the entrance to the Cenotaph. I consider that in this way, through the use of the trappings of honour awarded to the victor, I have emphasised the glory of the hero; also, that by its very style the monument demonstrates as plainly as possible the sorrow of fatherland and the desire to immortalise the memory of this hero.

The intention being for this kind of monument to give an impression of grief, I have avoided any richness of style. In order that it should retain a character of immutability I have not even allowed myself to break up the mass with detail. To the Pyramid I have given the proportions of an equilateral triangle because absolute regularity means a beautiful shape.

Vaulted roofs crown the interiors of all the monuments, the vaulting starting above the entablature. In this one I wished it to start at ground level, pursuant to my remarks above that these monuments must have proportions that are low and sunken, and that if the general effect is satisfying to the spectator, he will presume that part of it is hidden in the ground beneath.

I shall not give a detailed description of the conically shaped Cenotaph. As it has been thought out on the same principles as the one above, I should only be repeating myself. It is for the public to judge of the manner in which it has been decorated.

My mind still running on this kind of architecture, after having tried to give a picture of chthonic architecture, I had a new idea. It was that of an architecture of shadows.

Everyone is familiar with the result of placing an object against the light; the shadow thrown is shaped like the object itself. The beautiful art of painting was born from this natural phenomenon. Love, we are told, inspired the fair Djbutade with this idea. As far as I am concerned it was love of my art.

The uncultivated mind remains unmoved by the effects of nature, which are ever present and which, lacking the attraction of novelty, no longer stimulate curiosity. For the artist this is quite untrue; always under the stimulus of new discoveries, he spends his life observing nature.

2 He was killed at Sasbach, 1675.

Happening to be in the country where I was skirting a wood one moonlit night, my attention was excited by an effigy of myself, produced by the action of the light (this surely was nothing fresh to me). Owing to my peculiar frame of mind, the effect of this phantom self was one of deep sadness. The shadows of trees drawn on the ground affected me profoundly. My imagination working on the theme, I began to take note of everything that was sombre in nature. What did I see? A mass of objects, black against the palest light. Nature seemed to mourn beneath my eyes. Struck by the effect on my feelings, I endeavoured, from that moment, to apply the same principles to architecture: I sought to create a general effect through the use of shadows. To this end I thought that light (as I had observed it in nature) could complete everything engendered by my imagination. This was how my mind went to work whilst I was creating this new style of architecture.

Unless I am mistaken, by using this method funeral monuments can be given the character most in keeping with their function. I can imagine nothing more melancholy than a monument fashioned out of a surface that is level, bare and denuded, a material that absorbs all light, that is void of all detail, and whose decoration is formed by a play of shadows thrown by still deeper shadows.

No; no sadder picture could be drawn, and setting all beauty aside, no one could refuse to recognize in this creation an architecture that is the personfication of sorrow.

The homage which we are pleased to offer to the great has its source in feelings aroused by the exalted position to which we have raised them. We like to find in one of our fellow men a degree of perfection that enables us to see our own natures as touched by the divine. Our appreciation is the more acute in that, if our self-esteem fails to bridge the distance between our two selves, at least we are the less aware of how great that distance is.

To Newton[3]

O Mind so Sublime! Deep and all embracing Genius! Divine Being! Newton! Deign to accept such homage as my poor talents can offer! If I dare to make my plan public, it is because I am persuaded that I have surpassed myself in the work I am about to discuss.

O Newton! If it be the light radiating from your supreme genius that has fixed the earth in its course for us, I, in my turn, propose that you should lie wrapped in your discovery as in a mantle. In a sense it is your own self that will mantle you round, for how would it be possible to find, outside of yourself, one thing worthy of you! It was these feelings that determined me to fashion a representation of the earth as your sepulchre, with flowers and cypress, in the manner of the ancients, as an encompassing mark of homage.

The interior of the sepulchre is conceived in the same way. In using, Newton, your divine system to shape the sepulchral lamp which lights your tomb, have I not shown myself supreme? It was the only ornamentation I thought fit to use. It would have been sacrilege to have decorated this monument in any other way.

After having finished this work, a feeling of uneasiness came upon me which made me wish to express, in the interior of the tomb, ideas for which there seemed, in fact, to be no means of expression. You will see what study and perseverance can bring about, where a man has a real love for his art.

My mind was running on scenes of grandeur in nature. I bemoaned my inability to translate them. Newton belonged in the abode of the immortals, in the heavens themselves.

Look now at my design, there the impossible has been translated into fact. You see before you a monument in which the spectator finds himself transported, as if by magic, high into the very atmosphere, wafted as though on a cloud through infinite space. As a drawing can only render imperfectly so extraordinary an effect, giving nothing but a vague semblance

[3] [Isaac Newton (1642–1727), mathematician and natural philosopher, whose discoveries of the law of gravitation, of the compound character of white light, and inventions, a reflecting sextant, known as Hadley's sextant, for observing the distance between the moon and the stars, and theological writings made him a popular idol of enquiring, restive minds of the eighteenth century.]

of the shapes, I shall try to supplement it with the following description.

The monument is shaped in its interior like a vast sphere, with access to its centre of gravity through an opening cut in its base, on which I have placed the tomb. This shape has one unique advantage; whichever way you direct your gaze (the same is true in nature) you see nothing but a continuous surface with neither beginning nor end, and the more you look, the further this surface reaches out. This shape, never before put to use, and which is alone suited to this monument, is such, by reason of its curve, that the spectator can never draw near to what he looks upon; as though overpowered by a hundred circumstances, he is forced to remain in his allotted place which, fixed as it is at the centre, keeps him at a distance favourable to illusory effects. These delight him, but unable to satisfy his curiosity by a closer approach, his pleasure remains unclouded. Isolated on all sides, his gaze can but reach out to the boundless heavens. Only the tomb has material form.

The clear light of a night sky should be the only form of lighting for this monument, and should come from the stars and heavenly bodies decorating the vaulted heaven. The arrangement should follow that of nature. The stars are made and shaped by funnel-shaped opening, pierced from the exterior of the vault until they reach the interior with the desired shape. Light from outside, filtering through these openings into the dark interior, will pick out all the details of the vault with a sparkling, flashing effect. The verisimilitude of this method of lighting the monument will reproduce the brilliance of starlight.

Imagine how perfect an illusion you could create, by increasing or diminishing the light in the interior of the monument according to the number of stars; also, to what extent the darkness of the place would further the illusion.

It is nature who is the fount of all the impressions made on you by this lofty scene. It would be impossible, using ordinary artistic media, to produce like effects. How could you reproduce by means of paint, the azure of a clear night sky, without hint of a cloud, the colour barely discernible, lacking hue or tone, and against this sable background the winking stars, all scintillating light, must be pricked out.

In order to reproduce accurately every tone and effect that could aptly be used in such a monument, I had to use all the magic of my art, and, by painting after nature, bring all her

forces into play. This discovery in artistic method is mine. Do
I hear someone protest that he has seen something of the sort
before? Shall I have thrust before me, by way of example,
some place or other which is lighted by means of holes? I
know all this as well as the next man. But what manner of im-
pression do these places produce? I am not debating the
method, but the result; and should anyone presume to declare
that I have nothing new to offer, nothing sucked from my own
breast, why then, before the advent of Newton, did no one
see an apple fall to the ground? What happened, I shall ask,
before so divine a mind, etc., etc.? Finally, let me add that the
palette of the merest dauber is dressed in the same colours as
that of the most skilful artist; the ink with which the fool blots
his paper is identical with that of the man of genius.

Recapitulation

. . . In designing my funeral monuments, my intention has
been to lead man back to virtuous ideas by inspiring him with
a horror of death. Newton's Cenotaph was meant as the em-
bodiment of the greatest of all conceptions, that of infinity;
this lifts us on to the plane of contemplation when God is
immanence and celestial stirrings draw near.

What I will name the architecture of shadows is my own
discovery in art, which I willingly offer to those following me
in a career in the arts. . . .

THE MUSEUM

[The Museum is an architectural form typical of the end of
the eighteenth century and first half of the nineteenth century.
It was a by-product of the eighteenth century's compulsion to
systematize and classify accumulated knowledge and the ap-
pearance of a consciousness of history, for museums are of
two kinds—science and art. Each had the function to assemble
and care for material worthy of exhibition for the education
and enjoyment of the people. The art museum was the imme-
diate result of the excavations of the sites of Pompeii and
Herculaneum that yielded art objects requiring classification
and display. In the Museo Pio-Clementine, built 1769–74 at
the Vatican, the art objects of Greece and Rome were ar-

ranged to correspond to Winckelmann's discovery of the historical sequence of styles, which he had published in the preface to his *Monumenti Antichi Inediti* (1768). The Jardin des Plantes, in Paris, was developed by its director Georges Buffon (1707–88) into a scientific institution with single buildings called galleries for displays of Jean Lamarck's (1744–1829) classification of natural species and Georges Cuvier's (1769–1832) system of zoological classification.

In 1774, D'Angivillier, the Director of Buildings, pursuing a proposal of Denis Diderot, the encyclopedist, began the organization of the royal collections of paintings in the Grande Galerie of the Louvre and purchased paintings for the collection. The Grande Galerie was inaugurated as the nation's art collection by the Convention of Paris in 1793.

As a consequence of the role the art museum was assigned in the establishment of a nation's prestige, an identifiable museum architecture, imposing in character, was evolved to house the collected art treasures of the state. A style and form to enhance this quality, usually that of the classical temple, was chosen as appropriate to it.

The exterior form of the museum was that of a temple. Within the museum, heterogeneous art objects of different cultures and previous epochs were subjected to analysis, documentation, and classification. Chronology determined the arrangement of the objects. In some countries the visitor to a new museum was prepared for the exhibits by pictorial histories of culture or the arts painted in the foyer and on the stairways.

The nineteenth-century museum was separated from the collections in princely or royal galleries by the impersonal nature both of the installations and the acquisition of the objects. In the museum the single art work or fragment existed for itself, available for contemplation and stimulation, free from any specific purpose. The art museum was a treasury of objects that came to possess the quality of reliquaries whose presence augmented the quality of nationality. The French Republic's willingness to accept art objects in return for territorial or political concessions to enhance the capital of the nation and the rapaciousness of Napoleon for the same purpose, recalls the Crusaders' return from the conquest and sack of Constantinople (1206) with relics for their shrines.

The first national museum of mediaeval and renaissance sculpture, the Musée des Monuments Français, was formed

from the results of the nationalization of the church and the iconoclasm of the French Revolution that was directed against the religious and monarchical images, the symbols of their power.

The former Jardin des Plantes became the Museum of Natural History in 1794. As objects of natural science did not yet possess the magical quality of art objects, no special architectural type of building was provided to house them until the middle of the century, when a form related to the exhibition halls was considered appropriate for that purpose. At the end of the century, scientific exhibitions were provided with appropriate museum buildings and became temples to science.

In France, due to the nationalization that accompanied the Revolution, existing buildings were adapted for its museums. In other countries the architectural type of the museum was evolved after a study of the organization the French had devised for their collections following the Revolution.]

[ALEXANDER LENOIR (1762–1839) began his career in the studio of the painter G. F. Doyen. When, in 1789, the revolutionary National Convention nationalized the property of the church and a Commission of Monuments was appointed to choose from the art works it had acquired from the church, those for the Louvre, Doyen addressed a proposal that the former convent of the Petits-Augustins be utilized as a depot for art objects until their selection. Doyen's proposal was accepted and his pupil Lenoir was officially named his assistant and guardian of the depot. With the mounting political unrest, Doyen went to Russia in 1791, leaving Lenoir in complete charge.

Lenoir then used his office as guardian to lay claim to the paintings, sculpture, tombs, and ecclesiastical furnishings that the Commune of Paris was stripping from the churches. By his energy and zeal, Lenoir saved much from vandalism, from the lime-pits, and from the state's foundry—he camouflaged the bronze statues with plaster.

The Commission of Monuments asserted its claim to the paintings and these went to the Louvre, but Lenoir kept the sculpture, church furnishings, and stained glass. He then systematically arranged the objects and fragments chronologically and installed in separate rooms what he had classified

according to periods and designated them by style "Merovingian," "Carolingian," etc. By the nature of these installations, he contributed to the notion of the evolution of art.

On an order of the Committee of Public Instruction of which J. L. David was the dominant member, and in spite of the strong protestations of Quatremère de Quincy, the depot at the Petits-Augustins became the Musée des Monuments Français, the first chronologically arranged museum for mediaeval and renaissance sculpture in Europe, in October 1795. Lenoir wrote the instructive museum catalogue. To keep pace with the increase of its collection, he published four during the Revolution and eight up to 1816.

The Musée des Monuments Français was a primary force in the re-establishment of the worth of Christian art and, in winning an appreciation for it, thus contributed to its preservation.

It, the Conservatoire des Arts et Métiers and the Museum Napoleon, the former Louvre, enriched with art treasures levied from all Europe, established Paris as a mecca for art lovers during the years 1795–1816.

A unique feature of the Musée was the English-type garden in front of it, in which Lenoir rebuilt and often regrettably "restored" the sepulchral monuments he had saved, to form a type of outdoor museum. He gave it the name "Jardin Elysée" to recall the abode in ancient days of the shades of great men. Its atmosphere was one to provoke reverie and induce meditations of the past.

The defeat of Napoleon and the restoration of the Bourbons destroyed Lenoir's museum, for the restitution was ordered of the Musée's collections to the church. As the restitution was not made, in many instances, to the original location, further mutilation and destruction resulted.

With the dissolution of the Musée, some of the sepulchral monuments in the Jardin Elysée were transferred to the Cimetière de l'Est, the first secular cemetery, known as "Père La Chaise."

Lenoir drew twelve views of the different rooms and the "Jardin" of his Musée before its dismantling and the assignment of its site to the Ecole des Beaux Arts. These were engraved and published first in 1816 and again in 1821. These plates continued the influence of the Musée.

To compensate for the loss of his Museum, Lenoir was made administrator of the monuments of the church of St.

Denis. He was not however responsible for the disastrous installation of the tombs returned to that church. Lenoir deserves to be remembered as one of the creators of the contemporary museum and the originator of the outdoor museum.]

MUSEUM OF FRENCH MONUMENTS[1]

Preface

The cultivation of the Arts, in any nation, increases its commerce and its resources, improves the morals of the people, and renders them both milder and more disposed to pay obedience to the laws.

Impressed with this truth, the National Assembly, after having decreed that the estates of the clergy belonged to the Republic, directed the *Committee of Alienation* to watch over the preservation of those Monuments of the Arts which the Country possessed.[2]

The philanthropic La Rochefoucauld, President of the Committee, appointed several literati and artists for the purpose of selecting such Books and Monuments as the Committee might be inclined to preserve.

The Municipality of Paris, also, emulous of seconding the

[1] Quoted from Alexander Lenoir, *Museum of French Monuments,* translated J. Griffiths, Paris, 1803, pp. ix–xxiii, xxv–xxvii, lv–lvii; 59–63.

[2] The Athenians were more favorably circumstanced; having effected the expulsion of their tyrants, they changed the form of their Government, and proclaimed a Democracy. From that instant the people took a part in public affairs; the mind of every individual became more enlightened, and Athens raised itself superior to every other city in Greece. A correct taste being very generally established, and the opulent having obtained the admiration of their fellow citizens by the erection of public edifices, men endowed with talents of every kind immediately resorted to this magnificent city, where the arts and sciences fixed their residence; from thence, as from a common centre, they spread into foreign countries, and the progress of taste advanced in equal proportion with the prosperity of the state. Florence in more modern times has exemplified the truth of what we have advanced: no sooner had that city become opulent than the clouds of ignorance were dispelled, and the arts and sciences were seen to flourish.

views of the National Assembly, and charged with the execution of the decree, nominated, on their part, persons of acknowledged merit to assist those appointed by the Committee of Alienation in their enquiries: these men of science, thus united, formed what was termed the *Committee of the Monuments.*

Proper places were immediately fixed upon to receive the treasures which were to be rescued from destruction: the convent of the Little Augustines was chosen for the Monuments of Sculpture and for Pictures; the religious houses of the Capucins, Great Jesuits, and Cordeliers, for Books, Manuscripts, etc., and the Committee published scientific directions as to the mode of preserving the precious objects which it was intended to collect.

One of the members, M. Doyen, whose pupil I had been for fifteen years, proposed me to the Municipality, as a person qualified to take charge of the depot at the Little Augustines. I was appointed to the situation on the fourth of January 1791 and it is to the judgment of the President of the Committee that I owe the confirmation of the establishment itself, and my nomination, *by a decree,* to the place which I now hold. If since that date I have in any degree been successful in my exertions, I am indebted for it to the kindness of the celebrated antiquarian, Le Blond, who has obligingly assisted me with his advice.

From the Abbey of Saint Denis, which appeared to be destroyed by fire from the profoundest depths of its dreary vaults to the utmost summit of its towering roof, I recovered the magnificent Mausolea of Lewis XII, Francis I, and Henry II, but with grief I write it, these chefs-d'oeuvres of art had already experienced the fury of the barbarians: it was in 1795, that I collected the shattered remains, which I may yet restore to their original form. The tomb of Francis I is already exhibited in all its splendor, and that of Lewis XII is about to be erected in the Salon of the Fifteenth Century; truly fortunate! should I become the means of inducing posterity to forget these criminal depredations.

It was about this period, 1793, that Grégoire, President of the *Committee of the Arts,* which succeeded that of the Monuments, published three pamphlets against the spirit of Vandalism which had prevailed throughout France. A considerable number of copies of these interesting works were circulated in the Departments, and by this well-timed address,

Government secured many manuscripts, and other curious objects. In short, the zeal and activity of the Committee succeeded in recovering and preserving all the Monuments which still remained in the provinces.

Notwithstanding the numerous objections of many artists, who deemed them of no utility to the arts, I persevered in requesting that the Monuments of the Middle Ages might be sent to the Museum; and, after repeated solicitations, succeeded. Their importance may now be estimated, since they form the Salons of the two First Centuries in the Museum.

At the opening of the Royal Vaults in the Abbey of St. Denis, I had an opportunity of making many interesting observations. Several of the great personages, who in the early centuries had been interred in stone sarcophagi, were found with their clothes perfect, and with various other articles, which had been used by them whilst living. These objects of antiquity, important in establishing the chronology of *costume,* were unfortunately broken to pieces and conveyed to the Mint.

Such a considerable Collection of Monuments of every age struck me with the idea of forming a regular, historical, and chronological Museum, where a succession of French sculpture should be found in separate apartments, giving to each Salon the character and exact fashion of the age it was intended to represent; and of removing into other establishments the Paintings and Statues, which had no immediate connection with either the French history, or that of the arts in France. I presented this plan to the Committee of Public Instruction, who received me with kindness, and desired me to read it before them. The result was the establishment of a particular Museum at Paris for the French Monuments, and the unanimous adoption of the plans I proposed. At length, assisted by the enlightened counsels of men of learning, and of friends to the Arts, I am enabled to exhibit to the public the Salons of four Centuries complete, and a Sepulchral Chamber, constructed expressly for the purpose of receiving the Tomb of Francis I which I have perfectly restored.

An Introductory Hall appeared to me indispensable as an opening to the Museum. This apartment will contain Monuments of each century chronologically placed. The artist and the amateur will there see at one glance the infancy of the arts among the Goths; their progress under Lewis XII, their perfection under Francis I, the commencement of their decline

under Lewis XIV, a period remarkable in the history of paint-
ing for the flight of the celebrated Poussin,[3] and be enabled
to trace, step by step, upon the monuments of our own era,
the antique style restored among us, by the public lessons of
Joseph Maria Vien.[4]

It is this chronological series of Statues in marble, in bronze,
and in bas-reliefs, as well as the Monuments of celebrated
persons of either sex, that I propose describing in this work;
Monuments which have escaped the axe of the destroyers and
the scythe of time. I have also added a particular description
of certain Antique Monuments, which from their character
do not belong to this Museum (intended for French Monu-
ments only), and which have lately been conveyed from hence
to their respective Museums or Cabinets, as well as of various
Statues and Bas-reliefs, of which I have taken Casts; those I
mean to place in a particular Hall, for the purpose of elucidat-
ing the chronology of the art, principal object of my labors.
This rare Collection is composed of an Egyptian Monument
seen on both sides; of a series of antique Tombs brought into
France by the Ambassador Nointel, who travelled into Greece
and in the Archipelago for Lewis XIV and of a number of
statues which Robert Strozzi presented to Francis I . . .

An Elysium appeared to me conformable to the nature of
the establishment, and a garden adjoining to the house fur-
nished me with ample means for the execution of my plan: In
this undisturbed and peaceful retreat, more than forty statues
are distributed; and upon a grass plot, tombs appear to elevate
themselves with dignity, in the midst of silence and tranquil-
lity; pines, cypresses, and poplars surround them. Effigies
and urns enclosing the "hallowed ashes of departed worth,"
placed upon the walls, concur to inspire this delightful spot

[3] Poussin, unable to support the persecutions he experienced from
the malevolence of Simon Vouet, quitted Paris on a sudden, and
established himself at Rome in 1642.-T.

[4] A modern writer [Joseph Lavallée] has thus expressed himself:
"The order, the art, the melancholy magic which Le Noir has ex-
hibited in the arrangement of this Museum, give an idea at once of
his mind, his genius, and his knowledge. His powerful hand seems
as if supporting ages upon the brink of destruction, arranging each
in its place, and preventing their annihilation, for the purpose of
portraying their arts, their men of character, their tyrants, and
frequently their ignorance: let us retrace with this artist the ages
past, beginning with the tomb of Clovis," etc.

with that tender melancholy, which appeals so forcibly to the feeling mind.

Here may be found the tomb of Eloisa and Abelard, upon which I have had engraved the names of that unhappy pair! the Cenotaphes, and the reclined Statues of the good Constable Guesclin, and of Sancerre, his friend. In Sarcophagi, executed from my own designs, repose the illustrious remains of Descartes, Molière, Fontaine, Turenne, Boileau, Mabillon, and Montfaucon: farther on, an obelisk supports an urn, containing the heart of James Rohault, the worthy rival of Descartes; and near this philanthropic heart, is seen the affecting and modest epitaph of John Baptist Brizard, the favorite of Melpomene, who lately excited the public admiration in favor of the French Stage.

Introduction

Arts, as well as Empires, experience revolutions. They pass from a state of infancy through progressive improvement, to that of complete degradation, and return by degrees to the precise point from whence they set out.

Architecture may be considered as the most ancient of all the arts. The necessity of shelter, no doubt, excited in man the first idea of constructing cabins, and of using thatch to cover them; solicitious only at that time to procure what was strictly necessary, he cut down trees, sawed them into planks, and by these simple means formed a habitation for his family. By degrees this art improved and the idea of elegance followed that of necessity. Man, thus become an artist, proposed to himself in the search after beauty to erect statues and temples, and to raise palaces so substantially built as to defy the effects of time; the rustic cabins formed of simple pillars, in which, surrounded by his family, he enjoyed the pleasures of the golden age, no longer satisfied his wishes or his wants; stimulated by the means which civilization furnishes, despising his first attempts in the arts, he explored quarries, conquered the flinty nature of the granite and porphyry, gave them a brilliant polish, and overcoming every obstacle, magnificent cities rose up under his direction in the centre of extensive deserts.

It is only by the aid of Monuments, that an affixed area can be assigned to the arts. The vast lapse of time which took place from the establishment of the Assyrian Empire, to the flourishing periods of Greece, has occasioned so many ravages

in those countries, that not the smallest trace is left of the durable Monuments by which just inferences might be drawn, respecting the precise state of the arts in any nation. . . .

Versed from my infancy in the art of drawing, I became convinced that collections were of more service to the progress of the arts than schools, where the pupils never see any Monuments, nor hear lectures on the subject of the profession. The models that are before our eyes, and the comparisons which we make between the several degrees of merit in their execution, form the taste and constitute a methodical study; without this mode of interesting the mind, study is nothing more then routine; the art becomes a trade, and inevitably degrades itself.[5]. . .

Let us now trace the history of the arts in France, and endeavor, by means of the Monuments which we have before us, to show how the arts dependent on design, after having taken their rise in Asia, were transferred to the Gauls: let us inform our readers how they were there preserved, and what were the principal causes of their progress and their decline. "The principal object of a methodical history of the arts is to commence with their origin, to trace their progress and their variations to the utmost point of their perfection, and to mark their decline and fall even down to their total extinction."

Description of the Antique Casts

As soon as men became civilized, they employed themselves in the arts, as a necessary spur to the activity of commerce, which without their assistance would be languid and unproductive.

The ancients, impressed with this important truth, built temples and magnificent palaces for the purpose of assembling together learned men and artists.

These palaces and temples were distinguished by the name of museums; for the word museum not only indicates a place which contains monuments of the arts, but also that where artists meet for the purpose of conversing respecting them: such was the museum of Alexandria, in which its kings, and after the conquest of Egypt, the Roman Emperors, entertained

[5] These powerful reasons have determined me to open in the Museum under my direction, a theoretical course, and a practical school of the art of drawing.

with extraordinary magnificence a number of learned men, whose occupations were confined to the study of literature.

Plutarch attributes the invention of this museum to Ptolemy Philadelphus, an admirer of the arts and of learning, who, during his reign, applied himself to extend their influence in Egypt: *Ptolemeus qui primus viros doctos in museum convocavit.* That of Athens, where the literati, poets, and philosophers assembled, was a temple dedicated to the Muses, built at the foot of a small hill, situated within the ancient walls, opposite the citadel.

If we consider the chronology of past ages as an open book of instruction, in which the succession of events may be traced, we shall perceive the necessity of classing the monuments according to their dates, in following the line of demarcation which nature herself has indicated.

A museum in its institution ought consequently to have two objects in view; the one political, the other that of public instruction. In a political point of view, it should be established with sufficient splendor and magnificence to strike the eye and attract the curious from every quarter of the globe, who would consider it as their duty to be munificent amongst a people friendly to the arts; in point of instruction, it ought to contain all that the arts and sciences combined can produce towards the assistance of public teaching: such were the museums of the ancients, whose memory we still respect.

If for the success of the arts it were necessary to do away with academies, formed on an imperfect basis, their progress demanded that a clear and easy method of teaching should be instituted, and that the pupil might be enabled to consult the great masters with facility. These means of study naturally present themselves in a museum chronologically arranged, where youth will find, by the comparisons which they may themselves make, certain and proper models to direct their studies: for it is acknowledged, that in the sciences a man should be perfectly acquainted with the different works which have preceded his time, in that particular line which his taste may have induced him to embrace; and that it is only after a long study of nature and by comparing the masterpieces of great artists with her, that he can become a celebrated professor.

It is in consequence of the above being absolutely requisite for young students that I have found it indispensable to place the monuments in one museum, and to arrange them accord-

ing to their schools, and in chronological order. By adopting a similar arrangement, the Central Museum of Paintings is become a complete school or encyclopaedia, where students can easily perceive, in regular progression, every shade of imperfection, perfection, and decline, through which the arts dependent upon that of design have successively passed. This method ought to be followed by the directors of museums in general, if they would consider these establishments in a philosophical and political point of view, or if they would recollect that they are calculated to enlighten the next generation; and that the want of such advantages had for more than a century propagated a false taste.

[KARL FRIEDRICH SCHINKEL (1781–1841), the outstanding architect of Romantic Classicism, was born near Berlin where he studied with David Gilly and inherited many of the commissions of Friedrich Gilly, his son. David Gilly had founded the Bauschule in Berlin, choosing as his model the method and principles of "simplicity, convenience and economy" of J. L. Durand, professor at the Ecole Polytechnique. A familiarity with Durand's theories and, probably through him, with Ledoux's compositions is apparent in Schinkel's work.

After a study trip (1803–5) to Italy, Sicily, and France, the Napoleonic Wars having put a temporary end to building, Schinkel turned to painting where he proved himself to be a gifted romantic landscape artist. His paintings reflect the contemporary interest in the history of cultures. "Medieval Town on a River" (*Mittelalterlich Stadt am Strom,* 1815) is an imaginative projection of an idealized epoch of the past, and his "Development of Life on Earth" displays the interest in the philosophy of history. Schinkel was also employed in designing theater sets and popular dioramas.

His first commission, and one of his most successful buildings after being named State Architect by Friedrich Wilhelm III, King of Prussia, in 1815, was the Neue Wache, a guards' house built in 1816, which became the German national war memorial in 1931. Archaeological in detail, yet free of copying, it is outstanding for the beauty of its proportions, the broad plainness of its members suggesting Ledoux's work. Schinkel's Gothic style Kreuzberg War Memorial, executed in cast iron three years later, shows his versatility.

During 1812–18 Schinkel was occupied with the design of the Schauspielhaus [theatre] in Berlin, built in 1819–21, a commission that had been Friedrich Gilly's.

In part a result of the French Revolution and the formation of a national museum in Paris, there began a movement, related to the romantic attitude toward art, that transformed the private collections of kings and princes into collections of the state. Special buildings were required to house them and the acquisition of art works became a state responsibility related to national prestige. Schinkel was directed to prepare the design for a suitable museum, after he had viewed the museums in Paris and London. This journey Schinkel utilized to observe current innovations in construction. On his return to Berlin, as a counterpoise to the massive baroque palace, Schinkel erected a masterpiece of imaginative, functional planning, the "Altes Museum" with a long horizontal stoa-type façade, enriched by giant Ionic columns. In its restraint and fitness, the building is a significant achievement in Grecian classicism. A result of the careful archaeological research of the eighteenth century was that Schinkel and his generation were supplied with an accurate knowledge of classic style elements that permitted a free use of them.

Paralleling his work of the Museum, Schinkel designed in Gothic style the Werder Church (1825) built in local material of terra cotta and brick.

Schinkel built and remodeled numerous palaces and villas, especially successful being the Charlottenburg where he applied a severe geometric order to an asymmetrical composition, a characteristic of the picturesque style. He drew on his early study of the Acropolis for the accurate details of the classical elements for this and the Schloss Glienecke (1826). The Schloss Babelsberg (1834) shows the influence of Nash's castellated mansions that Schinkel had seen on his trip to England.

A building of international importance is the Gardener's House (1829–31) based apparently on Schinkel's observations of Italian villas, and notable in the transition from the Grecian to the asymmetrically towered Italian villa mode.

Schinkel was a complete master of romantic classicism in both its phases, the Greek revival and the subsequent eclecticism. In the range of his work and his daring experiments in all styles, Schinkel satisfies the obligation of the nineteenth-

century architect to invent new forms to meet the requirements of a changing social order.

SEE: L. D. Ettlinger, "A German Architect's Visit to England in 1826," *Architectural Review,* XCVII (1945), pp. 131–34.]

FROM SCHINKEL'S LEGACY[1]

Concerning the Construction of the Museum in Berlin

Schinkel's Report to His Majesty, the King, Berlin, January 8, 1823.

Most Serene, Almighty Highness, Most Gracious King and Lord!

Your Royal Majesty has been graciously pleased to commission me, at the end of last summer, to devise a plan for the tree lot and borders of the *Lustgarten.* I have already respectfully submitted a plan of this in which the whole was represented by means of a perspective projection. The most interesting subject occupied me, however, for sometime afterwards and thereby a thought forced itself upon my mind, a thought connected with the plan for the building of a new museum and several related buildings accepted in general at that time by Your Royal Majesty, which offered such definite advantages with regard to: the reduction of expenses over the last plan; the perfection and beauty of that building; the embellishment of the *Lustgarten* and finally, with regard to the utilization for warehouses, shipping, riverbank communication and convenience at the new Schlossbruecke, that I held it to be my duty to undertake promptly a detailed study, in order to present it most respectfully for Your Royal Majesty's gracious judgment. . . .

This advantage would be gained by this plan, that in the most beautiful part of the city a favourable place to build the new museum to stand alone has been found. Consequently all other buildings of similar size are omitted, the nearby buildings, however, that in this projected plan will be necessary, are of very modest portions.

[1] Translated from *Aus Schinkel's Nachlass,* von A. von Wolzogen, Berlin, 1863.

The buildings of the new museum according to the accompanying plans, the necessary removal of the old warehouse below the new *Schlossbrücke* and the change of the water communication, all this will probably not require greater expenditure than that which Your Majesty has already been pleased to accept for the earlier plan.

Your Royal Majesty will be graciously pleased to see that the reason for this respectful presentation as the sincere desire for a worthy project and advantageous to the commonweal and a performance of duty due Your Royal Majesty.

With deep respect, I remain ever Your Royal Majesty's most humble servent,

SCHINKEL.

Royal order to Privy Counselor for Architecture Schinkel, March 21, 1826.

As an aid in the future construction of the Museum here, it is important that you obtain very exact knowledge of the construction of the museums in Paris and London. I, hereby, charge you to travel there and to procure this knowledge. In Paris the *Hofrat* Baron von Humboldt will secure for you the opportunity, and in London, I, herewith, refer you to Freiherr von Maltzahn, my accredited Ambassador. For the cost of the journey and the expense of your stay in France and England, I have set aside, in accordance with your rough estimate, 1800 Taler, which the State and Finance Minister von Motz will have paid to you. Because of your proven circumspection and knowledge of architecture, I promise myself a profitable result for the above named purpose.

FRIEDRICH WILHELM

TRAVEL DIARY

(Paris, Sunday, April 30, 1826)

Today we saw the cathedral *Des Invalides* and then an iron steamship, which goes to Havre. The Prussian envoy, Baron von Werther, was not at home; but Alexander von Humboldt[2] was, from whose windows a beautiful view could be enjoyed. After this we visited the architects Percier and

2 [The famous German natural scientist, who visited South and Central America, 1799–1804.]

Fontaine,[3] the *Secretaire perpetuel de l'académie des beaux arts* Quatremère de Quincy, and the painter Gerard (François Pascal, Baron de Gerard, 1770–1837, a pupil of David, popular historical and portrait painter in Paris). The latter was sick; at his atelier we saw beautiful pictures, portraits and the *Battle of Austerlitz*.[4] Finally we also went to the museum of the sculptures in the Louvre. At noon we had luncheon at Erignon [a famous restaurant in Rue Neuve Des Petits Champs; open until 1838].

(Monday, May 1)

With Percier and Fontaine we undertook an inspection of the entire Louvre. They explained to me the building projects, which consist of a connection of the big galleries through staircases and over the middle portal. The interior restoration of the apartments of the king cost 1,700,000 Francs; previously these rooms were furnished for Eugène Beauharnais, former Viceroy of Italy. After the Café Ture at the Boulevard du Temple had offered some refreshments we took a long walk along the Boulevard to the Abbatoir or slaughterhouse in the Rue de Menilmontant,[5] and to the cemetery Père la Chaise, where the monuments, the beautiful view of Paris, the plantings of cypress, trees of life, etc., the approaching street, gardeners, holding out their plants for sale, all this kept us occupied.

(Wednesday, May 3)

We called for Mr. Knuth, went to see the preparations for the Jubilee fete[6] at the Place Louis XVI, and then in the gardens of the Tuileries we enjoyed the fragrance of the delicate lilacs, the broad roads, the box-tree borders around the lawns, the luxuriant display of flowers, the wonderful terraces with arbors and high clumps, and from there the view down on the gigantic town, fading away in the blue coloured mist. Then we visited Baron von Werther and M. della Fontaine whose bronze foundry in a cellar under an old chapel deserves attention. . . . First we saw the churches St. Germain des

[3] [They designed the Place Vendôme and the connecting streets.]
[4] [It was commissioned by Napoleon.]
[5] [Marche Popincourt, once the largest slaughterhouse in Paris, is no longer standing.]
[6] [During the Restoration Period, it celebrated Louis XVIII's return in 1814.]

Prés and St. Sulpice.[7] The exterior façade of the latter is interesting. On ground level is a beautiful *porticus,* upon which in the second, is a line of columns, in the upper level arches are standing. In a chapel inside the frescoes by pupils of Gerard are good. At the meat and vegetable market, I was puzzled by the big venetian blinds for closing the arcades, which are almost useless, or only seem to be for the purpose of giving air, because light does not penetrate them. In the Palace Luxembourg, we enjoyed the garden, a wonderful spacious place, bordered by terraces and tree-alleys, decorated with marble sculptures, lawn, lilac, roses, flowers of all kind, and water basins. From here on one side, one has the view of the observatory, on the other, at the end of a high vaulted alley, the most delightful view of the Pantheon. The Ecole de Médicine captivates one with its simple beautiful architecture; opposite stands a fountain in a Doric hall. Not far from the Pont Neuf, we encountered the procession of the king, which had started at Notre Dame; a large crowd of priests and courtiers surrounded him; all on foot. Then the beautiful simple iron dome construction in the *Halle au Ble* was carefully observed. It is 120 feet in diameter, the skylight in the dome 63 feet. The covering copper plates laid on it are not connected with pegs to the iron grate. The cast-iron rafters consist of 3 pieces in height; the cross connections are forged; the rafters 2½ to 1 ft. wide, the iron on it 3 inches thick, the grate about 1 foot square. Below everything rests on a crown. At the Diel's iron solder in the roof gutter, I observed small tears. The stone construction of the building mixed with bricks is beautiful, the double staircase excellently constructed. After we had changed our shoes at home, we went to the Café de la Rotonde in the Palais Royal. . . .

(Saturday, May 6)

Hittorf called for me at 10:30 and we went to the architect and colleague Huet, who was not at home; therefore we went on to Pacho's; but here as we met the same fate, we again tried our luck at Huet's and now found him at home. We saw his enormous work on the survey of buildings and entire towns in Egypt, Syria and Asia Minor, whereby I especially enjoyed the magnificent situation of Halicarnassos and Ephesus. Furthermore he showed us all kinds of sketches for

[7] [St. Sulpice, see Holt, Vol. II, p. 328.]

terraces and foundations, on one side only surrounded by steps, and on the other left open for the view of the ocean, Greek vaults of the earliest time, townwalls, gates, old towns, his large drawings of Athens, Rome and Thebes, of the pyramids geometrically projected and brought to one level, his sketch for the Arc de l'Etoile, views of Egyptian and Nubian monuments and of the propylaea. His atelier in its entirety is interesting. At two o'clock Herr von Humboldt introduced me to the Institute. Quatremère de Quincy sat me beside him and read a paper on the importance of *Symmetria* and *Eurithmia* in Vitruvius. After the meeting, my architectural portfolios were displayed; Herr von Humboldt and I explained them and Herr Debret[8] was ordered to make a résumé of it for the Institute. Percier was especially friendly to me, and I thanked him at this time for the pictures of the sculpture-museum in the Louvre, which the Comte de Clarac publishes, that he and Fontaine had sent to me. To this packet also was added the plan of these gentlemen for the restoration of the entire Louvre and as well as the Palace of the King of Rome with its surroundings.

(Monday, May 15)

With Rothschild I settled my money transactions, and received the value of 400 Thaler, which were paid in silver at the bank in Paris. Then I saw St. Geneviève[9] with the pictures in the dome by le Gros.[10] These represent St. Geneviève, Clovis, Charlemagne, Ludwig the Pious, and Louis XVIII with their wives, blessed by the saints; Louis XVI is in the upper region of the sky. The whole structure of the building lacks the true expression of art, albeit giving evidence of a lot of technique. Some more churches and also Gerard were visited. He spoke long with me about the wrong course the arts have taken in France; everything would be *decor,* the idea of the sacredness of art no longer exists, there a great deal would still be produced, but little that was good—so he thought. For my Berlin Museum he advised keeping the walls where the pictures are hung in a strong *sang de boeuf* and not in the usual greenish-grey middle tone. I was again attracted

[8] [François Debret, the architect.]
[9] [The Pantheon. It was used as a church from 1806–30 and 1851–85.]
[10] [Antoine J. Gros (1771–1835) executed them in 1824.]

to the garden of the Tuileries, whereafter luncheon was taken at Prevost with M. Blanc. . . .

(London, Friday, May 26)

After I had received from Graf Dankelmann at Rothschild, 100 £ Sterling for my expenses in England, I wrote letters to Berlin and sent them to Graf Lottum to take care of. Then I received the visit of Solly[11] and an invitation from him for Saturday evening. After this, we went out, and saw Regent's Crescent,[12] Regent's park with the new arrangements and palatial buildings, the Panorama, the Rotunda, the Diorama and on the Westside of Chancery Lane Lincoln's Inn or the old building of Justice. . . . From here we went to the church of Pancratius[13] constructed 1819–22 in New Road after the Erechtheum, Pandroseion and the Tower of the winds in Athens. Without the tower the building would be quite beautiful from the outside. Inside it is sober, especially the flat coffered ceiling and the low raised galleries. The two pulpits and reading desks are made from the well known Fairlop Oak which stood in the Heinault Wood and was blown down 1820. Mr. Inwood made the design. Next was visited St. James's Park and Westminster Hall, the old courthall with a beautiful, visible, decorated roof construction. The several bridges were inspected, namely first Westminster Bridge,[14] second Blackfriars Bridge[15] constructed with large ramps from both sides, serving also as foundations for houses; stairs lead up to it and the big arches are under the ramps; thirdly, Southwark Bridge[16] with three vaults of iron. In the evening we ate in St. Paul's Coffee-house.

(Saturday, May 27)

We received visits from Messers Volkert Aders and others, then drove to Ambassador Baron Maltzahn and with him

[11] [Edward Solly's collection of paintings was purchased for the Berlin Museum.]

[12] [Built by John Nash in 1819–23, named for the then Prince Regent, later George IV, is an early example of civic design. Humphrey Repton directed the planting according to principles of Picturesque landscaping.]

[13] [St. Pancras' New Church built by John Soane.]

[14] [This bridge was enlarged in 1859.]

[15] [Built 1760–69, by Robert Mylne. It was replaced in 1869 by Cubitt's iron bridge.]

[16] [John Rennie's cast iron bridge, set on stone piers, 1815–19.]

to the British Museum.[17] Herr Koenig[18] received us there. The antiquities are standing in the vestibule. The capitals of the columns in the main entrance hall are doric, the rings around the echinus simpler than usual. The new building is based on the architecture of the Erechtheum. All iron ceiling constructions are covered with wooden coffers. The large main staircase, each arm twelve feet wide, rests on cast iron beams; the stones are very weak; below every thing is pan-elled. The construction is not praiseworthy. The gallery of antiquities in a quite small room, illuminated from above, is very agreeable and comfortable to see. Delightful works of all kinds draw one's attention here; Greek marble sculptures and busts, the Portland Vase, a true wonder, the Greek vases, the bronzes, the collection of Mr. Payne Knight, etc. . . .

(Sunday, June 4)

After church in the morning, we made a call on Lord Aberdeen,[19] a simple polite gentleman, who received us in a large beautiful furnished salon with many armchairs, tables, sofas, that stand in the middle of the room. He looked at my plans for the new Berlin Museum. A visit we had intended to make on the painter Sir Thomas Lawrence, President of the Royal Academy, was in vain, and the same happened to us at the Marquis of Landsdowne in Berkeley Sq. Therefore, I went to Edward Solly, brought him my port-folios as a present, and he then accompanied me with Herr von Willisen and the Graf Lottum to the architect John Nash, who at this time was occupied with the construction of the Royal Palace[20] in St. James's Park. He lived like a Prince in Regent Street. Even the flight of stairs was magnificent, the walls panelled with imitated beautiful green porphyry. On the landing stood the model of the Parthenon. The doors fascinated me by their perfect imitations of the most precious kinds of wood. The salon, in which I was received by Mrs. Nash, was magnifi-cently decorated in white and gold. There were several gen-tlemen and ladies present, among others, Mr. Vernon Smith, the famous speaker of the opposition in the lower house, who

[17] [Designed by Sir Robert Smirke, 1823–47.]
[18] [Karl Koenig was called from Braunschweig, Germany, to ar-range the mineral collection.]
[19] [George Gordon, Earl of Aberdeen, Foreign Minister, 1846.]
[20] [Buckingham Palace; Nash began the remodelling in 1825 at the order of George IV.]

is a friend of Solly's, and in Mr. Nash's absence, guided us
around. In the large hall Raphael's Loggias [painted] on the
pilasters are beautifully and truly copied. In the side-niches
with a lilac background stand casts of the best ancient sculp-
tures and busts. Below is the library, in which one only sees
leather bindings; the walls are panelled with red marble plates.
On the tables stand plaster models. The illumination comes
through round openings in the ceiling and on the sides from
small lanterns. In the other rooms are copies of the best pic-
tures; for example the Danaë in Naples by Titian.

After I had delivered a letter to the Duke of Coburg, we
walked through St. James's Park, to see the palace-building of
Mr. Nash. The outer architecture is the usual; the plans by
order of the king could be as little out of the ordinary as the
structure itself. On a promenade through Green Park to the
Hyde Park I had the opportunity to see the endless crowd of
horsemen, carriages and people, that daily bears witness here
to the greatness and wealth of London. The magnificent wide
green spaces with their picturesque groups of colossal elms,
around which the cavalcade of equipages and horsemen moves
to and fro, and over which the pedestrians move about freely,
without being obliged to keep to the paths, offer a charming
view.

(Sunday, June 11)
The quiet day today was used for good-bye visits. After we
had been at Baron Maltzahn, Mr. Abers, etc., we went to Solly
and with him to the book store, which he directs, as well as
to the house of the architect, John Soane,[21] who has built the
bank and several other public buildings, churches, etc., in
London. His house is located in Lincoln's Inn Field, Nr. 13,
and is, as all London private houses, small. But in it are hidden
a great number of plastercasts, fragments of ancient sculp-
tures, pieces of architectural decoration, vases, sarcophagi,
bronzes, etc., which are arranged in the most fantastic way,
in small, sometimes only three feet wide rooms, lighted from
the top and from the sides. Medieval, ancient and modern
things are standing pell mell, high and low, in courts similar
to cemeteries and in chapel-like niches, in catacombs and
Salons, one Herculanian, the next gothic decorated. Every
where little dummies are attached, as they were when they

[21] [The great English architect, who gave his house to the nation
as a museum, in 1837. The Bank of England.]

were favoured during the last century in the princely country seats. The most remarkable object in the collection is the Egyptian sarcophagus[22] of oriental alabaster, which Belzoni had brought from the ruins of the ancient Thebes. It is covered, inside and out with fine hieroglyphs, that are incised and black inlayed. This is supposed to have served King Psammenit as a last resting place; Soane has paid 2000 pounds Sterling for it. Besides that, I was interested in the originals of Hogarth, "The Rake's Progress" and the "Humours of an Election"; as well as a beautiful Canaletto.

REPORTS TO THE KING OF PRUSSIA

Berlin, October 24, 1826

Most Serene, Almighty Highness, Most Gracious King and Lord!

The impression the Paris Museum gives is as great in the excellence of the art works as in the method of exhibition and decoration of the rooms.

The Museum of the Vatican in Rome gives the same effect. The museum in Berlin, so richly provided for by Your Royal Majesty's favour will have an important place among the other museums because of its contents. In the manner of its arrangement as well as the furnishing of the rooms, it will be distinguished in its simplicity and organic plan. The greatest effort will be made to achieve this simple dignity so that the building's appearance before the world may correspond to the intention of its great founder.

Led by these considerations, the journey to Paris and England, taken at the gracious command of Your Majesty, with its recent impressions filled me with certain requests for the Berlin Museum that I herewith respectfully present. It is known to Your Majesty that only because of the great simplicity of my building plan and with the severest economy that sound building construction permits, is it possible, for the maximum sum approved to erect a building, which would correspond to the dignity of the object, and in addition the disputed related buildings of all kinds and building sites. This dignity could only be established by the over-all proportions

[22] [It was found in 1817.]

but no means would be left for the ornamentation and the expense of the materials for the details.

To a certain degree, the latter should also be found in such a monument in order to be assured of a perfect impression. To achieve, in any extensive building, a true art work, it would, in general, be advantageous if, toward the end of the work, special funds were made available for the artistic finishing of all the parts, because as a rule, by this finishing at the last, the greatest effect for the public is attained.

The most desired requests will be clearly seen in the respectfully presented accompanying table in which the first column shows in which way the highest estimate approved allows for the realization of the objects. Column II: how the realization of these objects is desired. Column III: some remarks and reasons. Column IV: the additional expenses that originate in the above.

According to this, an annual subsidy of 14,500 Taler for four years (including this one) would give to the building a perfection, which would make it truly a monumental structure. After the end of the year 1828, when the museum will be already completely constructed, the finishing touches can be given to the exterior ornamentation without detriment to the building's use.

In deepest respect, I remain Your Royal Majesty's
Most devoted, servant,
SCHINKEL.

May 1827

Most Serene Highness, Almighty Gracious King and Lord!

Most respectfully I dare to ask Your Royal Majesty graciously to allow that the ever notable foundation of the new museum may be remembered for all time with a public inscription on the building.

At my request the Court (Hofrat) Counselor Hirt has devised an inscription and has conferred with our greatest philologists for their opinion; it runs thus: *Fridericus Guilelmus, III, Studio Antiquitatis-Omnigenaeet-Artium-Liberalium-Museum-Constituit. MDCCCXXVIII.*

Friedrich Wilhelm III has founded this repository for the study of all kinds of antiquities and free arts in 1828.

On the respectfully enclosed design of the main façade of

the new museum this inscription is worked into the frieze of the building.

Awaiting Your Royal Majesty's most gracious decision, I ever remain Your Royal Majesty's most humble servant,

SCHINKEL.

THE LIBRARY

[In all epochs the library has been man's device to thwart time's destruction of his accumulated store of knowledge, the products of his creative life, and the records of his achievements and institutions. The library preserves the past for the present and the future.

There have always been three types of libraries, the official type formed from archives in the palace and in the temple, the private library of individual scholars and scholarly princes and the monastic library. The origin of the present day library, with the methods that characterize it, was inaugurated by St. Benedict at Monte Cassino in the sixth century. Social and political changes at the end of the eighteenth century required that functional changes be made in the architectural form of the library as more people were admitted to the state and private libraries. Public reading rooms were needed and it was necessary that collections of archives and books be easily accessible to the reader. This required that the two be related to permit the library personnel to move easily between them.

In France the nationalization of the ecclesiastical libraries by a decree of the National Convention in 1789 and the transfer of their contents to depots produced a condition that called for an immediate solution. Numerous ingenious plans were devised and published by French architects, but the changing political events in the first decades of the century delayed the actual construction of any of them. Neither the British Museum, which is a library as well, designed by Robt. Smirke (1824), nor the Bavarian State Library (1831–40), built by Friedrich von Gaertner (1792–1847) for Ludwig II, offered a new architectural type to correspond to the new function of the library; such a type, however, was devised by Henri Labrouste for the Bibliothèque Nationale (1855).

The small public libraries in a variety of styles, a distinctive

feature of many towns in English-speaking countries in the first decade of the twentieth century, were the gift of Andrew Carnegie (1835–1919) to those towns willing to supply a site and maintenance in return for the building and its equipment.]

[HENRI LABROUSTE (1801–75) began his studies as an architect in the ateliers of the architects H. Lebas and A. L. T. Vaudoyer (1756–1846). Vaudoyer made the designs for the Grand Prix du Rome available to the architectural schools of Europe by his publication *Projects d'Architecture* (1806). On receiving the Prix du Rome in 1824, Labrouste devoted himself to completing designs for the restoration of the sixth-century Greek temple of Poseidon at Paestum, Italy. His rendering with the external color he had observed made the designs controversial and brought Ingres to his defense.

On Labrouste's return to Paris, he established his own atelier and became engaged in the numerous projects to restore existing monuments and transform Paris into a modern city of broad avenues and boulevards with the focal points of the new Louvre, the Opera and the Etoile. He was named architect (1840) of the Bibliothèque Sainte Geneviève. This task and that of a plan for a National Library had been the subject of many proposals since the Revolution. Labrouste, restricted by the narrow space opposite the Pantheon, designed a Renaissance revival building whose proportions, splendid masonry work and decoration make it the most distinguished structure of the 1840s in France. Equally distinguished is Labrouste's interior plan and his imaginative visible use of iron. He ingeniously supported the two barrel roofs of the reading room on arches of open iron work that sprang from a central row of slender iron columns.

In the administrative building next to the library and College Sainte Barbe, built in collaboration with his brother F. M. T. Labrouste (1799–1855), Henri showed fine coordination of the parts and originality of composition.

While he was thus engaged, Labrouste served as inspector of the reconstruction of the Palais des Beaux Arts, on the Commission of Historical Monuments, on the jury at the Ecole des Beaux Arts, and designed the lamps for the Pont de la Concorde. The last were done in connection with J. Hittorf's (1793–1867) decoration of the Place de la Concorde.

Labrouste was named architect of the Bibliothèque Nationale[1] in 1855 and was concerned for the rest of his life with the remodelling and restoration of Palais Mazarin that contained the library.

Labrouste's plan for the Reading Room (Salle de Travail) and the stacks (Magasin) (1862–68) offered a brilliant functional solution for the requirements of the library as well as an able use of iron and glass. For its construction within the Palace Mazarin, Labrouste advanced boldly beyond his construction method at Sainte Geneviève, where he was limited by the narrow site. Within the square of the Reading Room, Labrouste set two rows of light metal columns from which fan-like arches supported the terra cotta open-center domes, the light source for the room. An area for the library personnel linked the Reading Room to the book stacks, visible through a glass wall. The entire area of metal stacks is illuminated from the vast skylight.

It was Labrouste's original use of iron and glass, his functional design, and his fine sense of co-ordination that gave him his influence over the next generation of architects, notably Viollet-le-Duc, who sought the principles for the use Labrouste had made of iron in the construction of Gothic architecture.

SEE: Le Comte de Laborde, *De l'organization des Bibliothèques dans Paris, VIII lettre,* in *Etude sur la construction des Bibliothèques,* Paris, 1845, Vol. 5, pp. 27–30.]

THE RAILWAY STATION

[The invention (1769) of the steam engine by James Watt and its adaption by George Stephenson for the "Rocket," the locomotive that won the prize offered by the London and Manchester railway in 1829, led to a new building type in the architecture of the nineteenth century which challenged the creative and engineering ability of architects.

The great interior open space the station required for the trains and the crowds could be provided because new building materials, first of cast iron and wrought iron, and then of steel and glass, had become available to liberate architecture

[1] See Plates 36 & 37 for Ground Plan and Reading Room of the Bibliothèque Nationale.

from the limitations of masonry and wood. The use of these materials had been pioneered in the construction of public markets in Paris and in greenhouses in England, both buildings free from traditional architectural styles. The construction of the large iron arched train sheds of the station was simultaneous with and mutually beneficial to the erection of the "Crystal Palace" of the World's Exposition of 1851. That structure designed by Sir Joseph Paxton, the gardener and designer of conservatories, and built of cast iron and glass by the engineer-contractors, Fox and Henderson, created a new type of architectural space.

In the station the vast single train sheds that offered no outlet for the smoke were later replaced by platform covers. The large areas of vaulted open space were retained in the concourses needed to permit the rapid movement of the crowds of passengers.

Of the early railway stations the two most notable are F. A. Duquesney's (1800–49) Gare de l'Est (1847–52), Paris, and L. Cubitt's (1799–1883) King's Cross Station (1851–52) London. The vast central lunette of the front of the Gare de l'Est suggested the iron-glass shed with the 100 feet spans that it closed. When the station was doubled in size in this century the original features were repeated. The King's Cross Station with a front of large plain brick arches in the style of early classicism, to give a clear expression of the great arched sheds behind, is a major monument in railway station architecture.

The railroad required a station at each stopping place on its line across the country. This was a type of structure as new as the vast terminal station. However, the development of very original station plans was prevented by railroad companies who would purchase a single station plan, designed by an engineer or minor architect, and repeat the same plan throughout the length of the road.]

[F. LÉONCE REYNAUD (1803–80) was the engineer and architect of two of the earliest railroad stations in Paris, the Gare d'Austerlitz (1843–47) and the first Gare du Nord (1845–47). When this station was enlarged Reynaud served as the engineer and J. Hittorf (1793–1867), who was responsible for most of the Empire embellishment of Paris, was named as the architect.

Reynaud first published *Traité d'architecture* in 1850. A fourth edition appeared in 1875. His presentation of the contemporary architectural tasks provided a practical and useful text accompanied by instructive plates.

SEE: C. L. V. Meeks, *The Railroad Station,* New Haven, 1956.]

TREATISE ON ARCHITECTURE

Railroad Stations[1]

The establishment of the railroad gave birth to a large number of buildings of a very special nature. These are the great railroad stations for passengers and freight, workshops for maintenance and round-houses, buildings for various types of cars, restaurant rooms, shops, quarters for employees, etc. Some of these buildings demand and have received great elaboration; others recommend themselves by their multiplicity; all relate to railroad administration, the well-being of travellers or representatives of the railroad, and to the interests of the concessionary companies. Many of them present a rare quality in our old society, that of innovation. While our other buildings have been the object of long development and are distinguished only by nuances from those which preceded them, and belong as well to the past as to the present, these which we are considering here were entirely new creations, one could say, improvised by our generation. They are a spontaneous product of one of the most beneficent inventions of the epoch, and are called upon to satisfy demands which our fathers never suspected. This independence which we desire, these new forms, characteristic of our time, which one requires of our architecture, yet so unjustly sometimes reproaching architecture for not re-modelling the characteristics, they present themselves naturally here: arrangements without precedent, materials not utilized until now on a grand scale. These conditions essential for all genuine innovation force themselves upon these buildings and open new horizons to art. The creation of the railroads is too important a fact in the history of humanity, destined to exercise too great an influence on our

[1] Excerpt translated from Reynaud, Léonce: *Traité d'architecture,* II Part, 4th edition, Paris, 1878.

customs and institutions, not to affect powerfully our architecture. There is no longer need for the invasions of barbarians, founding of empires or mixture of races to renew societies, as well as the forms that express their customs and spirit. We have progress in science and industry, and they likewise produce profound revolutions, but peaceful revolutions and bring only benefits.

Consequently there is great importance to be attached to these new buildings, and especially to those which are particularly designed to serve the travellers, needing that distinction in the forms and that monumental character which we require for all our buildings used for public assembly. They recommend themselves especially to the interest of our architects, and they call for the architects' most serious thought. We expected to elaborate on this subject, to make known the different requirements of all the types of buildings of the station and to illustrate the subject with numerous examples; but it was soon evident that most of these buildings would require us to enter into details of railroad administration which would be too long and technical for a book of this nature, and besides would not be ample or precise enough to furnish all the details necessary for serious study. Therefore it seemed to us that we must restrain ourselves and refer the reader desirous of becoming completely informed to special treatises on the subject.

On the other hand, art does not have the rapid progress and the sudden developments of industry, with the result that the majority of the buildings of today for the service of the railroads leave more or less to be desired, be it in relation to the form or to the arrangement. Some stations appear to be appropriately arranged but having the character of industrial and provisional construction rather than that of building for public use. Others have been treated with a certain richness of architecture, but were conceived with the idea of producing an effect too stamped with reminiscences of the past. They have not taken sufficient count of the conditions that were imposed upon them, and err both in the foundation and in the form. No doubt it is useless to add that the former are preferable to the latter. If they can not be presented as complete solutions to the problem, they give at least satisfaction to serious interest. They are valuable advances, preparing the ways to the future by accustoming one to the characteristic forms, and demonstrating a judicious use of capital claimed

by urgent needs. But still this new order of composition promises more than it has as yet shown. We will limit ourselves therefore, to making this the object of several general considerations, and to place before the reader two examples of great railroad passenger stations.

The relative positions of the entrances and exits is the principal point to take into consideration in the establishment of a station placed at the head of the rail tracks. It is they that exercise most influence on the distribution and even on the organization of the service. In this respect, buildings constructed can be divided into three large classes:

1. The entrance and the exit are united under the same body of building placed at the head of the tracks, and in a direction common to that of the rails.

2. The entrance and the exit are open to the sides of the tracks and come out into separate courts.

3. The entrance or the exit having been established at the head of the tracks, the exit or the entrance is open to one of the sides. The circumstances have the task of clarifying the choice to be made in each particular case. . . .

All the parts of a large station should be generously conceived. They require amplitude and space. Let the vestibules and the waiting rooms be vast and high; let the sidewalks err more in an excess than an insufficient width, nor be cut by structural points of support; let the frame work that covers the tracks be bold, and let no supports be required that would hamper the service; let the entries and exits be well emphasized, numerous and of easy route; such are the most essential general conditions that pertain to the details of the arrangement.

As for the character, it does not seem that the moment has come to make it monumental. It is necessary without a doubt that the construction be solidly established; but there should be no excesses, and it does not seem that the most important role is to be played by stone. It is iron that forms the new tracks and a large place should be reserved for iron in the buildings that the tracks give rise to. It would be appropriate to glorify in some way the precious material that industry has given to architecture.

THE TALL COMMERCIAL BUILDING

[The tall commercial building, an innovation of the nineteenth century, came at the end of the century to a position of importance in the field of architecture that was equal to that of the church and the palace of previous periods. It was the product of the nineteenth-century technological and mechanical inventions and a result of economic factors. Its structure and form were developed in England and especially in America.

In the course of the century, commercial enterprises concentrated themselves in the center of the city, and there expanded with an augmentation in wealth. Soon they sought status for their individual firms by the construction of imposing buildings. In England and America the custom of living in individual dwellings led private persons to withdraw from the city to the suburbs leaving the city center to the office buildings required to house expanding businesses. Competition for the limited space increased the value of land, and space not available horizontally was sought vertically. In the European capitals this did not occur, for commercial offices and dwellings continued throughout the century to occupy the same structure.

Two inventions made the tall building possible. The invention of the elevator by E. Graves Otis in 1853 made possible the transportation of people within a building of any height. The invention of steel permitted the "skyscraper construction" devised (1883) by William L. Jenney. By this method the external walls supported nothing, but were themselves carried on the metal spandrels bolted to the internal steel-framed structure. The floors of reinforced concrete were spread between the steel spandrel beams. The building became a tall hollow rectangular cage with four supporting piers.

Twentieth-century architecture results from the nineteenth-century architects' creative solutions of the various problems involved in the construction of the tall office building.]

[LOUIS SULLIVAN (1856–1924) was born in Boston and began his architectural training at the Massachusetts Institute of Technology. He left to do drafting work in Philadelphia but,

when the depression of 1873 ended that employment, Sullivan joined his family in Chicago. He worked briefly with the architect William Jenney, who used both iron and steel in the multistoried buildings that the invention of the elevator had made possible and who invented the "skyscraper construction" in 1883. Determined to complete his architectural studies, Sullivan went to Paris and succeeded in passing the examinations to admit him to the Ecole des Beaux Arts and the atelier of Vaudremer, where H. H. Richardson had also studied. Only a brief trip to Italy interrupted his two years of study there.

Sullivan returned to Chicago in 1879, a city free from architectural tradition. Its geographical location provided rapid economic development and the devastation caused by the Great Fire of 1871 provided the opportunity to rebuild. Sullivan was employed by Denkmar Adler, and in 1881 the famous partnership of Adler and Sullivan was formed that lasted for fourteen years. Some of the buildings built by this firm for a variety of functions, of which Sullivan was the principal designer included in the "Chicago School," were the Rothschild Store (1880–81), the Ryerson Building (1881–83), the Troescher Building (1884), and the influential Chicago Auditorium (1887–89), a combination auditorium, hotel, and office building. In these buildings Sullivan's originality is likewise demonstrated in his type of ornament and his use of it.

In 1890 Sullivan realized that a totally different structural organization, based on different principles, was required for an office building built of steel. He proceeded from the principles of design he had learned at the Ecole des Beaux Arts to perfect a technique begun by others and created a static cage of steel to support the whole building with the steel columns visible between the windows. His artistic genius transformed the functional form into a form that is at once organic and aesthetically pleasing, as is seen in the evolution of the three buildings: Wainwright (1890–91), the tower-shaped Schiller Building (1891–92) and the Guaranty Building, Buffalo (1894–95), its clearest form. The last is excellent in the successful integration of architectonic and decorative effects.

Sullivan envisioned the World's Columbian Exposition of 1893 as a means to free architecture from academic conservatism. The results were quite the contrary, for specifications were given for a uniformity of design, height, material, and color to produce a harmonious ensemble. The public, unable to fix the true source of their pleasure, placed it in the

decoration which resulted in a popularity of the classic "beaux arts" style. Sullivan's Transportation Building was in contrast strikingly original; the bold flat entranceway that led to the arcaded sheds was decorated with a small scale pattern reminiscent of William Morris' manner.

In the ten years following the dissolution of the famous partnership, Sullivan worked with diminishing financial success, caused in part by his irascible character, until he went into bankruptcy. During this time, however, he designed the Condict Building (1897–99) in New York, the Gage Building (1899) in Chicago, and, what many consider his greatest building, the department store of Carson, Pirie & Scott (1904). The continuity of surface, the contrast of curved and angular areas, and the great amount of glass area, contributed important stylistic features to the architectural style that was evolving.

His last years (1906–24) Sullivan filled with minor commissions and occupied himself with lectures and writing *The Autobiography of an Idea.* In passages related in style to Walt Whitman and with a comparable faith in democracy, he gives a revealing and moving account of the evolution of his life and idea. *Kindergarten Chats,* his lectures to the Chicago Architectural Club and elsewhere, composed of fifty-two consecutive essays, were published serially in 1901 and made his ideas and theories known in Europe and America. Sullivan revised the texts to their present form in 1918.

Sullivan was one of western Europe's and America's great innovating influences, whose genius elevated the office building, a new type, to a position comparable to the palace and the church. His work was a major factor in the creation of the functional architectural design of the twentieth century.

SEE: Hugh S. Morrison, *Louis Sullivan, Prophet of Modern Architecture.*
Albert Bush-Brown, *Louis Sullivan,* New York, 1960.]

THE TALL OFFICE BUILDING ARTISTICALLY CONSIDERED[1]

The architects of this land and generation are now brought face to face with something new under the sun—namely, that evolution and integration of social conditions, that special grouping of them, that results in a demand for the erection of tall office buildings.

It is not my purpose to discuss the social conditions; I accept them as the fact, and say at once that the design of the tall office building must be recognized and confronted at the outset as a problem to be solved—a vital problem, pressing for a true solution.

Let us state the conditions in the plainest manner. Briefly, they are these: offices are necessary for the transaction of business; the invention and perfection of the high-speed elevators make vertical travel, that was once tedious and painful, now easy and comfortable; development of steel manufacture has shown the way to safe, rigid, economical constructions rising to a great height; continued growth of population in the great cities, consequent congestion of centers and rise in value of ground, stimulate an increase in number of stories; these successfully piled one upon another, react on ground values—and so on, by action and reaction, interaction and inter-reaction. Thus has come about that form of lofty construction called the "modern office building." It has come in answer to a call, for in it a new grouping of social conditions has found a habitation and a name.

Up to this point all in evidence is materialistic, an exhibition of force, of resolution, of brains in the keen sense of the word. It is the joint product of the speculator, the engineer, the builder.

Problem: How shall we impart to this sterile pile, this crude, harsh, brutal agglomeration, this stark, staring exclamation of eternal strife, the graciousness of those higher forms of sensibility and culture that rest on the lower and fiercer passions? How shall we proclaim from the dizzy height of this strange, weird, modern housetop the peaceful evangel of sentiment, of beauty, the cult of a higher life?

[1] Quoted from Louis H. Sullivan, *Kindergarten Chats* (revised 1918) and other writings, Wittenborn Art Books, Inc., New York, 1947.

This is the problem; and we must seek the solution of it in a process analogous to its own evolution—indeed, a continuation of it—namely, by proceeding step by step from general to special aspects, from coarser to finer considerations.

It is my belief that it is of the very essence of every problem that it contains and suggests its own solution. This I believe to be natural law. Let us examine, then, carefully the elements, let us search out this contained suggestion, this essence of the problem.

The practical conditions are, broadly speaking, these:

Wanted—1st, a story below-ground, containing boilers, engines of various sorts, etc.—in short, the plant for power, heating, lighting, etc. 2nd, a ground floor, so called, devoted to stores, banks, or other establishments requiring large area, ample spacing, ample light, and great freedom of access. 3rd, a second story readily accessible by stairways—this space usually in large subdivisions, with corresponding liberality in structural spacing and expanse of glass and breadth of external openings. 4th, above this an indefinite number of stories of offices piled tier upon tier, one tier just like another tier, one office just like all the other offices—an office being similar to a cell in a honey-comb, merely a compartment, nothing more. 5th, and last, at the top of this pile is placed a space or story that, as related to the life and usefulness of the structure, is purely physiological in its nature—namely, the attic. In this the circulatory system completes itself and makes its grand turn, ascending and descending. The space is filled with tanks, pipes, valves, sheaves, and mechanical et cetera that supplement and complement the force-originating plant hidden below-ground in the cellar. Finally, or at the beginning rather, there must be on the ground floor a main aperture or entrance common to all the occupants or patrons of the building.

This tabulation is, in the main, characteristic of every tall office building in the country. As to the necessary arrangements for light courts, these are not germane to the problem, and as will become soon evident, I trust need not be considered here. These things, and such others as the arrangement of elevators, for example, have to do strictly with the economics of the building, and I assume them to have been fully considered and disposed of to the satisfaction of purely utilitarian and pecuniary demands. Only in rare instances does the plan or floor arrangement of the tall office building take on an aesthetic value, and this usually when the lighting court is

external or becomes an internal feature of great importance.

As I am here seeking not for an individual or special solution, but for a true normal type, the attention must be confined to those conditions that, in the main, are constant in all tall office buildings, and every mere incidental and accidental variation eliminated from the consideration, as harmful to the clearness of the main inquiry.

The practical horizontal and vertical division or office unit is naturally based on a room of comfortable area and height, and the size of this standard office room as naturally predetermines the standard structural unit, and, approximately, the size of window openings. In turn, these purely arbitrary units of structure form in an equally natural way the true basis of the artistic development of the exterior. Of course the structural spacings and openings in the first or mercantile story are required to be the largest of all; those in the second or quasi-mercantile story are of a somewhat similar nature. The spacings and openings in the attic are of no importance whatsoever (the windows have no actual value), for light may be taken from the top, and no recognition of a cellular division is necessary in the structural spacing.

Hence it follows inevitably, and in the simplest possible way, that if we follow our natural instincts without thought of books, rules, precedents, or any such educational impedimenta to a spontaneous and "sensible" result, we will in the following manner design the exterior of our tall office building—to wit:

Beginning with the first story, we give this a main entrance that attracts the eye to its location, and the remainder of the story we treat in a more or less liberal, expansive, sumptuous way—a way based exactly on the practical necessities, but expressed with a sentiment of largeness and freedom. The second story we treat in a similar way, but usually with milder pretension. Above this, throughout the indefinite number of typical office tiers, we take our cue from the individual cell, which requires a window with its separating pier, its sill and lintel, and we, without more ado, make them look all alike because they are all alike. This brings us to the attic, which having no division into office-cells, and no special requirement for lighting, gives us the power to show by means of its broad expanse of wall, and its dominating weight and character, that which is the fact—namely, that the series of office tiers has come definitely to an end.

This may perhaps seem a bald result and a heartless, pessi-

mistic way of stating it, but even so we certainly have advanced a most characteristic stage beyond the imagined sinister building of the speculator-engineer-builder combination. For the hand of the architect is now definitely felt in the decisive position at once taken, and the suggestion of a thoroughly sound, logical, coherent expression of the conditions is becoming apparent. . . .

I assume now that in the study of our problem we have passed through the various stages of inquiry, as follows: 1st, the social basis of the demand for tall office buildings; 2nd, its literal material satisfaction; 3rd, the elevation of the question from considerations of literal planning, construction, and equipment, to the plane of elementary architecture as a direct outgrowth of sound, sensible building; 4th, the question again elevated from an elementary architecture to the beginnings of true architectural expression, through the addition of a certain quality and quantity of sentiment.

But our building may have all these in a considerable degree and yet be far from that adequate solution of the problem I am attempting to define. We must now heed the imperative voice of emotion.

It demands of us, what is the chief characteristic of the tall office building? And at once we answer, it is lofty. This loftiness is to the artist-nature its thrilling aspect. It is the very open organ-tone in its appeal. It must be in turn the dominant chord in his expression of it, the true excitant of his imagination. It must be tall, every inch of it tall. The force and power of altitude must be in it, the glory and pride of exaltation must be in it. It must be every inch a proud and soaring thing, rising in sheer exultation that from bottom to top it is a unit without a single dissenting line—that it is the new, the unexpected, the eloquent peroration of most bald, most sinister, most forbidding conditions.

The man who designs in this spirit and with the sense of responsibility to the generation he lives in must be no coward, no denier, no bookworm, no dilettante. He must live of his life and for his life in the fullest, most consummate sense. He must realize at once and with the grasp of inspiration that the problem of the tall office building is one of the most stupendous, one of the most magnificent opportunities that the Lord of Nature in His beneficence has ever offered to the proud spirit of man.

That this has not been perceived—indeed, has been flatly

denied—is an exhibition of human perversity that must give us pause. . . .

As to the former and serious views held by discerning and thoughtful critics, I shall, with however much of regret, dissent from them for the purpose of this demonstration, for I regard them as secondary only, non-essential, and as touching not at all upon the vital spot, upon the quick of the entire matter, upon the true, the immovable philosophy of the architectural art.

This view let me now state, for it brings to the solution of the problem a final, comprehensive formula.

All things in nature have a shape, that is to say, a form, an outward semblance, that tells us what they are, that distinguishes them from ourselves and from each other. . . .

Whether it be the sweeping eagle in his flight or the open apple-blossom, the toiling work-horse, the blithe swan, the branching oak, the winding stream at its base, the drifting clouds, over all the coursing sun, form ever follows function, and this is the law. Where function does not change, form does not change. The granite rocks, the ever-brooding hills, remain for ages; the lightning lives, comes into shape, and dies in a twinkling.

It is the pervading law of all things organic and inorganic, of all things physical and metaphysical, of all things human and all things superhuman, of all true manifestations of the head, of the heart, of the soul, that the life is recognizable in its expression, that form ever follows function. This is the law.

Shall we, then, daily violate this law in our art? Are we so decadent, so imbecile, so utterly weak of eyesight, that we cannot perceive this truth so simple, so very simple? Is it indeed a truth so transparent that we see through it but do not see it? Is it really, then, a very marvelous thing, or is it rather so commonplace, so everyday, so near a thing to us, that we cannot perceive that the shape, form, outward expression, design or whatever we may choose, of the tall office building should in the very nature of things follow the functions of the building, and that where the function does not change, the form is not to change?

Does this not readily, clearly, and conclusively show that the lower one or two stories will take on a special character suited to the special needs, that the tiers of typical offices, having the same unchanging function, shall continue in the same unchanging form, and that as to the attic, specific and

conclusive as it is in its very nature, its function shall equally be so in force, in significance, in continuity, in conclusiveness of outward expression? From this results, naturally, spontaneously, unwittingly, a three-part division, not from any theory, symbol, or fancied logic.

And thus the design of the tall office building takes its place with all other architectural types made when architecture, as has happened once in many years, was a living art. Witness the Greek temple, the Gothic cathedral, the medieval fortress.

And thus, when native instinct and sensibility shall govern the exercise of our beloved art; when the known law, the respected law, shall be that form ever follows function; when our architects shall cease struggling and prattling handcuffed and vainglorious in the asylum of a foreign school; when it is truly felt, cheerfully accepted, that this law opens up the airy sunshine of green fields, and gives to us a freedom that the very beauty and sumptuousness of the outworking of the law itself as exhibited in nature will deter any sane, any sensitive man from changing into license; when it becomes evident that we are merely speaking a foreign language with a noticeable American accent, whereas each and every architect in the land might, under the benign influence of this law, express in the simplest, most modest, most natural way that which it is in him to say; that he might really and would surely develop his own characteristic individuality, and that the architectural art with him would certainly become a living form of speech, a natural form of utterance, giving surcease to him and adding treasures small and great to the growing art of his land; when we know and feel that Nature is our friend, not our implacable enemy—that an afternoon in the country, an hour by the sea, a full open view of one single day, through dawn, high noon, and twilight, will suggest to us so much that is rhythmical, deep, and eternal in the vast art of architecture, something so deep, so true, that all the narrow formalities, hard-and-fast rules, and strangling bonds of the schools cannot stifle it in us—then it may be proclaimed that we are on the high-road to a natural and satisfying art, an architecture that will soon become a fine art in the true, the best sense of the word, an art that will live because it will be of the people, for the people, and by the people.

THE HOUSE

[The development of the individual dwelling or house was related to the economic rise of the yeoman and the artisan in the early Renaissance in Northern Europe.

The house became "domestic architecture" during the eighteenth century as a product of the increase of wealth in the middle class and the demand for more informality and comfort by the ruling class. It was also a result of social reforms that called for the improvement of housing conditions for the working population.

Domestic architecture in the first half of the nineteenth century was markedly eclectic in style. The choice of elements varied according to the place, materials, and time; the picturesque mode, the Italian villa and the temple-house were prevalent. The same diversity and eclecticism persisted throughout the century.

The interior plan of the house was greatly modified during the course of the century. At the beginning the plan was related to the profession of the owner, and resulted in an efficient grouping of rooms and a clearer distinction of their separate functions. At the end of the century the plan was transformed to provide for a more efficient performance of the services related to living. A planning innovation and a tendency begun in the 1790s that became common in the 1800s, was the opening of two rooms together. This tendency continued until only a partially defined space was arranged around a utility core.

As the detached house was the most common type of dwelling in the United States from its earliest settlement and was prevalent in England because of the early appearance of yeomanry, the detached house was developed principally in these two countries and influenced domestic architecture on the continent.]

ARCHITECTURE CONSIDERED IN RELATION TO ART, MORES, AND LEGISLATION[1]

Plan of a Country House for an Engineer

It would be an insult to educated men to leave them out of my plans, so I shall describe a house suited to a scholar burning his midnight oil for the benefit of society. Here the luxury of the arts will be banished, a simple façade is most suited to the modesty of a man who finds his satisfaction in being useful to his fellow-men. A stranger to the din of the outside world and confining himself to the society of a small circle of friends, he only needs small rooms whose walls can be covered with mementoes which powerfully stimulated the products of genius; the most important room will be a quiet study, away from the inevitable noise of the domestic round and from any interruptions, even affectionate, which might delay if not destroy the inspiration of the moment. It should be lit from above so that thought may not be distracted by exterior objects. An inner study is necessary affording extra protections against idlers and bores.

Books, apparatus for physics and mathematics, models of machines, these are the furnishings most cherished by a scholar. Enclosures of transparent glass allow all the objects laid out on vast shelves to be seen at a glance, but act as a barrier against damp and dust.

As comparisons are a vital food for man's imagination, his mind must be able to idle freely among its surroundings. So many fortunate discoveries have been due to the eye chancing upon objects seemingly unrelated and completely foreign to each other. The scholar's mind is never more completely occupied than when he gives an impression of complete inactivity: this seeming lethargy can be likened to the deceptive calm of Vesuvius; it is genius preparing to erupt.

If the architect, sacrificing his pride to simplicity and convenience, is able to procure an asylum for the scholar's meditation that is impenetrable, he will have deserved well of this

[1] Translated from Ledoux, *L'Architecture considérée sous le rapport de l'art, des moeurs, et de la législation.* For headnote on Ledoux, see p. 227.

country and discoveries useful to the progress of enlighten-
ment or increase of knowledge will be due to him.

Although the different sciences are connected in many as-
pects and nearly all have similar requirements, the architect
will nevertheless consult the particular scholar whose house he
is building.

A chemist's laboratory should not be arranged like a study
for a mathematician or an astronomer. The engineer's house
should include nearly everything needed by the others—librar-
ies, instruments, furnaces, workshops for casting and for car-
pentry, a smithy; nothing is outside the province of this valu-
able art, which the frivolous outlook of this century appears to
disdain.

Crowds will hasten to applaud the convulsive outbursts of
some tragedian, also a dancer's feats of strength and grace,
till their names re-echo with praise, but who has heard of the
engineer who rivals nature replacing an arm or leg for one
torn off by the furies of Bellone? The purely frivolous is sure
of universal admiration, so that people flock to gape at Vau-
canson's[2] Flute-player and his Duck, but one does not go to
watch wool, cotton, flax or silk being spun; nor the ingenious
mechanism that moved the Vatican obelisk, Sextus' Pyramid
and the pediment of the Louvre peristyle; nor the one that
plucked from the Finnish marshes the granite rock on which
is set the statue of Peter the Great.[3] Because of its simplicity
people despise a machine that can reduce the toughest metal
into spun and almost invisible wire. Both the coarse covering
for the poor man in his hut and the silken stuffs that furnish
the palaces of the nobleman are woven on looms that no one
has heard mentioned.

It is the engineer who hollows out those tubes of bronze,
iron or wood which discharge at our pleasure either terror and
death, or the waters pulping the material [for paper] destined
to store the recorded thought of bygone ages, making it in its
turn a torch for those to come.

It is the engineer who brings down the mast from the sum-
mit of the steepest rocks and who places on our ships those
masts whose height the eye must measure with respect those
mechanical marvels we owe to him in which a gentle vapor

[2] [He was noted for mechanical figures, some of which are still
preserved in Paris, (1709–82).]
[3] [By Etienne-Maurice Falconet (1716–91) erected in 1770 at Pet-
rograd, contemporary Leningrad.]

produces such powerful effects; those bridges flung boldly over the most turbulent rivers, these locks that control their dangerous levels; whilst the same mind contrived those domes that threaten the very sky; all this we owe to the engineer, yet this person, beyond price, lives usually unnoticed.

Let homage be paid to him now; let the last of our descendants honour the names of these new Archimedeses who are able to forge an indissoluble link between the happiness of the individual and the real interests of nations; above all let the architect be fully conversant with the laws and resources of engineering and never despise the principles of an art which can be of such profound service to him.

The elevations show the style thought suitable for the habitation of a scholar.

The plans indicate the needs.

The sections give the height of the floors.

The herb and vegetable gardens, the orchard are bordered by gentle water drawn from the Loue River. It is amongst such pleasant surroundings, each a source of inspiration to the scholar, that we have situated the different studies and workshops described above.

[ANDREW JACKSON DOWNING (1815–52) was the author of several influential books on gardening and plans for small houses. His father was a nurseryman at Newburgh on the Hudson, and Downing learned gardening from him and in association with the Austrian Consul General at New York, also a resident of Newburgh. His friend, the able architect A. J. Davis (1803–92), was the source of his knowledge of architecture. Downing had no formal education in either of these subjects.

Three years after Downing had designed and built his own house, he published *A Treatise on the Theory and Practice of Landscape Gardening, Adapted to North America, with a View to the Improvement of Country Residences and with Remarks on Rural Architecture* (1841). The next year, 1842, he amplified a single chapter on house design from the above into the important book, *Cottage Residences,* which had editions until 1879. Written in an informal style, a precursor of "do-it-yourself" books, it offered practical, concise suggestions

to the person who wished to direct either the building of his house or the laying out of his garden himself. Downing's expressed aim was to adapt the home to the site and to the means and character of the owner.

The distinctive exterior features of the "Downing house" were the battenboard walls, ample verandas and bay windows. In their interior design, there was an efficient grouping of the rooms and a recognition of the separate function of each. His view of the dignity and influence of the home was what differentiated it from similar books published in England, Germany, and Switzerland, and attracted the attention of the Europeans, and the visit of the Swede, Fredrika Bremer, who published *The Homes of the United States* (1849) with an introduction by Downing.

After a trip to England and France in 1850 to visit houses and gardens, Downing published *The Architecture of Country Houses*.

Downing was equally active as an horticulturist. His book *The Fruits and Fruit Trees of America* was published in 1845 and went into fourteen editions. When Congress resolved in 1851 to convert the public grounds near the Capitol, the White House, and the Smithsonian Institution into gardens, Downing was invited to submit the designs. These he completed just before he was drowned in escaping from a burning Hudson River ferryboat.

SEE: John Claudius Loudon, *Encyclopaedia of Cottage, Farm, and Villa Architecture and Furniture,* London, 1833.

 J. Gloag, *Victorian Taste,* London, 1962.]

COTTAGE RESIDENCES[1]

Preface. A hearty desire to contribute something to the improvement of the domestic architecture and the rural taste of our country, has been the motive which has influenced me in preparing this little volume. With us, almost every man either

[1] Quoted from A. J. Downing, *Cottage Residences; A Series of Designs for Rural Cottages and Cottage Villas, and their Gardens and Grounds Adapted to North America,* Part I, 3rd edition, New York, 1847.

builds, or looks forward to building, a home for himself, at
some period of his life; it may be only a log hut, or a most
rustic cottage, but perhaps also, a villa, or a mansion. As yet,
however, our houses are mostly either of the plainest and most
meagre description, or, if of a more ambitious, they are fre-
quently of a more objectionable character—shingle palaces,
of very questionable convenience, and not in the least adapted,
by their domestic and rural beauty, to harmonize with our
lovely natural landscapes.

Now I am desirous that every one who lives in the country,
and in a country-house, should be in some degree conversant
with domestic architecture, not only because it will be likely
to improve the comfort of his own house, and hence all the
houses in the country, but that it will enlarge his mind, and
give him new sources of enjoyment.

It is not my especial object at this moment, to dwell upon
the superior convenience which may be realized in our houses,
by a more familiar acquaintance with architecture. The ad-
vantages of an ingeniously arranged and nicely adapted plan,
over one carelessly and ill-contrived, are so obvious to every
one, that they are self-evident. This is the ground-work of
domestic architecture, the great importance of which is recog-
nised by all mankind, and some ingenuity and familiarity with
practical details are only necessary to give us compact, con-
venient, and comfortable houses, with the same means and in
the same space as the most awkward and unpleasing forms.

But I am still more anxious to inspire in the minds of my
readers and countrymen livelier perceptions of the Beautiful,
in everything that relates to our houses and grounds. I wish to
awaken a quicker sense of the grace, the elegance, or the
picturesqueness of fine forms that are capable of being pro-
duced in these, by Rural Architecture and Landscape Garden-
ing—a sense which will not only refine and elevate the mind,
but open to it new and infinite resources of delight. . . .

It is in this regard, that I wish to inspire all persons with a
love of beautiful forms, and a desire to assemble them around
their daily walks of life. I wish them to appreciate how su-
perior is the charm of that home where we discover the taste-
ful cottage or villa, and the well-designed and neatly kept
garden or grounds, full of beauty and harmony—not the less
beautiful and harmonious, because simple and limited; and to
become aware that these superior forms, and the higher and
more refined enjoyment derived from them, may be had at

the same cost and with the same labor as a clumsy dwelling, and its uncouth and ill-designed accessories. . . .

Architectural Suggestions

As the first object of a dwelling is to afford a shelter to man, the first principle belonging to architecture grows out of this primary necessity, and it is called the principle of *Fitness or Usefulness.* After this, man naturally desires to give some distinctive character to his own habitation, to mark its superiority to those devoted to animals. This gives rise to the principle of *Expression of Purpose.* Finally, the love of the beautiful, inherent in all finer natures, and its exhibition in certain acknowledged forms, has created the principle of the *Expression of Style.* . . . There are some rules of fitness of nearly universal application. Thus a dining-room should obviously have connected with it, either a pantry or a large closet, or both; and it should be so placed as to afford easy ingress and egress to and from the kitchen. The drawing-room, parlor, or finest apartment, should look out on the most beautiful view, either over a distant prospect, if there be such, or, if not, upon the fine home landscape of trees, lawn, or flower-garden. A library may occupy a more secluded position, and requires less attention to outward circumstances, as the *matériel* from whence it dispenses enjoyment is within itself. Again, there are other minor points more generally understood, which may be considered under this principle, and to which we need scarcely allude. Among these are the construction of proper drains to the kitchen and basement, the introduction of water pipes, cisterns, etc. A bathing room requires little space, and may be easily constructed in any cottage, and its great importance to health renders it a most desirable feature in all our houses. No dwelling can be considered complete which has not a water-closet under its roof, though the expense may yet for some time prevent their general introduction in small cottages.

In a country like ours, where the population is comparatively sparse, civil rights equal, and wages high, good servants or domestics are comparatively rare, and not likely to retain their places for a long time. The maximum of comfort, therefore, is found to consist in employing the smallest number of servants actually necessary. This may be greatly facilitated by having all the apartments conveniently arranged with reference to their various uses, and still further by introducing

certain kinds of domestic labor-saving apparatus to lessen the amount of service required, or to render its performance easy. Among those which we would, from experience, especially recommend for cottages, are the rising cupboard or dumb-waiter, the speaking tube, and the rotary pump. . . .

The universally acknowledged utility of closets, renders it unnecessary for us to say anything to direct attention to them under this head. In the principal story, a pantry or closets are a necessary accompaniment to the dining or living-room, but are scarcely required in connexion with any of the other apart-ments. Bedrooms always require at least one closet to each, and more will be found convenient. . . .

When we are necessarily restricted to the employment of a certain material, both fitness and good taste require that there should be a correspondence between the material used and the style adopted for the building. Heavy and massive architecture, a temple, a castle, or a mansion, should be built of stone only, or some solid enduring substance, but cottages in some light and fanciful styles may with more propriety be erected in wood, that material being in harmony with the expression of the form and outlines. There cannot well be a greater violation of correct taste, than to build a Gothic cas-tellated villa with thin wooden boards. It is a species of coun-terfeit coin which will never pass current with cultivated minds. . . .

Not a little of the delight of beautiful buildings to a culti-vated mind grows out of the *sentiment* of architecture, or the associations connected with certain styles. Thus the sight of an old English villa will call up in the mind of one familiar with the history of architecture, the times of the Tudors, or of "Merry England" in the days of Elizabeth. The mingled quaintness, beauty, and picturesqueness of the exterior, no less than the oaken wainscot, curiously carved furniture, and fixtures of the interior of such a dwelling, when harmoniously complete, seem to transport one back to a past age, the do-mestic habits, the hearty hospitality, the joyous old sports, and the romance and chivalry of which, invest it, in the dim retro-spect, with a kind of golden glow, in which the shadowy lines of poetry and reality seem strangely interwoven and blended.

So too an Italian villa may recall, to one familiar with Italy and art, by its bold roof lines, its campanile and its shady bal-conies, the classic beauty of that fair and smiling land, where pictures, sculptured figures, vases, and urns, in all exquisite

forms, make part of the decorations and "surroundings" of domestic and public edifices. A residence in the Roman style (more suitable than the Grecian) may, by its dignified elegance of arrangement and decoration, recall to the classic mind the famed Tusculum retreat of Pliny. And one fond of the wild and picturesque, whose home chances to be in some one of our rich mountain valleys, may give it a peculiar charm to some minds by imitating the Swiss cottage, or at least its expressive and striking features. A great deal of the charm of architectural style, in all cases, will arise from the happy union between the locality or site, and the style chosen, and from the entireness with which the architect or amateur enters into the spirit and character of the style, and carries it through his whole work. This may be done in a small cottage, and at little cost, as well as in a mansion, at great expense; but it requires more taste and skill to achieve the former admirably, although the latter may involve ten times the magnitude.

Design I

A SUBURBAN COTTAGE FOR A SMALL FAMILY

We have supposed this cottage to be situated in the suburbs of a town or village, and, for the sake of illustrating the treatment of a small portion of ground, we shall also imagine it to be placed on a lot of ground 75 feet front by 150 deep, which at the time of commencing the building, has upon it no trees or improvements of any description.

By referring to the plan of the first floor of this cottage, [Plate 41], the reader will perceive on the left of the hall, the parlor, or living-room, 16 feet by 22 feet, having in communication with it, a pantry, and a closet for books—each 4 feet by 8 feet. On the opposite side of the hall are the kitchen, 14 feet by 16, and a bedroom, 12 feet by 16 feet. In the plan of the chamber floor, there are four bedrooms of good size, and one of small dimensions. Sufficient cellar room will be obtained under the living-room, closets, and hall, and it will not therefore be necessary to excavate for this purpose under the kitchen and first floor bedroom; a circumstance which will lessen the expense in building the foundation walls.

This simple cottage will be a suitable one for a small family when the mistress wishes to have the management of the domestic affairs directly under her own personal care and super-

vision. In such a case it is indispensable to have the kitchen on the same floor with the living-room, though, if possible, not opening directly into it; as, in such a case, the smell arising from the cooking would be in unpleasant proximity to the latter. We have therefore placed it on the opposite side of the hall, though but a few steps from the living-room. In a cottage of this description, the master and mistress will generally prefer to have their own bedroom on the first floor, and we have accordingly placed it opposite the living-room.

Although this cottage is of very moderate size, yet, to a family of small means, leading a comparatively retired life, it will afford a great deal of comfort, and even a considerable degree of taste or neatness. The parlor or living-room is comparatively large; its outline is agreeably varied by the bay window opposite the fire-place—and the closet of books connected with it, indicating a certain degree of mental cultivation, may very fairly stand in the place of the library which forms one of the suite of apartments in a larger cottage or villa. On the other hand, the pantry opening into the same apartment renders it equally eligible and convenient as a dining-room. However large our dwelling-houses may be, including every grade from a cottage to a palace, if they are occupied by a family of moderate size, it will be found that more than one room is seldom used at a time, and that all the actual comforts of domestic life may be realized in a cottage of this class, containing only a single parlor or living-room, as well as in a mansion of a dozen apartments. . . .

As regards external effect, we think this cottage will be allowed to be very pleasing to the eye. Aside from any other quality, its uniformity will be a source of satisfaction to a larger class of persons who do not relish irregularity in any building. There are also several features entering into the composition of this cottage, which give it at once the air of something superior in design to ordinary buildings of the same class. The first of these is the veranda, ornamented by brackets between the supports, which shelters the entrance-door and affords an agreeable place both for walking in damp or unpleasant weather, and to enjoy a cool shaded seat in the hotter portions of the season. The second feature is the projection of the eaves, with the ornamental eave-board, which serves to protect the exterior more completely than any other form against the effects of storms, and gives character by its boldness and the deep shadows it casts upon the building. The

chimney tops are rendered sufficiently ornamental to accord
with the degree of decoration displayed in the other portions
of the cottage; and something of the bracketed character is
kept up in the dressings of the window and door-frames. The
projecting dormer-window adds beauty and gives importance
to the entrance front. . . .

[FRANK LLOYD WRIGHT (1869–1959) was born in Spring
Green, Wisconsin; however, the first ten years of his life were
spent in Massachusetts. While in the east, his mother, Anna
Lloyd-Jones—a member of a brilliant family of liberals, jour-
nalists, and clergymen who contributed to the progressive
aspects of the State of Wisconsin's government—became in-
terested in the Froebel "kindergarten." She secured for her
son the simple geometric blocks that Friedrich Froebel
(1782–1852), who had been trained as an architect, had
devised for creative play. Wright always acknowledged his
debt to the Froebel system of ordering related elements into
planned compositions of larger groups of forms. Eight years
after the family's return to Wisconsin, his erratic, musical fa-
ther deserted the family, and Wright secured employment
with a builder-architect, Allen Conover, in Madison, and fol-
lowed courses in civil engineering at the University of Wis-
consin.

After a brief apprenticeship with a well-trained eastern
architect, Lyman Silsbee—commissioned by Wright's uncle, a
prominent Chicago clergyman, to build the church of his con-
gregation—Wright secured a job in 1887 with Adler and Sulli-
van to prepare drawings for the Chicago Auditorium. After
two years, Wright's talent won him an office next to Louis
Sullivan. Their association was as profitable to them both as
had been that of Sullivan and Adler.

Wright worked as a draftsman on the firm's large buildings.
Most of the designing for the private houses commissioned
from the firm was assigned to him. This was Wright's first
independent work in the field of domestic architecture in
which he made his great contribution to western architecture.

In 1893 at the Columbian Exposition at the World's Fair,
Wright studied the Katsura Palace, a half-size model of a Japa-
nese wooden building erected there. The modular organization
of the building, the possibility of unifying the space units by

sliding panels, and the intimate relation between indoors and outdoors were all qualities that corresponded to his own desire.

By 1901 Wright evolved the Prairie House that revolutionized western European domestic architecture. The plan of it became widely known by its inclusion in a series of moderate-priced house plans the *Ladies' Home Journal* offered to its readers in 1900–1. In it was the germ of most of the ideas that are present in contemporary American domestic architecture. The main floor had few rooms, adjoining spaces were allowed to merge. The space was organized by means of a horizontal band running along the interior side wall, to correspond to the scale of the human figure. The interior space flowed around a utility core of fireplace and kitchen and outward to square or triangular cantilevered balconies hung from the central core. Leaded ornamental cubes of colored and opaque glass edged each windowpane to link it to the pattern of the house. The cube-shaped furniture, the built-in lighting fixtures, the built-in sideboards, closets, benches, and tables added to the organic functioning of the house as a living unit. The terraces, court and garden, depending on the site, were composed with the cubic units of the house to achieve a complete environment. The entire plan resulted from Wright's conception of the architect as a molder of men, and the house or home as his instrument.

The Robie House (1908, Chicago), and the Coonley House mark the refinement of the Prairie House, and the Kaufmann House (1936, Bear Run, Pennsylvania), its final and perfect expression. The Prairie House had a marked influence on domestic architecture in America and Europe. As the houses of Downing and the Red House of Webb, it was accompanied by significant developments in the decorative arts and crafts, household accessories and utensils, and established once more a relationship between the crafts and domestic life. The Prairie House also marked a return to a total plan for site, house, and garden, prevalent in the Renaissance. In it and every building he designed, the individual set the scale of proportions. It was a product of Wright's philosophy that called for the integration of man with nature, characteristic of much of nineteenth-century philosophy. The Usonian House, developed in the 1930s, simplified, concentrated and economical, offered a basic functional design to be varied by individual needs. It

was designed as all of Wright's work in relation to his conception of Broad Acre City, a city for ideal living.

In 1893, when Louis Sullivan discovered that Wright had accepted commissions for private houses independent of the firm, they quarreled and Wright established his own office.

Although the building of houses filled a major portion of his early career, Wright designed with equal originality any building: the Larkin Company, Buffalo (1904), with the first interior ventilating system; the Unity Church, Oak Park (1906); the Yahara Boat House, Madison (1902); and Midway Gardens (1914). These buildings, his famous designs at the annual exhibitions of the Chicago Architectural Club from 1894 on, and his lectures—one of the most important being "The Art and Craft of the Machine" (1901)—made Wright one of the best-known architects in the first decade of the century in the United States, which he continued to be for the rest of his life.

There was no building material that Wright did not experiment with and utilize with an imagination that equalled his originality in devising innovations in construction principles, such as floating tray-like supports to hold the individual units of the Imperial Hotel, Tokyo, or a center mast in the tall building from which cantilever floors extended.

Through the visits of the Dutch architect, H. P. Berlage (1856–1934), to Chicago in 1897 and 1911, Wright became a major influence in the architecture of Europe. Berlage, the influential teacher of the generation in Holland that shed academic forms, explored functionalism, and pioneered in low-cost housing, made known Wright's work on his return. The famous Berlin editor, Wasmuth, published under the supervision of Wright who was in Berlin for the exhibit of his work, *Ausgeführt Bauten und Entwürfe von Frank Lloyd Wright* (1910) and the following year, *Frank Lloyd Wright, Ausgeführte Bauten,* with an introduction by C. R. Ashbee (1863–1942), the English architect and founder of the Guild and School of Handicraft.

The cubistic abstract decorative elements in Wright's style awakened a responsive note in European painters, and especially in Holland where they sought style elements that affirmed geometric forms. The movement of abstract geometric art which Piet Mondriaan supported by the review *Der Stijl* (1917) bore a strong resemblance to Wright's forms. The Dutch magazine *Wendingen* published many of Wright's designs between 1920 and 1926, and a series of special issues

were devoted to his work in 1925. A German book on his work appeared in 1926, a French one in 1928, to make his work well known in Europe.

Although Wright spent two years, 1909–11, in Florence, Italy, it is difficult to discover any trace of European influence in his style.

In his numerous articles, books, and autobiography, Wright was a master, as Sullivan, of an exuberant prose with poetic cadence that is similar to Walt Whitman's style.

Wright overshadowed all other American architects during his lifetime, and joined with the greatest architects of Europe to produce the architectural forms of the twentieth century.

SEE: H. R. Hitchcock, *In the Nature of Materials: The Buildings of F. L. Wright, 1887–1941,* New York, 1941.

F. Gutheim, editor, *Frank Lloyd Wright on Architecture: Selected Writings, 1894–1940,* New York, 1941.]

A HOME IN A PRAIRIE TOWN[1]

This Is the Fifth Design in the Journal's New Series of Model Suburban Houses Which Can Be Built at Moderate Cost

A city man going to the country puts too much in his house and too little in his ground. He drags after him the fifty-foot lot, soon the twenty-five-foot lot, finally the party wall; and the homemaker who fully appreciates the advantages which he came to the country to secure feels himself impelled to move on.

It seems a waste of energy to plan a house hap-hazard, to hit or miss an already distorted condition, so this partial solution of a city man's country home on the prairie begins at the beginning and assumes four houses to the block of four hundred feet square as the minimum of ground for the basis of his prairie community.

The block plan to the left, at the top of the page,[2] shows an arrangement of the four houses that secures breadth and prospect to the community as a whole, and absolute privacy

[1] Quoted from Frank Lloyd Wright, "A Home in a Prairie Town", *Ladies' Home Journal,* February 10, 1901.
[2] [See Plate 42.]

both as regards each to the community, and each to each of the four.

The perspective view shows the handling of the group at the centre of the block, with its foil of simple lawn, omitting the foliage of curb parkways to better show the scheme, retaining the same house in the four locations merely to afford an idea of the unity of the various elevations. In practice the houses would differ distinctly, though based upon a similar plan.

The ground plan, which is intended to explain itself, is arranged to offer the least resistance to a simple mode of living, in keeping with a high ideal of the family life together. It is arranged, too, with a certain well-established order that enables free use without the sense of confusion felt in five out of seven houses which people really use.

The exterior recognizes the influence of the prairie, is firmly and broadly associated with the site, and makes a feature of its quiet level. The low terraces and broad eaves are designed to accentuate that quiet level and complete the harmonious relationship. The curbs of the terraces and formal inclosures for extremely informal masses of foliage and bloom should be worked in cement with the walks and drives.

Cement on metal lath is suggested for the exterior covering throughout, because it is simple, and, as now understood, durable and cheap.

The cost of this house with interior as specified and cement construction would be seven thousand dollars:

Masonry, Cement and Plaster	$2800.00
Carpentry	3100.00
Plumbing	400.00
Painting and Glass	325.00
Heating-combination (hot water)	345.00
Total	$6970.00

In a house of this character the upper reach and gallery of the central living-room is decidedly a luxury. Two bedrooms may take its place, as suggested by the second-floor plan. The gallery feature is, nevertheless, a temptation because of the happy sense of variety and depth it lends to the composition of the interior, and the sunlight it gains from above to relieve the shadow of the porch. The details are better grasped by a study of the drawings. The interior section in perspective shows the

gallery as indicated by dotted lines on the floor plan of the living-room.

The second-floor plan disregards this feature and is arranged for a larger family. Where three bedrooms would suffice the gallery would be practicable, and two large and two small bedrooms with the gallery might be had by rearranging servants' rooms and baths.

The interior is plastered throughout with sand finish and trimmed all through with flat bands of Georgia pine, smaller back bands following the base and casings. This Georgia pine should be selected from straight grain for stiles, rails and running members, and from figured grain for panels and wide surfaces. All the wood should be shellacked once and waxed, and the plaster should be stained with thin, pure color in water and glue.

EDITOR'S NOTE: As a guarantee that the plan of this house is practicable, and that the estimates for cost are conservative, the architect is ready to accept the commission of preparing the working plans and specifications for this house to cost Seven Thousand Dollars, providing that the building site selected is within reasonable distance of a base of supplies where material and labor may be had at the standard market rates.

IV. REALISM AND IMPRESSIONISM

[MICHEL EUGÈNE CHEVREUL (1786–1889), a professor of organic chemistry at the Museum of Natural History (Jardin des Plantes), was celebrated for his study of the components of fats and the nature of soap. As a young man, he had been appointed head of the dye laboratories at the Gobelin tapestry factory. To answer complaints on the quality of certain dye colors, Chevreul was led to a study of the various qualities of natural color. He formulated a result of his research in the law of complementary colors. He noted that light is the source of color and is colorless; but when it passes through a glass prism it separates into six colors, three of which are primary and three of which are compounded from the mixture of the simple colors in pairs. He noted that each primary color, red, blue, and yellow, is optically intensified by its complementary, blue by orange, red by green, and yellow by violet.

His is a first attempt to analyze color contrasts on a scientific basis, the result of the observation of natural phenomena and experimentation. He published his findings in *De la loi du contraste simultané des couleurs* in 1839, which formed the basis for the study of color throughout the nineteenth century. Chevreul provided the scientific foundation for Impressionist and neo-Impressionist painting. Chevreul was the proctor of young artists like Delacroix eager to acquire a scientific method to achieve greater luminosity in their painting.

SEE: Maria Schindler, *Pure Colour,* London, 1946.
 R. Rood, *Color and Light in Painting,* ed. by George Stout, New York, 1941.
 Johannes Itten, *The Art of Color,* New York, 1961.]

THE PRINCIPLES OF HARMONY AND CONTRAST OF COLOURS AND THEIR APPLICATIONS TO THE ARTS[1]

Author's Preface

This work is too remote from the science which has occupied the greatest part of my life, too many subjects differing in appearance are treated of, for me not to indicate to the reader the cause which induced me to undertake it: subsequently I shall speak of the circumstances which made me extend the limits within which it first seemed natural to restrain it.

When I was called upon to superintend the dyeing department of the royal manufactories (Gobelins), I felt that this office imposed on me the obligation of placing the dyeing on a new basis, and consequently it was incumbent on me to enter upon minute researches, the number of which I clearly foresaw, but not the variety: the difficulties of my position were greatly increased by numerous perplexing questions proposed to me for solution by the directors of that establishment; I was therefore obliged to arrange my labours differently than if I had been free from every other occupation.

In endeavouring to discover the cause of the complaints made of the quality of certain pigments prepared in the dyeing laboratory of the Gobelins, I soon satisfied myself that if the complaints of the want of permanence in the light blues, violets, greys, and browns, were well-founded, there were others, particularly those of the want of vigour in the blacks employed in making shades in blue and violet draperies, which had no foundation; for after procuring black-dyed wools from the most celebrated French and other workshops—and perceiving that they had no superiority over those dyed at the Gobelins— I saw that the want of vigour complained of in the blacks was owing to the colour next to them, and was due to the phenomena of contrast of colours. I then saw that to fulfil the duties of director of the dyeing department, I had two quite distinct subjects to treat—the one being the contrast of colours generally

[1] Quoted from *The Principles of Harmony and Contrast of Colours and their Applications to the Arts,* by Michel Eugène Chevreul, trans. by Charles Martel, pseud. of Thomas Delf, third edition, London, 1899.

considered, either under the scientific relation, or under that of its applications; the other concerned the chemical part of dyeing. Such, in fact, have been the two centres to which all my researches during ten years have converged.

The work I now publish is the result of my researches on *Simultaneous Contrast of Colours;* researches which have been greatly extended since the lecture I gave on this subject at the Institute on the 7th April, 1828. . . .

In fact, numerous observations on the view of coloured objects made during several months, verified by my pupils, and others much accustomed in their professions to judge of colours, and to appreciate the least difference in them, have first been collected and described as proved facts. Then, in reflecting on the relations these facts have together, in seeking the principle of which they are the consequences, I have been led to the discovery of the one which I have named the *law of simultaneous contrast of colours.* Thus this work is really the fruit of the method *a posteriori:* facts are observed, defined, described, then they become generalised in a simple expression which has all the characters of a law of nature. This law, once demonstrated, becomes an *a priori* means of assorting coloured objects so as to obtain the best possible effect from them, according to the taste of the person who combines them; of estimating if the eyes are well organised for seeing and judging of colours, or if painters have exactly copied objects of known colours. . . .

I beg the reader never to forget when it is asserted of the phenomena of simultaneous contrast, *that one colour placed beside another receives such a modification from it* that this manner of speaking does not mean that the two colours, or rather the two material objects that present them to us, have a mutual action, either physical or chemical; it is really only applied *to the modification that takes place before us* when we perceive the simultaneous impression of these two colours.
L'Hay, near Paris,
 19th April, 1835.

Introduction

(1) It is necessary, in the first place, to explain some of the optical principles which relate,
 Firstly, to the law of Simultaneous Contrast of Colours; and
 Secondly, to the applications of this law in the various arts

which make use of coloured materials to attract the eye.

(2) A ray of solar light is composed of an indeterminate number of differently-coloured rays; and since, on the one hand, it is impossible to distinguish each particular one, and as, on the other, they do not all differ equally from one another, they have been distributed into groups, to which are applied the terms *red rays, orange rays, yellow rays, green rays, blue rays, indigo rays,* and *violet rays;* but it must not be supposed that all the rays comprised in the same group, *red* for instance, are identical in colour; on the contrary, they are generally considered as differing, more or less, among themselves, although we recognise the impression they separately produce as comprised in that which we ascribe to *red.*

(3) When light is reflected by an opaque white body, it is not modified in proportion to the differently-coloured rays which constitute white light; only,

A. *If this body is not polished,* each point of its surface must be considered as dispersing, in every direction through the surrounding space, the white light which falls upon it; so that the point becomes visible to an eye placed in the direction of one of these rays. We may easily conceive that the image of a body in a given position, is composed of the sum of the physical points which reflect to the eye so placed, a portion of the light that each point radiates.

B. *When the body is polished,* like the surface of a mirror, for instance, one portion of the light is reflected irregularly, as in the preceding case; at the same time another portion is regularly or specularly reflected, giving to the mirror the property of presenting to the eye, properly situated, the image of the body which sends its light to the reflector. One consequence of this distinction is, that if we observe two plane surfaces reflecting white light differing from each other only in polish, it results that in those positions where the *non*-polished surface is visible, all its parts will be equally, or nearly equally, illuminated; while the eye, when it is in a position to receive only that which is reflected irregularly, will receive but little light from the polished surface; on the contrary, it will receive much more when it is in a position to receive light regularly reflected.

(4) If the light which falls upon a body is completely absorbed by it, as it would be in falling into a perfectly obscure

cavity, then the body appears to us *black,* and it becomes visible only because it is contiguous to surfaces which transmit or reflect light. Among black substances, we know of none that are perfectly so, and it is because they reflect a small quantity of white light, that we conclude they have relief, like other material objects. Moreover, what proves this reflection of white light is that the blackest bodies, when polished, reflect the images of illuminated objects placed before them.

(5) When light is reflected by an opaque coloured body, there is always

A reflection of white light—and

A reflection of coloured light;

the latter is due to the fact that the body *absorbs* or extinguishes within its substance a certain number of coloured rays, and *reflects* others. It is evident that the coloured rays reflected are of a different colour from those absorbed, they would reproduce white light. We shall return to this subject in (6).

(6) Let us now return to the relation which exists between the coloured light *absorbed,* and the coloured light *reflected,* by an opaque body, which makes it appear to us of the colour peculiar to this light.

It is evident, from the manner in which we have considered the physical composition of solar light (2), that if we reunited the total quantity of the coloured light *absorbed* by a coloured body, to the total quantity of coloured light *reflected* by it, we should reproduce white light: for it is this relation that two differently coloured lights, taken in given proportions, have of reproducing white light, that we express by the terms

Coloured lights complementary to each other, or

Complementary colours.

It is in this sense we say,

That Red is complementary to Green, and *vice versa;*

That Orange is complementary to Blue, and *vice versa;*

That Greenish-Yellow is complementary to Violet, and *vice versa;*

That Indigo is complementary to Orange-Yellow, and *vice versa.*

(7) It must not be supposed that a red or yellow body reflects only *red* and *yellow* rays besides white light; they each reflect *all kinds* of coloured rays: only those rays which lead us to judge the bodies to be *red* or *yellow,* being more numerous than the other rays reflected, produce a greater effect. Nevertheless, those other rays have a certain influence in

modifying the action of the red or yellow rays upon the organ of sight; and this will explain the innumerable varieties of *hue* which may be remarked among different red and yellow substances.

Method of Observing the Phenomena of Simultaneous Contrast of Colours

DEFINITION OF SIMULTANEOUS CONTRAST

(8) If we look simultaneously upon two stripes of different tones of the same colour, or upon two stripes of the same tone of different colours placed side by side, if the stripes are not too wide, the eye perceives certain modifications which in the first place influence the intensity of colour, and in the second, the optical composition of the two juxtaposed colours respectively.

Now as these modifications make the stripes appear different from what they really are, I give to them the name of *simultaneous contrast of colours:* and I call *contrast of tone* the modification in intensity of colour, and *contrast* of colour that which affects the optical composition of each juxtaposed colour. . . .

(11) The following experiment . . . is very suitable for demonstrating the full extent of contrast of tone.

Divide a piece of cardboard into ten stripes, each of about a quarter[2] of an inch in width, 1, 2, 3, 4, 5, 6, 7, 8, 9, 10, and cover it with a uniform wash of Indian ink. When it is dry, spread a second wash over all the stripes except the first. When this second wash is dry, spread a third over all the stripes except 1 and 2; and proceed thus to cover all the stripes with a flat tint, each one becoming darker and darker, as it recedes from the first (1).

If we take ten stripes of paper of the same grey, but each of a different tone, and glue them upon a card so as to observe the preceding gradation, it will serve the same purpose.[2]

On now looking at the card, we shall perceive that instead of exhibiting flat tints, each stripe appears of a tone gradually shaded from the edge *a a* to the edge *b b*. In the band 1, the contrast is produced simply by the contiguity of the edge *b b* with the edge *a a* of the stripe 2; in the stripe 10 it is simply by

[2] [See Plate 45.]

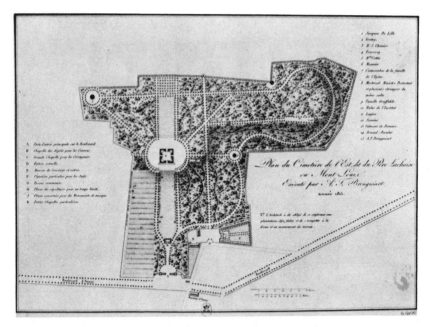

33. **Brongniart,** Plan of the Cemetery of the East, called *Père la Chaise* on Mont Louis. (photo: BIBLIOTHEQUE NATIONALE, PARIS)

34. **Von Schinkel**, Section, Altes Museum, Berlin. From Wohlzogen, *Schinkel Nachlass*. Berlin (1863)

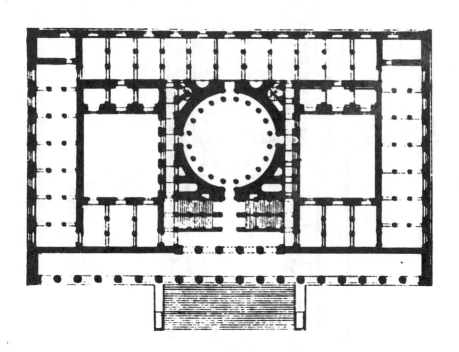

35. **Von Schinkel,** Ground Plan of First Floor, Altes Museum, Berlin.

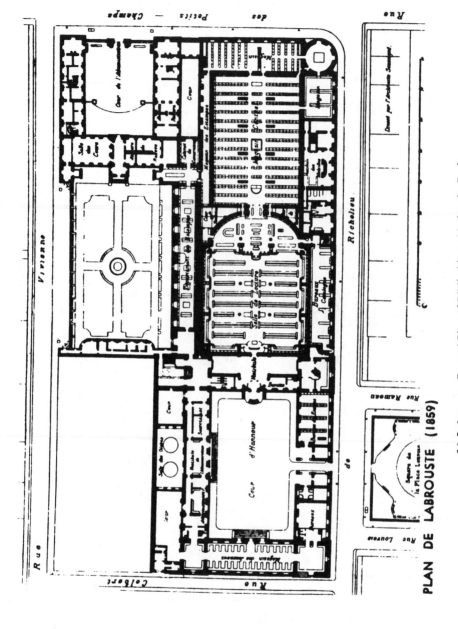

36. **Labrouste**, Ground Plan of Bibliothèque Nationale, Paris. (photo: NOUVELLES ANNALES DE CONSTRUCTION)

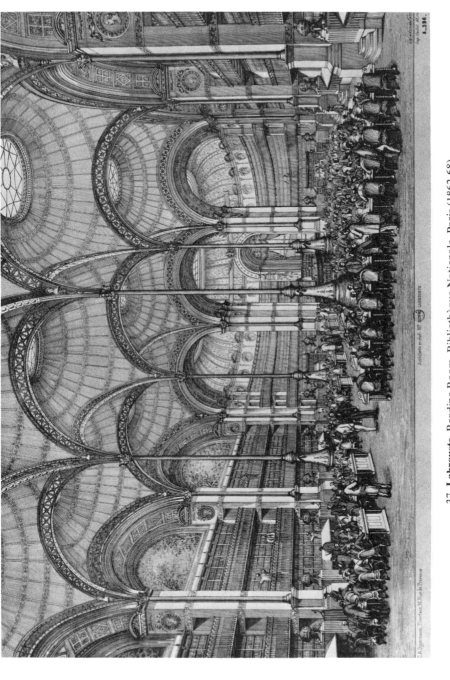

37. **Labrouste,** Reading Room, Bibliothèque Nationale, Paris (1862-68). (photo: NOUVELLES ANNALES DE CONSTRUCTION, SERIES DE BIBLIOTHÈQUES ET MUSÉES, NO. 1)

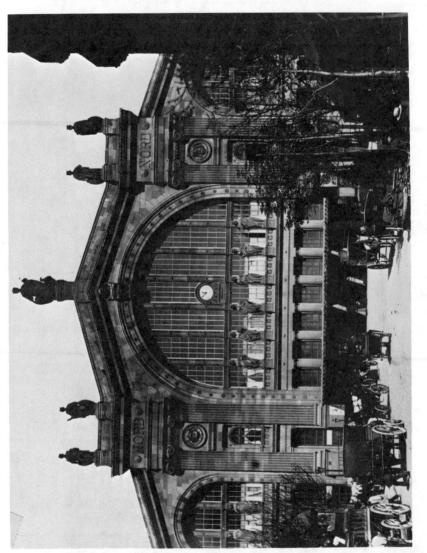

38. **Reynaud,** Gare du Nord (1865).
(photo: ARCHIVES PHOTOGRAPHIQUES)

39. **Sullivan,** Guaranty Trust Building, Buffalo, N. Y. (1894-95).
(CHICAGO ARCHITECTURAL PHOTO CO.)

40. **Ledoux,** Plan of a Country House for an Engineer.
From *Architecture Considered in Relation to Art,
Mores, and Legislation,* Paris, 1804

41. **Downing,** A Suburban Cottage, Design 1, Fig. 3, Fig. 4.
From *Cottage Residences*, New York, 1847

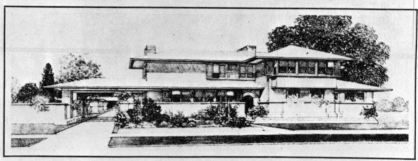

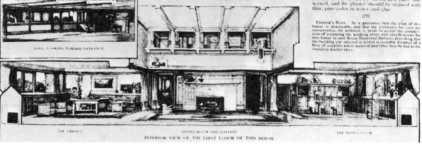

42. **Wright,** A Home in a Prairie Town.
From *Ladies' Home Journal,* Feb. 1901

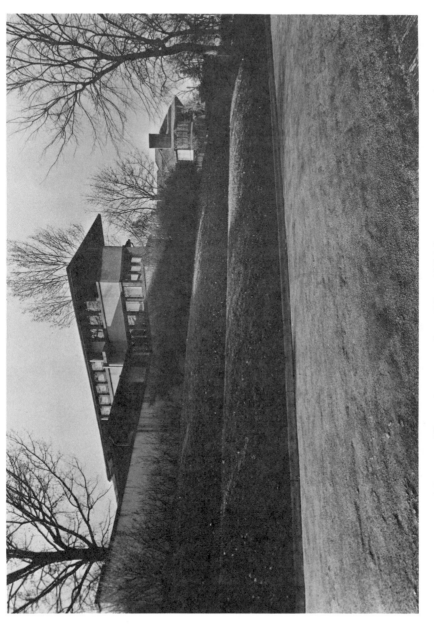

43. **Wright,** E. A. Gilmore House, Madison, Wis. (1908) (photo: MUSEUM OF MODERN ART)

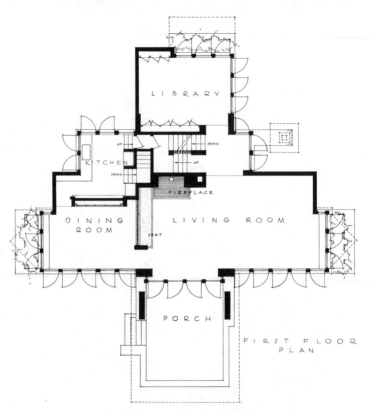

LIBRARY

KITCHEN

DINING
ROOM

LIVING ROOM

FIREPLACE

SEAT

PORCH

FIRST FLOOR
PLAN

44. **Wright,** Ground Plan of First and Second
Floors, E. A. Gilmore Residence.

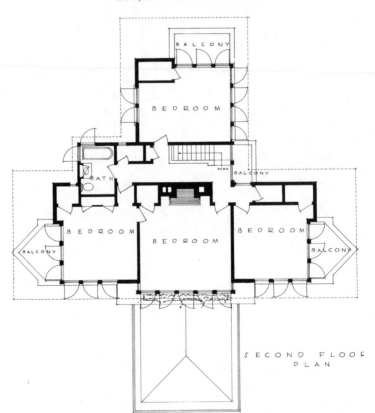

BALCONY

BEDROOM

BATH

BALCONY

BEDROOM

BEDROOM

BEDROOM

BALCONY

BALCONY

SECOND FLOOR
PLAN

45. **Chevreul,** Experimental Demonstration of
Contrast of Tone, Grey Scale.
From *On the Principles of Harmony and
Contrast of Colours,* London, 1855

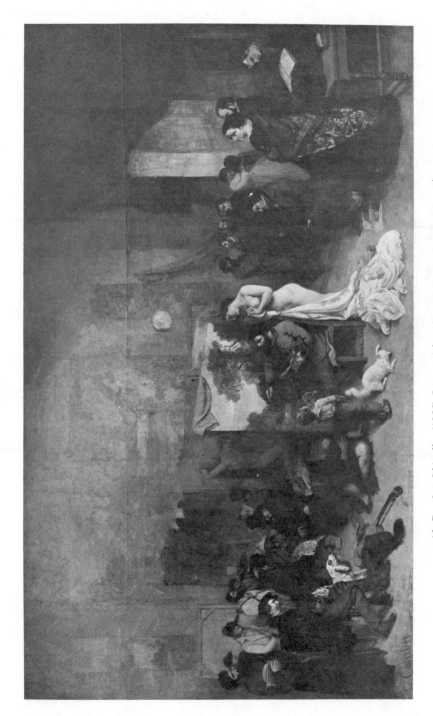

46. **Courbet,** L'Atelier (1855). Louvre (photo: ARCHIVES PHOTOGRAPHIQUES)

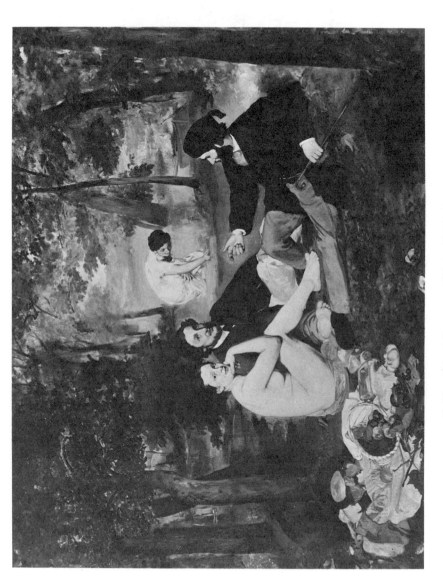

47. **Manet,** Le Déjeuner sur l'Herbe (1863), Louvre
(photo: ARCHIVES PHOTOGRAPHIQUES)

48. **Millet**, Woman Carrying Wood. Courtesy of Museum of Fine Arts, Boston, Mass.

the contact of the edge *a a* with the edge *b b* of the stripe 9. But in each of the intermediate stripes 2, 3, 4, 5, 6, 7, 8 and 9, the contrast is produced by a double cause: one, the contiguity of the edge *a a* with the edge *b b* of the stripe which precedes it; the other by the contiguity of the edge *b b* with the edge *a a* of the darker stripe which follows it. The first cause tends to raise the tone of the half of the intermediate stripe, while the second cause tends to lower the tone of the other half of this same stripe.

The result of this contrast is that the stripes, seen from a suitable distance, resemble channeled grooves (*glyphs*) more than plane surfaces. For in the stripes 2 and 3, for instance, the grey being insensibly shaded from the edge *a a* to the edge *b b*, they present to the eye the same effect as if the light fell upon a channeled surface, so as to light the part near to *b b,* while the part *a a* will appear to be in the shade; but with this difference, that in a real channel the lighted part would throw a reflection on the dark part.

(12) Contrast of Tone occurs with Colours, properly so called, as well as with Grey; thus, to repeat our experiment with the two portions *o', o* of a sheet of paper of a light tone of a certain colour, and the two portions *p', p* of a sheet of paper of a deeper tone of this same colour, we shall perceive that *o* contiguous to *p* will be lighter than *o'*, and *p* will be deeper than *p'*. We can demonstrate, as we have done before, that in starting from the point of contact the modification is gradually weakened.

EXPERIMENTAL DEMONSTRATION OF CONTRAST OF COLOUR

(13) If we arrange as before two portions *o, o'* of a sheet of unglazed coloured paper, and two portions *p, p'* of a sheet of unglazed paper of a different colour from the first, but resembling it as nearly as possible in intensity, or rather in tone (8), in looking at these four half-sheets *o', o, p, p'* for a few seconds, we shall see that *o* differs from *o'*, and *p* from *p'*; consequently the two half-sheets *o, p* appear to undergo reciprocally a modification of tint which is rendered apparent by the comparison we have made of their colours with those of *o'* and of *p*.

(14) It is easy to demonstrate that the modification which colours undergo by juxtaposition, is a tendency to weakening

starting from the line of juxtaposition; and that it may be perceived between two surfaces without their being in contact, it is sufficient to experiment as above (11).

(15) I will now cite seventeen observations made in conformity with the method prescribed (9) [only 5 are given].

(The colours experimented with must be
as nearly as possible of equal intensity.)

Colours experimented with	Modifications: inclines to
Red	Violet
Orange	Yellow
Red	Yellow
Blue	Green
Orange	Bright Red, or is less Brown
Green	Blue
Yellow	Orange
Blue	Indigo
Blue	Green
Indigo	Deep Violet

It follows, then, from the experiments described in this Chapter, that two coloured surfaces in juxtaposition will exhibit two modifications to the eye viewing them simultaneously, the one relative to the height of tone of their respective colours, and the other relative to the physical composition of these same colours.

THE LAW OF SIMULTANEOUS CONTRAST OF COLOURS, AND THE FORMULA WHICH REPRESENTS IT

(16) AFTER satisfying myself that the preceding phenomena constantly recurred when my sight was not fatigued, and that many persons accustomed to judge of colours saw them as I did, I endeavoured to reduce them to some general expression that would suffice to enable us to predict the effect that would be produced upon the organ of sight by the juxtaposition of two given colours. All the phenomena I have observed seem to me to depend upon a very simple law, which,

taken in its most general signification, may be expressed in these terms:

In the case where the eye sees at the same time two contiguous colours, they will appear as dissimilar as possible, both in their optical composition and in the height of their tone.

We have then, *at the same time,* simultaneous contrast of colour properly so called, and contrast of tone. . . .

(19) I have stated that simultaneous contrast may influence both the optical composition of the colours, and the height of their tone; consequently, when the colours are not of the same degree of intensity, that which is deep appears deeper, and that which is light, lighter; that is to say, the first appears to lose as much of white light as the second seems to reflect more of it.

Therefore, in looking at two contiguous colours, we have
Simultaneous Contrast of Colour, and
Simultaneous Contrast of Tone.

Distinction between Simultaneous, Successive, and Mixed Contrast of Colours

(77) BEFORE speaking of the connection between my own observations and those of others, upon contrast of colours, it is absolutely necessary to distinguish three kinds of contrast.

The first includes the phenomena which relate to the contrast I name *simultaneous:*

The second, those which concern the contrast I call *successive:*

The third, those which relate to the contrast I name *mixed.*

(78) In the *simultaneous contrast of colours* is included all the phenomena of modification which differently coloured objects appear to undergo in their physical composition and in the height of tone of their respective colours, when seen simultaneously.

(79) The *successive contrast of colours* includes all the phenomena which are observed when the eyes, having looked at one or more coloured objects for a certain length of time, perceive, upon turning them away, images of these objects, having the colour complementary to that which belongs to each of them. . . .

(81) The distinction of *simultaneous* and *successive* con-

trast renders it easy to comprehend a phenomenon which we may call the *mixed* contrast; because it results from the fact of the eye, having seen for a time a certain colour, acquiring an aptitude to see for another period the complementary of that colour, and also a new colour, presented to it by an exterior object; the sensation then perceived is that which results from this new colour and the complementary of the first.

(82) The following is a very simple method of observing the *mixed* contrast.

One eye being closed, the right for instance, let the left eye regard fixedly a piece of paper of the colour A: when this colour appears dimmed, immediately direct the eye upon a sheet of paper coloured B; then we have the impression which results from the mixture of this colour B with the complementary colour (C) of the colour A. To be satisfied of this mixed impression, it is sufficient to close the left eye, and to look at the colour B with the right: not only is the impression that produced by the colour B, but it may appear modified in a direction contrary to the mixed impression C+B, or, what comes to the same thing, it appears to be more A+B.

In closing the right eye and regarding anew the colour B with the left eye, many times running, we perceive different impressions, but successively more and more feeble, until at last the left eye returns to its normal state.

(83) If instead of regarding B with the left eye, which becomes modified by the colour A, we observe B with both eyes, the right eye being in the normal state, the modification represented by C+B is found much weakened, because it is really C+B+B.

(84) I advise every one who believes he has one eye more sensitive to the perception of colours than the other, to look at a sheet of coloured paper alternately with the left and with the right eye; if the two impressions are identical, he may be certain that he has deceived himself. But if the impressions are different, he must repeat the same experiment many times in succession; for it may happen that the difference observed in a single experiment arises from one of the eyes having been previously modified or fatigued.

(85) The experiment of which I speak appears to me to be particularly useful to painters.

I will now give some examples of *mixed contrast*.

(86) The left eye having seen Red during a certain time, has an aptitude to see in succession *Green,* the complementary

to Red. If it then looks at a Yellow, it perceives an impression resulting from the mixture of Green and Yellow. The left eye being closed, and the right, which has not been affected by the sight of Red, remaining open, it sees Yellow, and it is also possible that the Yellow will appear more Orange than it really is. . . .

(116) I must remark that all the colours (at least to my eyes) did not undergo equally intense modifications, nor were they equally persistent. For example, the modification produced by the successive view of yellow and violet, or of violet and yellow, is greater and more durable than that produced by the successive view of blue and orange, and still more so than that of orange and blue.

The modification produced by the successive view of red and green, of green and red, is less intense and less persistent.

Finally, I must remark that the *height of tone* exercises much influence upon the modification: for if, after having seen orange, we see dark blue, this latter will appear more green than violet, a contrary result to that presented by a lighter blue.

(117) I thought that it was the more necessary to mention under a special name the phenomenon which I call *mixed contrast,* as it explains many facts remarked by dealers in coloured stuffs, and is of much inconvenience to artists who, wishing to imitate exactly the colours of their models, work at them too long at a time to enable them to perceive all the tones and modifications. I will now state two facts which have been communicated to me by dealers in coloured fabrics . . .

(118) *First Fact*—When a purchaser has for a considerable time looked at a yellow fabric, and he is then shown orange or scarlet stuffs, it is found that he takes them to be amaranth-red, or crimson, for there is a tendency in the retina, excited by yellow, to acquire an aptitude to see violet, whence all the yellow of the scarlet or orange stuff disappears, and the eye sees red, or a red tinged with violet.

(119) *Second Fact*—If there is presented to a buyer, one after another, fourteen pieces of red stuff, he will consider the last six or seven less beautiful than those first seen, although the pieces be identically the same. What is the cause of this error of judgment? It is that the eyes, having seen seven or eight red pieces in succession, are in the same condition as if they had regarded fixedly during the same period of time a single piece of red stuff; they have then a tendency to see the

complementary of Red, that is to say, Green. This tendency goes of necessity to enfeeble the brilliancy of the red of the pieces seen later. In order that the merchant may not be the sufferer by this fatigue of the eyes of his customer, he must take care, after having shown the latter seven pieces of red, to present to him some pieces of green stuff, to restore the eyes to their normal state. If the sight of the green be sufficiently prolonged to exceed the normal state, the eyes will acquire a tendency to see red; then the last seven red pieces will appear more beautiful than the others.

Imitation of Coloured Objects, with Coloured Materials in a State of Infinite Division

INTRODUCTION

(255) Coloured materials (pigments), such as Prussian Blue, Chrome-Yellow, Vermilion, &c., are infinitely divided, so to speak, when ground, either pure, or mixed with a white material, in a gummy or oily liquid.

The reproduction of the images of coloured objects with these pigments is called The Art of Painting.

(256) There are two systems of Painting, the one consists in representing as accurately as possible, upon the flat surface of canvas, wood, metal, walls, &c., an object in relief, in such manner that the image makes an impression upon the eye of the spectator similar to that produced by the object itself.

(257) From this we learn that we must manage the light, the vivacity of colour for every part of the image which in the model receives direct light, and which reflects it to the eye of one who regards the object from the point where the painter placed himself to imitate it; while the parts of the image corresponding to those which, in the same object, do not reflect to the spectator as much light as the first—either because they reflect it in another direction, or because the salient points protect them more or less from the daylight—must appear in colours more or less dimmed with black, or, what is the same thing, by shade.

It is, then, by the vivacity of White or coloured light, by the enfeebling of light by means of Black, that the painter manages, with the aid of a plane image, to attain all the illusion of an object in relief. The art of producing this effect by

the distribution of light and shade constitutes essentially what is termed the art of *Chiaroscuro.*

(258) There exists a means of imitating coloured objects much simpler by the facility of its execution than the preceding. It consists in tracing the outline of the different parts of the model, and in colouring them uniformly with their peculiar colours. There is no relief, no projections; it is the plane image of the object, since all the parts receive a uniform tint: this system of imitation is *painting in flat tints.*

Painting in Chiaroscuro

ON THE COLOURS OF THE MODEL

(298) In painting, we recognise two kinds of perspective, the *linear* and the *aerial.*

The first is the art of producing, upon a plane surface, the outlines and contours of objects and their various parts in the relations of position and size in which the eye perceives them.

The second is the art of distributing, in a painted imitation, light and shade, as the eye of the painter perceives them in objects placed in different planes, and in each particular object which he wishes to imitate upon a surface.

It is evident that aerial perspective comprehends the observation and reproduction of the principal modifications of colours which I have just examined in succession, and that *true and absolute colouring* in painting can only be as faithful a reproduction of this as possible.

Painting on the System of Flat Tints

(301) In painting in flat tints, the colours are neither shaded nor blended together, nor modified by the coloured rays coming from objects near those imitated by the painter.

In pictures which belong to this kind of painting, the representation of the model is reduced to the observance of linear perspective, to the employment of vivid colours in the foreground, and to that of pale and grey colours in the more distant planes.

If the choice of contiguous colours has been made in conformity with the law of simultaneous contrast, the effect of the colour will be greater than if it had been painted on the system of chiaroscuro. When, therefore, we admire the beauty

of the colours of the paintings in flat tints which come from China, we must, in comparing them exactly with ours, take into consideration the system followed in them, otherwise we should exercise an erroneous judgment by comparing pictures painted on different systems.

(302) If it be indisputable that painting in flat tints preceded that in chiaroscuro, it will, I think, be an error to believe that at the point we have arrived at in Europe, we must renounce the first to practise the second exclusively, for in every instance where painting is an accessory and not a principal feature, painting in flat tints is in every respect preferable to the other.

(303) The essential qualities of painting in flat tints necessarily consist in the perfection of the outlines and colours. These outlines contribute to render the impressions of colours stronger and more agreeable, when, circumscribing forms clothed in colours, they concur with them in suggesting a graceful object to the mind, although in fact, the imitation of it does not give a faithful representation.

(304) We may, in conformity with what has been said, consider that painting in flat tints will be advantageously employed,

1. When the objects represented are at such a distance that the finish of an elaborate picture would disappear.
2. When a picture is an accessory, decorating an object whose use would render it improper to finish it too highly, on account of its price—such are the paintings which ornament screens, work-boxes, tables, &c.—in this case, the objects preferable as models are those whose beauty of colours and simplicity of form are so remarkable, as to attract the eye by outlines easily traced, and by their vivid colours: as birds, insects, flowers, &c.

Utility of the Law of Simultaneous Contrast of Colours in the Science of Colouring

(323) After having defined the principal modifications which bodies experience when they become apparent by means of the white or coloured light they reflect; after having examined painting, and defined colouring conformably with the study of these modifications—it remains for me to speak of the law of contrast of colours with respect to the advantages the painter will find in it when he requires:

1. To perceive promptly and surely the modifications of light on the model.
2. To imitate promptly and surely these modifications.
3. To harmonise the colours of a composition, by having regard to those which must necessarily be found in the imitation, because they are inherent to the nature of the objects which he must reproduce.

UTILITY OF THIS LAW IN ENABLING US TO PERCEIVE PROMPTLY AND SURELY THE MODIFICATION OF LIGHT ON THE MODEL

(324) The painter must know, and especially *see,* the modifications of white light, shade, and colours which the model presents to him in the circumstances under which he would reproduce it.

(325) Now what do we learn by the law of *simultaneous contrast of colours?* It is, that when we regard attentively two coloured objects at the same time, neither of them appears of its peculiar colour, that is to say, such as it would appear if viewed separately, but of a tint resulting from its peculiar colour and the complementary of the colour of the other object. On the other hand, if the colours of the objects are not of the same tone, the lightest tone will be *lowered,* and the darkest tone will be *heightened;* in fact, by juxtaposition they will appear different from what they really are.

(326) The first conclusion to be deduced from this is that the painter will quickly appreciate in his model the colour peculiar to each part, and the modifications of tone and of colour which they may receive from contiguous colours. He will then be much better prepared to imitate what he sees, than if he was ignorant of this law. He will also perceive modifications which, if they had not always escaped him because of their feeble intensity, might have been disregarded because the eye is susceptible of fatigue, especially when it seeks to disentangle the modifications the cause of which is unknown, and which are not very prominent.

(327) This is the place to return to *mixed contrast* in order to make evident how the painter is exposed to seeing the colours of his model inaccurately. In fact, since the eye, after having observed one colour for a certain time, has acquired a tendency to see its complementary, and as this tendency is of some duration, it follows, not only that the eyes of the painter, thus modified, will see the colour which he had looked at for

some time incorrectly, but will also see another which strikes them while this modification lasts. So that, conformably to what we know of mixed contrasts, they will see, not the colour which strikes him in the second place, but the result of this colour and of the complementary of that first seen. It must be remarked, that besides the defect of clearness of view which will arise in most cases from the want of exact coincidence of the second image with the first—for example, the eye has seen a sheet of green paper A, in the first place, and in the second place regards a sheet of blue paper B of the same dimensions, but which is placed differently—it will happen that this second image, not coincident in all its surface with the first, the eye will see the sheet B violet only in the part where the two images coincide. Consequently this defect of perfect coincidence of images will be an obstacle to the distinct definition of the second image and of the colour which it really possesses.

(328) We can establish three conditions in the appearance of the same object relative to the state of the eye; in the first, the organ simply perceives the image of the object without taking into account the distribution of colours, light, and shade; in the second, the spectator, seeking to properly understand this distribution, observes it attentively, and it is then that the object exhibits to him all the phenomena of simultaneous contrast of tone and colour which it is capable of exciting in us. In the third circumstance, the organ, from the prolonged impression of the colours, possesses in the highest degree a tendency to see the complementary of these colours; it being understood that these different states of the organ are not interrupted, but continuous, and that, if we examined them separately, it was with the view of explaining the diversity of the impression of the same object upon the sight, and to make evident to painters all the inconveniences attendant upon a too prolonged view of the model.

I have no doubt that the dull colouring with which many artists of merit have been reproached, is partly due to this cause, as I shall show more minutely hereafter (366).

(366) From what has been said, I believe that those painters who will study the mixed and simultaneous contrasts of colours, in order to employ the coloured elements of their palette in a rational manner, will perfect themselves in *absolute colouring* (298), as they perfect themselves in linear perspective by studying the principles of geometry which govern

this branch of their art. I should greatly err, if the difficulty in faithfully representing the image of the model, encountered by painters ignorant of the law of contrast, has not with many been the cause of a colouring dull and inferior to that of artists who, less careful than they in the fidelity of imitation, or not so well organised for seizing all the modifications of light, have given way more to their first impressions. Or, in other words, viewing the model more rapidly, their eyes have not had time to become fatigued; and, content with the imitation they have made, they have not too frequently returned to their work to modify it, to efface, and afterwards reproduce it upon a canvas soiled by the colours put on in the first place, which were not those of the model, and which will not be entirely removed by the last touches. If what I have said is true, there are some painters to whom the axiom, *Let well enough alone,* will be perfectly applicable.

Colour Printing[3]
on Calico Printing and Paperhangings

(370) I propose to examine only the optical, not the chemical, effects produced by patterns printed upon woven fabrics.

Printing on textile fabrics was for a long time limited, so to speak, to cotton cloths. It is only of late years that it has been extended to fabrics of silk and wool, for furniture and clothing. This branch of industry has now undergone an immense extension, fashion having accepted these products with extreme favour; but, whatever may be the importance of the subject, in a commercial point of view, I must treat it briefly. This book is not directed exclusively to that branch of inquiry, and as all the preceding part is intimately connected with it, I shall merely state some facts which show that, for want of knowing the law of contrast, the manufacturers and printers of cotton, woollen, and silk stuffs are constantly exposed to error in judging the value of recipes or colours, or as to the true tint of the designs applied upon grounds of a different colour.

[3] [These few examples of the application of the principles of harmony and contrast of color for the solution of specific problems were suggested by Professor William Homer.]

FALSE JUDGMENT OF THE VALUE OF RECIPES FOR
COLOURING COMPOSITIONS

(371) At a certain calico-printer's a recipe for printing
green had always succeeded up to a certain period, when it
began to give bad results. They were lost in conjectures upon
the cause, when a person at the Gobelins who had followed
my researches on contrast, recognised that the green of which
they complained, being printed on a ground of blue, inclined
to yellow through the influence of orange, the complementary
of the ground. She therefore advised that the proportion of
blue in the colouring composition should be increased in or-
der to correct the effect of contrast. The recipe, modified ac-
cording to this suggestion, gave the beautiful green which they
had obtained formerly.

(372) Thus every recipe for colours to be applied upon a
ground of another colour must be modified conformably to
the effect which the ground will produce. It is this great facility
in correcting the ill effect of certain contrasts which explains
why they so often succeed without being able to account for
it. Here, notwithstanding their colour, the eye judges them to
be colourless, or of the tint complementary to that of the
ground. These appearances have been the subject of questions
frequently addressed to me by the manufacturers of printed
stuffs, and by drapes: they are due to the *laws of simultaneous
contrast of colours*. In fact, when the patterns appear white,
the ground acts by contrast of tone (11); if they appear col-
oured (and this appearance generally succeeds to that where
they appear white), the ground then acts by contrast of colour
(13). The manufacturer of printed stuffs therefore will not
seek to attribute the cause of these phenomena to the chemical
actions in his operations.

(373) Ignorance of the law of contrast has, among drapers
and manufacturers, been the subject of many disputes, which
I have been happy to settle amicably, by demonstrating to the
parties that they had no possible cause for litigation in the
cases they submitted to me. I will relate some of these, to
prevent similar disputes.

Certain drapers gave to a calico-printer some cloths of single
colours—red, violet, and blue—upon which they wished black
figures to be printed. They complained that upon the *red*
cloths he had put green patterns; upon the *violet*, the figures
appeared *greenish-yellow;* upon the *blue*, they were *orange-*

brown or *copper*-coloured—instead of the *black* which had been ordered. To convince them that they had no ground for complaint, it sufficed to have recourse to the following proofs:
1. I surrounded the patterns with white paper, so as to conceal the ground; the designs then appeared black.
2. I placed some cuttings of black cloth upon stuffs coloured red, violet, and blue; the cuttings appeared like the printed designs, *i.e.*, of the colour complementary to the ground, although the same cuttings, when placed upon a white ground, were of a beautiful black.

(374) The modifications which black designs undergo upon different coloured grounds are the following:

Upon *Red* stuffs they appear *Dark Green.*

Upon *Orange* stuffs they appear of a *Bluish-black.*

Upon *Yellow* stuffs they appear *Black,* the violet tint of which is very feeble, on account of the great contrast of tone.

Upon *Green* stuffs they appear of a *Reddish-grey.*

Upon *Blue* stuffs they appear of an *Orange-grey.*

Upon *Violet* stuffs they appear of a *Greenish-yellow Grey.*

These examples are sufficient to enable us to comprehend their advantage to the printer of patterns, of colours complementary to the colours of the ground, whenever he wishes contiguous tints to be mutually strengthened without going out of their respective scales.

[GUSTAVE COURBET (1819–77), the first great "realist" of the nineteenth century, was born at Ornans near the Jura in southeastern France. He began to paint while studying law at Besançon, and then went to Paris (1839) to study art seriously. He entered a studio, but sought among the masterpieces at the Louvre methods to express himself. He also attended the Académie Suisse where no instruction was given but where one could draw from a model for a small fee. Many drew there; among them, Manet, Monet, Whistler, Millet, Cézanne.

In 1847 Courbet visited Holland where Frans Hals' paintings could be seen, a trip important for the development of his style. Between 1850 and 1855 he made several trips to Germany, staying in Munich—a center of the early German naturalists, Friedrich Wasmann (1806–86) and Karl Blechen (1798–1840)—and in Frankfurt, where he saw the outstanding exponent of naturalism, Adolf Menzel (1815–1905).

Courbet began to submit pictures to the Salon in 1844, but none were accepted until "L'Après Dîner à Ornans" and "Homme à la Pipe" in 1850. The robustness, the reality of the exterior form, and the sensation of its heaviness attracted attention. At no time was Courbet interested in representing the appearance of light. He worked from dark to light, employing a diffused light, as the Spanish school did to accentuate the weight and the mass of form. Courbet's aim was a "representation of the real and existing things."

This was an aim shared by exponents and defenders of realism who frequented two cafés, the Brasserie des Martyrs and the Andler Keller. Included in this group were the writer Philippe Duranty, founder of the magazine *Réalisme,* Jean Husson (called Champfleury), author of the novel *Les Amis de la Nature* (1859), the novelist Jules Castagnary, codifier of the principles of the realists, the poet Baudelaire, and the painters Louis Bonvin, Claude Monet, and others.

Courbet widened his aim of realism to "interpret the manner, ideas and proletarian aspects of our own time." P. J. Proudhon, the socialist, was able to persuade him briefly to use his brush for a social message. In many canvases Courbet seemed to convey a social idea merely by his choice of subject matter—"The Funeral at Ornans" (1850), "Stone Breakers" (1849), "Women Winnowing" (1853)—but this was always secondary, for his major concern was with the visual qualities. Nonetheless, his impetuous rebellious personality seemed to call forth a message from his work. It was the natural crude realism of his figures that caused the adverse criticism.

When two of his twelve canvases—"The Burial" and "The Artist's Studio"—were refused for exhibition at the Exposition Universelle in 1855, Courbet held an exhibition in a special building called "The Pavilion of Realism," situated beside The Exposition Gate. Here he exhibited forty-three canvases. The large painting "The Artist's Studio," the center of the exhibition, carried a subtitle "A real allegory, summarizing a phase in my artistic life that lasted seven years." The allegory was explained in a letter addressed to Champfleury printed in the catalogue. Courbet's paintings were executed in broad brush strokes with a thick impasto of paint, spread often with a palette knife, that gave them, in Baudelaire's words, a "solidité positive" that made up for their lack of intellectualization.

The first international exhibition held in Munich in 1869 included canvases of Courbet and Millet. Courbet, who was in Munich, exercised considerable influence on Wilhelm Liebl (1844–1900) and his group. During the years 1863–70 Courbet enjoyed success and prosperity, and turned to landscape painting, painting with Whistler and Monet on the Channel coast.

Courbet was not interested in the external appearances, but in the structure of the forms in landscape. He chose his subject matter from woodlands and rocky scenes that offered masses. He employed contrasting size to secure dramatic tension, as in "Dying Stag" (1861). In their organization and their emphasis on the structure of the natural forms, his landscapes show an affinity to those of C. D. Friedrich as well as to the great Baroque landscapists, Hobbema and Ruysdael.

Always associated with those possessed of a revolutionary rebellious spirit, he took an active part in the Commune established in Paris after France's defeat in the Franco-Prussian War. When he was elected president of a general assembly of artists, he abolished the Ecole des Beaux Arts, the Fine Arts section of the Institute, the Academy in Rome, and all medals, but continued the Salon jury. While Courbet was Curator of Fine Arts, the Vendôme Column—erected to commemorate Napoleonic victories—was torn down by a mob. At the time of the restoration, Courbet was held responsible for this and was imprisoned for six months. When the Column was rebuilt in 1873, he was directed to pay the costs of 300,000 Francs. Unable to do so, he fled to Switzerland where he lived near Vevey the last few years of his life.

SEE: G. Macke, *G. Courbet,* New York, 1951.

G. Boas, *Courbet and the Naturalistic Movement,* Baltimore, 1938.

EXHIBITION AND SALE OF FORTY PICTURES AND FOUR DRAWINGS OF THE WORK OF GUSTAVE COURBET[1]

Paris, 1885

The title of realist was imposed upon me as the title of romanticist was imposed upon the men of 1830. Titles have never (at any time) given an accurate idea of objects; if it were otherwise, works would be superfluous.

Without going into explanations of the greater or lesser accuracy of a categorization that no one, I hope, is supposed to understand clearly, I will limit myself to a few words of background development to eliminate some misunderstandings.

I have studied, not in any systematic spirit and without preconceived ideas, the art of the ancients and of the moderns. I have no more wish to imitate the former than to copy the latter; neither has my thought been to arrive at the lazy goal of ART FOR ART'S SAKE. No! I have simply wished to draw from the accumulated wisdom of tradition a reasoned and independent sentiment of my own individuality. To know in order to do, this was my thought. To be able to translate the habits, the ideas, the aspects of my epoch according to my understanding, to be not only a painter, but a MAN, in a word, to make living art, that is my aim.

LETTERS

To Champfleury [Jules Husson][2]

Paris, January 1855

My dear friend,

In spite of my tendencies toward hypochondria, I have started on an immense painting 20 feet long, 12 feet high: even bigger perhaps than the "Enterrement," which will show

[1] Translated from *Courbet, Raconté par lui-meme et par ses amis*, P. Cailler, Genève, Vol. I, p. 48, 1950.
[2] Translated from R. Huygh, G. Bazin, H. Adhémar, *L'Atelier du Peintre*, Paris, 1944.

that I am not yet dead, nor Realism either, because there is realism in it. It is the moral and physical history of my studio, first part; the people that serve me, that support me in my ideas and participate in my actions. These are people who live on life, who live on death; it is high society, low society, middle society; in a word, it is my way of seeing society in its interests and in its passions; it is the world that comes to me to be painted. You will see, this painting has no title, I will try to give you a better idea of it by describing it to you briefly.

The scene takes place in my studio in Paris. The painting is divided into two parts: I am in the middle painting, all the participants on my right, that is to say friends, fellow-workers, *les amateurs* in the world of art. On the left, the other world of everyday life; people, misery, poverty, wealth, the exploited and the exploiters; those who live on death. In the background, against the wall, are hung the paintings "Retour de la Foire," "Les Baigneuses," and the painting that I am painting. . . .

I will describe the personages to you starting on the extreme left. At the edge of the canvas is a Jew whom I saw in England, passing through the feverish activity of London streets while religiously carrying a small case on his right arm and covering it with his left hand; he seemed to say: I am the one who is on the right track; he had an ivory face, a long beard, a turban, and a long black robe that dragged on the ground. Behind him is a priest with a triumphant air and a red beery face. In front of them is a poor thin old man, an old republican of '93 (that Minister of the Interior, for example, who had been part of the Assembly when Louis the 16th was condemned! That one who was still following courses at the Sorbonne last year), a man of about 90, a sack in his hand, clothed in old white cloth, much patched. He is looking at romantic, castoff clothing at his feet (the Jew pities him); then a hunter, a reaper, a strong man, a clown, a secondhand clothing merchant, a workingman's wife, a workingman, an undertaker's assistant, a skull in a newspaper, an Irish woman nursing a child, a mannequin; the Irish woman is another English product; I met this woman in a London street; she was clothed only in a black straw hat, a ragged green veil, a black fringed shawl under which she carried a naked infant in her arms. The clothing merchant presides over all this: he spreads out his tawdry finery for everyone and they all pay the strict-

est attention, each in his own way. A guitar behind him and a feathered hat in the foreground.

Second part: Then comes the canvas on my easel and myself painting showing the Assyrian side of my face. Behind my chair is a nude model; she leans on the back of my chair watching me paint for an instant; her clothes are on the ground in front of the painting; there is a white cat near my chair. After this woman comes Promayat, with his violin under his arm, the way he is in the portrait he is sending me; behind him are Bruyas, Cuénot, Buchon, Proudhon (I would also like very much to see that philosopher, Proudhon, who sees things the same way we do; if he were willing to pose I would be happy; if you see him ask if I can count on him). Then comes your turn, in the foreground of the painting; you are seated on a stool, your legs crossed and a hat on your knees. Next to you even more in the foreground is a society woman with her husband, very luxuriously dressed. Then, on the far right, half seated on a table, is Baudelaire, who is reading in a large book; next to him is a negro woman looking at herself in a mirror very coquettishly. In the background can be seen, in a window alcove, two lovers who are murmuring sweet nothings; one is seated on a *hamac;* above the window are large draperies in green serge; some plaster casts stand against the wall, also a shelf on which there is a small bottle of wine, a lamp, paint pots, canvases turned toward the wall, a folding screen, then nothing more, just the great empty wall.

I have explained this all to you very badly, I started at the wrong end; I should have started with Baudelaire, but it's too long to start over, you must understand it as best you can. Those who want to judge it will have their work cut out, they will acquit themselves as best they can. For there are people who wake up with a start in the night crying out, "I want to judge! I must pass judgment!"

Imagine if you can, my friend, that having this painting in mind, I was overtaken by a bad case of jaundice that lasted over a month; I, who am always in a hurry when I resign myself to doing a painting, I will let you imagine how impatient I was, to lose a month, I, who didn't have a day to lose! I think that I will get there at last; I have still two days for each person, without counting the accessories; in spite of this it must be finished.

. . . I send you my heartfelt wishes.

GUSTAVE COURBET

To a Group of Students[3]

Paris, Dec. 25, 1861
Gentlemen and dear friends,

You want to open a painting studio in which you can freely continue your artistic education and you have been kind enough to offer to place it under my direction. Before I give any answer, we must be clear on the meaning of that word DIRECTION. I can not lend myself to there being a question of professor and student in our relationship.

I should explain to you what I recently said to the Congress at Anvers: I do not have, and I can not have, students.

I who believe that every artist should be his own master, can not think of making myself into a professor.

I can not teach my art, nor the art of any school, because I deny that art can be taught and because, in other terms, I maintain that art is completely individual, and the talent of each artist is only the result of his own inspiration and his own study of tradition.

In addition I say that art or talent to an artist can only be (in my opinion) the means of applying his personal faculties to the ideas and the objects of the time in which he lives.

Especially, art in painting can only consist of the representation of objects that are visible and tangible to the artist.

No age can be depicted except by its own artists. I mean to say by the artists that have lived during it. I believe that the artists of one century are completely incompetent when it comes to depicting the objects of a preceding or future century, in other words, to paint either the past or the future.

It is in this sense that I deny the term historical art as applied to the past. Historical art is, by its very essence, contemporary. Every age should have its artists, who will express it and depict it for the future. An age that has not been able to express itself through its own artists, does not have the

3 Translated from *Courbet, Raconté par lui-meme et par ses amis,* P. Cailler. Genève, 1950, Vol. 2, pp. 204–7. First printed in *Le Courrier du Dimanche,* Paris, December 29, 1861.
[With the help of the journalist, Castagnary, Courbet wrote and published this letter in reply to a request of some students who had withdrawn from the Ecole in protest of its methods. Though Courbet did not open a school, he did consent to give instruction and criticism to the students for about a year in a rented studio, where the model was usually a horse or bull held by a peasant.]

right to be expressed by outside artists. This would be falsifying history.

The history of an age finishes with the age itself and with those of its representatives who have expressed it. It is not given to new ages to add something to the expression of past ages, to aggrandise or to embellish the past. That which has been has been. It is the duty of the human spirit to always start anew, always in the present, taking as its point of departure that which has already been accomplished. We must never start something over again, but always march from synthesis to synthesis, from conclusion to conclusion.

The true artists are those who take up their epoch at exactly the point to which it has been carried by preceding ages. To retreat is to do nothing, is to work without result, is to have neither understood nor profited from the lessons of the past. This explains why all archaic schools have always ended by reducing themselves to the most useless compilations.

I also believe that painting is an essentially CONCRETE art and can only consist of the representation of REAL AND EXISTING objects. It is a completely physical language that has as words all visible objects, and an ABSTRACT object, invisible and non-existent, is not part of paintings' domain. Imagination in art consists in knowing how to find the most complete expression of an existing object, but never in imagining or in creating the object itself.

Beauty is in nature, and in reality is encountered under the most diverse forms. As soon as it is found, it belongs to art, or rather to the artist who is able to perceive it. As soon as beauty is real and visible, it has its own artistic expression. But artificiality has no business amplifying this expression. It can not enter into it without risking its distortion, and consequent weakening. The beauty based on nature is superior to all artistic conventions.

Here is the basis of my ideas in art. With such ideas, to think of opening a school in which conventional principles would be taught would be to return to the incomplete and banal premises which until now have everywhere directed modern art.

There can be no school, there are only painters. Schools only serve in the research on the analytical proceedings of art. No school can lead to synthesis in isolation. Painting can not, without falling into abstraction, allow one particular aspect of the art to dominate, whether it be drawing, color, composition,

or any of the other multiple aspects whose total constitutes this art.

Therefore I can not pretend to open a school in which to mold students, to teach this or that partial tradition of art. I can only explain to artists, who will be my collaborators and not my students, the method according to which, in my opinion, one becomes a painter which I have myself followed from my beginnings, leaving to each one the complete direction of his own individuality, the full liberty of his personal expression in the application of this method. The founding of a common studio, bringing to mind the fruitful collaborations of the studios of the Renaissance, can certainly be useful in attaining this end and contribute to opening the phase of modern painting. To attain it, I will lend myself with eagerness to all that you wish of me.

<div align="center">Yours with all my heart.</div>

<div align="right">GUSTAVE COURBET</div>

[JEAN FRANÇOIS MILLET (1814–75) was born at Gruchy near Greville on the coast of Normandy. Engravings in a Bible stimulated him to draw. His talent was recognized by the Department of Le Manche and a stipendium was given him for study at the Ecole des Beaux Arts, Paris. Millet entered the studio of Paul Delaroche (1797–1856), the painter of popular historical pictures. As he could not use the instruction given there for the work he wished to do, Millet withdrew to draw from the model provided at the Académie Suisse and, renting a studio, tried to support himself. When this proved impossible, Millet returned to Gruchy (1840) and continued to paint there. A painting accepted for the Salon of 1845 won him some friends and a little recognition. He returned to Paris, but the harsh criticism of his 1848 Salon entry, "The Captivity of the Jews in Babylon" (recently discovered by x-ray underneath his "Young Shepherdess" in the Boston Museum of Fine Arts), disheartened him. He moved to Barbizon in the forest of Fontainebleau in 1849 where a group of landscapists had been working since Théodore Rousseau (1812–67) had settled there in 1836. Millet's "Sower," exhibited in the 1850 Salon, announced his commitment to perfecting an art that would symbolize the work and dignity of the peasant and brought Millet serious critical attention and interested patrons. Because the subject matter of his pictures was that of the common man, writers ascribed to him political intentions and sympathies that Millet constantly disavowed. His only concern was to

secure from what was familiar in nature, a composition and a form to correspond to the image he had obtained.

Such pictures as the "Angelus" (1859) and "The Gleaners" (1857) illustrate his intention to secure an idea rather than realistic accuracy. His color is likewise employed to heighten the meaning of his representation as is seen in "Spring" (1873), one of the few pure landscapes he painted. The technique or mode of representation was secondary to the form of his subject. Millet obtained the form for the ideas he experienced after he had been confronted with a scene in nature, by three steps: first he saw, then he dreamt, and third he painted the resulting image. By this synthesizing process he achieved simplicity and monumentality. As Baudelaire noted in his Salon of 1859, "Millet wants to add to the inherent poetry of his subject, not extract."

It was not until the Salon of 1867 that Millet was given a medal of the first class and awarded the Legion of Honor. His paintings shown with Courbet's in Munich in 1869 contributed to the development of realism there.]

LETTERS TO ALFRED SENSIER[1]

[February 1850]

My dear Sensier,

Yesterday, Friday, I received the colours, the oil, canvas, etc., which you sent me, and the accompanying sketch of the picture. These are the titles of the three pictures destined for the sale in question:

(1) *A Woman Crushing Flax;*
(2) *A Peasant and His Wife Going to Work in the Fields;*
(3) *Gatherers of Wood in the Forest.*

I do not know if the word *Ramasseurs* can appear in print. If not, you can call the picture, *Peasants Gathering Wood,* or anything else you choose. The picture consists of a man binding sticks in a faggot, and of two women, one cutting off a branch, the other carrying a load of wood. That is all.

As you will see by the titles of the pictures, there are neither nude women nor mythological subjects among them. I mean

[1] Quoted from Julia Cartwright, *Jean François Millet: His Life and Letters,* The Macmillan Co., New York, 1902, pp. 105–7, 221–22.

to devote myself to other subjects; not that I hold that sort of thing to be forbidden, but that I do not wish to feel myself compelled to paint them.

But, to tell the truth, peasant-subjects suit my nature best, for I must confess, at the risk of your taking me to be a Socialist, that the human side is what touches me most in art, and that if I could only do what I like, or at least attempt to do it, I would paint nothing that was not the result of an impression directly received from Nature, whether in landscape or in figures. The joyous side never shows itself to me; I know not if it exists, but I have never seen it. The gayest thing I know is the calm, the silence, which are so delicious, both in the forest and in the cultivated fields, whether the soil is good for culture or not. You will confess that it always gives you a very dreamy sensation, and that the dream is a sad one, although often very delicious.

You are sitting under a tree, enjoying all the comfort and quiet which it is possible to find in this life, when suddenly you see a poor creature loaded with a heavy faggot coming up the narrow path opposite. The unexpected and always striking way in which this figure appears before your eyes reminds you instantly of the sad fate of humanity—weariness. The impression is similar to that which La Fontaine expresses in his fable of the Wood-cutter:

"Quel plaisir a-t-il eu depuis qu'il est au monde?
En est-il un plus pauvre en la machine ronde?"

In cultivated land sometimes—as in places where the ground is barren—you see figures digging and hoeing. From time to time, one raises himself and straightens his back, as they call it, wiping his forehead with the back of his hand—"Thou shalt eat bread in the sweat of thy brow."

Is this the gay and playful kind of work that some people would have us believe? Nevertheless, for me it is true humanity and great poetry.

I must stop, or I shall end by tiring you. You must forgive me. I am all alone, and have no one with whom I can share my impressions. I have let myself go, without thinking what I was saying. I will not start this subject again.

Ah, while I think of it, send me from time to time some of your fine letters, with the Minister's seal in red wax, and all possible decorations! If you knew the respect with which the postman hands me these letters, hat in hand (a very unusual thing here!), saying with the most deferential air, "This is

from the Minister!" It gives me a distinct position, it raises my credit, I can assure you; for, in their eyes, a letter with the Minister's seal comes, of course, from the Minister himself. Such an envelope is a great possession! . . . Tell me if there is any chance of an order. And do you know how Jacque's affairs are getting on? Good-bye.

<div style="text-align: right">J. F. MILLET</div>

Are Rousseau's pictures producing any great effect? Are they much of a success?

<div style="text-align: center">[May 1862]</div>

My dear Sensier,

This is the substance of what I have written to Thore about three of my pictures which are now on view at Martinet's rooms:

In the *Woman Drawing Water,* I have tried to show that she is neither a water-carrier nor yet a servant, but simply a woman drawing water for the use of her household—to make soup for her husband and children. I have tried to make her look as if she were carrying neither more nor less than the weight of the buckets full of water; and that through the kind of grimace which the load she bears forces her to make, and the blinking of her eyes in the sunlight, you should be able to see the air of rustic kindness on her face. I have avoided, as I always do, with a sort of horror, everything that might verge on the sentimental. On the contrary, I have tried to make her do her work simply and cheerfully, without regarding as a burden this act which, like other household duties, is part of her daily task, and the habit of her life. I have also tried to make people feel the freshness of the well, and to show by its ancient air how many generations have come there before her to draw water.

In the *Woman Feeding Her Chickens,* I have tried to give the idea of a nest of birds being fed by their mother. The man in the background works to feed his young.

In the *Sheep-Shearing,* I tried to express the sort of bewilderment and confusion which is felt by the newly-sheared sheep, and the curiosity and surprise of those who have not yet been sheared, at the sight of those naked creatures. I tried to give the house a peaceful and rustic air, and to make people see the green enclosure behind, and the sheltering poplars; in fact, as far as possible, I have tried to give the impression of an old building full of memories.

I also told him, in case he chooses to say so, that I try to make things look as if they were not brought together by chance or for the occasion, but were united by a strong and indispensable bond. I want the people I represent to look as if they belonged to their place, and as if it were impossible to imagine they could ever think of being anything but what they are. People and things should always be there for a definite purpose. I want to say strongly and completely all that is necessary. What is feebly said had better not be said at all, for then things are, as it were, spoiled and robbed of their charm. But I have the greatest horror of useless accessories, which, however brilliant they may be, can only weaken the subject and distract attention.

I hardly know if all this was worth saying—but there it is. You must give me your advice. Will you come on Saturday, as you had almost decided? Here, there is no news. The children's whooping-cough seems to be a little better. Our salutations.

<div style="text-align: right">J. F. MILLET</div>

[EUGÈNE FROMENTIN (1820–76) was trained in the studio of a conventional landscape painter, Louis Cabat (1812–93); however, he based his style on that of Delacroix and his technique. A trip early in his life to Algeria supplied Fromentin with the subject matter for his paintings and placed him as one of the first as well as the foremost "orientalist." The "Gorges de la Chiffa" exhibited in the Salon of 1847, by its arresting composition, color brilliance, and technical facility, won him recognition. Later (1852) as a member of an archaeological expedition to Algeria, Fromentin had further opportunity for observation and gave his romantic, melancholy paintings realistic accuracy in the detail of costumes and the depiction of customs.

As many other artists of the nineteenth century, Fromentin was a gifted writer of novels and essays. The literary style of his novel *Dominique* is marked by the same sensitive observation as his painting style. He made a valuable study of seventeenth-century Flemish and Dutch art, published in *The Old Masters of Belgium and Holland* (1876) (*Maîtres d'autrefois*). Fromentin based his appraisal of this school, especially the work of Rembrandt and Rubens, on his idea of the subjectivity

of artistic vision, that reality exists only in the manner of see-
ing. He analyzed the technical processes and paintings of these
masters from whom Delacroix, Rousseau, and other romanti-
cists had drawn their inspiration. Making his examination
from the point of view of an artist, he then rejected the need
for subject matter in a work of art and for the first time ex-
plained the value of coloring, its relation to light and its or-
ganization. In his admiration for the realistic portrayal of ob-
jects by the Netherland painters, and in spite of his belief in
the subjectivity of vision, Fromentin was critical of his con-
temporaries, the Impressionists, for their lack of drawing.
Fromentin differed from Baudelaire and maintained that an
artist can reconcile in his art style the tradition of the linear
representation of form and the tradition of chromatic repre-
sentation.]

THE INFLUENCE OF HOLLAND
UPON FRENCH LANDSCAPE[1]

One question presents itself, among many others, when
Dutch landscape is studied, and the corresponding movement
that took place in France about forty-five years ago is remem-
bered. One asks himself, what was the influence of Holland
upon this novelty; if it acted upon us, how, in what measure,
and at what moment; what could it teach us; finally, for what
reason, without ceasing to please, has it ceased to instruct us?
This very interesting question never has been, so far as I know,
studied to the purpose, and I shall not attempt to treat it. It
touches matters too near us, our contemporaries, living artists.
It may easily be understood that I should not be at my ease;
but I would like simply to express its terms.

It is clear that for two centuries we had in France but one
landscape painter, Claude Lorraine. This very great painter—
very French, though very Roman; a true poet, but with much
of that clear good sense which for a long time has produced
doubts as to whether we were a race of poets; good-natured
enough at bottom, though solemn—is, with more naturalness

[1] Quoted from E. Fromentin, *The Old Masters of Belgium and
Holland,* translated by Mary C. Robbins, Boston, Riverside Press,
1882, pp. 203–17. Footnotes are by the translator except those in
brackets, which are by the editor.

and less purpose, the match, in his style, to Poussin in historical painting. His painting is an art which marvellously well represents the value of our mind, the aptitudes of our eye; it does us honor, and will one day become one of the classic arts. It is consulted, admired, but not used; we especially do not confine ourselves to it, nor return to it, any more than we return to the art of *Esther* and *Bérénice*.

The eighteenth century occupied itself very little with landscape, except to introduce into it gallantries, masquerades, festivals, so-called rural or amusing mythologies. The whole school of David visibly disdained it, and neither Valenciennes,[2] nor Bertin,[3] nor their successors in our time, were of a humor to make it attractive. They sincerely adored Virgil, and also nature; but in truth it may be said that they had a delicate sense of neither one nor the other. They were Latin scholars who nobly scanned hexameters, painters who saw things in an amphitheatre, rounded a tree pompously, and gave the detail of a leaf. At bottom they perhaps enjoyed Delille[4] better than Virgil, made some good studies, and painted badly. With much more mind than they, with fancy and real gifts, the elder Vernet,[5] whom I had nearly forgotten, is not what I should call a very penetrating landscape painter, and I will class him, before Hubert Robert,[6] but with him, among the good decorators of museums and royal vestibules. I do not speak of Demarne,[7] half Frenchman, half Fleming, about whom Belgium and France have no desire to warmly dispute; and I

[2] A French landscape painter, pupil of Doyen. Toulouse, 1750–1819.

[3] The painter employed by Louis XIV at the Trianon. Member of the Academy at Paris, 1667–1736.

[4] Jacques Delille, a didactic poet, member of the French Academy, 1738–1813, who enjoyed an immense reputation at the end of the last century, and under the Empire. [He was buried at Père la Chaise, see pp. 264–65.]

[5] Claude Joseph Vernet, an eminent French marine painter, 1714–89. He was commissioned by Louis XV to paint the seaports of France, and fifteen of these pictures are now in the Louvre. He was the grandfather of Horace Vernet.

[6] Hubert Robert, architectural and landscape painter. Paris, 1733–1808.

[7] J. L. Demarne, a Flemish painter, pupil of Nicasius. Brussels, 1725; Paris, 1829.

think I could omit Lantara[8] without great harm to French painting.

It was necessary for the school of David to be at the end of its credit, for everything to have run short, and for people to be ready to reverse everything, as a nation does when it changes its taste, in order to show at the same time, in letters and the arts, a sincere passion for rural things.

The awakening began with the prose writers; from 1816 to 1825 it passed into verse; finally, from 1824 to 1830, the painters became aware of it and began to follow. The first impulse came to us from English painting, and consequently, when Géricault and Bonington acclimated in France the painting of Constable and Gainsborough, it was at first an Anglo-Flemish influence that prevailed. The coloring of Van Dyck in the backgrounds of portraits, the audacity and the fantastic palette of Rubens, are what served to release us from the coldness and conventionalities of the preceding school. The palette gained much thereby, poetry lost nothing, but truth was but half satisfied with the result.

Remark that at the same time, in consequence of a love of the marvellous which corresponded to the literary fashion of ballads and legends, and to the rather rosy color of the imaginations of those days, the first Hollander who whispered in the ear of the painters was Rembrandt. In a visible state or in a latent state, a little of the Rembrandt of warm mists is everywhere, at the beginning of our modern school; and it is precisely because Rubens and Rembrandt were vaguely felt to be hidden behind the scenes, that what was called the Romantic School was received with doubtful enthusiasm when it came upon the stage.

About 1828 there was a new life. Some very young men—there were even children among them—exhibited one day some very small pictures that were at once found eccentric and charming. Of those eminent painters I will name only two who are dead; or rather, I will name them all, saving my right to speak only of those who can no longer hear me. The masters of French contemporary landscape presented themselves together; they were Messieurs Flers, Cabat, Dupré, Rousseau, and Corot.

[8] Simon Mathurin Lantara, a celebrated landscape painter, born near Montargis, 1745; died, 1778. He excelled in moonlights and sunsets.

Where were they formed? Whence did they come? What drove them to the Louvre rather than elsewhere? Who led them, some to Italy, and others to Normandy? One might really think, so uncertain is their origin, their talents being to all appearance fortuitous, that we find in them the painters who disappeared two centuries before, whose history has never been well known.

However it may be with the education of those children of Paris, born upon the quays of the Seine, formed in the suburbs, learning one can hardly say how; two things appeared at the same time in them—landscapes simply and truly rustic, and Dutch formulas. This time Holland found the right hearers; she taught us to see, to feel, and to paint. Such was the surprise, that the intimate originality of the discoveries was not too closely examined. The invention seemed as new in all points as fortunate. People admired; and the same day Ruysdael entered France, a little hidden for the time being behind the glory of these young men. At the same moment it was discovered that there was a French country, a French landscape art, and museums with old pictures that could teach us something.

Two of the men of whom I speak remained nearly faithful to their first affections, or if they wandered from them for a moment, it was but to return at last. Corot detached himself from them from the beginning. The road he followed is known. He cultivated Italy early, and brought back from it something that was indelible. He was more lyrical, equally rural, less rustic. He loved woods and waters, but differently. He invented a style; he employed less exactitude in seeing things than subtlety in seizing what he could extract from them, and what might be separated from them. Hence his quite individual mythology and his paganism so ingeniously natural, which was in its rather vapory form only the personification of the very spirit of things. Nothing can be less Dutch.

As to Rousseau, a complex artist, much reviled and much renowned, very difficult to be defined with propriety, the most truthful thing that can be said is that he represents, in his beautiful and exemplary career, the efforts of the French mind to create in France a new Dutch art; I mean an art as perfect while being national, as precise while more various, and as dogmatic while more modern.

From his date and his rank in the history of our school,

Rousseau is an intermediary man, a transition between Holland and the painters to come. He derives something from the Dutch painters, and separates from them. He admires them, and forgets them. In the past he gives them one hand, but with the other he excites and calls to himself a whole current of ardor and good-will. In nature he discovers a thousand unwritten things. The repertory of his sensations is immense. Every season, every hour of the day, the evening and the dawn; all the varieties of weather, from the winter frosts to the dog-day heats; every altitude, from the beaches to the hills, from the plains to Mont Blanc; villages, fields, copses, forests, the naked land and all its cover of foliage—there is nothing which has not tempted him, arrested him, convinced him of its interest, persuaded him to paint it. It might be said that the Dutch painters had only revolved around themselves, when they are compared to the ardent explorations of this seeker of new impressions. All of them could have had their careers, with an abridgment of the drawings of Rousseau. In this point of view he is absolutely original, and in that very thing he belongs to his own time. Once plunged into the study of the relative, the accidental, and the true, one must go to the very end. Not wholly, but almost entirely alone, he contributed to create a school that might be called the School of Sensations.

What I desire to show, and that will suffice here, is that from the first day the impulse given by the Dutch School and Ruysdael, the direct impulse, stopped short, or was turned aside; and that two men especially contributed to substitute the exclusive study of nature for the study of the masters of the North—Corot, who had no union with them; and Rousseau, who had a livelier affection for their works, a more exact remembrance of their methods, but had also an imperious desire to see more, to see differently, and to express everything which had escaped them. The result was two consequent and parallel facts—studies subtler if not better made, and methods more complicated if not more learned.

What Jean Jacques Rousseau, Bernardin de Saint Pierre, Chateaubriand, and Sénancour, our first landscape masters in literature, observed at a glance, expressed in brief formulas, will be only a very incomplete abridgment, and a very limited survey on the day when literature shall become purely descriptive. In the same way the needs of travelling, analytical, and imitative painting found themselves greatly straitened in foreign styles and methods. The eye became more curious and

precise; sensitiveness, without being more lively, became more nervous; drawing penetrated farther; observations were multiplied; nature, more closely studied, swarmed with details, incidents, effects, and shades; a thousand secrets were demanded of her, that she had kept to herself either because no one had known how or because no one had wished to interrogate her profoundly on all these points. A language was necessary to express this multitude of new sensations; and it was Rousseau almost alone who invented the vocabulary we employ today. In his sketches and rough draughts and in his finished works you will perceive trials, efforts, inventions, successful or unsuccessful, excellent neologisms, or phrases hazarded, with which this profound seeker of formulas sought to enrich the ancient language and the ancient grammar of the painters. If you take one of his pictures, the best, and place it beside a picture by Ruysdael, Hobbema, or Wynants, of the same order and the same acceptation, you will be struck by the differences, almost as much as if you read, one after the other, a page of a modern descriptive writer, after having read a page of the *Confessions* or of *Obermann*.[9] There is the same effort, the same increase of studies, and the same result in the work. The terms are more characteristic, the observation more uncommon, the palette infinitely more rich, the color more expressive, even the construction more scrupulous. All seems to be more felt, everything is more thoughtful, more scientifically reasoned and calculated. A Hollander would gape with wonder at such scrupulousness, and be stupefied by such analytical faculties. And yet are these works better, more powerfully inspired? Are they more living? When Rousseau represents a White Frost on the Plain, is he nearer the truth than are Ostade and Van de Velde with their Skaters? When Rousseau paints a Trout-Fishing, is he graver, moister, more shady, than is Ruysdael with his sleeping waters and his sombre cascades?

What is positive is, that in twenty or twenty-five years, from 1830 to 1855, the French School had made great attempts, had produced enormously, and had greatly advanced matters, since, starting from Ruysdael with his Windmills, Flood Gates, and Bushes—that is to say, from a very Dutch sentiment expressed in wholly Dutch formulas—it had reached the point on one side of creating an exclusively French style with Corot,

9 [Etienne Sénancour (1770–1846), the author of *Obermann,* 1804, written under the influence of J. J. Rousseau.]

and on the other side of preparing through Rousseau the future of an art still more universal. Did it stop there? Not entirely.

Love of home has never been, even in Holland, anything but an exceptional sentiment and a slightly singular habit. In all epochs have been found people whose feet burned to go to some new place. The tradition of journeys to Italy is perhaps the sole one common to all the schools, whether Flemish, Dutch, English, French, German, or Spanish. From Both, Berghem, Claude, and Poussin to the painters of our day, there have been no landscape painters who have not longed to see the Apennines and the Roman Campagna, and there never has been a school local enough to prevent Italian landscape from introducing into it that foreign flower which has never borne anything but hybrid fruit. In the last thirty years people have gone much farther. Distant journeys have tempted the painters, and changed many things in painting. The motive for these adventurous excursions was at first that need of new ground proper to all populations grown to excess in one spot, a curiosity for discoveries, and a sort of necessity of changing place in order to invent. It was also the consequence of certain scientific studies whose progress was obtained only by travels around the globe, among climates and races. The result was the style you are familiar with—a cosmopolitan painting, rather novel than original, very slightly French, which will represent in our history (if history remarks upon it at all) but a moment of curiosity, uncertainty, and unrest, which is really only a change of air tried by people in not very good health.

However, without leaving France, we continue to seek for landscape a more decided form. It would be a curious work to record this latent elaboration, so slow and confused, of a new fashion which has not been discovered, which is even very far from being found; and I am astonished that criticism has not more closely studied this fact at the very time when it was being accomplished under our eyes.

A certain unclassing seems to be operating today among painters. There are fewer categories, I would willingly say castes, than there were formerly. History borders on genre, which itself borders on landscape and even on still life. Many boundaries have disappeared. How many new relations the picturesque has brought about! Less stiffness on one side, more boldness on the other, less huge canvases, the need of

pleasing, and pleasing one's self, country life which opens so many eyes—all this has mingled styles and transformed methods. It would be impossible to say up to what point the broad daylight of the fields, entering the most austere studios, has there produced conversions and confusions.

Landscape makes every day more proselytes than progress. Those who practise it exclusively are not more skilful on that account, but there are more painters who try it. *Open air,* diffused light, *the real sunlight,* take today in painting, and in all paintings, an importance which has never before been recognized, and which, let us say it frankly, they do not deserve.

All the fancies of the imagination, and what were called the mysteries of the palette at a time when mystery was one of the attractions of painting, give place to the love of the absolute textual truth. Photographic studies as to the effects of light have changed the greater proportion of ways of seeing, feeling, and painting. At this present time painting is never sufficiently clear, sharp, formal, and crude. It seems as if the mechanical reproduction of what is, becomes to-day the highest expression of experience and knowledge, and that talent consists in struggling for exactitude, precision, and imitative force with an instrument. All personal interference of sensibility is out of place. What the mind has imagined is considered an artifice; and all artifice, that is, all conventionality, is proscribed by an art which can be nothing but conventional. Hence the controversies in which the pupils of nature have numbers on their side. There are even scornful appellations to designate contrary practices. They are called *the old game,* as much as to say, an antiquated, doting, and superannuated fashion of comprehending nature by introducing one's own into it. Choice of subject, drawing, palette, everything participates in this impersonal manner of seeing and treating things. We are far from the ancient customs; I mean, the customs of forty years age, when bitumen rippled in streams upon the palettes of the Romantic painters, and passed for the auxiliary color of the ideal.

Every year there is a time and a place where these new fashions proclaim themselves with boldness—that is, at our spring exhibition. If you keep yourself at all familiar with the novelties there produced, you will remark that the most recent painting aims at striking the eye by salient, textual pictures, easily recognizable by their truth and absence of artifice, and also giving us exactly the sensations produced by what

we could see in the street, while the public is quite disposed to applaud an art which represents with so much fidelity its habits, its face, its clothes, its taste, its inclination, and its mind. But, you will say, the historical painter? In the first place, in the way things are going, is it quite certain that an historical school still exists? Finally, if this appellation of old fashion is applied still to traditions brilliantly defended, but very little followed, do not imagine that the historical painters escape the fusion of styles and resist the temptation of entering themselves into the current. They hesitate, they have some scruples, but finally they launch themselves in it. Look from year to year at the conversions that occur, and without examining profoundly, consider the color of the pictures alone; if from dark they become light, if from black they become white, if from deep they become superficial, if from supple they become stiff, if oily matter turns to thick impasto, and chiaroscuro into Japanese paper, you have seen enough to learn that there is a spirit which has changed its surroundings, and a studio which is open to light from the street. If I did not conduct this analysis with extreme caution, I would be more explicit and would make you touch with your finger undeniable truths.

The conclusion I wish to draw is that in the latent state, as in the state of professional studies, landscape has invaded everything, and, what is singular, while waiting for its own formula, it has overthrown all formulas, troubled many clear minds, and compromised some talents. It is none the less true that it is labored for; that the attempts undertaken are for its profit; and that to excuse the harm that it has done to painting in general, it would be desirable at least that it should gain something itself.

[EDOUARD MANET (1832–83) was a Parisian of sufficient means to paint as he chose. He studied for six years with the traditionalist painter Thomas Couture in spite of their basic differences, drew constantly at the Académie Suisse, and based his method of painting on the painting technique of Frans Hals and Velasquez, masters in the two schools that contributed to the formulation of realism in French painting in the middle of the century. As an aftermath of the Napoleonic conquest of Spain, two notable collections of Spanish art, Mar-

shal Soult's and Louis Philippe's, were formed, and, due to their accessibility to French artists, aroused great interest during the 1840s. The Spanish guitarist Huerta and a visit of bullfighters in the early 1860s added to the enthusiasm. Goya's "Los Disastres de la Guerra" and "Los Proverbios" were published in 1863 by the Real Academia de San Fernando that secured from Goya's son the original plates and brought Goya's arresting art to European artists.

Manet's first picture, "Spanish Guitar Player" entered at the Salon of 1861, received an honorable mention. His style that blended the emphatic outline and flat surfaces of the Japanese art, the broad brush work and chromatic unity of the Spanish school is found in "The Dead Toreador" (1863) and "Le Fifre" (1866) and is characteristic of Manet's painting technique in his first period. Never original in his compositions, he borrowed complete motifs for his brilliantly painted "Le Déjeuner sur l'herbe" (1863), "Olympia" (1865), and "Christ Insulted by the Soldiers" (1865). The first was the sensation of the Salon des Refusés, 1863, comprising the 4000 art works refused admission to the official Salon by the Jury and exhibited through the intervention of Napoleon III in the Palais de l'Industrie. The last two were the sensation of the Salon of 1865.

The violence of the derision directed against the "Olympia" led Manet to leave Paris for Spain. The two weeks there stimulated him to look for subjects in his immediate environment, as the Spanish had, and in doing so he conformed to Baudelaire's conception of "Le peintre de la vie moderne."

During the years, 1866–69, Manet was the center of a group that gathered at the Café Guerbois and came to be known from the district where Manet had his studio as "le groupe des Batignolles." Among them were Degas, Fantin-Latour, who painted the members, Cézanne, Monet, Renoir, Berthe Morisot, and the writers Zola and Duranty. The two writers were both Manet's ardent defenders, and Baudelaire moved on the fringe as a friend and admirer.

The refusal to include his painting in the World Exposition of 1867 led Manet to rent a shed on Avenue Alma and show fifty paintings, his work between the years 1859–67. This exhibition was not a success but made his work in its entirety known. Of great importance was "La Musique aux Tuileries" (1862). It is not an incident but an informal view painted out of doors rather than composed from studies from nature.

It began the painting "en plein air" and "impressionism." The note of explanation for the exhibition may have been written by the poet-sculptor Zacharie Astruc (1835–1907).

After 1870 Manet painted subjects from his surroundings, making each picture a self-contained entity. He did not conceive cycles or series as some of his contemporaries did. Although his color became increased in brightness and his technique was related to the Impressionists, the composition—all borrowed motifs having been discarded—was still based on classical methods of centering the subject and placing it at right angles to the frame, as illustrated by "The Bar of Folies Bergère" (1881–82). He was an ardent photographer and used photos for some of his paintings, and as a photograph his art fixed one moment forever.

Manet's illustrations of Poe's "The Raven" and Mallarmé's "L'Aprés-midi d'un Faune" (1875) mark the date of the revival of illustrations executed by the designing artist that had been the practice prior to the employment in the eighteenth century of an engraver to transfer the drawing to the plate.

Manet's interest in the aspect of things, in the characteristics of objects, and his technique of painting makes him one of the important innovators of the century.]

REASONS FOR HOLDING A PRIVATE EXHIBITION[1]

From 1861 onwards, M. Manet has exhibited or tried to exhibit.

This year he has decided to put the whole of his works directly before the public.

When first he exhibited in the Salon, M. Manet obtained an honourable mention. But afterwards, the repeated rejection of his work by the jury convinced him that, if the first phase of an artist's career is inevitably a kind of warfare, it is at least necessary to fight on equal terms—that is to say, to be able to secure publicity for what he has produced.

Without that, the painter too easily suffers an isolation from which egress is difficult. He is compelled to stack his canvases, or roll them up in a garret.

[1] Quoted from Théodore Duret, *Manet*, translated by J. E. Crawford Flitch, Crown Publishers, New York, 1937, pp. 46–48.

It is said that official encouragement, recognition, and re-wards are, for a certain section of the public, a guarantee of talent; they are informed what to admire and what to avoid, according as the works are accepted or rejected. But, at the same time, the artist is assured that it is the spontaneous impression which his works create upon this same public that is responsible for the hostility of the various juries.

Under these circumstances, the artist has been advised to wait.

To wait for what? Until there are no more juries.

The artist does not say to-day, "Come and see faultless works," but, "Come and see sincere works."

The effect of sincerity is to give to works a character that makes them resemble a protest, when the only concern of the painter has been to render his impression.

M. Manet has never wished to protest. On the contrary, the protest, quite unexpected on his part, has been directed against himself, because there exists a traditional teaching as to form, methods, modes of painting, and because those who have been brought up in this tradition refuse to admit any other. It renders them childishly intolerant. Any work not done according to their formulas they consider worthless; it provokes not only their criticism, but their active hostility.

The matter of vital concern, the *sine qua non,* for the artist, is to exhibit; for it happens, after some looking at a thing, that one becomes familiar with what was surprising, or, if you will, shocking. Little by little it becomes understood and accepted.

Time itself is always imperceptibly at work upon a picture, refining and softening its original harshness.

By exhibiting, an artist finds friends and supporters who encourage him in his struggle.

M. Manet has always recognised talent where he has met with it, and he has had no pretensions either to overthrow an established mode of painting or to create a new one. He has simply tried to be himself and not another.

Further, M. Manet has received valued encouragement, and recognises that the opinion of men of real ability is daily becoming more favourable to him.

The public has been schooled into hostility towards him, and it only remains for the artist to gain its good will.

May 1867.

[EMILE ZOLA (1840–1902), the son of an engineer, was born in Paris. At his father's death, the family moved to Aix in the hope of winning a suit against that city. Zola and Paul Cézanne attended the same school and, sharing a common interest in art and literature, became intimate friends.

When Zola failed the university entrance examinations, being dependent on his own resources, he obtained a position in a Parisian publishing house. To supplement his income, he began his novel *Contes à Ninon.* Cézanne joined him briefly in 1862.

By 1866 Zola had had sufficient success to give up his position and become a free-lance writer. One of his first assignments as a reviewer for the newspaper *"L'Evénement"* was to write the criticism of the Salon of 1866. In a series of original, outspoken articles, he defined realism as subordinate to temperament, pleaded for an artistic subjectivism, attacked the social conventions of art, and hailed Manet as the true artist. The articles aroused such public indignation that Zola's contract was canceled. In a volume entitled *Mes Haines* (1868) Zola included his articles on the Salon of 1866 (which he had published as *Mon Salon,* with a dedication to Cézanne, a sign of gratitude for his collaboration) and his art essays "Les Actualistes," which had appeared in *L'Evénement illustré* on the Salon of 1868.

At this time Zola frequented the Café Guerbois where Manet, Renoir, Monet, Cézanne, and the artists of the Independent and Impressionist Exhibitions met on Thursday evenings. He continued to write reviews supporting the rejection of mythological and historical subjects, and approving the new technique of flat surfaces and broken color. He asserted that good art is the product of the influences present in the era of its creation, and beauty in art is meaningful when it is in harmony with its age. Truth is the purpose both of art and of science. In his own voluminous work, Zola explored the earthy material aspect of humanity and described the deadening aspect of contemporary life in a turgid style. Zola's art criticism had a wide circulation and influence. Through the Russian novelist Ivan Turgenev he became a correspondent for *Messager de l'Europe* of St. Petersburg.

In three articles "Le Naturalisme au Salon" for *Le Voltaire*

he reviewed the Salon of 1880. These were written at the time Zola was assisting Cézanne financially. Zola, however, estranged himself from Cézanne, Manet, and other artists by *L'Oeuvre* (1886), a novel in his Rougon-Macquart series. The hero, Lantier, an artist with the recognizable traits of Manet and Cézanne, lacked sufficient genius and committed suicide. Cézanne never saw Zola again. The other artists resented this apparent conclusion that they and their efforts to find new techniques had failed. Zola, hurt by Cézanne's estrangement and impatient with Cézanne's apparent inarticulation both in his writing and in his painting, wrote a summary of his experience and recollections after seeing the Salon of 1896 in which he dismissed Cézanne as an "abortive" genius.

All Zola's writings attracted attention to social conditions in urgent need of reform. The most telling was his letter "J'accuse" (1898) attacking the hypocrisy of current social standards by accusing the army of anti-Semiticism in the trial of Captain Dreyfus. He was found guilty in the resulting libel suit.

On his death from accidental asphyxiation, Zola received a public funeral. He had already been acknowledged one of the great literary innovators of the second half of the century.]

MON SALON[1]

I. The Jury: April 27, 1866

The Salon of 1866 won't open until the 1st of May and only then am I permitted to judge the plaintiffs at the bar. But, before passing judgment on the artists admitted [to the Salon], I think it well to judge the judges. You know that in France we are very prudent, we never go anywhere without a passport duly signed and countersigned, and when we permit a man to do a somersault in public he must first have been examined at length by the proper authorities.

Since unsupervised manifestations of art could be the occasion for unforeseen and irreparable disasters, a guard is

[1] Translated from *Zola's Salons, recuellis, annotés et presenté* par F. W. J. Hemming et Robert Niess, Genève, 1959. "Mon Salon," I, II. "The Jury" appeared in *"L'Evénement,"* April 27 and 30, 1866.

placed at the door of the sanctuary, a sort of customs house for the Ideal, charged with probing packages and expelling all fraudulent merchandise attempting to enter the temple. May I be permitted a comparison, perhaps a little far fetched? Imagine that the Salon is an immense *ragout* which is annually served up. Each painter, each sculptor contributes his bit. However, since we possess a delicate stomach, it has been thought wise to appoint a whole battery of cooks to cook up these victuals of such varying taste and appearance. Fearing indigestion, the keepers of the public health were told: "Here are the ingredients for an excellent dish; be careful of the pepper, for pepper is heating; water the wine, because France is a great nation which must not lose its head."

After this it seems to me that the cooks have the stellar role. Since our admiration is seasoned for us and our opinions are pre-digested, we have the right to occupy ourselves first and foremost with these complacent gentlemen who are quite willing to watch that we do not gorge ourselves like gluttons on bad *potage*. When you eat a steak do you worry about the animal? You think only of thanking or cursing the scullion who serves it too rare or not rare enough.

It is well understood that the Salon is not an entire and complete expression of French art in the year of our Lord 1866, but that it is most certainly a sort of *ragout* prepared and simmered by twenty-eight cooks specially named for this delicate task.

A Salon, in our time, is not the work of artists, it is the work of a jury. Therefore, I concern myself first with the jury, the creator of those long, pale, cold halls in which are spread out, under a harsh light, all the timid mediocrities and reputations past their bloom.

Once upon a time, it was the Academy of the Beaux Arts that tied on the apron and put its hand to the dough. At that time, the Salon was a grey, solid dish, invariably the same. One knew ahead of time how much courage one needed to have in one's pocket to swallow those classical morsels, solidly round, without even one poor little angle, which slowly and surely choked you. A methodical, well-grounded cook, she had her personal recipes which she never varied; she cooked with an unshakable calm and conviction. She managed, no matter what the temperament or the time, to serve up the same dish to the public. The good public, suffocating, com-

plained at last. It begged indulgence and asked that it be served spicier, lighter dishes, more appetizing to the eye and to the palate.

You will remember the wails of that old academic cook. She was being deprived of the pot in which she had fried two or three generations of artists. She was left to whimper and the frying pan was given to other sauce curdlers.

Here one practical sense that we have of liberty and justice bursts forth. The artists complained about the academic coterie; they should choose the jury themselves, it was decided. From then on they would have nothing to fuss about; they would give themselves their personal, severe judges. Such was the decision.

Perhaps you think that all the painters, that all the sculptors, all the engravers, all the architects were called upon to vote. It is quite evident that you love your country blindly! Alas, the truth is sad, but I must avow that only those name the jury who have no need of a jury. You and I, who have a medal or two in our pockets, are allowed to go and elect this one or that one, whom we do not care much about anyway, because he hasn't the right to look at our canvases, whose admission is already an accepted fact.

But the poor devil, tossed out the door of the Salon five or six years running, has not even the permission to choose his judges, but is obliged to submit to those we give him out of comradeship or indifference. . . .

. . . I do not know how these judges understand their mission. Truly they do not give a fig for truth and justice. To me a Salon is never just the statement of an artistic movement. All France, those who see white and those who see black, send their canvases to tell the public, "This is where we are, the spirit moves and we move; here are the truths which we believe we have acquired in the past year." But, men, being placed between the artist and the public, with their all-powerful authority, show only a third, only a fourth of the truth; they amputate and present to the crowd only its mutilated corpse.

Let them realize they are there only to keep out mediocrity and vacuity. They are forbidden to touch things that are alive and individual. They may refuse, if they please—actually it is their duty—pensioners of academies, bastard pupils of bastard masters, but, please, will they respectfully accept free

artists, those who live outside, who search elsewhere and further afield for the strong and bitter realities of nature?

Do you wish to know how they proceeded to the election of this year's jury? A circle of painters, so I am told, made up a list which was printed and circulated through the studios of the voting artists. The entire list was accepted.

I ask you where is the interest of art among all these personal interests? What guarantees are given to young workers? Everything appears to be done on their account and they are declared difficult to please if they are not satisfied. We're joking, aren't we? But the question is a serious one and it is time to take a stand. I would prefer to have that good old cook of an academy taken back. No surprises with her; she is constant in her likes and dislikes. Now, with these judges elected out of *camaraderie,* one no longer knows which saint to call on. If I were a needy painter, my great care would be to guess whom I would have for judge in order that I might paint according to his tastes.

Among others, M. Manet and M. Brigot, whose canvases were accepted in previous years, have just been refused. Evidently these artists can not have done much worse, and I even know that their recent canvases are better; how, then, can this refusal be explained?

It seems to me that logically if a painter has been judged today worthy of showing his works to the public, his canvases should not be covered tomorrow. This, however, is the idiocy which the jury has just committed. Why, I will explain to you.

Can you imagine civil war among the artists? One group banishing another, those in power today show those in power yesterday the door. There would be a horrible uproar of hate and ambition, rather like a miniature Rome in the times of Sulla and Marius, and we, the good public, are entitled to the works of the triumphant faction! O Truth, O Justice!

The Academy never altered its judgments in such a manner. It kept people waiting at the door for years, but once in she never chased them out.

Lord save me from harping too much on the Academy. Only, the bad is preferable to the worst.

I do not even want to choose the judges and designate certain artists as being impartial jurors; Manet and Brigot would doubtlessly refuse M.M. Breton[2] and Brion, as they refused

2 Jules Breton (1827–1906), an historian of agricultural labors.

them. A man has his unalterable sympathies and antipathies. However, here it is a matter of truth and justice.

Create, therefore, a jury, no matter which. The more mistakes it makes, the more it spoils its sauces, the more I will laugh. Don't you think those men provide me with an amusing spectacle? They defend their little chapel with a sacristan's thousand petty tricks that I think funny.

But at least let us bring back the so-called "Salon des Refusés"[3] I beg all my confrères to join me. I would that my voice were louder, that I had more power to obtain the reopening of those halls where the public went to judge in its turn, both the judges and the condemned. There, for the moment, is the only way of satisfying every one. The rejected artists have not yet taken back their works; let us hurry to drive nails in somewhere and hang their pictures. . . .

II. The Jury: April 30, 1866

From all sides I am called upon to explain myself, people cry out insistently to have me name the artists of merit who were refused by the jury.

You see then that the public will always be the good old public. It is evident that the artists kept out of the Salon are as yet only the famous painters of tomorrow. I could list here merely names unknown to my readers. This is exactly what I am complaining about, these strange judgments which condemn to obscurity for many years serious young workers whose only fault is not to think like their *confrères*. It must be said that all personages, Delacroix and others, were kept from us for a long time by the decisions of certain cliques. I do not want this to happen again. And I am writing these articles precisely so that the artists, who will certainly be the masters of tomorrow, are not the persecuted of today.

I affirm outright that the jury which functioned this year judged according to a preconceived bias. A whole aspect of French art in our day has been intentionally hidden from us. I named M. Manet and M. Brigot because they are already known. I might have named twenty others belonging to the same artistic movement. This is to say, the jury did not wish to have the strong and living canvases, studies made in the midst of life and reality.

[3] [It was held in 1863.]

I know that the mockers will not be on my side. We are fond of laughing in France and I tell you that I will laugh louder than the others. "He who laughs last, laughs best!"

Yes, I make myself the defender of reality. I quietly admit that I admire M. Manet and declare that I care very little for all M. Cabanel's[4] rice powder, that I prefer the bitter and healthy scents of actual nature. However, each of my judgments will come in time. I will satisfy myself by stating here, and no one will dare deny me, that the movement that has been designated by the name "realism" will not be represented at the Salon. I know very well that Courbet will be there. But Courbet, it would seem, has gone over to the enemy. Ambassadorial emissaries have waited on him. The master of Ornans being a terrible roustabout whom one fears to offend, titles and honours were offered him if he would deny his disciples. There was mention of the great medal or even of the cross. The following day, Courbet went to M. Brigot, his pupil, and bald-faced, declared that he did not understand his philosophy of painting. Courbet's philosophy of painting! Poor dear master, Proudhon's[5] book gave you democratic indigestion. Please, remain the foremost painter of the time, become neither moralist or socialist! . . .

. . . No assembly, no meeting of men named for the purpose of taking some decision or other is ever a simple machine, turning only in one direction and responding only to one impulse. A delicate study must be made to explain each movement, each turn of a wheel. The vulgar see only the result obtained. The observer sees the vibrations of pulses which shake the machine.

I am going to try to take the jury apart piece by piece, to explain its mechanism to make the turning of its gears comprehensible. Because the Salon is its product, as I said, it is necessary to know each of the parts of this impersonal and multiple author.

The jury is composed of twenty-eight members, who are listed here in the order in which they vote; members named

[4] Alex Cabanel, an exponent of academic art, whose *Venus* was a highly praised nude [See Plate 49].

[5] Pierre-Joseph Proudhon (1809–65), the most important French socialist, and author of *Du principe de l'art et de sa destination sociale,* 1863, begun as commentary on Courbet's painting *Le Retour de la conference* and expanded to a treatise on art. See Sloane, *French Painting,* Princeton, 1951, pp. 65–68.

by artists already recipients of the medal: the messieurs Gérôme, Cabanel, Pils, Bida, Meissonier, Gleyre, Français, Fromentin, Corot, Robert Fleury, Breton, Hébert, Dauzats, Brion, Daubigny, Barrias, Dubufe, Baudry; Supplementary members: Isabey, deLajolais, Théodore Rousseau; members appointed by the administration: messieurs Cottier, Théophile Gautier,[6] Lacaze, marquis Maison, Reiset, Paul de Saint-Victor,[7] Alfred Arago.

I hasten to state that the government has no part in this. This is purely an artists' quarrel and I hope to keep every one who does not hold a brush in his hand out of it. I will only remark to M. Saint-Victor and above all to M. Théophile Gautier that they were rather harsh to young men whose only crime is an attempt to follow new paths. Doesn't M. Théophile Gautier who lets off such pretty fireworks in *Le Moniteur,* in honor of the canvases he nominated, remember 1830 when he wore a red vest? Alas, I know it well, it is no longer the time for red vests; we are no longer concerned with red vests, we are concerned with naked, living flesh, and I understand all the anguish of an old and unrepentant romantic who sees his god depart.

Twenty-one wheels remain on the machine. Here is the description of each of those wheels and an explanation of how they work.

. . . Cabanel. An artist overflowing with honors, using all his remaining strength to carry the burden of his glory, he is constantly occupied with preventing his laurels from dropping in the dust and having, therefore, no time for malice. He showed, I am assured, a great deal of gentleness and indulgence. I have been told that the grand Medal which he was awarded last year nearly suffocated him; he is still shamefaced about it, like a glutton who has eaten himself sick in public.

Meissonier.[8] Nothing takes so long to make, it seems, as jolly little men, for the titular artist of Lilliput, this homeopathic artist with the infinitesimal doses has been absent from

[6] Théophile Gautier (1810–72), the novelist and widely read, popular art critic, whose judgments were accepted with reverence.
[7] Paul Comte de Saint-Victor (1827–81), a conservative critic and journalist, an Inspector-General in the Ministry of Fine Arts.
[8] Erneste Meissonier, the very successful painter of historical subjects and scenes of everyday. The perfection of detail in his small canvases delighted his contemporaries.

almost every session. I am however, told that M. Meissonier
was present when the artists whose names begin with M were
judged.

Fromentin.[9] Great friend of M. Bida, he has been in Africa
and has brought back delightful subjects to paint on clocks.
His better ones ought to be eaten like sweetmeats. All these
suave artists who understand poetry, who lunch on a dream
and dine on a fantasy, are in holy terror of canvases remind-
ing them of Nature which they declared too dirty for them.

Corot.[10] A very talented artist, I will speak of him at
greater length later. He was weak in the defense of canvases
which should have appealed to him. To explain his attitude
in the jury, I will fall back on an anecdote. Last year during
the distribution of the medals, certain jurymen were in ecstasy
before a landscape of M. Nazon and maneuvered to obtain
a word from M. Corot. Finally, he, being tired, said, "I am a
good fellow, give him a medal, but I admit I do not under-
stand this picture at all."

Gérôme.[11] A very cunning and able jurist. He under-
stood the deplorable thing that was going to happen and de-
parted for Spain one day before the opening of the assizes, to
return exactly one day after they closed. All the jurists should
have copied this wise and prudent conduct. At least we would
have had a complete exposition.

Fleury.[12] A left-over romantic who has made himself ac-
ceptable by watering his wine. Very opposed to any new move-
ment. He judged for the Salon, but should have been in Rome
a month before where he has been named Director of our
School, replacing M. Schnetz. To say that M. Gérôme had
no excuse and he left and that M. Robert Fleury had an ex-
cuse and he stayed! But what can you do, there are men who
do their duty with firmness. I have been told that M. Fleury's

[9] Eugène Fromentin (1820–76), a painter of North African scenes
who is now best known as an author and critic. *Masters of Past
Time* (1875) was his popular, famous book. In his criticism he
supported Moreau and the Symbolists [See p. 357].
[10] Jean-Baptiste-Camille Corot (1796–1875), associated with Diaz,
Daubigny, Rousseau as an originator of modern French landscape.
[11] Jean Léon Gérôme (1824–1904), an academician, whose neo-
classic painting "Le Combat de Coqs" earned him popular acclaim
in 1847.
[12] Robert Fleury. He and Bouguereau were teachers at the famous
Académie Julian.

son is showing this year and that he will doubtless be awarded one of the forty medals.

Breton. This one is a young and militant painter, he is supposed to have cried when faced with M. Manet's canvases, "If we admit these, we are lost!" Who is his "we"? M. Breton has come as far as those peasants who have read *Lelia* and who versify in the evening while watching the moon. The *beau monde* talks of the nobility of his figures. Therefore, he does not want to let a single actual peasant into the Salon. This year he guarded its entrance and he unswervingly showed the door to all who exhale the powerful odor of the earth.

Shall we put the machine back together and make it run a while? Take the wheels tenderly, the little and the big, those which turn to the left and those which turn to the right. Adjust them and watch the work produced. The machine creaks at times, certain pieces insist on going their own way, but the whole thing does well enough. If all the wheels do not turn with the same impulse, they still manage to mesh with each other and to work together at the same task.

. . . You are familiar with the result; these empty, dismal halls that we will visit together. I know very well that I cannot convict the jury as the cause of our artistic poverty but I can call it to account for all the ambitious artists it discourages. . . .

III. Present-Day Art

Perhaps before publishing a particle of criticism, I should have categorically explained my views on art, what my theory of aesthetics is. I know that the bits and pieces of opinion which I have been obliged to let fall have contradicted accepted ideas and that these bald, apparently unsupported affirmations are resented.

I have my own little ideas like any other person. And like any other person, I think that my theory is the only true one. At the risk of boring you, I will set forth this theory. My likes and my dislikes are naturally deduced from it.

For the public, and I do not use the word in the derogatory sense—for the public a work of art, a picture, is an agreeable thing which moves the heart to delight or to horror; it is a measure where the gasping victims whimper and drag themselves beneath the guns which threaten them; or else it is a delightful young girl all in snowy white who dreams in the

moonlight, leaning on a broken column. I mean to say that most people see in a canvas only a subject which takes them by the throat or by the heart and they demand nothing further of the artist than a tear or a smile.

To me, and I hope to many, a work of art is, on the contrary, a personality, an individual.

I don't ask that the artist give me tender visions or horrible nightmares, I ask him to give himself, heart and body, to affirm loudly a powerful and personal spirit, a strong, harsh character, who seizes nature in his two hands and sets it down before us as he sees it. In a word, I have the most profound disdain for the little tricks, for the scheming flatteries, for that which can be learned at school, for that which constant practise has perfected, for all the theatrical *tours de force* of this Monsieur and all the perfumed revelries of that Monsieur.

But I have the deepest admiration for individualistic works which are flung from a vigorous and unique hand.

It is no longer a question here, therefore, of pleasing or of not pleasing, it is a question of being oneself, of baring one's breast, of energetically forging one's individuality.

I am not for any one school because I am for a true humanity which excludes coteries and systems. The word "art" displeases me. It contains, I do not know what, in the way of ideas of necessary compromises, of absolute ideals. To make art, is that not to create something outside of man and nature? I want them to create life; I want them to be alive, that they make new creations out of all contexts according to their own eyes and their own temperaments, that which I seek above all in a painting is a man, and not a picture.

There are, according to me, two elements in a work: the element of reality, which is nature; and the element of individuality, which is man. The element of reality, nature, is fixed, and always the same. It exists equally for every one. I will say that it may serve as a common measure, if I admit that there may be a common measure.

The element of individuality, man, on the contrary, is infinitely variable. No two works or characters are the same. If it were not for the existence of character, no picture could be more than a simple photograph.

Therefore, a work of art must be the combination of a variable element, man, and a fixed element, nature. The name "realist" does not signify anything to me who declares reality to be subordinated to temperament. Be realistic, I applaud;

but above all, be an individual and alive, and I applaud louder. If you depart from this reasoning, you are forced to deny the past and create definitions which you will have to enlarge each year.

For it is another good joke to believe that there is, where artistic beauty is concerned, an absolute and eternal truth. The One and Complete Proof is not made for us who fabricate every morning a truth which we have worn out by evening. Like everything else, art is a human product, a human secretion; it is our body which sweats out the beauty of our works. Our body changes according to climate and customs and, therefore, its secretions change also.

That is to say that the work of tomorrow cannot be that of today; you can neither formulate a rule nor give it a precept; you must abandon yourself bravely to your nature and not seek to deny it. You who spell your way painfully through dead languages, are you afraid of speaking your mother tongue?

IV. M. Manet, May 7, 1866

Even if we love to laugh in France, we possess, on occasion, an exquisite sense of courtesy and a perfect tact. We respect the underdog and defend to the limit of our power the cause of those who stand alone against the crowd.

Today I wish to extend a friendly hand to a painter whose confrères shut him out of the Salon. If I had not the great admiration that his talent has awakened in me to praise him for, I would still feel that he has been made out to be a pariah, a grotesque and unpopular painter.

Before speaking of those that everyone may go to see, of those who spread their mediocrity in broad daylight, I consider it my duty to give as much space as possible to those whose works have been willfully excluded and who were not thought worthy of appearing among fifteen hundred or two thousand weaklings whose works were received with open arms. . . .

I wish to explain my feelings about M. Manet as plainly as possible, not wanting any misunderstanding to exist between the public and myself. I do not and will not admit that a jury has had the power to prevent the public from viewing one of the most truly alive individuals of our day. My sympathies ly-

ing outside the Salon, I will not go into it until I have satisfied elsewhere my need of admiration.

It seems that I am the first to praise M. Manet unreservedly. This is because I care little for all these boudoir paintings, these coloured engravings, these miserable canvases where I find nothing alive. I have already said that character alone interests me.

I am accosted in the streets and told "you don't really mean it, do you? You're just starting out and want to draw attention to yourself. But since we're alone, let's have a good chuckle over the oh-so-funny *Dîner sur l'herbe* [later known as *Déjeuner sur l'herbe*], the *Olympia*, the *Jouer de fifre*."

Are we at such a pass in art that we are no longer free to admire whom we please? I am made out a youngster who lies to himself out of cunning. My crime?—to work to tell the truth at last about an artist whom they feign not to understand and who is chased like a leper from the little world of painting.

The majority opinion of M. Manet is as follows: M. Manet is a young dauber who locks himself in to smoke and drink with ne'er-do-wells of his own age. After he has drunk several kegs of beer the dauber decides to paint some caricatures and exhibit them that the public may make sport of him and remember his name. He goes to work, he does unheard of things, he holds his sides in front of his own picture. He dreams only of making fun of the public and making a reputation as an eccentric. . . .

I have been only once to M. Manet's studio. The artist is of medium stature, more slight than otherwise, with blond hair and a delicately colored face. He seems to be about thirty, his glance is quick and intelligent, his mouth mobile and slightly mocking from time to time. His whole face, irregular and expressive, has a certain indescribable fineness and energy. Even so, the man expresses in his gestures and in his voice, a profound modesty and gentleness.

He, whom the crowd treats as a waggish dauber, lives a secluded life with his family and keeps the regular hours of a bourgeois. He works relentlessly, always searching, studying nature, questioning himself and going his own path.

It was in that studio that I completely understood M. Manet. I had liked him instinctively; from then on I comprehended his talent, this talent that I will try to analyze. At the Salon his paintings stood out painfully under the hard light among the

penny pictures which had been pasted up around them. Now at last I saw them separately, as all pictures should be seen, in the place where they were painted.

M. Manet's talent consists of simplicity and accuracy. Undoubtedly, faced with the unbelievable nature of some of his fellow workers, he decided to interview reality with no one else present, to refuse all learned science, all inherited experience. He wished to take hold of art at its beginning, that is to say, with the accurate observation of objects.

He, therefore, placed himself courageously face to face with a subject; he saw that subject as large areas, as strong contrasts, and he painted with stubborn determination each object as he saw it. Who dares speak here of petty calculation, who dares accuse a conscientious artist of mocking at art and himself. These railers should be punished; they insult a man who will be one of our glories and they insult him meanly, laughing at one who does not stoop to laugh at them. I assure you that your grimaces and your giggles bother him little.

I saw *Dîner sur l'herbe* again, that masterpiece exhibited at the Salon des Refusés and I defy any of our fashionable painters to give us a wider horizon or one more filled with light and air. Yes, you are still laughing because you have been spoiled by M. Nazon's violet skies. This well constructed nature should displease you. Also, we have neither M. Gérôme's plaster Cleopatra, nor M. Dubufe's pretty pink and white demoiselles. Unfortunately all we can find there are everyday people who make the mistake of having muscles and bones like everyone else. I understand your disappointment and your gaiety in front of this canvas, your eye should be tickled with those pictures on glove boxes.

I saw the *Olympia* again too, which has the serious fault of resembling many young women of your acquaintance. Also, is it not an odd idea to paint differently from the others? If M. Manet had at least borrowed M. Cabanel's rice powder puff and applied a little make-up to Olympia's cheeks and breasts, the young lady would have been presentable. There is a cat there too that greatly amused the public. It is true that this cat is very comical, isn't it? and that one must have been mad to have put a cat in that picture. A cat, imagine that! and a black cat to boot! . . .

This is the impression above all that this canvas left with me. I do not believe that it is possible to obtain a more powerful effect with less complicated methods.

M. Manet's temperament is a dry one, a sharp, hot-headed one. He outlines his figures strongly, he does not retreat from nature's bluntness, he makes the transition from black to white without hesitation. He depicts in all their vigour the different objects that stand out from one another. His whole being leads him to see in terms of areas, of simple energetic fragments. It may be said of him that he is content to seek the accurate tones and place them next to each other on a canvas. By this means the canvas becomes covered with a strong and solid painting. I find in the picture a man with a curiosity for truth, who draws from it a world that lives in a powerful and individual way.

You know what effect M. Manet's canvases produced at the Salon. They simply burst the walls. All around them are spread the confections of the artistic sweetmeat makers in fashion, sugar-candy trees and pie-crust houses, gingerbread men and women fashioned of vanilla frosting. This candy shop becomes rosier and sweeter, and the vital canvases of the artist seem to take on a certain bitterness in the midst of this creamy flood. The faces made by the grown-up children who go through the hall are something to see. For two *sous* you could never get them to swallow honest, raw meat, but they eagerly lap up all the nauseating sweets they are served.

Never mind the neighboring paintings. Look at the living people in the hall. Study the contrasts of their bodies to the floor and the walls. Then look at M. Manet's canvases: you will see that they are true and powerful. Now look at the other canvases, those stupidly smiling ones around you; you break out laughing, don't you?

M. Manet's place is marked out in the Louvre as is that of Courbet and of every artist of a strong and unyielding temperament. Besides, Courbet and Manet have not the least resemblance to each other and if these artists are logical they should deny each other. It is precisely because they have nothing in common that each can go his own way.

I do not have a parallel to establish between them. I obey my own manner of seeing by not measuring artists according to an absolute ideal and by only accepting unique individuals who affirm themselves in truth and power.

V. The Realists in the Salon, May 11, 1866

I would be distressed if my readers believed for a minute that I am here as the standard bearer of a particular school. It would be a grave misunderstanding to make me out as a realist no matter what, a man enrolled in a particular party.

I belong to my own party, the party of life and truth, quite simply. I have a certain resemblance to Diogenes who sought a man: I seek, in art, men, new and powerful temperaments.

I don't care a fig for realism, in the sense that this term does not have any precise meaning for me. If you mean by this term the duty of all painters to study and depict nature, it cannot be disputed that all painters should be realists. Painting dreams is a game for women and children; men are charged with painting realities.

They take nature and they give it, they transmit it to us through their particular temperaments. Therefore each artist will give us a different world and I will willingly accept all these different worlds providing each is the living expression of a heart. I admire the worlds of Delacroix and of Courbet. Faced with this declaration, no one, I believe, can stick me into any one school.

Only, here is what happens in these days of psychological and physiological analysis. Science is in the air, in spite of ourselves we are pushed towards the close study of objects and happenings. Similarly each of the strong individual talents that now reveals itself, finds itself developing in the direction of Reality. The movement of the age is certainly towards realism, or rather positivism. I am, therefore, forced to admire men who appear to share a certain relationship, this is a relationship to the time in which they live.

But if tomorrow a different genius were born, a spirit moving in a different direction, with the power to show us a new earth, his own, I promise him my applause. I cannot repeat it too often, I seek men and not mannequins, men of flesh and bones revealing themselves to us, not lying puppets stuffed with sawdust.

People write me that I praise the "painting-of-the-future"! I do not know what this expression is supposed to mean, I believe that every genius is born independent and leaves no disciples. The painting of the future worries me little, it will be what the society and the artists of the future make it.

The great scarecrow, believe me, is not realism but temper-ament. Every man who is different is for that very reason an object of suspicion. As soon as the masses no longer under-stand, they laugh. A great deal of education is necessary to make genius acceptable. The history of art and literature is a sort of martyrology telling of the jeers which covered every new and different manifestation of the human spirit.

There are realists at the Salon—I am no longer speaking of temperaments—there are artists who pretend to give us true nature with all its crudities and violence.

To establish definitely that I don't care a fig for more or less exact observation if the powerful individuality which brings the picture to life is not there, I am first going to give my frank opinion of Messieurs Monet, Ribot, Vollon, Bonvin and Roybet.

I set Messieurs Courbet and Millet apart, wishing to devote a special study to them.

I admit that the canvas which held me the longest is *Camille* by M. Monet. It is an energetic and lively painting. I had just traversed those halls so empty and so cold, tired from having encountered no new talent, when I perceived that young woman trailing her long gown as she disappeared into the wall as though there were a hole there. You cannot believe how good it is to be able to admire for a while, when you are tired of laughing and shrugging your shoulders.

I do not know M. Monet; I do not believe that I had ever even seen one of his canvases. But I feel that I am one of his old friends and this because his picture tells one a whole tale of vitality and of truth.

Ah yes! here is temperament, here is a man amidst a crowd of eunuchs. Look at the neighboring canvases, see what a poor showing they make next to this window opened on nature. Here there is more than a realist, there is a delicate and strong interpreter who knew how to give every detail without falling into dryness.

Look at the dress. It is supple and solid. It falls softly, it is alive, it speaks aloud of who the woman is. That is not a doll's dress, one of those rags of mousseline which are used to clothe dreams; it is good solid silk, not in the least worn and it would be too heavy on M. Dubufe's confections of whipped cream.

People have written me saying; "You want realists, temper-aments, then take M. Ribot!" I deny that M. Ribot has a tem-

perament of his own and I deny that he truly paints nature as
it is.

Verisimilitude first: Look at that large canvas: Jesus is
among the scholars, in a corner of the Temple; there are
broad shadows, the light spreads itself in pale sheets. Where
is the blood, where is the life? That, reality?! But the heads
of that child and of those men are hollow; there is not a bone
in those flabby, bloated bodies. Is it because of the vulgar
types that are portrayed that you wish to give me this as a
realistic work? I call realistic a work which is alive, a work
with persons capable of moving and speaking. Here I see only
dead creatures, pale and decayed. . . .

Reality for many people—for M. Vollon, for example—con-
sists of the choice of a vulgar subject. This year M. Vollon
was a realist, showing a servant in her kitchen. The nice plump
girl has just come from the market and has put her provisions
on the floor. She wears a red shirt and leans against the wall,
showing her sunburned arms and her heavy face.

I see nothing real in this, as the servant is made of wood
and so well glued to the wall that nothing could detach her.
Objects behave differently in nature, in natural light. Kitchens
are usually full of light, and things therefore do not all take
on a well-baked color. Also, in interiors, contrasting areas
are vigorous even if softened, everything is not on the same
plane. Reality is more brutal, more energetic than this.

Paint roses but paint living roses if you call yourself a re-
alist. . . .

Here then are the realists in the Salon. I may have omitted
some but in any case I have named and studied the principal
ones. I wished merely, and I repeat, to make it understood that
I do not place myself in any school and that I ask of the artist
only that he be a personality and powerful.

I have tried to be even more severe as I was afraid of being
misunderstood. I have no sympathy for the [so-called] burden
of artistic temperament. I can do without that term—and I
accept only individuals who are truly and definitely individu-
als. Every school displeases me because a school is in es-
sence the negation of human liberty to create. In a school
there is one man, the master; the disciples are necessarily
imitators.

Therefore, no more Realism than any other thing. Let us
have truth, if you will, life, but above all different hearts and
hands, giving different interpretations of nature. The defini-

tion of a work of art cannot be other than this; a work of art is a corner of the universe viewed through a temperament.

[JAMES MCNEILL WHISTLER (1834–1903), the son of a U. S. Army engineer, studied drawing at the Imperial Academy of Fine Arts in Petrograd when his father directed the construction of the Russian railways. Whistler failed at West Point, then worked for a year as an engraver of charts and maps for the U. S. Coast and Geodetic Survey in Washington. There he learned to etch and developed his dexterity and skill as an engraver. He decided to be a painter and went to Paris, entering Gleyre's studio in 1855. Fellow students, Fantin-Latour and Bracquemond, called his attention to Lecoq de Boisbaudran's methods for training the visual memory. Lecoq, an artist and a teacher, had published a pamphlet, *The Training of the Memory of Art* in 1847. This pamphlet was much studied by artists who were dissatisfied with academic teaching methods for it taught the steps in memory training and how "to seize on the essential points of everything." Whistler developed an enthusiasm for Japanese art, which depicted essentials in quaint patterns, when prints were first shown at the Paris Exposition Universelle of 1855 by a syndicate from Holland, the only nation admitted at the time to Japanese ports.

Whistler's first enthusiasm was for the realism of Courbet, but he soon repudiated all realism related to socialism or local color. He elected to paint atmospheric reality. He sought an arrangement of color and light that would be a valid imitation of an appearance of nature. To such an impression, free from any literary content, Whistler assigned the title "Symphony" or "Nocturne."

In 1859 Whistler established himself in London and, except for painting excursions to the continent, lived there forty years to effect by his wit and artistic talent a revolution in English painting. His first picture, "At the Piano," was accepted at the Royal Academy in 1860. His portraits were "Arrangements" of tones and curvilinear designs on a flat background containing rectangular shapes. His "Symphony in White, No. 1," called by the public "Dame Blanche," was a sensation at the Salon des Refusés in 1863. It contained qualities found in Japanese art combined with Whistler's color and design in

which the description of personality is discovered in the color harmonies. His portraits are unnamed, for he held the public was not interested in their identity.

Turning his talent in the 1870s to the representation of landscape, Whistler created his pictures from memory in a chosen color harmony, and exhibited them as "Nocturnes." To the public accustomed to "reading" a story, and often a moral, in a picture, this was an affront, as Ruskin asserted. The famous libel suit which resulted won Whistler one farthing in damages and ruined him financially. He left London for a year in Venice, where he took up etching again. His book, *The Gentle Art of Making Enemies* (1893), was widely circulated and is his account of the episode.

His "Ten O'Clock Lecture," delivered and published in 1885, set forth his attitude on the nature of the artist and made him a leading spokesman of the "art for art's sake" group. Whistler asserted that the artist has no relation to the time in which he lives. The artist concerned with art for the sake of art leads two lives, one in the real world and the other in his fascinating world of art. The *Lecture* was translated by Stéphane Mallarmé and was widely read. Although Whistler moved to Paris in 1892, and was admired by J. Huysmans, the majority of French writers have ignored him as a forerunner of Post-Impressionism, and do not acknowledge his ascendancy over the British artists, or his contribution in bringing the art of the two countries together.

SEE: A. J. Eddy, *Recollections and Impressions,* Philadelphia, 1903.]

ACTION FOR LIBEL AGAINST MR. RUSKIN[1]

Yesterday morning the trial of an action for libel in which Mr. James Abbott M'Neill Whistler, an artist, seeks to recover damages against Mr. John Ruskin, the well-known author and art critic, was commenced in the Exchequer Chamber, before Baron Huddleston and a special jury. The case excited great interest, and the court was crowded throughout the entire day; even the passages to the court being filled.

Mr. Serjeant Parry, in stating the case to the jury, said the

[1] Quoted from *The Daily News,* London, Tuesday, November 26, 1878.

plaintiff had followed the profession of an artist for many years both in this and other countries. Mr. Ruskin, the defendant, was a gentleman well known to all of them, and he held perhaps the highest position in Europe or in America as an art critic. Some of his works, he thought he was not wrong in saying, were destined to immortality, and it was the more surprising, therefore, that a gentleman holding such a position could traduce another in a way which would lead that other to come into a court of law to ask for damages. He thought the jury, after hearing the case, would come to the conclusion that a great injustice had been done. Mr. Whistler was born in America. For many years his father was an eminent military engineer, and in that capacity he was engaged to construct a railway for the Russian Government. Mr. Whistler, the plaintiff, therefore resided in Russia, after which he followed his profession in France and Holland, and in the United States he had earned a reputation as a painter and an artist. Mr. Whistler, however, was not merely a painter, but was an etcher or engraver, and he had achieved considerable honours in that department of art. The gold medal was awarded to him at Amsterdam, and his works were exhibited both in the British Museum and at South Kensington. He had been for many years in this country exhibiting his works. He had also exhibited in France, in which country he was the pupil of a well-known painter. He was, in fact, a gentleman who for years had devoted himself to art and had endeavoured to live by that profession. In the summer of 1877 he exhibited several pictures at the Grosvenor Gallery. He also exhibited in the Dudley Gallery, and altogether he had been an unwearied worker in his profession, always deserving to succeed, and if he had formed an erroneous opinion even, he should not have been treated with contempt and ridicule by Mr. Ruskin. He ought rather to have been treated with the highest respect. Mr. Ruskin edited a publication called "Fors Clavigera," which had a large circulation amongst artists and art patrons. In the July number of 1877 there appeared a criticism of many matters besides art, but on the subject of art he first criticised in general terms what he called the modern school, speaking in complimentary terms of Sir Coutts Lindsay, and referring to Mr. Burne-Jones as an artist, after which came the paragraph which was the defamatory matter complained of, and which ran as follows:—"Lastly, the mannerisms and errors of these pic-

tures (meaning some pictures by Mr. Burne-Jones), whatever may be their extent, are never affected or indolent. The work is natural to the painter, however strange to us; and it is wrought with utmost conscience and care, however far, to his own or our desire, the result may seem to be incomplete. Scarcely so much can be said for any other pictures of the modern schools; their eccentricities are almost always in some degree forced; and their imperfections gratuitously, if not impertinently, indulged. For Mr. Whistler's own sake, no less than for the protection of the purchaser, Sir Coutts Lindsay ought not to have admitted works into the gallery in which the ill-educated conceit of the artist so nearly approached the aspect of wilful imposture. I have seen and heard much of cockney impudence before now, but never expected to hear a coxcomb ask 200 guineas for flinging a pot of paint in the public's face." Mr. Ruskin pleaded that the alleged libel was privileged as being a fair and bona fide criticism upon a painting which the plaintiff had exposed to public view. He submitted that the terms in which Mr. Ruskin had spoken of the plaintiff were unfair and ungentlemanly, and that they were calculated to, and had done him considerable injury, and it would be for the jury to say what damages the plaintiff was entitled to.

Mr. Whistler was then called, and he said—I am an artist and was born in St. Petersburg. My father was the engineer of the St. Petersburg and Moscow Railway. After leaving Russia I went to America, and was educated at West Point. I came back to England in 1865, or 1866. I resided in Paris for two or three years, and studied with M. Glare [Gleyre]. After leaving Paris I came to London, and settled here. While I have been in London I have continually exhibited at the Academy. The last picture I sent to the Academy was a portrait of my mother. The first picture that I exhibited in England, called "At the Piano," I sold to Mr. Phillips, R.A. Since then I have exhibited "La Mère Gerard," "Wapping," "Alone with the Tide," "Taking down Scaffolding at Old Westminster Bridge," "Ships in the Ice on the Thames," "The Little White Girl," and many others. I have also exhibited in Paris. These pictures were painted by me, as an artist, for sale. Subsequently to this I exhibited pictures in the Dudley Gallery. I have been in the habit of etching. A number of my etchings were exhibited at the Hague, and I received a gold medal for them, which was the first intimation I had that they were

there. There is a collection of my etchings in the British Museum. It is not complete. There is also a collection at Windsor Castle, in her Majesty's library. I exhibited eight pictures in the summer of 1877 at the Grosvenor Gallery. No pictures are exhibited there but on invitation. I was invited by Sir Coutts Lindsay to exhibit. The first was a "Nocturne in Black and Gold,"[2] the second a "Nocturne in Blue and Silver," the third a "Nocturne in Blue and Gold," the fourth a "Nocturne in Blue and Silver," the fifth "An Arrangement in Black" (Irving, as Philip the Second), the sixth "A Harmony in Amber and Black," the seventh "An Arrangement in Brown." And, in addition to these, there was a portrait of Mr. Carlyle. That portrait was painted from sittings which Mr. Carlyle gave me. It has since been engraved, and the artist's proofs, or the mass of them, were all subscribed for. All the Nocturnes but one were sold before they went to the Grosvenor Gallery. One of them was sold to the Hon. Percy Wyndham for 200 guineas, the one in blue and gold. One I sent to Mr. Graham in lieu of a former commission, the amount of which was 150 guineas. A third one, blue and silver, I presented to Mrs. Leyland. The one that was for sale was in black and gold. I know the publication called *Fors Clavigera*. I believe it has an extensive sale.

Since the publication of this criticism have you sold a nocturne?—Not by any means at the same price as before.

What pictures have you been able to get to-day for inspection of those that were in the Grosvenor Gallery?—The pictures of "Irving, as Philip the Second," and "Thomas Carlyle." I could obtain no more.

Is the one sold to Mr. Wyndham here?—I expected it, but a telegram has come saying it could not be lent.

Is the picture of "Irving, as Philip the Second" a finished picture?—It is a large impression—a sketch; but it was not intended as a finished picture. It was not exhibited as for sale. There were no paintings exhibited for sale but the Nocturne in black and gold.

What is your definition of a Nocturne?—I have, perhaps, meant rather to indicate an artistic interest alone in the work, divesting the picture from any outside sort of interest which might have been otherwise attached to it. It is an arrangement of line, form, and colour first; and I make use of any incident

2 [See Plate 50.]

of it which shall bring about a symmetrical result. Among my works are some night pieces; and I have chosen the word Nocturne because it generalises and simplifies the whole set of them.

Cross-examined by the Attorney-General—I have sent pictures to the Academy which have not been received. I believe that is the experience of all artists. I did not send any of those which were exhibited in the Grosvenor Gallery. The nocturne in black and gold is a night piece, and represents the fireworks at Cremorne.

Not a view of Cremorne?—If it were called a view of Cremorne, it would certainly bring about nothing but disappointment on the part of the beholders. (Laughter) It is an artistic arrangement. It was marked 200 guineas.

The Attorney-General—What was the "Arrangement in Amber and Black?"

Witness—It was a young lady in an amber dress with a black ground. The "Arrangement in Brown" was similar. These were impressions of my own. I make them my study. I suppose them to appeal to none but those who may understand the technical matter. I did not intend to sell the "Harmony in Amber and Black." The "Arrangement in Brown" was also the portrait of a lady. I have not got the "Harmony in Amber and Black." I painted that one. I believe that the "Arrangement in Brown" is here. I had made arrangements for the various pictures being shown at the Westminster Palace Hotel.

I suppose you are willing to admit that your pictures exhibit some eccentricities; you have been told that over and over again?—Yes; very often. (Laughter.)

You send them to the Gallery to invite the admiration of the public?—That would be such vast absurdity on my part that I don't think I could. (Laughter.)

Did it take you much time to paint the "Nocturne in Black and Gold," how soon did you knock it off? (Laughter.)—I knocked it off possibly in a couple of days—one day to do the work, and another to finish it.

And that was the labour for which you asked 200 guineas? —No; it was for the knowledge gained through a lifetime. (Applause.)

Mr. Baron Huddleston said that if this manifestation of feeling were repeated, he would have to clear the court.

Cross-examination resumed—You don't approve of criti-

cism?—I should not disapprove in any way of technical criticism by a man whose life is passed in the practice of the science which he criticises; but for the opinion of a man whose life is not so passed I would have as little opinion as you would have if he expressed an opinion on law.

You expect to be criticised?—Yes, certainly; and I do not expect to be affected by it until it comes to be a case of this kind.

Cross-examination continued—What was the subject of the "Nocturne in Blue and Silver" given to Mr. Graham?—A moonlight effect near Old Battersea Bridge.

What has become of the "Nocturne in Black and Gold"? —I believe it is before you.

You have not sold it?—No; but I have deposited it.

You can get it?—It would be very difficult. I believe you have it. (Laughter.)

The Attorney-General proposed to show to the jury the "Nocturne in Blue and Silver." . . .

The picture called the "Nocturne in Blue and Silver" was then produced in court.

Cross-examination resumed—That is Mr. Graham's picture, and is the "Nocturne in Blue and Silver." It represents Battersea Bridge by moonlight.

Baron Huddleston—Is this part of the picture at the top old Battersea Bridge? (Laughter.)

Witness—Your lordship is too close at present to the picture to perceive the effect which I intended to produce at a distance. The spectator is supposed to be looking down the river towards London.

The prevailing colour is blue?—Yes.

Are those figures on the top of the bridge intended for people?—They are just what you like.

That is a barge beneath?—Yes. I am very much flattered at your seeing that. The thing is intended simply as a representation of moonlight. My whole scheme was only to bring about a certain harmony of colour.

How long did it take you to paint that picture?—I completed the work of that in one day after having arranged the idea in my mind. . . .

Re-examined by Mr. Serjeant Parry—I have also painted the portrait of Mr. Carlyle, and a picture of a young lady, which have not been exhibited in the Grosvenor Gallery. Besides those portraits I have produced one other nocturne pic-

ture. The picture of Philip is a mere sketch unfinished. There is another picture which was at the Grosvenor called "A Variation in Flesh Colour and Green." There is another representing the sea-side and sand, called "Harmony in Blue and Yellow." The "Nocturne in Black and Gold" was the one to which Mr. Ruskin alluded. This subject of the arrangement of colours had been a life study to my mind. The pictures are painted off generally from my own thought and mind. Sketching on paper is very rare with me.

Do you conscientiously form your idea, and then conscientiously work it out?—Certainly.

And these pictures are published by you for the purpose of a livelihood?—Yes.

Your manual labour is rapid?—Certainly.

At this stage of the proceedings the court adjourned for luncheon, and for the purpose of enabling the jury to see the pictures in the Westminster Palace Hotel.

The jury having returned into court, the "Nocturne in Black and Gold" was produced.

By the Attorney-General—This is Cremorne?

(Laughter.)—It is a "Nocturne in Black and Gold."

How long did it take you to paint that?—One whole day and part of another. That is a finished picture. The black monogram in the frame was placed in its position so as not to put the balance of colour out.

You have made the study of art your study of a lifetime. What is the peculiar beauty of that picture?—It would be impossible for me to explain to you, I am afraid, although I dare say I could to a sympathetic ear.

Do you not think that anybody looking at that picture might fairly come to the conclusion that it had no peculiar beauty? —I have strong evidence that Mr. Ruskin did come to that conclusion.

Do you think it fair that Mr. Ruskin should come to that conclusion?—What might be fair to Mr. Ruskin I can't answer. No artist of culture would come to that conclusion.

You offer that picture to the public as one of particular beauty as a work of art, and which is fairly worth 200 guineas?—I offer it as a work which I have conscientiously executed, and which I think worth the money. I would hold my reputation upon this as I would upon any of my other works.

Re-examined by Mr. Serjeant Parry—That picture was painted not as offering the portrait of a particular place, but

as an artistic impression which had been carried away. Many of my works are sketches of scenes on the Thames. I live on the Embankment.

Mr. William Michael Rossetti[3] called and, examined by Mr. Serjeant Parry, said he had been connected with literature and art since 1850, and had from time to time been engaged in art criticism. He knew both plaintiff and defendant. He had seen the picture called "Black and Gold." He was aware of the nomenclature of Mr. Whistler's pictures, and he appreciated its meaning. He criticised the pictures in the exhibition of 1877 in the Grosvenor Gallery, and he had a knowledge of Mr. Whistler's other pictures generally.

What judgment have you formed upon them?—If I am to take that picture—the pale picture—I consider it an artistic and beautiful representation of a pale but bright moonlight.

Baron Huddleston—That is the blue and silver Nocturne, Mrs. Leyland's picture.

Serjeant Parry—Then take the other one—the other blue and silver. To that I apply nearly the same observation. The "Nocturne in Black and Gold" is an effort to represent something of an indefinite kind. Being a representation of night, it must be indefinite. It represents the darkness of night mingled with and broken by the brightness of fireworks.

What was your judgment of the works in the Grosvenor Gallery exhibited by Mr. Whistler?—Taking them altogether, I admired them much, but not without exception.

Do you, or do you not, consider them the works of a conscientious artist desirous of working well in his profession?— I do, decidedly.

By the Attorney-General—I do not myself paint; but I have been in the habit of writing out criticisms, and I have occasionally written severe criticisms. My criticism appeared in the *Academy*. I know Mr. Ruskin personally. He is a man much devoted to art, and has written much upon it. He is the Slade Professor of Fine Arts in the University of Oxford.

What is the peculiar beauty of the "Nocturne in Black and Gold"—the representation of the fireworks at Cremorne; is it a gem? (Laughter.)—No.

Is it an exquisite painting?—No.

[3] [A brother of the painter and poet, Dante Gabriel Rossetti, who was responsible for the publication of the pre-Raphaelite Brotherhood, *The Germ*. See page 132.]

Is it very beautiful?—No.

Is it eccentric?—It is unlike the work of most other painters.

Is it a work of art?—Yes, it is. It is a picture painted with a considerable sense of the general effect of such a scene as that, and it is painted with a considerable amount of manipulative skill.

Has there been much labour bestowed upon it?—No.

Two hundred guineas is a stiffish price, is it not, for a picture of that kind?—I don't know that I am called upon to express any opinion on that point.

The Attorney-General—I call upon you to do so.

The witness appealed to Baron Huddleston, who thought the question ought to be answered.

The Attorney-General—Is 200 guineas a stiffish price for a picture like that?

Witness—I think it is the full value of the picture. (Laughter.)

Do you think it is worth that money?—Yes.

And would you give that for it?—I am too poor a man to give 200 guineas for any picture.

By Mr. Serjeant Parry—Mr. Ruskin has, I believe, severely criticised the works of other artists. I adhere to the opinion I have stated as to the two lighter pictures. I do not look on the other, the darker picture, as an indifferent picture.

Mr. Albert Moore, called and examined by Mr. Petheran, stated—I am an artist. I have seen most of the picture galleries in Europe. I have studied in Rome, and have followed my profession in London for 15 years. I have had my pictures in the Academy and in the Grosvenor Gallery. I have known Mr. Whistler for 14 years. I have seen the pictures which have been produced here to-day. The two pictures produced, in common with all Mr. Whistler's works, have a large aim not often followed. People abroad charge us with finishing our pictures too much. In the qualities aimed at I say he has succeeded, and no living painter, I believe, could succeed in the same way in the same qualities. I consider them to be beautiful works of art. There is one extraordinary thing about them, and that is, that he has painted the air, especially in the "Battersea Bridge" scene. The picture in black and gold I look upon as simply marvellous.

Would you call it a work of art?—Certainly, most consummate art.

Is 200 guineas a reasonable price?—I should say that as prices go it is not an unreasonable price. If I were rich I would buy them myself. The picture of Mr. Carlyle is good as a portrait and excellent as a picture.

Is the picture with the fireworks an exquisite work of art?— There is a decided beauty in the painting of it.

Is there any eccentricity in these pictures?—I should call it originality.

The Attorney-General submitted that his learned friend had made out no case whatever, as he had not shown malice.

The Attorney-General then addressed the jury for the defence. . . . He would not be able to call Mr. Ruskin as he was far too ill to attend, but if he had been able to appear he would have given his opinion of Mr. Whistler's work in the witness-box. For years he had devoted himself to the study and criticism of art. Since 1869 he had been professor of the fine arts at the University of Oxford, and had written many works upon the subject of art. Judging from the contents of those works it was obvious that Mr. Ruskin was a man of the keenest appreciation of that which was beautiful. He was also a man who had the greatest love and reverence for art. He had the highest appreciation for completed pictures, and he required from an artist that he should be devoted to his profession, and that he should possess something more than a few flashes of genius. He held that an artist ought to entertain a desire not simply to gain a large sum for his work, but that he should struggle to give the purchaser something worth the money paid. He held further that no piece of work should leave the artist's hands which was capable of farther labour —of being farther improved. Mr. Ruskin entertaining those views as to the duty of artists, it was not wonderful that his attention should be attracted to Mr. Whistler's pictures, and to determine to subject them, amongst others, to criticism. He subjected the pictures to severe criticism, or if they chose, to ridicule and contempt. But if he honestly believed what he wrote he would have been neglecting his duty if he hesitated to express the opinions honestly formed. The learned gentleman was proceeding with his address when, it being four o'clock, the Court was adjourned till this morning.

[EDGAR DEGAS (1834–1917) was the son of a wealthy banker with relatives both in New Orleans and Naples. Prior to entering the Ecole des Beaux Arts, Degas studied with Lamothe, a pupil of Ingres. The latter's art was the formative element in Degas' style. In 1855, Degas entered the Ecole and during his six years there acquired an academic discipline, a foundation on which he would later experiment with certainty. His study was broken by frequent trips to Italy, where, attracted by Donatello's and Cellini's work, he considered becoming a sculptor.

He began his career as a painter with portraits and historical subjects in a style similar to Ingres, whose emphasis on the arabesque quality of line he admired.

In 1862 he met Manet, who became an intimate friend, and frequented with Zola, Duret, and the other members of the group the Café Guerbois. Degas, however, kept himself aloof, and during the years 1862–74, pursued his own interest, abandoning historical subjects, and focusing on the human figure in an effort to perfect his style. His search to fix the essential aspect of an object seen in a "casual" passing and to record a specific moment is illustrated by the painting "Comte Lepic with His Children in the Place de la Concorde" (1873). He was assisted by a knowledge of Japanese prints, which Mme Soyé had made available at her famous shop for oriental objects in 1862. The Japanese form of composition provided an impression of space into which Degas placed his ingeniously and accurately observed figures of horses and human figures. The "Cotton-Market" painted in New Orleans (1873) and "At the Races" (1872) show the development of this style.

Although a member of the circle of the impressionists, and while his work was shown in every Impressionist exhibition between 1874–86, except 1882, Degas never worked out-of-doors. He returned with numerous sketches to compose with detachment his representations of the circus, theater, café, ballet in which nothing "should seem to be accidental." The first exhibition of his work was held at Durand-Ruel's in London (1871) and attracted little attention.

The last twenty years of his artistic life (1886–1906), he concerned himself with fewer subjects, and concentrated on depicting certain movements, convinced as Ingres had been,

that only the human body lent itself to demonstrating the harmonious perfection of beauty.

He sought the essential truth behind appearance and after using other media selected pastel, whose delicate colors veiled the definite lines of his design.

Degas had a lifelong interest in sculpture, in representing the figure extended in three dimensional space. His sculpture of race horses and dancers shows his mastery in effecting a succession of views that unite the figure visually with the space in which it stands. All details are suppressed to give reality to "a movement on the wing." His work has the illusionism of the Baroque, but is free from academic treatment and is "impressionistic" in a suggestion of movement that is dependent on a play of light. The only sculpture Degas ever exhibited was the "Fourteen-Year-Old Ballet Dancer" shown at the Impressionist Exhibition of 1881. Its "terrible reality" shocked the public. Of the 150 wax models of sculpture found in his studio at his death, 73 were cast in bronze, each in 22 copies. All the originals were destroyed.

Scattered through his notebooks of drawings, Degas jotted down brief notes, random observations, and aphorisms that are the sum of his theoretical thought. His extremely poor eyesight led him to conserve it for his drawing and painting. He wrote few letters of general interest. The sonnets such as *A Mme Caron* or *Petite Danseuse,* which he composed at the time of his friendship with Mallarmé, are related to his paintings and reflect the same search for subtlety of expression and his passion for technical expression.

His art has great influence and appeal, for it conveys to the illusionary world of the theater, the ballet, and the circus a sense of reality and permanence.

SEE: P. A. Lemoisne, "Les Carnets de Degas au Cabinet des Estampes," Gaz. des B.A., April 1921, pp. 219–31.

D. C. Rich, *Edgar Hilaire Germain Degas,* New York, 1951.

D. Halévy, *Degas parle,* Paris, 1960; *My Friend Degas,* translated by Mina Curtiss, Wesleyan, 1965.]

SHOP-TALK[1]

The museums are there to teach the history of art and something more as well, for, if they stimulate in the weak a desire to imitate, they furnish the strong with the means of their emancipation.

The [Florentine] painters of the fifteenth century are the true, the only guides. If you are thoroughly imbued with them and if you ceaselessly perfect your means of expression by the study of nature you are bound to achieve something.

It is all very well to copy what you see; it is much better to draw what you see only in memory. There is a transformation during which the imagination works in conjunction with the memory. You put down only what made an impression on you, that is to say the essential. Then your memory and your invention are freed from the dominating influence of nature. That is why pictures made by a man with a trained memory who knows thoroughly both the masters and his own craft are almost always remarkable works; for instance, Delacroix.

Equip the studio with benches arranged in tiers to inculcate the habit of drawing objects seen from above and from below. Allow students to paint only images reflected in mirrors to instill a detestation of the *trompe l'oeil*. For portrait-studies, pose the sitter on the ground floor while the students work upstairs, so as to train them to remember shapes and never to paint directly.

No art was ever less spontaneous than mine. What I do is the result of reflection and study of the great masters; of inspiration, spontaneity, temperament—temperament is the word —I know nothing. When people talk about temperament it always seems to me like the strong man in the fair who straddles his legs and asks someone to step up on the palm of his hand.

Art is deceit. An artist is only an artist at certain hours through an effort of the will; objects possess the same appearance for everyone; the study of nature is a convention. Isn't Manet the proof? For although he boasted of seriously copy-

[1] Quoted from R. H. Ives Gammell, *The Shop-Talk of Edgar Degas,* University Press, Boston, 1961, pp. 10, 11, 15, 17–19, 22, 23, 28–32, 36, 38–39, 41.

ing nature he was the worst painter in the world, never making a brush-stroke without having the masters in mind.

A painting is a thing which requires as much knavery, as much malice, and as much vice as the perpetration of a crime. Make it untrue and add an accent of truth.

Art is vice. One does not wed it, one rapes it.

Art is dishonest and cruel.

Art cannot be made with an intent to please.

Just now fashion favors paintings by which you can tell the time of day as by a sundial. I don't like that at all. A painting requires a certain mystery, something undefined, a touch of fancy. When you continually dot all the *i*'s you end up being a bore. Even working from nature you have to compose. There are people who consider that forbidden. Speaking of that, Monet said to me, "When Jongkind needed a house or a tree he turned around and took them from behind his back." Well, yes, why not? Corot, too, must have composed from nature. His charm comes above all from that. A picture is an original combination of lines and tones that set each other off.

A picture must only be made from a study painted from nature. It is composed beforehand in your mind. The studies you have amassed are useful simply as supports, as valuable bits of information.

Your picture has not enough unity and that is inevitable because you did not paint it in your studio. And that was your mistake. You have tried to render the air of outdoors, the air we breathe, the *plein air*. Well, a picture is primarily a work of the imagination of the artist. It must never be a copy. If later you can add a few touches of nature, obviously that does no harm. The air you see in pictures by the masters is not breathable.

Drawing is not form but a way of seeing form.

Drawing is not what you see but what you must make others see.

Drawing is not form, it is your understanding of form.

Make a drawing. Start it all over again, trace it. Start it and trace it again.

You must do over the same subject ten times, a hundred times. In art nothing must appear accidental, even a movement.

Try for the spirit and love of Mantegna[2] combined with the dash and coloring of Veronese.[3]

Make people's portraits in familiar and typical attitudes.

Work a great deal at evening effects, lamplight, candlelight, etc. The intriguing thing is not to show the source of the light but the effect of the lighting.

Be sure to give the same expression to a person's face that you give to his body. If laughter is characteristic of a person, make him laughing.

After doing some portraits seen from above, I will make some seen from below. Sitting closer to a sitter and looking at her from below, I will see her head against the chandelier surrounded by crystals.

Study a figure or an object in every perspective. This can be done by using a mirror, without leaving one's place. The mirror could be tipped or lowered. One could move around it.

Hitherto the nude has always been represented in poses which presuppose an audience, but these women of mine are honest, simple folk, unconcerned by any other interests than those involved in their physical condition. Here is another; she is washing her feet. It is as if you looked through a keyhole.

Rembrandt, in his painting of Venus and Cupid, by breaking away from the traditional chubby and playful Cupid and by painting him as a little gypsy boy, a young tramp with dirty hands and an equivocal glance, has in a perfectly natural way, endowed this superb picture with just that element of the unexpected which provokes thought and brings to our minds the dramatic idea which is inherent in all works of art in which the truth about life is expressed without compromise.

When I want a cloud I take my handkerchief and crumple it and turn it around till I get the right light and there is my cloud.

You love and you make art only out of what you are accustomed to. The novel captivates and bores in turn.

That is my idea of genius, a man who finds a hand so lovely, so wonderful, so difficult to render that he will shut himself in all his life, content to do nothing but indicate fingernails.

One must have an exalted idea, not of what one does, but

2 [Andrea Mantegna (1431–1506), head of a school of painting in Padua.]
3 [Paolo Veronese (1528–88).]

of what one will some day accomplish. Otherwise there is no use working.

Work is the only possession you can make use of whenever you want it.

Painting is not very difficult when you don't know how . . . but when you know . . . oh! then, it's another matter.

It requires courage to make a frontal attack on nature through the broad planes and the large lines and it is cowardly to do it by the facets and details. It is a battle.

Everybody has talent at twenty-five. The difficult thing is to have it at fifty.

What a fine thing it is to have natural gifts and facility and how essential it is to have other things besides!

It is not difficult to get life into a six-hour study. The difficulty is to retain it there in sixty.

Monsieur, de mon temps on n'arrivait pas. [Sir, in my day one did not "make good."]

Ah! those people felt life. They never denied life. . . . May I be of their breed if I ever develop a character of enough conviction and stability to paint pictures that are tantamount to sermons.

If Raphael were to see a Cabanel he would say, "Oh dear! That's my fault." But looking at a Daumier he would chuckle, "Ha! Ha!"

O Giotto! teach me to see Paris, and you, Paris, teach me to see Giotto.[4]

What a great painter missed-out this Géricault was! He realized his inability to make the grade, and that with his fortune, his sureness of hand and everything else. There is something of Bandinelli[5] in this unfortunate Gaul!

From Italy to Spain, from Greece to Japan, there is not very much difference in technique; everywhere it is a question of summing up life in its essential gestures, and the rest is the business of the artist's eye and hand.

[AUGUSTE RODIN (1840–1917), a Parisian, studied first at the Ecole des Arts Décoratifs where Lecoq de Boisbaudran, creator of the method of drawing from memory, was a teacher. When he failed to secure admission at the Ecole des

[4] [A note made in his sketch-book on his first trip to Italy.]
[5] [Baccio Bandinelli (1493–1560), an Italian sculptor.]

Beaux Arts, he earned his living by working for sculptors who had received official commissions. He studied briefly with the sculptor of animals, Antoine Barye, and learned from him some of his techniques of imparting vitality to his figures. Rodin followed one of his employers, Carrier-Belleuse, to Brussels and worked there also for the Belgium sculptor, Van Rasbourg. There Rodin became familiar with Gothic and Flemish art free from the classical idealization of the Italians.

In Paris Rodin was a member of the group of Impressionists who gathered around Manet. Rodin's technique was similar to theirs, for he modeled with wax or clay, adding bit by bit to construct a form, as the painters added blobs of paint to construct their pictures and relied on light to give meaning to the form. In his titles Rodin designated the idea he wished the form to convey.

The first example of Rodin's innovating art, rejected by the Salon of 1864, was the "Man with the Broken Nose" (1864). The carefully calculated relation between the modeling and atmospheric luminosity endowed the head with a permanent impression of vitality. He obliterated the classical contour line and modeled the figure to permit a progression from view to view to result in an "all-around" form which fused with the enveloping atmospheric space, such as "St. John the Baptist Preaching" (1878).

Rodin conceived "The Burghers of Calais" (1884–95) as a series of figures on a low plinth advancing in space in the anonymity of sacrifice, but the unconventional plan for the installation was not accepted and the four figures were grouped together elevated above the ground.

The colossal nine-foot "Balzac" (1895–98) marks the beginning of a type of modern sculpture that is dependent on light to give meaning to the suggestive modeling. The statue was refused by the Société des Gens de Lettres who had commissioned it, and it was not exhibited until 1939.

Rodin was given a state commission for a door for the Musée des Arts Décoratif (1879) to be decorated with scenes from the "Inferno" of Dante's *Divine Comedy*. After seeing, on a trip to England (1881–82), William Blake's and John Flaxman's illustrations of Dante, Rodin transformed the assignment to a symbolic interpretation of the "Inferno" as the "Gate of Hell." With the acceptance of this commission, everything Rodin executed, except his portraits, was related in conception to it and found a place on the Gate to contribute

to the symbolic meaning of the total conception. So most of Rodin's work is to be found repeated in miniature on the "Gate of Hell" in its final version (1900). Universal recognition was accorded Rodin with the assemblage of his work at the Paris Exposition of 1900.

Between 1898–1910 Rodin carried on a series of conversations with Paul Gsell that gave an exposition of his theories of art. These were published as *L'Art*. Rodin wrote a notable book *Les Cathédrales de France* (1914).

After 1908 Rodin lived in the Hotel Brion, where, in keeping with the tradition of French kings, the state provided quarters to recognized artists and writers. The building was made by the state into the Rodin Museum, in exchange for Rodin's property and art work.

By his conception and treatment of sculpture, Rodin restored it as an art form to the repertory of creative expression in western Europe.

SEE: A. E. Elsen, *Rodin,* Museum of Modern Art, New York, 1963.

Carola Giedion-Welcker, *Contemporary Sculpture,* New York, 1961, revised edition.

R. M. Rilke, *Rodin,* translated by J. Lemot and H. Trausel, New York, 1945.]

MOVEMENT IN ART[1]

[The "Iron Age" and "St. John the Baptist"] are certainly among those in which I have carried imitative art farthest. Though I have produced others whose animation is not less striking; for example my "Bourgeois de Calais," my "Balzac," my "Homme qui marche" (Man walking).

And even in those of my works in which action is less pronounced, I have always sought to give some indication of movement. I have very rarely represented complete repose. I have always endeavoured to express the inner feelings by the mobility of the muscles.

This is so even in my busts, to which I have often given a certain slant, a certain obliquity, a certain expressive direction, which would emphasise the meaning of the physiognomy.

[1] Quoted from P. Gsell, *Art by Auguste Rodin,* translated by R. Fedden, Boston, 1912.

Art cannot exist without life. If a sculptor wishes to interpret joy, sorrow, any passion whatsoever, he will not be able to move us unless he first knows how to make the beings live which he evokes. For how could the joy or the sorrow of an inert object—of a block of stone affect us? Now, the illusion of life is obtained in our art by good modelling and by movement. These two qualities are like the blood and the breath of all good work. . . .

. . . I shall try to do justice to my reputation by accomplishing a task much more difficult for me than animating bronze—that of explaining how I do it.

Note, first, that *movement is the transition from one attitude to another.*

This simple statement, which has the air of a truism, is to tell the truth, the key to the mystery.

You have certainly read in Ovid how Daphne was transformed into a bay-tree and Procne into a swallow. This charming writer shows us the body of one taking on its covering of leaves and bark and the members of the other clothing themselves in feathers, so that in each of them one still sees the woman which shall cease to be and the tree or bird which she will become. You remember, too, how in Dante's *Inferno* a serpent, coiling itself about the body of one of the damned, changes into man as the man becomes reptile. The great poet describes this scene so ingeniously that in each of these two beings one follows the struggle between two natures which progressively invade and supplant each other.

It is, in short, a metamorphosis of this kind that the painter or the sculptor effects in giving movement to his personages. He represents the transition from one pose to another—he indicates how insensibly the first glides into the second. In his work we still see a part of what was and we discover a part of what is to be. An example [The statue of Marshal Ney by Rude][2] will enlighten you better.

. . . Well—when you next pass that statue, look at it still more closely. You will then notice this: the legs of the statue and the hand which holds the sheath of the sabre are placed in the attitude that they had when he drew—the left leg is drawn back so that the sabre may be easily grasped by the

[2] [François Rude (1784–1855). Famous for his sculpture on the "Arc de Triomphe." "Marshal Ney" stands near the Luxembourg Gardens, Paris.]

right hand, which has just drawn it; and as for the left hand, it is arrested in the air as if still offering the sheath.

Now examine the body. It must have been slightly bent toward the left at the moment when it performed the act which I have described, but here it is erect, here is the chest thrown out, here is the head turning towards the soldiers as it roars out the order to attack; here, finally, is the right arm raised and brandishing the sabre.

So there you have a confirmation of what I have just said; the movement in this statue is only the change from a first attitude—that which the Marshal had as he drew his sabre—into a second, that which he had as he rushes, arm aloft, upon the enemy.

In that is all the secret of movement as interpreted by art. The sculptor compels, so to speak, the spectator to follow the development of an act in an individual. In the example that we have chosen, the eyes are forced to travel upward from the lower limbs to the raised arm, and, as in so doing they find the different parts of the figure represented at successive instants, they have the illusion of beholding the movement performed. . . .

Have you ever attentively examined instantaneous photographs of walking figures? [That they never seem to advance. Generally they seem to rest motionless on one leg or to hop on one foot.]

Exactly! Now, for example, while my St. John is represented with both feet on the ground, it is probable that an instantaneous photograph from a model making the same movement would show the back foot already raised and carried toward the other. Or else, on the contrary, the front foot would not yet be on the ground if the back leg occupied in the photograph the same position as in my statue.

Now it is exactly for that reason that this model photographed would present the odd appearance of a man suddenly stricken with paralysis and petrified in his pose, as it happened in the pretty fairy story to the servants of the Sleeping Beauty, who were all suddenly struck motionless in the midst of their occupations.

And this confirms what I have just explained to you on the subject of movement in art. If, in fact, in instantaneous photographs, the figures, though taken while moving, seem suddenly fixed in mid-air, it is because, all parts of the body being reproduced exactly at the same twentieth or fortieth of a

second, there is no progressive development of movement as there is in art.

. . . it is the artist who is truthful and it is photography which lies, for in reality time does not stop, and if the artist succeeds in producing the impression of a movement which takes several moments for accomplishment, his work is certainly much less conventional than the scientific image, where time is abruptly suspended.

It is that which condemns certain modern painters who, when they wish to represent horses galloping, reproduce the poses furnished by instantaneous photography.

Géricault is criticised because in his picture "Epsom Races" (*Course d'Epsom*), which is at the Louvre, he has painted his horses galloping, fully extended, *ventre à terre,* to use a familiar expression, throwing their front feet forward and their back feet backward at the same instant. It is said that the sensitive plate never gives the same effect. And, in fact, in instantaneous photography, when the forelegs of a horse are forward, the hind legs, having by their pause propelled the body onward, have already had time to gather themselves under the body in order to recommence the stride, so that for a moment the four legs are almost gathered together in the air, which gives the animal the appearance of jumping off the ground, and of being motionless in this position.

Now I believe that it is Géricault who is right, and not the camera, for his horses *appear* to run; this comes from the fact that the spectator from right to left sees first the hind legs accomplish the effort whence the general impetus results, then the body stretched out, then the forelegs which seek the ground ahead. This is false in reality, as the actions could not be simultaneous; but it is true when the parts are observed successively, and it is this truth alone that matters to us, because it is that which we see and which strikes us.

Note besides that painters and sculptors, when they unite different phases of an action in the same figure, do not act from reason or from artifice. They are naïvely expressing what they feel. Their minds and their hands are as if drawn in the direction of the movement, and they translate the development by instinct. Here, as everywhere in the domain of art, sincerity is the only rule. . . .

Drawing and Colour

It ["The Embarkation for the Island of Cythera" by Watteau] is a delight that one cannot forget. But have you noted the development of this pantomime? Truly now, is it the stage? or is it painting? One does not know which to say. You see, then, that an artist can, when he pleases, represent not only fleeting gestures, but a long *action,* to employ a term of dramatic art.

In order to succeed, he only needs to place his personages in such a manner that the spectator shall first see those who commence this action, then those who continue it, and finally those who complete it. Would you like an example in sculpture?

. . . Here . . . is [a photograph of] the "Marseillaise" which Rude carved for one of the piers of the Arc de Triomphe. [Plate 52.]

Liberty is a breastplate of brass, cleaving the air with unfolded wings, roaring in a mighty voice, "Aux armes, citoyens!" She raises high her left arm to rally all the brave to her side, and, with the other hand, she points her sword towards the enemy. It is she, beyond question, whom you first see, for she dominates all the work, and her legs, which are wide apart as if she were running, seem like an accent placed above this sublime war-epic. It seems as though one must hear her—for her mouth of stone shrieks as though to burst your ear-drum. But no sooner has she given the call than you see the warriors rush forward. This is the second phase of the action. A Gaul with the mane of a lion shakes aloft his helmet as though to salute the goddess, and here, at his side, is his young son, who begs the right to go with him—"I am strong enough, I am a man, I want to go!" he seems to say, grasping the hilt of a sword. "Come," says the father, regarding him with tender pride.

Third phase of the action: a veteran bowed beneath the weight of his equipment strives to join them—for all who have strength enough must march to battle. Another old man, bowed with age, follows the soldiers with his prayers, and the gesture of his hand seems to repeat the counsels that he has given them from his own experience.

Fourth phase: an archer bends his muscular back to bind on his arms. A trumpet blares its frenzied appeal to the troops.

The wind flaps the standards, the lances point forward. The signal is given, and already the strife begins.

Here, again, we have a true dramatic composition acted before us. But while "L'Embarquement pour Cythère" recalls the delicate comedies of Marivaux, the "Marseillaise" is a great tragedy by Corneille. I do not know which of the two works I prefer, for there is as much genius in the one as in the other. . . .

Phidias and Michael Angelo

. . . We will talk of Phidias and of Michael Angelo, and I will model statuettes for you on the principles of both. In that way you will quickly grasp the essential differences of the two inspirations, or, to express it better, the opposed characteristics which divide them.

Phidias and Michael Angelo judged and commented upon by Rodin! It is easy to imagine that I was exact to the hour of our meeting. The Master sat down before a marble table and clay was brought to him. . . . Rolling balls of clay on the table, he began rapidly to model a figure, talking at the same time.

This first figure . . . will be founded on the conception of Phidias. When I pronounce that name I am really thinking of all Greek sculpture, which found its highest expression in the genius of Phidias.

. . . Well, then, let us examine it and see from what this resemblance [to the Greek] arises. My statuette offers, from head to feet, four planes which are alternatively opposed.

The plane of the shoulders and chest leads towards the left shoulder—the plane of the lower half of the body leads towards the right side—the plane of the knees leads again towards the left knee, for the knee of the right leg, which is bent, comes ahead of the other—and finally, the foot of this same right leg is back of the left foot. So, I repeat, you can note four directions in my figure which produce a very gentle undulation through the whole body.

This impression of tranquil charm is equally given by the balance of the figure. A plumb-line through the middle of the neck would fall on the inner ankle bone of the left foot, which bears all the weight of the body. The other leg, on the contrary, is free—only its toes touch the ground and so only furnish a supplementary support; it could be lifted without dis-

turbing the equilibrium. The pose is full of *abandon* and of grace.

There is another thing to notice. The upper part of the torso leans to the side of the leg which supports the body. The left shoulder is, thus, at a lower level than the other. But, as opposed to it, the left hip, which supports the whole pose, is raised and salient. So, on this side of the body the shoulder is nearer the hip, while on the other side the right shoulder, which is raised, is separated from the right hip, which is lowered. This recalls the movement of an accordion, which closes on one side and opens on the other.

This double balance of the shoulders and of the hips contributes still more to the calm elegance of the whole.

Now look at my statuette in profile.

It is bent backwards; the back is hollowed and the chest slightly expanded. In a word, the figure is convex and has the form of the letter *C*. This form helps it to catch the light, which is distributed softly over the torso and limbs and so adds to the general charm. Now the different peculiarities which we see in this statuette may be noted in nearly all antiques. Without a doubt, there are numerous variations, doubtless there are some derogations from these fundamental principles; but in the Greek works you will always find most of the characteristics which I have indicated.

Now translate this technical system into spiritual terms; you will then recognise that antique art signifies contentment, calm, grace, balance, reason. . . . The details, moreover, would add very little to it. And now, by the way, an important truth. When the planes of a figure are well placed, with decision and intelligence, all is done, so to speak; the whole effect is obtained; the refinements which come after might please the spectator, but they are almost superfluous. This science of planes is common to all great epochs; it is almost ignored today.

. . . Now I will do you another [figure] after Michael Angelo.

. . . Now! Follow my explanation. Here, instead of four planes, you have only two; one for the upper half of the statuette and the other, opposed, for the lower half. This gives at once a sense of violence and of constraint—and the result is a striking contrast to the calm of the antiques.

Both legs are bent, and consequently the weight of the body is divided between the two instead of being borne exclusively

by one. So there is no repose here, but work for both the lower limbs.

Besides, the hip corresponding to the leg which bears the lesser weight is the one which is the more raised, which indicates that the body is pushing this way.

Nor is the torso less animated. Instead of resting quietly, as in the antique, on the most prominent hip, it, on the contrary, raises the shoulder on the same side so as to continue the movement of the hip.

Now note that the concentration of the effort places the two limbs one against the other, and the two arms, one against the body and the other against the head. In this way there is no space left between the limbs and the body. You see none of those openings which, resulting from the freedom with which the arms and legs were placed, gave lightness to Greek sculpture. The art of Michael Angelo created statues all of a size, in a block. He said himself that only those statues were good which could be rolled from the top of a mountain without breaking; and in his opinion all that was broken off in such a fall was superfluous.

His figures surely seem carved to meet this test; but it is certain that not a single antique could have stood it; the greatest works of Phidias, of Praxiteles, of Polycletes, of Scopas and of Lysippus would have reached the foot of the hill in pieces.

And that proves how a formula which may be profoundly true for one artistic school may be false for another.

A last important characteristic of my statuette is that it is in the form of a console; the knees constitute the lower protuberance; the retreating chest represents the concavity, the bent head the upper jutment of the console. The torso is thus arched forward instead of backward as in antique art. It is that which produces here such deep shadows in the hollow of the chest and beneath the legs.

To sum it up, the greatest genius of modern times has celebrated the epic of shadow, while the ancients celebrated that of light. And if we now seek the spiritual significance of the technique of Michael Angelo, as we did that of the Greeks, we shall find that his sculpture expressed restless energy, the will to act without the hope of success—in fine, the martyrdom of the creatures tormented by unrealisable aspirations.

. . . When I went to Italy myself, with my head full of Greek models which I had so passionately studied at the

Louvre, I found myself completely disconcerted before the Michael Angelos. They constantly contradicted all those truths which I believed that I had definitely acquired. "Look here," I said to myself, "why this incurvation of the body, this raised hip, this lowered shoulder?" I was very much upset.

And yet Michael Angelo could not have been mistaken! I had to understand. I kept at it and I succeeded.

To tell the truth, Michael Angelo does not, as is often contended, hold a unique place in art. He is the culmination of all Gothic thought. It is generally said that the Renaissance was the resurrection of pagan rationalism and its victory over the mysticism of the Middle Ages. This is only half true. The Christian spirit continued to inspire a number of the artists of the Renaissance, among others, Donatello, the painter Ghirlandajo, who was the master of Michael Angelo, and Buonarotti himself.

He is manifestly the descendant of the image-makers of the thirteenth and fourteenth centuries. You constantly find in the sculpture of the Middle Ages this form of the console to which I called your attention. There you find this same restriction of the chest, these limbs glued to the body, and this attitude of effort. There you find above all a melancholy which regards life as a transitory thing to which we must not cling. . . .

V. ARTIST AND SOCIETY

INTRODUCTION

[The political events of the end of the eighteenth century altered the position of the artist in society. In the preceding centuries the talent of the artists had been employed in the service of the church, the nobility, corporations and associations, royalty—the different groups in society. The technical requirements of each art were taught the artist, such as the properties of color, the preparation of paint, panels, canvas, the use of the compass and square, the chisels and mallet, and the qualities and properties of stone and the method of their cutting. After learning from a master and assisting in the production of articles that society required, the artist, painter or sculptor, goldsmith, tapisser, then manufactured himself a diversity of products, all related to his talent which in this way had been developed to the fullest.

Every artist, until the sixteenth century, be he sculptor, goldsmith, or painter, received from the guild a technical training that enabled him to practise his art.

At that time as consequence of general social changes, the rise of the mercantile class, the decline of the guild, the change in processing and manufacture of goods, and the centralization of political power, division occurred in the training of the artists. The painter and sculptor became separated from the stone carver, the tapisser, the goldsmith, the engraver. They received training in art as a profession at an Academy of Fine Arts that was newly established by kings and princes for this purpose. The training was directed to the development of a proficiency in executing representational images, both in three dimensions, sculpture, and in two, bas-relief and painting, in the mode of expression that was established and accepted by the Academies and society in their respective interrelationship. The training in the technical or mechanical aspect of the arts

became secondary. As the nineteenth century approached, the mechanical or technical production of the art work was executed by a hired craftsman: the stone cutter, by a system of pointing, transferred the clay model to block and hewed it; the engraver engraved the drawing; the colors were manufactured, and specialists filled in the foliage, the animals, the architectural detail of a picture as was required by the color sketch of the painter. The artist became a gentleman of letters. The field in which his talents were trained and in which they could find expression constantly narrowed. He came to serve, by his production of representational pictures, statues, and emblems of status and power, the small group in his society that provided him with his training.

The political philosophy and the events that occurred at the end of the eighteenth century produced a radical change in the relationship of the artist and society in the nineteenth century. The social institutions that provided him with his training and support were swept away. In France, the artist became a citizen to serve the state, to provide it with its emblems of power, and to stage the festivals to magnify its "genius." There the Academy was denounced, abolished, and then re-instituted with a different name. But the program of training remained unaltered. Elsewhere, where events did not call for such a violent change, the seventeenth-century Academy continued to serve the traditional elements; the true artist turned away from it convinced that he stood in a unique position and that his genius called him to express for society only that of which he was aware or felt when he confronted nature. Feeling his separation from society, many European artists strove to establish communities in which to teach themselves the technical requirements of their arts, and to formulate doctrines to express their conception of art to the changed society. The Nazarenes, the Pre-Raphaelites, "Barbus," "Les Primitifs," the Barbizon landscapists, the various café groups in Paris of the second half of the century, the Nabis, etc., reflect this nineteenth-century tendency.

Simultaneously, economic changes altered the economic basis of the artist and the craftsman. No longer was there a single segment of society to receive the products of the artist, but the public. The industrialization of manufacture deprived the craftsman of his service as a designer and manufacturer. Only very gradually did industry realize its need for designers, and by the middle of the nineteenth century a few trade and tech-

nical schools were established, first in England and then on the Continent, to furnish industrial designers. Drawing for trade purposes was transferred to these schools from the art academies, which were now raised to be colleges of art. The art academy remained as an anachronism, for the instruction was not reformed to correspond to the changed position of the patron and the public vis-à-vis the artist.

In 1850, an invitation was extended to all countries to send products of their manufacture to the first World Exposition in London. The Crystal Palace, constructed of cast iron and glass, was built to house the exhibits and the great World Exhibition opened in 1851 to sum up the whole epoch. The visitors from all Europe suddenly saw that industry everywhere had been producing objects that were offensive to the eye in the vulgarness of their design and lack of taste.

Immediate steps were taken to rectify the situation. The instruction methods of trade and technical schools already established were reviewed. Vocational training and facilities to teach drawing were provided for young workers in some countries. Léon de Laborde, who directed the reforms in France, and Gottfried Semper, a refugee from Germany, first in England and then in Zürich—where he founded the famous Kunstgewerbe Schule (Applied Arts School)—contributed, as Ruskin and Morris, to the improvement of industrial art. In contrast to the two Englishmen, they accepted the machine and adapted programs of teaching to provide designs suitable for mechanical reproduction. All four recognized the need to familiarize the public with objects of good taste through museums of decorative arts.

The end of the nineteenth century is marked by efforts throughout Europe to revive the handicrafts and the training that produced them and to bring the talents of the artist once more to the service of society.

SEE: N. Pevsner, *Academies of Art, Past and Present,* Cambridge, 1940.]

ARCHITECTURE CONSIDERED IN RELATION TO ART, MORES, AND LEGISLATION[1]

The House of the Two Cabinet-Makers

Men, who usurp the common rights forgetting the common good and seeing only their own advantage, believe that they find in the mediocrity, which they share with the majority, a sort of compensation that lends them distinction. They have granted freedom to one area of the arts in order to dominate the other. Would you believe it? They do not wish that the arts which they define as fine arts and consider as luxuries should be within the reach of everyone. They wish that those arts which they call mechanical and which are more widely diffused since they supply the industrial part of the population, should suffer a debasement, satisfying their vanity. I have difficulty in conceiving this. In truth do you know of some arts which do not require the use of the hands, or any that forbid their use?

What is art? It is the perfection of skill. Does not draftmanship belong to all classes? He who takes the measure of a foot, of the body, who arranges or perfumes the hair, cuts the metals, melts them, gilds them, he who loads our table with lavish center pieces, he who builds palaces, who brings the gods into our temples, he who represents Olympus on those bold vaults that surprise our eyes: all is the work of craftsmen.

The average man is an artistic workman, the distinguished man is a workman who has become an artist. Here are two very distinct classes blended into one actual one. A genius is its common product. As it is unusual for him to injure a part of mankind, he only reaps the fruits of his isolation when Parque, the Goddess of Fate, has cut the thread of illusions.

He who knows most should instruct him who knows least; that is an obligation that he contracts with humanity. It is of his debt of gratitude to Nature who has favoured him.

You believe, therefore, that one should know the alphabet before forming the words? Yes; and that is not all: strictness

[1] Translated from C. N. Ledoux, *L'architecture considerée sous le rapport de l'art, des moeurs, et de la législation,* Paris, 1804, photographic copy, Paris, 1962. For headnote on Ledoux see p. 227.

in the choice of masters assures the public mores; but take care, a center of instruction often favours an outward manner; the credit which it acquires through the inaction of the ideas of those who are considered the *ne plus ultra* of perfection hold the attention of the multitude, dominate it and determine its prejudices.

Is the sun not more luminous than the stars that it reflects? Without doubt. But the comparison is not admissible. Are you ignorant of the fact that the best of laws degenerate into abuse? The rich corporations supported by the treasury limit their faculties to the narrow circle of their charter. Seldom do they go beyond what is required of them. They are the home of conventional talents that sparkle in society. That is where they shine without contradiction. The one scrutinizes the other in the light of their common weaknesses and their mutual deferences.

The majority live on servile opinion, the phantom of grounded reputations—they live at the expense of those of worth.

Sitting on the same bench, he who languishes in the legion already believes himself a clever general, a savant, an excellent artist. The latter has so completely assimilated the faults of the corporation that although he has need of improvement he makes no progress. Why? Because he has nothing to desire. His backward apathy melts at that encompassing hearth which destroys all creative seeds. If the artist isolates himself, he is regarded with suspicion. If he wants to rise, to think, to act independently or differently, he does it only at the cost of his tranquility. Persecution follows him and extends to his last offspring.

If workmen of all kinds were associated with the research of the educated, if the savants would call them to their discussions, imagine what the public cause would gain. If the dignity of the privileged corporations opposes this, general interest demands it. One must admit that it is example, opportunity that develops talents. It is study which propagated the different levels of instruction and although the nuances are not noticed by everybody, still they are apparent to the eyes of those men who do everything to make them more evident. . . .

O you, who collect the talents of all kinds, invite the working multitude to your séances. Your procedures will first be complicated, soon be simplified and then will pass through all

hands. Believe me, the temple of taste should be the equal of that of the gods. Its diameter is that of the universe. Its vault that of the firmament. Receive without distinction workmen of all types. Call on the workshop at all times of the day from one pole to the other; you will be surprised to learn from him whom nature has blessed, all that which your profound studies have refused to give you. Often, very often, studies will confuse your steps circumscribed as they are by rule; but electrify your thoughts, and unexpected fruit will be produced. (In talking freely with workmen, I have often had great benefit.)

To a skillful practise to which you will owe a part of your success, you will link a scholarly theory. If you will encourage by public compensations and by examples, you will obtain the good which you undoubtedly wish and which is expected of you. I ask of you where is the workman who will not be enthused at a recital of the wonders of Archimedes? Who is the builder who would not be roused if you spoke to him of a building of 300 feet high to be erected in the middle of a stormy sea; who is the painter who does not dedicate altars to Raphael in his soul?

I go farther, the virtue and the value of others develop in ourselves sensations which produce dynamic advances. Is there a soldier who does not feel elevated by the impression which Achilles' character makes on him? Every soldier is moved by Ajax's courage and the valor of Diomedes. There is no one who is not tempted to sharpen his saber at the sight of Maurice's tomb.

Judge the principle by the result. Homer, the first painter of nature wanders in Salamine and sings the adventures of Odysseus. Like a troubador or a chansonnier of today, he barely found his livelihood. How many workmen have started as he; are there many artists who have ended as he has?

The plans, sections and elevations are sufficiently detailed to show the spirit of variety which has determined the principle of design. Consider the porticoes facing the street, they close the display rooms where wealth comes to make its choice. The workshops, the ware-houses, occupy the foot of the garden, and are arranged on the public thoroughfare.

An analysis of this plan presents less interest than the analysis of an enlightened administration as the means to extend and to honor the abilities of the workman.

Indeed, how can one conceive that those who work during the night for the daytime pleasures of the rich, should be so

debased that their clothes are the uniform of servitude or the unveiled secret of their misery. Would it not be appropriate for the honor of humanity that the clothes required by the function of each should be kept in the store-rooms of the great theatre? There Man, discarding his working clothes, would find once more the manner of dress that contributes to the elevation of his being and the dignity which is due him in the social order.

STONES OF VENICE

Second, or Gothic, Period[1]
Chapter VI, The Nature of Gothic

. . . I shall endeavor therefore to give the reader in this chapter an idea, at once broad and definite, of the true nature of *Gothic* architecture, properly so called; not of that of Venice only, but of universal Gothic: . . .

II. The principal difficulty in doing this arises from the fact that every building of the Gothic period differs in some important respect from every other; and many include features which, if they occurred in other buildings, would not be considered Gothic at all; so that all we have to reason upon is merely, if I may be allowed so to express it, a greater or less degree of *Gothicness* in each building we examine. And it is this Gothicness—the character which, according as it is found more or less in a building, makes it more or less Gothic—of which I want to define the nature; and I feel the same kind of difficulty in doing so which would be encountered by any one who undertook to explain, for instance, the nature of Redness, without any actual red thing to point to, but only orange and purple things. . . .

. . . and it is so in a far greater degree to make the abstraction of the Gothic character intelligible, because that character itself is made up of many mingled ideas, and can consist only in their union. That is to say, pointed arches do not constitute Gothic, nor vaulted roofs, nor flying buttresses, nor grotesque sculptures; but all or some of these things, and many other

[1] John Ruskin, *Stones of Venice*, Vol. II, "The Foundations," Boston, 1853, pp. 152–208. For headnote on Ruskin see p. 117.

things with them, when they come together so as to have life. . . .

. . . We all have some notion, most of us a very determined one, of the meaning of the term Gothic; but I know that many persons have this idea in their minds without being able to define it: that is to say, understanding generally that Westminster Abbey is Gothic, and St. Paul's is not, that Strasburg Cathedral is Gothic, and St. Peter's is not, they have, nevertheless, no clear notion of what it is that they recognize in the one or miss in the other, such as would enable them to say how far the work at Westminster or Strasburg is good and pure of its kind: . . .

. . . And I believe this inquiry to be a pleasant and profitable one; and that there will be found something more than usually interesting in tracing out this grey, shadowy, many-pinnacled image of the Gothic spirit within us; and discerning what fellowship there is between it and our Northern hearts. . . .

IV. We have, then, the Gothic character submitted to our analysis, just as the rough mineral is submitted to that of the chemist. . . .

. . . Now observe: the chemist defines his mineral by two separate kinds of character; one external, its crystalline form, hardness, lustre, &c.; the other internal, the proportions and nature of its constituent atoms. Exactly in the same manner, we shall find that Gothic architecture has external forms, and internal elements. Its elements are certain mental tendencies of the builders, legibly expressed in it; as fancifulness, love of variety, love of richness, and such others. Its external forms are pointed arches, vaulted roofs, &c. And unless both the elements and the forms are there, we have no right to call the style Gothic. It is not enough that it has the Form, if it have not also the power and life. It is not enough that it has the Power, if it have not the form. We must therefore inquire into each of these characters successively; and determine first, what is the Mental Expression, and secondly, what the Material Form, of Gothic architecture, properly so called.

1st. Mental Power or Expression. What characters, we have to discover, did the Gothic builders love, or instinctively express in their work, as distinguished from all other builders?

V. Let us go back for a moment to our chemistry, and note that, in defining a mineral by its constituent parts, it is not one nor another of them, that can make up the mineral but the union of all: . . .

So in the various mental characters which make up the soul of Gothic. It is not one nor another that produces it; but their union in certain measures. Each one of them is found in many other architectures besides Gothic; but Gothic cannot exist where they are not found, or at least, where their place is not in some way supplied. . . .

VI. I believe, then, that the characteristic or moral elements of Gothic are the following, placed in the order of their importance:

 1. Savageness. 4. Grotesqueness.
 2. Changefulness. 5. Rigidity.
 3. Naturalism. 6. Redundance.

These characters are here expressed as belonging to the building; as belonging to the builder, they would be expressed thus: 1. Savageness, or Rudeness. 2. Love of Change. 3. Love of Nature. 4. Disturbed Imagination. 5. Obstinacy. 6. Generosity. And I repeat, that the withdrawal of any one, or any two, will not at once destroy the Gothic character of a building, but the removal of a majority of them will. I shall proceed to examine them in their order.

VII. 1. Savageness. I am not sure when the word "Gothic" was first generically applied to the architecture of the North; but I presume that, whatever the date of its original usage, it was intended to imply reproach, and express the barbaric character of the nations among whom that architecture arose. It never implied that they were literally of Gothic lineage, far less that their architecture had been originally invented by the Goths themselves; but it did imply that they and their buildings together exhibited a degree of sternness and rudeness, which, in contradistinction to the character of Southern and Eastern nations, appeared like a perpetual reflection of the contrast between the Goth and the Roman in their first encounter. And when that fallen Roman, in the utmost impotence of his luxury, and insolence of his guilt, became the model for the imitation of civilized Europe, at the close of the so-called Dark Ages, the word Gothic became a term of unmitigated contempt, not

unmixed with aversion. From that contempt, by the exertion of the antiquaries and architects of this century, Gothic architecture has been sufficiently vindicated; and perhaps some among us, in our admiration of the magnificent science of its structure, and sacredness of its expression, might desire that the term of ancient reproach should be withdrawn, and some other, of more apparent honorableness, adopted in its place. . . .

IX. If, however, the savageness of Gothic architecture merely as an expression of its origin among Northern nations, may be considered, in some sort, a noble character, it possesses a higher nobility still, when considered as an index, not of climate, but of religious principle.

In the 13th and 14th paragraphs of Chapter XXI. of the first volume of this work, it was noticed that the systems of architectural ornament, properly so called, might be divided into three: (1) Servile ornament, in which the execution or power of the inferior workman is entirely subjected to the intellect of the higher; (2) Constitutional ornament, in which the executive inferior power is, to a certain point, emancipated and independent, having a will of its own, yet confessing its inferiority and rendering obedience to higher powers; and (3) Revolutionary ornament in which no executive inferiority is admitted at all.

Of Servile ornament, the principal schools are the Greek, Ninevite, and Egyptian; but their servility is of different kinds. . . .

X. But, in the mediaeval, or especially Christian, system of ornament, this slavery is done away with altogether; Christianity having recognized, in small things as well as great, the individual value of every soul. But it not only recognizes its value; it confesses its imperfection, in only bestowing dignity upon the acknowledgment of unworthiness. That admission of lost power and fallen nature, which the Greek or Ninevite felt to be intensely painful, and, as far as might be, altogether refused, the Christian makes daily and hourly, contemplating the fact of it without fear, as tending, in the end, to God's greater glory. Therefore, to every spirit which Christianity summons to her service, her exhortation is: Do what you can, and confess frankly what you are unable to do; neither let your effort be shortened for fear of failure, nor your confession silenced for fear of shame. And it is, perhaps, the

principal admirableness of the Gothic schools of architecture, that they thus receive the results of the labor of inferior minds; and out of fragments full of imperfection, and betraying that imperfection in every touch, indulgently raise up a stately and unaccusable whole.

XI. But the modern English mind has this much in common with that of the Greek, that it intensely desires, in all things, the utmost completion or perfection compatible with their nature. This is a noble character in the abstract, but becomes ignoble when it causes us to forget the relative dignities of the nature itself, and to prefer the perfectness of the lower nature of the imperfection of the higher; not considering that as, judged by such a rule, all the brute animals would be preferable to man, because more perfect in their functions and kind, and yet are always held inferior to him, so also in the works of man, those which are more perfect in their kind are always inferior to those which are, in their nature, liable to more faults and shortcomings. For the finer the nature, the more flaws it will show through the clearness of it; and it is a law of this universe, that the best things shall be seldomest seen in their best form. . . . And therefore, while in all things that we see, or do, we are to desire perfection and strive for it, we are nevertheless not to set the meaner thing, in its narrow accomplishment, above the nobler thing, in its mighty progress; not to esteem smooth minuteness above shattered majesty; . . . But, above all, in our dealings with the souls of other men, we are to take care how we check, by severe requirement or narrow caution, efforts which might otherwise lead to a noble issue; and, still more, how we withhold our admiration from great excellences, because they are mingled with rough faults. Now, in the make and nature of every man, however rude or simple, whom we employ in manual labor, there are some powers for better things: some tardy imagination, torpid capacity of emotion, tottering steps of thought, there are, even at the worst; and in most cases it is all our own fault that they *are* tardy or torpid. But they cannot be strengthened, unless we are content to take them in their feebleness, and unless we prize and honor them in their imperfection above the best and most perfect manual skill. And this is what we have to do with all our laborers; to look for the *thoughtful* part of them, and get that out of them, whatever we lose for it, whatever faults and errors we are obliged to take with it.

For the best that is in them cannot manifest itself, but in company with much error. Understand this clearly: You can teach a man to draw a straight line, and to cut one; to strike a curved line, and to carve it; and to copy and carve any number of given lines or forms, with admirable speed and perfect precision; and you find his work perfect of its kind: but if you ask him to think about any of those forms, to consider if he cannot find any better in his own head, he stops; his execution becomes hesitating; he thinks, and ten to one he thinks wrong; ten to one he makes a mistake in the first touch he gives to his work as a thinking being. But you have made a man of him for all that. He was only a machine before, an animated tool.

XII. And observe, you are put to stern choice in this matter. You must either make a tool of the creature, or a man of him. You cannot make both. Men were not intended to work with the accuracy of tools, to be precise and perfect in all their actions. If you will have that precision out of them, and make their fingers measure degrees like cogwheels, and their arms strike curves like compasses, you must unhumanize them. . . . On the other hand, if you will make a man of the working creature, you cannot make a tool. Let him but begin to imagine, to think, to try to do anything worth doing; and the engine-turned precision is lost at once. Out come all his roughness, all his dulness, all his incapability; shame upon shame, failure upon failure, pause after pause; but out comes the whole majesty of him also; . . .

XIII. And now, reader, look round this English room of yours, about which you have been proud so often, because the work of it was so good and strong, and the ornaments of it so finished. Examine again all those accurate mouldings, and perfect polishings, and unerring adjustments of the seasoned wood and tempered steel. Many a time you have exulted over them, and thought how great England was, because her slightest work was done so thoroughly. Alas! if read rightly, these perfectnesses are signs of a slavery in our England a thousand times more bitter and more degrading than that of the scourged African, or helot Greek. Men may be beaten, chained, tormented, yoked like cattle, slaughtered like summer flies, and yet remain in one sense, and the best sense, free. But to smother their souls within them, to blight and hew into rotting pollards the suckling branches of their human intelligence,

to make the flesh and skin, which, after the worm's work on it, is to see God, into leathern thongs to yoke machinery with— this it is to be slave-masters indeed; and there might be more freedom in England, though her feudal lords' lightest words were worth men's lives, and though the blood of the vexed husbandman dropped in the furrows of her fields, than there is while the animation of her multitudes is sent like fuel to feed the factory smoke, and the strength of them is given daily to be wasted into the fineness of a web, or racked into the exactness of a line.

XIV. And, on the other hand, go forth again to gaze upon the old cathedral front, where you have smiled so often at the fantastic ignorance of the old sculptors: examine once more those ugly goblins, and formless monsters, and stern statues, anatomiless and rigid; but do not mock at them, for they are signs of the life and liberty of every workman who struck the stone; a freedom of thought, and rank in scale of being, such as no laws, no charters, no charities can secure; but which it must be the first aim of all Europe at this day to re- gain for her children.

XV. Let me not be thought to speak wildly or extrava- gantly. It is verily this degradation of the operative into a machine, which, more than any other evil of the times, is lead- ing the mass of the nations everywhere into vain, incoherent, destructive struggling for a freedom of which they cannot explain the nature to themselves. Their universal outcry against wealth, and against nobility, is not forced from them either by the pressure of famine, or the sting of mortified pride. These do much, and have done much in all ages; but the foundations of society were never yet shaken as they are at this day. It is not that men are ill fed, but that they have no pleasure in the work by which they make their bread and therefore look to wealth as the only means of pleasure. It is not that men are pained by the scorn of the upper classes, but they cannot endure their own; for they feel that the kind of labor to which they are condemned is verily a degrading one, and makes them less than men. Never had the upper classes so much sympathy with the lower, or charity for them, as they have at this day, and yet never were they so much hated by them: . . . I know not if a day is ever to come when the na- ture of right freedom will be understood, and when men will see that to obey another man, to labor for him, yield reverence

to him or to his place, is not slavery. It is often the best kind of liberty—liberty from care. . . .

XVI. We have much studied and much perfected, of late, the great civilized invention of the division of labor; only we give it a false name. It is not, truly speaking, the labor that is divided; but the men:—divided into mere segments of men—broken into small fragments and crumbs of life; so that all the little piece of intelligence that is left in a man is not enough to make a pin, or a nail, but exhausts itself in making the point of a pin, or the head of a nail. . . . And the great cry that rises from all our manufacturing cities, louder than their furnace blast, is all in very deed for this—that we manufacture everything there except men; we blanch cotton, and strengthen steel, and refine sugar, and shape pottery; but to brighten, to strengthen, to refine, or to form a single living spirit, never enters into our estimate of advantages. And all the evil to which that cry is urging our myriads can be met only in one way: not by teaching nor preaching, for to teach them is but to show them their misery, and to preach to them, if we do nothing more than preach, is to mock at it. It can be met only by a right understanding on the part of all classes, of what kinds of labor are good for men, raising them, and making them happy; by a determined sacrifice of such convenience, or beauty, or cheapness as is to be got only by the degradation of the workman; and by equally determined demand for the products and results of healthy and ennobling labor.

XVII. And how, it will be asked, are these products to be recognized, and this demand to be regulated? Easily: by the observance of three broad and simple rules:

1. Never encourage the manufacture of any article not absolutely necessary, in the production of which *Invention* has no share.

2. Never demand an exact finish for its own sake, but only for some practical or noble end.

3. Never encourage imitation or copying of any kind, except for the sake of preserving record of great works.

The second of these principles is the only one which directly rises out of the consideration of our immediate subject; but I shall briefly explain the meaning and extent of the first also, reserving the enforcement of the third for another place.

1. Never encourage the manufacture of anything not necessary, in the production of which invention has no share.

For instance. Glass beads are utterly unnecessary, and there is no design or thought employed in their manufacture. They are formed by first drawing out the glass into rods; these rods are chopped up into fragments of the size of beads by the human hand, and the fragments are then rounded in the furnace. The men who chop up the rods sit at their work all day, their hands vibrating with a perpetual and exquisitely timed palsy, and the beads dropping beneath their vibration like hail. Neither they, nor the men who draw out the rods, or fuse the fragments, have the smallest occasion for the use of any single human faculty; and every young lady, therefore, who buys glass beads is engaged in the slave-trade, and is a much more cruel one than that which we have so long been endeavoring to put down.

But glass cups and vessels may become the subjects of exquisite invention; and if in buying these we pay for the invention, that is to say for the beautiful form, or color, or engraving, and not for mere finish of execution, we are doing good to humanity. . . .

XXI. Nay, but the reader interrupts me—"If the workman can design beautifully, I would not have him kept at the furnace. Let him be taken away and made a gentleman, and have a studio, and design his glass there, and I will have it blown and cut for him by common workmen, and so I will have my design and my finish too."

All ideas of this kind are founded upon two mistaken suppositions: the first, that one man's thoughts can be, or ought to be, executed by another man's hands; the second, that manual labor is a degradation, when it is governed by intellect.

On a large scale, and in work determinable by line and rule, it is indeed both possible and necessary that the thoughts of one man should be carried out by the labor of others; in this sense I have already defined the best architecture to be the expression of the mind of manhood by the hands of childhood. . . . Now it is only by labor that thought can be made healthy, and only by thought that labor can be made happy, and the two cannot be separated with impunity. It would be well if all of us were good handicraftsmen in some kind, and the dishonor of manual labor done away with altogether; . . . All professions should be liberal, and there should be less

pride felt in peculiarity of employment, and more in excellence of achievement. And yet more, in each several profession, no master should be too proud to do its hardest work. The painter should grind his own colors; the architect work in the mason's yard with his men; the master-manufacturer be himself a more skilful operative than any man in his mills; and the distinction between one man and another be only in expression and skill, and the authority and wealth which these must naturally and justly obtain.

XXII. I should be led far from the matter in hand, if I were to pursue this interesting subject. Enough, I trust, has been said to show the reader that the rudeness or imperfection which at first rendered the term "Gothic" one of reproach is indeed, when rightly understood, one of the most noble characters of Christian architecture, and not only a noble but an *essential* one. It seems a fantastic paradox, but it is nevertheless a most important truth, that no architecture can be truly noble which is *not* imperfect. . . .

XXVI. The second mental element above named was Changefulness, or Variety.

I have already enforced the allowing independent operation to the inferior workman, simply as a duty *to him,* and as ennobling the architecture by rendering it more Christian. We have now to consider what reward we obtain for the performance of this duty, namely, the perpetual variety of every feature of the building. . . .

XXVII. How much the beholder gains from the liberty of the laborer may perhaps be questioned in England, where one of the strongest instincts in nearly every mind is that Love of Order which makes us desire that our house windows should pair like our carriage horses, and allows us to yield our faith unhesitatingly to architectural theories which fix a form for everything and forbid variation from it. I would not impeach love of order: it is one of the most useful elements of the English mind; it helps us in our commerce and in all purely practical matters; and it is in many cases one of the foundation stones of morality. Only do not let us suppose that love of order is love of art. It is true that order, in its highest sense, is one of the necessities of art, just as time is a necessity of music; but love of order has no more to do with our right

enjoyment of architecture or painting, than love of punctuality with the appreciation of an opera. . . .

XXVIII. . . . But it requires a strong effort of common sense to shake ourselves quit of all that we have been taught for the last two centuries, and wake to the perception of a truth just as simple and certain as it is new: that great art, whether expressing itself in words, colors, or stones, does *not* say the same thing over and over again; that the merit of architecture as of every other art, consists in its saying new and different things; that to repeat itself is no more a characteristic of genius in marble than it is of genius in print; and that we may, without offending any laws of good taste, require of an architect, as we do of a novelist, that he should be not only correct, but entertaining.

Yet all this is true, and self-evident; only hidden from us as many other self-evident things are, by false teaching. Nothing is a great work of art, for the production of which either rules or models can be given. . . .

XXXVIII. From these general uses of variety in the economy of the world, we may at once understand its use and abuse in architecture. The variety of the Gothic schools is the more healthy and beautiful, because in many cases it is entirely unstudied, and results, not from the mere love of change, but from practical necessities. For in one point of view Gothic is not only the best, but the *only rational* architecture, as being that which can fit itself most easily to all services, vulgar or noble. . . .

XXXIX. These marked variations were, however, only permitted as part of the great system of perpetual change which ran through every member of Gothic design, and rendered it as endless a field for the beholder's inquiry, as for the builder's imagination: change, which in the best schools is subtle and delicate, and rendered more delightful by intermingling of a noble monotony; in the more barbaric schools is somewhat fantastic and redundant; but, in all, a necessary and constant condition of the life of the school. . . .

XLI. The third constituent element of the Gothic mind was stated to be Naturalism; that is to say, the love of natural objects for their own sake, and the effort to represent them frankly, unconstrained by artistical laws.

This characteristic of the style partly follows in necessary

connexion with those named above. For, so soon as the work-man is left free to represent what subjects he chooses, he must look to the nature that is round him for material, and will endeavor to represent it as he sees it, with more or less accuracy according to the skill he possesses, and with much play of fancy, but with small respect for law. There is, how-ever, a marked distinction between the imaginations of the Western and Eastern races, even when both are left free; the Western, or Gothic, delighting most in the representation of facts, and the Eastern (Arabian, Persian, and Chinese) in the harmony of colors and forms. . . .

LXVII. I said, in the second place, that Gothic work, when referred to the arrangement of all art, as purist, naturalist, or sensualist, was naturalist. This character follows necessarily on its extreme love of truth, prevailing over the sense of beauty, and causing it to take delight in portraiture of every kind, and to express the various characters of the human countenance and form, as it did the varieties of leaves and the ruggedness of branches. And this tendency is both increased and ennobled by the same Christian humility which we saw expressed in the first character of Gothic work, its rudeness. For as that resulted from a humility which confessed the im-perfection of *workman,* so this naturalist portraiture is ren-dered more faithful by the humility which confesses the imperfection of the *subject.* . . .

LXXII. The fourth essential element of the Gothic mind was above stated to be the sense of the Grotesque; the ten-dency to delight in fantastic and ludicrous, as well as in sub-lime, images, is a universal instinct of the Gothic imagination.

LXXIII. The fifth element above named was Rigidity; . . . but *active* rigidity; the peculiar energy which gives ten-sion to movement, and stiffness to resistance, which makes the fiercest lightning forked rather than curved, and the stout-est oak-branch angular rather than bending, and is as much seen in the quivering of the lance as in the glittering of the icicle. . . .

LXXIV. . . . the Gothic ornament stands out in prickly in-dependence, and frosty fortitude, jutting into crockets, and freezing into pinnacles; here starting up into a monster, there germinating into a blossom; anon knitting itself into a branch,

alternately thorny, bossy, and bristly, or writhed into every form of nervous entanglement; but, even when most graceful, never for an instant languid, always quickset; erring, if at all, ever on the side of brusquerie. . . .

LXXVIII. Last, because the least essential, of the constituent elements of this noble school, was placed that of Redundance —the uncalculating bestowal of the wealth of its labor. . . . No architecture is so haughty as that which is simple; which refuses to address the eye, except in a few clear and forceful lines; which implies, in offering so little to our regards, that all it has offered is perfect; and disdains, either by the complexity or the attractiveness of its features, to embarrass our investigation, or betray us into delight. That humility, which is the very life of the Gothic school, is shown not only in the imperfection, but in the accumulation of ornament. The inferior rank of the workman is often shown as much in the richness, as the roughness, of his work; and if the co-operation of every hand, and the sympathy of every heart, are to be received, we must be content to allow the redundance which disguises the failure of the feeble, and wins the regard of the inattentive. There are, however, far nobler interests mingling, in the Gothic heart, with the rude love of decorative accumulation: a magnificent enthusiasm, which feels as if it never could do enough to reach the fulness of its ideal; an unselfishness of sacrifice, which would rather cast fruitless labor before the altar than stand idle in the market; and, finally, a profound sympathy with the fulness and wealth of the material universe, rising out of that Naturalism whose operation we have already endeavored to define.

LXXIX. We have now, I believe, obtained a view approaching to completeness of the various moral or imaginative elements which composed the inner spirit of Gothic architecture. . . .

[PIERRE JOSEPH PROUDHON (1809–65), the self-educated philosopher and socialist, was born at Besançon, France. A contemporary of Saint-Simon and Fourier, Proudhon's lifetime aim was to transform the contemporary social and economic system in order to obtain a society based on justice,

liberty, and equality. This, Proudhon believed, could be obtained by economic rather than political means. He devised a theory of property similar to that of capital that Marx formulated later, which Proudhon published first in *Qu'est ce que la propriété?* (1840) with the answer "property is theft." Proudhon was the first to use the word "anarchy" as the goal of society in the sense that government should be unnecessary because of man's ethical progress. Anarchy in his meaning expressed the highest perfection of social organization, for "government of man by man in any form is oppression."

Proudhon's greatest work, *Système des contradictions economique ou philosophie de la misère,* was published in 1846. Active in the revolution of 1848, he was elected to the national Assembly and there proposed high taxes on interest and rents and sought to establish a credit bank with interest-free loans.

A member of the revolutionary group of artists and writers who supported Gustav Courbet's manifesto to paint "the common and the modern," Proudhon created an aesthetic system in *Of the Principles of Art and Its Social Destination* (1865). In it he affirmed that the object of art, in Courbet's words, is "to lead us to the knowledge of ourselves, by the revelation of all our thoughts, even the most secret, all our tendencies, our virtues, our vices, our absurdities, and in this way to contribute to the development of our dignity, the perfecting of our being." Proudhon's definition of art as "an idealistic representation of nature and of ourselves, with a view to the physical and moral perfecting of our species" corresponded to his political theories.]

OF THE PRINCIPLE OF ART AND ITS SOCIAL PURPOSE[1]

Whether painters represent drunken priests as Courbet does, or priests saying mass like Flandrin, or peasants, soldiers, horses, or trees, or effigies of antique personages of

[1] Quoted from P. G. Hamerton, "Proudhon as a Writer on Art," *Thoughts About Art,* Boston, 1882, pp. 272–73, with the following footnote: Proudhon says that he judges works of art "especially by what he has learned in literature." Many others do so likewise, and yet literary influences are often very misleading in regard to painting and sculpture, and they are so precisely because there is a

whom we know next to nothing, or heroes of novels, or fairies, angels, gods, products of fancy or superstition—in what can all that seriously interest us? What good does it do to our government, our manners, our comfort, our progress? Does it become serious minds to concern themselves with these costly trifles? Have we time and money to spare? Certainly, we practical and sensible people, not initiated in the mysteries of art, have a right to ask this of artists, not to contradict them, but in order to be edified about what they think of themselves, and what they expect from us. Nobody, however, seems to have given a clear answer on these points.

Every two years—formerly it was every year—the Government regales the public with a great exhibition of painting, statuary, &c. Industry never had such frequent exhibitions, and she has not had them nearly so long. In fact, it is an artist's fair—putting their products for sale, and waiting anxiously for buyers. For these exceptional solemnities the Government appoints a jury to verify the works sent, and name the best. On the recommendation of this jury the Government gives medals of gold and silver, decorations, honourable mentions, money rewards, pensions. There are, for distinguished artists, according to their recognized talents and their age, places at Rome, in the Academy, in the Senate. All these expenses are paid by us, the profane, like those of the army and the country roads. Nevertheless, it is probable that no one, either on the jury, or in the Academy, or in the Senate, or at Rome,

great gulf between literary and pictorial or plastic conception, between the literary and pictorial habits of mind. For hundreds of years the literary habit of mind has been sedulously cultivated at Oxford, with the uniform result (until combatted of late by other influences) of inducing a contempt for art and artists in combination with a sort of resolute ignorance disdainfully unteachable. The literary mind tries to extract its own sort of material from the works of painters; and when there is not much of that sort of material to be extracted, it says "there is nothing in them. . . ." p. 271. Hamerton notes: "Proudhon defines art as *an idealist representation of nature and ourselves with a view to the physical and moral advancement* (perfectionnement) *of our species.*' This is one of the best definitions hitherto constructed. It includes natural truth, idealism, landscape art, figure design, and the influence of art as drawing attention to, and leading towards, the improvement of our physical and moral life. It misses, however, the affections and sentiments which cause the production of all art that touches us closely," p. 274.

would be in a condition to justify this part of the budget by an intelligible definition of art and its function, either private or public. Why can't we leave artists to their own business, and not trouble ourselves about them more than we do about rope-dancers? Perhaps it would be the best way to find out exactly what they are worth.

The more one reflects on this question of art and artists, the more one meets matter for astonishment. M. Ingres, a master painter, like M. Courbet, has become, by the sale of his works, rich and celebrated. It is evident that he, at any rate, has not merely worked for fancy's sake. Quite lately he has been admitted to the Senate as one of the great notables of the land. His fellow-townsmen at Montauban have voted him a golden crown. Here is painting, then, put on the same level as was religion, science, and industry. But why has M. Ingres been considered the first amongst his peers? If you consult artists and writers about his value, most of them will tell you that he is the chief, much questioned, of a school fallen into discredit for the last thirty years, the classical school; that to this school has succeeded another, which in its turn became the fashion, the romantic school, headed by Delacroix, who is just dead; that this one has given way, and is now partly replaced by the realist school, of which Courbet is the principal representative. So that upon the glory of Ingres, the venerable representative of classicism, are superposed two younger schools, two new generations of artists, as two or three new strata of earth are superposed on the animals contemporary with the last deluge. Why has the Government chosen M. Ingres, an antediluvian, rather than Delacroix or Courbet? Is art an affair of archaeology, or is it like politics, which has always been horrified by new ideas and walked with its eyes turned backwards in history? If so, then the last comers in painting would be the worst. Then what is the good of encouragement and recompenses? Let things go their own way, unless we would follow the advice of Plato and Rousseau, and ostracize this "world of art," sod of parasites and corruption.

[WILLIAM MORRIS (1834–96), the son of a prosperous broker, was a precocious reader and steeped himself as a child in Sir Walter Scott's novels—novels that dramatized medieval history.

Morris entered Exeter College in 1853 to study for the Anglican priesthood. Here he met Edward Burne-Jones, who became a lifelong friend and associate. Both turned from the church to the field of art as the means to improve their age. Morris began his study of architecture with G. E. Street (1824–81), the influential Italian Gothic enthusiast, whose senior clerk was Philip Webb. At the same time, Morris published a magazine devoted to social reforms which soon brought him into association with the slightly older medieval revivalists, John Ruskin and D. G. Rossetti, who also looked to the earlier epoch for the solutions to the contemporary social problems. Morris, Burne-Jones, and four other painters assisted Rossetti with decorations of the Union Debating Hall at Oxford (1857). Due to their ignorance of the technique, the frescoes were soon ruined, but Morris here discovered his talent for decoration which he then followed as a profession.

After his marriage in 1859 Morris commissioned Philip Webb (1831–1915) to build "Red House," his home. Related in design to the Middle Ages, it was original in its details and embodies Morris' principles of decoration and craftsmanship. It marks a turning point in the conception of the English house. With the help of friends, Morris designed and fashioned its decoration, furniture, and utensils. This work, and the desire to protest the poorly designed consumer goods offered to the public at the International Exhibition of 1851, led Morris to form a company that soon prospered. Rossetti, Burne-Jones, Madox Brown, Faulkner, Marshall, and Philip Webb collaborated with Morris to produce household articles and church furnishings and decorations. The firm of Morris, Marshall, Faulkner & Co. initiated a new phase in western art in which artists turned from the *beaux arts* to the design and actual production of useful articles.

With his activity as a master craftsman, Morris wrote numerous poetic romances. He found in the Icelandic Sagas material for a social utopia that he described in his epic poem

"Sigurd the Volsung." The Middle Ages were used by him as an indictment of the nineteenth century.

Morris maintained an active interest in socialism and joined the Social Democratic Federation. When faced with the actual consequences of his insistence on change in social institutions, he shrank from the political reality. "News from Nowhere" (1891) describes an England in which the principles of communism have been realized. The Peasants' Revolt of 1381 provided the subject matter for "A Dream of John Ball." His literal descriptions equal the paintings of the Pre-Raphaelites in their detailed re-creation of the simple beauty of all the furnishings of everyday life. He devoted his last years to printing, and with the close collaboration of Burne-Jones, he established the Kelmscott Press.

Morris was a follower of A. Welby Pugin (1812–52) and John Ruskin, but had more practical influence than either of them. In 1877 he formed the Society for the Protection of Ancient Buildings which still performs a valuable service. He created a group to protest the commercialism and ugliness of his epoch and insist on beauty in design and color independent of cost. He recognized "the unity of the art of an age and its social system." Unfortunately, the Arts and Crafts Movement and the Arts and Crafts Exhibition Society founded in 1888, that owed so much to Morris, carried out their activities divorced from industry, thereby depriving the artist of the opportunity of integration into the economic life of the industrial world. In Germany and Belgium Morris' conception was comprehended and translated into educational programs related to industrial design by Henry van de Velde (1863–1957), the first director of the *Bauhaus* at Weimar, and his successor, Gropius. Morris' practical revival of the craft processes, his re-establishment of the art of fine printing, and his demand that towns and country be developed for the welfare of the people, gave him wide and lasting influence.

SEE: P. Ferriday, *Lord Grimthorpe* (1957), for the Society for the Protection of Ancient Buildings.
N. Pevsner, *High Victorian Design,* London, 1951.]

THE LESSER ARTS[1]

Hereafter I hope in another lecture to have the pleasure of laying before you an historical survey of the lesser, or, as they are called, the Decorative Arts, and I must confess it would have been pleasanter to me to have begun my talk with you by entering at once upon the subject of the history of this great industry; but, as I have something to say in a third lecture about various matters connected with the practice of Decoration among ourselves in these days, I feel that I should be in a false position before you, and one that might lead to confusion, or overmuch explanation, if I did not let you know what I think on the nature and scope of these arts, on their condition at the present time, and their outlook in times to come. . . .

Now as to the scope and nature of these Arts I have to say, that though when I come more into the details of my subject I shall not meddle much with the great art of Architecture, and less still with the great arts commonly called Sculpture and Painting, yet I cannot in my own mind quite sever them from those lesser so-called Decorative Arts, which I have to speak about: it is only in latter times, and under the most intricate conditions of life, that they have fallen apart from one another; and I hold that, when they are so parted, it is ill for the Arts altogether: the lesser ones become trivial, mechanical, unintelligent, incapable of resisting the changes pressed upon them by fashion or dishonesty; while the greater, however they may be practised for a while by men of great minds and wonder-working hands, unhelped by the lesser, unhelped by each other, are sure to lose their dignity of popular arts, and become nothing but dull adjuncts to unmeaning pomp, or ingenious toys for a few rich and idle men.

However, I have not undertaken to talk to you of Architecture, Sculpture, and Painting, in the narrower sense of those words, since, most unhappily as I think, these master arts, these arts more specially of the intellect, are at the present day divorced from decoration in its narrower sense. Our subject

[1] Quoted from *The Collected Works of William Morris, Hopes and Fears for Art; Lectures on Art and Industry,* Longmans, Green and Company, 1914; Delivered before the Trades' Guild of Learning, December 4, 1877.

is that great body of art, by means of which men have at all times more or less striven to beautify the familiar matters of everyday life: a wide subject, a great industry; both a great part of the history of the world, and a most helpful instrument to the study of that history.

A very great industry indeed, comprising the crafts of house-building, painting, joinery and carpentry, smiths' work, pottery and glass-making, weaving, and many others: a body of art most important to the public in general, but still more so to us handicraftsmen; since there is scarce anything that they use, and that we fashion, but it has always been thought to be un-finished till it has had some touch or other of decoration about it. True it is that in many or most cases we have got so used to this ornament, that we look upon it as if it had grown of itself, and note it no more than the mosses on the dry sticks with which we light our fires. So much the worse! for there *is* the decoration, or some pretence of it, and it has, or ought to have, a use and a meaning. For, and this is at the root of the whole matter, everything made by man's hands has a form, which must be either beautiful or ugly; beautiful if it is in ac-cord with Nature, and helps her; ugly if it is discordant with Nature, and thwarts her; it cannot be indifferent: we, for our parts, are busy or sluggish, eager or unhappy, and our eyes are apt to get dulled to this eventfulness of form in those things which we are always looking at. Now it is one of the chief uses of decoration, the chief part of its alliance with nature, that it has to sharpen our dulled senses in this matter: for this end are those wonders of intricate patterns interwoven, those strange forms invented, which men have so long delighted in: forms and intricacies that do not necessarily imitate nature, but in which the hand of the craftsman is guided to work in the way that she does, till the web, the cup, or the knife, look as natural, nay as lovely, as the green field, the river bank, or the mountain flint.

To give people pleasure in the things they must perforce *use,* that is one great office of decoration; to give people plea-sure in the things they must perforce *make,* that is the other use of it.

Does not our subject look important enough now? I say that without these arts, our rest would be vacant and uninter-esting, our labour mere endurance, mere wearing away of body and mind.

As for that last use of these arts, the giving us pleasure in

our work, I scarcely know how to speak strongly enough of it; and yet if I did not know the value of repeating a truth again and again, I should have to excuse myself to you for saying any more about this, when I remember how a great man now living has spoken of it: I mean my friend Professor John Ruskin: if you read the chapter in the 2nd vol. of his *Stones of Venice* entitled, "On the Nature of Gothic, and the Office of the Workman therein," you will read at once the truest and the most eloquent words that can possibly be said on the subject. What I have to say upon it can scarcely be more than an echo of his words, yet I repeat there is some use in reiterating a truth, lest it be forgotten; so I will say this much further: we all know what people have said about the curse of labour, and what heavy and grievous nonsense are the more part of their words thereupon; whereas indeed the real curses of craftsmen have been the curse of stupidity, and the curse of injustice from within and from without: no, I cannot suppose there is anybody here who would think it either a good life, or an amusing one, to sit with one's hands before one doing nothing—to live like a gentleman, as fools call it.

Nevertheless there *is* dull work to be done, and a weary business it is setting men about such work, and seeing them through it, and I would rather do the work twice over with my own hands than have such a job: but now only let the arts which we are talking of beautify our labour, and be widely spread, intelligent, well understood both by the maker and the user, let them grow in one word *popular,* and there will be pretty much an end of dull work and its wearing slavery; and no man will any longer have an excuse for talking about the curse of labour, no man will any longer have an excuse for evading the blessing of labour. I believe there is nothing that will aid the world's progress so much as the attainment of this; I protest there is nothing in the world that I desire so much as this, wrapped up, as I am sure it is, with changes political and social, that in one way or another we all desire.

Now if the objection be made, that these arts have been the handmaids of luxury, of tyranny, and of superstition, I must needs say that it is true in a sense; they have been so used, as many other excellent things have been. But it is also true that, among some nations, their most vigorous and freest times have been the very blossoming-times of art: while at the same time, I must allow that these decorative arts have flourished among oppressed peoples, who have seemed to have no hope of free-

dom: yet I do not think that we shall be wrong in thinking that at such times, among such peoples, art, at least, was free; when it has not been, when it has really been gripped by superstition, or by luxury, it has straightway begun to sicken under that grip. Nor must you forget that when men say popes, kings, and emperors built such and such buildings, it is a mere way of speaking. You look in your history-books to see who built Westminster Abbey, who built St. Sophia at Constantinople, and they tell you Henry III, Justinian the Emperor. Did they? or, rather, men like you and me, handicraftsmen, who have left no names behind them, nothing but their work?

Now as these arts call people's attention and interest to the matters of every-day life in the present, so also, and that I think is no little matter, they call our attention at every step to that history, of which, I said before, they are so great a part; for no nation, no state of society, however rude, has been wholly without them: nay, there are peoples not a few, of whom we know scarce anything, save that they thought such and such forms beautiful. So strong is the bond between history and decoration, that in the practice of the latter we cannot, if we would, wholly shake off the influence of past times over what we do at present. I do not think it is too much to say that no man, however original he may be, can sit down to-day and draw the ornament of a cloth, or the form of an ordinary vessel or piece of furniture, that will be other than a development or a degradation of forms used hundreds of years ago; and these, too, very often, forms that once had a serious meaning, though they are now become little more than a habit of the hand; forms that were once perhaps the mysterious symbols of worships and beliefs now little remembered or wholly forgotten. Those who have diligently followed the delightful study of these arts are able as if through windows to look upon the life of the past—the very first beginnings of thought among nations whom we cannot even name; the terrible empires of the ancient East; the free vigour and glory of Greece; the heavyweight, the firm grasp of Rome; the fall of her temporal Empire which spread so wide about the world all that good and evil which men can never forget, and never cease to feel; the clashing of East and West, South and North, about her rich and fruitful daughter Byzantium; the rise, the dissensions, and the waning of Islam; the wanderings of Scandinavia; the Crusades; the foundation of the States of modern Europe; the struggles of free thought with ancient dying sys-

tem—with all these events and their meaning is the history of popular art interwoven; with all this, I say, the careful student of decoration as an historical industry must be familiar. When I think of this, and the usefulness of all this knowledge, at a time when history has become so earnest a study amongst us as to have given us, as it were, a new sense; at a time when we so long to know the reality of all that has happened, and are to be put off no longer with the dull records of the battles and intrigues of kings and scoundrels—I say when I think of all this, I hardly know how to say that this interweaving of the Decorative Arts with the history of the past is of less importance than their dealings with the life of the present: for should not these memories also be a part of our daily life? . . .

In explanation, I must somewhat repeat what I have already said. Time was when the mystery and wonder of handicrafts were well acknowledged by the world, when imagination and fancy mingled with all things made by man; and in these days all handicraftsmen were *artists,* as we should now call them. But the thought of man became more intricate, more difficult to express; art grew a heavier thing to deal with, and its labour was more divided among great men, lesser men, and little men; till that art, which was once scarce more than a rest of body and soul, as the hand cast the shuttle or swung the hammer, became to some men so serious a labour, that their working lives have been one long tragedy of hope and fear, joy and trouble. This was the growth of art: like all growth, it was good and fruitful for a while; like all fruitful growth, it grew into decay; like all decay of what was once fruitful, it will grow into something new.

Into decay; for as the arts sundered into the greater and the lesser, contempt on one side, carelessness on the other arose, both begotten of ignorance of that *philosophy* of the Decorative Arts, a hint of which I have tried just now to put before you. The artist came out from the handicraftsmen, and left them without hope of elevation, while he himself was left without the help of intelligent, industrious sympathy. Both have suffered; the artist no less than the workman. It is with art as it fares with a company of soldiers before a redoubt, when the captain runs forward full of hope and energy, but looks not behind him to see if his men are following, and they hang back, not knowing why they are brought there to die.

The captain's life is spent for nothing, and his men are sullen prisoners in the redoubt of Unhappiness and Brutality.

I must in plain words say of the Decorative Arts, of all the arts, that it is not so much that we are inferior in them to all who have gone before us, but rather that they are in a state of anarchy and disorganisation, which makes a sweeping change necessary and certain. . . .

You whose hands make those things that should be works of art, you must be all artists, and good artists too, before the public at large can take real interest in such things; and when you have become so, I promise you that you shall lead the fashion; fashion shall follow your hands obediently enough.

That is the only way in which we can get a supply of intelligent popular art: a few artists of the kind so-called now, what can they do working in the teeth of difficulties thrown in their way by what is called Commerce, but which should be called greed of money? working helplessly among the crowd of those who are ridiculously called manufacturers, i.e., handicraftsmen, though the more part of them never did a stroke of hand-work in their lives, and are nothing better than capitalists and salesmen. What can these grains of sand do, I say, amidst the enormous mass of work turned out every year which professes in some way to be decorative art, but the decoration of which no one heeds except the salesmen who have to do with it, and are hard put to it to supply the cravings of the public for something new, not for something pretty?

The remedy, I repeat, is plain if it can be applied; the handicraftsman, left behind by the artist when the arts sundered, must come up with him, must work side by side with him: apart from the difference between a great master and a scholar, apart from the difference of the natural bent of men's minds, which would make one man an imitative, and another an architectural or decorative artist, there should be no difference between those employed on strictly ornamental work: and the body of artists dealing with this should quicken with their art all makers of things into artists also, in proportion to the necessities and uses of the things they would make. . . .

For your teachers, they must be Nature and History: as for the first, that you must learn of it is so obvious that I need not dwell upon that now: hereafter, when I have to speak more of matters of detail, I may have to speak of the manner in which you must learn of Nature. As to the second, I do not think that any man but one of the highest genius, could do

anything in these days without much study of ancient art, and even he would be much hindered if he lacked it. If you think that this contradicts what I said about the death of that ancient art, and the necessity I implied for an art that should be characteristic of the present day, I can only say that, in these times of plenteous knowledge and meagre performance, if we do not study the ancient work directly and learn to understand it, we shall find ourselves influenced by the feeble work all round us, and shall be copying the better work through the copyists and *without* understanding it, which will by no means bring about intelligent art. Let us therefore study it wisely, be taught by it, kindled by it; all the while determining not to imitate or repeat it; to have either no art at all, or an art which we have made our own.

Yet I am almost brought to a stand-still when bidding you to study nature and the history of art, by remembering that this is London, and what it is like: how can I ask working-men passing up and down these hideous streets day by day to care about beauty? If it were politics, we must care about that; or science, you could wrap yourselves up in the study of facts, no doubt, without much caring what goes on about you—but beauty! do you not see what terrible difficulties beset art, owing to a long neglect of art—and neglect of reason, too, in this matter? It is such a heavy question by what effort, by what dead-lift, you can thrust this difficulty from you, that I must perforce set it aside for the present, and must at least hope that the study of history and its monuments will help you somewhat herein. If you can really fill your minds with memories of great works of art, and great times of art, you will, I think, be able to a certain extent to look through the aforesaid ugly surroundings, and will be moved to discontent of what is careless and brutal now, and will, I hope, at last be so much discontented with what is bad, that you will determine to bear no longer that short-sighted, reckless brutality of squalor that so disgraces our intricate civilization.

Well, at any rate, London is good for this, that it is well off for museums—which I heartily wish were to be got at seven days in the week instead of six, or at least on the only day on which an ordinarily busy man, one of the taxpayers who support them, can as a rule see them quietly—and certainly any of us who may have any natural turn for art must get more help from frequenting them than one can well say. It is true, however, that people need some preliminary instruction before

they can get all the good possible to be got from the prodigious treasures of art possessed by the country in that form: there also one sees things in a piecemeal way: nor can I deny that there is something melancholy about a museum, such a tale of violence, destruction, and carelessness, as its treasured scraps tell us.

But moreover you may sometimes have an opportunity of studying ancient art in a narrower but a more intimate, a more kindly form, the monuments of our own land. Sometimes only, since we live in the middle of this world of brick and mortar, and there is little else left us amidst it, except the ghost of the great church at Westminster, ruined as its exterior is by the stupidity of the restoring architect, and insulted as its glorious interior is by the pompous undertakers' lies, by the vainglory and ignorance of the last two centuries and a half —little besides that and the matchless Hall near it: but when we can get beyond that smoky world, there, out in the country, we may still see the works of our fathers yet alive amidst the very nature they were wrought into, and of which they are so completely a part. For there indeed if anywhere, in the English country, in the days when people cared about such things, was there a full sympathy between the works of man, and the land they were made for. . . .

Unless something or other is done to give all men some pleasure for the eyes and rest for the mind in the aspect of their own and their neighbours' houses, until the contrast is less disgraceful between the fields where beasts live and the streets where men live, I suppose that the practice of the arts must be mainly kept in the hands of a few highly cultivated men, who can go often to beautiful places, whose education enables them, in the contemplation of the past glories of the world, to shut out from their view the everyday squalors that the most of men move in. Sirs, I believe that art has such sympathy with cheerful freedom, openheartedness and reality, so much she sickens under selfishness and luxury, that she will not live thus isolated and exclusive. I will go further than this and say that on such terms I do not wish her to live. I protest that it would be a shame to an honest artist to enjoy what he had huddled up to himself of such art, as it would be for a rich man to sit and eat dainty food amongst starving soldiers in a beleaguered fort.

I do not want art for a few, any more than education for a few, or freedom for a few.

No, rather than art should live this poor thin life among a few exceptional men, despising those beneath them for an ignorance for which they themselves are responsible, for a brutality that they will not struggle with—rather than this, I would that the world should indeed sweep away all art for a while, as I said before I thought it possible she might do; rather than the wheat should not in the miser's granary, I would that the earth had it, that it might yet have a chance to quicken in the dark.

I have a sort of faith, though, that this clearing away of all art will not happen, that men will get wiser, as well as more learned; that many of the intricacies of life, on which we now pride ourselves more than enough, partly because they are new, partly because they have come with the gain of better things, will be cast aside as having played their part, and being useful no longer. I hope that we shall have leisure from war —war commercial, as well as war of the bullet and the bayonet; leisure from the knowledge that darkens counsel; leisure above all from the greed of money, and the craving for that overwhelming distinction that money now brings: I believe that as we have even now partly achieved LIBERTY, so we shall one day achieve EQUALITY, which, and which only, means FRATERNITY, and so have leisure from poverty and all its griping, sordid cares.

Then having leisure from all these things, amidst renewed simplicity of life we shall have leisure to think about our work, that faithful daily companion, which no man any longer will venture to call the Curse of labour: for surely then we shall be happy in it, each in his place, no man grudging at another; no one bidden to be any man's *servant,* every one scorning to be any man's *master:* men will then assuredly be happy in their work, and that happiness will assuredly bring forth decorative, noble, *popular* art.

That art will make our streets as beautiful as the woods, as elevating as the mountain-sides: it will be a pleasure and a rest, and not a weight upon the spirits to come from the open country into a town; every man's house will be fair and decent, soothing to his mind and helpful to his work: all the works of man that we live amongst and handle will be in harmony with nature, will be reasonable and beautiful: yet all will be simple and inspiriting, not childish nor enervating; for as nothing of beauty and splendour that man's mind and hand may compass shall be wanting from our public buildings, so

in no private dwelling will there be any signs of waste, pomp, or insolence, and every man will have his share of the *best*.

It is a dream, you may say, of what has never been and never will be; true, it has never been, and therefore, since the world is alive and moving yet, my hope is the greater that it one day will be: true, it is a dream; but dreams have before now come about of things so good and necessary to us, that we scarcely think of them more than of the daylight, though once people had to live without them, without even the hope of them.

Anyhow, dream as it is, I pray you to pardon my setting it before you, for it lies at the bottom of all my work in the Decorative Arts, nor will it ever be out of my thoughts: and I am here with you to-night to ask you to help me in realizing this dream, this *hope*.

VI. SEARCH FOR FORM
AND SYMBOLS

[CONRAD FIEDLER (1841–95), the son of well-to-do parents, studied law at the Universities of Berlin, Heidelberg, and Leipzig. After receiving his doctor's degree, Fiedler visited the Mediterranean countries and, while in Rome, met the German painter Hans von Marées. This meeting led Fiedler to devote the rest of his life to a study of the creative process. In 1874 the Bavarian sculptor Adolf Hildebrand joined von Marées and Fiedler in Florence, where von Marées had established a studio in a former cloister.

In observing the two artists and in discussions with them, Fiedler developed an original theory of the visual arts based on the actual facts in the creative process. He sought the origin of the creative impulse in painting, sculpture, and architecture and found that "perceptual experiences alone can lead the artist to artistic configurations." His "discovery" had no connection with the then current conceptions based on abstract categories such as "beauty" and "imagination" in the Kantian definition. Nor did Fiedler accept Hegel's theory of art of an idealistic type. Fiedler defined art as a separate method equal to philosophy for the acquisition of knowledge and truth. He held that the practise of art strengthens and furthers the moral values of the artist, values required for the production of art.

To Fiedler art had its own independence within a civilization, since it conforms in every epoch to laws of visibility, rather than those of nature. The painter's domain is light, shadow, form, and color from which he creates his work with the vision of his genius, unconcerned with logic or rational knowledge.

Fiedler published the results of his studies, *On Judging Works of Visual Art,* in 1876. This book was followed by *On*

Interest in Art and Their Promotion (1879), *Modern Natural-
ism and Artistic Truth* (1881), *On the Origin of Artistic Ac-
tivity* (1887), and *Hans von Marées, a Tribute to His Memory*
(1889).

Fiedler died suddenly, leaving three fragments of a treatise
on reality concerned with "the relationship of the artistic pro-
cess of work and the vision on which it rests." Here he ob-
served that an individual has access to the reality of truth only
by means of mental activity and, in the case of the artist, his
physical activity of painting or sculpture is an accompaniment
to this.

The sculptor Adolf Hildebrand spread the knowledge of
Fiedler's theory by applying it to sculpture in his book *The
Problem of Form* (1893). Heinrich Wolfflin, the Swiss art
historian, was assisted by Fiedler's theory in the establishment
of his five "forms of vision."

Fiedler's work, even though tinged with romanticism, is a
valuable contribution to the theory of visual art. It is of funda-
mental significance for an understanding of the mental pro-
cesses that underlay the creation of works of visual art.

SEE: C. Fiedler, *On Judging Works of Visual Art,* translated
 by H. Schaefer-Summer and F. Mood, University of
 California Press, 1949.

 C. Fiedler, *Essay on Architecture,* translated by Sinclair
 and Hammer, Lexington, Kentucky, 1954.

 H. Read, *Icon and Idea,* and *The Function of Art in the
 Development of Human Consciousness,* Harvard Uni-
 versity Press, 1955.]

THREE FRAGMENTS[1]

Reality and Art

INTRODUCTION

. . . Principle of artistic activity is production of reality in the
sense that in artistic activity reality attains existence, i.e., form,
in a definite direction.

[1] These are excerpts from *Three Fragments* from the posthumous
papers of Conrad Fiedler, translated by Thornton Sinclair and Vic-
tor Hammer, Lexington, Kentucky, 1951.

The arts observed generally from this point of departure.

Limitation of the task to plastic art, especially to sculpture and to painting.

More exact definition of the activity of the plastic artist. Emphasis—that the plastic artist also begins with the general human viewpoint, that he participates with the entirety of his nature in the total assets, the total pursuit of the human mind. His special gift separates itself from the totality of his nature, yet grows naturally from it and only in development gains predominance and self-determination. In no sense is it something added to the human nature of the artist, an enigmatic power, but rather something entirely natural, which only becomes wonderful and superhuman when raised to a very high degree. Every human capacity, if it rises very significantly above the average, is somehow incomprehensible.

Discussion of the fact that what the artist actually has in common with other men is often mistaken for artistic ability. Very natural error, sustained by the fact that the man not artistically gifted customarily follows the artist only so far as his own abilities permit. The manner and mode in which he assimilates artistic performance seem to him to correspond to the manner and form in which it originated. As a rule he remains emotionally tied to works of art, and what seems rational to him in the work of art serves only for the clarification and intensification of this emotional attitude.

Thus the real world of the artist remains closed.

When, among general human faculties certain ones prevail, artistic propensities may appear and in turn may develop into special artistic talent.

What then is this special artistic talent which would provide us with a clue to the understanding of artistic activity?

Where this talent exists it rests upon the ability to use, among other organs, the eye preponderantly and independently in developing sensory material into reality. Clearly, artistic talent rests upon a physiological foundation: it is a unilateral deviation from the normal human constitution, a kind of abnormality, but that is immaterial here. Here the explanation should not rest upon physical data; it deals only with the psychical aspect of the process, even though it presupposes that the psychical process depends on physical prerequisites. Assuming that reality is a product of the sentient-intellectual nature of man, this process is conditioned by the fact that in

this special case the eye plays the essential part in producing reality.

It seems strange at first that an organ, common to all men and extensively used by all, should be the active center of a performance limited to a few. Men readily admit that the activity of the artist is not only based on the use of the eye, but is unthinkable without it. Nevertheless, they assume a special artistic power apart from the eye and served by it only in an auxiliary capacity. And yet we may peer within the workshop of artistic activity only when we realize that in essence this activity depends entirely upon the eye. Only such realization can strip the artistic process both of the semi-mystical character which it possesses for some and of the trivial meaning attributed to it by others. Only such realization reveals it as a natural process which unfolds from the simplest beginnings to endless breadth and height.

If we are to understand that artistic activity depends in essence upon the eye and originates in the eye, we must first realize that the eye helps produce ordinary awareness of reality, but it helps only in an auxiliary capacity.

In visual activity artists do not differ from other persons, and this may be the very reason why no further advance has been made toward understanding artistic activity. We have just arrived at the threshold and have not yet glimpsed what lies beyond.

Artistically gifted people differ from others only in the way their eyes function; in every other respect they are equal. Unfolding and developing awareness of reality specializes in a particular manner in the artistically gifted, solely by virtue of the visual faculty.

In the artist, seeing develops in a way peculiar to him; it exhausts itself neither by aiding in the formation of images and concepts nor by the partially passive function of receiving impressions. Rather, it attaches to this passive function and advancing activity, for basically the behavior of the visual organ cannot be termed passive and simply receptive. Ordinarily visual activity does not continue beyond the point where it can halt in order to help form what are called ideas in the usual sense, which are the result of concerted action by different sensory organs. In the artist, instead of halting at this point and using what has been gained for other purposes, the visual activity isolates itself. Then, while developments based on other sensory activities are interrupted and halted, a de-

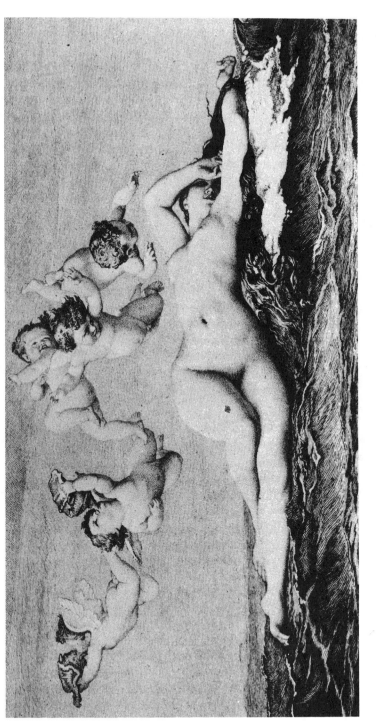

49. **Cabanel**, Birth of Venus. Engraving after the Painting. (photo: METROPOLITAN MUSEUM)

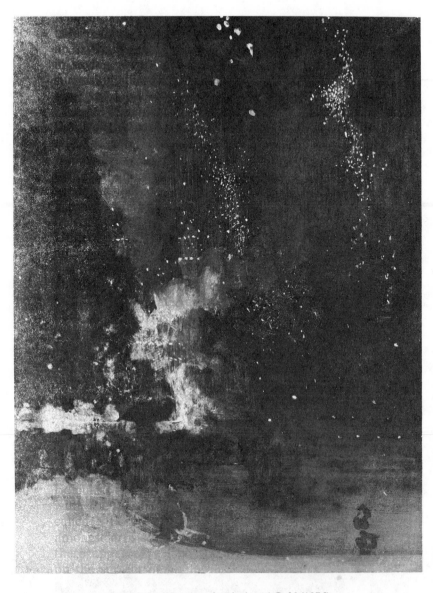

50. **Whistler,** Nocturne in Black and Gold (1876).
Courtesy Detroit Institute of Fine Arts

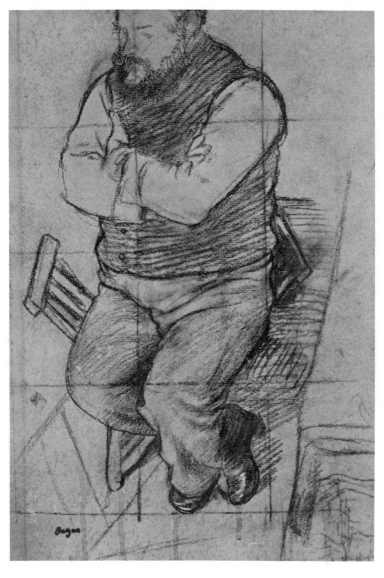

51. **Degas,** Study for the Portrait of Diego Martelli (1879).
Meta and Paul J. Sachs Collection
Courtesy of Fogg Art Museum, Cambridge, Mass.

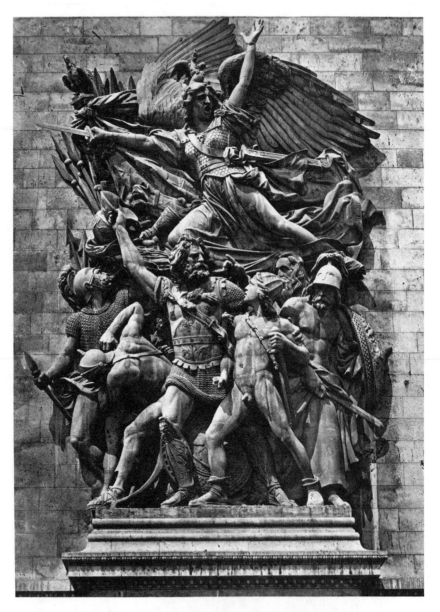

52. **Rude,** La Marseillaise, Arc de Triomphe, Paris (1833).
(photo: ARCHIVES PHOTOGRAPHIQUES)

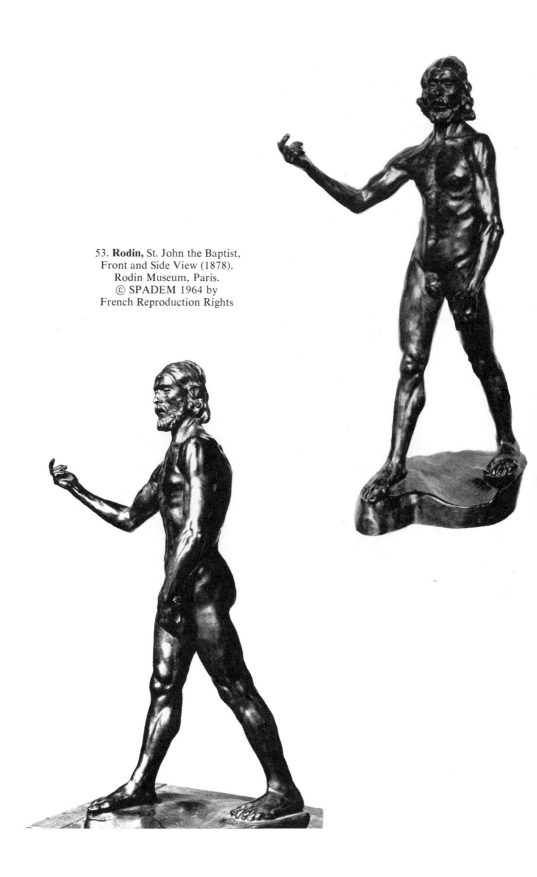

53. **Rodin,** St. John the Baptist,
Front and Side View (1878).
Rodin Museum, Paris.
© SPADEM 1964 by
French Reproduction Rights

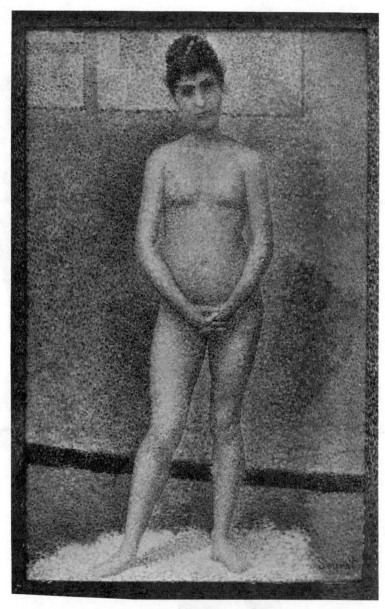

54. **Seurat,** Poseuse de Face (1888).
Louvre (photo: ARCHIVES PHOTOGRAPHIQUES)

55. **Van Gogh,** Sketch from Letter to Brother, Théo, Drenthe, September-November 1883. From *The Complete Letters of Vincent van Gogh,* New York Graphic Society, Greenwich, Conn.

56. **Van Gogh,** Sketch from Letter VI to Emile Bernard, Arles, June 1888. From *The Complete Letters of Vincent van Gogh,* New York Graphic Society, Greenwich, Conn.

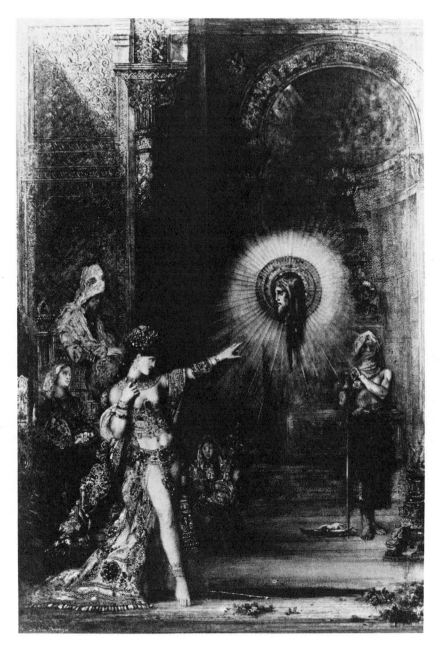

57. **Moreau,** L'Apparition (1876).
Musée de Luxembourg, Paris (photo: ALINARI)

58. **Redon**, The Raising of Lazarus, Meta and Paul J. Sachs Collection. Courtesy of Fogg Art Museum, Cambridge, Mass.

59. **Munch**, Dansemorro (1885). Oslo, Norway (photo: O. VAERING)

60. **Gauguin,** Old Women of Arles (1888). Gift of Annie Swan Coburn to the Mr. and Mrs. Lewis L. Coburn Memorial Collection. Courtesy of Chicago Art Institute

61. **Denis**, Hommage à Cézanne (1900). Musée d'Art Moderne, Paris
(photo: ARCHIVES PHOTOGRAPHIQUES)

62. **Vuillard,** Public Gardens (1894), Three Panels.
Musée d'Art Moderne (photo: ARCHIVES PHOTOGRAPHIQUES)

63. **Cézanne,** Apples and Oranges (1895-1900). Louvre
(photo: ARCHIVES PHOTOGRAPHIQUES)

64. **Cézanne**, The Bathers (1904). (photo: REUNION MUSEES NATIONAUX)

velopment gradually takes place within the artist in an entirely separate and completely independent world of forms.

. . . In and through artistic activity an intellectual process reaches the climax of its development and becomes something which before and outside it, did not exist intellectually or otherwise. Yet we cannot, for this reason, assert that the human intellect is incapable of developing, even without manipulation by the hand of the sculptor or that of the painter, images which are the mental models of the works later produced by the hand.

Here, though, we must make a distinction. Only too easily do we associate the ideas and the fanciful images which dwell in the human mind with the activity of the artist. When a man possesses a very lively imagination, has a warm receptive feeling for nature, and finds joy in existing works of art and remembers them, then we are accustomed to assume that he has artistic aptitude. Actually the mental state described has no connection with that state which distinguishes the truly artistic man. The world of imagination described above, livelier or weaker, richer or poorer, is part of the intellectual make-up of every man and is one of the elements which determines the direction and expression of intellectual life; it remains on the threshold of, but is not within, the artistic world of imagination. This world of imagination, even when it, in addition to what might be called its natural elements, is interspersed with reminiscences of the world of art (which have no other value or character than have the natural elements themselves), in no way conditions further development in a definite direction or expression in a definite form. Transitory and undeveloped, this world, which is in constant flux, may sink back into the darkness from which it rose. It can— and this usually happens—attain a fleeting existence in word or even in picture. Nevertheless this world of imagination does not rise into the realm of genuine creation, because mere illustrative expression is just as far from the true beginning of the infinite artistic processes as mere linguistic expression is from poetic or scientific language.

He who flatters himself with the illusion that a store of ideas and mental images will make it possible for him even to understand creative artistry is certainly in error. It is a widespread misconception that ordinary images can produce intellectual prototypes which need merely be executed in material in order to become works of art. In fact, whatever

deserves the name of artistic imagination can rise only from a creative process. The hand does not execute something which the mind could have formed previously, but rather the process in which the hand engages is a further stage of a single indivisible process. Although invisibly prepared in the mind, the process can reach this higher stage of development only by means of artistic manipulation. Supposing that men were born with all their mental faculties but without hands, their world of imagination, as described above, would not wither away. The rise of artistic imagination, however, would be just as impossible as would the rise of concepts and of ideas related to words if, for want of vocal organs, language could not come into being. Just as man without vocal organs could never have come upon the idea of language and thus of discursive thinking, so also, without the mechanical ability of the creative artist, man could never have succeeded in developing the images conveyed to him by the eye into those images which constitute the realm of art. . . .

In the artistic process not every work of art arises from the depths of the inchoate world of feeling and imagination. Rather, still on the way which is to lead him to new objectives, the artist, i.e., the person in whom this primordial process attains new individual life, suddenly finds himself in a world he recognizes as his own. In this world he first finds the foundation upon which he can build and the element in which he can progress. Within him stirs an impulse to develop what he perceives directly into something still unknown to him; and when he does so, even before he achieves physical results, he gains access to a world previously closed to him. . . .

What is this world the artist creates, but which must already exist that he may arrive at goals yet unattained, instead of tripping at his first step? It is the world of artistic imagination. To characterize this world is to explain art itself. The world of art is no world of beauty, but rather a world where imagination operates in a special manner and finds expression in works of art.

Although everyone is acquainted with mental images in the usual sense, not everyone realizes that there is also something which more properly deserves the name of image, something quite different from what men generally think of as a mental image and which often has been made the subject of scientific research, explanation and definition. By its very nature the ordinary world of images is common property in which there

is endless specialization. It manifests itself not only in man but also in much lower categories of organic life. We must assume indeed that it begins where we cannot even detect it. This world of mental images represents a kind of intermediate intellectual region, because the infinite stimuli which govern man through his sensory system, have already assumed mental form, but have not moved toward a higher stage of development.

This intermediate realm of mental images is characterized by confusion and by unremitting change. Here immediate impressions of the outer world mix in the brain with reproductive and associative processes to make a stream of images, a crisscross, appearance and disappearance, strengthening and weakening, a concentration and dispersion of images without pause. The lower categories of organic beings seem given to this endless flow of images. Occasionally an idea takes form and becomes an act or an expression; then the creature sinks back again, abandoning itself aimlessly to the stream of images.

Man too raises himself only gradually from this condition. Because for him this world of images becomes richer, the occasions multiply when he transitorily concentrates in form of an act or expression, but whatever lies beyond the sphere of his needs remains in the stage of irregular undeveloped imagination. Even the energy expended by the most active man upon the problems of life does not extend to this part of his inner being. Once he has accepted things as they are, man is content to remain passive. Man's custom of submitting to the world in this sense, without being compelled to grasp its significance, suppresses any consciousness of imperfection and arrested development within him. All sorts of things contribute to this feeling. In addition to language man inherits a whole series of visual formulas. Words, as well as these conventional pictures, are always ready to satisfy the urge to perform and to give the ideas back of them the illusion of permanence and certainty, although this is in fact only an illusion.

Generally men do not realize that, when they rescue themselves from the confusion and change of imagination, they become captives of a traditional system of forms. They misunderstand language because they believe that in language they possess a malleable expression of what really exists—a supple expression, following all the intricacies of truth and penetrating all its secret places. They feel sure of existence,

even without language, and look upon language as the ever ready and obvious means of expressing whatever is present. If they have any sense of deficiency, it is either the lesser feeling of inability to use language as a tool, or the greater feeling of the insufficiency of the world. They are not even conscious of the true deficiency. . . .

Even though the great majority of men, in using language, remain unaware of its restrictive character, its restrictive character was recognized long ago. This is not true of the visual forms by which men become conscious of the world. Here a much thicker veil of illusion hangs before their eyes. Even one who realizes that his conception of the world does not unfold and develop to perfection in language but rather succumbs to more or less conventional formulation, comforts himself by believing that behind, beside, and above the word stands reality in its entire richness and abundance. . . .

It may seem strange that, in regard to his visual images which seem so extraordinarily manifold, variable, and shaded, man should be subject to a formalism similar to that which we found in language. Yet this fact suffices to explain why man, exposed at every step to an unusual number and complexity of impressions, uses imaginative images with the same skill and ease as words. Here too man does not create the world but learns about it. Undoubtedly a productive process creates visual images when, upon reaching the mind, sensory stimuli are gradually built up into forms. Undoubtedly, however, man also may draw upon a capital of ready-made images and by using them dispense with all creative activity. He acquires this capital much less by his own efforts than by inheritance.

The actual situation resembles that in language. From impressions as well as from memories and from reminiscences, an inner world of unbroken ebb and flow develops. Like a shadow this world passes man's inner eye and makes him conscious that he lives in a colorful, wonderful world of forms. It also makes him conscious of inner abundance and inexhaustible wealth. From this world springs the urge to capture such intangible unceasing plenty, to develop and separate it into clear, tangible forms. Dissatisfied, man drifts about as upon the rolling waves of rising and sinking forms. Dissatisfaction must seize him again when, as he believes he faces a new task, he finds the work long since done. Instead of developing independent ideas independently, he finds himself

reduced to a set of formulas which convert this lofty inner world into the world of all men. Still he can do nothing about it.

Doubtless, the dark stream in which the beginnings of developing ideas and the fragments of past images float, does not pour through the minds of different men in the same manner. All men partake of this stream differently. Each man has his individual life. This life seems immeasurable to him, and it is so much his own that he believes it cannot be compared with any other. Whoever looks within himself, whoever is conscious of this uncontrollable stream which continuously fills his being, knows with certainty that this is his own intimate world and that no one else has access to it. He knows at the same time, however, that it resists his every effort to make it the subject of expression or communication. Indeed even an attempt to be more than generally conscious of it, or to consolidate this world, destroys it. In the instant of such an attempt, this general, yet highly individual, consciousness of reality fades away. In its place appears a single image which is no longer the exclusive property of the individual, but rather the common property of all men. This image can be expressed and compared; it is known and recognized everywhere. . . .

How does this generally valid aspect of the world come into being? Has man really come to the end when he attains this clarity and certainty regarding form, which is the clarity and certainty of all men? Does no escape remain other than into this fantastic, arbitrary, invented world?

By a natural process our visual images become distinct and clear. The quality of objects does not make us see them as we do; rather the character of our visual organs determines the color and forms of things. The assumption that the visual organs of normal men are the same leads to the further assumption that their visual images correspond. Demonstrated deviation in the visual perception of some individuals is explained by deviation in the character of their eyes. Only gradually does the child develop a clear picture of the objects which surround him. Only gradually in the process of development, which we must assume without ever being able to obtain knowledge of it, did the human race arrive at firmly set agreement regarding the appearance of things, and the reason for this agreement is assumed to lie in the character of things themselves. Seeing must be learned. Only by assuming complicated processes can we explain why the eye creates images

of color and form, but we cannot explore further this subject, on which there has been penetrating research. Yet we must remember that the eye alone does not produce visual images. The sensory organs help each other, and the sense of touch seems indispensable for the creation of what we call a true visual image.

The original creation of visual images can no more be observed than the first appearance of speech. In this process no one depends upon himself; no one starts at the beginning. Everyone receives the gains of those who preceded him. For this reason what the individual accomplishes seems to be not a free creative act of his mind but rather an earned share of a great, existing, fixed capital. Therein, however, lies the compulsion and the disappointment which awaits man. Proceeding from the obscure consciousness of infinity, man can merely reach a limited, although immense finiteness. His goal is set from the start. He cannot go further than to form a mental image for himself of a thing which is a right image, i.e., one which corresponds to the object itself.

Here we are misled. The object itself exists only in the image, only as an image; yet, what we [are used to] call a right mental image is only what corresponds to the assumed, established, image of all. This is the formalism, the convention, to which man is subject from the moment he begins to see and to think. No limitation exists outside or beyond human nature to which man has to bend as to a necessity, rather does he conform to an arbitrary agreement based upon deception. Because certain mental images of men correspond, men accept a result, and only an intermediate result at that, as their point of departure. Men assume that things have a definite form, and they assume that the individual's task is to make his images approach more and more to reality. In this spirit the grown and mature generation hands on its experiences to the rising generation, and the first attempts of children to give form to their impressions are guided by this spirit. This is the formalism of perception of which we said all men are unconscious slaves. Such formalism makes of reality something which can be broadened by individual learning but which is itself immovable and incapable of any development. Such formalism consigns everyone whose mental images do not correspond with the form of things, as reflected in the ordinary imagination, to the ranks of the abnormally constituted or of those who arbitrarily withdraw from the world of positive reality

in order to create an individual world which may possess many qualities of reality but never correspond to it. . . .

. . . Here too, if we measure the content of being by the content of consciousness, we realize that we cannot conceive of the concrete being of things as the same for all. On the contrary, when we examine this content, we do not find anything consistently definite and generally established, but something that becomes and vanishes in endlessly changing form and individually endless variety. Of course, this looks the same from the naïve realistic point of view because the intuitive images which form in the consciousness of the individual, differ, according to situation and opportunity, in quality and quantity in the greatest degree. But the fundamental difference is, that according to the naïve point of view, [the means for measuring] the store and character of perceptual images that are present in a consciousness, are always ready in the external world which exists outside this consciousness and every consciousness. Furthermore, according to common opinion, this always ready, given touchstone of completeness and truth, not valid for abstractions and for concepts, exists for intuitive images in the outer world. To him who understands that the content of being can consist only of perception and images, this reality, which for naïve consciousness is a model and cause of perception and imagery becomes simply an unconscious convention, in which the mental, formative process of a perceptual world comes to a seeming standstill. What does it mean when the individual is referred to the outer world as to a final tribunal that judges all opinion and all errors? Where does this outer world exist other than in human perception, and what is it that is assumed to be a measure of the world of perceptual images, which form in the individual differently than in the average perception? The fateful rule of so-called good common sense extends both to the world of concepts and to the world of sensory perception. In the latter the rule is still more disastrous because it is harder to detect. Where, in the field of abstract cognition, we search for truth with the feeling that we can never find it entirely, that we shall not see the end of the path along which we struggle forward, there it is so comfortable always to refer to the reliable testimony of the senses in regard to the form and color of things and to be able to force agreement with all normally constituted men. On that account also everyone believes that he can

pass final judgment on the correctness of the copy because he has the original.

This is the great impediment to unbiased understanding of arts: everyone believes he can reach a finality in the attainment of intuitive knowledge of things. If this is the case, certainly the old view is correct that art does nothing when it produces a copy of reality, because this reality existed before the copy, that it must use reality for higher purposes in order to become art. Here sceptical disintegration of what is accepted on faith is necessary before we can form an opinion corresponding to actual circumstances.

Man believes he can receive direct truth from the sensory perception of so-called reality; he believes that, assuming normal sensory organs and other normal conditions, sensory perception provides indubitable truth in the sense that the perceptual image formed in the individual consciousness is a true copy of observed reality. This is a kind of dogmatism. The scepticism which had already destroyed the dogmatism of knowledge in antiquity did not extend to the dogmatism of perception, and yet scepticism must be extended to it too.

The peculiar activity of the eye ends very quickly, and it gives way to activities which a blind man could undertake, once he had perceived the objective world. As far as the development of intuitive consciousness is concerned, in general the seeing and the blind differ little. Once the eye has, so to say, done its duty, the human mind can, with the perception coming through the eye, do everything it is accustomed to do, without calling upon this organ for help again. We must try to become quite clear about the role which the eye plays in the workshop of the intellect in order to understand that the ability of the eye is not exhausted at this point. Only when we fully realize this fact shall we be able to look into a sphere of intellectual activity whose essence will remain, nevertheless, quite unknown to man.

The essential thing about visual activity is that it ends every moment. In vision man uses an acquired habit. Experiments have been made to find out how the eye gradually comes to grasp form and color and to fit the impressions it receives together in images. The visual image does not enter the eye from the outer world in finished form to be transmitted by the eye to the imaginative consciousness. Vision is no inborn ability which can and must be exercised as inborn so long as the individual lives; rather it is a skill developed, trained, handed

down and learned. If we look upon vision as an innate ability, as people once did and as naïve consciousness still does today, then the business of seeing would, of course, end when it communicates pictorial knowledge of objects of the outer world to the mind. If, however, vision, as man usually exercises it, is not innate but learned by practice, the exercise of it does not imply the necessary and exhaustive use of the organ but only an arbitrary, customary use.

It is decisive progress to think of the formation of visual images as a process in which, somewhat as in speech where the activity is supported by customary exercise, vision is supported by instruction. Yet we have not drawn conclusions from this insight; we have examined the origin of vision but not what it achieves. In the case of men in general this achievement is limited.

The eye possesses, so to speak, a great treasury of formulas to which it refers the impressions which it receives. Thus the eye produces a visual image with which it is satisfied in so far as the impressions are completely absorbed in the formulas. Just as vocabulary can be richer or poorer according to the degree of intelligence, so can the mind be richer or poorer, depending on the store of formulas from visual comprehension. One is satisfied with few formulas which absorb the totality of his sensory impressions. Another brings a far greater number of formulas to the sensory impression; and since his picture is richer, it seems more exact to him and more like the object he sees. When two persons see a tree, each believes he sees it exactly; and yet the picture of the tree which forms in the eye of the one is very different from the picture which forms in the eye of another. One believes he sees the tree exactly when he has reduced the sensory impression to some general perceptual formulas. The picture which he receives will be exact but poor. He will not be aware of this; and outside his own mental images, he has no standard by which to measure this imaginative picture. The other will approach the sensory impression with quite a different apparatus of visual formulas, and for him the total appearance of the tree will consist of a much greater number of forms and colors. . . .

Other psychological activities begin, activities through which, from the perception through other sensory organs, knowledge is attained in continuous development. Helmholtz developed the basic principle of empirical theories of visual perception, explaining that sensory feelings are signs for our

consciousness, and that our reason must learn the meaning of these signs (Physiological Optics 1867, p. 797). These theories have made it, if not certain, at least very probable that even the simplest part of a sensory image is the result of very complicated sensory-psychological processes. Such processes occur unconsciously, however; and for practical purposes it makes no difference if, accepting the empirical theory, we think of them as acquired and learned or if we consider them innate according to the nativistic theory. In any case the activity which must take place in the sensory organ and in the mind, in order to produce a sensory image, is so swift and steady that sensory perception seems to occur directly and immediately. Thus sensory perception seems to be the opposite of discursive, conceptual cognition, which can be attained only gradually, step by step, and through conscious, intentional activity of the mind. This contrast seems incontestable so long as men can give no other content to the concept of sensory perception than that describable as a normal, complete, and correct image of a sensorily perceivable object of the outer world. It is also indicative that, in the activity of perceiving, man reaches this limit [of perception] regularly, and usually continues only in the direction of emotion or reflection: yet, the power of habit prevents him from recognizing it as a limit.

Third Fragment

When we thus understand the relationship of various human activities to each other, the assumption which has always controlled the explanation and evaluation of artistic activities ceases to exist. This is important. The position of artistic activity in the context of general human activity is altered because all reflection concerning art and works of art used to be poisoned from the very start by an erroneous assumption. Starting at a false point, such reflection moves in a false direction. This false relationship has not been overlooked, and often enough artists have complained of duress; but the position in which they have been driven seemed so irrefutably established philosophically that artistic activity has never succeeded in shaking off the constraint of theoretical opinion. This view derives its strength from the fact that, when reduced to its most trivial form, it is understandable even in its lowest stage of development while it is also capable of philosophical sub-

limation which preserves its power of conviction even in the highest spheres of culture. Now old and firmly rooted, it has established itself as an almost axiomatic assumption in the widest areas of reflection. Thus in any case, long evolution will be necessary to replace this view, apparently so natural but actually so artificial and forced, by the other, which should, to be sure, appear natural to the unsophisticated mind, but which, once this candor has been lost, can be retrieved only by great mental energy. . . .

The meaning of all artistic expression is no other than striving to develop the existing into still other forms of existence. Thus closes, as a result of this discernment, the wide gulf which divides scientific investigation and formative activity. Their distinction rests entirely on an assumption of existing reality upon which vital human powers ought to test themselves. Only when we learn to think of cognitive activity as formative and of formative activity as cognitive shall we scale the heights from which we see the various types of intellectual activity, not in conflict, but in parallel order.

A second deduction follows: the various forms used to express human intellectual activity always express only themselves. At the outset, then, we must reject as crude and misleading the idea that something can be expressed completely in any one form produced by man. Only when we free ourselves from this idea can we neatly distinguish the various means by which man attains certainty of existence. Then we understand that the value of an individual type of expression depends entirely upon what it, in contrast to other types, expresses. When we notice in the development of relationships between the various forms of expression how one is used to express another, we recognize only an incidental, perverted but frequent use of the form of expression.

Relationships of meaning played a great role in the old aesthetics. They had so overrun the entire concept of art that the value of a work of art depended much more upon what was expressed by false use of its forms than upon what it properly could express. The distinction between the form and content of a work of art rests in general upon this misunderstanding. Actually, however, we cannot distinguish form and content in a work of art because what a work of art expresses is not only inseparably bound to the form but it is the very structure which appears as form. The entire artistic content, the quality of a work of art, consists of the higher degree of development

of its form. Artistic ability is the ability to express, and whatever has not reached expression does not exist artistically. In art no disparity between content and form exists; both are equally defective or complete in a particular case. This has been misunderstood because every form of expression can be used, not only in its proper sense, but also improperly to express something which belongs to the area of another form of expression. One form of expression employs the signs of another, enriching the area of its own proper signs with those borrowed from the other area. If we, so to speak, read the signs of one form of expression in the sense of another, the separation of content and form which plays such a great role in the usual consideration of art occurs. We can easily be led astray, for to a man who lives in one form of expression, another form may be a scarcely comprehensible foreign language. By far the most usual form of expression, the form in which consciousness of reality develops so generally that it passes for the expression of reality proper, is that of concepts. Accordingly it is not surprising that we try again and again to use artistic forms to express conceptual content.

In this respect the ordinary observer who always begins by asking what the artist is trying to say in a work of art does not differ from the philosopher who believes that he knows better than the artist what the final and supreme content of artistic representation must be. Such persons believe that they thus heighten the significance of art, while in fact they stress an incidental meaning, which the forms of art can express only when forced, and they overlook what the artistic forms of expression bring into being. When we realize that each form of expression is itself a type of language which we cannot understand at all if we seek to interpret it in the sense of another language, we will become accustomed to the special language [of art] and we shall expect enlightenment concerning it to come only from that language itself. Whoever wishes to interpret the language of figurative art only by treating figurative [e.g. visual] forms of expression as supplements to the forms of conceptual language will never understand what is expressed in and through the forms of figurative art. All research concerning the relationship between the form which in the plastic arts appeals to the eye, and its otherwise expressible content, or intrinsic values if we wish to speak more elegantly and philosophically, does not touch the essence of what

the painter, sculptor, or architect does when he produces his work of art; and the same holds true of all the other arts.

Each art expresses only itself, and the value of its work cannot depend upon what an extra-artistic interest reads into it. Nowhere does a completely irrelevant method of judgment assume such proportions as in the area of artistic activity; nowhere does the incapacity for all relevant understanding step forward so presumptuously. Only the clearest understanding of the reason for this fact can help us here. When we have attained this insight, each form of expression to which human activity develops will stand, liberated and independent, beside the others; each will cease to be the victim of narrow, pedantic and especially of misleading methods of speculation.

The third and most important deduction is that each form of expression is a law to itself. No form of expression needs to obey an external law, nor is there a general or supreme law with which the special laws of the various forms of expression must be reconciled. Liberated from arbitrariness, each form of expression should follow its inner law; confusion regarding the products of artistic activity in relation to man results only from ignoring this inner law.

. . . No one, it seems, would think of seeking another standard to measure the inner value of scientific thought, but the fact that this actually is tried from time to time proves that thought is subject to another type of distortion. Powers such as religion, morals, and politics at times seek to make theoretical [scientific] thinking simply a means to their ends and attach no value to it except as it justifies their regulations, intentions, and ends. The accepted standard of intellectual culture has always been the extent to which scientific thinking, freed from foreign bonds, was in a position to follow only a law of its own. At present [latter part of the nineteenth century] the relationship is such that in lands of real culture scientific thinking is in principle recognized as subject to its own law, while in fact, of course, research still bows to many considerations foreign to itself.

Scientific research occupies this relatively favorable position because the law governing it is generally known and recognized. The arts must claim the same right. However, the reason for being subject to conditions which would be regarded as barbaric if they referred to the field of thought, lies in the fact that the inner law of the various artistic activities is not known, or at least not generally recognized: we do not

understand the language they speak. Artistic activities still await liberation from the bonds of the claims made upon them by many interests—religious, scientific, moral, philosophical, and aesthetic. Artistic activities are not acknowledged in their own form; they do not enjoy their own right. This, their proper form, ought to be recognized and established. We can never prevent the various intellectual activities from appropriating the results of artistic activity for their own purposes and from measuring them according to their own standards. This would be harmless if it were clear that art, when it tries to serve ends other than its own, must remain sterile. Art's own ends are usually ignored, however; and according to accepted opinion, it is the purpose of other intellectual forces to give content, meaning, and direction to art. It would seem that the content of all artistic activity could be provided solely by the common efforts of various intellectual activities, especially the aesthetic, philosophical, and, more recently, the scientific; but in fact, all such efforts must of necessity miss the real task. We face the peculiar spectacle that everything indirectly accomplished by art is alive and present to men, but that what art accomplishes directly remains unknown and for the majority does not exist. It is as though art itself were mute and others had always to speak for it.

A LETTER FROM FIEDLER TO HILDEBRAND

Berlin, 17 May, 1877

Dear Hildebrand!

I received your letter and am very glad that you are all well. I am not going to reply in detail today, but only obey the desire, alas never quite satisfied, to philosophize with you a little, in order to make progress on certain questions. In thinking about these without outside help, one easily comes to points from which it is difficult to go on. I find it altogether wrong when investigating the human mind that we stop with its faculty of cognition. The epistemological investigations now in the forefront of all philosophy do not exclude the existence of other faculties of the mind, such as the ethical and aesthetical ones (Kant's Practical Reason and Aesthetical Judgment). Apart from these however, they consider, as the proper ground and soil of human mental activity, the urge and the ability to penetrate the world, to see through it, in the widest

sense of the expression, to give by means of the laws of thinking, sense and order to what is perceived as incomprehensible chaos, and thus to create a reality which corresponds to the intellectual nature of man. Starting from this basis we were able to consider abstract, scientific cognition as only one part of this reality, and believed intuitive artistic cognition to be the other part. You know that we have not got very far in the attempt to define the nature of this artistic cognition, analogous to the nature of abstract cognition with its law of contradiction, its logical laws, etc. We do not even know whether such an attempt may ever succeed. Now, however, it occurs to me that the urge for cognition is not at all the basic spiritual urge. Before perceiving anything recognizable and in need of being recognized, man already feels the need to overcome the isolation in which he finds himself as an individualized component of nature. It seems to me that the consciousness of loneliness, of foreignness (which necessarily must arise in a being who finds himself suddenly in opposition to the whole context of unconscious nature to which it belongs, almost expelled from it on account of what we call his human consciousness of himself) is the first element on which we can lay our finger when we talk of human intellectual activity. The urge to escape from this isolation is the really productive urge in man, and his need for scientific cognition which seemed to us founded directly on the spiritual nature of man and in no need of further explanation, is now revealed as stemming from the desire of the individual to eliminate the dividing wall erected between him and nature; it is one of the means whereby man believes he is able to make his own again what he lost the moment that he became an independent being. And it really is not a desire for cognition which evokes artistic activity, for the reason, as it were, that scientific knowledge can explain the world only to a certain extent; thus, all true artistic activity springs from the need to overcome the distance between the individual and nature, to bring nature close and ever closer, until it can be grasped and held. Art then is not simply a sort of cognition, but rather one of the means by which man tries to extricate himself from his isolated position and tries to regain contact with nature. It is a question whether the intellectual process here involved is analogous to that which occurs in abstract cognition, or whether we do not have here a field of spiritual activity whose laws have not yet been established. At any rate the artist aims

at a much more concrete comprehension of nature than the abstract thinker whose purpose is not to make sure of the phenomena, but who, on the contrary, can accomplish his purpose only by eventually disregarding them. One should therefore, in respect to the artist, really not speak of cognition but of representation as the activity through which he attempts completely to master nature; one should call art not a mode of cognition, but one should see in art and cognition two means which man adopts in order to satisfy his highest and most urgent need to again grasp, in particulars, nature from whose totality he knows himself estranged. I would like to know whether you agree with me on the fact of the isolation of man and his urge, often passionate, to overcome this isolation by every means.

Another time more. My wife adds to this pale theory a gift from my life's golden tree.

[GEORGES SEURAT (1859–91) entered the Ecole des Beaux Arts in 1878, receiving instruction from Ingres' pupil Henri Lehman. Delacroix's writings led him to Chevreul's publication on the physical properties of color. He continued his study with *The Scientific Theory of Color* (1881) by the American physicist, O. N. Rood. Rood had discovered that color mixed by the eye is more intense than pre-mixed color.

When a study of Delacroix's paintings revealed that the painter had not observed with scientific precision the laws controlling color, Seurat attempted to reduce color to a scientific theory usable for the artist and thus reconcile science and art.

His painting, "Une Baignade à Asnières," refused for the 1884 Salon, was exhibited in the first show of the Société des Artistes Indépendants. It won for his color studies the collaboration of the painter Paul Signac. They endeavored to approach the color luminosity of nature by a technique of painting which would permit the single color elements to be mixed within the eye of the spectator. Seurat designated his technique as "divisionism" because of the separation of the various local colors, rather than employing the Impressionists' term "pointillism." His theory required the size of the brush stroke to be determined by the size of the canvas—and the color of the frame to contribute to the unity of the painting.

Seurat's paintings reflect both his search for the symbolic value of color and linear patterns and the influence of the scientific aestheticians of the period, especially Charles Henry. Henry, in keeping with the scientific preoccupation of his generation, devised a table to test whether a form was harmonious or not. This type of aesthetics, based on experiments of choice pioneered by the German aestheticians, H. Fechner (1834–87) and H. Helmholtz (1821–94), led to discussions of "divine proportions," the preoccupation of Renaissance artists. Seurat utilized the ancient Greeks' "golden section" —that the larger and smaller parts should stand in the same relation as the larger part to the whole to fix the proportions in a composition.

"Les Vingts," a group of Belgian artists and artists living in Belgium, invited Seurat to exhibit with them in 1887. His "Grande Jatte," an impression of a landscape and figures defined by unmixed color and line and synthesized in a definite arrangement free from suggestion of the accidental, was a sensation. The critic Felix Fénéon explained Seurat's work as "Neo-Impressionism." "Les Poseuses" (1888), "La Parade," "La Chahut," "Le Cirque" are demonstrations of his theory and brilliant accounts of contemporary life.

Convinced that basic rules of color harmony could be established as they had been for sound in music, Seurat stated his color theory in a letter to Maurice Beaubourg, the playwright and patron of the "Nabis."

Seurat died suddenly shortly before the opening of the "Artistes Indépendants" exhibition of 1891 in which "Le Cirque" was shown. Seurat's theories and six great paintings exerted a strong influence on the next generation, the Cubists and the Orphists.

SEE: D. C. Rich, *Seurat and the Evolution of "La Grande Jatte,"* Chicago, 1935.

J. Rewald, *Georges Seurat,* New York, 1946.

J. Itten, *The Art of Color,* translated by E. van Haagen, New York, 1961.]

EXCERPT OF LETTER TO MAURICE BEAUBOURG

August 28, 1890[1]

"In closing I will give you the note on esthetic and technique which finishes my work on Monsieur Christophe [his biography of Jules Christophe], and which is my own. I have modified it somewhat, it not having been well understood by the printers."

Esthetic

Art is harmony.

Harmony is the analogy of opposites, the analogy of similar elements, of *value, hue,* and *line,* considered according to their dominants, and under the influence of lighting, in gay, calm, or sad combinations.

The opposites are:

For value, a more {luminous / light} for a darker one.

For hue, the complementaries, i.e., a certain red opposed to its complementary, etc.

{ red-green / orange-blue / yellow-violet }

For line, those forming a right angle.

Gaiety of value is the light dominant; of *hue,* the warm dominant; of *line,* lines above the horizontal.　⤢

Calmness of value is the equality of dark and light; of hue, of warm and cool; and the horizontal for line.

Sadness of value is the dark dominant; of hue, the cool dominant; and of line, downward directions.　⤡

Technique

Granting the phenomena of the duration of the light-impression on the retina, synthesis necessarily follows as a resultant. The means of expression is the optical mixture of values, of hues (of the local color and the color of the illuminating light:

[1] Translated from G. Coquiot, *Seurat,* A. Michel, Paris, 1924, pp. 232–33.

sun, oil, lamp, gas, etc.), that is to say, of the lights and their reactions (shadows), in accordance with the laws of *contrast, gradation,* and irradiation.

The frame is in a harmony opposed to that of the values, hues, and lines of the picture.

[VINCENT VAN GOGH (1853–90) was the son of a Dutch Calvinist pastor. His father's brothers were art dealers. Through their influence, Vincent and his younger brother, Théo, secured employment with Goupil, a large French art firm. Vincent worked in their branch galleries in The Hague, London, Brussels, and Paris, the head office. Théo was employed in other branches.

After six years with Goupil's, Vincent quarreled with his employers. He taught briefly in England, then experienced a call to the ministry. When he failed the entrance examinations for the theology seminar, van Gogh completed a short training course for evangelical lay workers and went into the mining district of Belgium as a lay preacher. In the extreme poverty of these surroundings and of his own existence, van Gogh began to draw what he saw, and what he drew became a spiritualized experience for him.

Van Gogh announced his decision to become a painter in a letter (1880) to Théo. As his father had little sympathy with his plan, van Gogh was dependent on the financial help of Théo, employed now at Goupil's Paris office, and of a cousin, Mauve, a painter at The Hague. Van Gogh studied briefly at an art school in Brussels, but left when the traditional teaching method failed to supply him with the technique he needed to express his creative impulse. He went out to Drenthe, a village, to teach himself by drawing the peasants at work. Van Gogh continued his self-instruction for two years (1883–85), using the barn at his father's vicarage in Neunen as a studio. He painted the somber-toned "Potato Eaters" (1885) there.

To gain more technical proficiency, van Gogh entered the Academy at Antwerp. While he profited from a study of Rubens' color and technique, the Academy's conventional teaching offered him nothing. He went to Paris hoping to find what he sought there. Théo now had his own gallery and ar-

ranged for Vincent to enter Cormon's studio. Toulouse-Lautrec was also working there. His immediate appreciation of van Gogh's genius helped him gain confidence in his talent.

For two years in Paris, van Gogh had the benefit of association with Pissarro, Seurat, Signac, Gauguin, Lautrec, and Degas. Van Gogh joined Emile Bernard at Asnières, Brittany, for a month of painting and gradually perfected his own technique. He lightened his colors to pure color and elongated the pointillist dots into twisting lines. He bought Japanese prints at Siegfried Bing's shop, for that art offered him a style suited to his desire for an expressive line which he could combine with colors reflective of his mood. He painted over two hundred pictures, views of Paris, still lifes, and portraits before he left in February 1888 for Arles. Lautrec had said, "It is in the South that the studio of the future must be set up."

Van Gogh shared the dream of the mystics among early Romanticists—Runge and Blake—that in a community of like-minded artists the individual artist could best serve his art. In a social utopia the perfect art might be realized.

At Arles, van Gogh rented "a yellow house with a tiny white studio" and urged others to join him. Van Gogh now achieved his technique and style of painting that harmonized with his creative need to depict nature's eternal vitality. Intoxicated by the ecstatic movement he saw in nature, he identified his emotions with what he saw. He assigned, in a manner similar to Runge's, a personal symbolic meaning to each color —yellow was the color of love and friendship. Paintings such as "Sunflowers," "Iris," "Cypress Trees" may be described as visible poems composed with calligraphic brush strokes and symbolic colors to convey an impression of the eternal force van Gogh saw behind the screen of reality.

Eager to have a winter community of artists in Arles similar to that of the summer at Pont Aven and Asnières, van Gogh urged Bernard and Gauguin to join him. Under an agreement with Théo whereby he would supply paintings in exchange for his living, Gauguin went to Arles in October 1889. The creative process of the two artists was fundamentally different: Gauguin painted from memory; van Gogh required the immediate stimulus of a scene or an object to accomplish his act of creation. Under the tension caused by Gauguin's criticism and his attempt to alter his method of painting, van Gogh suffered a complete mental collapse, and cut off his ear. Gauguin returned at once to Paris.

Van Gogh was soon able to continue and painted "La Berceuse," "Still Life with Onions," and "Self Portrait with Cut Ear." However, when he again suffered from hallucinations, he returned to the hospital.

In spite of continuing mental deterioration, van Gogh's creative productivity in his periods of lucidity was prodigious. He executed some 150 canvases, among them "Cypresses," "The Hospital Yard," "Harvest." His work now received its first recognition with an enthusiastic appreciation written by Albert Aurier in the "Mercure de France" and its inclusion in "Les Vingts" exhibition in March 1890.

Van Gogh became a patient of Dr. Gachet at Auvers-sur-Oise near Paris at the end of May. In this sanatorium, van Gogh painted the "Mairie d'Auvers" and three large landscapes before he shot himself in an accident caused by his illness in a wheat field he had painted.

Van Gogh's letters, written first in Dutch and later in French, are moving documents of a Christian possessed with deep concern for his fellow man, and an artist who thought of his talent as an inadequate means to serve humanity.]

LETTERS[1]

To Théo van Gogh

[#336 Drenthe, Sept.–Nov., 1883]

Dear brother,

It is Sunday to-day and you are not out of my thoughts for a moment. I should think it quite appropriate to apply to business the words: "plus tu y resteras plus ça t'embêtera" [the more you stay in it, the more it will bore you], and to painting: "plus ça t'amusera," using "amusera" in a more serious sense of energy, cheerfulness, vitality.

Oh, I said, I should give Tom, Dick and Harry their due—by all means—let us do so, but having done justice to those things, aren't they absurd, those formalities and conventions, in fact, aren't they really *bad*?

In order to maintain a certain rank, one is obliged to commit certain villainies, falsehoods—willingly and knowingly,

[1] Quoted from *The Complete Letters of Vincent van Gogh,* Little, Brown & Company, Inc., Boston, Mass., 1958.

premeditatedly. That's what I call the fatal side, even of the *rayon noir,* let alone when there is no *rayon* at all.

Now take, for instance, the painters of Barbizon: not only do I understand them as men, but in my opinion *everything*— the smallest, the most intimate details—sparkles with humour and life. The "painter's family life," with its great and small miseries, with its calamities, its sorrows, and griefs, has this advantage of having a certain goodwill, a certain sincerity, a certain real human feeling. Just because of that *not* maintaining a certain standing, not even thinking about it.

. . . Do I say this because I despise culture? On the contrary, I say it because I look upon the real human feelings, life in harmony with, not against, nature, as the true civilization, which I respect. I ask, what will make me more completely human?

Zola says: "Moi artist, je veut vivre tout haut—*veut vivre*" [I, as an artist, want to live as vigorously as possible—(I) *want to live*] without mental reservation—naive as a child, no, not as a child, as an artist—with goodwill, however life presents itself, I shall find something in it, I will try my best on it. Now look at all those studied little mannerisms, all that convention, how exceedingly conceited it really is, how absurd, a man thinking he knows everything and that things go according to his idea, as if there were not in all things of life, a "je ne sais quoi"[2] of great goodness, and also an element of evil, which we feel to be infinitely above us, infinitely greater, infinitely mightier than we are.

How fundamentally wrong is the man who doesn't feel himself small, who does not realize he is but an atom.

Is it a loss to drop some notions, impressed on us in childhood, that maintaining a certain rank, or certain conventions is the most important thing? I myself do not even think about whether I lose by it or not. I know only by experience that those conventions and ideas do not hold true, and often are hopelessly, fatally, wrong. I come to the conclusion that I do not know anything, but at the same time that this life is such a mystery that the system of "conventionality" is certainly too narrow. So that has lost its credit with me.

What shall I do now? The common phrase is, "What is your aim, what are your aspirations?" Oh, I shall do as I think best —how? I can't say that beforehand—you who ask me that pre-

[2] For a meaning of this phrase see Hogarth, Holt, Volume II, p. 267.

tentious question, do you know what is *your* aim, what are *your* intentions?

Now they tell me, "You are unprincipled when you have no aim, no aspirations." My answer is, "I didn't tell you I had *no* aim, *no* aspirations, I said it is the height of conceit to try to force one to define what is indefinable." These are my thoughts about certain vital questions. All that arguing about it is one of the things of which I say "embetera."

Live—do something—that is more amusing, that is more positive. In short—one must of course give Society its due, but at the same time feel absolutely free, believing not in one's own judgment, but in "reason" (my judgment is human, reason is divine, but there is a link between the one and the other), and that my own conscience is the compass which shows me the way, although I know that it does not work quite accurately. . . .

. . . It seems to me that you, who are very young, do not act recklessly when you argue, I have had enough of the art-dealing business but not of art; I'll drop the business, and aim at the very heart of the profession.

That is what I ought to have done at the time. My making a mistake was perhaps a natural error of judgment, because then I did not know anything about teaching or about the Church—did not know anything about it, and cherished ideals about it.

You will say, "Doesn't one sometimes have ideas about art that are incompatible with existing conditions?" Well, answer that question for yourself. I also answer it for myself by asking, "Is Barbizon, is the Dutch school of painters a fact or not?"

Whatever may be said of the world of art, it is not rotten. On the contrary, it has improved and improved, and perhaps the summit has already been reached; but at all events, we are still quite near it, and as long as you and I live, though we might reach the age of a hundred, there will be a certain real vitality. So he who wants to paint must put his shoulder to the wheel. If the woman came, of course she would have to paint too.

Everybody would have to paint here—the wife of one of the Van Eyck's also had to do it. And I tell you that the people don't seem disagreeable or intriguing. There is a kind of benevolence in this place, and I think you can do exactly what

you think best. There is a surprisingly youthful atmosphere in existence here.

. . . If you have come to a decision for yourself, avoid other people, because they can only weaken your energy. Just at the very moment when one has not yet lost one's outer clumsiness, when one is still green, a "ni fait ni à faire" [neither done nor to be done] is enough to cause discouragement for half a year, after which one at last sees that one ought not to have let oneself be led astray.

I know the soul's struggle of two people: Am I a painter or not? Of Rappard and of myself—a struggle hard sometimes, a struggle which accurately marks the difference between us and certain other people who take things less seriously; as for us, we feel wretched at times; but each fit of melancholy brings a little light, a little progress; certain other people have less trouble, work more easily perhaps, but then their personal character develops less. You, too, would have that struggle, and I tell you, don't forget that you are in danger of being upset by people who undoubtedly have the very best intentions.

If you hear a voice within you saying: "You are not a painter," *then by all means paint,* boy, and that voice will be silenced, but only by working. He who goes to friends and tells his troubles when he feels like that loses part of his manliness, part of the best that is in him; your friends can only be those who themselves struggle against it, who raise your activity by their own example of action. One must undertake it with confidence, with a certain assurance that one is doing a reasonable thing, like the farmer drives his plough, or like our friend in the scratch below, who is harrowing, and even drags the harrow himself. If one hasn't a horse, one is one's own horse—many people do so here. [See Plate 55.]

There is a saying by Gustave Doré which I have always admired: "j'ai la patience d'un boeuf." I find in it a certain goodness, a certain resolute honesty—in short, that saying has a deep meaning, it is the word of a real artist. When one thinks of the man from whose heart such a saying sprang, all those oft-repeated art-dealer's arguments about "natural gifts," seem to become an abominably discordant raven's croaking. "J'ai la patience," how quiet it sounds, how dignified; they wouldn't even say it except for that very raven's croaking. I am not an artist—how coarse it sounds—even to think so of oneself—oughtn't one to have patience, oughtn't one to learn

patience from nature, learn patience from seeing the corn slowly ripen, seeing things grow—should one think oneself so absolutely dead as to imagine one would not grow any more? Should one thwart one's own development on purpose? I say this to explain why I think it so foolish to speak about natural gifts and no natural gifts.

But in order to grow, one must be rooted in the earth. So I tell you, take root in the soil of Drenthe—you will germinate there—don't wither on the side-walk. You will say there are plants that grow in the city—that may be, but you are corn, and your place is in the cornfield.

. . . I don't suppose I'm telling you anything new at all, I only ask, Don't thwart your own best thoughts. Think that idea over with a certain good-humored optimism instead of looking at things gloomily and pessimistically. I see that even Millet, just because he was so serious, couldn't help keeping good courage. That is something peculiar, not in all styles of painting, but to Millet, Israels, Breton, Boughton, Herkomer and others.

Those who seek real simplicity are themselves so simple, and their view of life is so full of willingness and courage, even in hard times.

Think these things over, write me about them. It must be "une revolution qui est, puisqu'il faut qu'elle soit" [a revolution that is, because it must be]. With a handshake,

Yours,

VINCENT.

[#402 Neunen, Dec. 1883–Nov. 1885]

Dear Théo,

By the same mail you will receive a number of copies of the lithograph. Please give Mr. Portier as many as he wants. And I enclose a letter for him, which I am afraid you will think rather long, and, consequently, unbusinesslike. But I thought that what I had to say couldn't be expressed more concisely and that the main thing is to give him arguments for his own instinctive feelings. And in fact, I also say to you what I write to him.

There is a school—I believe—of impressionists. But I know very little about it. But I do know who the original and most important masters are around whom—as around an axis—the landscape and peasant painters will revolve. Delacroix, Corot, Millet and the rest. That is my own opinion, not properly formulated.

I mean there are (rather than persons) rules or principles or fundamental truths for *drawing,* as well as for *colour,* which *one proves to fall back,* when one finds out an actual truth.

In drawing, for instance—that question of drawing the figure beginning with the circle—that is to say using elliptical planes as a foundation. A thing which the ancient Greeks already knew, and which will remain till the end of the world. As to colour, those everlasting problems, for instance, that first question Corot addressed to Français, when Français (who already had a reputation) asked Corot (who then had nothing but a negative or rather bad reputation) when he (F.) came to Corot, to get some information: "Qu'est-ce que c'est un ton rompu? Qu'est-ce que c'est un ton neutre?"

Which can be shown better on the palette than expressed in words.

So what I want to tell Portier in this letter is my firm belief in Eugène Delacroix and the people of that time.

And at the same time, as the picture which I am working on is different from lamplight scenes by Dou or Van Schendel, it is perhaps not superfluous to point out that one of the most beautiful things this country's painters have done is to paint *darkness* which nevertheless has *light* in it. Well, just read my letter and you will see that it is not unintelligible, and that it treats of a subject that just occurred to me while painting.

I hope to have some luck with that picture of the potato-eaters.

I am also working on a red sunset.

One must be master of so many things to paint rural life. But, on the other hand, I don't know anything at which one works with so much calmness, in the sense of serenity, however much one may worry about material things.

I am rather worried just now about the moving; it's no easy job, on the contrary. But it had to happen sometime—if not now, then later—and the fact is that in the long run it's better to have a place of one's own.

To change the subject. How striking that saying about Millet's figures is: *"Son paysan semble peint avec la terre qu'il ensemence!"* [His peasant seems to be painted with the earth he is sowing.] How exact and how true. And how important it is to know how to mix on the palette those colours which have no name and yet are the real foundation of everything. Perhaps, I daresay *positively,* the questions of *colour,* and

more precisely of broken and neuter colours, will preoccupy you anew. Art dealers speak so vaguely and arbitrarily about it, I think. In fact, painters do too. Last week I saw at an acquaintance's a decidedly clever, realistic study of an old woman's head by somebody who is directly, or indirectly, a pupil of The Hague School. But in drawing, as well as in colour, there was a certain hesitation, a certain narrow-mindedness—much greater, in my opinion, than one sees in an old Blommers or Mauve or Maris. And this symptom threatens to become more and more widespread. If one takes realism in the sense of *literal* truth, namely *exact* drawing and local colour. There are other things than that. Well, good-bye, with a handshake,

<div align="center">Yours,</div>

<div align="right">VINCENT.</div>

To Emile Bernard

<div align="right">VI. Arles, Mid-June 1888</div>

Dear old Bernard,

More and more it seems to me that the pictures which must be made so that painting should be wholly itself, and should raise itself to a height equivalent to the serene summits which the Greek sculptors, the German musicians, the writers of French novels reached, are beyond the power of an isolated individual; so they will probably be created by groups of men combining to execute an idea held in common.

One person may have a superb orchestration of colors and lack ideas. Another one is cram-full of new concepts, tragically sad or charming, but does not know how to express them in a sufficiently sonorous manner because of the timidity of a limited palette. All the more reason to regret the lack of co-operative spirit among the artists, who criticise and persecute each other, fortunately without succeeding in annihilating each other.

You will say that this whole line of reasoning is banal—so be it! However, the thing itself—the existence of a renaissance —this fact is certainly no banality.

A technical question. Just give me your opinion of it in your next letter. I am going to put the *black* and the *white* on my palette and use them just as they are. When—and observe that I am speaking of the simplification of color in the Japanese manner—when in a green park with pink paths, I see a gentleman dressed in black and a justice of the peace by trade (the

Arab Jew in Daudet's "Tartarin" calls this honorable func-
tionary a *zouage de paix*), who is reading *l'Intransigeant* . . .

Over him and the park sky of simple cobalt.

. . . Then why not paint the said *zouage de paix* with ordi-
nary bone black and the *l'Intransigeant* with simple, quite raw
white. For the Japanese artist ignores reflected colors, and
puts the flat tones side by side, with characteristic lines mark-
ing off the movements and the forms.

In another category of ideas—when for instance one com-
poses a motif of colors representing a yellow evening sky,
then the fierce hard white of a white wall against the sky may
be expressed if necessary—and in this strange way—by raw
white, softened by a neutral tone, for the sky itself colors it
with a delicate lilac hue. Furthermore, imagine in that land-
scape which is so naive, and a good thing, too, a cottage,
whitewashed all over (including the roof). Standing in an
orange field—certainly orange, for the southern sun and the
blue Mediterranean provoke an orange tint that gets more
intense as the scale of blue colors gets a more vigorous tone
—then the black note of the door, the windows and the little
cross on the ridge of the roof produce a simultaneous con-
trast of black and white just as pleasing to the eye as that of
blue and orange.

Or, to take a more amusing motif: imagine a woman in a
black and white checked dress in the same primitive land-
scape with a blue sky and orange soil—that would be a rather
funny sight, I think. In Arles they often do wear black and
white checks.

Suffice to say that black and white are also colors, for in
many cases they can be looked upon as colors, for their si-
multaneous contrast is as striking as that of green and red,
for instance.

The Japanese make use of it for that matter. They express
the mat and pale complexion of a young girl and the piquant
contrast of the black hair marvellously well by means of white
paper and four strokes of the pen. Not to mention their black
thornbushes starred all over with a thousand white flowers.

At last I have seen the Mediterranean, which you will prob-
ably cross sooner than I shall.

I spent a week at Saintes-Maries,[3] and to get there I drove

3 Saintes-Maries, a village on the Mediterranean coast, where Mary,
the sister of the Virgin, Mary Salome, the mother of the Apostles

in a diligence across the Camargue with its vineyards, moors, and flat fields like Holland. There, at Saintes-Maries, were girls who reminded one of Cimabue and Giotto—thin, straight, somewhat sad and mystic. On the perfectly flat, sandy beach, little green, red and blue boats, so pretty in shape and color that they made one think of flowers. A single man is their whole crew, for these boats hardly venture on the high seas. They are off when there is no wind, and make for the shore when there is too much of it.

Gauguin, it seems, is still sick.

I am wondering what you have been working at lately; myself, I am still always working at landscapes; here's a sketch. I should also love to take a look at Africa, but I have no definite plans for the future; that depends on circumstances.

What I should like to find out is the effect of an intenser blue in the sky. Fromentin[4] and Gérôme[5] see the soil of the South as colorless, and a lot of people see it like that. My God, yes, if you take some sand in your hand, if you look at it closely, and also water, and also air, they are all colorless, looked at in this way. *There is no blue without yellow and without orange* and if you put in blue, then you must put in yellow, and orange, too, mustn't you? Oh, well, you will tell me that what I write to you are only banalities.

A handshake in thought,

 Sincerely yours,

 VINCENT

[JORIS HUYSMANS (1848–1907), a Parisian, pursued a career of novelist and art critic while serving thirty-two years as a civil servant in the Ministry of the Interior. He published his first novel in 1874. Following the style of his friend, Emile Zola, Huysmans' second work, *En Ménage* (1881), is a detailed, realistic misanthropic account of disillusionment in a Parisian setting of artists' studios.

The newspaper *Le Voltaire,* at Zola's insistence, gave Huysmans the assignment to review the Salon of 1879. Huysmans

James and John, and Mary Magdalene landed in 45 A.D. Sarah, their servant, is venerated by the gypsies. They make their pilgrimage on the 24 and 25 May and 22 October.

[4] Eugène Fromentin (1820–76), a painter and writer. See p. 357.

[5] Jean Léon Gérôme (1824–1904), a painter and sculptor.

accurately pointed out the correspondence in the documentation of truth between contemporary painting and literature, the absence of literary content, and the unconventionality of the color of the "impressionists" who were exhibiting as the "Société des Artistes Indépendants."

As a critic of Salons and the Expositions (1879–81), Huysmans was brought into close association with artists, and especially with Gustav Moreau and Odilon Redon whose interest in the reality of the imaged world paralleled his own and led to the development of symbolism. Huysmans' collected reviews appeared as *L'Art Moderne* (1883).

In 1884 Huysmans published his startling book, *A Rebours* (*Against the Grain*), with the motto, "Needs must I rejoice beyond the age, though the world has horror of my joy and its grossness cannot understand what I would say." The protagonist, Des Esseintes, fashioned from traits of Ludwig II of Bavaria and the author, fled all that was detestable in the mundane environment to create a life and setting that fed his sensuous aesthetic pleasures. Huysmans' style, a microscopic analysis of the ordinary combined with a description of intense physical impressions, is a literary parallel to Moreau's pictorial style. It was by such means that Huysmans sought a "spiritualistic naturalism" and in this endeavor the symbolist writers and painters related themselves to the first Romanticists of the century, Runge and Friedrich.

A second collection of Huysmans' art criticism is *Certaines* (1889) in which he correctly discerned the genius of Degas, Whistler, Renoir, and other impressionists.

Confronted himself with the negation of the reality of life that he had set forth in *A Rebours,* Huysmans experienced conversion and entered the Roman Catholic Church in 1891 —as did many of his contemporaries who had likewise passed their formulative years in the romantic medievalism of the first half of the nineteenth century.

In a Benedictine monastery, Huysmans wrote his trilogy, masterpieces in style: *En Route* (1895), an account of his conversion; *La Cathédrale* (1898), on the symbolism of Chartres; *L'Oblat* (1903), on liturgy. In 1903 Huysmans republished *A Rebours* with an explanatory penitential preface.

SEE: A. Symons, *The Symbolist Movement in Literature,* 1899.]

AGAINST THE GRAIN[1]

Excerpt from Chapter V

Simultaneously with his [Des Esseintes] craving to escape a hateful world of degrading restrictions and pruderies, the longing never again to see pictures representing the human form toiling in Paris between four walls or roaming the streets in search of money, had obtained a more and more complete mastery over his mind. . . .

He had selected for the diversion of his mind and the delight of his eyes works of a suggestive charm, introducing him to an unfamiliar world, revealing to him traces of new possibilities, stirring the nervous system by erudite phantasies, complicated dreams of horror, visions of careless wickedness and cruelty.

Of all others there was one artist who most ravished him with unceasing transports of pleasure—Gustave Moreau.[2]

He had purchased his two masterpieces, and night after night he would stand dreaming in front of one of these, a picture of Salomé.

The conception of the work was as follows. A throne, like the high altar of a Cathedral, stood beneath an endless vista of vaulted arches springing from thick-set columns resembling the pillars of a Romanesque building, encased in many coloured brickwork, incrusted with mosaics, set with lapis lazuli

[1] Quoted from *Against the Grain* [*A Rebours*], by Joris K. Huysmans, with an Introduction by Havelock Ellis, The Modern Library, New York, 1930; pp. 141–50, 154–56.

[2] [Gustave Moreau (1826–99) was a pupil of Théodore Chassériau (1819–56). A trip to Italy in 1857 remained for Moreau a lasting impression and supplied elements for his eclectic style. He took his technique from Italy and Flanders and his subject matter from literary sources and his rich fantasy. His early work "Salomé" (L'Apparition) (1876) is a product of two principles of his art, a beautiful inertia and necessary richness. In his later work Moreau's subject matter is from an abstract realm, peopled by suggestions roused by classic literary subjects and colored by melancholy. By choosing his colors to heighten a picture's psychological impact and a technique to intensify its effect, Moreau is one of the most original and enigmatical artists of the nineteenth century.]

and sardonyx, in a Palace that recalled a basilica of an architecture at once Saracenic and Byzantine.

In the centre of the tabernacle surmounting the altar, which was approached by steps in the shape of a recessed half circle, the Tetrarch Herod was seated, crowned with a tiara, his legs drawn together, with hands on knees.

The face was yellow, like parchment, furrowed with wrinkles, worn with years; his long beard floated like a white cloud over the starry gems that studded the gold-fringed robe that moulded his breast.

Round about this figure, that sat motionless as a statue, fixed in a hieratic pose like some Hindu god, burned cressets from which rose clouds of scented vapour. Through this gleamed, like the phosphoric glint of wild beasts' eyes, the flash of the jewels set in the walls of the throne; then the smoke rolled higher, under the arcades of the roof, mingling its misty blue with the gold dust of the great beams of sunlight pouring in from the domes.

Amid the heady odour of the perfumes, in the hot, stifling atmosphere of the great basilica, Salomé, the left arm extended in a gesture of command, the right bent, holding up beside the face a great lotus-blossom, glides slowly forward on the points of her toes, to the accompaniment of a guitar whose strings a woman strikes, sitting crouched on the floor.

Her face wore a thoughtful, solemn, almost reverent expression as she began the wanton dance that was to rouse the dormant passions of the old Herod, her bosoms quiver and, touched lightly by her swaying necklets, their rosy points stand pouting; on the moist skin of her body glitter clustered diamonds; from bracelets, belts, rings, dart sparks of fire; over her robe of triumph, bestrewn with pearls, broidered with silver, studded with gold, a corselet of chased goldsmith's work, each mesh of which is a precious stone, seems ablaze with coiling fiery serpents, crawling and creeping over the pink flesh like gleaming insects with dazzling wings of brilliant colours, scarlet with bands of yellow like the dawn, with patterned diapering like the blue of steel, with stripes of peacock green.

With concentrated gaze and the fixed eyes of a sleepwalker, she sees neither the Tetrarch, who sits there quivering, nor her mother, the ruthless Herodias, who watches her, nor the hermaphrodite or eunuch who stands sabre in hand on the lowest step of the throne, a terrible figure, veiled to below the

eyes, the sexless dugs of the creature hanging like twin gourds under his tunic barred with orange stripes.

The thought of this Salomé, so full of haunting suggestion to the artist and the poet, had fascinated Des Esseintes for years. . . .

In the work of Gustave Moreau, going for its conception altogether beyond the meagre facts supplied by the New Testament, Des Esseintes saw realized at last the Salomé, weird and superhuman, he had dreamed of. No longer was she merely the dancing-girl who extorts a cry of lust and concupiscence from an old man by the lascivious contortions of her body; who breaks the will, masters the mind of a King by the spectacle of her quivering bosoms, heaving belly and tossing thighs; she was now revealed in a sense as the symbolic incarnation of world-old Vice, the goddess of immortal Hysteria, the Curse of Beauty supreme above all other beauties by the cataleptic spasm that stirs her flesh and steels her muscles—a monstrous Beast of the Apocalypse, indifferent, irresponsible, insensible, poisoning, like Helen of Troy of the old Classic fables, all who come near her, all who see her, all who touch her.

So understood, she belonged to the ancient Theogonies of the Far East; no longer she drew her origin from Biblical tradition; could not even be likened to the living image of Babylonish Whoredom, or the Scarlet Woman, the Royal Harlot of Revelations, bedecked like her with precious stones and purple, tired and painted like her; for *she* was not driven by a fateful power, by a supreme, irresistible force, into the alluring perversities of debauch.

Moreover, the painter seemed to have wished to mark his deliberate purpose to keep outside centuries of history; to give no definite indication of race or country or period, setting as he does his Salomé in the midst of this strange Palace, with its confused architecture of a grandiose complexity; clothing her in sumptuous, fantastic robes, crowning her with a diadem of no land or time shaped like a Phoenician tower such as Salammbô wears, putting in her hand the sceptre of Isis, the sacred flower of Egypt and of India, the great lotus-blossom.

. . . Be this as it may, an irresistible fascination breathed from the canvas, but the water-colour entitled "The Apparition" was perhaps even yet more troubling to the senses.

In it, Herod's Palace towered aloft like an Alhambra on light columns iridescent with Moorish chequer-work, joined

as with silver mortar, consolidated with cement of gold; arabesques surrounded lozenges of lapis lazuli and wound all along the cupolas, where on marquetries of mother-of-pearl, wandered glittering rainbows, flashes of prismatic colour.

The murder had been done; now the headsman stood there impassive, his hands resting on the pommel of his long sword, stained with blood.

The decapitated head of the Saint had risen up from the charger where it lay on the flags, and the eyes were gazing out from the livid face with its discoloured lips and open mouth; the neck all crimson, dripping tears of gore.

A mosaic encircled the face whence shone an aureola darting gleams of fire under the porticoes, illuminating the ghastly lifting of the head, revealing the glassy eyeballs, that seemed fixed, glued to the figure of the dancing wanton.

With a gesture of horror, Salomé's repulses the appalling vision that holds her nailed to the floor, balanced on her toe tips, her eyes are dilated, her hands grip her throat convulsively.

She is almost naked; in the ardour of the dance the veils have unwound themselves, the brocaded draperies of her robes have slipped away; she is clad now only in goldsmith's artistries and translucent gems; a gorget clips her waist like a corselet; and for clasp a superb, a wondrous jewel flashes lightnings in the furrow between her bosoms; lower, on the hips, a girdle swathes her, hiding the upper thighs, against which swings a gigantic pendant, a falling river of carbuncles and emeralds; to complete the picture, where the body shows bare betwixt gorget and girdle, the belly bulges, dimpled by the hollow of the navel that recalls a graven seal of onyx with its milky sheen and tint as of a rosy finger-nail.

Beneath the ardent rays flashing from the Precursor's head, every facet of her jewelled bravery catches fire; the stones burn, outlining the woman's shape in flaming figures; neck, legs, arms glitter with points of light, now red as burning brands, now violet as jets of gas, now blue as flames of alcohol, now white as moonbeams.

The dreadful head flashes and flames, bleeding always, dripping gouts of dark purple that point the beard and hair. Visible to Salomé, alone, it embraces in the stare of its dead eyes neither Herodias, who sits dreaming of her hate satiated at last, nor the Tetrarch, who, leaning rather forward with hands on knees, still pants, maddened by the sight of the

woman's nakedness, reeking with heady fumes, dripping with balms and essences, alluring with scents of incense and myrrh.

Like the old King, Des Esseintes was overwhelmed, over-mastered, dizzied before this figure of the dancing-girl, less majestic, less imposing, but more ensnaring to the senses than the Salomé of the oil painting. . . .

As Des Esseintes used to maintain: never before at any epoch had the art of water-colour succeeded in reaching such a brilliancy of tint; never had the poverty of chemical pig-ments been able thus to set down on paper such coruscating splendours of precious stones, such glowing hues as of painted windows illumined by the noonday sun, glories so amazing, so dazzling of rich garments and glowing flesh tints.

And, falling into a reverie, he would ask himself what were the origin and antecedents of the great painter, the mystic, the Pagan, the man of genius who could live so remote from the outside world as to behold, here and now in Paris, the splen-did, cruel visions, the magic apotheoses of other ages.

Who had been his predecessors? This Des Esseintes found it hard to say; here and there, he seemed influenced by vague recollections of Mantegna and Jacopo de Barbari; here and there, by confused memories of Da Vinci and the feverish colouring of Delacroix. But in the main, the effect produced by these masters' work on his own was imperceptible; the real truth was that Gustave Moreau was a pupil of no man. With-out provable ancestors, without possible descendants, he re-mained, in contemporary art, a unique figure. Going back to the ethnographic sources of the nations, to the first origins of the mythologies whose bloodstained enigmas he compared and unriddled, reuniting, combining in one the legends, derived from the Far East and metamorphosed by the beliefs of other peoples, he thus justified his architectonic combinations, his sumptuous and unexpected amalgamations of costumes, his hieratic and sinister allegories, made yet more poignant by the restless apperceptions of a nervous system altogether mod-ern in its morbid sensitiveness; but his work was always pain-ful, haunted by the symbols of superhuman loves and superhu-man vices, divine abominations committed without enthusiasm and without hope.

There breathed from his pictures, so despairing and so eru-dite, a strange magic, a sorcery that moved you to the bottom of the soul, like that of certain of Baudelaire's poems, and you were left amazed, pensive, disconcerted by this art that crossed

the last frontier-lines of painting, borrowing from literature
its most subtle suggestions, from the art of the enameller its
most marvellous effects of brilliancy, from the art of the lapi-
dary and the engraver its most exquisite delicacies of touch.
These two images of Salomé, for which Des Esseintes' ad-
miration was boundless, were living things before his eyes
where they hung on the walls of his working study on special
panels reserved for them among the shelves of books. . . .

CERTAINES[3]

Cézanne

In full illumination, in porcelain compotes or on white
cloths, brutal, rough pears and apples, shaped with a trowel,
intensified with twists of the thumb. Seen close to, a rough
assemblage of vermillion and yellow, of green and blue; from
a distance, the correct one, fruits meant for Chevet's show
windows, full-flavored and savory, enviable.

And truths unnoticed until then become apparent, strange
and true tones, *taches*[4] with a singular authenticity, shadings
on the table linen, vassals of the shadows spreading from the
curves of the fruits and scattered in vague and charming trac-
eries of blue which make these canvases, works which initiate
one into mysteries, when compared to the usual still-lifes em-
bossed in bitumen on unintelligible backgrounds.

[3] Translated from J. K. Huysmans: *Certaines,* Paris, 1889, p. 41,
Cézanne.

[4] [The following note is from P. G. Hamerton, *Painting in France,*
Boston, 1895, p. 47–48:]
"The language of English art-criticism is as yet so poor that it
often takes a paragraph of explanation to say what one would ex-
press in French by a single word. *Le but de l'art de Manet est sim-
plement la tache.* I cannot translate this into English. Things are
seen in nature as variously colored patches enclosed by more or
less definite boundaries. The most advanced artistic way of seeing is
that which sees the patches in their true relation. Artists may be
classed according to the kind of truth they look for; for instance,
David used to say that the outline was everything, and that, once
a good outline obtained, his pupils might put within it whatever
they chose. Another theory is that modelling is everything, and
there is also a theory that the 'patch' (which on the whole is the
best English word I can find for *la tache*) is everything. . . ."

Then sketches of landscapes in the open air, attempts that remain in limbo, fresh attempts spoiled by retouching, childish and barbarous sketches, and finally dumbfounding imbalances; houses tilting to one side as though they limped; twisted fruits in drunken potteries; nude bathers, delineated by insane but entrancing lines, for the glory of the eyes, with the energy of a Delacroix, without the refinement of vision and the skillful fingers, whipped on by a fever of spoiled colors, clashing, in relief, on the overburdened canvas which bends in defeat!

In conclusion, a colorist of revelation, who contributed more than the deceased Manet to the impressionist movement, an artist with diseased retinas who, in the exasperated misperceptions of his sight, discovered the beginnings of a new art, this is how that too often forgotten painter, Cézanne, can be summed up.

He has not exhibited anything since 1877, when he showed, at Le Pelletier, sixteen canvases, the perfect integrity of whose art long amused the crowds.

[ODILON REDON (1840–1916) grew up on a remote estate near Bordeaux. When he failed the entrance examination for the Ecole, he studied sculpture in Bordeaux. After a brief period in Gérôme's studio in Paris, he returned again to Bordeaux where he had the good fortune to meet the talented painter and etcher, R. Bresdin, who urged him to follow his own artistic bent. When Redon did return to Paris (1858), he worked in Gérôme's studio briefly, but soon switched to that of Corot, whose sensitivity to tonal values approximated Redon's natural inclination. Attracted to Rembrandt's etchings, Redon went to the Netherlands to study his art. In 1868, Redon sent to the Bordeaux newspaper, *La Gironde,* a series of articles on that year's Salon which were critical of Courbet and naturalism.

After serving in the army in 1870, Redon resumed his career as an artist, and enjoying financial independence, he developed his art as he chose, limiting himself to a medium of black and white, charcoal and lithography, and in subject matter to representations of the forms that haunted his imagination and dreams. His work reflected his obsession with the horror of the power of the supernatural. His gift was to endow fantasy—as Bosch, Dürer, Goya, and Blake had—with a plastic

form that made it appear probable and therefore fascinating. His work anticipates the Symbolists, for his idea is contained in a form "perceptible to the senses," according to A. Aurier's definition, and was continued in Surrealism. The younger artists, E. Bernard, M. Denis, E. Vuillard, and the other "Nabis" became his admirers.

In 1881 Redon held his own exhibition at La Vie Moderne, unnoticed except by Huysmans who, in a note appended to his Salon of 1882, recognized Redon's affinity to Goya's fantasies and Poe's moroseness. Through Huysmans, Redon met Mallarmé, the leader of the literary symbolist movement, and with the publication of Huysmans' novel *Against the Grain* (1884) both became better known. Redon was engaged in illustrating Mallarmé's *Un Coup de dés* at the time of the poet's death. A lithographic series followed in quick succession: "Dans le Rêve" (1879), "Edgar A. Poe" (1882), "Les Origines" (1883), "Hommage à Goya" (1885), "La Nuit" (1886), and the illustration of Flaubert's *La Tentation de Saint Antoine* (1888).

Redon was a co-founder of the Société des Artistes Indépendants and exhibited with them at the first Salon des Indépendants in 1884. In 1886 and 1890 he was invited to exhibit with Les Vingts in Brussels. As a member of the "Order de la Rose-Croix du Temple et du Graal" founded by J. Peladan, Redon's work was exhibited with E. Bernard, F. Hodler, and Jan Toorop in its first Salon of 1892.

In 1892 Redon began to work in color, choosing pastels that possess properties similar to charcoal. His color, whether in pastel or in oil, arranged with an unerring sense of design, lends probability to the chimera of his imagination and forms an art that suggests rather than defines. *A Soi-Même*, published for a few intimate friends, shows him to have been a gifted writer, with the same qualities of sensitivity, obtuseness, and mysticism found in his figurative art.

In 1904 Redon participated with Rouault and Huysmans in the establishment of the Salon d'Automne where his work was exhibited alone. He was the largest single exhibitor in the New York Armory Show, 1913.

SEE: R. Bacon, *O. Redon*, Geneva, 1956.]

A SOI-MEME[1]

Here [in Gérôme's studio] at the so-called l'Ecole des Beaux Arts I worked hard to try to depict forms. These efforts were vain, useless and without external result for me. I may now confide to you, after having thought over my abilities and strength during my entire life, that I was moved to go to the Academy by a sincere desire to take my place in the sequence of other painters, being a student as they had been, and awaiting approval and justice from others. I did not take into account the type of art which would move me, nor my own temperament. I was tortured by the professor. Whether he recognized the sincerity of my disposition for serious study, or whether he saw a timid, willing student, he very obviously tried to innoculate me with his way of seeing and to make a disciple out of me—or to disgust me with art itself. He overworked me, was severe; his corrections were so vehement that his approach to my easel alerted my comrades. All was in vain.

He recommended that I enclose in a contour a form that I saw palpitating. Under pretext of simplifying (and why?), he had me close my eyes to light and neglect the vision of substances. I was never able to do this. I only sense shadows, apparent relief; all contours are doubtlessly abstractions. The instruction I was given was not suited to my nature. The professor had the densest, the most complete misunderstanding of my natural gifts. He did not understand me at all. I saw that his eyes were voluntarily closed to that which my eyes saw. Two thousand years of evolution or transformation in the manner of understanding optics were very little compared to the distance created by our two contrary spirits. I was there, young, impressionable and inevitably of my own time, listening to some rhetoric that issued somehow from the works of a certain past. With strength, the professor drew a stone, the base of a column, a table, a chair, and inanimate accessories, a rock and all inorganic nature. The student could only see expression, the expansion of feeling triumphing over forms. It

[1] Translated from Odilon Redon, *A Soi-Même* Journal (1867–1915), "Notes sur La Vie, L'Art et Les Artistes," Corti, Paris, 1961, pp. 21 ff, 83–84, 162–63.

was impossible that there should be any ties between them, impossible that they should join; it would have been a surrender that would have made the student into a saint, which was an impossibility.

Few artists have been forced to suffer that which I really suffered after this, gently, patiently, without revolting, in order to place myself, with the others, in the ordinary rank and file. The works which I sent to the Salon that followed this instruction, or rather this folly, of the studio had, as you can well imagine, the same fate as my student works. . . . I was forced to become different from others, independent, by this solitude in which I was left. I am grateful for it today. There is a whole production, a whole movement of art which now circulates outside the official channels. I was led to the isolation in which I am, by the absolute impossibility of practising my art in any other way than the way I have always done it. I cannot understand that which is called "concessions"; one does not make art as one wishes. The artist is the day to day recipient of transitory elements in his environment; he receives from outside sensations that he transforms in a way that is destined, inexorable, and stubborn, according to himself alone. There is no real production except when, through the necessity of growth, one has something to say. I would even say that the seasons affect him; they increase or decrease his enthusiasm: this effort, that experiment, attempted outside the influences that are revealed to him by gropings and experience, are unfruitful for him if he neglects them.

I believe that I have tried to guide my faculties; I have sought conscientiously to understand myself in the midst of the awakening and the growth of my own creation, and with the desire to present it perfectly, that is to say, whole, independent, as it should be for its own sake. Did I have a draughtsman's temperament or a painter's? What use trying to discover it today? The rather useless distinguishing of these two aspects by pedagogues has little importance. However through analysis we do distinguish them. The practice of drawing came to me later, brought through will, slowly, almost painfully. By drawing, I mean here the power of objectively formulating the representation of things or people according to their personal character. I have always attempted it in the name of exercise, and because it is necessary to evolve in the most essential element of the art one practices; but I also obeyed the promptings of line itself—in the same way I gave way to the charm

of chiaroscuro, I also forced myself to depict through small things, with the greater part of the details showing, and in relief, a fragment, a detail. This was the study which I found most attractive without bothering myself as to its usefulness. These fragments have been useful to me many times since in reconstituting entities and even in imagining them. That is the mysterious path of effort and of product, on the way towards destiny. It is sometimes decisive, and very clearly determined for some. It was often troubled and unclear for me; but I never lost sight of a higher end and did not resist the attraction I felt for other arts. I was a faithful auditor at concerts. I always had a good book in my hands.

My contemplative tendency made my efforts towards an optical system painful. When did I become objective, that is to say, a close enough observer of things, perceptive enough of nature in itself, to proceed to my ends and appropriate for my own use visible forms? It was around 1865. We were in the midst of Avant-Garde naturalism; Courbet was spreading real painting around by the palette knife-fulls. This misunderstood classicist had all the youth, who were true painters, in ferment. Millet also shook the spirits of the fashionable world by drawing the peasant in wooden shoes and in the rusticity of his passive and bare existence. I had a friend who initiated me into theory and, by example, into all the sensualities of the palette. He was my opposite pole in many things. This was the source of interminable discussions. We did landscapes together in which I forced myself to represent the true color. I succeeded in doing studies at that time which are, without a doubt and incontestably, painting. . . .

What was it that made production so difficult for me in the beginning and made it come so late? Was it an optical system that did not agree with my gifts? A sort of conflict between the heart and the head?—I do not know.

However it may be, from my beginning I have always attempted perfection, and if you will believe it, perfection of form. But, let me tell you now, that no plastic form, I mean to say, form objectively perceived for itself, according to the Laws of light and shadow, by the conventional means of "modeling," can be found in my works. At the most I frequently attempted, in the beginning, and because one must know everything in so far as it is possible, to reproduce visible objects according to that kind of art having an antique optical system. I only did it as an exercise. But I tell you today, in full

conscious maturity, and I insist upon it, all my art is limited
to the sole resources of chiaroscuro. It also owes much to the
effects of abstract line, that agent springing from great pro-
fundity, and acting directly on the spirit. Suggestive art can-
not give anything without having recourse to only the mys-
terious play of shadows and to the rhythm of intellectually
conceived lines. Ah! did they ever have a higher result than
in the works of da Vinci! He owes to them his mystery and
the fertility of the fascination he exercises over our spirits.
They are the roots of the words of his language. And it is also
through perfection, excellence, reason, docile submission to
the laws of nature, that this admirable and sovereign genius
dominates all the art of forms. He dominates it even to their
essence! "Nature is full of infinite reasons which have never
been a part of experience," he wrote. It was for him, as it
assuredly was for all the masters the evident necessity and
the axiom. What painter would think otherwise!

It is nature also who commands us to obey the gifts it has
given us. Mine led me into dreams; I have experienced the
torments of the imagination and the surprises it has created
under my pencil; but I have conducted them and led them,
those surprises, according to the organic laws of art that I
know, that I feel, with the sole end of giving the onlooker,
through a subtle attraction, all the evocation, all the attrac-
tion of the uncertain at the boundary of thought. Nor have I
said anything that was not largely anticipated by Albert Dürer
in his woodcut "Melancholy." One might think it incoherent.
No, it is written, it is written according to line alone and its
powerful attributes. It is a grave and profound spirit which
rocks us there like the rapid and involved notes of a strict
fugue. After him we can only sing shortened motifs of a few
measures.

Suggestive art is like a radiation of things for a dream to-
wards which thought also tends. Decadent or not, this is the
way it is. Let us rather say that it is growth, evolution of art
for the soaring of our own life, its expansion, the highest peak
from which it takes flight or the moral maintenance of nec-
essary exaltation.

This suggestive art is entirely in the provocative art of
music, more freely, radiantly; but it is also in mine through
a combination of diverse elements gathered together, of
forms transposed or transformed, without any relation to con-
tingencies, but having a logic all the same. All the mistakes

that the critics made about me, when I began, came from the fact that they did not see that nothing must be defined, understood, limited, explained, because everything which is new, sincerely and docilely—like beauty, by the way—carries its significance within itself.

Designating my drawing by giving them a title is sometimes to designate too much. On them a title is only justified when it is indeterminate and even confusedly aiming at the equivocal. My drawings INSPIRE and cannot be defined. They determine nothing. They place us, as does music, in the ambiguous world of the indeterminate.

They are a type of METAPHOR, said Remy de Gourmont, in placing them apart, far from all geometric art. He sees in them an imaginative logic. I believe that this writer said in a few lines more than everything which had formerly been written on my early works.

Imagine arabesques or varied meanders, unrolling themselves, not on a plane, but in space, with all that the profound and indeterminate margins of the sky would furnish the spirit. Image the play of their lines projected and combined with the most diverse elements, including that of the human face; if this face has the particulars of those that we see daily in the street, with its fortuitous truth immediately real. Here you will have the ordinary combination of many of my drawings.

They are therefore—without an explanation that could be any more precise—the repercussion of a human expression, placed by an allowable fantasy in an interplay of arabesques, where, I sincerely believe, the action which will result from this in the spirit of the onlooker, will inspire him to fantasies whose significance will be great or small, according to his sensibility and the aptitude of his imagination to enlarge or to diminish all things.

And again, everything is derived from universal life; a painter who did not draw a wall vertical would draw badly because he would turn the mind away from the idea of stability. He who did not draw water horizontal would do the same (to only cite very simple phenomena). But there are in the world of plants, for example, secret and normal tendencies of life which a sensitive landscape artist cannot ignore: a tree trunk, with its characteristic of strength, throws out its branches according to the laws of growth and according to its vitality, which a true artist should feel and depict.

It is the same with animal or human life. We cannot move

our hand without moving our entire being, in obedience to the law of gravity. A draughtsman knows this. I believe I have obeyed these intuitive indications of instinct in the creation of certain monsters. They do not show, as Huysmans insinuated, the help of a microscope in front of the frightful world of the infinitely small. No. In constructing them I took the greatest care to organize their structures.

There is a kind of drawing that imagination has liberated from the embarrassing care of real details to serve with freedom only for the depiction of imagined things. I have done some fantasies with the stalk of a flower or the human face, or also with elements derived from skeletons, which are, I believe, designed, constructed, and built as they should be. They are so because they have an organism. Every time that a human figure does not give the illusion that it is going to, as one might say, step out of the frame to walk, move, or think, really modern drawing is not present. I cannot have taken from me the merit of giving the illusion of life to my most unreal creations. My whole originality consists therefore in making illogical beings come humanly alive according to the laws of logic, in putting as far as possible, the logic of the visible at the service of the invisible.

This drawing comes naturally and easily from the vision of the mysterious world of shadows to which Rembrandt gave the word in revealing it to us. But on the other hand my most fruitful working conditions, the most necessary to my growth were, I have often said it, to copy reality directly by carefully reproducing the objects of external nature in its smallest, most personal and accidental aspects. After making the effort of copying minutely a pebble, a blade of grass, a hand, a profile or any other item of organic or inorganic life, I feel a mental foaming coming on. Then I find it necessary to create, to let myself go in the representation of the imaginary. Nature dosed and steeped in this manner becomes my source, my leaven, my yeast. From this source I believe my true inventions come. I believe it of my drawings. And it is probable that even with the great part that weakness, inequality and imperfection play in everything that man creates, sight of them could not be endured for a moment (because the drawings are humanly expressive) if they were not, as I have said, formed, constituted and built according to the law of life and to the moral transmission necessary to everything that is.

Dimensions: Their Relationship to the Subject

In the great masters an exuberance of means may be seen that they do not themselves appear to realize. Their strength carries them too far; often they exceed the material limits in which they should frame their thoughts. The exaggeration into which they fall most easily is an excessive dimension of the surface upon which they draw or paint. Before or after having found the correct measure for the representation of their subject, or even simultaneously, they sometimes exceed it, and do not limit themselves to it. Genius is swelling, and producing fruits that are abundant but less than excellent.

Dürer did this when he cut into wood designs so large that they were more suited to the decoration of an apartment than of a book. Rembrandt, in spite of his genius with etching, could not help attempting very large plates; and it is easy to judge how far these are from the perfection which shines from the plates of ordinary dimension.

It is the same with painters and even more so, because it is easier in this art, which is obviously less limited than engraving, to let oneself go with the charm, the ambition of great productions.

The most perfect works have been produced in the dimensions indicated by taste and reason: but these dimensions that a mediocre artist finds easily, seem in more inspired artists, to be more the effect of accident than of conscience.

It would be interesting to find out what the works have been that were treated within pre-determined, absolute dimensions and to observe to what degree they have bloomed under different painters. . . .

Reflections on an Exhibit by the Impressionists

It is to be feared that Berthe Morisot[2] has already shown the measure of her talent; she is like a flower that has given its perfume and which fades, alas!, like all exquisite and passing blooms. Perhaps the only woman who has had ability as a painter. She has given some charming and very distinguished notes in this concert of uncompromising ones who now group themselves only under the banner of the independent artist.

[2] [Berthe Morisot (1841–95), French painter, influenced by Manet.]

In any case Berthe Morisot retains the marks of an early artistic education which sets her distinctly apart, with Degas, from that group of artists whose rules and formulas have never been clearly announced. Look at these water colors produced with such liveliness, these "taches," extremely subtle and feminine, they rest upon indications, linear intentions, which give her charming works an accent which is truly finer, more delicately formulated than that of others.

This is not to deny the entire legitimacy of those workers who never forget to place on the fronton of their temple (if there is a temple): EXPOSITION OF PAINTING. This slightly pretentious emphasis is readily permitted them when it is compared with so many others who are practically nothing and who fill the official galleries with their sad and heart-rending productions. What is their goal, what do they aim at?

They only wish to disengage light or color from its last attachments to classic painting. Classicists themselves, because they cede to this external ideal of concrete painting, they hope to put painting on the true terrain of hues used for the hue itself. The germs of this way of understanding the magnificent art of painting are in the last works of Corot and Millet. They manage, without opposing surfaces, without organizing planes, to produce vibrations of the tone that are viewed through the juxtaposition of a gray which disappears with distance and which produces a result at a distance of several paces from the painting. A type of painting which is very legitimate, especially when it is employed in the representation of exterior things in the full light of the sky. I do not believe that everything which moves behind the forehead of a man who listens to himself and meditates has anything to gain—I do not believe that THOUGHT taken for what it is in itself—has anything to gain by this stubbornness in only considering that which takes place outside our dwelling places. The expression of life can only appear different in chiaroscuro. Thinkers love the shadow, they walk in it, enjoy themselves in it, as if their brains found it their ELEMENT. Everything considered, these most estimable painters will not sow very fertile fields in the rich domain of art. "Man is a thinking being." Man will always be there in time, in duration, and everything which belongs to life cannot put him aside. On the contrary the future belongs to the subjective world.

Degas, the greatest artist certainly of this group, is a

Daumier holding his palette. It is the same deep and accurate observation of Parisian life.

(April 10, 1880.)

[EDVARD MUNCH (1863–1944), one of the founders of Expressionism and a representative of the "symbolistic" decade at the end of the nineteenth century, was born in Loyten, Norway, where his father was a physician. Munch studied at the School of Arts and Crafts and took private painting lessons. His literary interests brought him into the Kristiania-Boheme, an Oslo group led by the social radical poet Hans Jaeger, and to the brilliant Norwegian writers Ibsen, Knut Hamsun, and August Strindberg.

After a brief trip to Paris (1885), Munch began painting subjects related to death and states of psychic transitions, with a realism similar to Courbet and W. Liebl. "The Sick Girl," the first in a long series on this theme, is Munch's fusion of expressionism and naturalism into a haunting image.

After Munch's first exhibition in 1889, a government award enabled him to study until 1892 in Paris. Munch worked briefly in Léon Bonnat's studio, then by himself, and studied contemporary art on view in Paris. The centenary exhibition of French art, and a collection of Japanese prints, was at the World's Exposition. The Impressionist and Synthetist Groups were on exhibition at the Café Volpini. Théo van Gogh's gallery showed the work of Gauguin and van Gogh. Seurat's division of color offered him a method that lent itself to his expressionism. He used the "pointillist" style of painting in "Gambling Hall at Monte Carlo" (1892) and "The Kiss by the Window" (1892).

"The Frieze of Life" (1892) marked a turning point in his art style. This was a sequence of decorative pictures "which would collectively present a picture of life." A firm outline enclosing a flat surface of color, similar to that of Gauguin and the Nabis, was used for "The Cry" (1893), "Anxiety" (1894), "Melancholy" (1895).

Munch was invited by the "Verein Berliner Kuenstler" to exhibit with them in 1892. His fifty-five paintings presented such a shocking contrast to the traditional art represented there that the exhibition was closed. This Berlin episode had

a marked effect on the formulation of German expression-ism. A group of German progressive painters, among them Max Liebermann and Munch, held a separate exhibition in 1893. This group withdrew from the "Verein" to found "The New Secession" (1889), followed by similar groups, the Munich Secession (1893) and the Vienna Secession (1897). Munch lived in Berlin 1892–95. As his own style of expressive undulating lines matured, it contributed to the evolution of "Jugendstil" or "art nouveau."

Munch turned his talent to graphic art. The "New Secession" magazine, *Pan,* founded in 1895, included his lithographs with Toulouse-Lautrec's, Signac's, and others.' The first of his dramatic woodcuts, cut in 1896, contributed to the revival of that graphic art.

Munch designed the sets for Ibsen's *Peer Gynt,* produced by Lugné-Poë at the Theatre de l'Oeuvre, a center of Nabis activity. At the same time his paintings which comprised the "Frieze of Life" were exhibited at Siegfried Bing's Galerie de l'Art Nouveau.

Munch continued his stage designing in Berlin with sets for Max Reinhardt's notable production of Ibsen's *Ghosts* in 1906.

Among Munch's last works were four splendid murals for the University of Oslo.

Munch's talent enabled him to create symbolic images with universal meaning. His residence in Norway, France, and Germany and the exhibition of his work in these countries contributed to the creation of an international European art style.

SEE: F. B. Deknatel, *Edvard Munch* Catalogue, Museum of Modern Art, 1950.]

IMPRESSIONS FROM A BALLROOM, ST. CLOUD, 1889[1]

The Artist's Own Observations

A strong naked arm—a powerful tanned neck—a young woman leans her head against the curve of his chest. She shuts her eyes and listens with open, vibrant lips to the words he whispers into her long trailing locks. I was going to fashion

[1] Translated from Johan H. Langaard and Reider Revold, *Edv. Munch Fra Ar til Ar,* Oslo, Aschehoug, 1961, p. 83. [I am grateful to Dr. F. B. Deknatel for this text.]

it as I now saw it, but in a blue haze. The two of them, at a moment when they are no longer themselves, but merely one link out of the thousands of genealogical links that unite one generation with another.

People would understand what was sacred and great about it, and they would take off their hats as though they were in church—I was going to produce a great many pictures of this kind.

No longer would interiors be painted, pictures of people reading and women knitting—there would be living people, breathing and feeling, suffering and loving; I felt I should do this—it would be so easy. The flesh would take shape and the colours would live.[2]

[PAUL GAUGUIN (1848–1903) was born in Paris, the son of a journalist from Orléans who lost his employment with the restoration of the monarchy in 1851. The family embarked for Peru where Mme Gauguin's cousin was president of the country, and remained four years in Lima, until the receipt of an inheritance brought them back to Orléans, where Gauguin went to school. Ambitious to enter the navy, but not admitted to the examinations for the naval academy, Gauguin enrolled in the merchant marine in 1868 and served until 1871. Gauguin was then successfully employed in a brokerage firm. In his leisure, Gauguin began to paint and sculpt and had a small landscape accepted for the Salon of 1876. At this time, Gauguin met Camille Pissarro (1830–1903), his first and only teacher, who had come from the Danish colony of the Antilles Island. Through him, Gauguin met Manet, Monet, Cézanne, Renoir, and others who, under the title "Impressionists," had held their first exhibition in 1874. Gauguin exhibited with them in the Fifth Impressionist Exhibition of 1880. By 1883 Gauguin, confident of his ability to succeed as a painter, left the brokerage firm. After eight months without funds, he moved his family to Copenhagen, the home of his wife, where he acted as a representative for a French firm. He sent his work to an exhibition in Oslo (Kristiania) in 1885.

[2] [In his diary Munch made a drawing illustrating this scene, with the woman's head leaning against the man's chest. There are two paintings by Munch on this subject. I am grateful to J. H. Langaard of the Munch Museum for this note and illustration.]

His brother-in-law was the Norwegian landscapist F. Thaulaw. Unable to earn enough and finding Copenhagen uncongenial, Gauguin left his family and returned to France in 1885. From then on until the end of his life, he was seldom free from financial distress and his search for a place where he could work creatively at a minimum cost.

In the spring of 1887 Gauguin sailed to Martinique in the Antilles where he had visited as a sailor. A year later, ill and destitute, he returned to Paris, and Schuffenecker took him into his studio. Gauguin now worked in ceramics and wood carving. After Gauguin's first one-man exhibit, arranged by Théo van Gogh in 1888, Gauguin joined Vincent van Gogh at Arles, where both were supported by Théo in return for their paintings. After van Gogh's mental collapse, Gauguin alternated for two years between Le Pouldou, a village near Pont Aven, and Paris. At the World Exposition of 1889, Gauguin "discovered" Japanese art. This strengthened the sure sense of decorative design he had been developing and encouraged his use of flat planes of primary color enclosed with dark contour lines. At Pont Aven where E. Bernard, Sérusier, and others were working, and in discussions with them Gauguin evolved the theory of "synthetism" that called for a simplification of lines, colors, forms, and a suppression of all detail in order to achieve intensity. They looked to Poussin, Ingres, Puvis de Chavannes as their precursors, and to Japanese prints and the "primitives" as their prototypes. Some of his finest work, "Christ Jaune," "Lutte de Jacob," is of this period. In 1889 Gauguin exhibited his work with the Synthetists at the Café Volpini. His circle of acquaintances widened, for he frequented the Café Voltaire where the symbolists gathered: the writers Verlaine, A. Aurier, C. Morice; and the artists Rodin, Carrière, and others. He shared with Verlaine, Mallarmé and Huysmans the desire to escape contemporary life by flight to the remote and symbolic.

Restless and seeking isolation, he picked up a brochure of Tahiti and decided to go there. He offered thirty canvases for sale and with the proceeds left for Tahiti. He returned in 1893 and exhibited at Durand-Ruel forty-nine paintings and two pieces of sculpture. The unfamiliar subject matter prevented a general comprehension of Gauguin's intention, but his color harmonies and manner of composition made a profound impression on the younger artists. Gauguin decided to return again to Tahiti. He asked the friend of Edvard Munch, the

well-known Norwegian playwright, August Strindberg—with whom Gauguin had lived briefly in 1893—to write the catalogue preface. Strindberg's letter of refusal was used by Gauguin for the preface. Gauguin returned to Tahiti in 1895, living first at Papeete, then at Dominique in the Marquesas archipelago, where he died two years later. Paintings of his last period are "Nevermore," "Te Rerioa," "Trois Tahitiens," "Whence Come We?" and "Contes Barbares."

On his return from Tahiti in 1893, Gauguin wrote an account of his life there in *Noa-Noa* ("perfume" in Maori). Five of the eleven chapters, accounts of the ancient kingdom of Taaroa, were contributed by Charles Morice. To Gauguin's distress, Morice delayed the publication until 1901, and then because of his alterations Gauguin disapproved the edition. An exact text was published in 1924. Gauguin's article "Avant et Après" (1902) was published in the *Mercure de France*. He formulated his aesthetic principles in Racontars d'un Rapin (1902) and attempted to set down laws of color analogous to the laws of music in his *Notes Eparses*. The "Genèse d'un Tableau" is his explanation of his painting "L'Esprit des morts veille."

In Tahiti in August 1899 he started a satirical sheet *Le Sourire* which he illustrated with woodcuts, but only eight issues were published. He continued to do woodcuts after his move to the Marquesas.

Gauguin tried to discover the content and meaning of art, of which the Impressionists had lost sight in their concern for the appearance of things. He endeavored to find a new kind of figure painting that could claim to be a universal human symbol; therefore the invented form had to be free from "the illusion of the object." He insisted that any impression received from nature must be subjected to the mind for selection, arrangement, and synthetization. As he had been strongly influenced by Lecoq's method of memory training, he advised young artists to paint from memory what they had observed and correct the real perspective to make it believable. He urged his friends to treat religious subjects, the products of meditation. Paul Séursier and Maurice Denis utilized his expressive technique as the basis for French "art sacré." Gauguin exerted a strong influence on associates.

Gauguin's work is important in the symbolic and expressionistic use of color, a development that began with the first

romanticists, Runge and Blake, and continued through Gauguin to the Fauvism and into abstract expressionism.

SEE: J. de Rotoonchamp, *Gauguin,* Paris, 1925, 1925 ed.]

LETTER TO DANIEL DE MONFREID[1]

Papeete, Feb. 11, 1898

. . . I assure you I had resolved to die last December. But before dying I wished to paint a great picture which was in my head, and for that whole month I worked at it night and day in a tremendous fever. I can tell you, it isn't a picture like Puvis de Chavannes's, with studies from nature, preliminary cartoons, and all the rest of it. The whole thing is done offhand, with a coarse brush, on a piece of sacking full of knots and wrinkles, so its appearance is terribly rough.

They will say it has been left unfinished. It is true that one is not a good judge of one's own work, but, all the same, I believe not only that this canvas is better than all that have gone before, but in fact that I shall never do anything better or approaching it. Before dying I have put into it all my energy, so much passionate pain and a vision so clear that it needs no correction and conceals the hastiness of the work, bringing it all to life. This does not stink of the model, the craft, and the alleged rules—from which I have always emancipated myself, though sometimes with apprehension.

It is a canvas measuring fourteen feet nine inches by five and a half feet in height. The two upper corners are chrome yellow, with the inscription on the left and my signature on the right, like a fresco damaged at the corners and applied on a golden wall. Below on the right a baby asleep, then three women squatting on the ground. Two figures dressed in purple are confiding their reflections to each other; a figure, purposely drawn huge in spite of perspective, raises its arms and looks with astonishment at these two personages who dare to think of their destiny. A figure in the centre is plucking fruit. Two cats beside a child. A white goat. The idol, raising its two arms mysteriously and rhythmically, seems to foreshadow the future state. A seated figure appears to be listening to the

[1] Quoted from Pola Gauguin, *My Father Paul Gauguin,* translated from the Norwegian by Arthur G. Chater, New York, Alfred A. Knopf, and London, MacMillan Publishing Company, 1937, pp. 248-50.

idol; then an old woman near to death seems to accept it, resigning herself to her thoughts, and she brings the legend to an end; at her feet a strange bird, holding a lizard in its claws, represents the futility of empty words. The scene is by a stream in the woods. In the background the sea, then the mountains of the neighbouring island. In spite of the transitions of tone the aspect of the landscape from one end to the other is blue and Veronese green. From this all the nude figures stand out in a bold orange. Supposing one were to say to the pupils of the Beaux-Arts competing for the prix de Rome: "The picture that you have to paint is to represent: 'Whence do we come? Who are we? Whither are we going?' "—what would they make of it? I have finished a philosophical work on this theme compared with the Gospel; I think it's good. If I feel strong enough to copy it out, I will send it to you.

NOTES EPARSES[2]

It was in the days of Tamerlane,[3] I think in the year X, before or after Christ. What does it matter? Precision often destroys a dream, takes all the life out of a fable. Over there, in the direction of the rising sun, for which reason that country is called the Levant, some young men with swarthy skins, but whose hair was long, contrary to the custom of the soldier-like crowd, and thus indicated their future profession, found themselves gathered together in a fragrant grove.

They were listening, whether respectfully or not I do not know, to Vehbi-Zunbul Zadi, the painter and giver of precepts. If you are curious to know what this artist could have said in these barbarous times, Listen.

Said he: "Always use colours of the same origin. Indigo makes the best base; it turns yellow when it is treated with spirit of nitre and red in vinegar. The druggists always have it. Keep to these three colours; with patience you will then know how to compose all the shades. Let the background of your paper lighten your colours and supply the white, but never leave it absolutely bare. Linen and flesh can only be painted by one who knows the secret of the art. Who tells you

[2] Quoted from *Paul Gauguin's Intimate Journals;* translated by Van Wyck Brooks, Crown Publishers, New York, 1936, pp. 68–75.
[3] [In this tale Gauguin explains his technique.]

that flesh is light vermilion and that linen has grey shadows? Place a white cloth by the side of a cabbage or a bunch of roses and see if it will be tinged with grey.

"Discard black and that mixture of white and black they call grey. Nothing is black and nothing is grey. What seems grey is a composite of pale tints which an experienced eye perceives. The painter has not before him the same task as the mason, that of building a house, compass and rule in hand, according to the plan furnished by the architect. It is well for young men to have a model, but let them draw the curtain over it while they are painting. It is better to paint from memory, for thus your work will be your own; your sensation, your intelligence, and your soul will triumph over the eye of the amateur. When you want to count the hairs on a donkey, discover how many he has on each ear and determine the place of each, you go to the stable.

"Who tells you that you ought to seek contrast in colours?

"What is sweeter to an artist than to make perceptible in a bunch of roses the tint of each one? Although two flowers resemble each other, can they ever be leaf by leaf the same?

"Seek for harmony and not contrast, for what accords, not for what clashes. It is the eye of ignorance that assigns a fixed and unchangeable colour to every object; as I have said to you, beware of this stumbling-block. Practise painting an object in conjunction with, or shadowed by—that is to say, close to or half behind—other objects of similar or different colours. In this way you will please by your variety and your truthfulness—your own. Go from dark to light, from light to dark. The eye seeks to refresh itself through your work; give it food for enjoyment, not dejection. It is only the sign-painter who should copy the work of others. If you reproduce what another has done you are nothing but a maker of patchwork; you blunt your sensibility and immobilize your colouring. Let everything about you breathe the calm and peace of the soul. Also avoid motion in a pose. Each of your figures ought to be in a static position. When Oumra represented the death of Ocraï as of a victim who inspires him with pity, the mother, leaning against a pillar, reveals her hopeless grief in this giving way of her strength and her body. One can therefore without weariness spend an hour before this scene, so much more tragic in its calm than if, after the first moment had passed, attitudes impossible to maintain had made us smile with an amused scorn.

"Study the silhouette of every object; distinctness of outline is the attribute of the hand that is not enfeebled by an hesitation of the will.

"Why embellish things gratuitously and of set purpose? By this means the true flavour of each person, flower, man or tree disappears; everything is effaced in the same note of prettiness that nauseates the connoisseur. This does not mean that you must banish the graceful subject, but that it is preferable to render it just as you see it rather than to pour your colour and your design into the mould of a theory prepared in advance in your brain."

Some murmurs were heard in the grove; if the wind had not carried them off, one might perhaps have heard such evil-sounding words as Naturalist, Academician, and the like. But the wind made off with them while Mani knit his brows, called his pupils anarchists, and then continued:

"Do not finish your work too much. An impression is not sufficiently durable for its first freshness to survive a belated search for infinite detail; in this way you let the lava grow cool and turn boiling blood into a stone. Though it were a ruby, fling it far from you.

"I shall not tell you what brush you ought to prefer, what paper you should use, or in what position you should place yourself. This is the sort of thing that is asked by young girls with long hair and short wits, who place our art on a level with that of embroidering slippers and making toothsome cakes."

Gravely Mani moved away.
Gaily the young men rushed away.
In the year X all this took place.

[MAURICE DENIS (1870–1943), painter and writer, lived all of his life at St. Germain-en-Laye, a suburb of Paris. He attended the Lycée Condorcet where Mallarmé instructed in English, and his lifelong friends and associates, the future painters Vuillard and F. X. Roussel and the actor-director Lugné-Poë, were also pupils. When Denis, Vuillard, and Roussel went to the Académie Julian (1888), they were joined by Pierre Bonnard (1867–1947). The student-in-charge was Paul Sérusier (1863–1927). This group, influenced by Gauguin's

paintings in the exhibition of "Peintres Symbolistes et Synthetistes" held at the Café Volpini in 1889, formed themselves into the "Nabis," a corruption of the Hebrew word "Nebiim" meaning "prophets." Their theoretical concepts were influenced by Sérusier who had worked with Gauguin at Pont Aven, Brittany. Denis shared a studio with Vuillard, Bonnard, and Lugné-Poë, and all of them frequented Mallarmé's Tuesday evening gatherings. On Lugné-Poë's request, Denis formulated the "Nabis" aesthetic theory, and with it a new definition of a painting, in *The Definition of Neo-Traditionalism,* published in 1890. This important "Manifesto of Symbolism," as Denis later described it, in which his exact meaning is obscure at times, provided the theoretical basis for the Fauves and subsequent abstract artists.

The Nabis formed the nucleus of the group that played a decisive part in the movement that fostered the integration of the arts. They were associated with architecture as decorators, with the theater as stage designers, with literature as illustrators, and they opened new fields in the graphic arts by designing posters and theatrical programs. A conspicuous example in architecture are the murals of Denis, Roussel, and Vuillard in August Perret's ferro-concrete Théâtre des Champs Elysées. The "Revue Blanche" (1891), established by the Natanson brothers, did much to spread the influence of the symbolists, the Nabis, and Denis' theory. It published the symbolist writers, Gide, Proust, and others, the critics' explanations of the movement in the visual arts, and prints executed by the Nabis, Munch, and those stylistically related to them.

Denis' early paintings are illustrative of his theory. The forms are free from modeling, which was held to be superfluous, for meaning can be present only in lines and color. His fluid outlines and flat color show him stylistically dependent on Gauguin, and as a contributor to the evolution of the style known after 1896 as *l'art nouveau.* Illustrative of the intellectualizing and romanticizing tendency present in the Nabis, was Denis' painting "Hommage à Cézanne" (1900), a return to the classical "Apotheosis," a gathering of men of genius to glorify a genius, for which Ingres' "Apotheosis of Homer" (1827) and Henri Fantin-Latour's (1836–1904) "Hommage à Delacroix" (1864) were the immediate antecedents. Denis grouped his selection of gifted men, with Redon in their cen-

ter, to pay homage to Cézanne's creative power symbolized by a still-life painting.

Profoundly religious, Denis endeavored to free the contemporary religious art from its meaningless stereotypes, and did much for the creation of new forms in religious art. He and Sérusier shared the thought of the century's early Romanticists, that when the mind of an artist is devoted to exalted thoughts his art may become a transfiguration of nature. They looked to a harmony of forms based on correct measurements, such as the "golden section" of the ancients used by Seurat, or *Les Saintes Mesures* of Père Didier, to effect the transfiguration of their artistic productions.

Denis' importance was in being the spokesman for the new art concepts. As he perfected his style, his writings—notably *Charmes et leçons d'Italie* (1913)—have literary value. His essays (1890–1919) were published in *Théories* (1912) and *Nouvelles Théories,* a second volume of essays, followed in 1921. *Sérusier, Sa Vie, Son Oeuvre* (1942), written in memory of his collaborator, was published shortly before Denis' death in an auto accident in 1943.

SEE: Paul Sérusier, *A.B.C. de la peinture,* Paris, 1912.]

DEFINITION OF NEO-TRADITIONALISM[1]

I. Remember that a picture before it is a war horse, a naked woman, or some anecdote, is essentially a flat surface covered with colors arranged in a certain order.

II. I seek a painter's definition of that simple word "nature" which labels and sums up the most generally accepted art theory of this *fin de siècle.*

Probable: The sum of optical sensation? But, without mentioning the natural disturbances of modern eyes, who does not know the power of the mind's habits upon vision. I have

[1] Translated from Maurice Denis, *Théories:* 1890–1910, Paris, L'Occident, 1912, pp. 1–13.

The book is composed of various writings that have appeared in different publications. The first were written more than twenty years ago at the request of Lugné-Poë for *Art et Critique,* (23rd & 30th of August 1890) under the bizarre title "Definition of Neo-Traditionalism." It was a Manifesto of Symbolism. [From First Preface. The footnotes are by the editor.]

known young people to involve themselves in tiring optical gymnastics to be able to see the "trompe-l'oeil" in the *Le Pauvre Pêcheur:*[2] and they managed to do it, I know. M. Signac will prove to you by absolutely impeccable scientific means the necessity of his [own] chromatic perceptions.[3] And M. Bouguereau, if the corrections he makes in his studio are sincere, is convinced that he is copying nature.[4]

III. Go to the museum and consider each canvas separately, isolating yourself from the rest: each will give you, if not a complete illusion, at least an aspect of nature that pretends to be true. You will see in every picture what you wanted to see there.

If it is true that one comes by an effort of willpower to see "nature" in pictures, the reverse is also true. There is an undeniable tendency of painters to assimilate aspects [of objects] perceived in reality with the aspects already observed in painting.

It is impossible to determine all that might modify modern vision, but there is no doubt that the intellectual fever through which most young artists pass can create very real optical anomalies. It is very easy to see some grays as violet after spending much time deciding if they were or were not violet.

The irrational admiration of ancient pictures in which conscientious renderings of "nature" are sought—since they must be admired—has certainly deformed the eye of the masters of the Ecole.

Other disturbances arise from the admiration of modern paintings which are studied with the same spirit, or with a real taste for them. Has it been noticed that this undefinable "nature" is perpetually modifying itself, that it is not the same at the Salon of 1890 as at the salons of thirty years ago, and that there is a "nature" *à la mode*—a fancy as changeable as hats and dresses?

IV. In this way, by choice and by synthesis, a certain eclec-

[2] By Puvis de Chavannes (1824–98), painter, muralist, leader among the independents, whose studio became a school that continued the tradition of classical, decorative painting.

[3] Paul Signac (1863–1935), who with Seurat developed the art and theory of "neo-impressionism," and wrote *D'Eugène Delacroix au Neo-Impressionnisme,* 1899.

[4] Bouguereau, W. A. (1825–1905) winner of *grand prix* de Rome 1850, teacher at Beaux Arts for twenty-five years, Academician, an extremely popular painter, who became symbol of official art.

tic and exclusive habit of interpreting optical sensations is formed—which becomes the naturalistic criterion, the selfness of the painter, that which writers will later call temperament. It is a type of hallucination in which esthetics has no part, because reason entrusts itself to it and does not control it.

V. When one says that nature is beautiful, more beautiful than any painting, supposing that one remains in the conditions of esthetic judgment, one means to say that one's own personal impressions of nature are better than those of others, a thing which must be recognized. But what if one wishes to compare the hypothetical phantasy and the phantasmal—the fullness of the original effect, and the notation of this effect by this or that mind? Here the great question of temperament presents itself: "Art is nature seen through a temperament."

A very accurate definition because it is a very vague one, which leaves the important point uncertain: the criterion of temperament. Bouguereau's painting is nature seen through a temperament. M. Raffaelli is an extraordinary observer, but do you believe he is sensitive to beautiful forms and colours?[5] Where does the "painter's" temperament begin or end?

There is a science—do you know it?—which concerns itself with these things: esthetics, which establishes itself and defines itself, thanks to the practical researches of Charles Henry and to the psychology of Spencer and of Bain.

Before externalizing one's sensations just as they are, their value from the point of view of beauty should be determined.

VI. I do not know why painters have so misunderstood the epithet "naturalist" applied in a purely philosophical sense to the Renaissance.

I admit that "les Prédelles" by Angelico which is in the Louvre, "The Man in Red" by Ghirlandaio, and a number of other works by the primitives, remind me of "nature" more exactly than Giorgione, Raphael, or da Vinci. It is another way of seeing—these are different phantasies.

VIII. I do recognize that there is a large possibility that general opinion in this as in other insoluble questions, has some value—that a photograph shows the lesser or greater reality of a form and that a cast from nature is as "natural as is possible."

[5] J. F. Raffaelli (1850–1924), painter, sculptor, engraver, lithographer, whose success with representations of Parisian life permitted him to hold his own exhibitions. Member of impressionist group.

I will therefore say of this sort of work and of those which approach it, that they are "natural." I will call "Natural" the *trompe-l'oeil* of the public, like those grapes of the ancient painter, pecked by the birds, and the panoramas by Detaille[6] —where one is uncertain whether a certain canon in the foreground is real or on canvas.

IX. "Be sincere: it is sufficient to be sincere to paint well. Be naive. Paint simply what is seen."

What good reliable machines of rigorous exactitude one wanted to manufacture in the academies!

X. Those who frequented Bouguereau's studio received no other teaching, than on that day when the master pronounced: "The joints—that is drawing."

The anatomical complexity of the joints had fixed itself in his poor head as an extraordinary and desirable thing! Drawing is joints! The poor people who think this resembles Ingres! I would not be surprised if as an after-thought he felt he had improved upon Ingres. In naturalism he certainly has! He photographs.

It is in all this that we find the minor painters, who are today's masters. From the effervescence of romanticism, from the frequenting of Italian museums, from the obligatory admiration of the old masters, they have kept a vague memory of some motifs of the old masters—forever incomprehensible —to the distortion of their esthetic . . .

XI. The factors responsible for Meissonier's[7] reputation are: a) That distortion of intimate Dutch compositions. b) The literary spirit, abundantly (the cast of Napoleon's features, grotesque to us, borders on the sublime for the majority). The expressive heads are very humorous, the naive player, the clever man, the lighthearted, and the ironical. c) Above all the skill in execution, which makes us cry without reserve: "That is strong!"

XIII. A modern master said to one of the young neo-traditionalists, then still in school, *à propos* a very pale woman he had painted on whom the light played in rainbow arcs—and it was this colour which interested him, he had sought it for a whole week—"that is not natural, you would not go to bed

[6] Edouard Detaille (1848–1912), a pupil of Meissonier, the exponent of photographic, historical realism.

[7] J. L. Meissonier (1815–91). Illustrator, painter of *genre* scenes with accuracy of the Dutch school, a master of the *juste milieu*.

with that woman!" How much could be said from this point of view upon the morality of a work of art! Compare the symbols of the Phoenicians and the Hindus with pornographic photographs: the nudes of Chavannes, of Michelangelo, Rodin's scenes of passion, with what? With analytical works, with their *trompe-l'oeil,* amusing lewdness in the eyes of artless young men and old libertines; all the Baths, the Temptations, all the Andromedas, all the Models, all the Studies of the "young Academy" in the last fifteen Salons!

XIV. But have you noticed that presentiment of a return to beautiful things in the Impressionists? Manet is in the great tradition, that is known. All their imitators come from it to a search for more specially coloured bits of nature; the effects of sunlight, lanterns in the night, orientalism, the aurora borealis.

And they spoil the savour of their preliminary sensation, uniquely made of that special colour, by their disdain for composition and their concern to make it natural! Above all by the exasperating mania entrenched within us of modelling.

XV. "Art, that is when one could walk around it [the object],"[8] another definition of a mad man.

Is this not from Paul Gauguin, this ingenious and original history of modelling?

In the beginning, the pure arabesque with as little *trompe-l'oeil* as possible; a wall is empty: fill it with *taches* symmetrical in form, harmonious in colour (stained-glass windows, Egyptian paintings, Byzantine mosaics, kakemonos).

Then came the painted bas-relief (the metopes of Greek temples, the church of the Middle Ages).

The attempt of the ornamental *trompe-l'oeil* of Antiquity is taken up by the fifteenth century, replacing the painted bas-relief by painting with a bas-relief's modelling, which preserves, by the way, the original idea of decoration (the *Primitifs* remember under what conditions Michelangelo, the sculptor, decorated the vault of the Sistine Chapel).

The perfecting of this model: the modelling in the round this leads from the first Academy of the Carracci to our decadence. Art, that is when one could walk around [the object].

XVI. French sculpture of the early centuries (of the type of the portal of Vézelay) is known to derive from the Byzantine

[8] "L'Art c'est quand ça tourne."

illuminated manuscripts and not from reliefs. This makes understandable the use of folds of togas and ample drapery for simple arabesques to fill the spaces, folds drawn according to a very tasteful phantasy and carved in the stone, without corresponding to the possibility of draping an actual robe in the same manner. Paul Sérusier explained this device by archaic Athenas, Tanagra figures, the Victories from the temple of Nike Apteros, all Greek sculpture, all the Middle Ages, all the Renaissance. He added that this same concern for filling spaces, insipid to the normal eye, which invented unrealistic folds in drapery, produced in painting the modelling on the flesh. He cited a *bambino* by Raphael: " 'S' curves forming an empty space of enormous volume—to fill it, a delicate modelling sustaining the form."

O the multitude of great empty skies with the insignificant grey sea! And the horizon line an imperceptible detail in which literary critics have seen so many things!—And which may be reduced to "parallel lines on an atonal field." Think of the Renaissance's gilded white forms on blue (Veronese's clouds, Angelico's seraphim). Think of the marvelous cobalt or emerald backgrounds!

XVIII. The present time is literary to its marrow: refining minutiae, avid for complexities. Do you think that Botticelli intended to have in his "Primavera" that sickly delicacy, that sentimental affectation, that we have all seen in it? Well, then, work with that malice, with that after-thought, just see what formulae you will reach!

In all times of decadence, the plastic arts fade into literary affectations and naturalistic negations.

XIX. We demand too much when we demand quietness from our spirits. The people of the Renaissance let their works, infinitely profound and esthetic, gush from the abundance of their nature. A Michelangelo did not puff himself up like a Bernini or an Annibale Carracci to be impressive. His sensations, passing through the very sure knowledge he had of Art, became impressive by themselves. It was effort or straining that destroyed the Romantics.

XX. From the artist's state of mind comes unconsciously, or almost so, the whole *Feeling* of a work of art; "he who would paint the things of Christ should live with the Christ," said Fra Angelico. That is a truism.

Let us analyse: the Hemicycle of Chavannes at the Sor-

bonne, for which the vulgar find a written explanation necessary, is that picture "literary"? Certainly not, for such an explanation is false. The Baccalaureate examiners may know that a certain handsome form of an *ephèbe* languidly inclining toward something which looks like water symbolizes studious youth. Esthetes! Is this not a beautiful form? The depth of our emotion comes from the capability of these lines and those colours to explain themselves, by being simply lovely and divinely beautiful . . .

To continue: Does not the pettiness of *trompe-l'oeil*, sought or attained, contribute to the disagreeable effect I call "literary"?

I suppose that Friant[9] did the "Calvary" by Gauguin. This tends to become like F. Coppée's work.[10] This is because our impression of moral superiority, in front of the "Calvary" or the bas-relief *Soyez Amoureuses* could not come from the motif or motifs of nature depicted, but from the representation itself, its form and its colouration.

From the canvas itself, a plane surface covered with colours, springs emotion bitter or consoling, "literary" as painters say, without there being need of interposing the memory of another by-gone sensation (like that of the motif of nature that is utilized).

A Byzantine Christ is symbolic. The Jesus of modern painters, even dressed in the most exactly reproduced *kiffyed* is only literary. In one, the form is expressive; in the other, it is imitated nature which tries to be [expressive].

And as I said, every representation can be found to be natural, so every work of beauty can excite the higher emotions, the self-contained ones, the Extase of the Alexandrines. Even a simple experiment with lines, like Anquetin's *Femme en rouge* at the Champ de Mars, has an emotional value.[11]

Even the frieze of the Parthenon; even and above all, a great sonata by Beethoven!

XXII. There is the only one true form of Art. When unjustifiable preconceived opinion and illogical prejudices have

[9] E. Friant (1863–1932), a pupil of Cabanel, the popular painter of nudes.

[10] F. Coppée (1842–1908), poet and popular dramatist of scenes of everyday life, whose leading roles were played by Sarah Bernhardt.

[11] Anquetin (1861–1932), painter and designer of tapestries, member of Gauguin's group.

been eliminated, the field is left free to the painters' imagination, to the esthetes of beautiful appearances.

The neo-traditionalists[12] can not linger over scholarly and feverish psychologies, over literary sentimentalities, which call everything outside their emotional domain, legend.

It attains definitive syntheses. Everything is contained within the beauty of the work.

XXIII. The wretches who kill themselves to find something original in their servile skulls, new subjects or new visions! Refusing their worthwhile sensations because they have been taught to deny beauty, because they interpose their concern for *trompe-l'oeil* between the emotion and the work!

What are the distinguishing marks of the modern painters? It is often the vision (as I explained above): more often the procedure, still more often the subject.

What identical imagination! They all follow the same fashions. . . .

XXIV. Art is the sanctification of nature, of that nature which is everyone's who is content to live! The great art, that which is called decorative, of the Hindus, the Assyrians, the Egyptians, the Greeks, the art of the Middle Ages and the Renaissance, and the decidedly superior works of modern Art, what is it? Is it not the disguising of common sensations—natural objects—sacred icons hermitic and imposing?

The hieratic simplicity of Buddhas? of monks transformed by the esthetic sense of a religious race? Compare the lion of nature with the lions of Khorsabad; to which do we kneel? The Doryphorus, the Diadumenes, Achilles, the Venus de Milo, the Samothrace, that is truly the redemption of the human form. Is it necessary for the Saints of the Middle Ages to be mentioned? Must Michelangelo's prophets and the women of da Vinci be cited?

I have seen Pignatelli, the Italian, who posed for Rodin's *John the Baptist;* [see Plate 53] and he is, instead of the banal model, the apparition of the voice that walks, the venerable bronze. And the man that Puvis de Chavannes exalted into the Pauvre Pêcheur [Poor Fisherman] eternally sorrowful, what was he?

Universal triumph of the esthete's imagination over the efforts of stupid imitation, triumph of the emotion of Beauty over the naturalist lie.

[12] Denis, Vuillard, Bernard, the sculptor Maillol.

XIV. Have you noticed what the portrait has gained from this search for a highly "tapestry" effect? There is a beautiful imaginative painting, in spite of its timid proceeding, which dreams pastels of musical fantasy and portraits with the same dream. Don't you enjoy in the confusion of a Salon forgetting yourself before a Fantin-Latour?[13]

In this epoch of decadents who are the precursors—I hope —in this laborious preparation of something, those of us who lag are still the most finished.

I see *La Joconda* [Mona Lisa] again; O the voluptuousness of that happy convention which excluded life-likeness, the artificial and exasperating life-likeness of a waxen figure, that the others seek! And the light! and the air! The blue arabesques of the background, marvelous accompaniment of a caressing and conquering rhythm of the orange-hued motifs, like the seduction of the violins in the Tannhäuser Overture!

O Rixens, O Bonnat![14]

LETTER TO E. VUILLARD

Rome, February 15, 1898[15]

My dear Vuillard,

I am very glad that you thought of writing me. I have just been thinking of you recently and it is not only because of the Dreyfus affair. Rome produces its effect, we are having a pleasant time here; I am feeling very well, rather better, as regards my nerves, than at Florence. . . .

Now I begin to understand Raphael and this I believe to be a notable step in the life of a painter. Certainly this man is a prodigy, in twenty years he went from one end of his art to the other, he tried everything, succeeded in everything, he is incredibly varied. But we must overlook the appearance of his works (of almost all of them), and it is here that I find myself differing with you in thought these past days.

I believe that we are wrong to ask an immediate pleasure

[13] I. Fantin-Latour (1836–1904), painter and lithographer, known best for group portraits of his friends, e.g., "Hommage à Delacroix" (1864).
[14] J. A. Rixens (1846–1925), Léon Bonnat (1833–1922), painters whose work is characterized by a photographic reality.
[15] Translated from Maurice Denis, *Journal* (1884–1904) Vol. I., L. Colombe, Paris, 1957, pp. 133–35.

of a work of art, to ask that its exterior be pleasing, and that also we are wrong to think too much while we work on these qualities of appearance which are most characteristic of a quantity of mediocre, ephemeral and vain works, and on the contrary, in which deeply beautiful things are lacking. There is an error there, a fashion, an exaggerated reaction against an academic decadence and we must come to see this. Nothing is uglier than the "Last Judgement," and yet this is a marvel of painting. It is the same with the Raphaels in the Vatican; at first glance they could be any clear, harmonious and expressive primitive; and when one is truly in love with them one prefers them to all others. You will recognize that we could say the same of Poussin and Ingres, who are only the descendants of Raphael.

That which makes a work of art important is the fullness of the artist's effort, and the power of his will. This is why it is understandable that in Rome all the painters of the great period, and their meritorious students, such as Poussin and Ingres, only conceived of works in their finished state. I know of no other atmosphere which seems to me further removed from Impressionism. You hardly think of noting down from day to day your minor impressions even though they are delightful, you feel strong enough to undertake works whose execution would take two years like "The Vow of Louis XIII,"[16] I think; and I will certainly return confirmed in the ideas that I have already expressed to you on this subject when I was doing my portrait for the last Salon. . . .

Goodbye my dear Vuillard, excuse my chattiness.

Cordially yours,

MAURICE DENIS

[EDOUARD VUILLARD (1868–1940) attended the Lycée Condorcet and among its pupils were his friends, Maurice Denis, F. X. Roussel, and Lugné-Poë. Persuaded by Roussel to study painting, Vuillard, when he entered the Ecole des Beaux Arts, chose Jean Gérôme's studio. But it was his admiration of Puvis de Chavannes' quiet harmonious compositions and the simplicity of Japanese art that shaped his style.

Vuillard left the Ecole after two years and joined Bonnard,

16 [Painted by Ingres. See Plate 4.]

Roussel and Sérusier at the Académie Julian, where Adolphe Bouguereau (1825–1905) gave the instruction and criticism. This was the group of painters who with the sculptor Aristide Maillol became the "Nabis." Separating themselves soon from Denis' and Sérusier's intellectual conception of art as the materialization of "the idea," Vuillard, Roussel, and Bonnard depicted everyday themes in subtle tones rather than in Gauguin's pure color. Vuillard, who was especially stimulated by the flat planes and the asymmetrical composition of Japanese prints, arranged the familiar material from his immediate surroundings into decorative patterns of graduated color tones that suggest detachment, silence, and serenity.

Vuillard actively supported Lugné-Poë in the establishment of the Théâtre de l'Oeuvre, designed the sets for its opening (1893) with Ibsen's *Rosmersholm,* and supplied many of its posters and programs. He was one of the most skillful color lithographers in the group that made lithography such an important medium for advertising. He contributed to the movement and style of *l'art nouveau* by his murals in several private houses (1894–97), in the foyer of the Théâtre Comédie des Champs Elysées (1913), the Palais de Chaillot (1937), and the Assembly Hall of the League of Nations (1939).

Although Vuillard had achieved success by the 1890s—his first exhibition was held (1891) in the newly opened *Revue Blanche*—he was gradually forgotten until a retrospective exhibition held in 1938 brought him again to public attention.

SEE: C. Roger-Marx, *Vuillard: His Life and Work,* New York, 1946.
A. C. Ritchie, *Edouard Vuillard,* the Museum of Modern Art, New York, 1954.]

LETTER TO MAURICE DENIS[1]

[Paris] February 19, 1898

My dear Denis,

I suffer too much in my life, everywhere, in my work, from that which you discuss in your letter not to write you about it immediately. Help me define my thoughts.

It is not while I work that I think of those qualities of ap-

[1] Translated from Maurice Denis, *Journal* (1884–1904), Vol. I., L. Colombe, Paris, 1957, pp. 136–38.

pearance, of immediate pleasure. To generalize, I do not think of the quality of my acts when I do anything at all (think of my timidity, of my character). When I am lucky enough to work, to do anything, it is because I have within me an idea in which I have faith. Thus I do not pre-occupy myself with the quality of my result. I am *certain* that it has value; this corresponds to the generality, to the importance of that idea. In *those* moments of work don't talk to me of that "immediate pleasure, that external pleasantness" whose annoyance to a man of reflection I could understand. Better, you are going to win for I would not even understand what that meant.

But when I do not have faith!—I work, I do things obviously in bursts. In the intervals, you cannot imagine what sadness and moroseness there is. The ideas which guide me are like lightning bolts, but this does not mean that I do not admit the possibility of a more lasting light. Cross-examine me when you disagree with me. I will try to go back to the beginning.

I can easily understand it, but, through a constitutional weakness or a passing sickness, I actually experience only rarely that strength of will, that effort of which you like to speak. Our opinions are perhaps irreconcilable, would you have the patience to discuss it with me? You were accustomed early through nature, education, and circumstances to give a meaning to the word 'will.' Faced with certain results that pleased you, that you observed in others, in me for example, you give them logical causes according to your conceptions; perhaps in doing this you are misled. There was in my life, a moment in which, either through personal weakness or through a lack of solidity in my basic principles, everything was demolished. By process of elimination the groups of ideas that I had built up and in which I had faith have been reduced to elementary ideas. I say 'built up' because I have lived in spite of everything. In this wild tempest, I had no other guide than my instinct, pleasure, or rather the satisfaction that I found. In this way I became habituated to an excessive use of the words 'taste,' 'direct pleasure,' etc., whose dupe I am when I am defenseless, when I am not working. The feeling of certainty curtailed itself more and more; in particular, the work that I could have been doing became elementary. Happily for me I had friends. With their help I believed in the significance of simple harmonies of colors and shapes. This was the point where I was able only to write. But this was but the beginning of a dangerous convalescence.

Let us pass over this; the important thing is that I had enough to produce. And I allowed this to be called 'work.' This work gave results that permitted some grouping of satisfactory ideas, ideas that did not come into conflict with scruples on the necessity of finding everything within oneself (originality, personality and other vanities). I found in these the *same pleasure* as in the primitive attempts. This pleasure, this contentment, I feel, I understand, and I admit with you that it can be found in many different aspects, and that it can affect other, far more complicated characters. But, no matter what it may be, it remains necessary to me. Also I do not pretend to pass judgement. And if I were wise, I would always keep myself hidden so as to deceive no one, for the indifference which I show in front of a certain work of art, when I have a gleam of good sense I readily admit to be alone responsible for, and I admit the indifference not in judgement of the work of art but of the state I am in.

To sum it up, I have a horror, or rather, a cold fear of general ideas that I have not myself deduced, but I do not deny their value; I would rather be modest than to make a pretense to understand them. Be sure that I do not disdain what I enjoy when it appears. But I am much less solid than you think and I am astonished that you seriously disagree with me. A work of art whose execution would take two years! I know very well that that would be marvelous and I know that there have been those that have taken that long and that they give a great and almost unknown pleasure now to those who contemplate them. But personally I persist in trying to find in this pleasure a familiar sensation. In moments of weakness, until a certain excess of sadness strikes, I find myself changed enough so that I can leave the dead formulas and naturally find myself re-incarnating [sic] another one. . . .

Goodbye my dear Denis, answer if you have had enough patience to read this. Give my greetings to your wife to whom you most certainly owe a good part of your self-confidence.

Affectionately yours,

E. VUILLARD

[PAUL CÉZANNE (1839–1906) was the son of a banker at Aix-en-Provence. Together with his school companion, Emile Zola, Cézanne developed an enthusiasm for literature and art.

Cézanne began a study of law, but urged by Zola to join him in Paris, Cézanne obtained his father's permission to study painting there. He drew at the Académie Suisse but no instruction was given there, and his lack of technical proficiency discouraged him. While engaged on a portrait of Zola, he returned to Aix and entered his father's bank. He continued to paint and decorated the family's country house with the murals "Four Seasons."

In 1862 Cézanne again returned to Paris, establishing a continual pattern of alternating between the north and the south. He failed to gain admission to the Ecole des Beaux Arts, so he returned to the Académie Suisse, where he met Camille Pissarro and, through him, Renoir, and Monet, all of whom became lifelong associates. Cézanne joined the group of Manet's admirers that met at the Café Guerbois, bringing Zola with him. Cézanne and Zola visited together the two Salons of 1863, the official one and the "Refusés," and other exhibitions. The Delacroix retrospective exhibition (1864) exercised an influence on Cézanne, for until 1872 his natural inclination was toward romanticism as was shown by "The Orgy," "The Rape," and "The Temptation of St. Anthony." While painting strangely patterned canvases of discordant color at Estaque near Marseilles, Cézanne shed his early manner.

At the end of the Franco-Prussian War (1871), Cézanne returned to Paris. In the "Hanged Man's House" (La Maison du Pendu), painted near Paris, a tectonic sense of form defined by local color was united with the luminous tone of atmosphere.

At Pissarro's insistence, Cézanne's work was included in the first exhibition (1874) held by the Société Anonyme des artistes, peintres, sculpteurs et graveurs, referred to as the First Impressionist Exhibition, at Nadar's photography studio, Boulevard des Capucines. Formed by the frequenters of the Café Guerbois, the Société came to be known as the "impressionists" from a title of a Monet painting, "Impression: Sunrise," that was applied to the group by the critic Leroy.

Disturbed by Pissarro's critical reaction to "A Modern Olympia," "Landscape at Auvers," and "The Hanged Man's House," sensations of the exhibition, Cézanne worked alone at Aix for three years. He did not exhibit again with the Société until 1877, when his work was hung in a place of honor at the Third Impressionist Exhibition.

When his father, suspecting Cézanne's liaison with his

model and future wife, cut his allowance, Cézanne returned to the north (1878–80) and depended on Zola to meet his financial needs.

The majority of Cézanne's work during his prolific and mature period (1883–95) was spent in the depiction of landscape. To present the geometrical form below the surface incidents, he sought "the right motif" as his series of the Ste. Victoire mountain (1882–90) shows. Cézanne's still lifes, preferably "Apples and Oranges" (1895–1900), were his opportunity to create abstract compositions that retained the essence of the objects represented.

In the portraits of his classic period, "Woman with the Coffee Pot" (1890–94) was an example of his manner of combining geometric shapes and magnificent color.

In his series of single themes—the "Card Players," started in 1890, of which he did five; and the numerous "Bathers," first men and then women—Cézanne sought a more classical composition.

He resided at Fontainebleau and Paris during the major portion of the creation of these pictures.

As his style changed, Cézanne distanced himself from the Impressionists as a group. He never accepted the Impressionists' or Neo-Impressionists' pointillist technique of a division of color into paint elements. He "modulated" color by varying it between cold and warm, light and dark, dull or intense, within a continuous area of color. His paintings became known through their exhibition with "Les Vingts" (1897) in Brussels, at the World's Fair (1889), at Ambrose Vollard's shop (1895 and 1899), by the Société des Indépendants (1899 and 1901), at the Centennial exhibition (1900), at the "La Libre esthetique" (1901), Brussels. A room was given to his paintings at the Salon d'Automne (1904).

The publication of Zola's novel *L'Oeuvre* in 1886 broke their long association. Its main character, Lantier, an artist and a failure, possessed many recognizable traits of Cézanne as well as Manet. Cézanne withdrew within himself and was burdened by a sense of having failed in his calling. Deeply religious, he strove by means of his art to consummate a union with the Absolute.

In letters written at the end of his life, Cézanne often wrote what he thought would be beneficial for his correspondent's work and not necessarily a description of his own practice.

Cézanne's paintings are marked by a sensation of perma-

nence in a world of silence and classical tranquility. He perceived a geometric form underlying the confusion of nature, found confirmation for it in Kant's aesthetic theories, and verbalized his thought in the famous letter to Bernard that suggested to Picasso and Braque the feasibility to geometrize the forms of nature. Cézanne thus indicated to artists a way to continue his search for a balance between pure form intellectually realized and nature perceived sensorily.

SEE: Kurt Badt, *Die Kunst Cézanne,* Munich, 1957.]

LETTERS

To Charles Camoin[1]

Aix, 13th September, 1903

Dear Monsieur Camoin,

I was delighted to get your news and congratulate you on being free to devote yourself entirely to your studies.

I thought I had mentioned to you that Monet lived at Giverny; I hope that the artistic influence that this master cannot fail to have on his more or less immediate surroundings will be felt in accordance only with the strictly necessary weight that it can and must have on an artist young and well disposed towards work. Couture used to say to his pupils: "Keep good company, that is: Go to the Louvre. But after having seen the great masters who repose there, we must hasten out and by contact with nature revive in us the instincts and sensations of art that dwell within us." I am sorry not to be with you. Age would be no obstacle were it not for the other considerations which prevent me from leaving Aix. Nevertheless I hope that I shall have the pleasure of seeing you again. Larguier is in Paris. My son is at Fontainebleau with his mother.

What shall I wish you: good studies made after nature, that is the best thing.

If you meet the master [Claude Monet] we both admire, remember me to him. He does not, I believe, much like being

[1] Quoted from John Rewald (ed.), *Paul Cézanne: Letters,* translated by Marguerite Kay, Bruno Cassirer, Oxford, 1946, pp. 230–31.

bothered, but in view of the sincerity he may relax a little.
Believe me yours very sincerely,

PAUL CÉZANNE.

To Emile Bernard

Aix-en-Provence, 15th April, 1904

Dear Monsieur Bernard,

When you get this letter you will very probably already have received a letter coming from Belgium I think, and addressed to you to the rue Boulegon. I am well content with the expression of fine sympathy in art which you sent me in your letter.

May I repeat what I told you here: treat nature by the cylinder, the sphere, the cone, everything in proper perspective so that each side of an object or a plane is directed towards a central point. Lines parallel to the horizon give breadth, that is a section of nature or, if you prefer, of the spectacle that the Pater Omnipotens Aeterne Deus spreads out before our eyes. Lines perpendicular to this horizon give depth. But nature for us men is more depth than surface, whence the need of introducing into our light vibrations, represented by reds and yellows, a sufficient amount of blue to give the impression of air.

I must tell you that I had another look at the study you made in the lower floor of the studio; it is good. You should, I think, only continue in this way. You have the understanding of what must be done and you will soon turn your back on the Gauguins and the van Goghs!

Please thank Madame Bernard for the kind thoughts that she has reserved for the undersigned, a kiss from *père Goriot* for the children, all my best regards for your dear family.

To Emile Bernard

Aix, 12th May, 1904

My dear Bernard,

My absorption in my work and my advanced age will explain sufficiently my delay in answering your letter.

Moreover, in your last letter you discourse on such widely divergent topics, though all are connected with art, that I cannot follow you in all your phases.

I have already told you that I like Redon's talent enormously, and from my heart I agree with his feeling for and admiration of Delacroix. I do not know if my indifferent health will allow me ever to realize my dream of painting his apotheosis.

I am progressing very slowly, for nature reveals herself to me in very complex forms; and the progress needed is incessant. One must see one's model correctly and experience it in the right way; and furthermore express oneself forcibly and with distinction.

Taste is the best judge. It is rare. Art only addresses itself to an excessively small number of individuals.

The artist must scorn all judgement that is not based on an intelligent observation of character. He must beware of the literary spirit which so often causes painting to deviate from its true path—the concrete study of nature—to lose itself all too long in intangible speculations.

The Louvre is a good book to consult but it must only be an intermediary. The real and immense study that must be taken up is the manifold picture of nature.

Thank you for sending me the book; I am waiting so as to be able to read it with a clear head.

You can if you think it right, send Vollard what he asked you for.

Please give my kind regards to Madame Bernard, and a kiss from *père Goriot* for Antoine and Irene.

Sincerely yours,

P. CÉZANNE.

Aix, 26th May, 1904

My dear Bernard,

On the whole I approve of the ideas you are going to expound in your next article for the "Occident." But I must always come back to this: painters must devote themselves entirely to the study of nature and try to produce pictures which are an instruction. Talks on art are almost useless. The work which goes to bring progress in one's own subject is sufficient compensation for the incomprehension of imbeciles.

Literature expresses itself by abstractions, whereas painting by means of drawing and colour gives concrete shape to sensations and perceptions. One is neither too scrupulous nor too sincere nor too submissive to nature; but one is more or less master of one's model, and above all, of the means of ex-

pression. Get to the heart of what is before you and continue to express yourself as logically as possible.

Please give my kindest regards to Madame Bernard, a warm handclasp for you, love to the children.

PICTOR P. CÉZANNE.

Aix, 25th July, 1904

My dear Bernard,

I received the "Revue Occidentale" and can only thank you for what you wrote about me.

I am sorry that we cannot be together now, for I do not want to be right in theory but in nature. Ingres, in spite of his "estyle" (Aixian pronunciation) and his admirers, is only a very little painter. You know the greatest painters better than I do; the Venetians and the Spaniards.

To achieve progress nature alone counts, and the eye is trained through contact with her. It becomes concentric by looking and working. I mean to say that in an orange, an apple, a bowl, a head, there is a culminating point; and this point is always—in spite of the tremendous effect of light and shade and colourful sensations—the closest to our eye; the edges of the objects recede to a centre on our horizon. With a small temperament one can be very much of a painter. One can do good things without being very much of a harmonist or a colourist. It is sufficient to have a sense of art—and this sense is doubtless the horror of the bourgeois. Therefore institutions, pensions, honours can only be made for cretins, rogues and rascals. Do not be an art critic, but paint, therein lies salvation.

A warm handclasp from your old comrade.

P. CÉZANNE.

My kind regards to Madame Bernard and love to the children.

Aix, 23rd December, 1904

My dear Bernard,

I received your kind letter dated from Naples. I shall not dwell here on aesthetic problems. Yes, I approve of your admiration for the strongest of all the Venetians; we are celebrating Tintoretto. Your desire to find a moral, an intellectual point of support in the works, which assuredly we shall never surpass, makes you continually on the *qui vive,* searching in-

cessantly for the way that you dimly apprehend, which will lead you surely to the recognition in front of nature, of what your means of expression are; and the day you will have found them, be convinced that you will find also without effort and in front of nature, the means employed by the four or five great ones of Venice.

This is true without possible doubt—I am very positive—an optical impression is produced on our organs of sight which makes us classify as *light,* half-tone or quarter-tone the surfaces represented by colour sensations. (So that light does not exist for the painter.) As long as we are forced to proceed from black to white, the first of these abstractions being like a point of support for the eye as much as for the mind, we are confused; we do not succeed in mastering ourselves in *possessing ourselves.* During this period (I am necessarily repeating myself a little) we turn towards the admirable works that have been handed down to us throughout the ages, where we find comfort, a support such as a plank is for the bather. —Everything you tell me in your letter is very true.

I am happy to hear that Madame Bernard and the children are well. My wife and my son are in Paris at the moment. We shall be together again soon I hope.

I wish to reply as far as possible to the principal points in your kind letter, and please give my warmest regards to Madame Bernard and a good kiss for Antoine and Irene, and for you my friend, after wishing you a happy New Year I send you a warm handclasp.

P. CÉZANNE.

Aix, 21st September, 1906

My dear Bernard,

My cerebral disturbance is so great and I am so confused that I feared at one moment for my frail reason. After the terrible heat that we have just had a milder temperature has brought a little refreshment to our minds, and it was not too soon either; now it seems to me that I am better and that I think more correctly along the lines of my studies. Will I ever attain the end for which I have striven so much and so long? I hope so, but until it is attained a vague sense of uneasiness oppresses me which will not go before I have reached port safely, that is to say before I have realized something better than in the past, and in doing so proved the theories—which

in themselves are always easy; it is only giving proof of what one thinks that raises serious obstacles. So I continue to study.

But I have just re-read your letter and I see that I always answer off the mark. Be good enough to forgive me; it is as I told you, because of my constant preoccupation with the aim I have in view. I am always studying after nature and it seems to me that I am progressing slowly. I should have liked to have you here near me, for the solitude weighs rather heavily on me. But I am old and ill, and I have sworn to myself to die painting, rather than to go under in the debasing paralysis which threatens old men who are dominated by passions that coarsen their senses.

If I have the pleasure of being with you again one day we shall be better able to discuss all this in person. You must forgive me for continually coming back to the same thing; but I believe in the logical development of everything we see and feel through the study of nature and turn my attention to technical questions later; for technical questions are for us only the means of making the public feel what we feel ourselves and of making ourselves understood. The great masters whom we admire can have done nothing else.

A warm greeting from the obstinate macrobite who sends you a cordial handclasp.

P. CÉZANNE.

To His Son

Aix, 22nd September, 1906

My dear Paul,

I sent a long letter to Emile Bernard, a letter which reflects my mental preoccupations. I described them to him, but as I see a little further than he does and as the manner in which I told him of my reflections cannot offend him in any way even though I have not the same temperament nor his way of feeling, I have come to the conclusion that it is not possible really to help others. With Bernard it is true one can evolve theories indefinitely, for he has the temperament of a logician. I go into the country every day, the motifs are beautiful and in this way I spend my days more agreeably than anywhere else.

I embrace you and mamma with all my heart, your devoted father,

PAUL CÉZANNE.

My dear Paul, I have already told you that I am oppressed by cerebral disturbances, my letter reflects them. Moreover, I see the dark side of things and so feel myself more and more compelled to rely on you and to look to you for guidance.

INDEX

Abilgaard, N. A., 48 n, 71, 83
Abstract expressionism, 504
Académie Royale. *See* Royal Academy, Paris
Académie Suisse, 345, 353, 360, 522
Academies, art, role of, 415–17
"Achilles Receives the Ambassadors of Agamemnon," 32
"Actualistes, Les," 370
Adam, Robert, 250
Address on the Death of Thomas Banks, An, 30–32
Adler, Denkmar, 302
Adler and Sullivan, firm of, 320
Aeschylus, illustration of, 22
Against the Grain, 490
"Alone with the Tide," 392
Altes Museum, Berlin. *See* Berlin Museum
Amaury-Duval, 34 n–37
Amis de la Nature, Les, 346
"Angelus," 354
Anquitin, 515 n
Antiquités de la France, Monuments de Nîmes, Les, 250
"Anxiety," 499
"Apotheosis of Homer," 33
"Apples and Oranges" series, 523
Applied arts, 416–17; Morris on, 437–48
"Après Dîner à Ornans, L'," 346
Arago, Alfred, 377
Arc de Triomphe, 255–56, 262–63, 407 n
Architecture, of cemeteries, 264–71; of civic buildings,

248–55; Gothic, 135, 212–13, 282–83, 296, 421–33; of houses, 310–25; of libraries, 294–300; of office buildings, 301–10; of public monuments, 255–63; theories of: Boullée, 192–99, 265–68, Durand, 202–12, Viollet-le-Duc, 214–25
Architecture, An Essay on Art (Boullée), 191–98
Architecture Considered in Relation to Art, Mores, and Legislation (Ledoux), 229–42, 311–13, 418–21
Architecture of Country Houses, The, 314
A Rebours, 483–88
Armory Show, New York, 1913, 490
"Arrangement" series, 392–93
Art, L', 406
Art, history of, 274, 280–82; museums, 271–72, 283; training in, 415–17
Art and Craft of the Machine, 322
Art criticism. *See* Criticism, art
"Art for art's sake" movement, 172, 389
Artist and Society, The, 415–48
"Artist's Studio, The," 346, 349–50
Art Moderne, L', 482
Art nouveau, 213, 500, 508, 519
Art sacré, 503
"Arundel Mill and Castle," 115
Ashbee, C. R., 322
A Soi-Même, 490

Hunt, William Holman (*cont'd*)
Pre-Raphaelite Brotherhood,
131–40
Husson, Jean. *See* Champfleury
Huysmans, Joris K., 389, 481–
89, 496, 502; excerpt from
*Against the Grain (A Re-
bours)*, 483–88; excerpt from
Certaines, 488–89; on Cé-
zanne, 488–89; life, 481–82;
and Moreau, 483–88; and Re-
don, 490

Ibsen, Henrik, 499–500
"Icarus and Dedalus," 47
*Iconographie Chrétienne, His-
torie de Dieu,* 141
Iconography, 141
"Ideal City of Chaux" (Le-
doux), 189; excerpt, 228–42
Iliad, illustration of, 22, 101
Illustration, art of, 22, 94, 134–
35, 152, 368; Blake's, 101–2;
Redon's, 490
Imperial Hotel, 322
Impressionists, Cézanne's sepa-
ration from, 523; color the-
ory for, 327; derivation of
term, 522; exhibitions by,
400, 501, 522; Huysmans on,
481–82; pointillist technique
of, 468, 499, 523; van Gogh
on, 477
Industrial design, 437–48
Industrialization, effect on art
of, 415–17
Ingres, Jean Auguste Domi-
nique, 32–38, 41, 45–46, 171,
295, 468, 502, 518, 527;
"Apotheosis of Homer," 508;
on color, 37–38; doctrine of,
34–38; on drawing, 37; on
Greek art, 35; influence on
Degas, 35, 399; influence on
Nabis, 33; life, 32–33;
Proudhon on, 436

Institut des Beaux Arts, 14–15
"Iris," 472
"Iron Age," 406
Isabey, E., 377

"J'Accuse," 371
"Jacob Wrestling with the An-
gel," 152
Jameson, Mrs. Anna, 140–50;
life, 140–41; from *Sacred
and Legendary Art,* 142–50
Janmot, 36
Japanese art, influence of, 367,
388, 399, 472, 479–80, 499,
502, 518–19
Jardin Anglais, 264
Jardin des Plantes, 157, 272–73
"Jardin Elysée," 264, 274,
278–79
Jefferson, Thomas, 249–55; let-
ters on design of state capitol
of Virginia, 251–55; life,
249–50
Jena, 56
Jenney, William L., 301–2
"Jesus and His Apostles," 49
"Jewish Wedding in Morocco,"
151
Journal de Paris, 12–14, 40–51,
116
Journal des Débats, 42 n, 51
Journal of Eugène Delacroix,
excerpts from, 152–71
*Journey of the Young Anachar-
sis,* 4
Juel, J., 71
"Jupiter and Thetis," 32

Kant, 449, 466, 524
Kaufmann House, 321
Keats, John, 130
Kelmscott Press, 438
Kindergarten Chats (Sullivan),
excerpts, 303–9
King's Cross Station, 297
Kleist, von, 84
Klenze, von: Walhalla, 255

Grateful acknowledgment is made to the following for copyrighted material:

ART CATHOLIQUE Excerpts from *Theóries of Maurice Denis.* Reprinted by permission.

G. BELL & SONS, LTD. Excerpts from M. E. Chevreul, *The Principles of Harmony and the Contrast of Colours and their Applications to the Arts,* translated by C. Martel, reprinted by permission.

PIERRE CAILLER Excerpts from *Courbet, Raconté par Lui-même et Par Ses Amis,* reprinted by permission.

BRUNO CASSIRER, LTD. AND JOHN REWALD Excerpts from J. Rewald, *Paul Cézanne: Letters,* translated by M. Kay, reprinted by permission.

CROWN PUBLISHERS Excerpts from *The Journal of Eugène Delacroix,* translated from the French by Walter Pach, copyright 1948 by Crown Publishers, Inc. Excerpts from *Manet,* by Duret, translated by J. L. Flitch, copyright 1937 by Crown Publishers, Inc. Both reprinted by permission.

FABER AND FABER, LTD. Excerpts from *Garden Cities of Tomorrow* (published in the U.S. by M.I.T. Press), reprinted by permission of Faber and Faber, Ltd. and Edizioni Calderini Bologna.

VICTOR HAMMER Excerpts from *Three Fragments,* by Conrad Fiedler, translated by Victor Hammer, reprinted by permission.

P. H. HEITZ Excerpts from Adolf von Hildebrand, *The Problem of Form in Painting and Sculpture,* translated by M. Meyer and R. M. Ogden, reprinted by permission.

RENE HUYGHE, HELENE ADHEMAR Excerpts from *Courbet, L'Atelier du Peintre,* by René Huyghe and Hélène Adhemar, reprinted by permission.

ALFRED A. KNOPF, INC. Excerpts from Pola Gauguin, *My Father, Paul Gauguin,* translated by A. G. Chater, copyright 1937 by Alfred A. Knopf, Inc. Reprinted by permission of Alfred A. Knopf, Inc., and MacMillan Publishing Company (in the UK). Originally published in the UK by Cassell & Company, Ltd.

LA COLOMBE Extracts from the *Journal,* translated from Maurice Denis, reprinted by permission.

LIBRAIRIE DROZ Excerpts from *Zola's Salons,* by F. W. J. Heming and Robert Niess, reprinted by permission.

LIBRAIRIE JOSE CORTI Excerpts from Odilon Redon, *A Soi-même,* reprinted by permission.

LIVERIGHT PUBLISHING CORPORATION Excerpts from *Paul Gauguin's Intimate Journals,* translated by Van Wyck Brooks, copyright 1949 by Van Wyck Brooks, reprinted by permission.

LITTLE, BROWN & COMPANY, INC. Excerpts from *The Complete Letters of Vincent van Gogh,* reprinted by permission.

PHAIDON PRESS, LTD. Excerpts from Baudelaire, *The Mirror of Art,* translated by Jonathan Mayne, reprinted by permission.

PRINCETON UNIVERSITY PRESS Excerpts from Lopez-Rey, *Goya's Caprichos, Beauty and Caricature,* Volume I, reprinted by permission of Princeton University Press and Oxford University Press.

RANDOM HOUSE, INC. Excerpts from *Against the Grain,* by J. K. Huysmans, with an introduction by Havelock Ellis, reprinted by permission.

VERLAG PHILIPP RECALM Excerpts translated from *Deutsche Literatur, Hunstanschaung der Fruehromantik,* W. H. Wackenroder, and L. Tieck, *Herzensergiessungen Eines Kunstliebenden Klosterbruders,* edited by Dr. A. Miller, reprinted by permission.

THE UNIVERSITY PRESS Excerpts from *The Shop-Talk of Edgar Degas,* by R. H. Ives Gammell, reprinted by permission of the University Press and the author.

HANS VON HUGO VERLAG Excerpts from Gilly, *Wiedergeburt der Architectur,* by A. Rietdorf, reprinted by permission.

WITTENBORN ART BOOKS, INC. Excerpts from *Kindergarten Chats, and Other Writings,* by Louis Sullivan, reprinted by permission.